MODERNIST
AMERICA

Also by Richard Pells

*Not Like Us: How Europeans Have Loved, Hated, and Transformed
American Culture since World War II*

*The Liberal Mind in a Conservative Age: American Intellectuals
in the 1940s and 1950s*

*Radical Visions and American Dreams: Culture and Social Thought
in the Depression Years*

MODERNIST
AMERICA

■

ART, MUSIC, MOVIES,
AND THE GLOBALIZATION
OF AMERICAN CULTURE

■

RICHARD PELLS

Yale

UNIVERSITY PRESS

New Haven and London

Yale University Press books may be purchased in quantity for educa-
tional, business, or promotional use. For information, please e-mail
sales.press@yale.edu (U.S. office) or sales@yaleup.co.uk (U.K. office).

Set in Sabon and Helvetica type by The Composing Room
of Michigan, Inc.
Printed in the United States of America.

Library of Congress Cataloging-in-Publication Data
Pells, Richard H.
Modernist America : art, music, movies, and the globalization of
American culture / Richard Pells.
p. cm.
Includes bibliographical references and index.
ISBN 978-0-300-11504-8 (cloth : alk. paper) 1. Arts and glo-
balization—United States. 2. Arts, American—20th century.
3. Modernism (Aesthetics)—History—20th century. I. Title.
II. Title: Art, music, movies, and the globalization of American
culture.
NX180.G56P45 2011
700.973′0904—dc22
2010029944

A catalogue record for this book is available from the British Library.

This paper meets the requirements of ANSI/NISO Z39.48-1992
(Permanence of Paper).

10 9 8 7 6 5 4 3 2 1

For Molly, again

CONTENTS

PREFACE

On my seventh birthday, my mother organized a party and invited all the neighborhood children because she worried that, as an only child, I did not have enough friends. The high point of the party was a trip to the movies. I didn't make any friends at my birthday festivities, and I'm still not ecstatic about socializing. But I do remember the movie. It was John Ford's *Fort Apache,* with John Wayne and Henry Fonda.

Later, when I was a freshman at Rutgers, located thirty miles from Manhattan, I recall an upperclassman expressing horror that one of my fellow incoming students did not know where the Guggenheim Museum was. I didn't know where it was either. Or what it was. But I figured I'd better find out if I hoped to be "educated" at a time when a university education meant displaying (or at least faking) some knowledge about art, music, and literature.

It never occurred to me at the time that there might be a connection between John Ford and Frank Lloyd Wright. This book is about that connection. More generally, it is about how American architects like Wright and filmmakers like Ford (together with painters like Jackson Pollock, composers like Aaron Copland and George Gershwin, and musicians like Charlie Parker) translated an array of modernist ideas and techniques into a distinctively American idiom. And then how they converted an artistic revolution that was originally foreign, especially European, into a global culture that has dominated

our lives and our perspectives all through the twentieth and into the twenty-first century.

Most people, including me, who have written about the world-wide impact of American culture tend to emphasize the ability of foreigners to adapt America's cultural exports to their own needs and traditions. In this book, I am reversing the argument. What interests me here is how Americans have used and transformed the cultural influences they receive from abroad. American artists and filmmakers have always depended on foreign innovations, and they benefited throughout the twentieth century from the presence in the United States of émigré and refugee painters, architects, composers, and movie directors. Americans have been as much an audience for foreign works of art as they have been molders of the world's culture and values.

The artistic movement from abroad that most influenced the development of American culture in the twentieth century was modernism. *Modernism* is a notoriously elastic word. It can embrace any number of artists and writers, both in America and overseas. But for my purposes, modernism means the effort—beginning in the early twentieth century—to invent a new language to describe the scientific, political, and social upheavals of the modern world. That language could be literary, as in the case of the modern novel; visual, as in the case of painting, architecture, advertising and design, and film; or aural, as in the case of music. The point, however, was to force people to see, hear, and think about the world in entirely new ways, ways that made the bedlam of urban life, the unsettling effects of technological change, the transfer and "cleansing" of populations, the terrors of totalitarianism, and the impersonal butchery of modern warfare seem more intelligible if no less disorienting.

Modernist artists were also disdainful of the nineteenth century barricades between high and low culture. Instead, they persistently shifted back and forth between the realms of art and play, between the most obscure forms of painting and music and the desire to reach and enthrall an audience. And the modernists were self-referential; they called attention to their own personalities in their work, as if we were to admire not only the lines and colors on a canvas, or the structure of a building, or the lights and shadows in a movie, but the performance of the painter, the musician, the novelist, the architect, the cinematic

auteur. In this sense, the modernists were always actors—which is why acting itself, in the theater and the movies, became a symbol of the modernist revolution in all of the arts.

Apart from architecture, I do not devote much space to analyzing postmodernism. This is because the postmodern sensibility—particularly the blending of styles from high and popular culture, the attentiveness to profitability and public acceptance, and the celebration of the artist's persona—were already conspicuous in modernist art. Pablo Picasso and Marcel Duchamp were as eclectic in their creations, and as sensitive to the vagaries of the art market as well as the power of the media, as was Andy Warhol.

Similarly, Hollywood filmmakers—even those as stylistically eccentric as Orson Welles or Robert Altman—understood (as did the postmodernists, with their relentless reproductions of the images of Elizabeth Taylor and Marilyn Monroe) the links between the esthetic power of the cinema and the economic pressures of show business. Especially in America, long before the arrival of postmodernism, modernist art and commercial considerations were everlastingly fused.

The idea that American culture is central to the modernist experience might seem heretical to those who assume that America's creative spirit is best exemplified by Walt Disney and Louis B. Mayer. Americans have rarely been portrayed (or regarded themselves) as highbrow specialists in complexity and artistic sophistication; those roles are customarily reserved for Europeans and other members in good standing of the foreign intellectual elite. Americans, in contrast, are often dismissed as lowbrow entertainers, purveyors of popular culture for the masses.

But the modernists abroad were always fascinated with American culture—with its novels, its movies, its jazz, its Broadway musicals, its cities and skyscrapers, and (after World War II) its Abstract Expressionist paintings. Whether they worshiped Fitzgerald or Hemingway, Duke Ellington or Leonard Bernstein, *Citizen Kane* or *The Godfather,* foreigners recognized that, increasingly in the twentieth century, America was the land both of modernism and modernity, the place where you had to spend time if you wanted to absorb the latest trends in art, music, and the cinema.

America's reliance on foreign concepts and talent, as well as its af-

fection for anything new and surprising, made the United States the incarnation of our modernist view of the world. These were also the qualities that helped American culture become not so much foreign as familiar to people all over the planet.

My conception of culture, however sympathetic with the modernist project, may strike some readers—particularly in academia, among American historians—as old-fashioned. That is, I am less concerned with the issues of gender and class, or with the contours of everyday life—as momentous as these subjects are—than with the enduring importance of high culture and mainstream popular culture. I believe that a crucial component of America's history (as of any country's history) is its literature, its painting, its architecture, its music, and its films. And that these art forms are as illustrative of a nation's identity as its politics, its foreign policy, its economic institutions, and its social conflicts.

So I hope in this book that we can all be reminded, as I have been while I was writing it, why the lyrics of Cole Porter and Lorenz Hart were so dazzling, why the choreography of Jerome Robbins and Bob Fosse was so breathtaking, why Marlon Brando was such an astonishing actor, and why George Gershwin's *Rhapsody in Blue* and Miles Davis's *Kind of Blue* continue to define what is unique about America's music and its culture.

When I was young, I learned to love the movies of John Ford and the buildings of Frank Lloyd Wright. I still do. This book is, above all, a testament to that love.

Writing is a solitary, antisocial pursuit. You have to enjoy your own company—your own ideas, the sound of your prose, the rhythm of your sentences—in order to confront the computer screen each day. But no one writes a book without the suggestions, challenges, and emotional sustenance of friends.

I have been benefited immeasurably from the assistance of close friends in the writing of this book. Jessica Gienow-Hecht and I persistently argued about our mutual interests, joked about our frustrations as authors, and supported each other through the difficulties of turning embryonic thoughts into a finished work. She also read the chapter on classical music, forced me to sharpen my ideas, and en-

couraged me on occasions when I needed it most. Susan Glenn and Judy Siegel each read the chapter on Broadway and Hollywood musicals and provided equally discerning advice. Robert Abzug's technical expertise was indispensable as I was completing the book. More generally, I have been aided enormously by the insights of Rob Kroes, David Ellwood, and Winfried Fluck, who listened to my lectures in various European venues and inspired me to think more clearly about what I was saying. Just as important, all these friends gave me not only their abundant knowledge of particular topics but the invaluable gift of their camaraderie.

Karen Winkler allowed me to try out many of my ideas in numerous articles for the *Chronicle Review,* the magazine of the *Chronicle of Higher Education,* articles that, as a superb editor, she invariably strengthened. My editors at Yale University Press, Chris Rogers and Laura Davulis, were unfailingly helpful, alleviating the normal anxieties of an author and making the entire process of book publication smoother. Dan Heaton copyedited the manuscript with care, shrewdness, and humor. Additionally, I am grateful to Lara Heimert for having originally offered me a contract at Yale on the basis of a proposal that now bears little resemblance to the actual book. Finally, I received two fellowships from the University of Texas, which gave me time off to research and write portions of the book. I also received a University Co-operative Society Subvention Grant awarded by the University of Texas to help pay for the rights to the photographs of George Gershwin and Marlon Brando on the book cover.

Most of all, Molly Dougherty accompanied me—intellectually and psychologically—from the inception of the book until its completion. It was not just her salient recommendations about how to improve every page of the manuscript that mattered. She lived the book as much as I did. And she put up with me as she always has since the day we met. Without her presence in my life, I would never have felt so fulfilled. That is the reason this book is, again, for her.

Modernism in Europe and America

■

If you live in Oslo or Tokyo, São Paulo or Sydney, the emergence of a global culture is synonymous with the "Americanization" of the world. Because in these cities, and everywhere else, the artifacts of America's culture are inescapable.

When foreigners worry about the impact of American culture on their own societies, they are not thinking of America's literature, painting, or ballet. Americanization has always meant the worldwide invasion of Hollywood movies, television programs, jazz, rock and roll, advertising, theme parks, shopping malls, fast food, and now the Internet. No wonder, then, that people abroad believe that the United States systematically exports its cultural values while everyone else is a passive recipient, molded and manipulated by the insidious power of the American media. No wonder, too, that the apparently one-sided cultural relationship between America and the rest of the planet gives rise to persistent complaints overseas that Hollywood, McDonald's, and Disneyland are eradicating regional and local idiosyncrasies—disseminating images and subliminal messages so beguiling as to drown out the competing voices in other lands.

Yet in the nineteenth and early twentieth centuries, the perception of the United States as a cultural "hegemon" would have seemed ludicrous both to foreigners and to Americans. Then, Americans suffered

from a deeply ingrained sense of cultural inadequacy. In a country where P. T. Barnum and Buffalo Bill were superstars, and where the benefactors of museums and symphony orchestras sought respectability by buying up European paintings and musicians at exorbitant prices, the cognoscenti regarded American culture as derivative, provincial, second-rate, a pitiable imitation of what was going on in the arts across the Atlantic. Over there—in London, Paris, Vienna, Berlin—was where Americans had to be if they wanted to learn, humbly, about the latest trends in science, painting, literature, music, even movies.

Neither of these notions—that America was once a cultural backwater and is now a cultural behemoth—bears much resemblance to the truth. Whether before World War I or after World War II, the cultural connections between the United States and the world have never been as unequal as the presumptions about America's earlier inferiority or its contemporary dominance suggest. On the contrary, the relationship has always been reciprocal. The United States was, and continues to be, as much a consumer of foreign intellectual and artistic influences as it has been a shaper of the world's entertainment and tastes.

The real issue, though, is not which continent is culturally ascendant in any given era, but how people use, modify, and reinterpret the cultural transmissions they receive from other countries. In the early twentieth century, no cultural movement in Europe had a greater impact on American artists and writers than modernism. Modernist painters, composers, and novelists shattered the esthetic conventions and philosophical faiths of the nineteenth century, first in Europe and then in the United States. And, in the wake of the massacres of World War I, the modernists created a genuinely new culture for the twentieth century.

But the new culture turned out to be neither highbrow nor European. Instead, America transformed what was initially an avant-garde and parochial project, appealing largely to the young and rebellious in Western society, into a popular culture with global appeal.

Nor was modernism just an insurrection in the arts. It was also a response to the phenomena we have all been living with for more than one hundred years: urbanization, the revolution in science and technology, the acceleration of news and information, new kinds of enter-

tainment, and the displacement and migration of entire populations in the midst of war, totalitarianism, and terror.

No nation has embodied or tried, not always successfully, to cope with these upheavals more than America. So the modernist view of the world, however much it originated in Europe, ended up being distinctively American. The United States did not invent modernism. But as the land of modernity, speed, immigrants, skyscrapers, movies, and immense political and economic power, America became modernism's cosmopolitan home.

The Modernist City

The rise of modernism coincided with, and depended upon, the emergence of huge, glittering metropolises in the late nineteenth and early twentieth centuries. Just before the outbreak of World War I, London's population had grown to five million. London's foremost rivals in Europe, Paris and Berlin, had populations of three million and two million, respectively. By 1920 the five boroughs of New York City boasted a population of more than five million.[1]

Yet it was not only the size of these and other cities in Europe and the United States that inspired the modernist movement in literature and the arts. Cities were also sanctuaries for a jumble of ethnic groups, as well as for writers uprooted from the claustrophobia of the countryside and for innumerable eccentrics in flight from bourgeois expectations. Vienna, for example, was among the five largest cities in the world in 1890, chiefly because it beckoned to people of various nationalities and intellectual inclinations from throughout the Austro-Hungarian empire.[2] The international complexion of urban life in Vienna and elsewhere was exceptionally stimulating, especially for those young men and women fresh from the provinces who needed the sophistication of the big city to reflect on the home towns they'd escaped—like James Joyce, who could write about Dublin most incandescently from the perspective of Zurich, or Ernest Hemingway, who began to portray ex-soldiers returning awkwardly to the American Midwest or seeking solace on fishing trips in upper Michigan once he'd settled in Paris.

Cities also provided the infrastructure for cultural improvisation.

Here, in the city centers or bohemian enclaves, were the publishing houses with quirky editors looking for unconventional manuscripts, the offices of offbeat newspapers and "little" magazines, alternative bookstores and art galleries, experimental theaters and cabarets, and concert halls offering the most cacophonous music yet composed. The city, too, was the habitat of trendy audiences willing to pay for the privilege of being stunned or lampooned.

So it was hardly surprising that the urban scene was often the subject of modernist paintings and novels. Impressionist canvases were filled with urban imagery, from shimmering cathedrals to ballet rehearsals to city dwellers strolling or picnicking in the park. In their collages, the Cubists used newspapers, posters, sheet music, the fragments of everyday life in the city. Joyce's *Ulysses* could have served as a street map of Dublin, just as Hemingway's *The Sun Also Rises* guided the reader through the boulevards, restaurants, and hotel bars of Paris and Madrid.

At the same time, modernist "schools" of art were closely identified with particular cities. In Germany, Die Brücke, a precursor of Expressionism, flourished in Dresden between 1905 and 1913, while Wassily Kandinsky's Blaue Reiter group found a home in Munich in 1911. The Dadaists loudly launched themselves at their very own Cabaret Voltaire in Zurich in 1916, but quickly established outposts in Berlin, Cologne, Barcelona, Paris, and New York.[3]

Of all the European cities, none was more modernist than Paris. By the early twentieth century, the legendary city was attracting novelists, poets, painters, composers, and political exiles from all over Europe, as well as from other parts of the world, including America. Particularly in the years between 1900 and 1930, Paris offered shelter, temporary or permanent, to a galaxy of international intellectuals, artists, and performers—among them the scientist Marie Curie; the composers Claude Debussy and Maurice Ravel; the actress Sarah Bernhardt, one of the first celebrities in the twentieth century theater; the "exotic" African American singer and dancer Josephine Baker; writers as impenetrable as Gertrude Stein and James Joyce, or as lucid as Ernest Hemingway and F. Scott Fitzgerald; the Cubist insurgents like Pablo Picasso and Georges Braque; and the jazz musician Sidney Bechet.[4] Paris had become the cultural capital of the West, a position it would retain

until World War II, when its exalted status was supplanted by New York.

The symbol of Parisian modernity was the Eiffel Tower, which opened at the Paris Universal Exhibition in 1889. A celebration of modern engineering, technology, and design, it remained the tallest landmark in the world, at 984 feet, until the construction of the Chrysler and Empire State Buildings in New York in the 1930s. But the Tower's real embrace of the future occurred in the second decade of the twentieth century, when it began to transmit radio signals, heralding the birth of an entirely new form of communication and popular culture.[5]

Paris's major competitor as a home to the modernist intelligentsia and artistic elite was Vienna, at least until the end of World War I and the disintegration of the Austro-Hungarian empire. Thereafter, the city of Gustav Mahler and Sigmund Freud lost its cultural centrality in the German-speaking world to Berlin. Particularly for Jewish writers, playwrights, and filmmakers, Berlin in the 1920s seemed a place of greater freedom and tolerance than they had experienced in the stodgier, Ringstrasse-encircled, and supposedly more anti-Semitic Vienna.

It is impossible now to visualize what pre-Hitler Berlin was actually like. The reality of life in Berlin in the 1920s and early 1930s has been superceded by the indelible image of Joel Grey, with his rouged cheeks and serpentine smile, welcoming us all to the cabaret. Of course, Grey's master of ceremonies could have been a character in an Otto Dix painting or a Fritz Lang movie.

Indeed, Bob Fosse's version of Berlin was not entirely fanciful. Between 1918 and 1933, the years of the jittery Weimar Republic, Berlin was drenched in artistic (and sexual) innovation, as well as economic turmoil and political violence. Berlin was where the young modernists from the rest of Germany and central Europe established themselves, not just in the city's signature cabarets, but in theaters, concert halls, and the new German film industry. Here, in Mitte, Charlottenberg, or on the Kurfürstendamm, you could find Max Reinhardt, Bertolt Brecht, Kurt Weill, and Erwin Piscator planning new plays with dissonant music, extravagant staging, and bizarre acting styles, preferably featuring some newcomer like Peter Lorre. Here too you could watch Bruno Walter and Otto Klemperer conduct symphony orches-

tras, as well as see the latest Expressionist movies in the recently opened and gleaming movie palaces.[6]

With its scorn for philosophical pretentiousness, a conspicuously German affliction, Berlin became the principal meeting place in Europe for high and low culture. Which was one reason why the cabarets played such a crucial role in mingling the tastes of the intellectuals and the masses (or their more dissolute representatives). And why Alfred Döblin's 1929 novel *Berlin Alexanderplatz* reflected (like Joyce's *Ulysses*) the modernist fixation with the seedy demimonde of the twentieth-century metropolis. Because of its insouciant mixture of serious art and bawdy entertainment, Berlin was the European city that most resembled New York.

But then, maybe no city, either in Europe or in the United States, resembled New York. Although Chicago had become America's second-largest city by the late nineteenth century, with a thriving urban culture that included a major museum and university, one of the country's preeminent symphony orchestras, and numerous foreign-language newspapers and theaters, New York—or more particularly Manhattan—was the city most travelers from abroad or from the American hinterlands felt they had to see.[7] By the 1920s people everywhere were gazing at images of Manhattan's skyline, enshrined in countless newspaper and magazine photographs, and above all in the movies. The New York skyscrapers became the prime symbols of America's emerging wealth and power.

More than any city in the world, New York epitomized modernity. This was not because other cities were unfriendly to the construction of tall edifices; Parisians grew to love their Eiffel Tower, while Chicagoans appreciated the muscularity of Louis Sullivan's architecture. Within the first two decades of the twentieth century, many cities besides New York were filled with cars, buses, taxis, subways, and elevated lines. Nor was the rapid adoption of new technologies, like electricity, a uniquely American trait. In the late nineteenth century, European city governments saw electricity as a valuable tool for civic boosterism, so they began using artificial lights to outline monuments, bridges, and public buildings. Indeed, the French pioneered in the development of electric and neon lights; by 1900 the Champs-Elysées and its adjoining streets were among the most illuminated boulevards on earth.[8]

New York, however, exploited every type of electric light—arc lights, carbon-burning lights, spotlights, floodlights, searchlights, lights that jiggled or blinked on and off, lights in black and white as well as in color—not just to brighten the streets but to turn whole areas, like Broadway and Times Square, into dazzling spectacles of advertising and show business. Every possible façade was lit: the marquees of theaters, movie palaces, and vaudeville houses; the outdoor signs of hotels and restaurants; the glossy windows of department stores; and, of course, the silhouettes of the skyscrapers.[9] In a pattern that would be repeated in other forms of cultural adaptation, Americans—or in this case New Yorkers—expanded on and redefined the sights and sounds of modernity far beyond what people in London or Paris might have envisioned or tolerated.

Underneath the lights, New York was a city teeming with immigrants. As was America itself. Between 1880 and 1920, twenty-eight million immigrants came to the United States. Most lived in cities. New York had the largest influx of newcomers: thirteen million arrived between 1890 and 1919, the majority from Italy and eastern Europe. By the 1920s nearly half of all New Yorkers were Catholic, another third were Jewish, and only 15 percent were white Anglo-Saxon Protestants.[10] In fact, more Jews lived in New York than in Warsaw. There was a growing Asian and Hispanic presence in New York as well.

In response to these strangers engulfing the United States with their disparate religions, "alien" social customs, and potentially dangerous political beliefs, Congress severely reduced immigration in 1924 and imposed quotas that favored immigrants from northern and western Europe. Yet in the 1920s a person could still walk for blocks in lower Manhattan, Brooklyn, or the Bronx without hearing a word of English spoken or seeing an English-language sign.

Over time, the immigrants in New York and throughout the country played a crucial role in the development of American science, literature, painting, architecture, music, movies, fashion, and food. They served as a transmission belt for foreign ideas, and helped create in the United States a culture more cosmopolitan than anywhere else.

But they paid a high price for their impact on American culture and society. The novels, plays, and memoirs about immigrant life—written not only by Europeans but also by Hispanics and Asians—are

filled with confessions of duplicity and betrayal. The central issue of immigration and assimilation was always fought out within families. And in this tormenting struggle, parents and children were mutually implicated.

In these accounts, there is first of all the archetypal immigrant father (or sometimes the grandfather) who speaks with a thick Irish brogue, a Sicilian or Cantonese dialect, or a Yiddish accent. This is a man who admires the culture and traditions of whatever country he has left behind, who was once a figure of authority and respect on whom others relied for his political wisdom, his love of opera, or his knowledge of the Torah. Now, in the bizarre new world of America, he is bewildered, without moral stature, a relic from another time and place, incapable of passing on what he knows to his son or daughter. He is frustrated with but resigned to his loss of prestige and position.

Second, there is the mother—shrewd, realistic, self-sacrificing, urging the children to become "American." She is the one who tells them to speak only English, compete for high grades in school, escape the poverty and ineptitude of the father, do better and rise higher in the new land than the parents ever could.

Finally, there are the children themselves—though in immigrant chronicles more often the son. He is the "golden boy," agile of mind and fast on his feet, who will redeem the sufferings and anxieties of his parents. Yet he is also, as Alfred Kazin poignantly recalled of his adolescence in *A Walker in the City*, the young man suspended on the Brooklyn Bridge, looking back to the ghetto in Brownsville and ahead to Manhattan, the city of the Americans. He recognizes that in order to cross the bridge and prosper in America he must repudiate the values, the codes, and the language of his parents. And he knows that this is exactly what his parents want him to do, no matter how much they regret their loss of influence over him. In the distance he must travel, physically and intellectually, from the old neighborhood, he is fulfilling his parents' dreams even as he rejects their lives.

These psychic strains between first-generation immigrants and their progeny, the private conflicts between parents and children each in agony over what they had to give up in order to get ahead, were echoed in the experience of African American artists and writers trying to succeed in a white society. This was especially true in New York,

where, as a consequence of African Americans migrating in large numbers from the rural South to the urban North during and after World War I, Harlem became the cultural capital of black America. Harlem was filled with newspapers, theaters, and jazz clubs. But African American intellectuals and performers were usually reliant upon white patrons, publishing houses, and record producers—by the 1930s, even the Communist Party—to reach an audience beyond the precincts of Harlem. This dependence too frequently meant subordinating one's own cultural inclinations to the tastes of white mentors and spectators.[11] So the costs of success for African Americans, as for immigrants, often required a disloyalty to one's cultural ancestry.

Nonetheless, immigrants and African Americans were both indispensable to New York's modernity. They enhanced the city's reputation for being open to new people and new ideas. But especially for those with ambitions to be writers or artists—whether they were second-generation immigrant, black, or native-born whites—Manhattan, like Paris and Berlin, offered a sense of freedom from the respectable bourgeoisie. The craving to escape the pressures of small-town traditions and family aspirations, to get on a train (even if it was only a subway) and flee to the big city, was central to the modernist impulse in Europe and America. In this sense, modernists everywhere were immigrants, uprooted from their past.

And in America, no city offered more diversions for the deracinated modernist than New York. By the second decade of the twentieth century, a new species had begun to stalk the American cultural landscape: the New York Intellectual. In the years before America's entrance into World War I in 1917, New York became the headquarters for a generation of earnest young reformers and revolutionaries, in politics and the arts: Alfred Stieglitz, Max Eastman, Emma Goldman, John Reed, Mabel Dodge, Eugene O'Neill. Like their counterparts in prewar Paris and Vienna, the New York intellectuals were primarily devotees of high culture. They wrote for "little" magazines like Eastman's *The Masses;* they debated the destiny of experimental theater groups like O'Neill's Provincetown Players; they attended the latest exhibitions of avant-garde art at Stieglitz's 291 gallery; they read John Reed's reports on the Mexican and Bolshevik revolutions; and they chattered all night about each other's escapades at Mabel Dodge's salon.

Moreover, just as the Parisians had their bohemian oases in Montmartre or on the left bank of the Seine, so the New Yorkers had Greenwich Village—with its relatively low rents, ubiquitous lofts, bars, coffeehouses, and intimate restaurants. The "Villagers" thought of themselves as belonging to a community of like-minded souls; they lived in a neighborhood where everyone seemed to be working on an article (perhaps about the glories of socialism) or a novel (more often about the glories of sex).[12] Most of all, as in the European bohemias, Greenwich Village was where you could tinker not just with unconventional theories but with your own life. Everything, from politics to personality, was subject to renovation.

After World War I, however, the tone of intellectual life in New York changed. Haunted by the cruel reality of trench warfare in France, and disenchanted with Woodrow Wilson's crusade to make the world safe for democracy, the New York intellectuals became less passionate about political and social issues. Now it was more important to be droll, impudent, even frivolous, than to wait for the revolution. To be "serious" meant paying attention to literary craftsmanship: Max Eastman, with his raucous denunciation of the war in *The Masses,* had given way to Maxwell Perkins, sitting quietly at Scribner's, editing *The Great Gatsby, The Sun Also Rises,* and Thomas Wolfe's *Look Homeward, Angel.* Meanwhile, the fabled "round table" at the midtown Algonquin Hotel—where newspaper columnists like Dorothy Parker and Alexander Woollcott and Broadway playwrights like George S. Kaufman made clever lists of the intellectually overrated—replaced Greenwich Village as the place to be seen and heard. In effect, New York in the 1920s was what Woody Allen imagined it to be fifty years later in *Manhattan:* a city where you could sit with Diane Keaton on a park bench, gazing lovingly at the 59th Street Bridge, with the sounds of George Gershwin's *Rhapsody in Blue* soaring in the background.

The magazine that typified this intellectual urbanity in the postwar years was the *New Yorker,* launched in 1925 by Harold Ross, and featuring contributors like Parker, Woollcott, James Thurber, S. J. Perelman, and John O'Hara. In any issue, one could find essays on the theater, art galleries, books, restaurants, and New York nightlife—a range of topics that reflected the magazine's casual blending of erudition and entertainment, all presented with an insider's wit that

only Manhattanites, certainly not old ladies in Dubuque, could appreciate.[13]

But old ladies all over America could understand a competing magazine, also based in New York. Henry Luce's *Time* made its debut in 1923, the first mass-circulation weekly newsmagazine that covered not only politics, the economy, and international affairs but also sports, movies, and the arts. Its confident, worldly prose style gave readers the sense that they too could be in the know without having to live in Manhattan or overhear the conversation at the Algonquin. Indeed, *Time* captured better than the *New Yorker* the fact that the city was home not only to artists and intellectuals but to the commercial theaters on and off Broadway, the radio networks, the leading advertising agencies, and the banks and investment houses that financed the Hollywood studios.

At the same time, the sober *New York Times* coexisted in the city with the most widely read of all America's tabloid papers, the *Daily News*, begun in 1919. Thus New York, even more than Berlin in the 1920s, bombarded its inhabitants with a volatile potpourri of the high-minded and the raffish.

The disregard for cultural borders—the appetite in the 1920s for ideas as well as gossip, for the sonorous punditry of Walter Lippmann and the staccato bulletins of Walter Winchell, for the latest novels and the newest celebrities—was central to New York's (and to America's) modernism.[14] And this combination of elite and popular culture made the United States an object of fascination to foreigners, at the same moment that American novelists, artists, composers, and scientists looked abroad for less adulterated models of cultural sophistication.

Transatlantic Expatriates

The 1920s was the mythic decade for American expatriation to Europe. For many aspiring bohemians, Chicago or New York was merely a way station on their obligatory journey to Paris or the south of France. All the American acolytes, in the arts as well as the sciences, seemed to be living in Europe at some point in the 1920s, sitting at the feet of the masters, absorbing the innovations of modernist composers in Paris, the psychoanalytic theories of Freud in Vienna and Jung in

Zurich, the revolution in physics in London and Copenhagen. As Hemingway recalled, Europe was a "moveable feast" for the intellectually famished Americans—and also a temporary haven, in Malcolm Cowley's classic account of his expatriate generation, before the exiles eventually returned to the United States.

The urge to leave America for the Old World, however, was hardly unique to the 1920s. Throughout the nineteenth century and into the twentieth, writers from Nathaniel Hawthorne to Henry Adams, Henry James, and T. S. Eliot had complained that American life lacked density, an awareness of class and tradition, a sensitivity to the weight of institutions and social nuance so pervasive in Europe, all of which provided the necessary conditions for the emergence of great literature.[15] Above all, they charged, Americans did not appreciate their artists; the destiny of a writer in the United States was loneliness, isolation, and marginality. A historian and novelist might live in the shadow of the White House, as did Henry Adams, but he would still be ignored in the land of Ulysses Grant, Jay Gould, and Buffalo Bill. Thus those in search of respect and influence had to spend most of their time (like James, Eliot, and Ezra Pound) in London, or in France (like Adams) admiring the spiritual power of Mont Saint Michel and Chartres.

The lament that American history and society lacked complexity was peculiar, given that in the nineteenth century the country experienced the conquest of a continent, wars with Mexico and Spain along with the virtual extermination of the native American population, the growth of cities, the creation of an industrial economy, massive immigration, a bloody civil war over the institution of slavery, and an increasingly important role on the world stage. Nevertheless, whatever the realities of the American past or present, the intellectuals' feelings of alienation from their homeland persisted from the 1830s through the 1920s (and in the case of African American expatriates, like Richard Wright and James Baldwin, throughout the 1940s and 1950s as well).

Yet even as American writers and artists continued to flee to Europe, their European counterparts were traveling to the United States. Expatriation was always a shared transatlantic affair. Where the Americans were entranced with European culture, the Europeans were often

mesmerized by America's youthfulness and energy, its industrial dy-
namism, the speed of its factories and assembly lines, its cornucopia of
consumer goods, its streamlined cities and skyscrapers, its worship of
machines and gadgets, its incessant advertising and devotion to slang,
and especially its superior plumbing—all the paraphernalia of modern
life that Europeans couldn't find, or imagine, at home.

So, many Europeans came to America in the teens and 1920s
as visitors, lecturers, and momentary residents: the artists Marcel
Duchamp, Francis Picabia, and Fernand Léger; the composers Igor
Stravinsky, Maurice Ravel, Béla Bartók, Darius Milhaud, and Sergei
Prokofiev (all of them following in the footsteps of Antonín Dvořák's
sojourn in America in the early 1890s); and the Spanish writer Fed-
erico García Lorca.[16] Their fame, if not their numbers, exceeded those
of the Americans who sailed to France. But their pilgrimage to the New
World, the start of a century-long flow of foreign talent to America,
particularly foreshadowed the thousands of European refugees escap-
ing Hitler in the 1930s who would find a permanent sanctuary in the
United States.

The tendency on the part of Europeans to identify America with
modernity was widespread by the early twentieth century. Yet such an
assumption also reflected for Europeans the lure of the "other," of the
exotic civilization across the ocean with its standardized products and
commercial acumen, while they conveniently forgot how much these
same features of contemporary life existed closer to home.

The United States, after all, did not invent smoke-belching facto-
ries or large industrial cities, nor was its economy singularly dependent
on machines and mass consumption. The British were pioneers in the
construction of railroads. The French developed department stores in
the mid-nineteenth century, and were the leading manufacturers both
of movies and automobiles before World War I. The first radios ap-
peared in Italy, not the United States.[17] Amusement parks opened in
London, Copenhagen, and Vienna before anyone dreamed of a Coney
Island on the outskirts of New York. Meanwhile, pedestrian shopping
districts and sprawling bazaars, the precursors of American malls, were
indispensable parts of urban life in most European, Middle Eastern,
Latin American, and Asian cities.

When it came to modernity, the true American specialty was not

invention but adaptation. Just as American artists, writers, and entertainers would reassemble and repackage the cultural ideas they received from abroad before retransmitting them in altered form to the rest of the world, so American industrialists adopted foreign economic innovations and transformed these into consumer products on a global scale.

No American was more adept at converting a European discovery into a lucrative enterprise than Henry Ford. Ford inaugurated his assembly line in 1913 in order to manufacture cars more quickly and at lower cost. By 1925 Ford's assembly line could produce an automobile every ten seconds, and (with the debut of the Model T) the price of his cars had declined from $825 in 1908 to $290 in 1924, making them affordable for middle- and working-class customers in America and abroad. As a result, every second car on the roads of the world was a Ford.

Henry Ford dethroned the French as the foremost builder and seller of automobiles. Indeed, André Citroën, the principal French carmaker, was now copying Ford by adopting his assembly line techniques. It was not surprising, then, that Ford—along with quintessential American problem solvers like Thomas Edison and Wilbur and Orville Wright, and that apostle of managerial efficiency Frederick Winslow Taylor—became culture heroes for Europeans, especially in Germany, in the 1920s.[18] They were seen as the embodiments of what the Germans called *Americanismus:* the faith in the virtues of mechanization, rationality, practicality, and profit.

The Americanization of automobile manufacture was only the most dramatic example of America's growing impact on the world economy, particularly during and after World War I. While the war damaged the economies of the European combatants, it accelerated America's industrial output and sales overseas. In the first decade of the twentieth century, the United States exported 16 percent of its manufactured goods to Europe; by 1927 that figure had risen to 27 percent.[19] Throughout these years, American products—telephones, typewriters, sewing machines, cash registers, elevators, cameras, phonographs, toothpaste, and packaged food—became familiar items in the European marketplace. As did the names of American companies. Singer, International Harvester, General Electric, Westinghouse, H. J.

Heinz, American Tobacco, and Carnation Milk were increasingly recognizable brands for European and other foreign consumers.

Consequently, whether or not European artists and intellectuals actually visited the United States in the teens and 1920s, they were surrounded by reminders of America's growing economic and cultural clout. But what really intrigued them about America was not its products or its technology but the vitality of its popular culture. The European avant-garde—otherwise committed to the creation of modernist novels, poems, plays, and paintings—were enchanted, some of the time, with America's vaudeville shows, its cartoons and comic strips, its movie stars, and its jazz-based dance styles. If Henry Ford was an idol in Europe, so too were Charlie Chaplin and Louis Armstrong, and later (especially in France) Mickey Mouse.[20] From this perspective, American popular culture offered to modernism a verve and simplicity that the European intellectual elite could not supply.

There was, of course, a certain patronizing quality about the European affection for America's cultural "primitivism." In commending American entertainment for its lack of pretense and its flair for improvisation, its spontaneity and aversion to serious thought, even for its vulgarity, European intellectuals were also implying that America posed no threat to the high culture or artistic preeminence of France, Germany, or Britain.

Yet American writers as well were intermittently captivated by their country's popular culture, and not just when they read all about it in the pages of the *New Yorker* or *Time,* or in the columns of Damon Runyon and Walter Winchell with their Broadway guys-and-dolls patter, or when they eavesdropped on Duke Ellington's music at Harlem's Cotton Club. In *Manhattan Transfer* and *U.S.A.,* John Dos Passos drew on newspaper headlines, the lyrics of popular songs, advertising jingles, the techniques favored by silent film directors like D. W. Griffith of telling parallel stories featuring multiple characters, and biographies of celebrities to capture the sounds and images of American life in the first three decades of the twentieth century, thereby fashioning a new kind of novel that fused the high and the low.

Ultimately, the European and American expatriates, as well as those who chose to stay home, were borrowing styles and attitudes from one another—sharing ideas about what mattered, culturally and

commercially, in the modern world. Hence, they regarded themselves as citizens not of a particular country but as members of an international (or at least a transatlantic) artistic community, embracing an intellectual and esthetic cosmopolitanism that enabled them to confront the cataclysms of the early twentieth century.

All Faiths Shaken

"On or about December 1910," Virginia Woolf famously declared, "human character changed." Near the end of F. Scott Fitzgerald's first novel, *This Side of Paradise,* published in 1920, his young hero Amory Blaine laments that his generation has grown up "to find all Gods dead, all wars fought, all faiths in man shaken." In *The Education of Henry Adams,* an autobiographical portrait of what it was like to be a nineteenth-century man trying to adjust to a twentieth-century world, first circulated privately in 1907 before its wider publication in 1918, Adams observes that each person has to "invent a formula of his own for his universe, if the standard formulas failed."

By the dawn of the twentieth century, the standard formulas had failed for many educated people, both in Europe and the United States. What Woolf, Fitzgerald, and Adams were describing was the demise of the nineteenth-century trust in a predictable universe, with its eternal truths, its unassailable natural and moral laws, and its limitless social and technological progress guaranteed by a munificent God. These beliefs accompanied the Victorian assurance that human beings were perfectible, and that art and religion could liberate people from their animal instincts and their sinful pasts.[21] Now, all the comfortable assumptions of the nineteenth century were being demolished by new theories about how the cosmos actually worked, and by the realization (as revealed in the carnage of World War I) that human beings were as prone as ever to acts of savage destruction.

A major reason for the smashing of nineteenth-century certitudes was the impact of modern science, especially physics. Beginning in the 1890s and continuing into the 1930s, physics entered a golden age, and the ideas pouring out of laboratories in England, Denmark, and Germany affected not only other scientific disciplines but every aspect of

culture as well. In 1895 Wilhelm Röntgen discovered X rays. In 1900 Max Planck designated the quantum, an atom of radiation, as the new building block of the universe. In 1905 Albert Einstein introduced his "special theory of relativity," followed by his *General Principles of Relativity* in 1915, both of which questioned the solidity of matter and stressed the constantly changing character of space and time. In 1911 Ernest Rutherford delivered a lecture in Manchester, England, explaining the basic structure of the atom, and he went on to split the atom in 1919. In 1921 Niels Bohr, who had confirmed and unified the quantum theories of Planck, Rutherford, and Einstein, opened his Institute of Theoretical Physics in Copenhagen, attracting other leading European physicists like Wolfgang Pauli and Werner Heisenberg. In 1927 Heisenberg developed his "uncertainty principle" which emphasized the extent to which the very act of observation and measurement altered the results of an experiment, so that only probability—not fixed or objective truths—could come close to uncovering the secrets of the scientific universe. Together, these ideas depicted a world in which reality was never stable, "facts" were always impermanent and ambiguous, nature was ruled by chance rather than by a divine plan, and no scientific occurrence (or, by implication, human endeavor) was quite what it seemed to be.[22]

Modernists in literature and the arts were therefore responding to a situation in which traditional forms of knowledge no longer satisfied the hunger for absolutes. Just as physicists dwelt in a realm of uncertainty, so modernists stressed the unpredictability of human life and the absence of any agreed-upon set of moral values. In a world without order or logic, a world of random events rather than linear progress, neither artists nor writers were able to uphold the premodern ideal of a unified vision or single narrative technique. Instead, one's view of the universe could be only partial and fleeting. Consequently, a new esthetics had to be invented, one that would capture the fragmented and discontinuous quality of personal experience. This ambition resulted in a style committed not to a precise point of view but to multiple perspectives—an art like Cubism or a novel told through a character's fractured stream of consciousness.[23]

And to portray the chaotic universe in which people found them-

selves, artists had to depend on their own inner resources. So, along with Einstein, Bohr, and Heisenberg, Sigmund Freud became one of the most influential theorists of the early twentieth century.

From the moment his *Interpretation of Dreams* was published in 1900, with its emphasis on the role of the unconscious in human behavior, Freud's ideas were enthusiastically embraced and popularized, especially in America. Indeed, after Freud's only visit to the United States, where he lectured at Clark University in 1909, he became a sage not only for American psychoanalysts but also for novelists, social critics, and public-relations executives. It helped that his nephew Edward Bernays was a leading advocate for the use of Freudian theory in advertising. In typically American fashion, a European idea—meant to untangle the childhood complexes and neuroses that damaged people in their maturity—was adapted to the practical demands of selling merchandise.[24] Still, in a more serious vein, Freud's concepts reinforced the modernist conviction on both continents that the artist's emotional cravings and intuitions were a more reliable guide to understanding the world than were the claims of politics or philosophy.

The lessons of Freud and the physicists may have undermined the Victorian confidence in the rationality of nature and society. But while the modernists of the early twentieth century were more skeptical of the prospects for human improvement, they were hardly indifferent to social issues. The Dadaists and Surrealists loved to publish manifestos advocating an assortment of revolutionary projects. The Bauhaus architects in Germany were committed to new forms of socialist housing for the working class. The trial and convictions of Nicola Sacco and Bartolomeo Vanzetti in 1921 infuriated intellectuals all over the world; the global movement, ultimately futile, to set aside their death sentences and free them from prison inspired John Dos Passos to begin work on the trilogy that became *U.S.A.*

Yet these engagements were sporadic or limited to specific causes. Until the 1930s, when the flirtation with Marxism and the Soviet Union became almost compulsory, the modernists distrusted ideologies and political parties. Unwilling to subordinate their own artistic inclinations to someone else's utopian scheme, they insisted on their freedom to interpret the world in any way they pleased.

This was not, however, an exercise in solipsism. Nor were the

modernists taking refuge in some idyllic notion of art for art's sake. Their aspirations were more flamboyant, more earthshaking.

True, most modernists regarded themselves as members of a worldwide avant-garde. And they detested the values and tastes of the bourgeoisie, no matter where these agents of conformity and standardization, these representatives of international Babbitry, reigned. (Sinclair Lewis was the first American novelist to win the Nobel Prize for literature, in 1930, probably as much for telling the European elite what they already believed about the banalities of the American middle class as for his talents as a writer.) The masses, plainly, were not the modernists' preferred clientele. Rather, they painted, composed, and wrote for a coterie of equally alienated mavericks, who could appreciate works that were experimental, uncompromising, and above all difficult to look at, listen to, or comprehend.[25]

But the point of the modernist mission was to compel audiences, at first tiny and then potentially large, to understand a world that was now neither cheerful nor familiar. To do this required a transformation not in politics or in the subjects of a novel or a painting but in the linguistic and visual style with which writers and artists communicated with people. Culture, in this view, was not a tool to comfort or preach to the public, or to elevate its morality. It was instead a device to provoke and disorient, as a first step to forcing readers and viewers to reinterpret their experiences at a time when conventional explanations about the natural world and human behavior were obsolete. In effect, people had to learn once more how to speak, see, and hear before they could discover how to think and live in the twentieth century.

In this effort, the meaning of a work lay in its formal qualities, not in its content. Hence, the modernists deliberately called attention to language in their novels (as in the case of James Joyce); to optics in their paintings (as in the case of the Impressionists); to the lines, colors, and designs on a canvas (as in the case of the Cubists or Wassily Kandinsky); to the materials in and function of their architecture (as in the case of Louis Sullivan, Walter Gropius, and Ludwig Mies van der Rohe); or to the structure of music instead of its melodies (as in the case of Igor Stravinsky and Arnold Schoenberg). The goal was no longer to reproduce but to manipulate and distort reality in order to create both a new consciousness and a conception of an alternative ap-

proach to life.[26] Modernist art could not be socially uplifting or polit-
ically didactic. But it might reawaken people's imaginations and alter
their perceptions of the world in ways that realistic novels, representa-
tional paintings, melodious symphonies, and mind-numbing institu-
tional reforms could never achieve.

Ironically, at the very moment the modernists were calling for an
esthetic revolution, the new types of popular culture—particularly
radio and the movies—were also encouraging audiences (the mass au-
dience, rather than just the avant-garde) to hear and see in entirely new
ways. But the modernists and the media had more in common than
seemed initially apparent. The modernists, after all, wanted to shock
their audiences. Which they succeeded in doing. Modern painting and
literature—with its emphasis on visually misshapen nudes, overt sex-
uality, and meditations on violence—was attacked by the guardians of
middle-class morals for being degrading and obscene, and for appeal-
ing to the baser instincts of humanity. These were the same accusations
aimed at the pictures turned out by the crude immigrant moguls who
ran the new Hollywood studios. Was it possible that Pablo Picasso and
Louis B. Mayer shared similar ambitions and sensibilities?

For American novelists, at least, such a marriage of artistic inno-
vation and commercial success was not only imaginable but routine.
They saw themselves as rebels, occasionally as entertainers, but mostly
as professional writers, making a living with their work. And they
hoped to produce best-sellers; F. Scott Fitzgerald and Ernest Heming-
way, along with less audacious writers like Dorothy Parker, Damon
Runyon, James Thurber, and Ring Lardner, worried constantly about
the details of book contracts, sales figures, and marketing campaigns.
Even Gertrude Stein, the most legendary of American expatriates but
also an expert self-publicist, managed in 1934 to land on the best-seller
list with *The Autobiography of Alice B. Toklas.*[27]

Moreover, for all the modernist talk about stylistic experimenta-
tion, the need to dispense with plots and conventional narratives,
American writers were still creating characters and telling stories. *The
Great Gatsby,* for example, was at heart a thriller, with Nick Carraway
as a private eye (the ancestor of Sam Spade, Philip Marlowe, and Jack
Nicholson's J. J. Gittes) who unmasks the mystery of Gatsby's past but
is powerless to prevent his doom. So, at the end of the novel, while

Nick (his bags packed, eager to return to the purity of the Midwest) meditates on the tragedy of Gatsby's and America's dream, the reader feels like shrugging at the wasted Long Island lives. Forget it, Nick. It's Chinatown.

Whether the modernists were artistic revolutionaries or celebrities (and often they were both), 1913 was the year of their ascendancy. This was the moment when Igor Stravinsky's ballet *The Rite of Spring* made its debut in Paris, greeted by outrage from the audience; when Marcel Proust published *Swann's Way*, the beginning of his seven-volume *Remembrance of Things Past,* and D. H. Lawrence brought out *Sons and Lovers;* when the Armory Show opened in New York and many Americans were exposed for the first time to Postimpressionist, Cubist, and abstract paintings; and when Charlie Chaplin came to Hollywood to make movies for Mack Sennett.[28]

But 1913 was also the last year of peace before the "great" war erupted in August 1914, the war that confirmed the idea that all the gods and faiths of the nineteenth century were truly dead. As, by 1918, was a generation of European youth. The number of casualties in the war was horrific, especially in the titanic battles on the western front, where soldiers, huddled in trenches or shrouded in mud and dust, hurled themselves into a nightmare terrain of machine gun and artillery fire, mingled with poison gas, a "no man's land" no army controlled and in which little ground changed hands. At the battle of the Somme in 1916, 60,000 British troops out of a total of 110,000 were killed or wounded—in one day. By the end of the war, 900,000 British soldiers had been slaughtered. The figures were even more calamitous for the other combatants: Austria-Hungary lost 1.1 million soldiers, while France suffered 1.4 million casualties, Russia 1.8 million, and Germany 2 million. When Italian, Serb, and Turkish losses were included, together with 117,000 Americans, nine and a half million soldiers died in World War I.[29]

The war reinforced the modernist insistence that writers had to devise new ways of describing a traumatized "wasteland" of now-irrelevant ideals, religions, and doctrines. Indeed, one of the worst casualties of World War I was language. Governments had justified the war with a torrent of abstractions: God and country, patriotic duty, imperial glory, national honor, civilization versus barbarism, making the

world safe for democracy. But the war's bloodbaths, the irrationality of soldiers being mutilated or killed because they happened to be in the wrong place at the wrong time when the shell burst or the mine exploded, drained these slogans of meaning. The abstractions could no longer explain or console.

No novelist, on either side of the Atlantic, was more offended by the prewar and wartime abuse of words than Ernest Hemingway. In 1929 Hemingway published *A Farewell to Arms,* in which his protagonist, an American ambulance driver in Italy, sums up his disgust with the war's rationalizations: "I was always embarrassed by the words sacred, glorious, and sacrifice. . . . Abstract words such as glory, honor [and] courage . . . were obscene beside the concrete names of villages, the numbers of roads, the names of rivers, the numbers of regiments and the dates."[30]

Hemingway had worked as a reporter for six months in 1917 and 1918 at the *Kansas City Star.* There he learned the virtue of brevity, precision, and clarity, of straightforward declarative sentences with concrete nouns and verbs unencumbered by extraneous adjectives.[31] In the 1920s he applied these rules to his fiction and created a prose style designed to purify the English language, a style that distinguished between words employed to generalize, inflate, or coerce and those used to designate specific objects, places, feelings, and acts. He was now striving for a minimalist vocabulary that corresponded to the unvarnished, incorruptible truth of a person's experience.

Like other modernist novelists, however, Hemingway was not seeking just to change the way people spoke or read (although he, more than any other novelist of the twentieth century, altered our patterns of speech and how we reacted to the written word). Hemingway was preeminently a "postwar" writer—in the sense that he tried to make accidental catastrophe, which was the ultimate terror of modern warfare, not reasonable but at least intelligible. And he was also the poet of survival and readjustment, the essential dilemmas of every postwar era.

In 1926 Hemingway published his first and most poignant novel, *The Sun Also Rises.* His central character, Jake Barnes, has been wounded (like Hemingway himself) in that "dirty" war. No priest or philosopher, no political creed or lingering belief in the justice of a jingoistic crusade, can offer comfort. Self-preservation depends on emo-

tional neutrality, on escaping the insanity of grand strategies and ideological platitudes. Jake has to improvise a new form of conduct based on discretion and restraint, without resort to fake sentiments and excessive romantic displays, a set of values embedded in the elementary activities of eating and drinking and talking with a few similarly afflicted comrades who understand the need for psychological shelter and recovery.

But recuperation is possible. As long as you don't expect a cure. Or a revelation. "Perhaps," says Jake, "as you went along you did learn something. I did not care what it was all about. All I wanted to know was how to live in it. Maybe if you found out how to live in it you learned from that what it was all about."[32] Just so you realized that, in life, the cost of wisdom is always high and the bill always arrives.

And if your wound, physical and existential, makes it impossible to be with the woman you love, don't indulge in fantasies. "Oh, Jake," Lady Brett muses, "we could have had such a damned good time together." To which Jake replies, in what is one of the saddest but least self-pitying endings to a novel ever written, "Yes. . . . Isn't it pretty to think so?"[33]

If *The Great Gatsby* was a mystery tale, *The Sun Also Rises* was a love story. But one in which happiness is yet another illusion when war has become the metaphor for life in the twentieth century. In such circumstances, "heroism" is foolish and suffering is bearable only if defeat—though not humiliation—is accepted as inevitable. The world will break you in the end, the narrator of *A Farewell to Arms* acknowledges. What's left is to survive "strong at the broken places." Failure may be inescapable. So too are the dogmas and inanities of "statesmen" and generals. Yet for Hemingway, and for most of the modernists in the early twentieth century, moral choices and personal resistance were still necessary. These, however, were rooted solely in the authority of one's private vision.

Hemingway detested the rhetorical embellishments of nineteenth-century literature. And he (like his American contemporaries) was captivated with the stylistic innovations of Joyce and Proust, among other European masters. So he created a terse and hard-boiled language, devoted to reproducing as authentically as possible an individual's most precious emotions, the ones that could not be put into words. This laconic style, originally an adaptation of the modernist desire to reno-

vate prose, became a model for twentieth-century journalism, detective fiction, and movie dialogue. Thus Hemingway's legacy was felt more in popular culture than among the avant-garde.

Still, the avant-garde too, particularly in Europe, embraced Hemingway at his best. American novelists like Hemingway, Fitzgerald, Dos Passos, and William Faulkner were shaped by the European modernists, but they eventually influenced their mentors. In particular, the raw power of Hemingway's prose, and his ability to dramatize the sensation of living in a world of absurdity, became enormously popular with Italian novelists in the 1930s who were nauseated by Mussolini's bombast, and with French writers like Jean-Paul Sartre and Albert Camus after World War II who wanted to puncture the bourgeois stuffiness of French life.[34] In both of these instances, American literature—initially molded by European ideas—became a template for world literature in the second half of the twentieth century.

For the moment, though, the European and American modernists had figured out how to cope, artistically, with a world whose most soothing assumptions had been annihilated by science, psychoanalysis, and war. For Picasso, Joyce, Stravinsky, and Hemingway, that was almost enough.

The New Culture

They had, however, one additional task. For modernist novelists, painters, and composers on both sides of the Atlantic, creating an art more attuned to the convulsions of the twentieth century also meant discarding nineteenth-century assumptions about what "culture" was, and what role it should play in society. The principal foe of the modernists was not mass entertainment but an older version of "high" culture—what German intellectuals called *Kultur,* otherwise defined by the British philosopher Matthew Arnold as "the best that has been thought and known in the world."

Those in the nineteenth century who believed in this hierarchical conception of culture were tenacious in defending the purity of literature, classical music, and stately paintings against the intrusions of folklore and popular amusements. No one was supposed to confuse Tolstoy's *War and Peace* with a dime novel, opera with Wild West

shows, the Louvre with Coney Island. High culture was intended to be educational, contemplative, and uplifting.

These doctrines didn't imply that a Charles Dickens never indulged in melodrama or that Brahms disdained the use of popular songs. Or that Chinese or Japanese authors and painters refused to draw on oral or folkloric traditions. But the nineteenth-century barriers between high and low culture were meant to be resolutely, if imperfectly, maintained.

The distinction between art and entertainment had not always been so dogmatically upheld. Renaissance painters like Michelangelo, Rembrandt, and Rubens were in business to please their customers, whether these were aristocratic patrons or bourgeois merchants. Buyers typically determined the subject matter of Italian, Dutch, and Flemish paintings. Shakespeare was similarly entrepreneurial, and cared about how many tickets he sold for his plays. Bach, Mozart, and Beethoven, as well as novelists from Cervantes to Dickens, hoped their work would be popular and profitable.[35]

The blurring of cultural boundaries was especially noticeable in the United States in the early nineteenth century. American audiences often demanded that symphony orchestras include band music in their programs, while opera singers were expected to perform both Mozart and Stephen Foster. Theaters, concert and lecture halls, and opera houses all provided opportunities for diversion as much as instruction. And all were open to the public, not just to the wealthy or the learned.

None of this suggests that one should be nostalgic for some halcyon era in the past when culture was classless, communal, or "democratic." Nor was there anything inherently admirable about "active" spectators participating in the show. In Elizabethan England or Jacksonian America, louts in the cheap seats heckling performers enhanced neither the works of art nor the audience's enjoyment of the evening. Moreover, many people in America and in Europe were illiterate, or too poor to buy books, or too distant from the cultural venues. So, people's familiarity with novels, plays, and paintings was limited even before the late nineteenth century, when the partisans of high culture began to segregate themselves from the rabble.

This stratification of culture was more pronounced in America than in Europe during the massive wave of immigration that followed

the Civil War. Sites in New York like the Metropolitan Opera House, the Metropolitan Museum of Art, and Carnegie Hall became shrines to the European classics. In part, the reverence for the European art of the past three hundred years was a reflection of America's feelings of cultural inferiority. How could any American aspirant in the arts, having just stumbled out of the wilderness, match Shakespeare, Beethoven, Brahms, Wagner, Dostoevsky?

But the American veneration of European culture was also an effort by the privileged to elevate the masses, to teach them proper behavior and good taste. If this wasn't possible, then those already endowed with a respect for the European masterpieces could withdraw into their own luxurious asylums, shielding themselves from the chaotic and alien babble in the streets.[36] In either case, the people who served on the boards of libraries, auditoriums, and galleries could think of themselves as the sentinels of high culture, guarding the fortress of art, literature, and music. And along the way, they would continue to be the arbiters of what was refined and inspirational.

The American (and European) elites were convinced that only they understood the moral purpose of great art and how it should be worshiped. The canon was to be approached with awe and decorum, as if one were in a cathedral. Or, as the years wore on, in a university classroom where scholars converted art, music, and literature into subjects of arcane study in a language unintelligible to amateurs.[37]

Not surprisingly, by the early twentieth century, the untutored on both continents rejected the condescending attitudes and cultural preferences of their upper-class counselors. Instead, they turned to all those more comprehensible types of entertainment that the rich and the intelligentsia labeled uncouth, one-dimensional, escapist, and mass-produced: vaudeville, musical comedies, radio, movies. For the common people in Europe and the immigrants in America, the comic strip replaced painting, jazz and popular songs replaced grand opera, and films replaced plays.[38]

It was precisely this demarcation between high and low culture that the modernists sought to overcome. Indeed, the arrival of modernism coincided with the emergence of new forms of commercial entertainment and mass communications. Modernist writers and artists lived in a world filled with tabloid newspapers, posters and billboards,

magazines designed for readers of every class and region, and an advertising industry as skilled at publicizing books and paintings as at selling cigarettes and soap detergents. The modernists themselves were equally adept at promoting their own works, and at dreaming up marketable names for their latest movements.[39] Cubism, Futurism, Expressionism, Dadaism, Surrealism—these were brands as much as descriptions of some new artistic method.

Still, the modernists' intent, especially in Europe, was not to surrender to the gaudy allure of the media, or to turn their works into products for mass consumption. Their objective instead was to use the techniques and content of popular culture to reinvigorate novels, paintings, and music. In their view, the high culture of the nineteenth century—the culture of the Romantics and the Victorians—was exhausted and nearly comatose. A more vibrant culture in the twentieth century would have to blend the serious and the irreverent, the complex and the playful.

The European modernists believed that they could utilize popular culture for their own lofty goals. But this idea, once it migrated across the Atlantic, got lost in translation. In America, as it turned out, modernism proved more useful for the architects of popular culture. In Europe, Dadaism ridiculed the snobbery of elite cultural institutions; in America, it helped reinforce the already existing appetite (particularly among immigrant audiences) for "low-class," disreputable movies and vaudeville shows. In Europe, Surrealists were fascinated with the artistic implications of Freudian dreams and fantasies; in America, Surrealism lent itself more often to the wordplay and psychological symbolism of advertisements, cartoons, and theme parks. In Europe, Stravinsky and Schoenberg experimented with atonal symphonies and ballets; in America, their discoveries validated the rhythmic and melodic inventiveness of jazz.

The European modernists certainly did as much to subvert the reign of nineteenth-century high culture as did the movies. But the results of their cultural insurgency, in America and eventually in the rest of the world, were very different from what they had anticipated or desired. In the end, a revolutionary new culture born in Paris, Vienna, Berlin, and New York found an enduring, if improbable, home in Hollywood.

Painting Modernity

■

The calamities of the twentieth century occurred, for the most part, outside the United States. War and revolution destroyed nineteenth-century Europe, convulsed Latin America, and traumatized both the Middle East and Asia. But no nation, including an America previously sheltered from the rest of the planet's bloodbaths, was left undamaged.

How, if you are an artist anywhere, do you portray the harrowing nature of modernity? And how, if you are an American artist, do you participate in—and try to visualize for yourself—the mayhem of the modern world?

You make the art of modernity your own. You make it American. And so, what begins as an insurrection in European painting in the late nineteenth and early twentieth century, a reaction to the chaos of European politics and culture, becomes a tale of the Americanization and popularization of modernist art once the United States emerged as a global superpower after World War II. Modernism in painting, as in so many other realms of cultural and intellectual life, took refuge and flourished in the country that was initially uneasy with and sometimes hostile to all the new ways of depicting the disorders of the contemporary world.

The Revolution in Art

It started quietly enough, as a series of optical experiments in recording one's shifting impressions of people, buildings, and landscapes. In the late nineteenth century, mostly in France, a new generation of artists—led by Claude Monet, Pierre-Auguste Renoir, Edgar Degas, Georges Seurat, and Camille Pissarro—were wrestling not so much with the changes in their society as with a crisis in painting itself. Why carry on the tradition, prevalent since the Renaissance, of realistic portraiture when photographs (and later movies) could capture so much more effectively what the world looked like? Would the camera, whether taking snapshots or filming people in motion, make painting obsolete?

In response to these challenges, the Impressionists, joined by Vincent van Gogh and Paul Cézanne, devised a fresh and crafty justification for their art. Now, painting would stop trying to replicate nature. Instead, artists should rely on their fleeting observations of, and inner feelings about, the scenes and objects they encountered, whether in Paris or the south of France. With talent and luck, their visual perceptions could be just as original as and even more distinctive than those of a photographer.

Yet the subjects of the Impressionists' paintings were always meant, like photos, to be intelligible. A viewer could still recognize the dancers in a Degas, the pears or burnt-orange rooftops in a Cézanne, the blistering sun or starry evenings in a van Gogh, the Sunday strollers in a Renoir or Seurat, a church or a field of water lilies in a Monet—no matter how much the churches or the lilies might be shrouded in mist. In their persistent devotion to an authentic, though idiosyncratic, portrayal of the external world, the Impressionists and the Postimpressionists were premodernist. They had not yet fully imagined a type of painting in which the conventions of realism and representation were superfluous.

In 1907, two years after Albert Einstein stunned his fellow physicists with his "special theory of relativity," a young Spanish painter scandalized the art world with a bizarre, almost indecipherable, portrait of five prostitutes. Pablo Picasso's *Les Demoiselles d'Avignon*, like Einstein's theory, forced people—and not just in the sciences or the

arts—to jettison their customary modes of seeing and understanding. In Picasso's case, *Les Demoiselles d'Avignon* launched the modernist revolution in painting that would continue, in different forms and in a variety of countries, for the rest of the twentieth century.

Nothing about Picasso's painting was "lifelike" in any customary meaning of that word. There was no deference to the Renaissance's efforts at three-dimensional perspective. The ladies of the night, unimpressed by their prospective customers, had faces that resembled African tribal masks (Picasso, like Paul Gauguin and Henri Matisse, was fascinated with exotic, non-European cultures).[1] Yet their eyes, unlike those of their African muses, sometimes threatened to float into their ears. Their torsos, meanwhile, resembled a pornographer's idea of fecundity. Overall, their anatomy was geometrical, if geometry had been invented by Dr. Caligari. The ultimate effect was intentionally outrageous, at least by the standards of museumgoers who had only recently come to accept the distortions of the Impressionists, if not the manias of van Gogh.

The patrons of art, however appalled by Picasso's latest work, hadn't seen anything yet. Straightforward painting, the kind that could be enjoyed or revered, was gone. *Les Demoiselles d'Avignon* led directly, before the outbreak of World War I, to the Cubist deformations of "real" life in the canvases of Picasso and Georges Braque.

Like the Impressionists, the Cubists were interested in how people saw the world, rather than in the world itself. The Cubist vision, however, was less cohesive, more attuned to our disjointed and erratic perceptions of faces, bodies, and the detritus of daily life. So the subjects of their paintings were evanescent, as if all we could hope to do was glimpse a person or a scene before it changed or vanished before our eyes. The point, therefore, was to capture on a canvas some sensation of how things and people look from an assortment of angles and points of view, when nothing is fixed or stable but perpetually in flux. The Cubist paintings, with their flattened space and asymmetrical configurations, were no longer a reflection of reality; these mannerisms became the sole focus of our attention.[2] What we were to appreciate was the artist's ingenuity, and his or her ability to disconcert an otherwise self-satisfied audience. This was a truly modernist conception not only of the purpose of art but of the splintered nature of life in the new century.

The Italian Futurists, too, were enchanted by change and motion, as well as by the velocity of modern civilization. In 1909 in Milan, the poet Filippo Marinetti released his *Manifesto of Futurism,* a rapturous celebration of cars, trains, airplanes, any machine that moved. In their paintings, the Futurists attempted—as had the Cubists—to convey an impression of people in frenzied activity through innumerable images superimposed upon one another.[3] For the Italian modernists, there was no past or present, no traditional assumption of cause and effect, but only a future in which everything happened simultaneously and with kaleidoscopic speed.

In their preoccupation with motion and multiple perspectives, with the flow of time and the disintegration of faces, bodies, and scenes into tiny components, Picasso, Braque, and the Futurists were plainly influenced by the movies, by a film director's reliance on editing and montage, and especially by the need for modernist artists to compete with the power and appeal of the cinema. Yet perhaps the only way to reestablish the importance of painting was to jettison the notion that art could somehow emulate the newfangled techniques of mass culture.

Between 1910 and 1916 Wassily Kandinsky in Munich and Piet Mondrian in the Netherlands turned painting into an exercise in pure abstraction by emphasizing shapes and colors unconnected to objects or human beings, whether either of these were in motion or at rest.[4] Here the rationale for art was the practice of painting on its own terms, not on the effort to mirror—even in the most fragmented form—the social and cultural paroxysms of modernity. And it was abstraction, more than Cubism or Futurism, that would become the trademark of modernist art.

But not before the war and its aftermath inspired other movements, notably Dadaism and Surrealism, each seeking to grapple artistically with the transformations of the early twentieth century. Dadaism, though, was less an intensification of the trends in avant-garde painting than an outpouring of rage (and deranged laughter) at the senseless bloodshed of World War I. Founded in Zurich in 1916 by the Romanian poet Tristan Tzara, and thriving until the early 1920s, Dadaism spread to cities in Germany, Spain, and France, becoming for a while a pan-European response to the apparent lack of meaning, logic, and rationality in the wartime and postwar world.

At its peak, Dada attracted iconoclastic artists like Man Ray, Max Ernst, and Marcel Duchamp. Yet its real métier was performance, not painting. Its jokes, skits, poems, and songs seemed more at home in a cabaret or as a vaudeville act, designed to amuse or irritate the European bourgeoisie.[5] Perhaps, then, it was appropriate that Dadaism, with its overtones of show business, had a more enduring impact in America—from Duchamp's fictitious "sculptures" of bicycle wheels and urinals to the mass-produced cartoonlike facsimiles of Pop Art—than it did in Europe.

Surrealism, the successor in the 1920s to Dadaism, was more sober and more philosophically coherent but no less charmed by the notion of art as entertainment. The Surrealists had principles, theories, and a by-now obligatory "manifesto," written by André Breton in 1924. But the central Surrealist hypothesis was borrowed from Sigmund Freud: that painting should be an impulsive rendering of the artist's unconscious anxieties and cravings. Hence the obsession in Surrealist artworks with dreams, nightmares, and fantasies, and with the suspicion that modern urban civilization was a mirage, a hallucination in which anything (cities, clocks, faces) was likely to melt in the earth's scorching deserts.[6]

Because of its conception of the unconscious as a storehouse of eerie pictures swirling in one's mind in the dead of night, Surrealism (unlike Dadaism) motivated a number of artists—Giorgio de Chirico, Joan Miró, Yves Tanguy, René Magritte—to produce their most memorable, and also most fashionable, paintings. The Surrealists were not in the business, like Picasso or Kandinsky, of making art difficult for or incomprehensible to ordinary viewers. Indeed, they were even more fascinated with popular culture, and especially the movies, than were their predecessors. Their idols included the French pre-Surrealist filmmaker Georges Méliès, as well as Mack Sennett, Charlie Chaplin, and Buster Keaton.[7]

So, finally, modernism arrived at the cinema when Surrealism's superstar, Salvador Dalí, cowrote the screenplays for Luis Buñuel's *Un Chien Andalou* in 1929 and *L'Âge d'or* in 1930. Instead of competing with the movies, some artists—particularly those, like Dalí, with a gift for self-promotion—were learning to embrace the medium that most threatened, in America if not in Europe, to make painting irrelevant.

Modernist Art in America:
From the Armory Show to MoMA

If foreigners in the nineteenth century belittled the originality and quality of American culture, so too did many Americans. Granted, the United States had produced some noteworthy, though too often unread, novelists and poets: Nathaniel Hawthorne, Edgar Allan Poe, Herman Melville, Walt Whitman, Emily Dickinson. Yet even the most well-known American novelist of the nineteenth century, Mark Twain, owed his fame more to his skills as a public performer than to his reputation as the author of *Huckleberry Finn*.

In his transformation from a novelist to a showman, Twain anticipated the tendency of Americans to turn their writers into celebrities, as in the later instances of Ernest Hemingway and F. Scott Fitzgerald. Of course, all three novelists collaborated in the process of converting their private lives and media-fueled images into convenient surrogates for their more demanding literary achievements. As a result, more Americans knew—or thought they knew—about the relationship between Scott and Zelda from lurid accounts in newspapers and magazines than had ever read Fitzgerald's own portrait of his tormented marriage in *Tender is the Night*.

No such notoriety attached to America's painters, especially not in the nineteenth century. Thomas Eakins, Albert Pinkham Ryder, Winslow Homer, and Mary Cassatt were largely invisible, both as artists and as personalities. Besides, with the exception of Cassatt, who was strongly influenced by the French Impressionists, the Americans continued to emphasize technically precise and mostly realistic compositions: portraits, landscapes and seascapes, historical and literary scenes.[8] Theirs was an esthetic, however esteemed, that was being demolished in Europe by the beginning of the twentieth century.

Meanwhile, as a way of compensating for America's presumed artistic mediocrity, some of the country's most prominent capitalists— Andrew Carnegie, Henry Clay Frick, Andrew Mellon, J. P. Morgan, and John D. Rockefeller—became ravenous collectors of the European masters. As the new custodians of Western art, they accumulated a treasury of paintings that ranged from the Renaissance to the nineteenth-century Romantics. They also helped to finance the construc-

tion of palatial museums in America's major cities. The Boston Museum of Fine Arts and the New York Metropolitan Museum of Art were founded in 1870; the Art Institute of Chicago followed in 1879. With their imposing columns, marbled staircases, and awed clientele, these buildings (particularly New York's Metropolitan) resembled not only Greco-Roman temples but also banks.[9] Architecturally, the museums linked America both with the illustrious history of Western culture and the current efflorescence of American commerce.

The priceless collections in private mansions and in the museums demonstrated how much Americans admired traditional painting. And how wedded they were to the notion that art should be both gorgeous and edifying. What Americans did not want, or understand, were pictures that defied the received wisdom of art as a tribute to the grandeur of Western civilization.

As a result, "contemporary" art was mostly excluded from the national consciousness. Insofar as American viewers were exposed to anything vaguely modernist, the first major exhibit of Impressionist art was held in New York in 1886. The Chicago World's Fair in 1893 also featured paintings by Degas, Monet, Renoir, and Pissarro.[10] For those who saw these exhibitions, Impressionism may have seemed like a revelation, an unnerving intimation of the art of the future. Still, for most Americans, painting continued to mean clear brushstrokes and identifiable scenes, not some hazy sensation of how sunlight and shadows made one's perceptions of the world indeterminate.

But by the first decade of the twentieth century, two people—Gertrude Stein and Alfred Stieglitz—became pivotal in introducing Americans to modernist art. Of the two, Stein was the more legendary advocate of modernism because her apartment in Paris served as a salon for avant-garde European artists, and because her friend Picasso painted her portrait (with her face a typically African mask) in 1906. Moreover, she hosted meetings between young American expatriates and Picasso, Matisse, and Constantin Brâncuşi, allowing the American ingénues (especially the painters Max Weber and Marsden Hartley and the photographer Edward Steichen) to glimpse not just the work but the charisma of the century's new artists.[11]

Stieglitz brought Europe's modernism closer to home. Where Stein was the quintessential émigré, spending most of her life in France,

Stieglitz studied in Germany in the 1880s but returned to New York as
an apostle of artistic experimentation. Initially interested in photogra-
phy as an expression of one's private vision rather than as a tool of
journalistic or documentary-style objectivity, Stieglitz in 1902 created
a group called Photo-Secession (the name was meant to suggest simi-
larities with the Secession movement of avant-garde artists in Vienna
in the 1890s). In 1903 he launched the magazine *Camera Work.*

By 1905, however, Stieglitz had turned increasingly to painting as
the decisive weapon that might revolutionize culture and the larger so-
ciety. Opening a gallery at 291 Fifth Avenue in New York, Stieglitz
began to hold exhibitions of the Impressionists and their descendants.
For the remainder of the decade, aspiring American artists as well as
trendy museumgoers could see—often for the first time—the works of
Renoir, Henri de Toulouse-Lautrec, Cézanne, Matisse, Auguste Rodin,
Brâncuşi, and Picasso. In addition, Stieglitz sponsored the careers of
America's own embryonic modernists: Weber, Hartley, John Marin,
Arthur Dove, Charles Demuth, and above all Georgia O'Keeffe (Stieg-
litz's lover and future wife).

Eventually, Stieglitz grew disenchanted with the more outlandish
manifestations of modernism (Dada was too slapstick for his fastidious
sensibilities), and he closed his gallery in 1917. For a while, though,
Stieglitz kept the cognoscenti in New York reasonably well informed
about the most recent artistic developments in Europe.[12]

However much they championed modernist painting and sculp-
ture, neither Stein nor Stieglitz had as widespread an impact on Amer-
ican audiences as occurred in 1913, courtesy of the Armory Show in
New York. The prototype of all the extravaganzas that would typify
museum programming in the later twentieth century, the Armory Show
was a project dreamed up by three relatively conventional American
painters, Arthur Davies, Walt Kuhn, and—the only one of the three
who was a participant in Stein's salon—Walter Pach. Their original
idea was to mount an "international exhibition of modern art" that
would include both European and American painters. But in traveling
through Europe in 1912 to acquire paintings, prints, drawings, and
sculptures for their exhibit, they quickly became entranced with the
power and superiority of European modernism, particularly Cubism.
Hence, the exhibition, which opened on February 17 at the armory of

the New York National Guard's 69th Infantry Regiment at 25th Street and Lexington Avenue, turned into a showcase for the works of van Gogh, Gauguin, Cézanne, Matisse, Braque, Picasso, Brâncuşi, Kandinsky, Edvard Munch, and Fernand Léger.[13]

By far, the Armory Show's most provocative painting was Marcel Duchamp's *Nude Descending a Staircase*. A dazzling blend of Cubist and Futurist influences, the painting offended audiences not only because of its enigmatic title but also because they couldn't detect either a nude or a staircase. This was an abstract escapade beyond anything American painters or their patrons were accustomed to. So Duchamp's *Nude* exemplified, to its befuddled viewers, the utter impenetrability of modernist European art.

Although the works of many American painters (like Cassatt, Hartley, Stuart Davis, and John Sloan) were represented at the show, the Americans clearly felt eclipsed by the Europeans. The Americans seemed too wedded to realism, and too esthetically cautious next to Picasso, Duchamp, or Kandinsky.[14] Indeed, the Armory Show demonstrated how predictable much of American art still was, despite the efforts of Stein and Stieglitz to familiarize their protégés with the innovations of the European avant-garde.

The Armory Show ran in New York for a month before journeying on to Chicago and Boston. By the summer of 1913, nearly 300,000 people had seen the exhibition in the three cities.[15] Whether they approved of what they saw was uncertain. Still, the show had an irreversible effect on the future of America's art and culture. It taught the public—together with America's painters, critics, and collectors— what was authentically "modern" about the European art of the early twentieth century. And it underscored the indisputable (though not necessarily permanent) preeminence of Paris as the home of the most adventurous styles and ideas in painting and sculpture. But the show also established New York as a new locale for galleries presenting modernist painting—a phenomenon that would culminate with the creation of the Museum of Modern Art in 1929.

The road from the Armory Show to the Museum of Modern Art was paved by crusaders and affluent benefactors. Duchamp, who was profoundly skeptical of all highbrow conceptions of art, became the most implausible missionary. After coming to live in New York in

1915, he embarked on a campaign to make Manhattan a center of modernism that could compete with Paris. To accomplish this goal, he urged American painters to modify or even discard some of the techniques of the European avant-garde, but in any case to concentrate on American topics.

Duchamp himself rarely painted while he was in the United States, but he functioned as an impresario for two groups that embraced his ideas. One was the salon of Walter and Louise Arensberg, which served as a meeting place between 1915 and 1920 for French and American artists, writers, composers, and performers. At any moment, one might encounter in the Arensberg living room the painters Charles Sheeler and Charles Demuth, the poets William Carlos Williams and Wallace Stevens, the composer Charles Ives, and the dancer Isadora Duncan, all of them listening to Duchamp pontificate on the need to Americanize modern art.

The second, and more momentous, enterprise was Katherine Dreier's Société Anonyme, which she founded along with Duchamp and Man Ray in 1920. Dreier, like the Arensbergs, was a wealthy fan and collector of modern art. But she did more than preside over conclaves of youthful modernists in her home and encourage informal conversations between European and American painters. Relying heavily on the recommendations of Duchamp, Dreier arranged exhibitions in New York in the 1920s of works by Cubists like Picasso, Braque, and Juan Gris, as well as the more abstract paintings of Kandinsky and Paul Klee.[16] Consequently, her Société Anonyme was a major precursor of the Museum of Modern Art.

One result of all this activity was to encourage European and American artists to focus on New York as a theme of their work. For painters on both sides of the Atlantic, the enchantment with America's premier city supplanted the nineteenth-century love affair with rural landscapes like mountains, waterfalls, and western panoramas. Manhattan lent itself to the modernist esthetic because its sleek skyscrapers, flashing lights and gaudy billboards, taxis and subways, and bustling crowds made it seem a city in constant motion and thus the physical incarnation of a Cubist or Futurist painting.[17]

No artist was more attuned to New York as the perfect modernist entity than Joseph Stella. An Italian immigrant, Stella converted the

Futurism of his native land into a distinctively American genre, especially in his five-panel painting *The Voice of the City of New York Interpreted,* completed in the 1920s. Stella's panels juxtaposed Manhattan's harbor, the Battery, the Brooklyn Bridge, Times Square, the inevitable skyscrapers, busy pedestrians, and the subway, creating a blur of urban images that turned New York into the definitive symbol of the speed and vitality of American life in the twentieth century.[18]

New York may not truly have been all that modern: it had, like every city, its nineteenth-century parks, playgrounds, river walks, ornate churches, and tranquil neighborhoods. But by the end of the 1920s Manhattan had become not just a favorite subject for avant-garde painters but the place where modernist art itself was about to be put on unparalleled display.

Throughout the 1920s, interest in modern art was growing in New York and in other American cities. As an increasing number of galleries allocated some space to an occasional modernist work, critics began to evaluate the artists in magazines and professional journals, and more people were tempted to purchase one or two of the paintings for their homes. In addition, the modernist esthetic was attracting art students, fashion designers, and advertising executives.[19] So the circumstances seemed favorable for the opening of a museum devoted entirely to modernism.

The Museum of Modern Art (or MoMA, as it came to be known) was the brainchild of three exceedingly rich women: Abigail Rockefeller, Lizzie Bliss, and Mary Quinn Sullivan. Like Katherine Dreier and later Peggy Guggenheim, they were avid collectors of modernist art, with plenty of cash to subsidize the careers of individual painters. In this, they all resembled Gene Kelly's swanky patron (played by the elegant Nina Foch) in *An American in Paris.*

Rockefeller, Bliss, and Sullivan, however, were not just upperclass ladies who lunched. They were visionaries, serious about erecting a museum to honor the modernist painters and sculptors of the early twentieth century. The Rockefeller family were the key supporters, donating land for a building a block away from the new Rockefeller Center, on West 53rd Street, and bankrolling the museum as it expanded in the 1930s.[20] Soon, the women and their advisory board hired a young director, Alfred Barr.

Barr had taught one of the first courses in an American university on modern art and architecture, at Wellesley in 1926. He also traveled widely in 1927 in Europe and the Soviet Union, where he met many of the painters, architects, and designers, especially at the Bauhaus in Germany, whom he would ultimately exhibit at his museum.[21] Now, at the age of twenty-seven, Barr became the chief publicist and master of ceremonies at MoMA when it opened its doors to an American audience in 1929.

Much to the annoyance of America's contemporary artists, Barr's notion of modernist painting, at least during the 1930s, was almost exclusively European. In the midst of a decade overflowing with social and ideological allegiances, Barr ignored the proletarian esthetic of the New Deal's Federal Art Project. No murals of heroic workers awakening the masses graced MoMA's walls. Instead, Barr's early shows, all of them popular, were dedicated largely to the Postimpressionists like van Gogh, Gauguin, and Cézanne—artists unlikely, by this time, to intimidate the museum's customers.

But Barr grew more audacious by the mid-1930s. In 1936 he offered the public a major exhibition on "Cubism and Abstract Art"—a show consisting of 386 paintings, sculptures, photographs, and posters. A year later, Barr mounted his most eccentric show to date, which he titled "Fantastic Art, Dada and Surrealism." The media coverage of this exhibition was astonishing. The Dadaists and the Surrealists, avant-garde to the core, might well have been amused to discover that their works as presented by MoMA were now being featured in *Life* magazine stories and Hollywood newsreels.[22] Both shows, together with his Picasso exhibit in 1939, confirmed Barr's status as America's leading expert on modernist art—the man whose museum you had to visit, whose catalogues accompanying his exhibitions you had to read, whose opinions you had defer to if you wanted to talk knowledgeably about what had gone on in Paris or Zurich, or in Munich and Berlin (before the Gestapo knocked on the door).

Although Barr believed in the primacy of European art, such that few American painters could gain admission to his pantheon, there was one sense in which he and his museum were characteristically American. Barr's definition of modernism was flexible. He had little respect for the preservation of rigid boundaries between high and "low" cul-

ture. On the contrary, MoMA was committed to exhibitions not only of modernist painting and architecture but also of photography, posters, advertising, and packaging. To a much greater extent than the Cubists, Barr was captivated by the ways that the artifacts of a commercial civilization could be transformed into art.

Above all, Barr recognized the centrality of the movies in modern culture. His Dada and Surrealism show, for example, included drawings from Walt Disney's animated films.[23] In 1935 Barr started a film department for the museum, with the British movie critic Iris Barry as director. MoMA's emphasis on film was unprecedented; no other museum administrators besides Barr and Barry, either in the United States or Europe, thought movies were so essential to an appreciation of modernism.

Barry's film library, over time, developed into one of the largest collections of books on movies one could find anywhere.[24] And long before there were seedy "art houses" and late-night independent television stations screening "old" movies, MoMA was holding revivals of classic American and foreign films, including the dramas of D. W. Griffith and the early comedies of Charlie Chaplin.

In making movies a subject worthy of study, Iris Barry was constructing an official narrative of world cinema just as Alfred Barr had provided the standard account of the evolution of modern art. In effect, both Barr and Barry were suggesting that the painter, sculptor, or architect was no more creative than the advertising executive or the movie director—and that, in America, high culture and popular culture were equally modernist.

By the close of the 1930s the world's most important museum for modern art and culture was located not in Europe but in the United States. Indeed, in a decade of totalitarian assaults, a lot of them murderous, on every artist associated with the European avant-garde, MoMA symbolized the emergence of America as the nation that promised to protect and broaden the values of modernism in the West. Yet the triumph of the modernist impulse in the United States did not go unchallenged by American painters themselves, particularly by those with a very different estimation of what a country ensnared in a Great Depression required from its native artists.

Americana and Alienation in the 1930s

The 1930s is commonly regarded as one of the most "radical" decades in American history. It was certainly an era of extraordinary political innovation, much of this due to the reforms enacted by Franklin Roosevelt's New Deal to cope with the problems of poverty, unemployment, and the disintegration of the American economy. The 1930s was also a time when a significant number of Americans flirted with Marxist movements and ideas, and with the notion that the prototype for a more humane society could be found only in the Soviet Union. But regardless of the competition between liberal and socialist agendas, the Depression compelled America's writers and artists to experiment with new, more publicly oriented, forms of literature, painting, theater, and music. In all these endeavors, the values of community and collective action displaced, for a moment, the habitual American veneration of individualism and self-reliance.

Yet the enduring works of the 1930s in America had little to do with the issues of the Depression. Nor with the promise of salvation from a particular creed. The greatest American novelist of the 1930s was not some ardent practitioner of social protest but William Faulkner, the writer more sensitive than all of his contemporaries to the implacable burdens of primordial folk tales and family tragedies. Though Faulkner's prose was too intricate for the majority of readers, the best-selling novel of the decade, another excursion into both the albatross and consolations of American remembrance, was *Gone with the Wind*.

Meanwhile, no angry paintings of rural poverty or working-class deprivation exceeded in popularity the inspirational illustrations of Norman Rockwell for the covers of the *Saturday Evening Post*. Likewise, the movies that dependably attracted audiences in the 1930s were comedies, musicals, and gangster films, not timely melodramas about social injustice. The gaunt face of Henry Fonda as John Steinbeck's Tom Joad in the movie version of *The Grapes of Wrath* was no more potent an icon of the 1930s than Fred Astaire's top hat and tails. And the most treasured play of the decade was not Clifford Odets's *Waiting for Lefty*, with its vociferous tribute to New York taxi drivers on strike, but Thornton Wilder's *Our Town*, a gentle portrait of what

might happen over a lifetime to husbands, wives, and children in a
small fictional New England village called Grover's Corners.

Wilder's evocation of a simpler, more innocent America high-
lighted an additional attribute of the decade's culture. For writers and
artists, it was desperately important to find something alive and good
in the United States, to recognize the inherent strength and resilience of
the American people, despite the collapse of the country's economic
system. It also seemed necessary to discover what was distinctive (and
superior) about American life, compared with the specter of tyranny in
Germany and Japan. Thus the burgeoning interest in the American
past, as reflected in the enthusiasm for historical novels or in Henry
Ford's Greenfield Village, an affectionate re-creation of an early-nine-
teenth-century town. The same antiquarian fervor led to the Rocke-
feller-financed restoration of colonial Williamsburg in Virginia. What
all of this signified was a renewed appreciation not just for a more un-
complicated time in the nation's history but for the virtues of democ-
racy and the essential decency of the average citizen—the near-mythical
"common man" who was celebrated in both Franklin Roosevelt's
speeches and Frank Capra's movies. So the passion of writers and
artists for social change in the 1930s coexisted with a reaffirmation of
America's cultural traditions and political ideals.[25]

The assertion of America's moral difference from the rest of the
world, along with the emphasis on uniquely American themes, did not
mean that foreign styles and ideas had been purged from the nation's
artworks. Now, however, the major artistic influence came not from
Europe but from Mexico.

Murals, as a form of civic art and as a social and political alter-
native to the alleged solipsism of easel painting, were the specialties of
Diego Rivera, David Siqueiros, and José Orozco. All three were parti-
sans of Mexico's revolution in the early twentieth century, and they
were equally electrified by the prospect of further Bolshevik-style up-
risings beyond the Rio Grande.

The inflammatory implications of Mexican painting became un-
mistakable when Rivera was commissioned in 1932 to produce a mural
for the lobby of the RCA Building in Rockefeller Center. As Rivera's
painting took shape, it featured the usual Marxist pageantry: a por-
trait of Lenin surrounded by joyful workers and Soviet flags, contrasted

with pictures of grotesque capitalists delighted to make money from germ warfare. Among the capitalists offended by these scenes was the young Nelson Rockefeller, a trustee of the Museum of Modern Art and executive vice president of Rockefeller Center, who had approved the selection of Rivera to help decorate the family building. Rockefeller eventually fired Rivera and ordered the mural destroyed.[26]

Despite the controversy over Rivera's homage to class warfare, the Mexican muralists seemed a model to many American artists of how, in the depths of the Depression, they too could be socially engaged. The Americans did not necessarily share the Mexicans' devotion to Marxism. Instead, mural and other types of public painting in the United States became one more way for Americans to explore their history, and to visualize the nation as a diverse but vibrant community rather than as a random collection of narcissists.

The opportunity for these revelations was provided by the New Deal—initially an unlikely source, given that Americans had long been suspicious of governmental support for the arts. Unlike almost every other Western nation, the United States had never had a ministry of culture, nor was there much reliance on state funding for symphony orchestras, ballet companies, museums, or theaters. Moreover, during the 1930s, amid the spectacle of the Nazis' torchlight parades and the propaganda emanating from German radio broadcasts and Leni Riefenstahl's movies, politicians as well as ordinary citizens in the United States were worried about their own government's use of culture and the media to manipulate public opinion. It was remarkable, then, that the Roosevelt administration was able, beginning in 1935, to launch and sustain the Federal Art, Music, Theater, and Writers' Projects as part of its WPA programs.

The New Deal's rationale for these cultural undertakings was that (just like construction workers) writers, musicians, painters, and actors had to eat—and, more important, to utilize their skills for the benefit of what Roosevelt called the "forgotten" Americans. Additionally, the agencies' directors, like the Federal Art Project's Holder Cahill and the Federal Theater's Hallie Flanagan, embraced the decade's conviction that writers and artists should immerse themselves in the sometimes obscure details, past and present, of American life.

With this mission in mind, the Theater Project performed not for

affluent audiences on Broadway but in working-class and African American neighborhoods, outside factory gates, and in nondescript towns whose residents had never before seen a play. The Writers' Project interviewed thousands of blue-collar laborers, impoverished farmers, miners, lumberjacks, waitresses, and former slaves; and it published guidebooks that surveyed the history, folklore, ethnic and racial composition, and ecology of every state. The Music Project held free concerts and transcribed half-forgotten sea chanteys, cowboy and gospel songs, Indian dances, and Protestant hymns. The preservationist spirit, particularly of the Writers' and Music Projects, coincided with the desire in the 1930s to uncover, through the compulsive accumulation of statistics and cultural artifacts, the hidden meaning of the American experience.

During its brief life span, between 1935 and 1943, the Federal Art Project—which at its height had five thousand artists on its payroll —turned out more than 2,500 murals (most of them adorning the walls of post offices and county courthouses), nearly 18,000 sculptures, 108,000 easel paintings, and 2 million prints and posters.[27] Although there were occasional experiments with abstraction at the Art Project, the prevailing esthetic was realistic and instructional—a style antithetical to modernism. The Project's artworks were designed for popular rather than elite consumption. The murals especially told stories about regions and local communities that people could instantly comprehend. And they permitted artists to feel that they were bonding with regular people—an aspiration many American painters of the 1930s shared with both Diego Rivera and Norman Rockwell.

The nostalgia for small-town and rural life that pervaded the New Deal's cultural projects was meant to comfort the populace in an age of fear and uncertainty. These sentiments also informed the work of Thomas Hart Benton and Grant Wood, members of a group of midwestern artists known as the Regionalists. Though Benton had once dabbled in modernism, by the 1930s he and his colleagues loathed any form of painting that was nonrepresentational, vaguely Parisian, or ostentatiously snooty. What they wanted was a scrupulously "American" art—paintings that were rooted in the rituals and myths of the national heartland.

Like the muralists at the Federal Art Project, the Regionalists

yearned for paintings that were intelligible to viewers who knew nothing about Cubism or Surrealism. But far more than their counterparts at the Art Project, the Regionalists succeeded in reaching the masses. Wood's *American Gothic,* completed in 1930, with its archetypal rural couple armed with stern gazes and a sturdy pitchfork, became the decade's most famous American painting, the quintessential symbol of the country's ability to endure hard times. Benton's paintings, similarly drenched in Americana, landed him on the cover of *Time* in December 1934, the first American artist to receive such star treatment.[28]

The broad appeal of the Regionalist paintings naturally attracted the attention of corporate executives, eager to market their wares to the largest possible audience. In 1941 George Washington Hill, the president of the American Tobacco Company, hired Benton and other Regionalists to create some advertisements for his Lucky Strike cigarettes. The result was a series of pictures—which ran during 1942 in *Time, Life, Fortune,* and the *Saturday Evening Post*—portraying tobacco country as a rural nirvana, filled with lavish crops and jovial farm workers.[29] These were agricultural fantasies unknown to the destitute sharecroppers who populated Erskine Caldwell's *Tobacco Road* or James Agee's *Let Us Now Praise Famous Men.*

As advertisers realized, the Regionalists' esthetic was reassuring, and thus good for business. There was nothing reassuring about the works of Edward Hopper, the era's most enigmatic and least political artist. Nor did Hopper's style lend itself to the selling of cigarettes or any other product. Though Hopper started out as a commercial artist, the mood of his paintings in the 1930s and early 1940s was too austere to endorse the pleasures of consumption, especially in a decade of massive unemployment and compulsory frugality.

Apart from his distaste for modernism, Hopper had little in common with the artists of the 1930s. No hunger for community animated his works, as they did the paintings of the Mexican muralists, the Federal Art Project, or the Regionalists.[30] Nor were Hopper's scenes teeming with workers, farmers, shoppers, people embroiled in their hectic lives, as was the case with Benton. In an age of social consciousness, Hopper's paintings were antisocial. His characters were invariably pictured alone, particularly when he focused on a woman, sitting by herself in a hotel room or a railroad car, or standing as an usher in the

corridor of a movie theater engrossed in her own reveries. In Hopper's best-known painting, *Nighthawks* (1942), two men and a woman are seated in a diner, staring at their coffee or at their fingernails or into space, ignoring the counterman, solitary and introverted even in the company of other people.

The lack of human connection or any feeling of social solidarity in Hopper's paintings made his work seem irreconcilable with the politics or the values of the 1930s. Hopper was the artist of the future: the visual poet of introspection and alienation, of bleak cities and abnormally quiet small towns, of morose people almost sinister in their isolation.

Hopper loved the movies, like so many Americans during the Depression decade. Yet to look at his painting of a man and a woman working (or possibly plotting) in an office at night, or his portrait of deserted buildings lining some mean street on an early Sunday morning, is to glimpse not a 1930s-style Hollywood romance or a screwball comedy but the beginnings of film noir. Indeed, it's easy to imagine that one day Hopper's remote gas station or desolate Cape Cod houses might turn into the Bates Motel.

Hopper may have been an anomaly in the 1930s, and a visionary thereafter. Yet even his paintings contributed to one of the central paradoxes of the decade's culture. The rebellion against modernism, evident in Hopper's canvases as well as in the works of the Federal Art Project and the Regionalists, coincided with the emergence of the Museum of Modern Art as America's most influential celebrant of modernist painting, sculpture, and architecture. But in a decade whose esthetic principles were shaped less by Alfred Barr than by Thomas Hart Benton, Edward Hopper, and Norman Rockwell, a question loomed: could modernist painters match the power of their antimodernist rivals in portraying, explicitly and eloquently, the crises of the 1930s?

The answer came from a European, not an American, artist. And it emerged from the Spanish Civil War, the tragedy that would signal the end of the Depression as the major preoccupation of artists and writers in the 1930s, and the beginning of far worse horrors than they could have envisaged.

On April 26, 1937, a squadron of German planes bombed a Basque

town in northern Spain, called Guernica. Of Guernica's seven thousand residents, an estimated sixteen hundred were killed or wounded, and 70 percent of the town was demolished.[31] Meanwhile, the Loyalist government in Madrid had asked Pablo Picasso to create a mural for the Spanish pavilion at the 1937 International Exposition in Paris. Picasso's work, titled simply *Guernica,* became the most unforgettable painting of the 1930s, if not of the twentieth century. With its allegorical but graphic black-and-white images of innocent people and animals howling in agony, the painting was a modernist testament to the horror of twentieth-century warfare, especially the deliberate terrorizing of civilian populations through the saturation bombing of cities—a tactic that would be used by all sides during World War II, culminating in the dropping of atomic bombs on Hiroshima and Nagasaki.

Guernica proved that there was no incongruity between modernism and political protest or moral rage. Picasso, though, could be more sardonic than strident about the devastation inflicted on his native land. In 1940, after the Nazis occupied Paris, where Picasso lived, he handed out prints of *Guernica* to the jubilant German officers. One of the conquerors asked him, "Did you do this?" "No," Picasso replied, "you did."

But Picasso was no Dadaist with a zest for black comedy. Upon the defeat of the Loyalists in 1939, he insisted that his painting not be hung in any Spanish museum until the death of the fascist despot Francisco Franco and the resurrection of democracy in Spain. So, after wandering to Scandinavia and London, *Guernica* arrived in 1939 at the Museum of Modern Art, where it became the centerpiece of the museum's collection for the next forty-two years, the painting that overshadowed all the other modernist masterpieces at MoMA, until it returned to Madrid and now-democratic Spain in 1981.

The migration of *Guernica* to MoMA signified not only the compatibility of modernist art and contemporary politics, but a transformation that was about to occur in the cultural relationship between Europe and the United States. *Guernica* was a refugee in the form of a painting. It would be accompanied by thousands of human exiles from Europe, who found an unexpected shelter for themselves and their work in America.

The Exodus from Europe

No single person in the twentieth century was more responsible for shifting the cultural balance of power from Europe to America than Adolf Hitler. Within months after he became chancellor of Germany on January 30, 1933, Hitler launched a massive purge of German intellectual life.

The "cleansing" of German culture began on May 10, when right-wing students at the direction of Nazi officials tossed twenty-five thousand volumes of "un-German" books into bonfires, not just in Berlin but in nearly every university town in the country. Among the proscribed authors were Karl Marx, Sigmund Freud, Bertolt Brecht, and those two notorious antiwar (and thus anti-Nazi) novelists Erich Maria Remarque and Ernest Hemingway.

Ever since the original infernos, the Nazi book burnings have reverberated throughout the West because they symbolized the death of the modernist spirit in Europe. François Truffaut's landmark 1962 film *Jules and Jim* is partly a tale about early-twentieth-century European intellectuals—writers and readers whose lives are molded by books. Their literary and sexual idyll comes to a close near the end of the movie when they (and we) watch newsreels of books being torched. By the 1930s the world of Truffaut's characters, along with their books, has been consigned to the flames. Soon, the books will be followed by bodies.

The attack upon German writers and intellectuals did not stop with the suppression of their published works. Within months, professors (many of them physicists, mathematicians, chemists, economists, and sociologists) were fired from their university positions. Then, in October 1933, the Nazis denounced psychoanalysis as a "Jewish science," and its practitioners were prohibited from engaging in therapy or holding academic appointments.

Jews, of course, were not specialists only in psychoanalysis. To the Nazis, they seemed to dominate the German media as newspaper owners and journalists, and they were equally prominent in music, film, and the theater. Indeed, their visibility in the arts outweighed their relatively small presence in the German population. Out of 65 million people living in Germany in 1933, only 500,000 were Jewish. Never-

theless, the 1935 Nuremberg laws stripped Jews of their citizenship and their legal rights. By November 1938, in the wake of the pillaging on *Kristallnacht* of Jewish homes and synagogues, along with Jewish-owned shops and department stores, the lives of all the Jews in Germany were clearly in peril.[32]

And so they fled—starting with German intellectuals of all religious persuasions, but eventually escalating into a Europe-wide evacuation. At first, the émigrés hoped that Nazism might be a temporary phenomenon and that with its collapse they would be able to return to their native lands. A substantial number, therefore, initially chose to stay in Europe, where they still felt culturally at home. They relocated to London (as did Freud after the absorption of Austria into the Third Reich in 1938), Paris (which took the place of Berlin as a temporary headquarters for German novelists and film directors), Amsterdam (whose most illustrious refugee writer turned out to be a fourteen-year-old girl named Anne Frank), and Prague (before the dismemberment of Czechoslovakia at the Munich conference in 1938). But after Germany's conquest of Poland in 1939 and its invasion of western Europe in the spring of 1940, an entire generation of endangered writers and scholars sought to escape the Continent altogether.

Throughout the decade, a growing number of refugees had begun to consider another, more distant, sanctuary. Although the United States often appeared too provincial and too inhospitable to either the classical or modernist culture of Europe, America had always been the ideal destination for people who were uprooted and in transition. And even though the immigration laws of 1924 restricted the flow of newcomers to the United States, there were still ways to enter America, if you had special skills or connections.

Gradually, the refugees were psychologically deserting Europe before they reached America. As Jews or Marxists or both, they were regarded by many of their fellow Europeans as outsiders; as writers or artists, they were cosmopolitan but cut off from their own societies. They were ready, consciously or not, to move on.

In essence, the rise of Nazism reversed the historic migration of American expatriates to Europe. From 1933 on, the most creative European intellectuals, novelists, artists, musicians, filmmakers, and scientists set off for America, where they discovered, sometimes to their

astonishment, that the New World provided a haven and sustenance for the culture of the Old.

The roster of émigrés was dazzling, especially in the sciences. One of the first physicists to arrive in the United States was Albert Einstein, who accepted a position in 1933 at the new Institute for Advanced Study in Princeton. Einstein served as the supreme symbol of the refugee scientist and intellectual in flight from the malevolence of Nazism, who transported himself with some apprehension to America.[33] He was followed by Enrico Fermi, Leó Szilárd, Hans Bethe, Edward Teller, and Victor Weisskopf, all of whom would ensure their fame forever either at the Manhattan Project or at Los Alamos as the men who helped create the atom bomb.

Within a short time, the physicists were joined by a galaxy of political and social scientists: Erik Erikson, Hannah Arendt, Leo Strauss, Erich Fromm, Paul Lazarsfeld, Max Horkheimer, and Theodor Adorno. The anthropologists Claude Lévi-Strauss and Bronislaw Malinowski came, together with the psychologists Karen Horney and Bruno Bettelheim. So too did the philosophers Herbert Marcuse and Rudolf Carnap, and the theologian Paul Tillich. Some of the most well-known European playwrights and novelists also resettled in America: Brecht, Remarque, Thomas Mann, and Vladimir Nabokov.

Modernist painters and sculptors were particularly vulnerable to persecution by the Nazis, first in Germany and later in occupied Europe. In 1933 the Nazis fired a number of painters whose works were deemed odious or "Jewish"—including Paul Klee, Max Beckmann, and Otto Dix—from their positions as teachers in German art schools. In 1936 the National Gallery in Berlin was forced to close all its rooms devoted to modern art.[34] Then in 1937 the Nazis mounted an exhibition in Munich of what they characterized as "degenerate" European art. Their definition of depravity comprised the major artistic movements of the late nineteenth and early twentieth centuries, the very movements the Museum of Modern Art was simultaneously honoring: Impressionism, Cubism, Expressionism, Dadaism, and Surrealism. Among the works the Nazis condemned were those of Klee, Beckmann, Dix, George Grosz, Max Ernst, Lyonel Feininger, Marc Chagall, Piet Mondrian, and Wassily Kandinsky.

The artists in Germany and elsewhere became part of the Euro-

pean Diaspora. By the late 1930s and early 1940s, Kandinsky, Mondrian, Grosz, Feininger, Fernand Léger, Salvador Dalí, Joan Miró, and Yves Tanguy had all departed for the United States.

Others were still in Europe just as the gates to America closed. In 1940 the Department of State made it harder for all European writers and artists to emigrate. Unsympathetic to people it assumed were Jews or socialists and therefore security risks, the State Department delayed or stopped issuing visas to Europeans trapped in Holland, Belgium, and France.

In response, a newly formed Emergency Rescue Committee dispatched Varian Fry, a young Harvard-trained classicist and writer, to Marseilles, now under the control of the Vichy government after France surrendered to the Germans in June 1940. Like one of the shady characters peddling counterfeit jewelry and documents at Rick's café in *Casablanca*, Fry raised money on the black market, forged passports, bribed consular officials for exit visas, booked illegal passage on ships, and discovered hidden routes across the Pyrenees into Spain. Those whom he smuggled out of France included artists like Chagall, Ernst, Jacques Lipchitz, and Marcel Duchamp (who had returned to France in 1923)—in addition to Hannah Arendt and the chief theoretician of the Surrealists, André Breton.[35] At the end of his operation, shut down by the French police in the summer of 1941, Fry had helped approximately fifteen hundred people escape from Europe.

Most of the émigrés to America, whatever their vocations, were implacably urban. Their natural habitats in Europe were Vienna, Berlin, and Paris. For many, New York felt familiar, with its delicatessens, bookstores, galleries, movie theaters, and irreverent slang. Fifth Avenue, after all, was not noticeably different from Berlin's Unter den Linden or Paris's Champs-Élysées. Despite the Europeans' cultural arrogance, which their American counterparts often detested, the legendary modernists were here in the flesh, most of them (especially the artists) in Manhattan. American painters no longer needed to wait for a MoMA retrospective on the Cubists or Surrealists. The names the Americans revered were now their neighbors, the people they ran into every day on the streets in midtown or Greenwich Village.

In fact, so many European painters had turned up in New York that a display of their works was held in Manhattan in 1942. Entitled

"Artists in Exile," the exhibition featured paintings by Mondrian, Chagall, Léger, Dalí, Ernst, and Tanguy. The show, in turn, intensified the desire of American artists to create works at least equal to those of the Europeans in their midst.[36]

But what if a refugee were transplanted to a far-off, sun-soaked, American-style dreamscape like southern California? Mann, Marcuse, Adorno, Horkheimer, and Brecht all found themselves adrift in Los Angeles, surrounded by a Hollywood culture they didn't understand or respect. Consequently, they kept their distance, refusing (except when necessary) to speak English or socialize with the uncouth crowd at the movie studios.[37] On the other hand, there were dozens of refugee composers, directors, writers, and actors who did assimilate to Hollywood, and they, in time, altered the style and content of American movies.

Yet wherever they landed, the émigrés represented for Europe a hemorrhage of talent and intellect from which the Continent has never really recovered. Meanwhile, by the end of World War II, New York and Los Angeles had replaced Paris and Berlin as the home of modernist culture, just as Washington supplanted London as the center of Western political power. To mark the emergence of America's cultural preeminence, a new American art appeared—no longer insular, as in the 1930s, but indisputably modernist and global in its impact.

The Internationalism of Postwar American Art

They were called Abstract Expressionists, a perfect name for the American painters who seized the mantle of modernism from the Europeans during and after World War II. The label implied that the Americans were blending the nonrepresentational art of the Cubists with the psychological intensity of the Surrealists and German Expressionists, but converting these "foreign" movements into an idiosyncratic form of painting now possible only in the United States.[38]

Several of the Abstract Expressionists were themselves immigrants. Mark Rothko arrived from Russia as a child with his family in 1913. Arshile Gorky escaped from Armenia and the Turkish slaughter of his people in 1920. Willem de Kooning, from Rotterdam, stowed away on a British freighter, reaching America in 1926.

But by the 1930s, their voyage to the New World behind them, they had become "American" painters, sharing (along with their future Abstract Expressionist colleagues) the social, if not the esthetic, predilections of most of the decade's artists and writers. Rothko, Gorky, and de Kooning all worked on the Federal Art Project, as did Jackson Pollock. In addition, Pollock studied for a while with Thomas Hart Benton, absorbing Benton's fondness for large canvases and vivid colors, and trying to imitate the rippling silhouettes of Benton's bodies and objects. Pollock was similarly attracted to the Mexican muralists, mainly because of the ambitious scale of their paintings.[39]

Yet the Abstract Expressionists were never content to be cultural nationalists or political partisans, nor did they want to specialize in the "American scene." Instead, they longed to be members of an international avant-garde. Soon, they revolted against the artistic conventions of the 1930s. Where the Mexican muralists and the painters employed by the Federal Art Project had been Marxist or populist in their commitments and sensibilities, and concerned with pictorially dramatizing the issues of the Great Depression in a manner their viewers could easily grasp, the works of the Abstract Expressionists were introspective, apolitical, and inaccessible to the uninitiated. What mattered to them was an art endowed with covert, rather than explicit, meanings. Though many of the Abstract Expressionists had participated in the left-wing movements of the 1930s, their wartime and postwar radicalism was stylistic, not ideological.

Moreover, like the European modernists, the Abstract Expressionists were not interested in maintaining the fantasy that art was meant to reproduce or illuminate the outside world. From the Cubists on, the quality of a painting was supposed to depend on how well the artist used the flat picture plane (since the reliance on perspective was passé), on the blending or clash of colors, on the artist's intimate encounter with the canvas rather than with external events, topics, or people.[40] The painting itself was the subject the viewer should concentrate on, nothing more.

It was not surprising, then, that the real mentors and role models for the Abstract Expressionists were not Benton or Diego Rivera but those Europeans who emphasized the formal properties of a painting, who had tinkered with new structures and materials as well as with

patterns of color and geometric shapes—artists like Picasso, Kandinsky, and Mondrian. This preference for abstraction was bolstered by the émigrés the Americans met in Manhattan's restaurants, galleries, and lofts. Among the most significant of the newcomers was Hans Hofmann, a disciple of Picasso and Kandinsky and a true believer in abstract art. Hofmann had first come temporarily to the United States from Germany to teach at Berkeley in 1930. With the rise of the Nazis, he emigrated permanently and opened the Hans Hofmann School of Fine Arts in New York in 1933. Thereafter, his students included Pollock, Rothko, Robert Motherwell, Clyfford Still, and William Baziotes, all of them founders of Abstract Expressionism.[41]

No European artists, however, influenced the Americans more than the Surrealists. Because the Abstract Expressionists regarded painting as a form of self-discovery, the Surrealist preoccupation with unconscious creativity, with the artist's emotions and intuitions, and with the sort of free associations that occurred in dreams reinforced the Abstract Expressionists' (and especially Pollock's) inclination to work quickly and impulsively—as if all those dribbles and blotches on a canvas were a reflection of inner states of feeling, unmediated by thought or intention.[42]

Nevertheless, the Abstract Expressionists' attraction to Surrealism was motivated less by the theories of the interwar European avant-garde than by attitudes embedded in America's culture and history. Could any idea be more American than the notion of painting as an expression of the artist's individuality, a fulfillment of his or her quest for identity? Pollock did spend two years in Jungian analysis, exploring universal archetypes and myths. But he, together with the rest of the Abstract Expressionists, was using Surrealism and psychoanalysis to "Americanize" Europe's modernism, making painting more an instrument of personal liberation than an attempt (as some of the Europeans had hoped) to transform the values and perceptions of the bourgeoisie.

The specific techniques of the Abstract Expressionists were also typically American. For them, painting was a performance, filled with improvisations, like a jazz soloist's riff on a familiar theme or a Method actor trying to fathom a character's motivation before the debut of a play. Pollock's famous "drip" paintings resembled an extemporized dance, with Pollock hurling paint at a canvas stretched out on a floor,

using the rhythmic movements of his hands and body to conjure up in-
tricate designs, his sticks and brushes an extension of his physical and
emotional agility. Pollock often listened to jazz while he was painting,
as if his art were a visual analogue to the music of Charlie Parker and
Dizzy Gillespie.[43]

The results, on canvas, were less important than the act of paint-
ing itself, at least according to the critic Harold Rosenberg, who was
entranced with the impetuosity of the Abstract Expressionists.[44] The
American artist in this view was a risk taker, in love with spontaneity
and incessant experimentation, continually reinventing himself or her-
self with each creation—an adventurer in the wilderness (Pollock was
born in Wyoming) where the squares couldn't follow.

But the squares did follow, once they were told by guides like
Rosenberg and Clement Greenberg what artistic territories the hip new
American painters were opening up. And once their works started ap-
pearing in all the prestigious venues formerly reserved for the Euro-
pean modernists.

Indeed, success came swiftly. By the early 1940s the Abstract Ex-
pressionists began to display their paintings in many of the chic New
York galleries—especially the one called Art of This Century, launched
in 1942 by Peggy Guggenheim. A classic but wealthy expatriate who
had lived in Europe since the 1920s, Guggenheim acquired a large num-
ber of modernist works just before World War II: paintings by Braque,
Klee, Kandinsky, Mondrian, Miró, de Chirico, and Dalí; sculptures by
Brâncuşi, Lipchitz, and Alberto Giacometti. Like one more character
out of *Casablanca,* she returned to the United States on a midnight
flight from Lisbon in July 1941 with her lover, Max Ernst, and her art
collection, aiming to establish another site in Manhattan for the exhi-
bition of twentieth-century European masterpieces.

Yet she soon offered space in her gallery to the Americans. Dur-
ing the two years after the gallery opened, Art of This Century featured
one-man shows by Motherwell, Rothko, Baziotes, Still, and particu-
larly Pollock, whose exhibit in 1943 confirmed the arrival of a new
generation of modernist American painters as talented and innovative
as their European competitors.[45]

Guggenheim closed Art of This Century in 1947 and moved back
to Europe, eventually housing her collection in Venice—one of the first

locations on the Continent where viewers could see American works alongside those of the Europeans. But other museums in the United States were now enlarging their space and building new wings for the presentation of modern American art. By the early 1950s no important museum was without a drip painting by Pollock, a series of black-and-white abstractions by de Kooning, an example of Rothko's rectangles, a monochrome canvass by Barnett Newman.[46]

The verification of the Abstract Expressionists' triumph occurred in 1952, when the Museum of Modern Art—previously indifferent to American painting—held an exhibition devoted to the works of Pollock, Rothko, and Still.[47] MoMA was also buying Abstract Expressionist paintings for its permanent collection, thereby admitting the Americans into the canon of modernism.

MoMA's stamp of approval enhanced the value of Abstract Expressionist works in the private art market. Where the painters of the 1930s had been put to work by the WPA beautifying government buildings, the Abstract Expressionists depended on art dealers and auctioneers who capitalized on America's postwar affluence and the tendency of the well-to-do to treat modern art either as an investment or as decoration for the interiors of their mansions and corporate suites. After all, what could look better in a home or an office than a canvas that didn't call attention to some jarring subject (a penniless migrant laborer or a rural farmer with a pitchfork glaring at the guests) but was filled merely with innocuous colors and diagonal lines (nicely matching the carpet and the furniture)?

Besides, the purchase of an Abstract Expressionist painting could improve the image of a corporation or a department store. In the 1950s one could stumble across a Pollock or a de Kooning at the headquarters of IBM, the Chase Manhattan Bank, and Hallmark Cards, as well as on the posh walls of Nieman Marcus in Dallas.[48]

The publicity that flowed from the auctions, sales, corporate and department store displays, and rising prices of Abstract Expressionist paintings added to the notoriety of the American artists. Having learned from but no longer subservient to the Europeans, the Abstract Expressionists were ascending—with the assistance of the media—to the status of culture heroes. Magazines like *Time, Life, Newsweek,* and *Fortune* had been running articles on modernist artists since the 1930s,

often focusing on the flamboyant private lives of Picasso and Salvador Dalí. After World War II the magazines turned their attention to the Americans, treating them sometimes with derision but increasingly with respect.

Of all the Abstract Expressionists, Pollock became the media's megastar. As early as 1949, *Life* published an article entitled "Jackson Pollock: Is He the Greatest Living Painter in the United States?" Although the title was intended to be facetious, the text was accompanied by quotations from Pollock and reproductions of his paintings, all of which helped introduce him as a serious if iconoclastic artist to the general public. Then, in 1950, the photographer Hans Namuth took dozens of pictures and shot a twenty-minute film of Pollock at work in his studio in East Hampton, Long Island. Clad in a T-shirt, blue jeans, and cowboy boots, Pollock looked more like a typical American construction worker than an effete European artist in a Parisian garret.[49]

Pollock also resembled the new actors who were emerging in the theater and the movies by the 1950s. He was, in the eyes of his fans, the Marlon Brando of American painting: rebellious, unpredictable, explosive in his passions and his intermittent (usually alcoholic) rages. *Time* made the analogy with Brando clear when it published an article in 1956 on Pollock and his colleagues called "The Wild Ones" (invoking Brando's iconographic role in the 1953 film), as if the Abstract Expressionists were members in their spare time of a motorcycle gang, roaring through the complacent landscape of postwar American life.[50] The connection between the Abstract Expressionists and the Method actors deepened when Pollock was killed in 1956 at the age of forty-four in a car crash, just as James Dean—another maverick living fast and dying young—had ended his brief life a year earlier.

Hollywood, though, did not know what to make of the Abstract Expressionists. The model for modern art in *An American in Paris,* released in 1951, is still Impressionism. Gene Kelly's ambition in the movie (besides dancing to Gershwin) is to be another Renoir, not a Pollock or de Kooning.

Yet it was Pollock, de Kooning, Rothko, and Motherwell who had become household names by the 1950s. While Thomas Hart Benton and Norman Rockwell had been popular in the 1930s, their reputation was based exclusively on their works. Now, for the first time in

its history, the United States had some full-fledged celebrity artists, equivalent to Hemingway and Fitzgerald in literature, as well known for their personalities and public images as for their paintings.

And the fame of the Abstract Expressionists was a global, not just an American, phenomenon. The world's growing familiarity with the works of the Abstract Expressionists was in part a consequence of America's political and economic supremacy after 1945. American culture and American power were now inextricably joined. Just as foreigners were affected by the goals of America's diplomacy, so they needed to know about developments in American literature, science, and social thought. America was not only the new colossus in international affairs; its artists and intellectuals were also the new cosmopolitans.

Still, not everyone abroad was awed by America's postwar sophistication. From the 1940s on, the United States was engaged in an epic struggle with the Soviet Union, waged as much for global cultural influence as for military advantage. In a contest to win the "hearts and minds" of those people throughout the world who did not wish to chose sides between the superpowers, it mattered whose civilization seemed superior. Both the Soviet Union and the United States deployed all the cultural weapons in their arsenal: novels, poetry, plays, opera, ballet, concerts (symphonic as well as, in the American case, jazz), student and faculty exchanges.

Art was among the most important of those weapons. From the point of view of officials in the State Department, the Abstract Expressionists could serve as an advertisement for American values in the Cold War. While Soviet artists, bowing to the dictates of the Kremlin, continued to employ the clichés of "socialist realism," America's modernists were presumably unfettered by ideology. They were free, the diplomats argued, to "express" their individualism without having to answer to cultural commissars. Hence great painting like theirs could flourish only in a society that was open and democratic, a society that treasured nonconformity and competition as catalysts for artistic achievement. Although the Abstract Expressionists might have thought this explanation for their prominence was bizarre, they became (whether they wanted to or not) an essential ingredient in America's cultural diplomacy, a means of contrasting the vibrancy of life in the United States with the monotony of totalitarianism.

During the 1950s and 1960s the State Department and the United States Information Agency (created in 1953 to administer the government's cultural programs) collaborated with the Rockefeller Foundation and the Museum of Modern Art in mounting exhibitions, many of them featuring the Abstract Expressionists, throughout the world. In 1951 Washington funded an exhibit of modern American painting at a cultural festival in West Berlin. Here, thousands of Germans first glimpsed the paintings of Pollock and Rothko. At the same time, the State Department's America Houses (located in all the major cities of West Germany) were holding constant exhibitions of American painting, sculpture, and photography. The U.S. Information Agency sent modernist American paintings to Latin America, the Middle East, Africa, Asia, and even the Soviet Union by the 1960s. Modern American art was also being displayed in U.S. embassies and consulates, this at a time when it was still possible to enter an American installation overseas that didn't look like a fortress where a visitor had to run a gauntlet of security checks.

In the cultural Cold War, the Museum of Modern Art's involvement was crucial. As the gatekeeper of modernism, MoMA added legitimacy to the government's efforts to promote American art. In 1953 MoMA purchased a pavilion at the Venice Biennial Exposition for a presentation of American painting, the only nongovernmental patron at an event designed to trumpet the cultural accomplishments of all the participating countries. In 1958 MoMA organized a European exhibition, "The New American Painting," dedicated to the Abstract Expressionists. The show traveled to Basel, Milan, Madrid, Berlin, Brussels, Amsterdam, London, and Paris. In each of the cities, museumgoers were obliged, sometimes reluctantly, to acknowledge the ascendancy of American art.[51]

However much the Cold War inspired these international exhibitions, they were a sign that Abstract Expressionism was by midcentury the world's most influential artistic movement, one that painters in other countries would have to emulate if they wanted to keep up with the Americans. But if American art was now the embodiment of modernism, it was also becoming mainstream. What had begun with the Impressionists as an uprising against conventional painting, and as an effort to disturb the bourgeoisie, was turning into a hit with the public—in the United States and all over the world.

The Popularization of Painting

From the early twentieth century, modernist artists incorporated elements of popular culture into their works. Cubist paintings and collages were filled with newsprint, brand names, labels, advertising slogans, handbills, graffiti, scraps of wallpaper—the debris of a consumer culture transmuted into a new form of art.[52] For Picasso and Braque, the nineteenth-century distinctions between the sensibilities of the elite and the tastes of the lower classes had evaporated.

But no European artist had less regard for the sacred precincts of high culture than Marcel Duchamp. In the "readymades" he created in the second decade of the twentieth century, Duchamp set out to puncture the assumption that art should be idolized, that it was somehow "above" the rubbish of daily life. Anything found in junk stores or on the street could be considered art, especially any item that was mass produced. Unlike the Cubists, Duchamp did not believe that such products needed to be altered or rearranged on a canvas; you could simply present a snow shovel, a typewriter, a bottle rack, a bicycle wheel, or a urinal as an object of esthetic delight.

Yet Duchamp was willing to tinker with, or make fun of, the most hallowed masterworks in the temple of high culture. Just so the viewer knew that traditional conceptions of painting were being deflated, Duchamp offered up his version of the *Mona Lisa* in 1919, complete with a mustache and goatee, converting the most famous painting in the history of Western art into a cartoon.[53]

So when Pop Art appeared in the United States in the late 1950s and 1960s, its fascination with movie stars, comic strips, and packaging—what seemed like all the trappings of America's commercial civilization—had a European pedigree. The Pop Artists, as cavalier about the borders between highbrow and lowbrow as the Cubists or Duchamp, were not so much abandoning modernism as amplifying its irreverence.

Still, the Pop Artists were strikingly American in their love affair with consumerism and mass entertainment. Where the Cubists had used popular culture for their own artistic purposes, the Pop Artists wallowed in the most banal manifestations of marketing and media hype. Greed, self-indulgence, the flashing of wealth, these were not the

enemies of Andy Warhol, Robert Rauschenberg, Jasper Johns, Roy Lichtenstein, or Claes Oldenburg. Instead, they reveled in the materialism of a country saturated with shopping malls, fast-food joints, used-car lots, tabloid newspapers, and advertisements for every conceivable product. For the Pop Artists, the point was not to find artistic alternatives to American capitalism, as the painters of the 1930s or even the Abstract Expressionists had done, but to acknowledge and unveil the hidden beauty of a culture addicted to the pleasures of buying and selling.

The Pop Artists' affection for America's entrepreneurial spirit derived from their background as commercial illustrators and creators of ad campaigns. Warhol, in particular, got his start dressing windows in department stores, as well as designing book jackets for New Directions Press, album covers for RCA Victor, stationery for Bergdorf Goodman, and Christmas cards for Tiffany. More than any of the other Pop Artists, Warhol was spellbound by how businesses operated and by the techniques of mass production.[54] No lonely artist inspecting his psyche in a threadbare studio, Warhol worked out of what he called "The Factory," surrounded by assistants and sycophants, manufacturing endless copies of a single image, insisting on the bond between art and the assembly line.

But the Pop Artists, including Warhol, were following in the tradition less of Henry Ford than of Marcel Duchamp. If, as Duchamp believed, a toilet could be an artistic gem (all that gleaming curvilinear porcelain), then why not innumerable duplicates of a Coca-Cola bottle or a Ballantine beer can, a box of Brillo pads or Kellogg's corn flakes, a can of Campbell's soup or Del Monte peaches, a pack of Lucky Strikes or an American flag? Yet where Duchamp had often infuriated viewers with his indecipherable nudes and his mockery of Leonardo da Vinci, here was an art everyone could identify with, or at least smile at. Pop Art was not abstract like Kandinsky or Pollock, disconcerting like Dalí or de Chirico, or mysterious like Hopper. Its subjects were familiar, mundane, a collection of objects people saw each day in their kitchens and at grocery stores, or in a Fourth of July parade.

They could not, however, have known that this was truly art until the Museum of Modern Art told them so. In 1961 MoMA held an ex-

hibition called "The Art of the Assemblage," which was one of the first official tributes to the importance of Pop Art. Thereafter the accolades multiplied. In 1962 the Sidney Janis gallery in New York presented the works of Warhol, Lichtenstein, and Oldenburg in a show that captured the attention of dealers, affluent investors in the latest artistic fads, and the media. In 1964 Pop Artists were featured at the New York World's Fair. Throughout the rest of the decade, Pop Art turned up regularly at worldwide exhibitions, including the Venice Biennale, where Rauschenberg became the first American artist ever to win the festival's international grand prize for painting.[55] By the 1960s the Pop Artists had replaced the Abstract Expressionists as America's preeminent contributors to the global art scene.

Given their lofty status at home and abroad, no artists were less interested in acting like a bunch of alienated, misunderstood geniuses. The Pop Artists, especially Warhol, wanted to be famous (for longer than fifteen minutes) and commercially successful. They were themselves entrepreneurs, thrilled by the escalating prices of their paintings, and they knew the value of publicity and self-promotion (as had Picasso, Dalí, and Pollock).

But if Pollock was the Marlon Brando of American painting, Warhol was Mel Brooks. "That's it, baby," yells Zero Mostel's Max Bialystock out of his office window to a rich passerby in *The Producers,* "when you've got it, flaunt it, flaunt it!" Warhol flaunted it. He became a star, frequently photographed and written about, as if his constant appearances in gossip columns were what every celebrity artist with a press agent deserved. No wonder, then, that Warhol's most well-known portraits were of other stars, in the movies and politics—Elizabeth Taylor, Marilyn Monroe, Elvis Presley, Jacqueline Kennedy—all thriving in a universe just like his, a world of illustrious and instantly recognizable faces, products of the celestial mechanics of fame.

The triumph of the Pop Artists, as of the Abstract Expressionists, seemed to prove that modernism in America was no longer adversarial, no longer the foe of bourgeois complacency. On the contrary, modernist painting was now respectable.

The metamorphosis of America's artists from rebels to deities was accentuated by the steady rise in museum attendance during the second half of the twentieth century. In 1954 as many people in the United

States went to museums and galleries as bought tickets for Hollywood films (although this statistic said more about the postwar decline in movie attendance than it did about the surge in the number of American art lovers). Nonetheless, going to a museum was very much like entering a movie theater, particularly since both were making money off big-budget extravaganzas. Museums, including MoMA, were raising their ticket prices and selling the equivalent of popcorn in their restaurants, as well as providing guided tours augmented by videos and touch screens. At the end of a viewer's visit, shops awaited filled with reproductions, postcards, books, and brochures.[56] The blockbuster shows and the museums' concession stands had developed into another form of mass entertainment.

Meanwhile, just as with film studies, modernist art became a fixture in university curriculums—supplemented by well-known artists-in-residence boosting the reputation of the faculty, and glossy on-campus galleries exhibiting some donor's bequest. To lots of critics, this academization of modern art signified that the movement had lost its subversive ambitions; what was once proudly avant-garde was by the 1980s and 1990s conventional and routine.[57]

Most of the critics' laments reflected a snobbery toward anything that might appeal to ordinary people. The fact that modernist artists, at least in America, were finally admired, that their work was accepted instead of ignored, was hardly a sign they had lost their capacity for innovation and provocation. Besides, as in every cultural endeavor— whether it was art, music, or movies—to be popular was not necessarily bad and to be neglected was not necessarily good.

In reality, the viewing and appreciation of modernist painting had become a shared experience for many Americans. But the not-so-secret desire for public recognition actually began in Europe, with Picasso and his eye on the art market, and the Dadaists and Surrealists with their eyes on the audience. So it was not surprising that modernism's greatest conquest should occur in precisely the country where art and amusement were eternally joined.

The Globalization of American Architecture

■

When European and Mexican painters came to America in the 1930s and during World War II, they were role models, compelling their American apprentices to listen respectfully and acquiesce. When foreign architects visited or sought refuge in the United States during the same years, they arrived as supplicants, forced to adjust their theories to already existing American architectural traditions.

Americans in the late nineteenth and early twentieth centuries may have thought their literature, art, and "serious" music were mediocre compared with the high-powered creations of the artistic giants in other lands. But the flamboyance of American architecture was a prominent exception to the nation's sense of cultural inferiority. Louis Sullivan, Frank Lloyd Wright, and the designers of America's skyscrapers were seers and entrepreneurs; they realized, as foreigners frequently did not, what Americans wanted from their fabulous cities, and from the quieter neighborhoods beyond the cacophony and commotion that prevailed downtown.

In their recognition of the discordant cravings in American culture, particularly the desire for a tranquil suburban oasis amid the urban hullabaloo, America's architects—no strangers to the seductions of wealth and publicity—understood how to appeal to a fickle, ambivalent populace. Wright, who cultivated his fame as tenaciously as

did Jackson Pollock or Andy Warhol, perceived that architecture could be both an advertisement for one's own outsized personality and a day-dream of an alternative life. And he created idiosyncratic dwellings that could potentially serve as the basis for new types of communities in the United States as well as abroad.

Thus, just as foreign filmmakers landing in Hollywood in the 1920s and 1930s adjusted their talents to the requirements of the movie studios, so foreign architects, most of them refugees, tailored their principles to the values of America's pioneer architects, and to the urban and suburban culture in which the American master builders instinctively thrived. As a result, the global impact of the modernist architecture that first transfigured Chicago and New York rested on quintessentially American ideas.

The Urban Silhouette in America

From the beginning, the hallmark of American architecture was its eclecticism. America's builders borrowed ideas and techniques from everywhere, as did their counterparts in all the other arts. Then they adapted these foreign styles to the necessities of America's burgeoning urban civilization.

No one cared about authenticity, not in a country—as Henry Adams noted—that worshiped multiplicity. The nineteenth-century American cityscape was littered with neoclassical banks and court-houses, Romanesque railroad stations, universities and churches with pseudo-Gothic spires, and stately homes that imitated Georgian mansions or French châteaus. Even the statues of the nation's heroes appeared more Greek than American.

This was not, however, simply a matter of ransacking the architectural past to beautify the American present. What American engineers and designers tried to do was integrate the glories of earlier cultures with the new technologies of the modern world. Hence, John and Washington Roebling—the creators of the Brooklyn Bridge, which opened in 1883—fused old-fashioned granite and limestone with steel suspension cables, topped off with Gothic arches. Their bridge was a masterpiece of American ingenuity, but it was additionally a tribute to esthetic habits rooted in the Middle Ages and the Renaissance.

Yet before long, in reaction to the accelerating pressures of commerce and white-collar work, a distinctive American architecture emerged, one that carried fewer reminders of distant cultures and eras. America's businessmen needed not just banks and factories but office buildings—the taller the better to shuffle the mounting piles of paper, operate the new telephones and typewriters, monitor the stock prices on Wall Street, and dispatch merchandise all over the planet.

To erect the secular towers that corporate America demanded, architects dispensed with stone and brick in favor of iron and steel. And they had to devise a means (like the elevator, introduced in 1857) for employees to speedily ascend to their aeries on the twentieth or fiftieth floor. Once these ingredients were in place, the skyscraper became America's signature building, and an embodiment of modernity that looked like no other structure on earth.

Which did not mean that America's early-twentieth-century skyscrapers discarded all references to the past. The corporate executives who paid for the buildings yearned for opulence and exoticism along with efficiency. The architects responded with ornaments both spectacular and impractical: zigzag motifs based loosely on Native American and Mexican culture, geometric patterns from Africa and the ancient Middle East, updated versions of medieval gargoyles, random curlicues, a panoply of visual symbols that made the edifice memorable if a bit frivolous. By the 1930s, though, the dominant style was Art Deco—a sleek testament, often in black and white, to urban sophistication that could be found not only in the interiors of the skyscrapers but in hotels, apartment buildings, nightclubs, restaurants, theaters, and the movie sets of musicals and screwball comedies.[1]

The skyscraper flourished in most American cities, but it epitomized the economic primacy and cultural elegance of New York. From Daniel Burnham's triangular Flatiron Building, erected in 1902, to William Van Alen's Chrysler Building (1930) with its hood ornaments and radiator caps alluding to Chrysler's luxury cars of the late 1920s, to William Lamb's Empire State Building (1931), these were Manhattan's ultimate landmarks—endlessly photographed, painted, and filmed, as well as fantasized about by people in the American provinces and overseas.

No building better captured the spirit of America's urban culture,

or of its mass entertainment, than Rockefeller Center. Started in 1930 and completed in 1939, designed by Raymond Hood, Rockefeller Center took up eight square blocks of midtown Manhattan, and housed (among innumerable other offices and suites) the headquarters of Henry Luce's magazines and the Radio Corporation of America (the parent of RCA Victor phonographs and records, NBC, and RKO Pictures).

As the nation's leading benefactors of art and high culture, the Rockefellers originally imagined that their skyscraper would provide a new home for the Metropolitan Opera.[2] But elite aspirations gave way, as they usually did in America, to popular tastes. Hence, the opera house turned into Radio City Music Hall, a shrine for Busby Berkeley–style musicals, concerts, and movies. Meanwhile, Rockefeller Center itself became the incarnation both of a dazzling new American architecture and a glitzy celebration of American show business.

This was the sort of mad concoction that more austere architects, in America and in Europe, abhorred. What they believed in was rationality, not exuberance. And so they set out to create an architecture that did not indulge the whims of the rich but that might instead solve the problems of modern society, whether in the Old World or the New. Fun would soon be banished; sobriety would soon be embraced. Except, inevitably, in an America that was Puritanical on Sunday morning and Babylonian on Saturday night.

The Sage of Suburbia

Even as the first skyscrapers arose in the United States, more often in Chicago than in New York, architects quarreled about their untidy facades. To a critic and prophet like Louis Sullivan, the soaring buildings seemed cluttered with extraneous decorations, burying the underlying structure in an avalanche of kitsch. What a truly modern American architecture required, Sullivan and those with similar opinions argued, was an honesty and simplicity befitting a nation of pragmatists who valued common sense, not capriciousness.

"Form follows function," Sullivan proclaimed in 1896, decades before the Bauhaus architects in Germany adopted his aphorism. A building's actual uses should determine its style. Scrap the ornaments

and emphasize the steel skeleton. Then you'd know that what you were gazing at was a genuine American factory or office tower, not a stage set or a three-ring circus.

Yet Sullivan was never a purist about clean lines and stark surfaces. His own constructions (like the Wainwright Building in St. Louis in 1891 and the Carson Pirie Scott Department Store in Chicago in 1899) were embellished with ironwork trellises and semicircular arches. Form, on occasion, could interrupt function.

Sullivan's disciple Frank Lloyd Wright also wanted to create an indigenous American architecture, one that replaced "fake" ornamentation with "natural" components like untreated wood, glass, and stone.[3] But Wright was not much interested in skyscrapers, nor was he always as wedded to the American vernacular as he sounded.

On the contrary, Wright was a cosmopolitan, attentive to foreign architectural styles, especially if they came from Japan. Wright was first exposed to Japanese architecture in 1893 at the Chicago World's Fair, where one of the most popular tourist attractions was a small-scale reproduction of a Japanese wooden temple. Thereafter Wright became a passionate collector of Japanese prints. More important, he made eight trips to Japan between 1905 and 1922, studying Japanese art and architecture, and designing the Imperial Hotel in Tokyo. What Wright chiefly admired about Japanese houses was their reliance on unadulterated materials, their horizontal contours, their open areas, and their structural clarity, all in contrast to the overstuffed and chaotic ambience of American homes.[4]

Yet Japanese formality and an eye for the tiniest detail had little in common with American sprawl. Wright therefore translated Japanese architectural concepts into a more casual and expansive American idiom. During the first decade of the twentieth century, Wright experimented with what he called "prairie" houses, combining the free-flowing aura of Japanese interiors with a deep-rooted American attachment to the surrounding landscape. His prairie houses consisted of one floor with an overhanging roof, a massive chimney in the living room, and no attics or basements.[5] The shape was streamlined, graceful, and built close to the ground, taking advantage of the limitless space in America's hinterlands.

By the 1930s the influences on Wright seemed less Japanese than

Jeffersonian. He spent half the decade developing his ideas for a "Broad-acre City," which would be the last word in modern American living. But his scheme was antithetical to anyone's conception of urban life. Wright envisioned a subdivision of homes, each sitting on an acre of land, encircled by gardens and wild vegetation, in a decentralized neigh-borhood with few office or apartment buildings, much less theaters and restaurants.[6] Here, after the final stop on the trolley line, we would dis-cover a prosperous community of self-sufficient landowners in one-family houses, at ease with nature, and far away from the congestion and disorder of America's cities.

Wright's social, if not his architectural, ideals had grown less modernist and more traditional. Indeed, in his effort to recover and re-furbish what was essentially a rural past, Wright shared the longings of Regionalist painters like Grant Wood and Thomas Hart Benton to lo-cate some bedrock American values in the midst of the Great Depres-sion.

Broadacre City, as Wright conceived it, was never built. But part of his vision of how Americans ought to live was attained, though not in the way he anticipated. After World War II, the prairie house turned into a ranch house, and Wright's Jeffersonian yeoman became a bour-geois suburbanite. In effect, Wright—who personified the modernist architect as genius and rebel, the designer of the vertiginous Guggen-heim Museum in New York—managed at the same time to be the most domesticated of America's builders.

Although Wright was the American architect best known to for-eigners during most of the twentieth century, Louis Sullivan's ideas car-ried more weight, especially with Europeans. Indeed, during the late nineteenth and early twentieth centuries, Chicago was a mecca for Eu-ropean architects, engineers, and city planners attracted to the stylistic asceticism of Sullivan's buildings.[7]

Among the pilgrims was the Austrian architect Adolf Loos, who lived in Chicago and elsewhere in the United States between 1893 and 1896. After his return to Vienna, Loos published an essay in 1908 en-titled "Ornament and Crime," in which he condemned all decorations as corrupt and superfluous. He then proceeded to design a Sullivan-type office building in the heart of ornate Vienna, on the Michaelerplatz, near one of the entrances to the Hofburg Palace. Loos's stripped-down

edifice mocked Vienna's imperial grandeur and enraged the citizenry. But its severe exterior was a harbinger of an architectural modernism, born in Chicago, that would shortly conquer the world.

Wright's style was harder for foreigners to duplicate. So his reputation abroad was decidedly mixed. On the one hand, the immaculate elegance of his houses, unsullied by the bric-a-brac of daily life, seemed a symbol of a more rational future, at least in the realm of interior decor. Thus Wright was especially popular with Dutch, German, Austrian, and Czech architects in the teens and 1920s—a period during which two young Viennese designers, Richard Neutra and Rudolph Schindler, came to America to work with Wright before moving on to California to create their own modernist residences in the promised land. Then in the 1950s, at the height of the Cold War, Wright's work was featured in exhibitions in France and in Italy, where the State Department and the U.S. Information Agency seized on his fame to advertise the virtues of American architecture. In addition, Wright's fascination with Native American, Aztec, and Mayan themes endeared him to architects in Mexico, Chile, and Brazil.[8]

On the other hand, many European modernists in the 1920s and 1930s complained that Wright's values were too individualistic, too romantic, and too rustic—in short, too "American" for export.[9] Besides, to European architects sensitive to the need (after both world wars) for mass housing, a freestanding suburban castle was hardly the ideal for a planned, semisocialist, society.

Wright's problem was that he wanted to build houses people wanted to live in. His European rivals wanted to build utopias. For a time, their dreams of constructing "machines for living" overshadowed his definition of freedom as a house, and a room, of one's own.

The Americanization of the Bauhaus

For many Europeans between the world wars, modernist architecture meant more than just designing new types of houses or office buildings. Architects in the Netherlands, Germany, and France promised to revolutionize the way people lived by creating communities based on the principles of science, technology, and human engineering.

At least these were the animating ideas behind the manifestos and

drawings European architects presented to the public during the inter-war years. And no one had more ideas about the transformative pur-poses of architecture than Charles-Édouard Jeanneret-Gris, who assumed the regal name of Le Corbusier. Born in Switzerland but characteristi-cally French in his love of abstractions, Le Corbusier was always more of a theorist than a builder. Yet he shared with his contemporaries in Europe a hostility to any architectural style that reeked of the past, es-pecially one draped in irrelevant ornamentation or that catered to atavistic pastoral ideals.

Le Corbusier, unlike Wright, was preeminently an urban plan-ner. His city of the future was based on industrial materials and meth-ods, befitting the modern machine age. At the city's core would be colossal residential towers, with each apartment conforming to a pre-determined size and shape, and featuring white stucco walls, a large expanse of windows, and single bare lightbulbs. The towers were to be surrounded both by meticulously designed parks (for the healthy uses of leisure time) and by superhighways, speeding people from "home" to work, without their having to endure the congestion, the bicycles, or even the inhabitants of a typical European city.[10]

But when it came to urban anarchy, nothing in Le Corbusier's view exceeded the unplanned, unregulated, mismanaged American city. In 1935 Le Corbusier traveled for the first time to the United States, at the invitation of the Museum of Modern Art. Armed with his pre-scriptions for a more sane civilization, he delivered twenty-one lectures to universities and cultural organizations in the East and Midwest—a tour that enhanced his status with his American audiences as the most visionary of European architects.

Le Corbusier's lectures, however, also confirmed his image as a classic (and therefore arrogant) European intellectual, with plenty of opinions about but little concrete knowledge of the complexities of American urban life. In his eyes, America's cities wasted their natural and social resources: they were too decentralized and too willing to el-evate the wishes of real estate developers and individual homeowners over the larger needs of society. Even America's majestic skyscrapers exemplified this urban disarray; they existed in splendid isolation, with no coherent connection to each other or to the requirements of a ra-tional metropolis. A truly "radiant" American city, Le Corbusier

claimed, would be logical, disciplined, and well run, like a factory.[11] His American hero appeared to be Henry Ford, definitely not Frank Lloyd Wright.

Le Corbusier's audiences listened politely. Then they dismissed his nostrums as impractical, autocratic, and anticapitalist. Indeed, the kind of structures he was describing seemed more suited after World War II to Brasília (the new capital of Brazil and a planned city based in part on Le Corbusier's concepts) and to the Stalinist housing projects that blighted the urban landscapes of the Soviet Union and Eastern Europe.

Nevertheless, Le Corbusier was perceived by his American hosts in the 1930s as the archetype of a modernist architect. Soon they encountered other Europeans with similar hypotheses, but whose blueprints and actual buildings the Americans took far more seriously.

The architects who ultimately had the greatest impact on the profile of the American city were working in Germany in the 1920s and early 1930s. In 1919 a new architectural school, called the Bauhaus, opened in Weimar, where it remained until 1925 before moving on to Dessau and eventually to Berlin in 1932. The Bauhaus's most charismatic directors were Walter Gropius (who presided over the Bauhaus at the peak of its influence, from 1919 to 1927) and Ludwig Mies van der Rohe (who ran the compound from 1930 until its demise in 1933). The Bauhaus did not specialize only in architecture; it offered courses in the crafts, graphics, and furnishings. On its illustrious faculty were the designers Marcel Breuer, Herbert Bayer, Josef Albers, and László Moholy-Nagy, together with the painters Paul Klee, Wassily Kandinsky, and Lyonel Feininger. The Bauhaus became an epicenter of German modernism in all of the arts.

While the members of the Bauhaus rarely dreamed up projects as grandiose as Le Corbusier's, they were no less revolutionary in their ambitions. Many regarded themselves as socialists, committed to the construction of collective housing for the German (and European) working class.

What, then, did the workers crave in their homes? Nothing opulent or bourgeois, the Bauhaus declared—no thick rugs, heavy drapes, lamps enveloped in tassels, gratuitous throw pillows, decorative plants, or any item that might interfere with the utilitarian and well-propor-

tioned contours of their white-walled apartments. The appropriate furniture, echoing the industrial world in which the workers toiled, would be made of tubular steel, bentwood, cane, or canvas, all of it sitting on linoleum floors. Outside, the façade was to be unadorned and the roof would be flat.[12]

Whether such houses might actually have appealed to the proletariat, in Germany or elsewhere, was never tested. Instead, the Bauhaus architects and designers spent the 1920s publishing articles promoting their ideas, and creating prototypes of the dwellings and furnishings they had in mind. Still, their approach—with its emphasis on machine-made materials, clean lines, and rigorous functionality—was indisputably modernist. And it was the Bauhaus's modernism, rather than its socialism, that attracted artists, intellectuals, and museum curators in the United States.

By the mid-1920s, news about the Bauhaus was spreading both in Europe and America, largely through books and essays, illustrations in magazines, and documentary films. The Bauhaus's first appearance in the United States took place at Harvard in an exhibit that ran from December 1930 to January 1931. Another exhibition was held in Chicago, also in 1931. Both shows—based on models, photographs, and examples of Bauhaus graphics and typography—introduced the works of Gropius and Mies to American architects and critics.[13]

But the three men most responsible for bringing the Bauhaus's architecture to America were Henry-Russell Hitchcock, Philip Johnson, and Alfred Barr. Hitchcock and Johnson, like Barr, had journeyed in the late 1920s to Europe, where they all absorbed the ideas of Le Corbusier, Gropius, Mies, and the Dutch architect J. J. P. Oud. In 1929 Hitchcock published *Modern Architecture: Romanticism and Reintegration,* which summarized the latest trends in European building and design for an American audience. Then in 1932 Barr created a Department of Architecture at the Museum of Modern Art, installing Johnson as director. Thereafter MoMA became the principal champion in America of Europe's modernist architecture.

In 1932 as well, MoMA mounted one of its most influential shows, "Modern Architecture: International Exhibition." Organized by Johnson and curated by Hitchcock, the exhibit focused on the projects of Le Corbusier, Oud, Gropius, and Mies, though some of Frank

Lloyd Wright's works were belatedly included. Using models, draw-
ings, and photographs, Johnson and Hitchcock offered museumgoers
(initially in New York and then across the country) a wide-ranging
view of the new architecture.

Hitchcock wrote the catalog for the show, which he and Johnson
expanded into a book called *The International Style: Architecture since
1922. Style* was the operative word. Barr, Hitchcock, and Johnson ig-
nored the Bauhaus's social objectives, especially its devotion to the im-
provement of working-class housing. They chose to concentrate on the
Bauhaus as an exclusively esthetic phenomenon that had universal im-
plications beyond the specific problems or ideological debates in Ger-
many or in Europe in the early 1930s.[14] By stressing the formal qualities
of the architecture, MoMA helped facilitate the Bauhaus's acceptance
among Americans who were less concerned with the intricacies of Eu-
ropean politics than with whether the Bauhaus buildings were alluring
or hideous.

Yet it was Europe's politics, not just the Bauhaus style, that trans-
formed American architecture. In April 1933 the Nazis closed the
Bauhaus. Worker housing in a genuinely socialist Germany was not
what Hitler and his own favored architect, Albert Speer, envisaged for
the thousand-year Reich. Within a few years, most of the Bauhaus fac-
ulty—including Breuer, Albers, Moholy-Nagy, and Bayer—resettled
in the United States. Gropius, who had visited America in 1928 and
shared the enthusiasm of German artists and intellectuals for American
skyscrapers, jazz, and movies, became chairman of Harvard's Depart-
ment of Architecture in 1937.[15] In 1938 Mies was appointed dean of
the Architecture School at Chicago's Armour Institute of Technology
(later renamed the Illinois Institute of Technology). In these positions,
Gropius and Mies were able to teach their theories to a young genera-
tion of American architects eager to learn about German modernism,
but also intent on adapting the Bauhaus's philosophy to conditions in
the United States.

The utopian ideals of the Bauhaus were never transferable to a
country that prided itself on its practicality. But as it turned out, the
Bauhaus's techniques and stylistic motifs were readily applicable to the
construction of commercial skyscrapers, luxury apartment buildings,
university dormitories, museums, shopping malls, vacation homes, and

country estates. If architectural modernism simply meant straight lines, a reliance on the most functional building materials, and a minimalist interior decor, then these devices could serve the requirements of business just as effectively as the needs of any other institution. So, by the end of the 1930s and certainly after World War II, the Bauhaus style became the corporate style: cool, sleek, powerful, and efficient. Ironically, the Bauhaus's success in America had more to do with the triumph of capitalism than with the notion that architecture could produce a new kind of society.[16]

The buildings Gropius and Mies designed in America in the 1950s and 1960s had a greater impact on other architects, both in the United States and abroad, than any of their ventures in Germany in the 1920s. Among Gropius's characteristic works was the Harvard Graduate Center (1949–1950), a group of bleak rectangular dormitories for graduate students that looked and felt more like file cabinets than cozy residences for the university's very own proletariat. Gropius was also the lead architect for the Pan Am (now MetLife) Building in New York (1958–1963) and the John F. Kennedy Federal Office Building in Boston (1963–1966). Mies, asserting "less is more," proceeded to prove his point by designing (with Philip Johnson) the Seagram Building, which was completed in 1958, a New York skyscraper of luminous glass and steel that became the emblem of urban America in the postwar years.

These smooth, slablike structures were replicated in most of America's cities. You could see their facsimiles in the United Nations Secretariat (indebted especially to the ideas of Le Corbusier); the Lever House on New York's Park Avenue, which deliberately mirrored the Seagram Building; and the creations of I. M. Pei, a Chinese émigré and a student of Gropius, who designed the John Hancock Tower in Boston in 1976 and the East Building of the National Gallery of Art in Washington in 1978. Pei also managed, in 1989, to offend the majority of Parisians with his modernist glass pyramid that stands incongruously in front of the Louvre.

Indeed, Pei's pyramid exemplified the American penchant for adopting and modifying a foreign idea, and then reexporting it in a new incarnation to the rest of the planet. Once the Bauhaus had been "Americanized," its methods were sent back to Europe and Asia after

World War II as a model for the reconstruction of bombed-out cities like Rotterdam, Cologne, Frankfurt, and Tokyo. Along the way, America converted what had originally been a distinctive, if localized, movement by Dutch and German architects into a truly "international" style. Moreover, the worldwide influence of America's most famous postwar skyscrapers, like the Seagram Building and the Lever House, symbolized not only the victory of modernist architecture but also the emergence of the United States as a global power.

One reason for the intercontinental success of American architecture was that its techniques were easy to copy. In West Germany, for example, architects wishing to extol their country's postwar "economic miracle" could erect modern office buildings based on the pictures they saw in American magazines, the exhibits they attended at the America Houses (particularly the one in West Berlin that looked in its drab simplicity as if it had been designed by a Bauhaus architect just before he fled Germany), and the streamlined American consulates in Düsseldorf, Stuttgart, and Munich.[17] It helped the modernist cause that one of the Bauhaus idols, Mies van der Rohe, returned briefly to Berlin to design the New National Gallery, which opened in 1968.

The French were more selective in their acceptance of American-style architecture. Still, they occasionally succumbed—as in the case of the Tour Montparnasse in Paris, constructed between 1969 and 1972, with fifty-nine floors of offices, making it the tallest skyscraper in France, but one that could have been located in any American city. Similarly, the Pompidou Center—designed by the Italian architect Renzo Piano and his British partner Richard Rogers—refused in typical modernist fashion to hide its steel skeleton, air ducts, and escalator. The Center, when it was finished in 1977, became the home in Paris of modern and postmodern art, but the building itself was a testament to Louis Sullivan's maxim that form really did follow function.

Asian architects seemed even more eager to embrace America's modernism, which explained why so many office and apartment buildings in Hong Kong and Singapore were indistinguishable from those in Atlanta or Dallas. But by the end of the twentieth century, Asian styles were having a renewed influence on the United States. Just as Frank Lloyd Wright had been deeply affected by Japanese architecture early in the century, so American architects and urban planners began in the

1980s to pay increasing attention to developments in Japan.[18] Perhaps, then, it was fitting that the architect selected to revamp the Museum of Modern Art, which reopened in 2004, was neither an American nor a European but Yoshio Taniguchi, who had studied with Gropius yet whose work was best known in Japan.

There was only one problem with the postwar dominance of America's modernist architecture. The "glass boxes" were universally detested by the public and a growing number of critics. But the decisive challenge to the modernist reign came not from curmudgeons like Tom Wolfe or Britain's Prince Charles, or from any detractors abroad, but from America's own architects who sought from the 1960s on to achieve a new synthesis of function and form.

The Postmodernist Mystique

During the 1960s and 1970s, the deficiencies of modernist architecture, at least in the United States, were becoming more noticeable. The once-gleaming façades of the skyscrapers looked increasingly soiled and weather-beaten.[19] Moreover, the downtowns of most American cities, sprinkled with modernist office towers, were interchangeable; driving in from an airport, you usually didn't know where you'd landed.

Worst of all, when architects weren't building steel-and-glass images of modernity, they were constructing grim, Stalinist-style housing projects frequently afflicted by poverty, drugs, and crime. No housing complex better illustrated the gloomier aspects of modernism than Pruitt-Igoe, opened in 1955 in St. Louis. Pruitt-Igoe's architect was Minoru Yamasaki, a second-generation Japanese-American, thoroughly committed to modernist principles, who later designed the World Trade Center in New York. But the St. Louis project, the last remnant of the Bauhaus-inspired dedication to creating a working-class community through architecture, quickly turned into a slum, hated by everyone who lived there. In 1972, with most of its apartments vacant for years, it was demolished.[20]

By 1981, when Tom Wolfe published *From Bauhaus to Our House,* a hilarious satire on the hauteur of the "silver princes" like Gropius and Mies, the revolt against modernist architecture was well

under way. Indeed, the same year that Pruitt-Igoe was dynamited, Robert Venturi published *Learning from Las Vegas,* a title guaranteed to make the modernists apoplectic. Before teaching architecture at the University of Pennsylvania and Yale, Venturi studied in the 1950s at the American Academy in Rome, where he had fallen in love not with the city's grand monuments but with its cafés, piazzas, and pedestrian bustle. Subsequently, Venturi became equally fond of all the manifestations in America of everyday life: gas stations, strip malls, fast-food restaurants—any structure that seemed familiar, reassuring, and antielitist.[21] Thus what attracted Venturi to Las Vegas was its hybrid, if extravagant, architecture, and its insouciant blend of folk and show business traditions. In his view, the ubiquitous casinos and neon signs were America's colloquial answer to Europe's castles and cathedrals.

For Venturi, pure theory was now out and a hodgepodge of styles was in. To Mies's dictum that "less is more," Venturi replied that "less is a bore." Yet Venturi's postmodernist pronouncements had more impact on his contemporaries than did his actual buildings. Instead, it was Philip Johnson—the ardent publicist in the 1930s for the International Style—who produced a skyscraper that rejected many of the most cherished tenets of modernism. In 1984 Johnson designed the AT&T (later the Sony) Building in New York, with an arched entranceway and a roof adorned with a "Chippendale" pediment that transformed the entire edifice from an exercise in functionalism into an insignia for a corporation. Johnson's building also reproduced the kitschy ornamentation of the Chrysler and Empire State Buildings, not the monotony of Mies's archetypal glass boxes.

But for postmodern garishness, no architect surpassed John Portman. A real estate developer as much as an architect, with no ties to the academic world and its esthetic dogmas, Portman specialized in the multistory atrium hotel (such as his Hyatt Regency in Atlanta in 1967, the Bonaventure Hotel in Los Angeles in 1976, and the Marriott Marquis Hotel in Times Square in 1985). All of these featured balconies, walkways, fountains, artificial lakes, and a central atrium rising dramatically from the lobby to the ceiling of the hotel.[22]

Checking in at one of Portman's hotels, or those of his imitators, was like entering a theme park. And in fact, Disney World employed a

number of postmodernist architects in the 1980s, precisely because their buildings were so theatrical and embroidered with jokes, visual puns, and the spirit of play.

For a while, the postmodernist architects were celebrities, supplanting their modernist predecessors. Their works were praised in the *New York Times,* in the architecture schools, and at *Time* magazine, on whose cover Philip Johnson appeared in 1979.[23]

Yet they were no more successful than Le Corbusier, Gropius, or Mies in making American cities distinctive, or in integrating residential with commercial neighborhoods. Venturi might have been impressed with Rome's round-the-clock urban vitality, but the downtowns in most of America remained open for business during the day before becoming desolate at night. Las Vegas, Disney World, and a Portman hotel were artificial contrivances, as were the efforts near the end of the twentieth century to renovate waterfronts and gentrify a street or two in the city centers. None of these schemes could restore the lifelessness of downtowns from Detroit to Dallas to Denver.

The obstacle that architects in the United States confronted— whether they were modernist or postmodernist, émigrés or native-born —was the historic American dislike of cities, an aversion that originated in the warnings of Thomas Jefferson and James Madison against erecting European-style metropolises (with their crowds, violence, and class warfare) on America's shores. Consequently, the notion—except in New York, San Francisco, or New Orleans before Katrina—that you should be able to walk from your house to a restaurant, a movie theater, a market, or a shop was inconceivable to most Americans, including those who had emigrated from cities in Europe, Latin America, and Asia. What Americans longed for, as Frank Lloyd Wright understood, were suburbs and single-family homes, with multiple cars in the driveway, ready at the turn of the ignition key to hurtle down the highway to the malls and the multiplexes.

Cities in the United States were never going to resemble Rome, Vienna, Seville, or Amsterdam. Still, there were two visionaries who tried to re-create the ambience of Europe's cities in the United States. One succeeded spectacularly; the other failed miserably. But neither was able to fundamentally alter the antiurban prejudices of their fellow citizens.

From the Glass Box to the Big Box

The decline of the downtowns in American cities coincided with the explosive growth of suburbs, especially after World War II. As more affluent people abandoned the city centers, department stores, movie theaters, and restaurants either closed permanently or followed the middle-class migration to suburbia.

Yet it was not inevitable that there should be a rigid geographical separation in America between where people lived and where they shopped or entertained themselves. Models for the intermingling of commercial and residential districts existed throughout the world. In the 1830s and 1840s, for example, iron-columned, gaslit, glass-covered arcades appeared in many parts of Paris. The arcades were heated during the winter, and offered an abundance of shops, cafés, and bistros, all in close proximity to people's apartments. Although they were soon replaced by luxurious department stores, another Parisian innovation, the arcades were duplicated or modified in other countries, not only elsewhere in Europe but also in Latin America and in certain cities in the United States.[24]

Among the Americans inspired by the arcades and other pedestrian shopping areas in Europe's cities was J. C. Nichols, a legendary real estate developer in Kansas City, Missouri. Nichols had traveled to Europe as a college student at the end of the nineteenth century and had come away impressed with both the urban markets and the architecture of Spain. For years after his trip, he imagined the possibility of a European-style neighborhood in Kansas City that combined stores, restaurants, a movie theater, apartment buildings, and private homes.

Beginning in 1922 Nichols designed and vigilantly supervised the construction of what he called the Country Club Plaza, located at the time on the outskirts of Kansas City. The name suggested the two goals Nichols had in mind. On the one hand, the "plaza" merged Spanish, Portuguese, and Moroccan architecture—including courtyards, stucco buildings with red tile roofs and Baroque towers, sidewalks inlaid with art, murals and sculptures, elaborate fountains, and wrought-iron gates. On the other hand, "country club" implied that the surrounding area was to be inhabited primarily by wealthy residents living in upscale apartments, and in palatial houses which Nichols himself would build along Ward Parkway and Wornall Road.

Above all, Nichols's Plaza was supposed to be, and turned into, the hub of an authentic urban community. By the 1930s, with the opening of the nearby University of Kansas City and the Nelson Art Gallery (housing one of the largest collections in the country of Imperial Chinese paintings and drawings, as well as a substantial number of Thomas Hart Benton's works), the Plaza became as much a center of culture as of commerce.

Nichols was able to realize his dream because he enjoyed the support of Kansas City's economic elite and of the municipal government —which meant, at least through the 1930s, the political machine of Tom Pendergast. More important, Nichols had complete control not only of the Plaza's architectural style but also of the land that stretched for miles beyond the Plaza. He could create entire neighborhoods of fashionable homes on tree-lined streets, some of them overlooking spacious parks, and all within walking distance (or more often a short drive) of the Plaza. As the city expanded, as people moved from Missouri to Kansas, and as malls started to multiply all over the landscape, the Plaza remained an elegant though somewhat lonely illustration of how residences, businesses, and the arts could be joined in an American city.

Such a mixture was harder to achieve in post–World War II America. Even in Kansas City, the charm and convenience of the Plaza could not halt the flight of much of the population to the suburbs. The question, then, was whether a suburban mall serving the middle class as well as the rich could become not just a random assortment of stores but the heart of a vibrant community of homes, schools, and theaters.

One man hoped so. If J. C. Nichols was trying to transplant Seville to Kansas City, Victor Gruen yearned to reproduce Vienna's Ringstrasse outside Detroit and Minneapolis.

Gruen was born and grew up in Vienna and studied architecture at the Vienna Academy of Fine Arts. He was also both Jewish and a socialist, two attributes conspicuously unwelcome in Austria after the Germans marched into the country in 1938. Gruen fled to America within months after the Anschluss. But he carried with him memories of an urban life filled with pedestrians on the Ringstrasse, strolling in and out of shops, coffeehouses, restaurants, and galleries, relishing all the pleasures that a prosperous city could offer.

In 1954 Gruen got his chance to re-create his version of a European community in America when Hudson's Department Store, whose profits were decreasing as people moved away from downtown Detroit, commissioned him to design an open-air suburban shopping center, called Northland Mall, with a branch of Hudson's as the anchor store. Two years later, Gruen was hired as the architect for Southdale in Edina, Minnesota, near Minneapolis and St. Paul—the first enclosed, climate-controlled mall in the United States.

In each instance Gruen was not interested simply in providing one-stop shopping for the new suburbanites. Rather, he wanted to bring the city itself to the suburbs. He visualized his malls as a series of arcades with wide sidewalks or corridors where people from all over town could gather—eating, drinking, and socializing even when the shops weren't open, just as they did in Vienna, Paris, and Amsterdam. The malls, in turn, were to be situated close to houses and apartment buildings, schools, hospitals, parks, lakes, auditoriums, and museums. In short, Gruen's mall would be the center of a revitalized city, and an example of urban planning intended to alleviate the chaotic sprawl of the suburbs.

Yet unlike Nichols's Plaza, Gruen's malls (and he designed others in the 1960s, near Chicago and in Orange County) were never the center of anything except shopping. Partly this was because the majority of malls in America were constructed on the least expensive land, far away from the pricier suburban enclaves. The malls, therefore, were accessible only by cars. Moreover, the accelerated depreciation allowance, enacted into the tax code in 1954, permitted a developer to recoup the cost of his investment in a few years, encouraging him to keep on building malls elsewhere, disregarding the urban amenities so dear to Gruen. In addition, zoning restrictions persistently segregated businesses from residential areas, reinforcing the American desire for a bucolic existence uncontaminated by the clamor of the cash register.

Consequently, what Gruen actually invented were the models for every subsequent mall in the United States: two or three levels of shops and department stores, connected by escalators, with a fast-food court in the center. The number of these malls grew from three thousand in 1960 to approximately forty thousand at the end of the twentieth cen-

tury. And most of them were essentially big boxes surrounded not by parks but by vast parking lots.

By 1978 Gruen had returned to Vienna, denouncing the American malls as a perversion of his original idea. Even worse, the malls were following him to Europe, proliferating like weeds all over the Continent, including near the country house where he had taken refuge. Gruen started out longing to remake America in the image of Vienna; he now feared that all he had accomplished was to make Vienna look like America.[25]

But in the case of the biggest box of all, the Americanization of Europe as well as the rest of the world wasn't so easy. From 1992 on, Walmart—among the most astute and aggressive of American retailers —focused increasingly on its international operations, seeking to expand its sales and profits in overseas markets by opening stores and acquiring discount chains in other lands. By 2009 Walmart had established thirty-seven hundred outlets in fourteen foreign countries.

Nevertheless, what worked in the United States did not always succeed abroad. Walmart found it surprisingly difficult to transmit its practices (low prices, stringent control over inventory, an infinite variety of products on the shelves) to countries with shoppers whose habits and expectations were different from those of American consumers. In Europe and Asia people often preferred to shop daily for fresh produce, chickens, bread, or household goods at outdoor markets, bakeries, or small grocery stores where they knew the vendors, rather than buying in bulk once a week at a place whose ultrafunctional architecture resembled a dingy warehouse.

More significant, Walmart suffered from its identity as a uniquely American enterprise. To foreigners, Walmart was yet another weapon in America's cultural invasion, trying (like Microsoft and McDonald's) to substitute its alien values, especially its devotion to efficiency, for local tastes and a more leisurely lifestyle.

As a result, Walmart was eventually forced to shut down some of its overseas stores, particularly in Germany and South Korea, and to revise its policies to conform to the customs of foreign consumers. Its problems abroad did not, of course, mean that Walmart wasn't flourishing in the global marketplace. Early in the twenty-first century, Walmart shoppers spent $100 billion annually in its stores abroad.[26] But

Walmart's troubles in many countries did suggest that there were limits, economically and culturally, to what America could export to the world. And while, architecturally, the skyscrapers, malls, and Walmarts made cities everywhere seem more homogeneous, the omnipresence of these American institutions did not diminish the distrust that ordinary people in most societies outside the United States felt about America's modernism.

Modernism in the Marketplace

■

One of the most alarming characteristics of American modernism for foreign intellectuals and social critics was the ease with which it was used to sell products. After all, if modernist painters and architects were mainly interested in stylistic experimentation, then the new visual techniques they developed could serve any purpose, including the demands of commerce. Indeed, the modernist emphasis on crisp lines, abstract designs, and uncluttered imagery was perfectly suited to the needs of advertising, packaging, fashion, and interior decor. Moreover, the modernists, in the words of Ezra Pound, were always trying to "make it new." And no one was more interested in innovation and novelty than the American entrepreneur.

In a nation where the boundaries between high culture and kitsch were forever unclear, it was possible to imagine that art could be found as much in the arrangement of merchandise in a department store window, in the graphics of a magazine advertisement, in the silhouette of a woman's dress, or in a streamlined kitchen appliance as in the paintings hanging in a museum. Certainly the curators of exhibitions at the Museum of Modern Art appeared to think that when it came to stylistic ingenuity, there was not much difference between a Kandinsky canvas and a Kelvinator refrigerator.

Yet the marriage of art and commerce was not uniquely Ameri-

can. The esthetics of marketing was a universal phenomenon. Whatever someone was selling—whether Christianity in the paintings and sculptures in Gothic cathedrals, or the ecstasies of bourgeois life in the seventeenth-century Dutch portraits of Amsterdammers consuming immense quantities of food and drink, or the charms of the cancan dancers at the Moulin Rouge in Toulouse-Lautrec's posters—few artists were untarnished by the craving to entice the customer (or the patron paying the bills).

There was, however, a divergence between foreign (especially European) snobbery toward the marketplace and the enthusiasm with which Americans seemed to embrace the spectacle of money changing hands. American artists, as well as the émigrés who launched new careers in the United States in the 1920s and 1930s, were unapologetic about their work for the ad agencies, the fashion magazines, and the art departments at the movie studios. This passion for profits is what made the American merger of culture and salesmanship so infuriating to foreign elites, but so tempting to consumers all over the world.

The Department Store as a Work of Art

Despite the persistent foreign allegation that the United States is a country addicted to the brazen display of wealth and material possessions, Americans did not invent consumerism. By the eighteenth century, the prerequisites for mass consumption existed in Britain, the Netherlands, France, Germany, and Italy. In each of these lands, one could find a proliferation of shops crammed with clothing and household goods, and an increasing reliance on publicity and promotional sales campaigns. All of this bustle was inspired by the growth in the size of the middle class and the Enlightenment's endorsement of economic progress and personal gratification as the signs of a rational civilization.[1]

If anything, Americans arrived late at the market. Not until the nineteenth century did European travelers to the United States begin to notice that the New World, the hope of humanity, was becoming instead the home of materialism and greed, inhabited by people who were not only culturally uncouth but who spent most of their time frantically pursuing the "almighty dollar."

Still, it was Europeans, not Americans, who dreamed up the most opulent shrine to consumerism: the department store. With the founding in 1838 of Le Bon Marché in Paris, palatial department stores began to spring up in many of the major European cities over the next seventy years. In Paris alone, Le Printemps, La Samaritaine, and Galeries Lafayette were all competing with Le Bon Marché for upscale customers by the 1890s. Meanwhile, affluent Londoners could chose between Harrods, Whiteleys, or Selfridges. Stockmann opened in Helsinki in 1862, while Wertheim and Kaufhaus des Westens (colloquially known as KaDeWe) became the leading destinations for prosperous Berliners by the start of the twentieth century.

America's retailers were quick to imitate their European counterparts. Throughout the late nineteenth and early twentieth centuries, they established their own versions of the lavish, European-style emporiums. John Wanamaker visited Paris in the 1880s to study the interiors of Bon Marché and Printemps, so that he could copy their layout and design for his own department store in Philadelphia, called—in a typical bow to the proprietor—Wanamaker's.[2] Soon every ambitious American city in the East and Midwest boasted of a flagship store catering to the middle- and upper-class consumer. New York, naturally, had the greatest number of such outlets: Macy's, Bloomingdale's, Lord & Taylor, Bergdorf Goodman, B. Altman. But Boston took pride in Filene's; Detroit in Hudson's; Chicago in Marshall Field's and Carson Pirie Scott.

What all of these stores, on both sides of the Atlantic, had in common was that—unlike the smaller specialty shops of the eighteenth century where bargaining was routine—a customer could now browse for clothes, furniture, kitchenware, toys, and any other conceivable product, all being sold at fixed prices under one roof. But it wasn't just that department stores made shopping easier. The original department stores (in contrast to their low-rent successors, the malls and the Walmarts) were selling a sensation of luxury along with the merchandise. Though the basements featured inexpensive goods for the hoi polloi, the upper floors became oases for the wealthy, particularly if they were women, the department stores' most prized clients. Here, amid the apparel and the furnishings, a woman shopper was surrounded by lush

carpets and drapes, beauty salons, child-care centers, chic restaurants, libraries, and sumptuous bathrooms.[3]

In fact, the experience of roaming through a department store—with its majestic staircases and balconies, its elegant interiors embroidered with gilded mirrors and indirect lighting to illuminate the products in all their magical radiance, its tuxedoed musicians at baby grand pianos, and its employees behaving as much like ushers as salespeople—was like enjoying an evening at the theater or an opera house.[4] The department store owners believed that sales and profits depended on giving the consumer a heavy dose of drama and fantasy. No wonder, then, that L. Frank Baum, the author of *The Wizard of Oz,* began his career by helping to turn department store windows into Emerald Cities, complete with exquisite mannequins enveloped in jewelry and furs. When shoppers were transfixed by the spectacle in the display cases and the showrooms, there was no need to pay attention to the man behind the curtain.

The department stores also resembled art galleries. For some customers, the stores were as important as any museum, or even the Armory Show, in introducing them to modern painting. Gimbels, for example, decorated its outlets in New York, Philadelphia, Cleveland, and Cincinnati with Cézannes, Picassos, and Braques. Lord & Taylor mounted an exhibition of modernist art in 1928, similarly featuring the Cubists. Other stores, like Carson Pirie Scott, focused on American painters, especially William Glackens and John Sloan at a show in 1918.[5] Presumably, this devotion to art enhanced the prestige both of the stores and the products they were selling.

Most of all, the department store itself, in Europe and America, had become a work of art. Theatrical, glamorous, enchanting, the stores made consumerism not only seductive but esthetically pleasurable. Nevertheless, the proprietors of America's department stores also understood that, basically, they were in show business. And—just like theater managers, museum directors, and carnival barkers—they had to get the customers, the rubes as well as the patricians, inside the tent. For that, they needed to advertise. The ad—particularly the modernist ad—turned into an essential accessory for the mass consumption of the twentieth century.

Selling Modernity

Through much of the nineteenth century, a word (or maybe a para-graph) seemed to be worth a thousand pictures. At least that was the impression conveyed through the interminable columns of print in the pages of American newspapers and magazines. So if you wanted to in-troduce a product to prospective buyers, you devoted long and intricate sentences to describing its innumerable benefits.

By the beginning of the twentieth century, however, new tech-nologies (notably in color printing and in the invention of the halftone process that made it possible to reproduce drawings and photographs on a massive scale) transformed the nature of advertising as well as the newspapers and periodicals in which the ads appeared. Now companies could rely on carefully constructed images, graphics, and visual sym-bols to communicate with customers, which was advantageous in a country like America, with millions of immigrants who responded more readily to pictures than to the English language.[6]

These developments coincided with the growth of national brands, publicized in mass-circulation magazines and therefore in-stantly recognizable to consumers throughout the United States. From the 1880s on, *Ladies' Home Journal, Collier's, Cosmopolitan, Vogue, Vanity Fair,* and the *Saturday Evening Post* emerged as the most im-portant venues for advertising products and fashions through illustra-tions and photos that were often more mesmerizing than the text of a story.

With the additional debut of *Time* and the *New Yorker* in the 1920s, magazine advertising had become big business. To satisfy the desire of corporate executives and department store owners to make their products look more beguiling and exclusive, major advertising agencies like N. W. Ayer in Philadelphia, together with J. Walter Thompson and Batten, Barton, Durstine & Osborn in New York, en-gaged well-known artists and photographers to design layouts in a va-riety of journals.

Some of the artwork was conventional, like the illustrations of Maxfield Parrish and Norman Rockwell. But Charles Sheeler's photo-graphs of Kodak cameras, L. C. Smith typewriters, Champion spark-plugs, and Firestone tires were sufficiently eye-catching that his work

began to show up on a regular basis in *Vogue* and *Vanity Fair,* neither of them noted for their fascination with auto parts. Edward Steichen, a disciple of Alfred Stieglitz, served as the leading fashion photographer for both magazines, dispensing with idyllic images of beautiful products and blissful consumers in favor of more modernist techniques featuring geometric lines and stark contrasts between light and shadow.[7] Yet whatever their styles, Parrish, Rockwell, Sheeler, and Steichen were all interested in captivating a mass audience. And none believed that advertising and art were incompatible.

No ad agency was more successful than N. W. Ayer in finding ways, in print and pictures, to appeal to consumers. The copywriters at Ayer created some of the most memorable slogans of the twentieth century: "When it rains it pours" for Morton salt in 1912; "I'd walk a mile for a Camel" for Camel cigarettes in 1921; "A diamond is forever" for De Beers Mining Company in 1948; "Reach out and touch someone" for AT&T in 1979; "Be all you can be" for the U.S. Army's recruitment drive in 1981.

Still, the Ayer agency was more committed than many of its competitors to the use of modernist artists, due largely to the influence of its art director from 1929 to 1964, Charles Coiner. Coiner believed that avant-garde techniques—like those of the Cubists, the Futurists, and the Bauhaus designers—could be adapted to the needs of corporate advertising because these styles would associate a product with modernity and also attract better-educated, more affluent customers. A master showman with the esthetic sophistication of MoMA's Alfred Barr and the commercial acumen of P. T. Barnum, Coiner managed to enlist some of the foremost modernists, American and European, for his ad campaigns. On behalf of companies like De Beers, Dole Pineapple, and the Container Corporation of America, Coiner hired and handsomely compensated Pablo Picasso, Salvador Dalí, Man Ray, Fernand Léger, Raoul Dufy, Georges Rouault, Georgia O'Keeffe, László Moholy-Nagy, and Herbert Bayer. Coiner encouraged all of them to attach their signatures to the advertisements on which they worked, just to make sure the viewers of the ads knew they were being exposed to great art along with the sales pitch.[8]

In effect, Coiner was popularizing highbrow art by making what was once visually abstruse now more lucid and helpful to consumers.

As with the modernist shows in department stores, Coiner's avant-garde ads allowed people who had never gone near the Museum of Modern Art to become familiar with contemporary trends in painting and design.

What did they see in the ads that Coiner and other similarly inclined art directors devised in the 1920s and 1930s? The reliance on modernist methods certainly accelerated the tendency among advertisers to use fewer words and more startling imagery. A typical ad might be filled not with exhortations to buy a product but with abstract forms, zigzag or diagonal lines, angular shapes (whether of bodies, cars, or appliances), austere graphics, and asymmetrical layouts. Above all, the ads conveyed a sense of motion and speed, as if a woman's dress or a man's golf clubs were akin to an airplane: sleek, dynamic, and up-to-date.[9]

Since advertisements sold dreams as much as merchandise, the Surrealists were especially popular with agency art directors, magazine editors, clothing designers, and department store owners. MoMA's exhibition of Dada and Surrealist paintings in 1937 sparked the interest of those in the advertising and fashion world who appreciated the commercial implications of what Alfred Barr called "fantastic" art.

Thus Man Ray's photographs—often of models erotically posed—appeared regularly in *Harper's Bazaar* during the late 1930s. But the Surrealist in greatest demand was Salvador Dalí. Dalí developed a reputation for outlandish fashion ensembles when he collaborated with the Italian designer Elsa Schiaparelli, for whom he concocted a white dress adorned with images of lobsters, a pink belt with a woman's lips for a buckle, and a hat in the shape of a shoe.

Dalí first visited the United States in 1934, and lived in the country throughout the 1940s. While in América, he frequently worked for *Vogue* and for Bonwit Teller, which employed him on several occasions, once to help decorate its Christmas display window. Dalí's contribution included a jumble of teaspoons scattered on the floor, a dinner jacket embroidered with cocktail glasses, and a set of ghostly fingers encased in fur-lined nails reaching toward a mannequin whose head was composed of red roses.[10] Because of these fabrications—fanciful or repulsive, depending on the viewer's point of view—Dalí became a celebrity in America, an artist whose name was synonymous not only

with the cultural aspirations of the advertising and fashion industries but with the eccentricities of high modernism.

Not every advertisement in the 1930s was modernist and disconcerting. Like much of American painting during the Great Depression, the majority of ads in newspapers and magazines were more "realistic" (at least in their style if not in their content) and less conspicuously experimental.[11] While some advertisements and illustrations, like those of Thomas Hart Benton and Norman Rockwell, reminded viewers of the virtues of the American Dream, other sales promotions exploited the fears of people in the midst of hard times—as if the lack of a Gillette shave or the stigma of clogged pores untreated by some miraculous facial cream could cost a man or a woman a job or friends. Still, whether the tone of the ad was uplifting or menacing, the message was blunt: the misfortunes of your life could be remedied either by a continuing faith in the resilience of American capitalism or by the purchase of our shampoo, razor blades, or detergent.

Yet once prosperity returned to America after World War II, ads seemed free to indulge again in humor and subtlety—especially if they were crafted by hip new agencies like Doyle Dane Bernbach, whose droll campaign for the Volkswagen "bug" in 1959 contrasted the car's diminutive simplicity with the chrome-plated monsters that ruled America's roads. In addition, modernist designs reappeared, based sometimes on the paintings of European refugee artists (as in the case of L'Oréal's use of Piet Mondrian's red, blue, and yellow rectangular grids on the bottles of its hair-grooming products).[12] The work of the Pop Artists was always conducive to moving the merchandise. Even when Pop Art became psychedelic in the late 1960s, it was still rooted (as was the counterculture) in a reverence for salesmanship and public relations.

For many Americans in the first half of the twentieth century, advertising was a surrogate for modernist art. But the esthetic movement that had the most far-reaching commercial impact, particularly in the 1920s and 1930s, was Art Deco. Its influence transcended advertising, and it reflected perfectly the symbiosis in America between modernism and the marketplace.

Art as Decoration

The term Art Deco, like modernism itself, originated in Europe—specifically at the Exposition Internationale des Arts Décoratifs et Industriels Modernes, held in Paris in 1925. But also like modernism, Art Deco became as much an American as a European phenomenon, once it was applied to every imaginable item for sale to the American consumer.

The style of Art Deco was both "primitive" and modernist. On the one hand, it drew on imagery (especially the ziggurat form) from ancient Egypt and Mesopotamia, together with African ivory and zebra skins, geometric patterns in Native American pottery and baskets, and the sunburst motifs in Aztec art. On the other hand, Art Deco relied on aluminum and stainless steel to give objects an elongated, streamlined, and aerodynamic look appropriate to the age of machines, technology, and high-speed travel. As a result, the eclectic elements of Art Deco could be seen in the design of skyscrapers, airplanes, railroad engines, train stations, ocean liners (leisurely but luxurious), and automobiles, as well as in couches and tables, radio sets, irons, toasters, lamps, clocks, and jewelry. Whatever Art Deco owed to the architecture and symbols of antiquity, or to Cubism, Futurism, and the distortions of German Expressionism, it was an artistic movement that consumers, mainly if they were well heeled and urbane, could understand.[13]

Art Deco particularly affected the contour of women's clothes. Advertisements in fashion magazines and dresses in department stores stressed the stark beauty of angular and jagged lines, to be worn by tall and lean women with exceedingly long necks, the better to show off their expensive earrings and necklaces.[14] Anyone buying these clothes would never be mistaken for a traditional mother and housewife. Instead, she might resemble a ballerina, an athlete, or a man's unconventional partner in shared adventures, an undomesticated Lady Brett Ashley in Hemingway's *The Sun Also Rises,* or, later, a Katharine Hepburn sparring onscreen with Spencer Tracy.

A new generation of designers in the United States used Art Deco to change the way not only women but products were packaged. Norman Bel Geddes, Walter Teague, and Raymond Loewy (who grew up

in Paris but emigrated to America in 1919) were not avant-garde artists or architects. Their backgrounds were in the theater (Bel Geddes had developed a new type of high-intensity lighting that could shine any color and isolate any spot on the stage), advertising, and window displays. They were in the business of making an unforgettable impression on the audience or the customer. And so they believed that the physical appearance of a package was as important as what it contained. If, for instance, one could make a commonplace object, like a camera or a refrigerator, seem as swift and forceful as the locomotive of the 20th Century Limited, then shoppers would be emotionally (and maybe sexually) aroused, and more likely to buy the article.[15]

Bel Geddes, Teague, and Loewy refurbished familiar products for their employers during the 1920s and 1930s: Texaco gas stations, Kodak cameras, Steuben glassware, and Pyrex ovenware, as well as the packaging of Lucky Strike cigarettes. But their vision of an Art Deco–inspired universe was fully expressed at the New York World's Fair in 1939. The pavilions they designed—notably Bel Geddes's "Futurama" exhibit for General Motors—pointed to a future filled with shimmering buildings, seven-lane highways, and high-tech industries.

The fair was a fantasy. As was Art Deco in its idealization of gleaming furniture surrounding a brassy, independent woman in an elegant evening gown, ready to dance cheek to cheek on a polished nightclub floor with a slender gentleman, graceful and impeccably clothed. There was only one place where the dreamworld of Art Deco could be realized, and that was in the movies.

The Art Deco esthetic, with its upper-class connotations, was pervasive in Hollywood movies during the interwar years. It was visible in the sets of romantic melodramas, sophisticated comedies, musicals, and even gangster films, whose mobsters were homicidal but always dapper. The use of Art Deco in a variety of movie genres provided countless opportunities for the studios to bask in their own opulent fashions and lighting. But Art Deco also allowed Hollywood to associate itself with modernist styles, which (once they were glorified in the movies) then affected the design of clothes and office furniture in cities throughout America.

By the early 1920s most of the Hollywood studios, like the advertising agencies in New York and Philadelphia, had hired art direc-

tors. Many of these were initially trained as painters, architects, or interior decorators. The studios recruited them in part to bolster Hollywood's claim that its movies were a form of art as well as entertainment.[16] The primary job of the art directors, however, was not to create sets or costumes themselves but to manage huge art departments staffed by people who were actually responsible for how a movie, and its actors and actresses, looked.

Among the leading, and ultimately legendary, art directors were Cedric Gibbons at MGM, Hans Dreier at Paramount, and Van Nest Polglase at RKO. Gibbons, the son of an architect, studied at the Art Students League in New York before going to Hollywood to work for Samuel Goldwyn in 1918 and then for MGM in 1924. He also attended the Paris Decorative Arts Exposition in 1925, which helped convert him into an advocate of Art Deco.[17] With its style in mind, Gibbons designed the curvilinear, highly polished Oscar statuette, which was first awarded to winners in 1929. During the 1930s Gibbons was the art director for *Grand Hotel* (with its glistening lobby full of glossy people, and its geometric patterns engraved on the marble floors), *The Merry Widow* (for which he won one of his own Oscar statues), *Ninotchka* (with Greta Garbo, the embodiment of Art Deco's glamorous exoticism even when she was impersonating a Soviet commissar), and *The Wizard of Oz* (L. Frank Baum's fabulous city of smoke and mirrors, an apt metaphor for Art Deco, brought to the screen).

Hans Dreier grew up in Germany, where he intended to become an architect. But in 1919 he was hired as an assistant art director by UFA (Universum Film AG), the largest movie studio in Germany. Although UFA's directors, writers, and actors were supremely talented, Dreier soon left for the United States, going to work at Paramount beginning in 1923.[18] As Paramount's supervising art director from the 1930s until 1950, Dreier blended German Expressionism and Art Deco. Along with other Hollywood art directors, Dreier presided over a range of movies, including comedies like the Marx Brothers' *Duck Soup* and Preston Sturges's *The Lady Eve.* Yet he achieved his most striking effects collaborating with other UFA alumni who had also found a home at Paramount: Ernst Lubitsch (*The Love Parade*), Josef von Sternberg and Marlene Dietrich (who was, in *Morocco* and *Shanghai Express,* as enigmatically alluring as Garbo), and eventually Billy

Wilder (*Double Indemnity* and *Sunset Boulevard,* the 1950 film for which Dreier won an Oscar).

Art Deco was exceptionally suited to movie musicals in the 1930s. The musicals habitually emphasized a woman's body, draped in a lustrous outfit, dancing in a modernist ballroom full of glittering furnishings and grand staircases, or amid dozens of fountains that resembled ice sculptures in a Busby Berkeley–style production number.[19] Indeed, the mechanical precision of Berkeley's chorus lines, with their intricate dance configurations shot from the ceiling, seemed as abstract as a Futurist painting.

Van Nest Polglase was not as obsessed with the female form as was Berkeley. Polglase was another art director who started out as a student of architecture and interior decor before entering the movie business in 1919 and becoming head of the art department at RKO in 1932. In *Top Hat, Swing Time,* and *Shall We Dance,* Polglase transformed not just Ginger Rogers but also Fred Astaire into icons of Art Deco—particularly the angular Astaire, with his burnished black top hat, tails, and walking stick, set off by his immaculately white shirt.[20]

Yet despite their monochrome modernity, the classy sets for Fred and Ginger's musicals were no match for the Expressionist aura of Charles Foster Kane's Xanadu. Polglase was nominated for an Oscar for his art direction on *Citizen Kane,* the most visually extravagant film on which he ever worked. But the style of *Citizen Kane* was less a testament to the Art Deco of the 1930s than a harbinger of postwar film noir.

In fact, the popularity of Art Deco was already fading by the 1940s, not only in the movies but among middle-class consumers who were never able during the Depression or World War II to afford the inflated prices of the clothes and furniture displayed in magazine advertisements and in Hollywood. Meanwhile, as more films began to be shot on location in the 1950s, the importance of studio art departments and their directors declined.[21]

Nevertheless, Art Deco remained influential until the 1960s as a symbol of modernism, if not in America or Europe, then in countries like Cuba, India, and the Philippines, where architects and their rich clients were still enamored with Hollywood's version of luxury. For postwar Americans, though, the preferred mode was the stripped-down

International Style, which could be seen in the living rooms and kitchens of apartments and ranch houses across the land.

The Modernist Home

The furniture was known, generically, as Danish Modern. The Formica tables with their spindly legs, the stiff bentwood rocking chairs, the flimsy cabinets, and the narrow couches you kept sliding off of and couldn't stretch out in, these were the antitheses of Art Deco.

Yet even customers who were bewildered by modern art and by Bauhaus designs seemed willing to stuff their homes with objects that were spartan, functional, and usually uncomfortable. Perhaps this was a testimony to the effectiveness of the advertising people saw every Sunday in the supplements of their newspapers, or in magazines like *House and Garden,* which patiently explained to readers in the 1950s how the modernist esthetic could be adapted to kitchen appliances, dishes and utensils, fabrics, and low-cost bedroom sets.

Most of these products did not come from Denmark or anywhere else in Europe. They were, though, inspired by experiments in Sweden and Finland with laminated teak and plywood, materials that were lighter (both in color and weight) and felt more "contemporary" than the dark walnut or mahogany used in traditional American furniture. Thus, after World War II, the American designers Charles and Ray Eames constructed plywood and fiberglass chairs modeled on the Finnish creations of Alvar Aalto, whose work was first exhibited at the Museum of Modern Art in 1938 and at the New York World's Fair in 1939. But anything that appeared streamlined and futuristic—high-tech refrigerators and ovens, Scandinavian-style glassware, high-fidelity phonographs with plenty of silver dials, televisions flaunting their complex control panels—was popular with American consumers.[22]

To spruce up their houses with more splashes of color, home-owners could purchase fake replicas of modern art that had been applied to or superimposed on the most utilitarian items: shower curtains with reproductions of Van Gogh's sunflowers, wallpaper imitating scenes from Matisse and Miró, floor tile whose patterns resembled Pollock's drip paintings. All of this pseudomodernist decor would invariably be topped off by a gigantic plant looming in the living room

because, as Tom Wolfe observed in *From Bauhaus to Our House,* "the furniture was so lean and clean and bare and spare that without some prodigious piece of frondose Victoriana from the nursery the place looked absolutely empty."[23]

By the early 1960s modern European design had become thoroughly Americanized. And the style was ubiquitous not just in American homes but, increasingly, throughout the world. American design firms and furniture manufacturers had opened offices in Asia, Europe, and Latin America, and they were regularly participating in trade fairs in countries from Japan and India to Morocco and France.[24]

The high point of America's overseas promotion of its home furnishings occurred in 1959 at a cultural exhibition in Moscow. In the context of the Cold War, the United States Information Agency decided to show the Soviet proles how well the average American family lived. The Agency erected a model of what it called a "typical" American home, a suburban ranch house packed with the artifacts of a consumer society, including a kitchen with a modern refrigerator, stove, and garbage disposal. It was in this "kitchen" that Richard Nixon "debated" Nikita Khrushchev, with news photos of their encounter flashed all over the planet. Momentarily, the Cold War dissolved into a quarrel about which country made better washing machines.

Three million Russians visited the exhibit. The administrators of USIA had good reason to feel triumphant.[25] As in the case of American painting and architecture, American design had exploded into an international phenomenon.

But the sights of American life—whether communicated through advertising or paintings, or in skyscrapers and houses—could not compete for worldwide influence with the sounds of American music. A Charles Coiner or a Cedric Gibbons worked, literally, behind the scenes. Out front, when the curtain went up, the incontestable American stars on the global stage—all of them as modernist as Jackson Pollock—were Aaron Copland, Duke Ellington, and George Gershwin. It was their music—along with the symphonies, concertos, and songs of other composers and performers—that defined for audiences everywhere what they loved about the exuberance of American culture.

From *The Rite of Spring* to *Appalachian Spring*

■

Americans never embraced Europe's modernist music with the enthusiasm they showed for its contemporary painting, architecture, and design. In the years after World War II, the majority of Americans grew accustomed to seeing the modernist esthetic on display in museums, in the configuration of office buildings, in department and furniture stores, and in homes. Meanwhile, the paintings of the Cubists and the Surrealists were selling briskly and at hefty prices on the American art market. But with the exception of Igor Stravinsky, no European composer in the twentieth century was as famous or as fashionable in America as Pablo Picasso or Salvador Dalí.

Indeed, most of the repertoire in concert halls or on FM radio stations specializing in "classical" music came from the eighteenth and nineteenth centuries. No conductor in the United States would dream of programming an entire evening of Karlheinz Stockhausen. A Leonard Bernstein might insert before the intermission some European piece composed after 1930, but the second half of the concert would feature nothing later than a symphony by Gustav Mahler. Even in the instance of Stravinsky, the audience might hear *The Rite of Spring* or *Petrushka,* both written in the early twentieth century, but no sampling

of Stravinsky's twelve-tone experiments in the 1950s. As for playing the works of Arnold Schoenberg, Stravinsky's foremost rival in the creation of modernist music, Bernstein would rarely risk alienating season–ticket holders or the members of the Philharmonic board. In short, the eyes of the American people had accepted and absorbed the disturbing features of modernist art, while their ears continued to reject the dissonance of modernist music.

Still, some American composers—notably Aaron Copland—managed to adapt the musical innovations of the Europeans to ballets, symphonies, and suites that sounded simultaneously traditional and modernist. With a blend of avant-garde techniques, hymns, jazz, and folk melodies, a distinctively American music emerged that attracted audiences in the United States and around the world.

The popularity of this music did not alter the American public's distaste for modernist compositions filled with atonal shrieks. But it did indicate that American composers, like American artists, were capable of producing works as ingenious as those of their foreign mentors and competitors. So at midcentury, American music became—at least for the moment—a truly international phenomenon.

Classical Music in America

Historians commonly describe the pre–Civil War era as a time when the borders between "serious" and popular music were imprecise. The music of Bach was more technically sophisticated than that of a marching band, but both charmed the middle class as well as the rich in America. Newspapers frequently advertised concerts as a form of entertainment, no different from horseraces or minstrel shows. Musicians and conductors were not considered members of a cultural elite. As mere fiddlers and band leaders, they might have to amuse the public with excerpts from symphonies or chamber music one night, and with polkas and square dances the next.[1]

Whether such an egalitarian culture ever really existed during these years, the no-trespassing signs segregating classical from lowbrow music began to spring up in America by the late nineteenth century. Now symphonies were to be honored, if not necessarily enjoyed. They were to be performed as written, in full, by professional musicians,

without interruptions or eccentric interpretations, and certainly without being supplemented by popular tunes.[2]

Nor was it legitimate any longer to play serious music in parks, in parades, on street corners, or anywhere a crowd gathered. Cities, throbbing with wealth and hungry for status, established municipal orchestras. Among the most prominent were the New York Philharmonic, founded in 1842; the Boston Symphony Orchestra, in 1881; and the Chicago Symphony Orchestra, in 1891. These institutions required concert halls and opera houses in which to perform. In New York alone, the Metropolitan Opera opened its doors in 1883, followed by Carnegie Hall in 1891. And to make sure there would be a plentiful supply of musicians, even some who were born in America, the Juilliard School (originally called the Institute of Musical Art) was launched in New York in 1905 as a music academy that might eventually equal the conservatories of Berlin and Vienna.

Theodore Thomas, the conductor of the New York Philharmonic from 1877 to 1891 before he moved on to start the Chicago Symphony, epitomized the type of visionary who yearned to elevate America's musical tastes. Not only was he contemptuous of popular music, but he insisted that audiences be attentive and polite at all orchestral performances. He also imposed a formal dress code on his musicians and the spectators, preferably evening gowns for the ladies and tuxedos for the gentlemen.

Nevertheless, Thomas understood that orchestras ought to be profitable, and that the bills for the glitzy carpets and chandeliers had to be paid—largely by upper-class patrons who were lifetime benefactors, but additionally by the less persnickety customers in the balcony. Although Thomas had been born in Germany, he came to the United States as a child, and he was sufficiently American to grasp the connection between the box office and classical music.[3]

The music Thomas and other conductors programmed, however, was predominantly European. Most audiences were either ignorant or intolerant of American composers, and therefore favored the masterpieces particularly of the Germans and Austrians: Bach, Mozart, Beethoven, Mendelssohn, Schumann, Schubert, and Brahms. So conductors like Thomas, even as they hoped for the development of American compositions, complied with the preferences of their clientele.

The affinity for Germanic music was reinforced by the six million German immigrants who came to the United States between 1830 and 1920. As an ethnic group devoted to the arts and eager to transfer the high culture of their homeland to the New World, German immigrants were energetic in supporting orchestras, choral societies, and music festivals that featured the works they remembered and adored.[4] Hence the German and central European Romantic tradition was what most people in America, not only in the nineteenth century but well into the twentieth, defined as classical music.

At the same time, the widespread conviction that American music was second-rate led some of the same millionaires who were collecting European paintings for their mansions and museums to collect European musicians for their concert halls and opera houses. A European violinist or pianist possessed the stature that no American counterpart could match.[5] It was not surprising, then, that orchestras throughout the country were dominated by European, and above all German, musicians—many of whom were lured by the higher salaries they could command in America, courtesy of the bankrolls of the Morgans, Mellons, and Carnegies.

European conductors were similarly in demand. Leopold Damrosch, for example, was born in Prussia and had conducted the Breslau Symphony Orchestra before coming to the United States in 1871. In 1878 he founded the New York Symphony Society as a competitor to the New York Philharmonic (the two organizations eventually merged in 1928). Damrosch conducted at the Metropolitan Opera as well, where he introduced the music of Wagner to American audiences. When he died in 1885, his son Walter (also born in Prussia) took over the New York Symphony and helped inaugurate Carnegie Hall.[6] Walter Damrosch would later be instrumental in bringing European classical music to American radio audiences.

The most illustrious European conductor and composer who emigrated to the United States at the dawn of the twentieth century was Gustav Mahler. Having led the Vienna Court Opera for the previous ten years, Mahler accepted the directorship of the Metropolitan Opera in 1907 (an appointment he shared with Arturo Toscanini, fresh from La Scala in Milan).[7] Mahler went on to conduct the New York Philharmonic until his death in 1911.

The infatuation with German music and musicians temporarily evaporated after America's entrance into World War I in 1917. Beethoven and Wagner were now regarded as subversive. The German-born conductor of the Boston Symphony, Karl Muck, was jailed for allegedly refusing to open his concerts with "The Star-Spangled Banner"; he was also suspected, falsely, of sending coded messages to phantom German U-boats roaming off the New England coast. Yet once the war ended, German and other European music regained its eminence in orchestra catalogues.[8]

European soloists and composers found a trip to America even more lucrative than musicians or conductors who held permanent positions with orchestras. Beginning with the Swedish soprano Jenny Lind, whom P. T. Barnum imported in 1850 and transformed into a celebrity by advertising her exotic beauty and personality as much as her voice, the Europeans discovered that they could give the American public what it wanted to hear and return to their countries well compensated for their brief visits. Peter Ilyich Tchaikovsky toured the United States in 1891, conducting his own music. He was followed by Richard Strauss in 1904, Sergei Rachmaninoff in 1909, Sergei Prokofiev in 1918, Béla Bartók in 1927, and Maurice Ravel in 1928.[9] The violinists Jascha Heifetz and Fritz Kreisler and the pianists Vladimir Horowitz and Artur Rubinstein were also treated like stars while performing in America during the early twentieth century.

Concerts, though, were sedate affairs compared to the opera. Despite the erection in many cities of luxurious opera houses, their private boxes reserved for the local elite, opera (teeming with lurid melodrama and spectacular sets) remained a popular art—especially among Italian immigrants who knew every aria from Verdi and Puccini.

So of all the European musical luminaries who came to the United States, none was more idolized than Enrico Caruso. Caruso was a full-fledged culture hero, his tenor as much a beacon as the Statue of Liberty, and not just for Sicilians and Neapolitans hoping to succeed in America.

Caruso arrived in New York in 1903 to sing at the Metropolitan Opera. Yet his fame rested less on his live performances than on his 260 recordings. His schmaltzy version of the clown's "Vesti la Giubba" (put on the costume even if one's wife is unfaithful) from *Pagliacci* was

the first record to sell one million copies. This feat confirmed opera's continuing appeal to immigrants and ordinary Americans, not purely to bankers and industrialists in search of high culture. It also pointed to the role that the emerging new media—records and radio—would play in making classical music accessible to those who didn't live in New York or couldn't afford a seat at the Met or Carnegie Hall.

When Caruso died in 1921, at the age of forty-eight, his records had made him as legendary as Rudolph Valentino, another exemplar of "foreign" passion whose early death enhanced the mythology of his life. But there was, in Caruso's triumph in America, an additional link to Valentino and the movies. Just as America's wealth tempted European conductors, musicians, and opera stars, so Hollywood seduced European directors and actors. In the end, Europe suffered a drain of talent in the late nineteenth and early twentieth centuries that only accelerated once the psychopaths in the 1930s goose-stepped to power.

Music and the Media

For many middle-class Americans at the dawn of the twentieth century, music was something not just to hear in concert halls or opera houses but to be played on the piano in the home. The pianos weren't Steinways; they were mostly mass-produced, making them (along with music lessons for the children) less costly. Indeed, 1 in 252 Americans purchased a piano in 1910. More important, the ability of children and their parents to play a piano became a sign of a family's civility.[10] Thus we have the cherished image, perpetuated in movies like *Meet Me in St. Louis,* of someone performing at a piano in a living room or parlor while the rest of the family, together with friends and neighbors, gathered round to listen or sing.

The problem was that not everyone could play the piano like Vladimir Horowitz or sing like Judy Garland. Moreover, the music itself—whether a concerto or a popular song—was often too difficult, in its structure and harmonies, for amateurs. The availability of sheet music helped. So, too, did the advent of player pianos and piano rolls, where automatic chords and arrangements prepared by professional musicians allowed families to sing along without having to touch a piano key or a pedal. But the technical demands of playing Bach or

singing a Gilbert and Sullivan tune, much less a Wagnerian aria, meant that music making—in America and throughout the world—became increasingly the province of specialists.[11]

Of course, despite their lack of dazzling proficiency, people never stopped singing or playing pianos and other musical instruments. They did, however, come to rely—especially in America—on the phonograph and the radio as the channels through which music of all kinds entered their homes.

In 1877 Thomas Edison invented the phonograph, for which he received a patent in 1878. Edison's early phonographs used wax cylinders for recordings. But by 1896 the cylinders were being superseded by flat discs which sounded better in reproducing music and the voices of singers.

As a result, the Victor Talking Machine Company, launched in 1901, began signing up some of the most illustrious singers and soloists in the music business—not only Caruso but also Heifetz, Kreisler, and Rachmaninoff (a celebrated pianist as well as composer)—to contracts over the next two decades. Their miniature performances, lasting no longer than the four minutes a twelve-inch 78 rpm classical music disc would permit, were captured on records with regal red labels or "seals" to distinguish them from recordings of "corny" popular music. The prestigious Red Seal logo reinforced the notion that those who recorded for Victor were the stars of the musical universe.

Orchestras, though, were at a disadvantage because acoustical recordings, widely used until the mid-1920s, had a restricted frequency range that could not always pick up the sounds of every instrument. In 1925 both Victor and the Columbia Record Company adopted a new microphone based on an electrical system developed by Western Electric. Now the music of an entire orchestra could be replicated and amplified. And in 1926 the first albums containing dozens of discs were introduced, making it possible for orchestras and opera companies to record complete works.[12] At this point, the musicians and conductors of the Boston Symphony Orchestra, the New York Philharmonic, and the Metropolitan Opera could share in the stardom of the soloists.

The effect of all these technological improvements was to enable classical (and popular) music to be part of people's everyday lives, available at any time to anyone with the cash to buy a phonograph and

a record, regardless of whether they themselves could also sing or struggle with a violin.[13] Consequently, classical music—at least in the early twentieth century—was never the exclusive possession of an elite audience defending the boundaries of high culture.

Yet records had a dual, sometimes contradictory, impact on the transmission of music within and beyond America. On the one hand, recordings of jazz, blues, country music, and popular songs—which dominated record sales in the 1920s and 1930s—were crucial in circulating American music all over the planet. On the other hand, as in the case of live performances at the opera or in symphony halls, most of the classical recordings in America featured European music.[14]

Still, the supremacy of the European canon was not unchallenged. Other foreign sounds penetrated a country with immigrants not only from Europe but from Latin America. During the teens and 1920s, Victor and Columbia established recording studios in Mexico City, Buenos Aires, Santiago, Lima, and Rio de Janeiro, where they could sign up local performers whose styles were a mixture of Spanish, Portuguese, and Latin American influences.[15] Understandably, recordings of Mexican vocalists were particularly popular in the southwestern United States. So what Americans heard on their phonographs was eclectic and cosmopolitan.

But starting in the late 1920s and extending into the Great Depression, when record sales plunged, whatever music Americans paid attention to came less from their turntables than from their radio sets. In fact, from the moment the first station, KDKA in Pittsburgh, went on the air in 1920, music was a staple of radio programs. Neighborhood singers, choral groups, barbershop quartets, bands, organists, pianists, anyone with even the slightest musical aptitude who could help fill up the air time was welcome.

The slapdash music that typified the broadcasts of hundreds of local stations soon diminished with the emergence of network radio. David Sarnoff—a Russian Jewish immigrant who arrived in America as a child in 1900, turned himself into an expert in wireless communications, and eventually became the general manager of the Radio Corporation of America in 1921—was committed to the idea that radio could be a medium not merely of entertainment but of high culture and

classical music. In 1926 Sarnoff founded the National Broadcasting Company under the auspices of RCA. Its first nationwide broadcast on November 15 featured a concert by the New York Symphony under the baton of Walter Damrosch.[16]

A year later the Columbia Phonographic Broadcasting System appeared. It was renamed the Columbia Broadcasting System by William Paley—the son of a Ukrainian Jewish immigrant who owned a cigar company—when Paley and his family took over the network in 1928. Though both NBC and CBS began as relatively small endeavors, with between sixteen and nineteen outlets, they grew to dominate radio broadcasting by the end of the decade.

Each network, especially Sarnoff's, extensively programmed live performances of concerts and operas. The Boston Symphony Orchestra, directed from 1924 to 1949 by the Russian-born Serge Koussevitzky, gave a concert on NBC in 1926 that attracted one million listeners. The New York Philharmonic, under Arturo Toscanini, began Sunday afternoon broadcasts on CBS in 1930. By 1934 these Sunday concerts—introduced and explained by the influential music critic Deems Taylor—reached an audience estimated at nine million Americans.[17] Then, on Saturday afternoons, commencing in 1933, people could hear broadcasts on NBC of full-length operas direct from the Metropolitan Opera House. Saturday afternoons at the Met represented for many avid middle-class consumers of culture the pinnacle of "serious" music on the radio.

My mother was one of those who listened faithfully to the Met every Saturday. She insisted I listen too. But she always made chocolate pudding during the broadcasts, and let me lick the pot, maybe because she hoped the opera would go down sweeter. It didn't, yet I still remember—as does everyone else who ever heard him—the comforting, quintessentially radio voice of Milton Cross describing the sets and the stories.

To some degree, Sarnoff's and Paley's devotion to classical music was motivated by a desire to put on enough "public service" programming so that the federal government would not interfere with their networks' more commercial operations. Yet as Jews, from immigrant backgrounds, Sarnoff and Paley were not just entrepreneurial but also

culturally ambitious.[18] Their promotion of music was one way of distinguishing themselves from their coarser brethren, like Jack Warner and Harry Cohn, out in Hollywood.

As it happened, there was not much difference between making money and making music on the radio. Corporations, too, thought it beneficial for their images and their products to sponsor opera and concert broadcasts. So, many of the music programs were brought to you by Ford, General Motors, Philco, Chesterfield Cigarettes, Firestone Tires, Texaco, Bell Telephone, and General Electric. Classical music, which was easier to absorb on the radio than on breakable records that required the aficionado of Beethoven or Rossini to constantly change discs, therefore became a major form of art, advertising, and enjoyment on NBC and CBS.[19]

Conductors particularly noticed that radio broadcasts could be a means of expanding the audience for classical music, as well as a vehicle to enhance their own fame. Maestros like Koussevitzky and Toscanini became more renowned because of their presence on the radio than they might have been had they confined themselves exclusively to the concert hall. Audiences could hear their voices talking about their musical preferences, see their publicity photos in magazines and newspapers, and thus elevate them into fantasy figures, comparable to movie stars. Meanwhile, the conductors could try to use their status as celebrities to improve the musical tastes of the masses.

The ambition to be a mentor as well as conductor especially appealed to Walter Damrosch. From the instant he appeared on NBC's initial broadcast in 1926, Damrosch recognized the importance of radio not only in reaching musically sophisticated listeners but also in educating those throughout America who knew little about Beethoven or Brahms. From 1928 until 1942, Damrosch was NBC's music director, hosting the network's *Music Appreciation Hour,* a series of concerts and lectures broadcast weekly during the daytime and aimed at students in elementary and secondary schools. NBC provided teachers with textbooks and worksheets to accompany Damrosch's instructions. The lectures, though, were not meant just for young people in school, and the program was popular with adults who wanted to learn more about music. Damrosch concentrated on the giants of European music, from Bach, through Mozart and Beethoven, to Brahms and Wagner.

Although Damrosch was interested in contemporary and American (notably Gershwin's) music, few modernist or atonal sounds troubled the audience or the lesson plan.[20]

Leopold Stokowski was far more charismatic than Damrosch, and he had an even greater awareness of music's dependence on the media. Born and raised in London, though of Polish ancestry, Stokowski was sufficiently exotic in his background, accent, and demeanor to captivate American audiences who believed he was the personification of a "European" conductor. Stokowski arrived in America in 1905, directed the Cincinnati Symphony Orchestra from 1909 to 1912, and then took over the Philadelphia Orchestra until the late 1930s. He developed a histrionic style of conducting, with spotlights in the music hall focused on his intense facial expressions and flowing hair, or on his hands conducting without a baton.

Unlike many of his counterparts, Stokowski felt comfortable with the new music of the early twentieth century, and he experimented with the works of Mahler, Stravinsky, Schoenberg, Dmitri Shostakovich, and Jean Sibelius. But he too wanted to seize the attention of a broad audience. He and his Philadelphia Orchestra appeared regularly on NBC beginning in 1929.

For Stokowski, however, the ultimate audience for serious music was not in the living room, listening to the radio, but at the movies. Along with other popular radio stars (Jack Benny, George Burns and Gracie Allen, Martha Raye, and Benny Goodman), Stokowski appeared as himself, conducting Bach, in the film *The Big Broadcast of 1937*. The same year he conducted and acted in *One Hundred Men and a Girl*, opposite Deanna Durbin. After these agreeable encounters with Hollywood (topped off, purportedly, by an affair with Greta Garbo), Stokowski would go on to collaborate with Walt Disney on *Fantasia*, an ingenious effort to make classical music both uplifting and entertaining for moviegoers.

No conductor, however, was more famous or more fervently worshiped in America than Arturo Toscanini. By the 1930s Toscanini had been shuttling between Italy and the United States for most of the century, conducting at La Scala, the Metropolitan Opera, and the New York Philharmonic. In 1937 David Sarnoff, in one of his most spectacular accomplishments, recruited Toscanini to direct a new venture

in music: the NBC Symphony Orchestra. Both NBC and CBS had retained house orchestras in the past, but none had the impact of Sarnoff's creation from its birth until its final broadcast in 1954.

Other conductors, including Stokowski, led the NBC orchestra over the years, but its performances and selections of music were always identified with Toscanini. And Toscanini's choices were traditional—usually from the nineteenth century, and customarily German or Austrian. During the late 1930s and World War II, as a compliment to his adopted country, Toscanini did program some works by George Gershwin and Aaron Copland, and he conducted the premier of Samuel Barber's *Adagio for Strings*. Yet for the most part, Toscanini gave his radio audience what it expected from a legendary interpreter of the classical European composers.[21]

The era when radio was the principal transmitter of Europe's music to the American middle class lasted for only twenty-five years. By the 1950s broadcasts from concert halls and the maintenance of network orchestras grew too expensive, given the collapse of radio's nationwide audience under the onslaught of television. Classical music on the radio was relegated to local FM stations, with their smaller, more dedicated clientele.

Programs devoted to classical music did show up sporadically on television. In 1951, on Christmas Eve, Gian Carlo Menotti's one-act opera *Amahl and the Night Visitors* appeared on NBC as the debut production of the *Hallmark Hall of Fame*. This was the first opera specifically composed for television. Thereafter NBC televised the opera every year around Christmas, from 1952 until 1966, although by the 1960s it was broadcast in the afternoons rather than in prime time because the network's executives had lost faith in any opera's capacity to attract a mass audience.

Television could have been invented just to display Leonard Bernstein's multiple talents. Eloquent, photogenic, theatrical, Bernstein gave compelling lectures on music, starting in 1954, for *Omnibus,* a cultural program funded largely by the Ford Foundation, and broadcast first on CBS, later on ABC and NBC. Bernstein's triumphs as a conductor at the New York Philharmonic and as a Broadway composer fit in splendidly on a program that managed during its run to combine opera and plays, painting and literature, Charlton Heston and James Dean.

Bernstein also offered a series of Young People's Concerts from 1958 to 1972, many of them televised by CBS.

Nevertheless, television was never as hospitable a medium for the dissemination of classical music as records and radio had been. Somehow, watching musicians perform on a diminutive screen did not have the same allure as hearing the power of the music on a recording or radio set.

Still, critics often claimed that even the phonograph and the radio made listeners more passive, more reliant on distant and deified soloists and conductors, less able or willing to make music themselves.[22] Yet listening to music can be just as imaginative an activity as reading a book. Moreover, records and radio could not only stimulate a greater interest in classical music but inspire people to take up a musical instrument (which was certainly the impact of jazz and rock recordings).

The real question for Americans was whether the country would ever appreciate its own music instead of simply idolizing the sounds from abroad. Because only when American composers and their audiences overcame their feelings of cultural inferiority could a genuinely national music emerge.

The Quest for an "American" Music

The notion that music ought to express a nation's soul was widespread in the late nineteenth and early twentieth centuries. The hunger for a national music was evident not only in countries with long-established cultural traditions but even more so in newly emerging lands whose political identities remained unsettled or whose ethnic self-image was fragile. It was therefore the special task of the composer to write music that would mystically embody a country's founding myths, its rural legends and ancient memories. Thus Stravinsky and Mussorgsky in Russia, Sibelius in Finland, Grieg in Norway, Wagner in Germany, Bartók in Hungary, and Dvořák and Smetana in Czechoslovakia all used folk melodies, peasant dance tempos, and regional themes and instruments in their symphonies, chamber music, ballets, and operas.[23]

In the United States too, between the 1850s and the 1920s, there were attempts to develop a characteristically American music—much of it rooted in New England hymns, sea chanteys, black gospel and

work songs, and Scotch-Irish folk ballads. The New Orleans–born Louis Gottschalk, for example, became in the 1860s one of America's leading pianists and composers, drawing on his Creole background and his familiarity with African and Caribbean music to win considerable fame, though less in the United States than in Paris, where he studied and frequently performed. Around the turn of the century, Edward MacDowell composed piano suites with names like *Woodland Sketches, Sea Pieces,* and *New England Idylls,* each of them commemorating America's rural and nautical past. One of his students, Henry Gilbert, incorporated black spirituals and ragtime into his works, anticipating the central role that jazz would play in all of American music.[24]

MacDowell's compositions, in particular, were conventionally Romantic. No one ever thought the music of Charles Ives was predictable. Ives also wanted to create an indigenous American music, but he was equally entranced with the dissonant styles emerging in Europe before World War I. So he occasionally injected into his Protestant hymns, patriotic anthems, marches, and folk songs an atonal complexity worthy of Schoenberg.[25] Yet by the 1920s the works of both MacDowell and Ives were rarely heard, and their names grew increasingly obscure.

It was ironic that, during these years, the best-known piece of "American" music was written by a European. In 1892 Antonín Dvořák came to the United States for three years to direct the National Conservatory of Music in New York, an institution modeled on the Paris Conservatory but designed to train American composers and musicians who might contribute to the formation of a national musical culture. Dvořák agreed with the Conservatory's goals, and even helped lay the foundations for the realization of an American music through one of his students, Rubin Goldmark, who later went on to teach George Gershwin and Aaron Copland.

While at the Conservatory, Dvořák published an article in *Harper's Magazine* in 1895 entitled "Music in America," in which he urged composers to rely on the motifs of "plantation melodies and slave songs," as well as on Native American dances and chants. Although Dvořák studied transcriptions of Native American music and was influenced by the rhythms of Henry Wadsworth Longfellow's

poem *The Song of Hiawatha,* the closest he probably got to a real Indian was when he attended a performance of Buffalo Bill's Wild West Show.

Still, in 1893 Dvořák composed his ninth symphony, called *From the New World.* The symphony did contain references to black and Native American music, and it also tried to convey in its chords and harmonies the sweep of the prairie in the age of the pioneers. But Dvořák's symphony was essentially a European work, residing easily within the tradition of late-nineteenth-century classical music of the sort one could readily hear in Prague or Berlin.[26]

The effort to create an American music was promising but for the moment premature. It would not be until the 1930s that an enduring national music appeared, but one that was also inspired by the revolution in European music about to erupt at the beginning of the twentieth century.

The Sound of Modernity

Over the years, modernist music would have many names. At various points, music critics called what they heard neoclassical or twelve-tone or serialism. Like Cubism, Futurism, Surrealism, and Abstract Expressionism, the names referred to different compositional techniques. But just as modernist painters were responding to a world in which conventional portraiture no longer captured the disjointed and sometimes terrifying nature of contemporary life, so modernist composers rebelled against the nineteenth-century assumption that music should be both soothing and inspirational.

For composers like Schoenberg and Stravinsky, the desire to create lush melodies that evoked feelings of sadness or love, or that stirred up a Wagnerian sense of patriotic fervor at a time when soldiers were being annihilated in World War I, was obsolete and obscene. Gone were the soaring themes and harmonies of nineteenth-century Romanticism. Now music was to be "cooler," the style more emotionally restrained, the themes more fragmentary and the rhythms more irregular, the effort to "move" an audience less blatant.[27] Above all, as with modernist painters and architects, modernist composers forced the listener to pay attention to the structure of a work, the relationship (if any) be-

tween notes and chords. What mattered was the music itself, not allusions to the outside world.

During the first three decades of the twentieth century, Arnold Schoenberg's compositions (among them the symphonic poem *Pelleas und Melisande* in 1903, the song cycle *Pierrot lunaire* in 1912, and *Five Piano Pieces* in 1923) became progressively more atonal and abstract. Working mostly in Vienna and Berlin, Schoenberg discarded the lavishness of nineteenth-century symphonic music, writing usually for smaller orchestras and chamber groups. Once he fully developed his twelve-tone system by the 1920s, Schoenberg tried never to repeat a chord or a melody. No theme would be central; every note was equal in importance to every other. Indeed, Schoenberg's works were as much mathematical as musical.[28] And when *Pelleas und Melisande* and *Pierrot lunaire* were performed in New York in 1915 and 1923, respectively, American audiences reacted as if they were hearing an exceptionally incomprehensible version of Einstein's theories of relativity.

Schoenberg's music was almost too cerebral to be controversial. People had to have at least a dim idea of what a composer was doing before they became enraged. But audiences did recognize, however vaguely, the distortions they were hearing in the works of Igor Stravinsky; no modernist composer could more easily scandalize them than this "madman" from Russia.

In 1910 in Paris, Sergei Diaghilev's Ballets Russes performed Stravinsky's first ballet, *The Firebird*. This was followed in 1911 by *Petrushka*. But it was in 1913, with the initial performance of *The Rite of Spring,* that Stravinsky's music caused a commotion in Paris comparable to the angry bewilderment Marcel Duchamp's *Nude Descending a Staircase* elicited the same year at the Armory Show in New York. In Stravinsky's case, the music itself was nearly impossible to hear since fistfights broke out in the theater as some in the audience whistled, howled, and booed, while others cheered and applauded. Not even the arrival of the Paris police could suppress the chaos.

Yet *The Rite of Spring* was not as mystifying as Duchamp's nude. As in his earlier ballets, Stravinsky drew on Russian folk themes and mythology; indeed, *The Rite of Spring* was based on a pagan fer-

tility ritual from Russia's prehistoric past. But despite the presence of these recognizable motifs, Stravinsky's score contained no predictable melodies. The music was dissonant, polyrhythmic, and alarming to those in the audience who expected one more classically composed ballet.[29]

That was the trouble. Stravinsky and other modernist composers appeared unsympathetic to the wishes of their audiences. Like the Cubists, the Futurists, and the Dadaists, the composers cared little about making people comfortable, or creating art forms that were easy to fathom. On the contrary, atonal music seemed deliberately intended to infuriate both the elite and the middle class. Yet the motives of the painters and the composers were the same: to make people see and hear differently, to expose them to the disruptiveness of the modern world through new types of visual designs and new cascades of sound.

Nonetheless, Stravinsky was as interested as Picasso in having his works revered. And in attaining a measure of stardom along the way, not only in Europe but also the United States. In 1916, on tour in America, the Ballets Russes first put on *The Firebird* and *Petrushka* in New York. In 1922 *The Rite of Spring* premiered as an orchestral suite, performed by the Philadelphia Orchestra with Leopold Stokowski conducting. Although American audiences were as baffled by the compositions as their European counterparts had originally been, all three scores were emerging as archetypes of modernist music. Consequently, when Stravinsky himself visited America in 1925, he and his music were already famous.[30]

By the 1920s Stravinsky—far more than Schoenberg—had also become a model for young American composers. Just as he integrated Russian folk melodies into modernist ballets, so they wanted to write music that was both "American" and avant-garde. Thus modernism liberated a new generation of American composers from their precursors' dependence on eighteenth- and nineteenth-century European music, the music that most Americans still heard in their concert halls and opera houses as well as on records and the radio. But what the American composers now began to create was a music that (unlike their European contemporaries) turned out to be intricate and accessible all at the same time.

The Modernization of American Music

One way for American composers to overcome their sense of cultural provincialism was to enthusiastically embrace the techniques of modernist music. Yet it would not be enough simply to imitate the works of Stravinsky or Schoenberg, Claude Debussy or Maurice Ravel. To mimic the masters might only reinforce the view (prevalent in the United States as well as in Europe) that America's "serious" music was unoriginal and unimaginative. Instead, the Americans tried to link their own musical traditions with a European movement that was transforming harmonies, rhythms, and sounds.

Nowhere else in Europe could one be both American and modern than in Paris in the 1920s. In 1921, at the age of twenty, Aaron Copland sailed to France with his cousin, Harold Clurman.[31] Their journey together was a symbol of the changes soon to occur in American culture. Just as Copland would alter American music by the 1930s, so Clurman in the same decade would help revolutionize American acting. And in each instance, the men who most influenced them were Russian: for Copland, Stravinsky; for Clurman, Constantin Stanislavski.

American composers like Copland and Virgil Thomson naturally felt more at home in France than in Germany or Austria. In cosmopolitan Paris they could socialize with Gertrude Stein, Ezra Pound, and James Joyce. In addition, modern French music seemed leaner, less burdened with the theoretical implications so dear to Schoenberg and his Viennese disciples, Alban Berg and Anton Webern. So Copland enrolled at the new American Conservatory at Fontainebleau, just outside Paris, which Walter Damrosch had helped establish as a music school for aspiring American composers and musicians.[32]

Among the teachers at the Conservatory was the legendary Nadia Boulanger, whose students ultimately included Copland, Thomson, Roy Harris, Walter Piston, and Marc Blitzstein. At Boulanger's Wednesday teas and summer parties, the Americans could encounter Stravinsky, Ravel, and Darius Milhaud. Stravinsky, though, was Boulanger's hero, and she encouraged her students to adopt his neoclassical style, to fuse tonality with experimental harmonies and counterpoints. Stravinsky quickly emerged as Copland's own favorite composer, largely

because of Stravinsky's merger of modernism and Russian folk materials, just when Copland himself was becoming increasingly interested in jazz and American popular music.[33]

Indeed, Copland (like other expatriates in Paris) discovered that —sometimes to their amazement—America's culture was now considered chic, especially because of the presence in France of American jazz musicians and Hollywood movies. As a result, at the very moment that Copland was attracted to modernist music because of its transnational appeal, its rejection of chauvinistic tropes and melodies, he was also growing more at ease with the traditions of nineteenth- and early-twentieth-century American music. It was this combination of modernism and nationalism that characterized Copland's scores from the 1920s until the end of his life.

For Copland in the 1920s, jazz was where modernist and "American" music intersected. Copland's interest in jazz was aroused not only by its popularity with composers like Stravinsky, Milhaud, and Ravel but by his own exposure to jazz bands and soloists in the midtown clubs of Manhattan and in Harlem after he returned to New York in 1925.[34] The rhythmic novelty of jazz, its syncopation and "blue" notes, its effortless switches between major and minor keys, made jazz—while rooted in African American musical traditions—seem also contemporary and sophisticated. Moreover, jazz could be the mechanism by which a modernist composer might reach a sizable audience in the United States. After all, Copland's chief competitor in America, George Gershwin, was already demonstrating the uses of jazz as a central component of serious (and popular) music.

In the mid-1920s, therefore, Copland composed a series of jazz-inflected works. Copland's *Symphony for Organ and Orchestra,* his first public success, received its initial performances in 1924 with the Boston Symphony Orchestra, under the direction of Serge Koussevitzky, and at Walter Damrosch's New York Symphony. Koussevitzky and Damrosch were among the few conductors in the United States committed to modern American music, and Koussevitzky in particular became Copland's foremost interpreter until Leonard Bernstein assumed that role in the 1940s and 1950s. Copland followed the organ symphony with *Music for the Theater* in 1925 and *Concerto for Piano and Orchestra* in 1926—which, with Copland at the piano and its jazz-

like impressions of modern urban life, appeared to be his answer to Gershwin's *Rhapsody in Blue*.[35]

Though Copland continued to rely on jazz idioms throughout his career, he never ascended, as did Gershwin and Duke Ellington, to the pantheon of jazz composers. In fact, by the end of the 1920s Copland's music temporarily grew more dissonant, and thus less agreeable to ordinary listeners, especially in his *Piano Variations* of 1930.

But in the dawning era of economic collapse and global war, Copland and his colleagues in the United States embarked on a more sweeping effort to "Americanize" modernist music. What they achieved was the conversion of an international musical movement into a celebration of American mythology.

"The thirties were a time of fulfillment for musicians of my age," Virgil Thomson recalled, "because . . . our country was ready for us." The nation seemed especially ready for a new American music—the creation of which, in Thomson's view, was a "far worthier aspiration than any effort to construct a wing, a portico, even a single brick that might be fitted on to Europe's historic edifice."[36] Thomson exaggerated the extent to which his generation of composers divorced themselves from European classical and modernist music. But he was right that for the first time in the musical history of the United States, there was now a large audience for symphonies, concertos, ballets, and documentary film scores that sounded idiosyncratically American.

One reason that composers like Copland, Thomson, Harris, Piston, Blitzstein, Roger Sessions, and Samuel Barber found American audiences hospitable to their music was the impact of the New Deal's Federal Music Project. The Project brought music of all types—classical, jazz, and folk—to millions of people, most of whom had never attended a concert. At the height of its influence in the late 1930s, the Project had established thirty-four new orchestras, hosted music festivals and sponsored music education courses in public schools, sponsored choral and chamber groups, offered free or low-priced concerts and operas in cities and in the countryside, and paid or supplemented the salaries of sixteen thousand musicians (one of whom was my father, a violinist with the Kansas City Philharmonic).[37]

The hunger for an American music, however, was stimulated by the Depression itself, and by the need to distinguish the virtues of

America's democratic civilization from the menace and malevolence of the totalitarian regimes in Germany, Italy, and Japan. How better, then, than for Americans to be reminded in their music that anthems for the master races of the world could never equal a fanfare for the common man, or that in America it was a gift to be both simple and free.

Still, during the 1930s and the war years, American composers confronted a paradox. On the one hand, they wanted to write the kind of music their audiences yearned to hear, and in so doing contribute to the rediscovery and commemoration of America's history and its culture. On the other hand, they tried to remain faithful to the modernist lessons they had learned in Paris in the 1920s. So they attempted—not always successfully—to synthesize the reassuring chords and folk tunes of nineteenth-century American music with the jazz syncopations, the dissonant bridges between recognizable melodies, and the atonal experimentation that characterized Europe's modernist compositions.[38]

Virgil Thomson exemplified this desire to mix avant-garde and American music. Born in Kansas City, Thomson was raised on Protestant hymns, Stephen Foster's songs, and Scott Joplin's ragtime. By the 1920s, though, he had migrated to Paris to study with Nadia Boulanger and absorb the musical ideas of Stravinsky and other modernists congregating in France.

In 1927 Thomson began a collaboration with Gertrude Stein that led to a new kind of American opera: *Four Saints in Three Acts,* performed first in Hartford before opening on Broadway in 1934. The opera was based on Stein's abstract and often unintelligible libretto, which liberated Thomson to write any sort of music he wished. Although the opera was set in sixteenth-century Spain, Thomson drew on his "Southern Baptist upbringing in Missouri," using hymns and popular ballads sung by an all-black cast (a stunning operatic event in a country accustomed to seeing African American singers mostly in minstrel shows, and one that preceded by a year the debut of Gershwin's *Porgy and Bess*). The opera ran for sixty performances—but its surprising triumph in the mid-1930s was not easily repeated in subsequent productions after World War II.[39]

Thomson went on to compose what became his best-known works: the scores for two documentary films directed by Pare Lorentz and funded by the New Deal's Resettlement Administration, *The Plow*

That Broke the Plains (1936) and *The River* (1938). In both films, Thomson relied on music that sounded typically American to audiences in the 1930s. As the camera caressed the open plains and their fields of wheat, or marveled at the majesty of the Mississippi River and its tributaries, Thomson provided cowboy songs, spirituals, dance music, marches—anything that might evoke the earlier, unspoiled America of Grant Wood and Thomas Hart Benton, Norman Rockwell and Thornton Wilder, before the floods and the dust storms of the 1930s impoverished the land and the people who lived on it. The music was compelling and poignant, if also a bit sentimental. But nostalgia and sentimentality were often at the heart of the culture of the 1930s; you could not only hear it in Thomson's melodies but see it in Frank Capra's movies and read it in the decade's best-selling novels, like *Gone with the Wind*.

Aaron Copland, even when he seemed most wistful about a vanished America, was never as sappy as Capra could be. Neither was he as dogmatic as Thomson about the virtues of modernism. (Thomson served as the chief music critic for the *New York Herald Tribune* from 1937 until 1951, and in that capacity had many censorious things to say about what he considered the unadventurous compositions of his contemporaries and rivals, especially Gershwin.) Where Thomson judged, Copland encouraged—what he wanted was a music created by his generation of composers that would sum up the history, but also the potential, of America.

Like many of his fellow artists and writers, Copland was a man of the left. At various times, he was a member of every imaginable organization associated with the Communist Party and its principal contraption in the late 1930s and 1940s, the Popular Front. Among the groups Copland joined were the National Council of American-Soviet Friendship, the American Music Alliance of the Friends of the Abraham Lincoln Brigade, and the Artists' Front to Win the War.[40]

Yet despite his involvement with the Popular Front's political and cultural causes, Copland was more interested in finding ways for music itself, rather than ideology, to inspire a mass audience in the United States. He solved this problem in his own work by writing suites, ballets, and film scores (winning a Best Music Oscar in 1950 for *The Heiress*) that intermingled classical and modernist European styles with

American folk music and jazz—in short, a mixture of high and popular culture at which artists and composers in America had always excelled.

Between 1938 and 1945 Copland enjoyed his greatest success with American audiences. In the early 1930s Copland had traveled to Mexico, and by 1936 he completed *El salón México,* which premiered in the United States in 1938. The piece was filled with references to Mexican folk songs and dances, this at a moment when a large number of American writers and muralists were intrigued by the peasant culture of Mexico.

Copland followed his tribute to Mexico with two ballets celebrating the American West. The first ballet, in 1938, was *Billy the Kid* (which coincided with the Depression-era attraction to outlaws, usually played in the movies by James Cagney or Edward G. Robinson).[41] The second ballet, in 1942, was *Rodeo,* choreographed by Agnes de Mille, whose evocations of "buckaroos," ropers and wranglers, and Saturday night "hoe-downs" appealed so much to Richard Rodgers and Oscar Hammerstein that they enlisted her a year later to design the dances for *Oklahoma!*

A year earlier, in 1941, Henry Luce (the powerful publisher of *Time* and *Life* magazines) had written a bombastic editorial in *Life* about America's destiny, entitled "The American Century." In response, Vice President Henry Wallace gave a speech in 1942 in which he told Americans that they were actually living not in a future Pax Americana but in the "century of the common man." Copland, reflecting the populist rhetoric of the 1930s, set Wallace's proclamation to music.[42] The result was one of Copland's most famous compositions, *Fanfare for the Common Man.*

All of these works relied on Copland's signature use of brass, woodwinds, and drums—the instruments that, unlike traditional violins, were central to modern music, whether symphonic or jazz. In the case especially of American music, this was the sound that listeners would always identify as Coplandesque.

None of Copland's compositions, however, so embodied his musical ideas, or his assimilation of modernist techniques to "American" themes, as his 1944 ballet, choreographed by Martha Graham: *Appalachian Spring.* The ballet's first public presentation, with Graham as

the lead dancer, was held at the Library of Congress on October 30. By 1945 Copland had not only won a Pulitzer Prize for the ballet but had transformed it into an orchestral suite whose popularity was further enhanced through recordings by Serge Koussevitzky with the Boston Symphony Orchestra and Leonard Bernstein with the New York Philharmonic.[43]

Though Martha Graham was a thoroughgoing champion and practitioner of modern dance, she was also (like Copland) fascinated with the symbols of the American past.[44] The ballet therefore focused on the rituals of rural life in springtime—courtship, marriage, family, farming, religion—all of it taking place in a nineteenth-century Shaker community in Pennsylvania.

But the ballet reflected as well the central values of the 1930s and the war years, encapsulated in the opening lyrics of the Shaker hymn which served as the main theme of the work. The words "'Tis the gift to be simple, 'tis the gift to be free / 'Tis the gift to come down where we ought to be" were, in this context, an ode to one's native soil, to the bedrock steadiness and indestructibility of the American people and their way of life, the sort of emotion one could find expressed by Ma Joad in *The Grapes of Wrath,* by the Stage Manager in *Our Town,* and by the entire cast at the end of *Oklahoma!*

Yet if *Appalachian Spring* embraced the virtues of a pristine America, it owed a debt to Stravinsky's *The Rite of Spring.* Copland, like Stravinsky, combined dissonance with folk melodies, modernist rhythms with memorable harmonies. At this point, however, Copland had not departed entirely from tonality, as Schoenberg had done in the early twentieth century or as Stravinsky would do in the 1950s. Copland's music in the 1930s and 1940s sounded "modern," but without challenging the expectations of his listeners or offending their sensibilities. Copland's brand of modernism was as far as most American composers, with a craving to appeal to a large audience, were willing to go at midcentury. Hence there would be no Parisian-style riots at any performance of *Appalachian Spring.*

On the contrary, though Copland's sympathies were with the left, sympathies that got him into trouble during the McCarthy era in the early 1950s, his music was easily appropriated by advertising agencies, television programs, and political campaigns, none of which had any

connection to the "radical" movements of the 1930s. Indeed, the rhetoric of the Popular Front itself was supremely patriotic rather than dissident, particularly during World War II. Thus Copland's *Fanfare for the Common Man* and the "Simple Gifts" section of *Appalachian Spring* were frequently used after the war as introductions to sports shows and television news documentaries.[45] The music had become instantaneously familiar though the reasons for its composition were long forgotten.

Throughout his career, even when he did experiment in the 1950s and 1960s with Schoenberg's twelve-tone techniques, Copland (like Gershwin before him) was dismissed by many critics as too popular, too eager to please audiences, too reluctant to fully take on the difficulties of avant-garde music. Yet among concertgoers and ballet enthusiasts at home and abroad, Copland's stature as the man whose music captured the American landscape and the country's distinctive identity was unquestioned. And as if to underscore Copland's preeminence as America's most important composer, his music became widely admired at precisely the instant when Europe's modernist composers, escaping the Nazi ovens, found a new home in the United States.

The Internationalization of American Music

From January 1933, when Hitler rose to power in Germany, until the end of World War II, approximately fifteen hundred musicians, conductors, and composers left Europe for the United States. As was the case with scientists, artists, writers, scholars, and filmmakers, the majority of the refugee musicians were Jewish.[46] They included some of the twentieth century's most prominent creators and interpreters of European music: the composers Igor Stravinsky, Arnold Schoenberg, Paul Hindemith, Béla Bartók, Darius Milhaud, and Kurt Weill; the conductors Otto Klemperer, Bruno Walter, George Szell, Erich Leinsdorf, and Dimitri Mitropoulos; the pianists Rudolf Serkin and Artur Schnabel; the cellist Gregor Piatigorsky. In addition, there were numerous musicians, less well known, who escaped to America in the hope of finding jobs with orchestras, chamber groups, or opera companies—anything that might allow them to continue their careers in a nation perhaps not

as erudite about classical music as were the lands from which they fled, but one that was definitely less threatening to their very survival.

Some, like Stravinsky and Schoenberg, Walter and Klemperer, settled at least for a time in southern California. They lived in or close to Los Angeles, a city that must have seemed to them as if it were on a different planet from Berlin, Vienna, or Paris. Others found work all over the country, though their positions were often temporary. Bruno Walter was especially peripatetic, conducting at the Los Angeles Philharmonic, the Chicago and Philadelphia Symphony Orchestras, the New York Philharmonic, and as a substitute for Toscanini at the NBC Symphony Orchestra. Otto Klemperer conducted at the Los Angeles Philharmonic as well, and at the Pittsburgh Symphony Orchestra. George Szell conducted both at NBC and the Metropolitan Opera before he was appointed music director of the Cleveland Orchestra in 1946. Erich Leinsdorf also conducted at the Met and with the Rochester Philharmonic before eventually becoming music director of the Boston Symphony Orchestra in 1962.

A number of composers and musicians turned themselves into teachers. Hindemith, who emigrated to the United States in 1940, taught at Yale and at the Berkshire Summer Festival, where one of his students was Leonard Bernstein.[47] Milhaud taught at Mills College in Oakland; one of his most notable students was Dave Brubeck, who named his eldest son, also a jazz pianist, Darius. Rudolf Serkin, himself a student of Schoenberg in Vienna, came to America in 1939 and taught at the Curtis Institute of Music in Philadelphia before founding the Marlboro Music School and Festival in Vermont in 1951, an institution dedicated to encouraging a greater interest in chamber music in the United States. Gregor Piatigorsky served as head of the cello department at the Curtis Institute in the 1940s, at Boston University in the 1950s, and at the University of Southern California in the 1960s and 1970s. Even the most celebrated European teacher of all the young American composers, Nadia Boulanger, came to America in 1940 after the German conquest of France. During World War II, she taught at Wellesley, Radcliffe, and Juilliard, before returning to France at the end of the war.

The European composers, soloists, and conductors had less difficulty adjusting to America than did émigré intellectuals. First, many of

the musicians and conductors had already performed in the United States in the teens or 1920s, so they were familiar with, and to, American audiences. Second, they did not need to be fluent in English to play a concerto, lead an orchestra, or teach students; their artistry and their acceptance in America depended on their musical talent, not on their flair with words.[48] Most of all, they had arrived in a country that, since the nineteenth century, was enamored with European symphonies and operas. Hence the European composers, even if they were modernist, possessed the stature not always granted to a novelist or social scientist whose works, whether published in ponderous German or in elegant French, were unknown in the United States.

None of this meant, however, that it was easy for the Europeans to adapt to or comprehend their new land. The experiences of the two most famous contemporary European composers, Schoenberg and Stravinsky, were illustrative of the dilemmas—and the opportunities —all the Europeans encountered in America.

In the eyes of the Nazis, Schoenberg was guilty of two unpardonable crimes. He was Jewish, and he was a composer of modernist (and therefore decadent) music. So he departed Germany in May 1933 and landed in New York in October. By 1934, in search of a better climate for his asthma, Schoenberg had moved to Los Angeles, where he lectured first at the University of Southern California before joining the faculty at UCLA.[49] Among his students was John Cage, who would go on to be the ultimate postmodernist composer, confounding his audiences in 1952 with a piece that was cloaked in silence rather than any identifiable sound—not exactly what Schoenberg had in mind for modern music.

Meanwhile, Schoenberg (like many refugees) was both captivated and appalled by American popular culture. Europe had grand opera; America had soap operas on the radio and musicals on Broadway. Nevertheless, Schoenberg relished playing tennis with George Gershwin and Charlie Chaplin. And, living near the heart of Hollywood, Schoenberg (who adored movies) had as some of his private students Franz Waxman, Hugo Friedhofer, and Alfred Newman, all of them successful Hollywood composers. Given their example, Schoenberg hoped to write a film score of his own.

Yet Schoenberg's one chance to break into movies was a comic

failure. Irving Thalberg, Louis B. Mayer's golden boy and the head of production who specialized in "prestige" pictures at MGM, interviewed Schoenberg about writing the music for the film adaptation of Pearl Buck's Pulitzer Prize–winning novel *The Good Earth*. The novel and the movie dramatized the plight of peasants in China. What Schoenberg knew about either China or peasants was unclear. No matter, Schoenberg demanded (for the then-princely sum of $50,000) not only that nothing be changed in his score but that he should choose the key in which the actors spoke, and rehearse them until they understood that this was the work of Schoenberg, not of Pearl Buck or MGM.[50] Thalberg thanked the great man for his suggestions, but somehow a contract with the studio never materialized.

As a composer, Schoenberg could not make concessions to the requirements of American culture. The music he wrote until his death in 1951 (like his *Violin Concerto* in 1936, his *Piano Concerto* in 1942, and *A Survivor from Warsaw* in 1947) was modernist, serialist, and indisputably European. For Schoenberg, America remained a pleasant but peculiar place, not entirely suitable for a composer who wanted to transform the music of the modern world.

Stravinsky was more flexible. Leaving France in 1939, he lectured at Harvard before migrating to Los Angeles in 1941. But his reputation preceded him wherever he went in America. Stravinsky was treated as a celebrity, partly because of his earlier visit to the United States in the 1920s, and also because American composers like Aaron Copland were his acolytes.

Like Schoenberg, Stravinsky was fascinated with movies. At one point, he considered collaborating with Chaplin on a film.[51] And he was initially delighted that Walt Disney used *The Rite of Spring* as one of the animated works in *Fantasia*—until the music critics accused Disney of polluting the classics with inane cartoons, whereupon Stravinsky acted as if he'd had nothing to do with such a middlebrow project. Still, Stravinsky did compose works for radio and movies, including *Scherzo à la Russe* for a 1944 radio broadcast of Paul Whiteman's orchestra, and various sketches for film scores that he incorporated into his *Symphony in Three Movements* in 1945. Also in 1945 Stravinsky wrote the *Ebony Concerto* for Woody Herman's jazz band, a tribute to a music that was unquestionably American.

Although Stravinsky continued to compose modernist and experimental works, using twelve-tone methods in his 1957 ballet *Agon*, choreographed by George Balanchine for the New York City Ballet, he became an icon, similar to Albert Einstein—the symbol of a refugee idolized by Americans, even if they were clueless about his ideas or his art. Stravinsky appeared on the cover of *Time*, frolicked at the Playboy mansion, claimed Orson Welles and Harpo Marx as his close friends, and dined at the White House with the Kennedys.[52] His was the classic immigrant's tale of how, with lots of talent and even more self-promotion, anyone could make it in America.

The presence of all these émigré Europeans in the United States demonstrated that America had become after 1945 the center of the Western musical world. In addition, the development of American-born and increasingly American-trained composers, conductors, and musicians meant that the United States was no longer musically inferior to Europe or dependent on its conservatories, orchestras, and opera stars. Quite the opposite, American orchestras, soloists, and opera singers were now in demand, not only in Europe but all over the globe. So too was the work of American composers; their compositions had become part of the international repertoire.[53]

The popularity abroad of American musicians was fueled in part by the State Department in its cultural battle with the Soviet Union during the Cold War. In postwar West Germany, the works of Copland, Thomson, and Roy Harris were regularly played at concert halls and in America Houses, all as an adjunct of the effort to persuade Germans that the United States had a high culture worth appreciating. Additionally, the State Department sent the Symphony of the Air (the successor to NBC's Symphony Orchestra after it disbanded in 1954) on an Asian tour which attracted huge audiences in Japan, South Korea, Taiwan, the Philippines, Thailand, Singapore, and Malaysia.[54] At the same time, American violinists like Isaac Stern and opera stars like Marian Anderson gave government-sponsored concerts in Europe and Asia.

The Soviet Union itself became a venue for American orchestras and soloists. In 1956 the Boston Symphony became the first American orchestra to perform in the Soviet Union. In 1958 the American pianist Van Cliburn won the first International Tchaikovsky Piano Competi-

tion, held in Moscow. On his return to New York, he received a ticker-tape parade, as if he were America's answer to the Russian Sputniks circling the earth.

But no American was as spellbinding a global performer as Leonard Bernstein. Beginning in the late 1940s Bernstein was invited to conduct in London, Paris, Amsterdam, Brussels, Prague, and Tel Aviv. Moreover, he was the first American to conduct an opera at La Scala, Toscanini's former shrine.

In 1959 Bernstein and the New York Philharmonic journeyed to the Soviet Union as part of an epic tour of Europe and the Middle East. Bernstein played an American composition, often by Copland, at each of his concerts in Russia. In the spirit of "peaceful coexistence," Bernstein also lectured his audiences on the affinities between American and Russian music—the similar use of national folk melodies in the works of Copland, Stravinsky, and Dmitri Shostakovich (though Stravinsky, having left Russia before the Bolshevik Revolution, was no hero of the Soviet Union, and Shostakovich had for years been in and out of favor with that superb music critic Comrade Stalin). However controversial his forays into musical diplomacy, Bernstein's appearance in the Soviet Union was a striking success.

An even more spectacular coup was scored by the Philadelphia Orchestra when, in 1973, it became the first American orchestra to perform in China. Its tour was negotiated by Henry Kissinger as part of Richard Nixon's strategy of normalizing relations, political as well as cultural, between China and the United States.[55]

Yet for all the global impact of America's music and musicians, the American public was still resistant to modernist works. One reason for their hostility to modern music was the haughty attitude of certain postmodernist American composers like Milton Babbitt, who published an article in *High Fidelity* magazine in 1958 entitled "Who Cares if You Listen?"[56] Babbitt, a pioneer of electronic music, was clearly more interested in winning the approval of academic experts than he was in reaching ordinary concertgoers. While European audiences tended to be more sympathetic with serialism and synthesizers, most American listeners had little patience with music that sounded abstruse, tuneless, and self-indulgent.

More important, nineteenth-century symphonies and operas, all

still respected in the United States, could stir up the emotions of audiences and make them feel as if they understood the universal themes of the music or could connect with the tales being told in an opera. That sense of exhilaration seemed absent in modernist music. But one could find it elsewhere: in jazz or Broadway musicals, both of which became in the twentieth century the most treasured music of the American people. Classical and modernist music always had to compete with jazz bands and popular songs. For those who danced to the rhythms and listened to the lyrics, this was the music, more than any other, that touched the deepest feelings of their lives.

All That Jazz

■

When Bob Fosse reused the title of the opening number of his 1975 musical *Chicago* for his autobiographical film *All That Jazz* (1979), he was honoring a dance tradition in the United States that was rooted in America's most distinctive music. For in the history of Western modernism, the unrivaled American contribution—beyond painting and literature—had always been jazz.

Raucous, dissonant, and disturbing to the genteel middle class (like the music of Europe's avant-garde composers in the twentieth century), jazz was irrefutably modernist. And as with other modernist art forms that flourished in urban locales like Paris or Berlin, jazz was a music planted firmly in America's cities rather than in the countryside. In America, the homes of jazz were New Orleans, Kansas City, Chicago, and New York.

Jazz was also modernist in its emphasis on the innovative, on the desire (in Ezra Pound's dictum) to make it continually new.[1] Jazz symbolized the rebellion against bourgeois refinement, against the polite and the predictable in song and dance. Above all, jazz was an art of outsiders who functioned best as dazzling if sometimes alienated soloists, an art created largely by African American musicians who flourished on the margins of the official culture. But whether black or white, the jazz performer was the ultimate bohemian, relying on his

spontaneity and improvisational talents, and on constant experimentation, expressing his inner passions through his music just as Proust had done through his novels or Picasso through his paintings.

Yet though jazz shared the modernist agenda, it was rarely highbrow. Most of the time, as seemed fitting for an American art, jazz was preeminently a music of shrewd bandleaders and entertainers who were making a living with their highly polished skills, whose show business careers depended not only on hard work and their own inspiration but on an awareness of what the public wanted.[2] Jazz therefore demanded extraordinary proficiency with instruments (particularly reeds, brass, piano, and drums). But jazz required as well a stage presence and an attentiveness to commercial expectations. It was precisely this sensitivity to the varying tastes of the audience, and to the shifting trends in popular culture in the United States and abroad, that made jazz at once a uniquely American and a global music through much of the twentieth century.

The Cosmopolitan Origins of Jazz

Although people everywhere regard jazz as an indigenously American music, its roots were in fact international. The impact of African, South American, Caribbean, and European rhythms and melodies shaped the way black and white jazz musicians played their instruments, composed songs, invented new chord progressions, and performed before audiences.

Clearly, the influence of African and African American music was crucial in the formation of jazz. The very structure of jazz—the importance of rhythm and syncopation, the reliance on percussion to provide the beat and propel the music, the use of call-and-response instrumental techniques inherited from African American work songs —depended on traditions originating in Africa and transported by slaves to the New World. Moreover, both in Africa and in black America, music was a communal art, stimulating a tribe or an audience to participate actively in the performance—particularly by dancing, stomping, clapping, or singing.[3]

One of the central components of jazz, ingrained in the African American experience, was the "blue" note. Blues, either vocal or in-

strumental, arose from black spirituals, gospel music, field hollers, shouts, and chants. By emphasizing the third and seventh notes of the scale, the melody usually in a minor key, with the phrasing often slurred to produce a slightly "flat" sound, early jazz musicians and composers turned the blues into a lament, a commentary on the hardness of life, but also into an occasional expression of joy. Among the most famous examples of the blues in the second decade of the twentieth century were the "St. Louis Blues," "Beale Street Blues," and "Memphis Blues," all of these the creations of the black composer W. C. Handy.

Yet jazz musicians were supremely eclectic. If the utilization of Mexican guitars aided the music, they welcomed the instrument to the jazz ensemble. And they especially borrowed from the music of Europe. Jazz incorporated the patterns of German and Italian marching bands, British hymns, Scottish ballads, Irish jigs and reels, French quadrilles, and Polish polkas. In addition, jazz relied more on European instruments than on those from any other region or continent. A jazz band, whether in the early or later years of the twentieth century, was typically made up of cornets, trumpets, trombones, clarinets, flutes, pianos, basses, and above all saxophones (the invention of a Belgian, Adolphe Sax, in the 1840s). While instruments like the cornet and the saxophone were not normally part of the European symphonic tradition, their use—along with the more familiar brass and woodwinds—made jazz accessible to white audiences in the United States.[4]

In sum, jazz was a mixture of African rhythms, Latin American folk music, and European harmonies and dances. Given these hybrid antecedents, jazz represented what was most cosmopolitan about American culture.

The fusion of African American and European music could be seen in ragtime, the precursor in the 1890s of full-blown jazz. On the one hand, rag got its name because its rhythms seemed "ragged" to Europeans and to white Americans. Rag was the antithesis in its syncopation to the conventional 3/4 or 4/4 time of nineteenth-century waltzes, sentimental ballads, hymns, and marches. Hence rag recalled the more allegedly "primitive" elements of African and African American music.

On the other hand, rag sounded "contemporary." An instru-

mental music designed originally for the piano, and spread in the first decade of the twentieth century through sheet music and piano rolls, rags were written down, just like European-style compositions, rather than transmitted aurally as with tribal chants or slave songs.[5] As a result, rag appealed not only to African Americans but also to whites because it allowed them, vicariously, to evade the proprieties of Victorian culture. Ragtime therefore introduced a large, heterogeneous audience to a music that seemed urbane, debonair, and rousing in its modernity.

For a time, no one was more successful at popularizing ragtime than the African American composer Scott Joplin. In 1899 he published one of his best-known works, the "Maple Leaf Rag," which sold over a million copies of sheet music and became an essential part of the repertoire for dance and brass bands. In 1902 Joplin composed "The Entertainer," the rag that Marvin Hamlisch adapted in 1973 as the theme music for *The Sting*. Joplin even completed an opera, *Treemonisha*, in 1910, though this work was never performed during his lifetime. It was not surprising that Joplin might want to write an opera, since his works were filled with European harmonies, carefully constructed melodies, and familiar march motifs, all of which made rag comprehensible to the white public.[6] Though Irving Berlin's first major hit, "Alexander's Ragtime Band," published in 1911, outsold any of Joplin's compositions, Joplin remained a pioneer both for ragtime pianists and for jazz musicians.

Yet for all of Joplin's musical sophistication, he could not match the complexity of the music beginning to develop in the country's most legendary port city. Nowhere was the cosmopolitanism of American musical culture more evident than in New Orleans. The city and its music drew on a variety of influences. On any day or night, one could hear the echoes of music from Africa, Spain, France, Mexico, Haiti, Cuba, and South America. New Orleans musicians were also comfortable with blues, rags, marches, and popular songs.[7] Their music accompanied funerals, parades, and Catholic festivals like Mardi Gras. All of these ceremonies provided the basis for the emergence of jazz.

This musical potpourri was embodied and best exploited by the Creoles of New Orleans. Creoles were proud of their French or Spanish ancestry. They arrived in New Orleans in the early nineteenth century, mostly from Haiti and the Dominican Republic. Of mixed blood,

caught halfway between white and African American society, the Creoles sought to maintain their European (particularly their French) culture and language. Artisans or operators of small businesses, able to read music and often formally trained to play instruments, familiar with operatic arias, they saw themselves as the inheritors and protectors of European rather than African music.

Nonetheless, with the coming of segregation after the Civil War, the Creoles' semielite status in New Orleans society eroded. Identified now by "pure" white people as entirely "black" and subject to racial discrimination, the Creoles were increasingly affected by African American music and culture. So as musicians, they started to experiment with ragtime and the blues, performing in African American bands and funeral processions.[8] Eventually, because of their ability to blend European and African American music, they became the most inventive jazz performers in New Orleans. Indeed, their names made up an honor roll of early jazz: Sidney Bechet on clarinet and saxophone, King Oliver on cornet, Kid Ory on trombone, and Jelly Roll Morton on piano.

The golden years of New Orleans jazz were brief. When the federal government in 1917 shut down "Storyville," the red-light district in New Orleans that was presumably a threat to the health of soldiers and sailors in wartime, the place where jazz had blossomed no longer served as the hub of the new music. Jazzmen, in search of jobs, began to move to Kansas City, Chicago, and ultimately New York. Consciously or not, they were participating in the epic migration of African Americans who fled the South during and after World War I for freer and better conditions in the cities of the North. But the jazz musicians took with them the multinational qualities of their New Orleans music. And by the 1920s, with the appearance of a fresh generation of musical stars, America—white and black—entered what F. Scott Fitzgerald famously called the Jazz Age.

From Armstrong to Ellington:
The Spread of Jazz in the 1920s

Ironically, the first national and international jazz stars were neither Creole nor African American. In 1917, five white musicians from New Orleans, performing in New York under the name of the Original Dix-

ieland Jazz Band, made a recording of two numbers—"Livery Stable Blues" and "Dixie Jass Band One-Step"—which became instant hits. To conform to the three-minute duration of a ten-inch 78 rpm popular music disc, they used a fast tempo, which listeners associated with New Orleans–style jazz. The record and their subsequent recordings turned the group, temporarily, into representatives of the new music. In 1919 they were playing not only in New York but also in London, and they helped launch Fitzgerald's jazz age.[9]

By the early 1920s, however, white record company executives recognized that there was a substantial market, in the United States and abroad, for recordings of Creole and African American musicians. King Oliver, Kid Ory, Jelly Roll Morton, and Sidney Bechet all started to record. As their reputations spread through their records, blues and jazz became indispensable ingredients in America's popular music.[10] Moreover, other jazz musicians, no matter where they lived and played, could hear and learn from the recordings of the masters.

No musician's records were more revered or imitated by his peers than those of Louis Armstrong. Starting out in New Orleans before moving to Chicago, Armstrong began to record in 1923 with King Oliver's band. But his fame exploded with the sixty-five "Hot Five" and "Hot Seven" recordings he made between 1925 and 1928, all of them regarded at the time and ever since as jazz classics. So much so that near the end of *Manhattan,* when Woody Allen reminds himself of all the things that make life worth living, he includes among the inventory (along with Groucho Marx, Swedish movies, and Cezanne's apples and pears) Armstrong's 1927 recording of "Potato Head Blues."

Armstrong combined an African American beat, blues, European harmonies, and the highest notes imaginable on a cornet or trumpet. Most of all, he improvised. Where the original New Orleans jazz had featured the playing of a unified ensemble, Armstrong turned jazz into a soloist's art. And a vocalist's art as well, since by the 1930s Armstrong was singing as much as playing his trumpet, largely because of a lifelong injury to his lip.

Yet Armstrong was more than a superb musician. He was also a consummate entertainer whenever he worked before live audiences or performed on the radio and later in movies.[11] Like his contemporary Duke Ellington, Armstrong never acknowledged any conflict between

art and commerce. Instead, Armstrong was both a musician and a businessman, committed to achieving success with as wide an audience as possible. And his self-conscious role as a showman helped expand the reception of jazz in America and throughout the world.

One reason why Chicago in the early 1920s was so alluring to African American musicians like Armstrong was that it had the same raffish quality of life as New Orleans. During Prohibition, Chicago was at the core of organized crime. The illegal manufacture and distribution of alcohol supported innumerable speakeasies, where patrons could drink dubious cocktails and hear the jazz that had flowed on the riverboats up the Mississippi from New Orleans.

Chicago was also a city of immigrants and their children—Germans, Poles, Czechs, Italians, Jews—many of them influenced by the musical traditions of their various ethnic groups. So it was not surprising that a white Jewish musician in Chicago like Benny Goodman —already familiar with the modernist works of Stravinsky, Debussy, and Ravel—should be attracted to the new jazz of African American performers at the same time. Armstrong, Oliver, and Bechet were role models to young white trumpeters, pianists, clarinetists, and saxophonists just learning how to play jazz.

But there were white musicians who served as mentors too. Bix Beiderbecke, of German descent, grew up in Iowa, not in New Orleans, before he left as an adolescent for Chicago. He quickly became a prodigy on the cornet, developing a tone that was mellower and more "European" than Armstrong's piercing sound.[12] Goodman, on clarinet, emulated Beiderbecke's lyricism. Beiderbecke therefore emerged as the first white jazz musician who earned the respect of other white and African American performers.

By the late 1920s, however, New York was supplanting Chicago as the center of jazz. Bechet, Armstrong, Oliver, Morton, and Beiderbecke all emigrated to Manhattan. As in Chicago, there were plenty of speakeasies, cabarets, dance halls, hotels, and nightclubs where jazz could be played, usually for a white middle-class audience. More important, New York was where the record companies and radio networks were located, each of them providing outlets and employment for white and black jazz musicians. In New York one could find a mix-

ture of show business and music—music that was simultaneously modernist and popular.

Among the jazz musicians in New York, no one combined art and commercial entertainment with more flair than the pianist and composer Duke Ellington. Born and raised in Washington, D.C., the child of a middle-class black family, Ellington arrived in New York in the early 1920s. In 1927 and for the next five years, Ellington performed at the Cotton Club in Harlem, a place equivalent in the annals of African American music to Carnegie Hall (where blacks could not appear until the late 1930s). During his time at the Cotton Club, Ellington led a band, played every type of music from jazz to dance numbers and revues, and began to write songs. Among his most illustrious compositions, most of them created in the 1930s and early 1940s, were "Mood Indigo," "It Don't Mean a Thing (If It Ain't Got That Swing)," "Sophisticated Lady," "Do Nothing till You Hear from Me," and "I Got It Bad and That Ain't Good."

Unlike the tunes of George Gershwin, Ellington's works were meant primarily as part of the instrumental repertoire for his band, rather than as ballads to be sung in a Broadway show or in a Fred Astaire movie. But Ellington's music was as diverse and as ambitious as Gershwin's. Ellington wrote for small jazz ensembles and large orchestras, and he turned out more complicated suites and tone poems that resembled the work of the "serious" modernist composers he admired. In 1943, for example, Ellington composed a jazz suite, *Black, Brown and Beige,* which was performed at Carnegie Hall. The piece was occasionally dissonant and atonal, exceeding in its modernist techniques Gershwin's celebrated *Rhapsody in Blue.*[13] So here was Ellington the artist, on a par not only with Gershwin but also with Aaron Copland, even if Ellington didn't always get the recognition his white competitors enjoyed.

Yet like other African American musicians, Ellington's fame depended not on concerts or even on live performances at the Cotton Club. It was through records and radio broadcasts that Ellington, along with Armstrong, gained a large collection of fans. And those fans multiplied not just in the United States but all over Europe as America's jazz found an international audience.

The Jazz Age Abroad

Throughout the 1920s and 1930s jazz and the movies were America's leading cultural exports to the world. Records, radio programs, films, and touring bands permitted foreigners to see and hear Louis Armstrong, Duke Ellington, and other American jazz musicians. Consequently, jazz acquired listeners not only in Europe (especially in Scandinavia, Britain, France, and underground in Germany during the Nazi regime) but also in the Soviet Union, Australia, China, Japan, South Africa, Argentina, Brazil, and Mexico.[14]

Europeans in particular became interested in the United States and in African American culture partly because of the transport of jazz to their countries. Yet their notions of what jazz represented could be stereotyped and contradictory. For many European artists and intellectuals, jazz epitomized their fascination with whatever seemed "primitive" or exotic in the early twentieth century. Pablo Picasso was drawn for a time to the use of African masks in his paintings. Later, in the mid-1920s, Parisian audiences flocked to Josephine Baker's barebreasted "la danse sauvage" in her Revue Nègre. Both Picasso's masks and Baker's dancing, as well as African American jazz, symbolized to French audiences an art form that was sensual, impulsive, uncerebral, and therefore un-European.

But jazz was also an emblem of the modernity and cleverness of America—qualities that made the urban industrial New World so appealing to many young Europeans between the wars. Furthermore, jazz sounded nimble and unassuming, unlike the gloomy pretentiousness of Wagner or Mahler. Jazz, as an idiosyncratically American art, was thus irresistible to the European avant-garde. Far from thinking jazz was crude and simplistic, European modernists welcomed the music into the domain of high culture. And they began to use jazz as a significant facet of their Dadaist experiments, their Surrealist spectacles, and their musical compositions—adapting America's music to their own cultural needs.[15]

As it happened, ordinary Europeans were often initially exposed to jazz through the concerts of white American performers. Jazz was, in this guise, a dance music served up by white bandleaders, notably Paul Whiteman, who billed himself as the "King of Jazz." Whiteman

toured Britain in 1923, France in 1926, and Germany in the late 1920s (the publicist for his show in Berlin was a young screenwriter named Billy Wilder).[16] The popularity of Whiteman's concerts suggested that audiences in Europe were more willing to accept the music if it was played first by whites rather than only by blacks.

These racial prejudices soon evaporated. Indeed, it was usually in Stockholm, Copenhagen, London, and Paris that African American jazz musicians enjoyed more rapid acceptance than they did in the United States. Sidney Bechet, for instance, became a celebrity in France, almost equal in his fame to Maurice Chevalier and Édith Piaf, after his tours there in the 1920s. The saxophonist Coleman Hawkins spent much of the 1930s in England, France, the Netherlands, and Denmark, performing before audiences who applauded him as if he were an opera star, not merely a horn player.

But the greatest sensations when they arrived in Europe were Louis Armstrong and Duke Ellington. Their records in the late 1920s had preceded their appearances and had prepared European audiences for their music. During the early and mid-1930s, Armstrong performed in Scandinavia and in England, where he was "received" by the Prince of Wales in 1932. Ellington was also welcomed by British royalty and by the classical musical elite in England during his tour of the country in 1933. In fact, Ellington was treated not just as a jazz pianist or bandleader but as a serious American composer, comparable in the eyes of some British critics to Stravinsky and Bartók, a judgment formerly accorded only to George Gershwin but not yet to Aaron Copland or the other members of Copland's musical generation.[17]

The comparison with Stravinsky was not overblown, since several European modernist composers were adopting jazz as a key component of their works. During the teens and 1920s European composers regarded jazz both as modern and as the folk music of African Americans. These twin cultural muses were as immensely seductive to composers as they had been to other European artists and writers. To the Europeans, jazz, with its blue notes, its syncopated rhythms, and its reliance on "new" instruments like the saxophone, could be utilized as a weapon in their rebellion against the oppressive classical music tradition of the nineteenth century. In addition, European composers were affected not only by the ragtime and jazz of North America but also by

dance music from Cuba and South America, especially rumbas and tan-
gos. In short, they borrowed and then "Europeanized" fragments of
popular music from the United States and Latin America.

Claude Debussy attempted to merge ragtime and concert music,
copying Scott Joplin's piano style in his own "Golliwog's Cakewalk,"
a portion of a suite called *The Children's Corner* that Debussy wrote
in 1908. Similarly, Stravinsky was attracted to jazz because of its rhyth-
mic innovations. So he created his version of jazz, using rags, blues,
and tangos in several pieces composed in 1918 and 1919, including
Piano-Rag-Music, Ragtime for 11 Instruments, and *L'Histoire du sol-
dat*—the latter scored for violins, double bass, clarinet, bassoon, cor-
net, trombone, and drums. And Maurice Ravel, influenced by Gershwin,
utilized blue notes in two of his piano concertos composed in 1930 and
1931.

The problem was that neither Debussy, Stravinsky, or Ravel was
genuinely familiar with the way jazz was played in the United States.
Darius Milhaud, however, traveled to America in 1922 and spent a lot
of time listening to authentic jazz bands in Harlem. Then, in 1923, he
wrote *La Création du monde,* a ballet that included jazz motifs to be
performed by saxophones, trumpets, flutes, and a piano. Meanwhile,
the sets and costumes—based on African sculptures and masks—were
designed by Fernand Léger.[18] In this work, Milhaud came much closer
to the modernist and occasionally dissonant type of jazz that could be
heard not only in Gershwin's *Rhapsody in Blue* but in the nightclubs
and speakeasies of Manhattan. As a result, Milhaud's ballet helped
make jazz an international music—though the real thing still depended
on musicians like Armstrong and Ellington.

Apart from Stravinsky, who continued to experiment periodically
with jazz over the next twenty-five years, most European composers
soon jettisoned their efforts to make use of jazz in their modernist
works. Perhaps jazz was just too popular with ordinary people to main-
tain its charm for the avant-garde.[19] But jazz remained a subject of in-
tellectual scrutiny, particularly on the part of critics who saw in the
music an invigorating synthesis of modernist and mass culture.

Just as a group of young French film critics in the 1950s (François
Truffaut, Jean-Luc Godard, Claude Chabrol) "discovered" Holly-
wood's movies and invented the auteur theory, so in the 1930s a num-

ber of European music critics elevated America's jazz into a serious form of art. The records and live performances of Louis Armstrong and Duke Ellington, like the later films of certain directors (Orson Welles, Howard Hawks, Nicholas Ray, and the very un-American Alfred Hitchcock), were praised for their stylistic eccentricities, their personal vision, and their imperviousness to European-style abstractions. Whether the subject was jazz or the movies, the European critics displayed the same eagerness to celebrate American popular culture at the expense of Europe's highbrow haughtiness.

By the early 1930s jazz criticism in Europe was becoming far more advanced than in the United States. In 1932 a Belgian writer, Robert Goffin, published *Aux frontières du jazz*. This book was followed in 1934 by the French critic Hugues Panassié's *Le Jazz hot*, which was revised and published in English in America in 1936. Panassié especially emphasized Louis Armstrong's music as the exemplification of American jazz. Also in 1936 Charles Delaunay published *Hot Discography* in Paris; an American edition followed in 1938. Delaunay's book was the first thorough compilation of jazz recordings from the teens through the 1930s.[20]

Because they treated jazz as an art rather than simply as entertainment, all these authors helped make the music a subject of earnest study in the United States. But as in the case of film criticism, it took European writers to tell the Americans what was valuable about their own artistic endeavors—a sign that the worth of America's culture still depended on European confirmation.

Moreover, Europe's jazz (and later its film) critics adopted a vaguely condescending tone when they analyzed American culture. The Europeans' admiration for the spontaneity and technical agility of America's jazz performers made it seem as if intellect, knowledge, and ideas played no role in the music itself. The Americans were being complimented for their lack of artifice and their improvisational skills, not for their understanding of musical complexity. In effect, the European critics were advising the Americans to stick with what they were good at, like "hot" jazz, and leave the cool creations of the avant-garde to Europe's composers and soloists.

Nevertheless, American jazz had an impact not only on European critics but also on Europe's musicians. Indeed, the presence of Ameri-

can musicians in Europe, either living there like Sidney Bechet and Coleman Hawkins, or traveling throughout the continent like Armstrong and Ellington, inspired acolytes and imitators among Europe's own emerging jazz performers. In Britain, for example, a growing number of jazz musicians, joined by immigrants from the Caribbean, began to play in clubs, theaters, and dance halls. In France, musicians drew on the tradition of French folk songs, but injected these with jazz rhythms, thereby domesticating what was originally an American import. Elsewhere in the world—in South America, Africa, and Asia—jazz bands sprang up, with band members learning their craft through the records of America's musicians.[21]

One of the few foreign musicians, though, who actually affected American performers was the Gypsy guitarist from Belgium, Django Reinhardt. American guitarists copied his techniques in the same way that European trumpeters and pianists were imitating Armstrong, Ellington, and Jelly Roll Morton. Indeed, Reinhardt's influence on his American counterparts indicated that jazz by the 1930s was becoming a transatlantic, if not a global, music.

Yet at home in America, the jazz that everyone heard abroad was about to change. The era of "swing" would soon eclipse the tradition of New Orleans jazz at which so many African American musicians excelled. As a result of this transformation, American jazz became "whiter," more popular, and more commercially successful than it had ever been in the 1920s.

Swing Time

On December 5, 1933, with the ratification of the 21st Amendment to the Constitution, prohibition in the United States officially ended. Its repeal had a direct effect on jazz because bands could now play in more legitimate venues—in restaurants, hotels, nightclubs, and ballrooms, all of them serving alcohol legally to their patrons.

Most of those patrons were white. What they wanted were dance bands that could entertain them without intruding on their conversations—bands whose music was "smooth," polished, and innocuous. In response, bandleaders like Paul Whiteman, Rudy Vallee, Eddy Duchin, and Guy Lombardo deemphasized the cacophony of New Or-

leans jazz in the 1920s, and the matchless improvisations of soloists like Louis Armstrong or Bix Beiderbecke. They relied instead on arrangements that were sugary, even sappy, but that pleased the audiences who wished to listen or dance sedately to the music of the big bands. Some of this music still sounded a bit like traditional jazz, with its effervescent beat, its use of strident trumpet blasts and growling trombones, and a blurred phrasing that dimly resembled blue notes.[22] But the music bore little relation to the concept of jazz as an art form that European critics were promoting in the 1930s.

Among the major differences between the Dixieland sounds of the 1920s and the popular music of the 1930s was the increasing dependence on radio broadcasts, rather than records, as the medium through which people became acquainted with jazz—whether genuine or diluted. White dance bands became staples of network programming during the Depression as radio brought into people's living rooms across the country the thrill of Manhattan's night life. Live hookups from ballrooms, hotels, and clubs made audiences in the provinces want to see and hear their favorite bands, many of which went on tour during the summer months. Radio provided bands with a national exposure that recordings could not duplicate.[23]

But radio also kindled a revolt against the "sweet" music of Whiteman, Lombardo, and Duchin. By the mid-1930s, the music people were listening to in their homes, in dance halls, and in concerts was called "swing." Swing was the music of big bands, not the small combos of the 1920s. Swing featured large brass sections, heavy beats, spectacular drummers, and intricate arrangements that favored ensemble performances rather than soloists. Although a swing arrangement did set aside time for soloists, once the solo was finished, the musician sat down and rejoined the band, merging his identity with his fellow performers.[24]

Moreover, because of the time constraints on radio—particularly the need to restrict a number to the minutes available before a sponsor's advertisement—swing was more disciplined and more standardized than the music of the 1920s. Indeed, swing was an archetypal music for the 1930s, with its stress on the playing of a cohesive group, not an assortment of individual performers each pursuing his own moods and talents. In this sense, swing was another example of the "social" art of

the 1930s, comparable to mural painting, the novels of John Steinbeck, and the ballets of Aaron Copland.

Because arrangements were central to the success of a big swing band, the arranger of jazz orchestrations in the 1930s seemed the equivalent of a composer in classical music. An adroit arranger could turn a simple melody into a complex harmony for the brass, reed, and rhythm sections of the band.[25] The arranger most adept at these tasks was Fletcher Henderson. Born to a middle-class African American family in Georgia, trained originally as a classical pianist, Henderson moved to New York in 1920 to become a bandleader, helping to import Louis Armstrong from Chicago. By the mid-1930s, Henderson had become the chief arranger for Benny Goodman, and was responsible for much of the music that defined the art of swing.

The band members and their arrangers were all part of a collective, a community of musicians who played with one another for the benefit of the audience. Still, swing bands were hierarchically organized. At the top was the bandleader, a celebrity often with a baton in his hand, conducting his "orchestra" just like Leopold Stokowski or Arturo Toscanini. The white bands led by Tommy Dorsey, Artie Shaw, Harry James, and Glenn Miller, as well as the African American big bands of Duke Ellington and Count Basie, all had their unique musical styles, their familiar theme songs, their dress codes, their synchronized movements, and the initials of the bandleader inscribed on their bandstands. Their demeanor on stage could be boisterous, but the musicians and their leader took themselves seriously, hoping to share in some of the prestige of the highbrow concert hall.

Yet whatever their artistic aspirations, swing bands were part of the entertainment world. Their success was tied not just to radio broadcasts or to skilled musicians and astute bandleaders, but to managers, booking agents, theater operators, and hotel owners. Consequently, swing blended art and entrepreneurship, converting a genuine jazz style into a national and profitable fad, especially with the young.[26]

If anything, the popularity of swing coincided with the emergence of a new youth culture in the 1930s. This was a culture less sanguine and less flamboyant than the one F. Scott Fitzgerald chronicled in the 1920s. The generation of the 1930s was instead composed of adolescents seeking relief, often through music, from their dismal prospects

during the Great Depression. And the musician and bandleader most adored by the young in the 1930s was Benny Goodman.

Goodman was the child of Jewish immigrants from Poland. Music, for Goodman, was a form of economic and social advancement, just as it was for African American musicians in the 1920s and 1930s. But in Goodman's case, the music he grew up with in Chicago was not only classical music and jazz but the klezmer music he often heard in his synagogue. Klezmer bands—usually made up of a clarinet, a cornet, a violin, an accordion, a tuba, and a bass—flourished in the ghettos of eastern Europe. The bands, playing dance music that sometimes sounded as much as if it came from New Orleans as from Minsk, usually performed at Jewish weddings and festivals. Klezmer music was vivacious, but it also relied on the syncopated rhythms and minor keys that were reminiscent of the blue notes of jazz.[27] So, influenced by both klezmer music and jazz, as well as by his early training in classical music, Goodman fused Jewish, European, and African American styles in the way he played the clarinet.

By the late 1920s Goodman had moved from Chicago to New York, playing in big bands like Paul Whiteman's, and in the orchestra pits of Broadway shows. In 1934, encouraged by his manager and brother-in-law, John Hammond, Goodman organized his own twelve-piece band. Hammond himself became a legendary agent and manager, not just for Goodman but for Harry James, Count Basie, and Billie Holiday (and later for Aretha Franklin, Bob Dylan, Leonard Cohen, and Bruce Springsteen). Hammond's greatest impact on Goodman, however, was to persuade him to integrate his all-white band with "guest" artists who were African American. In 1936 Goodman formed a quartet that featured the white drummer Gene Krupa and the black musicians Teddy Wilson on piano and Lionel Hampton on vibraphone. Their first hit recording was "Moonglow," a piece they performed at all of Goodman's subsequent concerts.

In 1934 Goodman's band appeared for several months on an NBC radio show called *Let's Dance*. Goodman's spot on the program was for half an hour, between 12:30 A.M. and 1:00 in the East. After the show ended in the spring of 1935, Goodman took his band on tour, with only modest success. Then he arrived on the West Coast, where, because of the three-hour time difference, youthful audiences

had heard him on the radio not after midnight but between 9:30 and 10:00 P.M. In August 1935 Goodman encountered hoards of these new young fans when he played the Palomar Ballroom in Los Angeles. Some listened; others danced. Goodman's concert at the ballroom was broadcast nationwide, and suddenly he became the most famous jazz musician and bandleader in America—a position he held for the rest of the decade.

On January 16, 1938, the status of jazz as America's national music was verified when Goodman, with his band and quartet, gave a concert at the country's shrine of classical music, Carnegie Hall. The concert was a testimonial to jazz as a music as worthy of respect as the symphonies of Beethoven or Brahms. Goodman's band did not try to water down the jazz they had been playing across the country. Nor did Goodman seek to refine jazz by making it somehow sound like European concert music, as Paul Whiteman had done. The expensively attired audience at Carnegie Hall heard the same music that Goodman performed in dance halls, ballrooms, and theaters, on the radio, and on records. They also heard echoes of klezmer music in Ziggy Elman's trumpet solo on "And the Angels Sing" and in Goodman's own solo on "Sing, Sing, Sing." But whether the music was Jewish or swing (and it was both), Goodman—more than any other musician—had moved jazz from the periphery to the center of American culture.[28]

And to the center of international culture as well. During the 1950s and 1960s Goodman's band traveled under the auspices of the State Department to Asia, South America, the Soviet Union, and Europe. Meanwhile, Goodman frequently returned to his roots in classical music, recording Mozart's Clarinet Quintet in 1938, and commissioning works for clarinet from Béla Bartók, Paul Hindemith, and Aaron Copland.[29]

Yet for all that Goodman achieved in his later career, his concert at Carnegie Hall marked the summit of swing. Swing continued as a popular music through the end of the 1930s and into the 1940s, especially with Glenn Miller supplying the soundtrack for the war years until his death in a plane crash in 1944. But there were sidemen with the big bands—a trumpeter called "Dizzy" Gillespie with Cab Calloway's band, and out in Kansas City a young saxophonist named Charlie Parker playing with Jay McShann—who had a different type of music in their minds. If the headliners of the 1930s were Benny,

Satch, Duke, and the Count, the stars of the late 1940s and 1950s were to be Bird, Dizzy, Miles, and Trane. They transformed jazz into an art music beyond anything the French critics of the 1930s had anticipated. After them, American jazz would never be the same.

Modernist Jazz

It was first called bebop, or sometimes rebop (which is what Stanley Kowalski told Blanche DuBois to cut out in *A Streetcar Named Desire*). It was tried out, originally in obscurity, at dives like Minton's Playhouse or Monroe's Uptown House, both in Harlem. But after World War II, it became the music that cool and not-so-cool people drank, smoked, and listened to, in the evening and into the middle of the night, for the next fifteen years—on stereos, on far-off radio stations with strong signals, and in clubs. For many, the sound of a muted trumpet, a dissonant saxophone solo, or a rippling piano provided the background music for their lives.

Bebop emerged in the wake of the musical and economic exhaustion of swing. The music played by the swing bands, as reflected in the arrangements of Glenn Miller's orchestra, grew more formulaic and less adventurous. Meanwhile, during the war, the bands were affected by limitations on travel within the United States, and by the fact that many jazz musicians were serving in the armed forces. Once the war ended, it was increasingly difficult for twenty-piece bands to retain their audiences, in large part because of the competition from television, the move of the white middle class to suburbia, and the rise of the baby boom, which shifted the spending of money away from an evening's entertainment to the needs of a burgeoning family. Finally, as radio networks declined in importance, there were fewer live broadcasts from dance halls and ballrooms, the sort of programming that had been instrumental in popularizing swing in the 1930s.[30]

The fading of the big bands, white and black, made it harder for African American musicians to find work as bandleaders or even as sidemen. Bebop, however, offered new economic opportunities because it was—as in the 1920s—primarily the music of small combos.

More significant, bebop provided outlets for jazz musicians— almost all of them African American—to escape the collectivist con-

straints and relative anonymity of the big bands. Rather than disappearing into the group as they had in the 1930s, bebop musicians like Dizzy Gillespie, Charlie Parker, the pianist Thelonious Monk, the guitarist Charlie Christian, and the drummers Kenny Clarke and Max Roach began in the early 1940s to use jazz as a tool of self-expression. Just as the Abstract Expressionists revolted against the political and social didacticism of the Federal Art Project, so the beboppers rejected the regimentation of swing. Once again, jazz (like painting) became spontaneous and experimental, a method of displaying one's personal creativity—all the values that distinguished postwar American culture from the communal ethic of the Depression decade.

The driving concept of bebop was that it was "modern," a music played by younger musicians (most of them born in the late teens and 1920s) who were revolting against what they considered the obsolescence of the swing played by an older generation of performers.[31] For example, swing bands often used popular songs, faithfully rendered, as a source for their dance music. Bebop did not abandon the melodies of the Great American Songbook (the compositions of George Gershwin, Irving Berlin, Cole Porter, and Richard Rodgers and Lorenz Hart). What the beboppers did instead was to substitute more complicated harmonies and rhythms for the original songs, as if the musicians were floating above and reinventing the tunes on which their solos were based.

Essentially, bebop (and all of its successors in the 1950s) combined popular ballads written largely by white composers with African American blues and modernist European music. Indeed, bebop often sounded a lot like a modification of Stravinsky and Schoenberg, composers whose music many of the beboppers were familiar with.[32] Modern jazz was at times abstract, atonal, dissonant, full of new harmonic structures, complicated chord changes, and unpredictable phrasing—all of which made the music seem jarring and chaotic to the uninitiated.

Moreover, bebop musicians presented themselves to their audiences as charter members of a jazz avant-garde. With the exception of Dizzy Gillespie, who quipped with and took pleasure in his audience, they rejected the showmanship of a Louis Armstrong or Duke Ellington. Appearing on stage in berets, shades, and goatees, clad in dark suits that frequently made them look like morticians, grim-faced and

sometimes refusing to bow or acknowledge an audience's appreciation, they projected a cool detachment that befit an insurgent artist, not an eager-to-please entertainer. The beboppers reeked of alienation, another postwar posture, and one they again shared with some of their most enthusiastic fans, the Abstract Expressionists.

The jazzmen's atelier was the jam session, held 'round midnight at Minton's, Monroe's, or the Onyx nightclub on 52nd Street. Here they could test solos and riffs, fresh techniques and ideas, and find out who among them had the chops to play the new music. Audiences were sometimes admitted, but the jam session was an occasion for the beboppers to perform for one another, playing what they—not the customers—wanted to hear.[33] This was music that a jazz enthusiast might or might not admire, but it was music on the musician's own terms. At most, bebop was meant to be contemplated rather than danced to; listening, with polite applause after a number was finished, became the proper response of the sophisticated (usually white) audiences who learned through the jam sessions how to comprehend the music.

Yet the beboppers wanted people to buy their records and attend their public concerts. Like their predecessors, the beboppers were still making a living with their work; they yearned to be revolutionary but also commercially successful. And with Parker and Gillespie as the two leading pioneers of modernist jazz, they found the fame that had eluded them with the big swing bands. After all, you know you've made it when they name a jazz joint after you, as in the case of Birdland, a tribute to Parker's nickname and his music.

Like other bebop musicians, Parker was at home with a variety of musical styles: blues, atonality, harmonic complexity, high-speed tempos, improvisation. But Parker had a special affection for modernist composers like Stravinsky, Bartók, and Hindemith. As a consequence, when Parker performed in Paris in 1949, he included the opening notes of *The Rite of Spring* in his solo on one of his signature numbers, "Salt Peanuts." And in 1951, at Birdland, with Stravinsky himself in attendance, Parker used a motif from *The Firebird* in his performance of another of his famous pieces, "Koko."[34] Parker's ability to unite jazz with modernist music made him the dominant saxophonist of his generation. Thus he was another exemplification of the ways that American

artists in every field used European high culture as a stimulus for a new form of mass culture.

Parker's main collaborator in the creation of modern jazz, Dizzy Gillespie, was equally adept at unfamiliar rhythms and chord structures. For all his jokes and pranks on stage, Gillespie was a serious musician who organized one of the few successful big bands of the late 1940s, converting the modernist style into a popular idiom. In 1947, following in the tradition of Benny Goodman, Gillespie performed at Carnegie Hall, along with Charlie Parker and Ella Fitzgerald.[35] By the 1950s Gillespie (again like Goodman) had become an international jazz star, touring in France and the Middle East.

For Parker, Gillespie, and other modern jazz musicians, the introduction of the long-playing album in 1948 liberated them to experiment with lengthy solos and even more imaginative improvisations. The LP albums could replicate the musicians' jam sessions and their performances in clubs. More important, the albums could provide a unifying theme or "concept," much like classical recordings, increasing people's awareness that jazz was not just an amusement but a genuine artistic enterprise.

By the early 1950s, in part because of the extended duration of numbers on an LP album, the frenetic qualities of bebop gave way to the more leisurely sounds of "cool" jazz. Cool jazz was as modernist and as innovative as bebop. But to be cool meant to be more restrained, musically if not also emotionally. Cool jazz was more lyrical than bebop, less jittery, more reliant on muted trumpets with little or no vibrato, and on saxophones whose often ethereal tone was gentler than the edgy blare of Charlie Parker's performances.

No one personified coolness more than Miles Davis. Davis grew up in East St. Louis, Illinois. He moved to New York in the mid-1940s, ostensibly to study at Juilliard, where he was influenced by the works of Stravinsky and Sergei Prokofiev.[36] But Davis spent most of the decade playing his trumpet in bands and quintets with Dizzy Gillespie and Charlie Parker. Appropriately, his first album, recorded in 1949 and 1950, was called *Birth of the Cool*. Like his contemporaries, he was also attracted to the jazz-inflected songs of composers like George Gershwin. Hence Davis recorded his own version of *Porgy and Bess* in 1958.

During the 1950s Davis customarily behaved in concert as if he wished he were somewhere else, rather than facing a naïve public he assumed knew nothing about his music. Sometimes he turned his back on audiences while he played, or stalked off stage and smoked a cigarette when his colleagues took solos. But Davis's impassive demeanor did not stop him from being worshiped by his fans—both white and African American.

Nor did it prevent him, in 1959, from producing the most haunting album in the history of jazz, *Kind of Blue*. Davis teamed up with John Coltrane and Cannonball Adderley on saxophone, Bill Evans and Wynton Kelly on piano, Paul Chambers on bass, and Jimmy Cobb on drums to create a quiet, meditative mood piece, epitomized by the opening track called—both pensively and impudently—"So What." Davis and Coltrane were never more in sync, musically, with each other. And the performances they gave on the record were never more influential. Over the years, *Kind of Blue* became the best-selling jazz album of all time.

Cool jazz, of course, was not restricted to sinuous trumpet and saxophone solos. It could also be jazz as chamber music, at least as written and played by the Modern Jazz Quartet in the 1950s. With the classically trained pianist John Lewis as "music director" and Milt Jackson on vibes, the MJQ specialized in Bach-like fugues, Baroque counterpoint, and suites that seemed more suitable for concert halls and university auditoriums than for dingy nightclubs. Lewis especially wanted to link jazz to classical music. So the blues that he and Jackson regularly played were always technically precise, streamlined, and upscale, as if they might as well be members of a string quartet as a group of highly skilled jazz artists.

Whatever their ambitions, not all the cool jazzmen of the 1950s were African Americans. The saxophonists Stan Getz and Gerry Mulligan each popularized the mellow tones of cool jazz with their recordings and live performances.

But by far the best known of the white musicians who prospered in the era of cool jazz was Dave Brubeck. Brubeck studied musicology not only with Darius Milhaud but also with Arnold Schoenberg. Unlike Thelonious Monk or John Lewis, Brubeck adopted a more percussive piano style, more a pounding of chords than lightning

flashes of fingers on the piano keys. Yet Brubeck's eccentric rhythms accentuated his desire to experiment with time signatures. With a quartet whose musical identity was shaped especially by the poetic saxophone of Paul Desmond, Brubeck cut one of the most famous albums of the 1950s: *Time Out*. The initial number, "Blue Rondo à la Turk," based on a Turkish rhythm, began in 9/8 time, and all the subsequent tracks featured different beats to the bar. Nevertheless, the differing rhythms did not deter audiences from buying Brubeck's albums. And when "Take Five," in 5/4 time, was released as a single, it sold more than a million copies, the first jazz instrumental to accomplish that feat.[37]

The success of Parker, Gillespie, Monk, Davis, Coltrane, Brubeck, and the Modern Jazz Quartet was a testament to the popularity of postwar jazz, whether in its bebop or cool incarnations. In addition, all these musicians traveled the world, playing to reverent audiences from Asia to Africa to Europe, just as Louis Armstrong, Duke Ellington, and Benny Goodman were still doing. The American jazz musician was incontestably a global superstar from the 1930s until the 1960s.

Then the music changed yet again—and this time the audience, in America if not overseas, vanished. The music of the 1960s sounded neither traditional nor modernist; it resembled instead a postmodernist jumble of screeches and yowls. So, as the fans in the United States departed, jazz lost its status as a distinctively American music.

Global Jazz

In 1960 the saxophonist Ornette Coleman recorded an album called *Free Jazz: A Collective Improvisation*. The title of the album, as well as the music itself, heralded a new type of avant-garde jazz. Characterized by irregular meters and individual musicians playing at different tempos, with less obvious rhythmic motifs and sometimes the absence of any recognizable beat or melody, this was a music that relied on waves of pure and often atonal sound. "Free" jazz, as the name implied, lacked any of the musical signposts that audiences were accustomed to in the performances of a Louis Armstrong, a Benny Goodman, or even a Charlie Parker or a Miles Davis.

Nonetheless, free jazz became the prevailing style during the

1960s; it could be heard not only in Coleman's records, but in those of John Coltrane (particularly his 1965 album *Ascension*), Archie Shepp, Albert Ayler, and Sun Ra. Like the postmodernist concert music of John Cage and Milton Babbitt, free jazz was abstract, disorienting, and hard on the ears. And it drove all but the most dedicated jazz worshipers away.

The majority of Americans—white and black—simply stopped listening to postmodern jazz. For many African Americans, the complexities of free jazz (and modernist jazz of all sorts) had little in common with Dixieland music or swing, much less with gospel hymns or the blues. Beginning in the 1950s blacks—in search of a music that had its roots in African American culture—turned increasingly to rock and roll. Meanwhile, white intellectuals and artists, like the Beats, had identified in the 1950s with black jazz musicians as the embodiments of alienation and rebelliousness. But now—with the advent of Bob Dylan, the Beatles, and the Rolling Stones—rock seemed more "relevant" and more revolutionary to young, middle-class, countercultural whites than did the jazz of the 1960s.[38]

To the extent that jazz found a home in the 1960s, it was no longer in clubs (which were either shutting down or hiring rock musicians to entertain the patrons), but in the universities. As in the case of literature, jazz ceased to be a popular art form. Instead, it became a subject of study, encased in theory, with jazz musicians as members of university faculties. Their music could still be heard on college radio stations and in concerts on campuses.[39] But the flight to the academy further isolated jazz musicians from African American and white audiences.

There were efforts among jazz musicians in the late 1960s and 1970s to regain some of their popularity with their former clientele. In 1969 Miles Davis recorded *Bitches Brew*, a commercially successful attempt to link jazz and rock. In 1973 the pianist Herbie Hancock released an album called *Head Hunters*, with "Watermelon Man" as its best-known number. Davis and Hancock both utilized synthesizers and electronic keyboards to combine jazz, rock, and 1970s-style funk. For the moment, these examples of "fusion" jazz were trendy and profitable.

Still, jazz by the 1960s and 1970s had lost its centrality in Amer-

ican musical life. But jazz remained enormously popular abroad, where people were never as hostile as they were in the United States to the postmodernist experiments of Coltrane and his contemporaries. The passion for jazz, it seemed, now rested with audiences in other countries, not in the land where it was born and had thrived for most of the twentieth century.

Indeed, jazz was a staple of popular culture in Europe and elsewhere throughout the second half of the twentieth century. In France during World War II, listening furtively to jazz was seen as a means of resisting the Nazi occupation. After the war ended, bebop recordings became widely available in Britain and in Western Europe, notably in Germany, where the records offered adolescents an antidote to the rubble of their cities.

But as in the 1920s and 1930s, records did not have the same authority as the live performances of jazz musicians. In 1949, for instance, a weeklong international jazz festival was held in Paris, the largest congregation of jazz musicians any European city had ever hosted. Organized by Charles Delaunay, the festival featured Sidney Bechet, Charlie Parker, Kenny Clarke, and Miles Davis.[40] Among the fans at the festival were the French existentialists, who, like the Beats in America, regarded African American jazzmen as rebels and outsiders, the sort of marginal souls who populated their own novels and plays.

The foreign interest in jazz was additionally nurtured by the American government. Just as the State Department exported Abstract Expressionism and other forms of American culture during the Cold War, so it sent America's leading jazz musicians on tours of Western and Eastern Europe, the Soviet Union, the Middle East, Africa, Asia, and Latin America. The State Department—apparently unfamiliar with the history of American jazz musicians traveling abroad from the 1920s on—hoped that foreign audiences would recognize (as if they were still unaware) that American jazz was as artistically commendable as European classical music and Soviet ballet. Moreover, by sponsoring the jazz concerts of African American musicians, the State Department could try to undermine the prevalent belief that the United States was nothing more than a nation of segregationists. The public-relations value of jazz was further amplified by lectures and concerts at the

America Houses in West Germany, and by Willis Conover's *Music USA*—the Voice of America's most popular program, broadcast nightly for one hour starting in 1955, with an estimated thirty million listeners, many of them in Eastern Europe and the Soviet Union.[41]

Given the persistent foreign attraction to jazz in all of its manifestations, it was not surprising that by the 1960s free jazz should have been more appreciated overseas than in the United States. Ornette Coleman, Archie Shepp, and Albert Ayler were idolized particularly in Eastern Europe, where a music that ignored the rules of conventional jazz symbolized the longing to defy the oppressions and rigidity of the existing Communist regimes.[42]

More important, jazz was becoming a genuinely global music, and one that affected jazz performers in the United States. As early as 1947 Dizzy Gillespie invited the Cuban percussionist Chano Pozo to join the rhythm section of his big band, thereby helping to incorporate a Latin American beat into Gillespie's own repertoire.[43] In the 1950s and early 1960s Gerry Mulligan and Stan Getz were influenced by Brazilian jazz, especially the compositions of Antônio Carlos Jobim and João Gilberto. In 1963 Getz recorded his international hit "The Girl from Ipanema," sung by Gilberto's wife, Astrud. At the same time, the flutist Herbie Mann was using both Brazilian and Afro-Cuban music in his concerts and albums. By the 1970s Latin American rhythms and melodies had become a permanent fixture in American jazz.

In the meantime, jazz performers like John Coltrane were drawing on the music of India and North Africa. And the South African trumpeter Hugh Masekela became a major influence both in American jazz and popular music.

Thus American jazz—which had begun as a mixture of African, Caribbean, South American, African American, and European music—was returning to its foundations as a cosmopolitan art, transforming and being transformed by the world's music. It was this blending of musical ingredients, tastes, and traditions that had always made jazz appealing not only to biracial and multiethnic audiences in the United States but to equally multicultural audiences all over the planet.

Although jazz relinquished much of its popularity in the United States in the late twentieth century, no other American music—not

even rock and roll or the music of Broadway—could claim to have had such long-lasting impact on international audiences. The globalization of American jazz, then, was a supreme example of how much America's culture continued to influence, as well as be dependent upon, the cultures of other countries.

They're Writing Songs of Love

■

The magnetism of jazz, in America and throughout the world, was evident not only on the recordings and in the live performances of a Benny Goodman or a Billie Holiday but also on the Broadway stage and in Hollywood musicals. Unlike a lot of nineteenth-century European operas, with their disastrous romances or visions of a Wagnerian apocalypse, many of America's musicals—especially between the two world wars—were bouncy, impertinent, and full of clever lyrics and syncopated rhythms. Hence the musicals borrowed from and embodied the jazz mystique.

And as with jazz, the tone of the Broadway and movie musicals of the 1920s and 1930s—most of them shaped by Manhattanites— was urban and urbane. Despite the fact that Cole Porter hailed from Indiana and Fred Astaire grew up in Nebraska, you could never imagine either of them as a rural hayseed or a working stiff. They resided (for Astaire onscreen and, in Porter's case, in real life) in a world of posh furniture and burnished floors, of well-cut suits and stylish gowns, of nightclubs saturated in Champagne and cigarette smoke. For perhaps the only time in a country historically suspicious of urban culture, the city Porter and Astaire memorialized seemed an ideal place to live.

Also like jazz, American musicals converted works of high art— notably ballet and opera—into a popular culture that blended tap and

modern dance with comic dialogue and sardonic love songs. But it was precisely this metamorphosis that allowed America's musicals to be exportable to other countries. Shows that succeeded on Broadway invariably traveled abroad—first to London, and then to the rest of Europe as well as to Latin America and Asia. Similarly, Hollywood musicals attracted foreign audiences and transformed popular American songs into international hits. Even though most countries dubbed the dialogue in American movies, they left the musical segments alone. So people overseas could both appreciate the dancing of Astaire or Gene Kelly and hear their voices performing the original lyrics of a song.

In all these ways, the music of George Gershwin, Irving Berlin, Cole Porter, Richard Rodgers (partnered with Lorenz Hart or Oscar Hammerstein), and Leonard Bernstein appealed as much to people in Berlin and Buenos Aires as to audiences in a Broadway theater or in a picture palace in Peoria. No longer just a distinctively American creation, the musical—whether on stage or screen—became part of a global culture.

From Swanee River to Tin Pan Alley

In the nineteenth century, much of American popular music—whether sung around a piano in a parlor or played by a band in a park—was not strikingly original. Instead, America's music was derived from English and Irish ballads, Scottish folk tunes, German drinking songs, Italian arias, and African American gospel melodies.[1] Even native composers like Stephen Foster were dependent on European musical conventions. Foster's most beloved songs—"Oh! Susanna," "Beautiful Dreamer," "Jeanie with the Light Brown Hair," "Swanee River"—reflected an Old World romanticism with which Americans felt comfortable for most of the century.

Foster was only one of America's successful early composers. Beginning in 1892, Charles Harris's "After the Ball" sold five million copies of sheet music, a record for its time. In addition, songs like "In the Good Old Summertime," "Wait till the Sun Shines, Nellie," "Down by the Old Mill Stream," and "Shine On, Harvest Moon" idealized a rural and small-town America, a land (however rapidly it was indus-

trializing) where every man could still hope to marry a girl "just like the girl that married dear old Dad."

Band music was equally nostalgic, as well as patriotic, particularly when written and conducted by John Philip Sousa. The son of an immigrant trombonist from Portugal, Sousa became director of the United States Marine Band in 1880. By 1892 he was leading his own band, which specialized in some of his most well-known compositions: "Stars and Stripes Forever," "The Washington Post March," and "Semper Fideles." Though Sousa carried on the tradition of the Irish bandmaster providing the music for military parades, he also admired the role of highbrow German conductors in nineteenth-century America. Consequently, he minimized the use of earsplitting trumpets and thumping drums in favor of softer strings and woodwinds, instruments that made his band music sound more serious and symphonic.

These stylistic adjustments eventually allowed Sousa to transcend the nationalist mood of the United States even as the country was building a large navy and embarking on its own imperial adventures. Indeed, by the opening of the twentieth century, people all over the world embraced Sousa and his music. In 1900, 1901, and 1905, Sousa's band played throughout Europe as well as in Japan (where his music, despite its "American" attributes, continued to be popular with army leaders and educational officials up to and after World War II).[2] In 1910 Sousa took his musicians on a world tour that included England, South Africa, Australia, and New Zealand. Sousa was therefore the first American composer and bandleader to enjoy the perquisites of global celebrity.

At home, however, the music was changing, becoming less bucolic, harder-edged, more urban. "The Sidewalks of New York" began to replace "My Old Kentucky Home" as an informal American anthem. New York City itself was turning into the home and the source of America's music.

And at the center of this musical creativity, the site where songs were written and sold, was Tin Pan Alley. Located first in the Bowery in the 1880s, Tin Pan Alley migrated uptown, following the major theaters and vaudeville houses to Union Square in the 1890s, West 28th Street between Broadway and Sixth Avenue in 1910, and to the area surrounding Times Square by the 1920s.[3] The Alley got its name from

the clamor of piano music that could be heard from the open windows of buildings, all of it sounding like the clash of kitchen pans.

But the real function of Tin Pan Alley, whatever its address, was to provide an enclave for New York's composers, arrangers, and music publishers. Firms like M. Witmark & Sons depended especially on song "pluggers" (which is how the young Irving Berlin and George Gershwin started out, presenting the numbers of other, equally hopeful composers to theater owners, booking agents, and singers looking for new material). The publishing houses also maintained close contacts with vaudeville entertainers who traveled throughout the country, enabling the publishers to sell their sheet music in cities and towns far from the hubbub and glamour of Manhattan. Vaudeville, in particular, was the chief vehicle in the late nineteenth and early twentieth centuries for advertising popular songs and elevating them into nationwide hits.[4]

By 1914, with the formation in New York of the American Society of Composers, Authors, and Publishers (ASCAP), the music business became more professionalized. ASCAP demanded that vaudeville houses, record companies, and later radio stations pay songwriters and music publishers for the performance of their works. Composers of popular songs were no longer itinerant amateurs; they would be artists equivalent to novelists and playwrights, protected by copyrights and benefiting from royalties.

In the 1920s, as vaudeville declined in importance, the music publishers came to rely more on recordings, the radio networks, and the Hollywood studios (especially after the transition to sound films) to popularize and disseminate their songs. In fact, the studios—seeking a steady supply of music—began to buy up the publishing houses. In 1929, for example, Warner Brothers purchased the Witmark Company, thereby guaranteeing that Witmark's composers would write exclusively for Jack Warner's studio.

All of these trends meant that the music of the early twentieth century sounded more "modern." Ragtime- and jazz-influenced songs supplanted the maudlin ballads of the nineteenth century. And many songs themselves were shorter, the lyrics more succinct but also more consequential, in order to fit on a record that lasted only three or four minutes. Meanwhile, radio—being a more intimate medium than vaudeville—placed a premium on songs aimed at an individual listener,

songs that conveyed a personal message from a man to a woman or vice versa, rather than those designed for a family singing together after dinner or the four-part harmony of a barbershop quartet.[5] So in the first decades of the twentieth century, with the emergence of new types of music, Tin Pan Alley helped lay the foundations for the development of a commercially successful and artistically ingenious musical theater in America.

Musical Images of London, Vienna, and New York

Musicals are what America has instead of opera. Or at least what Americans preferred when, in the later years of the twentieth century, they coughed up $100 for a theater ticket. Even in less pricey eras, musicals were not as elitist as operas, nor were they as low-rent as vaudeville or burlesque. Musicals were meant to be relished by the prosperous and moderately sophisticated middle class.

Still, musicals in America could trace their lineage to the more scandalous forms of vaudeville and burlesque, as well as to the European tradition of grand opera and its humble offspring, the Viennese operetta (or what the French called opéra bouffe).[6] Like America's painting and architecture, its classical music and jazz, Broadway musicals mixed elements that were indigenous to the United States with imports from abroad.

Actually, the most popular musicals of the late nineteenth century came from London, and they re-created—more often satirized— the world of the British empire. In the 1870s and 1880s American audiences came to adore the lyrics of William Gilbert and the music of Arthur Sullivan. For an evening of parody and farce, nothing in American entertainment could match the wit of Gilbert and Sullivan's *H.M.S. Pinafore* (first performed in Boston and New York in 1878 and 1879, before journeying throughout the land), *The Pirates of Penzance* (which received its world premier not in London but in New York in 1879), and *The Mikado* (a hit all over America after its debut in England in 1885).

Unlike the authors of nineteenth-century melodramas, Gilbert and Sullivan cared less about the plots of their musicals or the love affairs of their characters than about the intricate rhythms of their songs

and the dexterity of the lyrics. It was as if their musicals existed not to reproduce or romanticize some version of reality on stage but to highlight (in an almost modernist vein) the utter artifice of the theatrical experience.

Gilbert's lyrics in particular—with their double and triple rhymes, their puns, and their sheer pleasure in the use of the English language —influenced Ira Gershwin (who wrote the words for most of George's songs), Cole Porter, and Lorenz Hart. In the 1950s another clever wordsmith, Tom Lehrer, would compose "The Elements," a Gilbertian recitation of the periodic table set to the music of Sullivan's "Major General's Song" from *The Pirates of Penzance,* in which chromium and curium were made to rhyme with californium and fermium.

Yet at the end of the nineteenth century, Gilbert and Sullivan's works, however comic, could also summon up a wistfulness for the English countryside and for English mores, in much the same way that Kenneth Grahame's *The Wind in the Willows* induced a nostalgia for rural England among Anglo-American readers when his novel was published in 1908. This turn-of-the-century identification with England came at precisely the moment when America was being inundated with immigrants who, presumably, could not appreciate the linguistic verve of Gilbert and Sullivan, much less the poetry of Shakespeare.[7]

If for some Americans, Gilbert and Sullivan's extravaganzas commemorated the culture of England, operettas sentimentalized the spirit of pre–World War I Vienna. No Middle European operetta was more admired in America than Franz Lehár's *The Merry Widow,* first performed in Vienna in 1905 before opening on Broadway to enthusiastic crowds in 1907. Operettas struck a fashionable compromise in early-twentieth-century America between the complexity of opera and the vulgarity of vaudeville. Moreover, although operettas required classically trained singers and took place in exotic Old World locales (Vienna, Paris, mythical postage-stamp countries in eastern Europe), they were performed in English, with dialogue rather than recitatives, so that American audiences could decipher the convoluted stories and appreciate the semioperatic music.

In addition to *The Merry Widow,* other operettas were immensely popular in America, due largely to the works of three émigrés from Eu-

rope. Victor Herbert—the most ambitious of the three—was born in Dublin, studied cello in Germany, came to the United States in 1886, and wound up conducting the Pittsburgh Symphony Orchestra from 1898 to 1904. Though he wanted to compose operas and symphonies, he turned to operettas because that's where the money was.[8] In the first decade of the twentieth century, three of his operettas—*Babes in Toyland, The Red Mill,* and *Naughty Marietta*—all suited the less lofty tastes of his audiences.

Herbert was followed by Sigmund Romberg from Hungary and Rudolf Friml from Prague. The years of their greatest success were in the 1920s, with Romberg's *The Desert Song* and *The New Moon* (both with lyrics by Oscar Hammerstein) and Friml's *The Vagabond King* and *Rose Marie* (the latter also in conjunction with Hammerstein). Indeed, *Rose Marie* was the most profitable Broadway show until *Oklahoma!* opened in 1943.[9]

The popularity of operettas was reinforced by the movies, especially in the 1930s. In 1934 Ernst Lubitsch—another émigré, this time from Berlin—offered his own droll rendition of *The Merry Widow,* starring Maurice Chevalier and Jeanette MacDonald (who proved, in this movie at least, that her flair for comic acting exceeded her limited talents as a singer). Lubitsch's film was a classic musical in a decade of classic musicals.

Yet the golden age of operettas was already passing by the end of the 1920s. Perhaps the operettas were too "European" and too lavish in their sets and story lines for the average theatergoer. What the audience increasingly seemed to desire were musicals that focused more on American characters, and that employed jazz motifs rather than grandiose duets and arias.

Even in the first two decades of the twentieth century, the operetta's main competitor was the revue. Revues carried on the traditions of the minstrel show, as well as those of burlesque and vaudeville. The shows featured the specialized turns of their stars—Eddie Cantor, Fanny Brice, Will Rogers, W. C. Fields, Sophie Tucker, Ed Wynn, the African American comedian Bert Williams—together with extraneous "plots" that tried but usually failed to connect the acts and the production numbers.

The architect of the revue, more than anyone else, was Florenz Ziegfeld. The Ziegfeld Follies, which lasted from 1907 to 1931, was originally modeled on the Folies Bergère in Paris. In America, however, the revues were governed by the inclinations of their producers, whether Ziegfeld, Earl Carroll with his Vanities, or George White with his Scandals. They hired the composers and performers, coordinated the stage sets and costumes, invented skits, and chose much of the material for their shows.

Among the most prominent songwriters who contributed to Ziegfeld's Follies were Herbert, Friml, Irving Berlin, and Jerome Kern. But the signature of the Follies was the chorus line—eye-catching and erotically clothed women whose synchronized dancing influenced the cinematic choreography of Busby Berkeley (who worked for Ziegfeld before he settled at Warner Brothers).[10]

There were African American revues as well. Among the most notable was *Shuffle Along,* with music and lyrics by Noble Sissle and Eubie Blake, which debuted in 1921 and ran for 484 performances. The cast of the show included Paul Robeson, with a young Josephine Baker in the chorus. Because of its success, *Shuffle Along* helped inspire a fad in the 1920s for revues starring black singers and dancers.[11]

The deepest impact of the revues, however, was on early musical comedy, a homegrown alternative to European-style operettas. The entertainer most responsible for the birth of musicals drenched in Americana was George M. Cohan. The composer of songs like "The Yankee Doodle Boy," "You're a Grand Old Flag," "Give My Regards to Broadway," and "Over There," Cohan linked vaudeville with ragtime. And he used urban American slang and contemporary settings to create stories and characters that could not exist anywhere except New York.[12] His shows and his music exuded the confidence that reflected the mood both of Manhattan and America as it entered World War I and the jazz age that ensued.

Cohan was an Irish-Catholic American. But it was Jewish songwriters, lyricists, and entertainers who perfected the modern musicals of the 1920s and beyond. For Jews, Broadway was the avenue that permitted them, more than any other ethnic group, to enter and conquer America.

Jews and Show Business

In Sidney Lumet's *The Pawnbroker* (1964), Sol Nazerman—a Holocaust survivor played with quiet ferocity by Rod Steiger—explains to his young Puerto Rican assistant the "secret" of the Jews' entrepreneurial success. "You start off with a period of several thousand years," Nazerman snarls, "during which you have nothing to sustain you but a great bearded legend. . . . You have no land to call your own, to grow food on or to hunt. You have nothing. You're never in one place long enough to have a geography or an army or a land myth. All you have is a little brain . . . and a great bearded legend to sustain you and convince you that you are special, even in poverty. But this little brain, that's the real key, you see."

With this little brain, Jews in the shtetls of eastern Europe excelled in culture as well as in commerce. They were, after all, people of the book as much as of business—steeped in literature, philosophy, the Talmud, and the Torah. So they could serve the financial and artistic needs of their Gentile neighbors—that is, when the neighbors weren't indulging in bloody pogroms.

Within the ghettos, Jews celebrated most religious holidays with songs and dances. Their musical heritage, along with their commercial acumen, emigrated with them to the New World. In America, particularly in the late nineteenth and early twentieth centuries, new industries were opening up to those, like the Jews, who had an exceptional ability both to entertain and make money.[13] In vaudeville, on Tin Pan Alley, on Broadway, and in Hollywood, none of these venues governed by the Anglo-Saxon elite, there were few discriminatory barriers to block the ascent of an ambitious songwriter, comedian, or film producer. For upwardly mobile Jews who yearned to escape Brooklyn or the Lower East Side, who recognized the economic opportunities available in a land wedded to popular culture, and who knew how to please an audience and simultaneously profit at the box office, there was no business like show business.

Not everyone could take Manhattan as sensationally as Irving Berlin, George Gershwin, or Richard Rodgers and Lorenz Hart. But they were only the best known of the pilgrims from the lesser streets and outer boroughs to Broadway. In the years between the two world

wars, three-quarters of the lyricists and half the composers on Tin Pan Alley were Jewish.[14] Like the budding moguls in Hollywood, Jewish songwriters encountered no prejudices among their peers, because all their peers came from the same humble beginnings (except for the relatively affluent Rodgers and Hart, who met at Columbia). Given their musical roots and their theatrical expertise, as well as the absence of any hierarchy in the entertainment world, the Jews came to dominate Tin Pan Alley and Broadway. Off stage and on—as in the case of Al Jolson, Eddie Cantor, the Marx Brothers, Sophie Tucker, and Fanny Brice—they were triumphant.

Yet for all their cultural achievements, they remained (at least in their own minds) outsiders. So in their music (and sometimes, like Jolson and Cantor, in blackface) they identified with the cultural alienation of African Americans. Jews and blacks understood bigotry, whether in the obvious form of segregation or in the more tepid but no less odious manifestations of anti-Semitism. Not only did both groups have a shared sense of marginality when it came to their position in American society, but eastern European cantorial music had a tonal and structural affinity with African American music, especially a mutual fondness for minor chords and blue notes. The Jewish attraction to a music filled with melancholy was reinforced by the fact that a number of songwriters—among them Berlin and Harold Arlen—were the sons of cantors, fathers whose singing was as saturated with sorrow as the sound of a wailing trumpet in an African American jazz band.[15]

There was a certain presumption in Jews equating their status with blacks in America. Jews were not just entertainers; they owned many of the theaters and ran the movie studios together with the radio networks, whereas blacks could only scuffle for a part on stage or on screen, often cast in the most stereotypical and demeaning roles. Nonetheless, the common sense of sadness among Jews and blacks, of feeling deviant and disconsolate even in the promised land, led to the blending of Jewish and African American musical styles.

Indeed, the music of Tin Pan Alley and Broadway was never too distant from the music of Harlem. Jazz was a staple in popular songs, notably in the compositions of Gershwin and Arlen, who transposed the boisterous improvisations of a Louis Armstrong into calmer melodies suitable for white tastes. Meanwhile, Sophie Tucker combined

Jewish and black influences in her vaudeville and theater performances, converting "My Yiddishe Momme" into as treasured a hit as her theme song, "Some of These Days."

But no one exploited the connections between African American and Jewish music more lucratively than Al Jolson. Another son of a cantor, Jolson was born in Lithuania, emigrating with his family to the United States in 1894. Throughout his career, Jolson and his hit songs —like "Swanee" (written by Gershwin) and "Rock-a-Bye Your Baby with a Dixie Melody"—mixed black and Jewish sensibilities. In his act Jolson mimicked both the minstrel singer on bended knee and the liturgical sobs of a rabbi.

Jolson's most famous impersonation of a black and Jewish performer was in *The Jazz Singer* (1927), originally a play and then a movie based on his own life. Here Jolson (first as Jakie Rabinowitz and then as the more Americanized Jack Robin) is torn between his rabbinical father's desire for him to sing the "Kol Nidre" in the synagogue at the start of the evening service on Yom Kippur and his own craving to be a show business star. Eventually, he accomplishes both, reciting the prayer and also singing five "jazz" numbers throughout the movie (including Irving Berlin's "Blue Skies"). Jolson finishes the film with a lachrymose rendition of "My Mammy," sung in front of a Broadway audience, honoring his mother, who is pictured in the song as both classically Jewish and Aunt Jemima.

Whether Jolson's or anyone else's tunes were truly Jewish or black, or merely a simulation of two authentic traditions, the words to their songs mattered as much as the music. And for those who wrote the lyrics, the real influences were neither eastern European nor African American. Writers like Ira Gershwin and Lorenz Hart married the sophistication of European high culture to an American (and New York) vernacular, creating a poetry of irony and romance, of wit and longing, that became the trademark of the Broadway musical.

The Lyricists

The Great American Songbook was also the Great American Wordbook. What was memorable about American songs, particularly from the 1920s to the 1940s, were not only the melodies but the lyrics. In-

deed, it was impossible to separate Cole Porter's music from his words. The same was true for Irving Berlin. And George Gershwin's songs were inextricably tied to the lyrics of his brother, Ira, just as the tunes of Richard Rodgers in the interwar years were unimaginable without the acerbic rhymes of Lorenz Hart.

The importance of language to the music coincided with the era of sound—on the radio, in the gangster films and screwball comedies of the 1930s, and in the mouths of the fast-talking guys and dames who populated Broadway plays and Hollywood musicals. To be sophisticated meant to be verbally nimble, to converse intelligently, to toss off a bon mot, just like Dorothy Parker, George S. Kaufman, and the other denizens of the Algonquin round table. So a lyricist was another kind of playwright, humorist, and gossip columnist, but within the confines of the popular song.

The structure of that song was different in the nineteenth century. Then most songs had lengthy introductory verses that told an intricate story, often half-spoken by the singer, before a brief chorus emerged containing the main melody. By the early twentieth century, the chorus had become more significant than the verse, which sometimes disappeared altogether to conform to the rigid three-minute time frame of a record.[16]

Now a typical Tin Pan Alley tune ran thirty-two bars, opening with two eight-bar repetitions of the melody, followed by an eight-bar "bridge," before returning to an eight-bar reprise of the melody at the end of the song. This AABA format allowed composers to churn out songs quickly and easily. But for a lyricist, the trick was to elude and transcend the constraints of Tin Pan Alley's formula—to avoid the "June-moon" clichés and standardized sentiments that such a protocol imposed.

Not all songwriters or lyricists limited themselves to thirty-two bars. Yet no matter how long the number, the lyricist still had to come up with words to fit the music, to make sure there were enough vowels at the end of a line to enable the singer to hold a note, and to devise phrases and thoughts that matched the rhythms of the song.[17]

To accomplish these tasks, many lyricists drew on the lessons of modernism, juxtaposing high-cultural symbols with references to the artifacts of everyday life (primarily those that existed in cities like New

York, among middle- and upper-class Americans). These were also writers familiar with British prose and poetry, with the phrases and images in works from Shakespeare to Lewis Carroll, and especially with the banter of Gilbert and Sullivan. They could have been poets, essayists, or novelists, and some of them wished they were. Lyricists like Ira Gershwin and "Yip" Harburg wanted in their spare time to contribute pieces to the *New Yorker, Vanity Fair,* or the *Smart Set.*[18] The words they supplied for the songs were polished and literate even as they chronicled the predictable fluctuations in a romance. If they'd asked Lorenz Hart, he probably could have written a book, or at least a preface on how two lovers met.

The lyricists depended on their listeners to grasp the allusions. As would be the case with the new comedians of the 1950s and 1960s (Sid Caesar, Mort Sahl, Mike Nichols and Elaine May, Woody Allen), the lyricists appealed to an educated clientele, people who recognized the cultural citations and got the jokes in Cole Porter's "You're the Top," and who could brush up on their own Shakespeare after seeing *Kiss Me, Kate.*

This amalgamation of high life and slang, of intellectual erudition and the garbled phrases of daily conversation, could be heard in Irving Berlin's "Puttin' on the Ritz." Strolling down Park Avenue, an average Joe might mix with Rockefellers, who walk with sticks or "umberellas" in their "mitts." Meanwhile, the remembrance of conventional objects and forms of daily behavior could be a sign of deeply felt love, as in Ira Gershwin's "They Can't Take That Away from Me," where you can eulogize your lover by recalling how she wears her hat, holds her knife, and sips her tea.

The master of cross-cultural metaphors was Cole Porter. His "list" songs, like Picasso's Cubist collages or Duchamp's readymades, were catalogues of witty references to high and low culture. "You're the Top" fuses European institutions and classics with American popular icons, rhyming the National Gallery with Garbo's salary, a symphony by Strauss with Mickey Mouse, the inferno's Dante with the great Durante. In Porter's world, anyone could enter high society as long as he or she learned Porter's lexicon (and maybe dressed and danced like Fred Astaire or Ginger Rogers).

But the words weren't designed merely to be clever. Neither were

they intended to be topical, unless observations about politics or daily events could amuse an audience (as George and Ira Gershwin managed to do in their longest-running Broadway show from 1931, *Of Thee I Sing*). During the Great Depression, American songs and their lyrics rarely mentioned the problems of poverty and unemployment. Yip Harburg's words to "Brother Can You Spare a Dime" in 1931 and Marc Blitzstein's Brechtian musical in 1937 about organizing a labor union, *The Cradle Will Rock,* were notable exceptions to the apolitical character of American popular music. The more customary way of acknowledging the Depression was by satirizing its hardships or minimizing its existence. In "We're in the Money," from the movie *Gold Diggers of 1933,* Al Dubin's lyrics declared that there would be no headlines about breadlines, at least not in this song.

The music of Tin Pan Alley and Broadway, like Hollywood's movies in the 1930s, more often focused on personal feelings than on social commentary. Between 1920 and 1940, 85 percent of America's songs dealt with love, particularly the initial exhilaration and eventual demise of an affair.[19] Many of the lyrics about love were caustic, even cynical. The view of romance was frequently tough-minded and hard-boiled, like the plots of a Dashiell Hammett or Raymond Chandler detective novel, as if the songs were written as much for Humphrey Bogart as for Fred Astaire.

No lyricist was more skeptical about the blissfulness of being in love than Lorenz Hart. In "Spring Is Here," a singer's heart doesn't go dancing or find a waltz entrancing. Instead, Hart's words conceded the physical defects in a lover, a "funny valentine" whose body was "less than Greek" and whose mouth was "a little weak," whose looks were "laughable" and thus "unphotographable."

Moreover, for Hart, unlike Ira Gershwin, love was not necessarily here to stay. You often found yourself on your own, ordering orange juice for one and playing solitaire, uneasy in your easy chair. Or you wished you were in love again, savoring the broken dates and endless waits, the "conversation with the flying plates." Because at the end of a romance, when love congealed, it gave off the aroma of a performing seal—which is what you would expect from being double-crossed by a "pair of heels." In Hart's universe, the lady was always a tramp, but one who could bewitch, bother, and bewilder you forever.

Lyrics like these did not require an operatic voice. They needed a singer who instinctively understood the words—someone like Astaire, Gene Kelly, or Frank Sinatra. It was hardly accidental that both Kelly and Sinatra starred in Rodgers and Hart's *Pal Joey,* Kelly on Broadway in 1940, Sinatra in the movie version in 1957. Sinatra especially was a genius at interpreting lyrics, at articulating the emotions of the listener alone in his or her darkened room, as he proved in his albums of the 1950s, where he specialized in the music of the Gershwins, Porter, Berlin, Harold Arlen, Duke Ellington, and Rodgers and Hart.

For a time, the emphasis on words stimulated a new type of musical theater, one in which (unlike operettas) the ability to "act" a song, to convey meaning through lyrics, as Rex Harrison did in *My Fair Lady,* was as central as the music itself. Of course, words continued to count in the songs of Bob Dylan, Paul Simon, Joni Mitchell, the Beatles, and Stephen Sondheim. But in the years after World War II, in the era of rock and roll, when Sinatra gave way to Elvis Presley, an audience familiar with books, plays, and poems, an audience that prized smart lyrics, gradually vanished. Presley seemed "inarticulate." You couldn't understand the words and the words didn't matter anyway. Sound—of the talkies, of radio, of the machine-gun chatter of a Walter Winchell gossip column, of the city itself—was no longer a novelty or a necessity. The movies became more visual and television replaced radio. One could see rather than hear the connections between people; the blanks didn't need to be filled in with verbal explanations. So words were less vital in providing information, creating a mood, or delivering an idea.

In fact, by the 1950s it was not admirable to be clever. It was more important to be cool—to be laconic and restrained rather than verbally effusive, to be a finger-snapper rather than a ballroom glider like Astaire or an energetic acrobat like Kelly. Which is why "Cool," the brilliant and jazzy Jerome Robbins dance number in *West Side Story,* was emblematic of the new age and the new unemotional ethic.

Still, while they reigned, America's lyricists helped create some of the most innovative music and musicals of the twentieth century. And they did so not just by themselves, but in collaboration with a generation of gifted composers who were—like their counterparts in painting and jazz—at once artists, entertainers, and entrepreneurs.

The Songwriters

He was a chameleon as a composer. Irving Berlin wrote tunes in every conceivable genre, from jazz to marches, from love songs to holiday commemorations and patriotic anthems.

Berlin's versatility as a songwriter sprang from his Jewish background as well as his rapid adaptation to the demands of American culture. Born in Russia in 1888, he came with his family to America in 1893. As a child, Berlin spoke mostly Yiddish. But when he started singing on street corners and in saloons, Berlin was already immersing himself in the diversity of American music. As an archetypal immigrant songwriter, Berlin exploited every foreign and native musical tradition he encountered. His early compositions were a jumble of English music hall songs, Stephen Foster melodies, Irish and Italian folk ballads, comic Yiddish lyrics, ragtime, and jazz.[20]

Berlin's first blockbuster triumph, selling two million copies of sheet music in 1911, was "Alexander's Ragtime Band." A mixture of syncopated rhythms and familiar refrains, the song helped prepare white listeners, in America and in Europe, where it was also a hit, for the onslaught of jazz and the blues. Berlin himself went to Europe in 1913, to discover that he was now, as a result of "Alexander's Ragtime Band" and other early tunes, a transatlantic songwriting star.[21]

Yet Berlin was quintessentially American in his eclecticism and his willingness to blend high and popular culture, thereby liberating American songs from their dependence on European musical conventions. He could write songs as jazzy as "Blue Skies" and "Heat Wave," as witty as "Steppin' Out with My Baby" and "Anything You Can Do (I Can Do Better)," and as melodramatic as "How Deep Is the Ocean?" and "Always."

No matter how prolific his output, Berlin—unlike Gershwin—rarely composed works that violated the rules of the well-made popular song. His music could be performed effortlessly by a Fred Astaire or an Ethel Merman, or by an amateur singer in the shower.

But like Gershwin, Berlin realized by the 1930s that he could make more money for less work in Hollywood than on Broadway.[22] One of Berlin's most successful ventures in movies was to write the songs for *Top Hat* in 1935. Here, Astaire could court and capture Gin-

ger Rogers to the rhythms of "Cheek to Cheek" and "Isn't This a Lovely Day?"

The movies, the Broadway shows, and the larger culture began to change in the late 1930s and 1940s, and Berlin—always alert to his audience's shifting tastes—changed with them. As was true for the new wartime and postwar team of Richard Rodgers and Oscar Hammerstein, Berlin turned to less urban, more nostalgic songs. Some of this material was even jingoistic, certainly in the case of "God Bless America," first written in 1918 in the midst of America's involvement in World War I but revised and reintroduced by Kate Smith in 1938. The song became an ode to America's ultimate victory in World War II. Similarly, Berlin—the son of Russian Jewish immigrants—composed "White Christmas" and "Easter Parade," both of them honoring, though in secular nods to the virtues of home and family life, the most sacred of Christian holidays.[23] Meanwhile, Berlin's greatest Broadway achievement, *Annie Get Your Gun* in 1946 (which Rodgers and Hammerstein produced), was both a humorous and an affectionate homage to the late-nineteenth- and early-twentieth-century Wild West Shows of Buffalo Bill, and hence a celebration of the vanished American past.

Despite his periodic tributes to America's history and its most cherished customs, Berlin was a thoroughly "modern" composer. And one who enjoyed a global popularity.[24] You could hear Berlin tunes sung in cafés or played on the radio all over the world. His songs were filled with energy, with evocations of sophisticated love affairs where people changed partners and continued to dance, and with the jangling sounds of the city as much as the gentler tones of the countryside. By the time he died, at the age of 101 in 1989, Berlin had transformed American music, making it sound more contemporary. Equally important, he expanded the possibilities for greater experimentation on the part of other songwriters, none more stunning in his talent than George Gershwin.

Although Gershwin's parents, like Berlin's, were Russian Jewish immigrants, Gershwin was more conversant with the trends in early-twentieth-century "serious" music. Where Berlin was, musically, an autodidact, Gershwin had two teachers, Charles Hambitzer and Rubin Goldmark, who introduced him to the works of Franz Liszt and

Frédéric Chopin, as well as to the more modernist compositions of Debussy and Ravel. By the 1920s Gershwin was also familiar with the music of Stravinsky, Schoenberg, Shostakovich, and Milhaud.

Yet he did not need to free himself, as did so many other American composers, from Europe's symphonic traditions. As a song plugger and writer of piano rolls during his adolescence, Gershwin was equally at home with America's ethnic and popular music. In his own compositions, he was influenced by Jewish prayer chants, African American spirituals, vaudeville, revues (he contributed to George White's Scandals from 1920 until 1924), operettas, Scott Joplin's rags, jazz, and the songs of Tin Pan Alley.[25] And, like Berlin, Gershwin understood that songwriting was a means of escaping his immigrant background and becoming an American celebrity.

Gershwin's first hit, in 1919, was "Swanee," sung and recorded by the biggest star in America, Al Jolson. The song sold a million copies of sheet music and two million records in the United States and abroad. None of Gershwin's later songs exceeded the commercial success of "Swanee." But the experience taught him that writing first-rate songs, while rewarding financially and emotionally, did not encompass all that he wanted to accomplish. In a typical American manner, Gershwin hoped to be both a highbrow artist and a lowbrow entertainer—a composer of concertos and operas as well as a creator of Broadway shows and music for the movies.

For Gershwin, jazz was the means to link concert and popular music. Gershwin regarded jazz as primarily an "American folk music." But it might, he believed, be "made the basis of serious symphonic works . . . in the hands of a composer with talent for both jazz and symphonic music"—a composer, in short, like Gershwin.[26]

Gershwin got his chance to prove that jazz could be America's unique musical art form in 1924 in a concert advertised as "an experiment in modern music," held at New York's Aeolian Hall. The concert was the brainchild of Paul Whiteman. Whiteman (like European critics in the 1930s) considered jazz America's most original music.[27] But Whiteman wanted to elevate jazz to the level of classical music, which in his case meant removing jazz as far as possible from its New Orleans and African American roots. In effect, Whiteman was trying to domesticate jazz for a white audience.

As a result, much of the music performed at Aeolian Hall did not really resemble jazz, nor was it particularly "modern." Among the composers represented at the concert were Victor Herbert and Rudolf Friml, though the program did include songs by Jerome Kern and Irving Berlin.

Seated in the audience were many of the luminaries of the American and European musical worlds: Sergei Rachmaninoff, Jascha Heifetz, Fritz Kreisler, Leopold Stokowski, Walter Damrosch, and John Philip Sousa. But not until they heard the opening clarinet glissando of Gershwin's *Rhapsody in Blue,* with Gershwin himself at the piano, were those in the audience aware that they were listening to something genuinely new. While Gershwin did not engage in the improvisational bravado of a New Orleans jazz musician, no other composer—in America or in Europe—had incorporated jazz as effectively into a work for the concert hall.[28] Indeed, the *Rhapsody* converted the idioms of jazz and the blues into an American version of Europe's modernist music.

Neither did any work sound quite as "urban" as the *Rhapsody* (unless it was Gershwin's *An American in Paris* in 1928). Each composition invoked the commotion and vitality of city life, whether in New York or in Paris. So it was appropriate that Woody Allen used *Rhapsody in Blue* at the beginning of his film *Manhattan,* as an accolade to the splendor of the New York skyline.

In the *Rhapsody* and in his *Concerto in F,* which premiered at Carnegie Hall in 1925 with Walter Damrosch conducting the New York Symphony, Gershwin had composed complex works that were accessible to the public, even to people not especially well acquainted with either jazz or modern music. While the *Concerto in F* was harder for audiences to appreciate than the *Rhapsody,* it still reflected the influence of jazz, Tin Pan Alley, and Broadway.[29]

Gershwin's American rivals, however, were not mesmerized. The popularity of his works made them instantly suspicious. Aaron Copland and Virgil Thomson both dismissed Gershwin, no matter his aspiration to combine jazz with serious concert music, as just another composer of popular songs. Yet it was precisely those songs—"I Got Rhythm," "Fascinating Rhythm," "Summertime," "'S Wonderful," "Nice Work if You Can Get It"—that attracted actual jazz musicians

and singers who included them in their concerts and albums from the 1930s on.[30]

European critics and audiences were more receptive to *Rhapsody in Blue* and the *Concerto in F*. So, too, were composers like Ravel, Paul Hindemith, and Kurt Weill, each of whom adopted Gershwin's jazz motifs in his own music.[31] Some of this fondness for his works may have reflected the snobbish notion (echoed later in the French praise for jazz and Hollywood's movies) that Gershwin's music was as adept as one could expect from an American artist. Still, the Europeans were eager to welcome Gershwin into the ranks of their own modern composers.

Consequently, when Gershwin traveled to Europe in 1928, he was treated like an idol. As America's most famous composer, he attended performances of the *Rhapsody* held in his honor in Paris and Vienna. And he met with all the European modernist superstars: Stravinsky, Schoenberg, Prokofiev, Ravel, Milhaud, Weill, and Alban Berg.

At one point, Gershwin asked Nadia Boulanger if he could study with her. She replied that she had nothing to teach him. When he raised the same question with Stravinsky, the Russian responded by asking Gershwin how much money he made in a year. Told that Gershwin's annual income was in the six figures, Stravinsky (never indifferent to wealth) mused: "In that case . . . I should study with you."[32]

Gershwin's trip to Europe inspired him to write *An American in Paris,* which reflected his feelings as a slightly homesick but manic tourist in the City of Light. The tone poem fortified his reputation as a composer of serious works. By the 1930s *Rhapsody in Blue,* the *Concerto in F,* and *An American in Paris* were developing into staples of the American and European concert repertoire.

Yet it was as a composer of popular songs that Gershwin became best known, at least to audiences in the United States who went to Broadway shows, watched Hollywood musicals, bought records, or listened to the radio. Gershwin wrote his most unforgettable songs for Broadway musicals in the 1920s—from his first hit in 1924, *Lady, Be Good!* (which starred Fred and Adele Astaire) to *Girl Crazy* in 1930.[33] In the 1930s he wrote the score for two Astaire musicals, *Shall We Dance* and *A Damsel in Distress,* both released in 1937. His songs

could be romantic ("Embraceable You," "Someone to Watch Over Me"), satirical ("Let's Call the Whole Thing Off," "They All Laughed"), or poignant ("A Foggy Day," "But Not for Me"). In all of them, jazz played a prominent role, with "blue notes" sprinkled throughout the music.

But none of Gershwin's works was as extensive in its use of jazz and in its deference to African American culture, nor as ambitious in its conception, as his opera *Porgy and Bess,* the work that became his masterpiece. *Porgy and Bess* had two earlier incarnations—as DuBose Heyward's best-selling novel *Porgy* in 1925, and as a play in 1927 written by Heyward and his wife, Dorothy. Gershwin conceived of his version as a full-blown opera, complete with arias, duets, recitatives, and sizable production numbers.[34] In addition to Gershwin's music (which combined European, African American, and Russian Jewish melodies), *Porgy and Bess* had a libretto by DuBose Heyward and lyrics by Ira Gershwin and Dorothy Heyward. Gershwin, if not his colleagues, insisted that the work was a "folk opera," but all the "folk" music was his—including the opera's most renowned songs: "Summertime," "It Ain't Necessarily So," and "I Got Plenty o' Nuttin'."

Porgy and Bess opened on Broadway in October 1935. It was directed by Rouben Mamoulian, an émigré from Armenia and a pioneer Hollywood filmmaker, who had also directed the play (and would later direct Rodgers and Hammerstein's *Oklahoma!* and *Carousel*). The debut was disheartening, since the opera ran for only 124 performances. Apparently, audiences could not decide whether *Porgy and Bess* was truly an opera or just another Broadway musical with several popular songs.

The critics—white and black—were merciless. Virgil Thomson sneered that Gershwin had no clue how to write an opera (in contrast, presumably, to Thomson's own *Four Saints in Three Acts*). Duke Ellington complained that Gershwin knew little about black culture and was indulging in crude racial stereotypes.[35] Yet these attacks may well have been motivated more by envy than by an honest effort to evaluate Gershwin's opera.

If the initial reaction to *Porgy and Bess* was distressing, subsequent productions turned the opera into an unambiguous success. In 1942 Cheryl Crawford—one of the founders in the early 1930s of the

Group Theater—revived *Porgy and Bess* on Broadway but converted the recitatives into spoken dialogue, making the work less of an opera and more like a traditional musical. Crawford's alterations flourished at the box office, in part since audiences were now familiar with the songs from recordings and radio broadcasts.[36]

In 1943 *Porgy and Bess* had its European premier in Copenhagen, with an all-white cast, which seemed tolerable to Denmark's wartime Nazi occupiers. During the 1950s the opera appeared, sometimes under the sponsorship of the State Department, in England and Western Europe, the Soviet Union, the Middle East, and Latin America. In 1955 *Porgy and Bess* became the first American opera to be performed at La Scala in Milan. Yet for all its popularity overseas, *Porgy and Bess* was not blessed by the Metropolitan Opera until a production in 1985. By this time, the opera—a landmark of American music—was a fixture on the international stage.

Gershwin did not live to see the triumph of his opera. Afflicted with a brain tumor, he died in 1937, at the age of thirty-eight. Throughout his career, his works were often disparaged for being too "American," and hence too commercial, too middlebrow, and too reliant on the tropes of Tin Pan Alley. Yet Gershwin—more than any his contemporaries—was able to synthesize serious and popular music, modernism and jazz. Moreover, no other American's works, not even those of Aaron Copland, have been as widely performed by the world's orchestras, opera companies, and soloists.[37] Gershwin thus became the model for other songwriters and composers in their own efforts to translate America's music into a global phenomenon.

The members of Gershwin's generation of songwriters (they thought of themselves as colleagues more than as competitors) were influenced by different tendencies in his music. Jerome Kern, a child of German Jews who studied music briefly in Heidelberg, wrote his first international hit, "They Didn't Believe Me," in 1914. But his interest, like Gershwin's, in black culture was reflected in his groundbreaking musical, *Show Boat,* which appeared on Broadway in 1927, with lyrics by Oscar Hammerstein. *Show Boat,* based on Edna Ferber's best-selling novel from 1926, was the first "book" musical in which the characters and the story were closely linked to the songs, an innovation that predated *Oklahoma!* by sixteen years.

Show Boat adopted the style of Europe's operettas to explore the legends and darker undercurrents of America's past.[38] More specifically, it dealt with the themes of racism and miscegenation, not the usual topics for Broadway musicals in the 1920s. Songs like "Ol' Man River" and "Can't Help Lovin' Dat Man," with their reliance on the blues and on African American dialect, could have easily appeared in *Porgy and Bess.*

But *Show Boat,* unlike *Porgy and Bess,* made money from the start, running on Broadway until 1929. Moreover, though people treasured the popular songs written, often incidentally, for other contemporaneous musicals, *Show Boat* became one of the few musicals from the 1920s and 1930s to be continually revived after World War II, in America and abroad. Meanwhile, Kern went on to write the songs (like "The Way You Look Tonight" and "A Fine Romance") for what was arguably Fred Astaire's best musical, *Swing Time* in 1936.

Cole Porter came from a more cosmopolitan background than did Kern or Gershwin. Born to an Episcopalian family in Peru, Indiana, a graduate of Yale and an expatriate in Europe in the 1920s, Porter joked upon his return to America that he needed to learn how to write "Jewish" songs—songs with blue notes that alternated between major and minor chords.[39] He succeeded, though, with compositions like "What Is This Thing Called Love?" "Just One of Those Things," "Ev'ry Time We Say Goodbye," and "It's All Right with Me" that were less jubilant and more distrustful than Gershwin's songs about the prospects of being in love.

No songwriter besides Gershwin used jazz more effectively than Harold Arlen. But he could be as pessimistic as Porter when it came to writing love songs. In Arlen's world, it was always stormy weather, the blues usually came in the night, the man (or girl) invariably got away, and at closing time you needed one more for your baby and one more for the road. Of course, Arlen's most famous song—"Over the Rainbow," sung by Judy Garland, and nearly cut from *The Wizard of Oz* —was a fantasy about escaping from all the world's troubles, or at least from the gloomy conditions of living in Kansas during the Depression years.

Kern, Porter, and Arlen wanted, above all, to write hit songs and shows. Like Gershwin, however, Richard Rodgers also yearned to con-

nect high culture with mass entertainment. In some of the musicals he wrote with Lorenz Hart—*A Connecticut Yankee, The Boys from Syracuse, By Jupiter*—Rodgers drew on Mark Twain, Shakespeare, and ancient Greek mythology. In addition, Rodgers enlisted George Balanchine, who choreographed many of Stravinsky's most important ballets and had emigrated to the United States in 1933, to design the dances for *On Your Toes* in 1936 and *Babes in Arms* in 1937, as well as *The Boys from Syracuse* in 1938.[40] For "Slaughter on Tenth Avenue," the extended dance number in *On Your Toes,* Balanchine blended Rodgers's jazz themes with the techniques of modern ballet.

For all the luster of the individual songs written during the interwar years by Berlin, Gershwin, Kern, Porter, Arlen, and Rodgers and Hart, most of the musicals in which the songs appeared (with the exceptions of *Show Boat* and *Pal Joey*) were quickly forgotten. But the nature of the American musical was about to change. With the arrival of shows that merged the songs and the plots, the Broadway musical would become one of the main forms of popular culture in postwar America and around the world.

The Golden Age of Broadway Musicals

During and after World War II, America's musicals were profoundly different from what they had been in the 1920s and 1930s. Then songwriters and lyricists had hoped for popular hits, their success dependent on record sales and radio programs, not on the shows for which they were initially composed. It was often assumed that most listeners had never seen or heard of the musical in which the songs first appeared.[41] In the 1940s and 1950s the shows mattered: it was impossible to separate the music from the musicals. "Oh What a Beautiful Mornin'" summoned up images of Oklahoma's rustic charm, just as "Some Enchanted Evening" transported you to an island in the South Pacific. These were not the sorts of songs that Frank Sinatra could make his own as he had the urban blues of the 1930s.

In part, the transformation of the Broadway musical reflected the end of the Great Depression, the patriotism of the war years, and the affluence of postwar America. But the disappearance of the old-style musical also coincided with George Gershwin's death in 1937. In the

same year, Cole Porter was injured in a horse-riding accident that crushed his legs, leaving him crippled and in terrible pain for the rest of his life. Although Porter remained productive, both these events suggested the passing of a musical theater rooted in showstopping tunes and the emergence of an art form in which the story was as significant as the songs.

The "new" musical was best symbolized in the contrast between the songs Richard Rodgers wrote with Lorenz Hart and those he wrote with Oscar Hammerstein. In 1942 *By Jupiter* opened on Broadway. It turned out to be the last show on which Rodgers and Hart collaborated. At the time, Rodgers was interested in composing a musical version of Lynn Riggs's 1931 play *Green Grow the Lilacs,* which was set in Oklahoma at the start of the twentieth century. Rodgers had begun to realize that, in the midst of World War II, the cleverness and urbanity of the musicals of the 1920s and 1930s were no longer fashionable. Instead, people seemed to want a greater emphasis on simplicity, and on an embrace of the country's rural and regional traditions.[42] So Rodgers was ready to follow in the artistic footsteps of Thornton Wilder, Norman Rockwell, and Aaron Copland.

Lorenz Hart, however, was no Thomas Hart Benton, enthralled by the "common man" (or woman). A classic city boy, and an increasingly morose alcoholic, Hart rarely woke up to—or was capable of writing about—beautiful mornings. Oscar Hammerstein could not have conceived of a show with a character as cynical as Joey Evans, the "star" of *Pal Joey.* Hart—the man who thought up the lyrics to "Manhattan"—could hardly have written a musical as cheery as *Oklahoma!* (though he might have contributed a song about how poor Jud was dead, shot in the head).

Hart and Hammerstein were antithetical in the words they used and the feelings they expressed. Hammerstein had written dreamy operettas with Sigmund Romberg and Rudolf Friml in the 1920s, and the sentimentality of these works never left him even when he was dealing with more serious subjects (as in the case of *Show Boat* and *South Pacific*). Wit and irony were not his specialties, as they were for Hart. Rather, Hammerstein cared about the details of daily life, to be rendered as much as possible with an uncomplicated, even cockeyed, optimism. Moreover, while Hart was content to write ingenious lyrics,

Hammerstein delivered messages, especially on the themes of war and racial prejudice. For Hammerstein, the audience needed not only to be entertained but to be carefully taught.

With Hart, Rodgers had always written the music first. Hart supplied the words later, his rhymes adjusting to Rodgers's mostly jazz rhythms. Now Rodgers wrote the music to fit Hammerstein's more oratorical lyrics. Thus Rodgers's music became less conversational but more emotional, less a product of Tin Pan Alley and more operatic.[43]

Indeed, while many critics have preferred Rodgers and Hart to Rodgers and Hammerstein, this is not because the quality of Rodgers's music declined. If anything, Rodgers's music grew more complex and the melodies soared, the dances became grander and the waltzes (as at the beginning of *Carousel*) were more evocative of the play the audience was there to see. Instead, what the critics disliked was the banality of the words, and the faux populism that converted a Broadway musical into a pretentious—rather than satirical—political statement. They wanted an American *Threepenny Opera,* not a ersatz European *Sound of Music.*

Yet the disdain for Hammerstein's lyrics paled before the success of the musicals he wrote with Rodgers. None of Rodgers and Hammerstein's works was more of a smash than their first show, *Oklahoma!,* which debuted on Broadway in 1943 and ran for five years and a record-shattering 2,212 performances. Its popularity was enhanced by the cast album, which sold more than a million copies when it was originally released, and made cast albums obligatory for every other musical. *Oklahoma!*'s album allowed people who had not seen the show to imagine themselves sitting in the theater, watching the singers and dancers on stage.[44] The album was therefore instrumental in establishing the Broadway musical as an essential component of America's wartime and postwar culture.

Show Boat, Of Thee I Sing, and *Pal Joey* had all combined a story with songs. But what made *Oklahoma!* special was its even more sophisticated fusion of music, dance, and drama. Among *Oklahoma!*'s most innovative qualities was its dream ballet, choreographed by Agnes de Mille. Here, the dancers (cast by de Mille as much for their acting ability as for their physical grace) illuminated both the plot and their characters' personalities. Though de Mille was influenced by George

Balanchine, she was more interested—both in *Oklahoma!* and in *Carousel,* which she also choreographed—in blending modernist ballet with American folk dances.

Because of de Mille, dream ballets became a fixture in American musicals for the rest of the 1940s and into the 1950s. And in movies too, as in the case of Gene Kelly's seventeen-minute fantasy ballet near the close of *An American in Paris.*[45]

Still, for all its stylistic modernity, *Oklahoma!* was—as de Mille recognized—an exercise in Americana. It was also a celebration of the end of the Great Depression. In 1939 John Steinbeck had portrayed an Oklahoma in *The Grapes of Wrath* that, like the rest of America, was still marked by scarcity and deprivation. Now, in 1943, Rodgers and Hammerstein created a mythical Oklahoma that, unlike Steinbeck's dust bowl, was a bountiful land where the corn grew as high as an elephant's eye. Their musical summed up the spirit of a people who had finally freed themselves from the constraints of the 1930s and could once again relish the vitality of the United States.

Audiences elsewhere could also appreciate the music and the tale. When *Oklahoma!* opened in London in 1947, it was as popular as it had been in America. By the 1950s the show was drawing large crowds in France and Italy and would soon be performed throughout the world.[46] *Oklahoma!* was thus a global as well as an American success story.

Rodgers and Hammerstein's affection for the American past surfaced again in 1945, in *Carousel.* The musical was based on Ferenc Molnár's *Liliom,* first performed in 1909. Rodgers and Hammerstein transplanted the play from Budapest to a New England fishing village and filled it with pastoral images and semioperatic soliloquies. But for Rodgers and Hammerstein any country's past would do, including Thailand's, as in *The King and I,* which began its Broadway run in 1951.

Yet with World War II still vivid in people's minds, Rodgers and Hammerstein turned in 1949 to the present with *South Pacific.* They adapted the musical from two stories in James Michener's *Tales of the South Pacific* (one of which, the story of an American lieutenant and a Tonkinese girl, was itself influenced by Puccini's *Madame Butterfly*).[47] *South Pacific* was not only Rodgers and Hammerstein's most contem-

porary but also their most serious musical, with an elegant score that revealed the psyche of the characters more intimately than had their previous works. In this show, a woman could be as corny as Kansas in August without sounding inane. Meanwhile, the nurses, the Seabees, and the naval officers confronted—as their audiences were having to do —the dawn of America's cosmopolitan encounters, the nation's arrival as a global superpower when the country knew (as the French planter, Emile de Becque, observes) what it was against in the world if not what it was for.

South Pacific might well have been Rodgers and Hammerstein's finest work, its songs (especially "Bali Ha'i," "Younger Than Springtime," and "This Nearly Was Mine") less earnest but more moving than in any other show they wrote. *The Sound of Music* in 1959 was their last musical, a more one-dimensional and less plausible treatment of the war years (or of the Nazi menace) than *South Pacific*. Hammerstein died in 1960, and Rodgers was never able to equal the triumphs he enjoyed with his partner. But the movie version of *The Sound of Music* in 1965, starring Julie Andrews, became the most profitable film version ever made of a Broadway musical, attracting enthusiastic audiences at home and abroad.

Throughout the 1940s and 1950s Rodgers and Hammerstein had competitors, capable of writing at least one musical that entered Broadway's pantheon. Just as Irving Berlin proved in 1946 with *Annie Get Your Gun* that he could write an integrated Broadway musical, so Cole Porter demonstrated in 1948 with *Kiss Me, Kate* that he could do it better or as well. Where Berlin was fascinated in *Annie Get Your Gun* with the connections between the Wild West and show business, Porter —not surprisingly—turned to high culture as the source of his ideas and his songs. The plot of *Kiss Me, Kate* focused on the efforts of an acting troupe to put on a modern musical version of Shakespeare's *The Taming of the Shrew*. The premise allowed Porter to convert some of Shakespeare's lines into song lyrics, notably in "I've Come to Wive It Wealthily in Padua" and "Where Is the Life That Late I Led?"[48]

Porter's most inspired number was "Brush Up Your Shakespeare," in which two gangsters use the titles of the Bard's plays to dispense advice to lovers, in the show and in the audience. If, for example, your girlfriend doesn't respond "when you flatter 'er," rely on what

"Tony" told "Cleopaterer." And if she complains that your behavior is "heinous," then kick her in the "Coriolanus." The public in the late 1940s got the Shakespearean allusions: the show was a success on Broadway and, more predictably, in London.

Yet no adaptation of a literary or dramatic source was more commercially successful or wittier than *My Fair Lady*. With lyrics by Alan Jay Lerner and music by the Viennese émigré Frederick Loewe, *My Fair Lady* was based on George Bernard Shaw's *Pygmalion*. The show retained much of Shaw's dialogue. *My Fair Lady* also reflected the influence of Gilbert and Sullivan, particularly in the patter songs performed by Rex Harrison as the haughty phoneticist Henry Higgins. Still, despite its British roots, *My Fair Lady* presented a traditionally American message. At the end of the musical Eliza Doolittle returns to Higgins (which she does not do in *Pygmalion*), implying that love, or at least fondness, can overcome any linguistic or class conflicts—the very opposite of the lesson Shaw intended.

Happy endings, however, work overseas as they do in America. *My Fair Lady* debuted on Broadway in 1956 and ran for 2,717 performances, exceeding the record set by *Oklahoma!* The cast album became a best-seller, signifying how important Broadway musicals were in America in the 1950s.[49] In the meantime, the London production, beginning in 1958, lasted for 2,281 performances, a record for an American musical abroad. Eventually, the show appeared around the world, with Eliza speaking in the accents of Berlin, Amsterdam, Prague, and Tokyo.

Yet at the moment musicals were most dominant in the culture, they were having less impact on the tastes of a younger audience, more taken with rock than with a romantic Broadway tune. Part of the reason for the decline of interest among the young was precisely that Broadway shows were no longer written to produce independent hits. Some songs, of course, did reach the radio disc jockeys and record buyers: "Maria" from *West Side Story,* "Aquarius/Let the Sunshine In" from *Hair,* "Send in the Clowns" from Stephen Sondheim's *A Little Night Music.* But popular music, the kind young people wanted to hear or dance to, now came from the Beatles, not from Irving Berlin.

By the 1970s musicals appealed increasingly to older adults, especially those who could afford the escalating price of a theater ticket.

And Broadway's composers were discovering that they could no longer look to Hollywood, as they had in the 1930s and 1940s, for commercial or artistic salvation.

The Golden Age of Hollywood Musicals

For a quarter of a century, from the late 1920s until the mid-1950s, musicals written specifically for the movies were an indispensable part of Hollywood's annual production schedule. Beginning with MGM's *The Broadway Melody* in 1929 (which won the Oscar for best picture), the movie industry depended on musicals to attract audiences and make money. The studios also relied on Broadway singers, dancers, and songwriters, who provided the talent and the material for most of Hollywood's musical extravaganzas.[50]

Yet initially, the customs of the stage musical did not translate easily to film. In the early talkies, in contrast to the theater, it was disconcerting for a character to erupt without warning into a song and then return to speaking without the audience first having applauded.[51] How, then, could movies alternate smoothly between dialogue and music?

One answer was to invent a new genre: the backstage musical. In films like *42nd Street, Gold Diggers of 1933,* and *Footlight Parade* (all made by Warner Brothers, the studio that specialized in backstagers), the main characters were performers. Thus it seemed normal for a James Cagney or a Dick Powell, a Joan Blondell or a Ruby Keeler, to move from rapid-fire speech to a song and dance number.

From 1933 to 1937 the chief choreographer of the Warner Brothers musicals was Busby Berkeley. Berkeley began his career directing parades and drills for the United States Army in 1918 before being hired by Florenz Ziegfeld to devise dance routines for Ziegfeld's Follies. The Follies, with its showgirls, its precision dancing, and its majestic staircases, became the foundation of Berkeley's choreography when he joined Warner Brothers.

Berkeley transformed these dance motifs into a gleaming cinematic spectacle. Indeed, his choreography deliberately called attention to techniques available only in film. In particular, Berkeley had a penchant for overhead shots that converted his dance pageants into a kalei-

doscope of abstract designs. To a degree, Berkeley's dances—with their meticulous geometrical patterns and their dozens of anonymous men and women assembled in a massive chorus line—were a monument to the collectivist ethic of the 1930s. But since his movies were populated with schemers, con artists, and would-be stars with unquenchable ambitions, the plots were devoted more to the search for commercial triumph and personal vindication than to a celebration of communal values.[52]

For a time, Berkeley's esthetic shifted movie musicals from an emphasis on singing to a glorification of dancing. Especially tap dancing, which was the most influential form of dance in the American theater and on screen. Tap dancing had been shaped by English and Irish folk dances, Spanish flamenco, and African American step dances during the heyday of the minstrel shows in the nineteenth century. Popularized in the twentieth century by black dancers like John Bubbles and Bill "Bojangles" Robinson, tap dancing became a mandatory skill for nearly all movie actors in the 1930s. James Cagney, George Raft, Mickey Rooney, Buddy Ebsen, Ruby Keeler, Ann Miller, Eleanor Powell—all of these stars were proficient at tap.[53] In fact, tap dancing—as conveyed in movies shown throughout the world—seemed to epitomize American culture as much as did Westerns and gangster films.

Yet the ability to tap dance did not really solve the problem of creating plausible musicals beyond those that featured people putting on a show. What Hollywood needed was someone who could dance (whether tap, or ballroom dancing, or ballet) and sing in a conversational voice, who could make dancing and singing a natural extension of walking and talking.[54] And who could do all of these things both with aristocratic elegance and a down-home "democratic" charm.

Frederick Austerlitz was born at the turn of the century in Omaha, a thousand miles—physically and psychologically—from Broadway or Hollywood. In 1905, when they were taking dance instructions, he and his sister changed their names to Astaire. By the 1920s Fred and Adele had made it to New York and London, appearing in musicals by George Gershwin and other major American songwriters. Their partnership ended in 1932, when Adele married and Fred found himself searching for a new career in the movies.

After his screen test at RKO, a report concluded (according to

Hollywood folklore) that he couldn't sing or act, but that he could "dance a little." RKO hired him anyway, hoping to make musicals that might be different from the standard operettas and backstagers being released by the other studios. Formed in 1928 by RCA from a merger of the Keith-Albee-Orpheum theater chains and Joseph P. Kennedy's Film Booking Office, RKO was not an especially distinguished studio. It had neither the glamour of MGM or Paramount, nor the hard-boiled panache of Warner Brothers. During the 1930s and early 1940s its most notable films were *King Kong, Bringing Up Baby,* and *Citizen Kane*—and, as it turned out, the black-and-white musicals of Fred Astaire and Ginger Rogers.

Astaire and Rogers made nine films together in the 1930s. The most memorable of these were *Top Hat,* in 1935, with music by Irving Berlin; *Swing Time,* in 1936, with music by Jerome Kern; and *Shall We Dance,* in 1937, with music by George Gershwin.

Regardless of the composer, Astaire exercised control over the entire look and style of his movies, not just the songs and the dance routines. His artistic ideals were antithetical to those of Busby Berkeley. Where the dancers in Berkley's chorus lines were indistinguishable and interchangeable, like the workers on an assembly line, Astaire used dance (usually solos or duets) to express his and Rogers's distinctive personalities. Moreover, unlike the relentless editing within Berkeley's numbers, Astaire insisted that his dances be shot as much as possible in a single long take, so that the audience could see the dancer's face and full body at all times, thus accentuating the flow of the dance itself. And since Astaire—like other American dancers and choreographers—blended tap, ballroom and jazz dancing, and ballet, sometimes in the same number, the barriers between classic and popular dancing (of the sort one might find in a European work) dissolved in Astaire's movies.

Whether Astaire dressed in formal evening clothes or more casual attire, whether his character seemed at home in high society or came from the more plebeian middle class, the plots of his films were reminiscent of the screwball comedies of the 1930s.[55] The relationship between Astaire and Rogers was always marked by misunderstandings, mistaken identities, competition, and sexual tensions—none of these resolvable until they danced in each other's arms, their way of making love. But Rogers never swooned. Like Katharine Hepburn and Cary

Grant in *Holiday* and *The Philadelphia Story*, this was a love affair between equals, or at least between two people who were equally eccentric.

After a while, the stories—if not the dances—in the Astaire/Rogers musicals became repetitive. By the end of the 1930s the team broke up. Soon Astaire moved to MGM, the studio known for its glossy Technicolor musicals during the 1940s and 1950s. In the postwar years, Astaire danced with Judy Garland, Cyd Charisse, and Leslie Caron. But he seldom recaptured the spark that he shared with Ginger Rogers, even when he reunited with her one more time, in 1949, in *The Barkleys of Broadway*.

One of the people most responsible for the popularity of MGM's wartime and postwar musicals was the producer Arthur Freed. In contrast to the musicals at Warner Brothers and RKO in the 1930s, Freed —like Rodgers and Hammerstein—often focused in the 1940s on the American past, and on a midwestern world far removed from the streamlined modernity of Manhattan. In *Meet Me in St. Louis* (1944), Judy Garland's family ultimately decides not to depart for New York; it's better to have a romance with the boy next door, and to enjoy a merry little Christmas in the comfort of one's own house rather than in a lavish nightclub in the big city.

Nostalgic or not, two of Freed's films won Oscars for best picture: *An American in Paris* (1951) and *Gigi* (1958)—Lerner and Loewe's first musical after *My Fair Lady*, this one composed directly for the movies. But what may have been Freed's greatest production, *Singin' in the Rain* (1952), won no Oscars at all.

Freed benefited from having superb talent at his disposal—not only Fred Astaire and Judy Garland, but also Vincente Minnelli (who directed *Meet Me in St. Louis, An American in Paris,* and *Gigi*). Above all, Freed had Gene Kelly. With his assertive physical style, his muscular dancing, and his flashy smile, Kelly was the embodiment of MGM's liveliest musicals. Moreover, in the movie version of Leonard Bernstein and Jerome Robbins's *On the Town* (filmed on location in New York), *Singin' in the Rain,* and *It's Always Fair Weather,* Kelly was not only the lead song-and-dance man, but also the codirector, with Stanley Donen.

Like Astaire, Kelly combined tap dancing, ballet, and modern

dance. But it was impossible to visualize Kelly, unlike Astaire, in a top hat and tails. Kelly's character might be a baseball player, a sailor, a silent film star trying to adapt to sound, or an artist hoping to succeed in Paris, but in none of these roles was Kelly suave or upper class. Nor did he make dancing look effortless, as did Astaire. Instead, you could see the hard work involved in Kelly's dancing, the athleticism, the power it took to jump or to lift a woman into the air.[56] At these moments, Kelly's legendary smile looked almost like a grimace. But Kelly was also showing off, and you had to admire the fun he was having dancing and singing in the rain.

It was in his dream ballets, however, that Kelly brooded, the smile erased by sadness, even when he danced with Cyd Charisse or Leslie Caron. There is no Ginger Rogers in these ballets to add a touch of humor or a hint of a happy ending. In Kelly's fantasies, no one falls or stays in love. At the end, Kelly is simply left, alone, staring at a rose.

An American in Paris, of course, was an homage to the music of George Gershwin, never more so than when Oscar Levant imagines he is conducting an orchestra and playing every instrument in a performance of the *Concerto in F.* The movie was also a tribute to Hollywood's idea of modern art—which meant French art of the late nineteenth and early twentieth centuries. Minnelli, the film's director, had been heavily influenced by Impressionism when he was an art student.[57] So, too, is Kelly's character, Jerry Mulligan, who seems never to have heard of Jackson Pollock, and who has decided to journey to postwar Paris, not Manhattan, to study the latest trends in modernist painting. Hence in the concluding ballet, the sets reflect the esthetic world before abstract art, with allusions to Raoul Dufy's Place de la Concorde, Manet's flower market, Renoir's Pont Neuf, Van Gogh's Place de l'Opéra, Maurice Utrillo's vision of Montmartre, and Toulouse-Lautrec's Moulin Rouge.

But the real work of art is the ballet itself, danced to Gershwin's own *An American in Paris.* Kelly was never better as a dancer, or more poignant as an actor. At this moment, he was a match—stylistically and emotionally—for Fred Astaire.

Kelly and Astaire dominated the golden age of Hollywood musicals. Yet by the mid-1950s that era was ending. Given the competition from television and other leisure pursuits, it was becoming too expen-

sive for the studios to maintain large orchestras and a corps of singers and dancers signed to long-term contracts.[58] It seemed simpler and cheaper to buy the rights to Broadway shows and adapt them to film rather than to develop ideas for original musicals. And it was also more profitable to cast the movies with box office stars who couldn't necessarily sing or dance—like Rossano Brazzi in *South Pacific,* Sidney Poitier in *Porgy and Bess,* Natalie Wood and Richard Beymer in *West Side Story,* and Audrey Hepburn in *My Fair Lady.*

For these movies, the studios recruited directors who had no experience with musicals. So, Fred Zinnemann directed the film version of *Oklahoma!,* Joseph Mankiewicz directed *Guys and Dolls* (here, at least, Marlon Brando as Sky Masterson actually sang his own songs rather than having them dubbed), Robert Wise directed *West Side Story* (after his codirector, Jerome Robbins, was fired from the picture) and *The Sound of Music,* George Cukor directed *My Fair Lady,* and Francis Ford Coppola directed *Finian's Rainbow.*[59] Apparently, the notion that musicals required directors who knew something about the genre was now considered quaint.

The overblown musicals of the 1960s could still win Oscars for best picture, as in the case of *West Side Story, My Fair Lady, The Sound of Music,* and *Oliver!* But the movie musical had lost its vigor and artistic creativity. Or so it seemed until a few movies in the 1970s reinvented the musical for a brand new audience, in America and abroad.

It Don't Worry Me: Musicals in the 1970s

"It's show time, folks." This is a line that could have been exclaimed in every Warner Brothers backstage musical of the 1930s. In fact, it is uttered repeatedly by Bob Fosse's alter ego, Joe Gideon, in *All That Jazz* (1979), as he gazes at himself in a mirror in the morning—a haggard man, with a perpetual cigarette dangling from his mouth, confronting another day when he's expected to edit a movie and choreograph a dance for an upcoming Broadway show.

As it happened, all the great movie musicals of the 1970s— Fosse's *Cabaret* (1972), Robert Altman's *Nashville* (1975), John Badham's *Saturday Night Fever* (1977), and *All That Jazz*—were in large part about show business. Yet they differed from their backstage pred-

ecessors in that now the stories mattered, and so did the acting. The plots of earlier movie musicals, and of Broadway shows as well, usually had to be endured before the songs began. So directors needed singers and dancers (like Astaire, Kelly, and Garland) who could act reasonably well when called upon to deliver their lines. What the movies of the 1970s required were superb actors who could sing (like Liza Minnelli and Joel Grey), dance (like John Travolta), or at least pretend to be musical (like Roy Scheider). In Altman's case, the actors in *Nashville* (and in his last film, *A Prairie Home Companion*) were encouraged to write and perform their own songs.

Most of the musicals before the 1970s, in Hollywood and on Broadway, ended happily, with a man and a woman acknowledging the power of their love for each other. In contrast, the movie musicals of the 1970s ended darkly, with couples breaking up, or one of the main characters getting shot or dying from a heart attack. Indeed, the specter of death—of a partnership or even of a country's ideals—hovered over these films. And the audience was not to be trusted; out there, among the fans, there might be a psychotic or even some Nazi storm troopers, waiting to destroy the world of the people on stage.

Of these movie musicals, the only one adapted from Broadway was *Cabaret*. With songs by John Kander and lyrics by Fred Ebb, *Cabaret* was based on the stories in *Goodbye to Berlin* by Christopher Isherwood, set in the waning days of the Weimar Republic. You can't create a Broadway show or a movie about Berlin in the late 1920s and early 1930s without summoning up the Expressionist atmosphere of a Fritz Lang film, or echoing the words and music of Bertolt Brecht and Kurt Weill. It helped, on stage, that one of the main characters, Fräulein Schneider, was played by Lotte Lenya, Weill's wife and a star of *The Threepenny Opera,* both in its original presentation in Berlin in 1928 and in its revival in New York during the 1950s. As the director of *Cabaret* on Broadway, Harold Prince understood that the music—rather than simply propelling the plot, as in traditional musicals—was to provide an ironic commentary on the characters and the era they inhabited. His production, which debuted in 1966, ran for 1,165 performances in New York and opened in London in 1968.

Instead of reverently transferring the Broadway show to the screen, Bob Fosse reimagined it as a work of cinema. Some characters

and songs were eliminated, new songs like "Mein Herr" and "Maybe This Time" were added, themes like homosexuality were emphasized, and Sally Bowles (originally British) was transformed into an American to accommodate Liza Minnelli. Fosse continually cut back and forth between the musical numbers at the Kit Kat Club and the lives of his characters outside the club, so that each scene was a metaphor for both the spirit of the cabaret and the larger political climate of Berlin.[60]

Most of all, Fosse brought to the film his background as a dancer. He had grown up in the honky-tonk culture of vaudeville and burlesque, and his dance routines in *Cabaret* were suffused with jazz rhythms, sensuality, and bravado, as much as they imitated the dissonant sounds of Kurt Weill (who was himself fascinated by jazz). In the shows Fosse choreographed and directed on Broadway (like *The Pajama Game, Damn Yankees, Sweet Charity,* and *Pippin*), as well as in his films, his numbers always seemed to feature the hunched shoulders and pelvic thrusts of his dancers, clothed in black, their knees bent and their feet turned in, their fingers snapping as they slinked across the stage or the screen, wearing bowler hats and gloves, and making love (so it appeared) to the chairs and the floor.[61]

Only once in the movie was there a song performed outside the cabaret, in a beer garden. But this sequence is the most chilling moment in the film. The camera focuses on the blond hair and angelic face of an adolescent with a choirboy voice. As the camera pans down, we discover that the boy is in uniform, a member of the Hitler Youth, and what he sings is "Tomorrow Belongs to Me." By the end of the song, the whole crowd in the beer garden, except for one old man, is standing and singing along with him, as he gives the Nazi salute. This scene foreshadows the close of the film, after the sinister but burned-out master of ceremonies has bid everyone farewell, and the camera focuses on the reflection of the audience in the chrome along the side of the stage. With drums rolling, the camera picks out the Nazis seated amid the burghers and their female companions, the presence of these brown-shirted thugs a symbol of what "tomorrow" will really bring.

Fosse won an Oscar for best director, edging out Francis Ford Coppola for *The Godfather*. Liza Minnelli as Sally Bowles won the Oscar for best actress, and Joel Grey as the M.C. won for best supporting actor. *The Godfather* was a masterpiece, but so too was

Cabaret—the most disturbing movie musical ever made . . . until *Nashville*.

Many people don't think of *Nashville* as a musical, though it is an acerbic portrait of the country music industry. Robert Altman had already revised the war movie genre with *MASH* in 1970 and the Western with *McCabe and Mrs. Miller* in 1971. So why not re-create the musical as a satire of the culture and politics of the 1970s?

The movie was classic Altman; it could never have been dreamed up or shot by anyone else. All the Altman stylistic trademarks saturate the film: improvisation, overlapping dialogue, twenty-four characters with interlocking stories, the tale told from multiple points of view so that the audience (like the befuddled journalist from the BBC) is not sure whom to focus on or whose drama is central to the meaning of the movie. Actually, the audience isn't really meant to unravel the plot. The total, all-enveloping experience of watching the film is ultimately what counts.

Yet there is a dominant theme. The events of *Nashville* coincide with a celebration of America's bicentennial birthday. "We must be doing something right," Henry Gibson as Haven Hamilton sings, "to last two hundred years." But the bicentennial is an opportunity for the inhabitants of *Nashville* to claim their rungs on the ladder of country music fame, even if this means competing for prominence at a sleazy political rally. The stars are unctuous and self-regarding. And they'll do anything to seduce anyone. "I'm easy," a folk singer played by Keith Carradine croons to an entire room full of women, each one hoping she's the one he wants to bed.

All the songs comment on the characters, their ambitions, and their bottomless capacity for moral compromises. Except in the case of Barbara Jean (played by Ronee Blakley), the prima donna of country music, whose songs reflect her loneliness and fragility. She's a rural version of Judy Garland, emotionally unstable, overwhelmed by the pressures of being a star, for whom "my Idaho home" is a fantasy land to which, in her celebrity, she can never return.

Judy Garland's Dorothy gets to leave Oz and go home to Kansas. Barbara Jean's destiny, however, is to be shot by a member of her worshipful audience, as John Lennon would be murdered a few years later. The shooting is a reminder of all the assassinations that plagued Amer-

ica in the 1960s and 1970s.[62] "This isn't Dallas," Haven Hamilton whines. "It's Nashville."

Then he hands the microphone to an aspiring singer with the anonymous name of Albuquerque who has lurked throughout the movie at the periphery of the action. Here's her chance, as in so many backstage movie musicals, to walk out on the stage and become a star. In her moment in the spotlight, she breaks into one of the most mordant songs in the history of musicals: "You may say I ain't free / But it don't worry me." As the camera cuts back and forth between Albuquerque and the dazed crowd, before pulling back to reveal the entire mad spectacle, what she is singing is a new, uproarious, but hardly inspirational American anthem. Moviegoers are left not with a sense of exultation, as at the end of *Oklahoma!,* but only with an ironic Altmanesque shrug.

Bob Fosse's *All That Jazz* owed less to Warner Brothers, MGM, or Broadway than to Federico Fellini. Roy Scheider's Joe Gideon is like Marcello Mastroianni's Guido in *8½.* Both Guido and Gideon are beleaguered by actors, producers, press agents, critics, ex-wives, and current lovers. Gideon, however, is also trying to ignore his own mortality. Meanwhile, he's seeking to finish a movie and put on a Broadway show. "What's the matter?" he asks God, as if He were the lead reviewer for the *New York Times.* "Don't you like musical comedy?"

As in *Cabaret,* the movie shifts between a gloomy story and audacious musical routines—including one called "Take Off with Us" in which the dancers remove most of their clothes, not the kind of choreography one might find even in a Busby Berkley film. But it is, as Gideon's ex-wife admits, "the best work you've ever done, you son of a bitch."

The movie was semiautobiographical: Fosse suffered a massive coronary while he was working on a film about Lenny Bruce and rehearsing the musical that became *Chicago.* In the movie, Gideon, recovering from a heart attack, envisions his illness as the occasion for one more spectacular production number.[63] "Bye Bye Life" is the film's showstopper, sung and danced (mostly by Ben Vereen) to the exuberant applause of everyone in Gideon's world—all of this just before he surrenders to the waiting arms of "Angelique," clad entirely in white,

a woman as the angel of death. Where Guido at the close of *8½* embraces his life, Gideon vanishes into a body bag. For all its erotically charged music and dance, Fosse's film was ultimately grimmer than Fellini's comic meditation on the cinema.

The modernist disparity between the realism of everyday life and the grand illusions of the stage—a conflict explored in *Cabaret, Nashville,* and *All That Jazz,* as well as in *Saturday Night Fever*—was the signature theme of American musicals in the 1970s, and one that captured audiences overseas, where all four films were major hits. *All That Jazz,* in fact, won the Palme d'Or at the Cannes film festival. Each of these movies also had an impact on later movie musicals—particularly Baz Luhrmann's *Moulin Rouge!* (2001), Rob Marshall's film rendition of Fosse's *Chicago* (2002), and Tim Burton's adaptation of Stephen Sondheim's *Sweeney Todd* (2007). Most of all, they shaped the musicals that appeared on Broadway in the final decades of the twentieth century, musicals that broke with the tradition of Rodgers and Hammerstein as much as the new movies departed from the style and story lines that had once attracted audiences to the dancing and singing of Fred Astaire and Gene Kelly.

Modernist Musicals on Broadway

If conventional musicals might be going out of fashion on Broadway, then what would replace them? One possibility was to try to reinvent the stage musical in the same way that Bob Fosse or Robert Altman had transformed the movie musical. In some instances, this could mean adopting the techniques of modernism to call the audience's attention to the structure and style of the musical itself, to experiment with more contemporary forms of music (like rock, rap, or atonality), and to dramatize a "concept" rather than just a story. These changes might make the musical more abstract and less purely entertaining, but they could also enliven the genre and attract new theatergoers, especially those interested in dance or opera.

In *On the Town* (1944) and *West Side Story* (1957), Leonard Bernstein and Jerome Robbins provided two early indications of what a "modernist" American musical might look and sound like. Bernstein was the heir, musically, to George Gershwin and Aaron Copland. Like

theirs, his cultural roots were Russian and Jewish. And like them, Bernstein wanted to create a new American music, one that could be both "serious" and popular, and that drew heavily on jazz. Robbins, too, came from a Russian Jewish background and sought to blend high art with popular culture.[64] For Robbins, this meant intermingling modern dance and ballet in a choreography that, at least on Broadway, was less full of folk idioms (of the sort that Agnes de Mille favored) and more evocative of urban jazz.

On the Town originated as a ballet called *Fancy Free.* Although Bernstein altered the music for *On the Town,* and Betty Comden and Adolph Green supplied the lyrics and the book for the musical, both works were about three sailors on shore leave, experiencing New York as a "helluva town" (changed in the Gene Kelly movie to a "wonderful" town) where the "Bronx is up and the Battery's down." The ballet and the musical were each drenched in the jazzy rhythms of the city. Additionally, Bernstein and Robbins were following the example of Gershwin in *Rhapsody in Blue,* interpreting New York as the site of modernity. In short, *On the Town* was a Broadway show that celebrated the merger of classical and popular music, and where the dances were as important as the songs or the plot.

Starting in 1949 Bernstein and Robbins, along with the playwright Arthur Laurents and eventually Stephen Sondheim (serving solely as a lyricist), were at work on a musical version of *Romeo and Juliet.* By 1957, when *West Side Story* debuted on Broadway, they had converted Shakespeare's play into a saga of juvenile gang warfare on the streets of New York. Now New York was no longer a wonderful town. Somewhere, there might be a place for the two lovers, Tony and Maria, but it was clearly not New York.

In 1954 Bernstein wrote the score for *On the Waterfront,* and its moody music seemed like a rehearsal for *West Side Story*'s mixture of jazz, rock, and Latin American cadences. Essentially, though, *West Side Story* was as much about dance as about its doomed lovers. Numbers like the opening "Jet Song," "America," "Cool," and the rumble between the Jets and the Sharks became the hallmarks of *West Side Story,* as famous as the music and the lyrics. So it was appropriate that Robbins received credit for having "conceived," directed, and choreographed the show.[65] Robbins was, as much as Bernstein, the "auteur"

of *West Side Story,* and his prominence would inspire later director-choreographers like Michael Bennett and Bob Fosse.

Perhaps because of its modernist music and dance, *West Side Story* was a hit not only on Broadway but overseas. The show began in London in 1958 and ran for 1,039 performances, until 1961. In 1962 the London production toured Scandinavia. Meanwhile, other productions of *West Side Story* played in Israel, the Middle East, and Africa.

With its reliance on jazz and its occasional allusions to the rhythms of rock and roll, *West Side Story* influenced later American musicals—notably *Hair* (1968) and *Rent* (1996). Both of these shows, like *West Side Story,* became enormously popular abroad. *Hair* was staged not only in London, where it ran for more than five years, but also in Western and Eastern Europe, Scandinavia, Brazil, Argentina, Japan, and Australia. Similarly, *Rent* (a rock musical based on Puccini's *La Bohème*) has been performed in more than twenty languages, from Europe to Africa and from Asia to Latin America.

The legacy of *West Side Story* was also evident in the dance musicals of the 1970s, particularly Fosse's *Chicago* (with its minimalist sets and jazz score by Kander and Ebb) and *A Chorus Line.* Directed by Michael Bennett, with music by Marvin Hamlisch, *A Chorus Line* was based on tape-recorded group therapy–style workshops in which dozens of dancers discussed their ambitions and the difficulties of their careers. Bennett then molded the tapes into a show about dancers on Broadway—in effect, a musical (very much like Fosse's *All That Jazz*) about the joys and frustrations of creating musicals. While the show, in typical modernist fashion, was self-referential, an "inside" view of the dancer's life in a chorus line, it was a gigantic hit in New York, where it lasted for 6,137 performances, the longest-running Broadway musical up to that time. Productions of *A Chorus Line* were also mounted across the globe, and the show became one of the most successful of Broadway's exports to the world.

Stephen Sondheim's musicals were more complex and less immediately accessible to a mass audience. Sondheim was once a protégé of Oscar Hammerstein, but he later studied with Milton Babbitt. Sondheim's musicals—like *Company, Follies, A Little Night Music* (based

on Ingmar Bergman's *Smiles of a Summer Night*), *Sweeney Todd*, and *Sunday in the Park with George*—were antithetical to Rodgers and Hammerstein's notion of what constituted a smooth and lyrical Broadway show. Sondheim's music was usually tonal, but he experimented with dissonant harmonies and intricate melodies that could have been written as easily by Stravinsky as by a Broadway composer. Moreover, his shows were principally about characters and themes, like the experience of a painting by Georges Seurat bursting into life.

Most of Sondheim's compositions could not be easily detached from the shows in which they appeared. They were clearly not intended to be additions to the Great American Songbook.[66] On the contrary, they were semioperatic, which is why both *Sweeney Todd* and *A Little Night Music* have often been performed in opera houses abroad, rather than simply as touring editions of a typical Broadway musical.

The majority of successful musicals on Broadway, however, were neither modernist nor thematic. The way to compete over the past forty years with other forms of popular entertainment was to put on shows with massive special effects, as if these were substitutes on stage for movies, MTV music videos, or rock concerts. Such shows employed synthesizers, wireless microphones, and sets that often overpowered the performers.[67] Broadway also depended on imports from England or France, as in the case of *Les Misérables* and Andrew Lloyd Webber's *Evita, The Phantom of the Opera,* and *Cats.* All of these extravaganzas, along with the adaptation of Walt Disney's animated movie *The Lion King,* were immensely profitable.

Still, from the influence of Gilbert and Sullivan and the European-style operettas, to George Gershwin's synthesis of classical music and jazz, to the blend of high and low culture in the lyrics of Cole Porter and Lorenz Hart, to Jerome Robbins's use of modern dance in shows like *On the Town* and *West Side Story,* to Stephen Sondheim's experiments with semioperatic musicals, American composers combined a modernist esthetic with popular culture. And they invented a form of art and entertainment that was popular throughout the world. In this sense, they were following the examples of America's modernist painters, its refugee and native-born architects, its advertisers and designers, its "serious" composers, and its jazz musicians.

But Broadway's musicals, even with fog machines and high-decibel sound systems, could never match the realism or the spectacle audiences could enjoy on the screen. So no matter how modernist or popular Broadway musicals were with both an American and an international clientele, Hollywood became the locale most responsible for the global impact of American culture.

"I Was Just Making Pictures"

FROM CHARLIE CHAPLIN TO CHARLIE KANE

■

In F. Scott Fitzgerald's *The Last Tycoon,* Monroe Stahr—a movie producer modeled on MGM's Irving Thalberg—has imported a novelist from New York named George Boxley to write screenplays. Boxley rarely goes to the movies, knows nothing about how they're made or why they appeal to the public, and submits scripts that are full of "talk." So Stahr makes up a scene for Boxley: a mysterious woman enters Boxley's office while he's there, dumps some coins on his desk, and prepares to burn her black gloves in the stove by the wall. At that moment Boxley's telephone rings, she answers it, and says that she's never owned a pair of black gloves in her life. Then she hangs up and lights a match by the stove, and suddenly Boxley sees that there is another man in his office watching every move the woman makes.

Boxley is transfixed. "What happens?" he asks Stahr. "I don't know," Stahr shrugs. "I was just making pictures."

We're all transfixed. And we have been for more than one hundred years. Since the dawn of the twentieth century, movies have been the most important and the most popular form of art and entertainment in the modern world.

As both art and entertainment, films have utilized the techniques of modernism. On the one hand, the editing of movies is much like the

paintings of the Cubists, the Futurists, and the Surrealists. Panoramic long shots intermixed with medium shots and close-ups, cross-cutting between different characters and stories in different places, quick action scenes alternating with those that have slower rhythms, flashbacks and flash-forwards, and varied camera angles all combine to create a feeling of movement as well as a sometimes fractured sense of time and reality.[1] The fragments of experience, captured in a single shot and then juxtaposed with other shots to produce a multiplicity of perspectives, are the cornerstones of the cinema, and they are also central to the modernist view of the world.

On the other hand, moviemaking—at least in the United States— has always been a business, merging the vision of the director or the star with assembly line forms of mass production. In addition, films have used elements from literature and drama as well as from vaudeville and the circus, thereby obliterating (as modernist painters and composers often did) the conventional boundaries that separated high from low culture.

If the movies are modernist, they are equally cosmopolitan, especially in America. In the twentieth century, Hollywood emerged as one of the cultural capitals of the modern world. But it was never an exclusively American capital. Like other cultural centers—Paris, Vienna, Berlin, New York—Hollywood was home to an international community of artists and their merchandisers. Its film studios were built by immigrant entrepreneurs who drew on the talents of actors, directors, writers, cinematographers, editors, composers, costume and set designers from all over the world. One of the first "American" movie stars, after all, was Charlie Chaplin, whose comic skills were honed in British music halls.

Yet more than the Abstract Expressionists, the refugee architects, the modernist composers like Aaron Copland and George Gershwin, the jazz musicians, and the creators of the Broadway musicals, Hollywood's artists and studio heads were responsible for America's most influential cultural export. However reliant it was on the skills and imagination of foreigners, Hollywood turned out movies that defined America—its dreams, symbols, stories, and values. Thus America's culture became a global phenomenon in large part because of the "pictures" that the people in Hollywood just happened to make.

The Birth of the Cinema

Thomas Edison was an inventor, not a moviemaker. But in the 1890s he and his chief assistant, William Dickson, were among the pioneers on both sides of the Atlantic who made film viewing possible. At the start of the decade, Edison and Dickson created their kinetograph, a primitive movie camera, and soon afterward the kinetoscope in which twenty-second to one-minute silent films could be shown to individual viewers in a manner resembling a peep show. Edison and Dickson displayed their inventions at the Chicago World's Fair in 1893. A year later, kinetoscope parlors were flourishing in several American cities, including New York, Chicago, and San Francisco, housed mostly in penny arcades, hotel lobbies, and amusement parks.[2]

The French, however, seized the initiative in film exhibition and ultimately in filmmaking—a lead they did not surrender until World War I. The initial contest between the Americans and the French was over the techniques of movie projection. In 1895 in Paris, Auguste and Louis Lumière introduced a projector that could show images on a screen to a group of people, rather than just to one viewer peering through Edison's kinetoscope. Suddenly, the commercial implications of film exhibition were evident. The Lumière brothers, as alert as Edison to the financial rewards of mass culture, began to promote their discovery around the world.

Edison, no slouch when it came to competition, devised better cameras and projectors near the end of the decade, cornering the market in the United States. Yet Edison and the Lumières were primarily tinkerers rather than showmen. They were more concerned with the improvement of movie equipment than with how films could entertain the public.[3]

Georges Méliès, another Frenchman, was in many ways the first true filmmaker, the spiritual ancestor of George Lucas. In 1902 he concocted a movie called *A Trip to the Moon*. Though his camera never moved, his film was surfeited with special effects, trick photography, and fantastic sets, all in the service of a futuristic tale about scientists building a spaceship to land on the moon.[4]

Méliès, though, was not alone in perceiving the magical potential of the movies. By the beginning of the twentieth century, movies were being made in Scandinavia, Belgium, Austria, Italy, Spain, Mexico, and

Japan, as well as in France and America. And they were being shown in more reputable settings, like nickelodeons and small movie theaters, some of them run by people who sensed that films might be a revolutionary art form for the twentieth century. In 1909 the first movie house opened in Dublin, established by an obscure young novelist named James Joyce.[5]

Despite Méliès's fabrications, most early films consisted simply of someone or something—a dancer, an acrobat, a worker leaving a factory, a train, the ocean—moving in front of a stationary camera.[6] The notion that shots could be edited to tell a story was virtually unknown.

But not for long. Among the staples of filmmaking in the first decade of the twentieth century were Westerns. Drawing on the popularity of dime novels and Wild West shows, movie Westerns depended from the outset on outdoor shooting in eye-catching landscapes, horses, trains, physical exploits, and therefore a moving camera that could record the action and directors who could arrange shots to simulate a plot.

What could better capture the attributes both of the "West" and of film than a tale about some bandits on horseback robbing a train and being pursued also on horseback by a posse representing the forces of law and order? In 1903 Edwin S. Porter—a cameraman and head of production at Edison's studio—made a twelve-minute-long movie called, appropriately, *The Great Train Robbery*. He used many of the ingredients that would become prerequisites for Western directors from John Ford to Sam Peckinpah. Porter, filming on location (though in New Jersey, not Monument Valley), cut between a telegraph operator and his daughter, and between the holdup of the train and the chase, ending with a gun battle in which the outlaws are killed. The camera panning from one spot or character to another, the parallel editing between events taking place at the same time in different locations, the intermingling of separate shots to propel the story instead of relying on a single scene to encompass the action, all these marked the beginning of narrative filmmaking in America.

Of course, Porter never envisioned a train robbery and a chase as intricate or as spectacular as the one in *The Wild Bunch*. But Porter's movie demonstrated the value (and profitability) of a thrilling cinematic

yarn. The film also testified to the enduring allure of the West; by 1910 more than 20 percent of all the movies made in America were Westerns.[7]

And these, along with comedies and melodramas, were being screened increasingly in what were called nickelodeons—small theaters with wooden benches or chairs where, for five cents, a viewer could see a short film at any time of the day or night. The first nickelodeon opened in Pittsburgh in 1905. Five years later, ten thousand nickelodeons had spread throughout the country. By this time, 26 million Americans were going at least once a week to a nickelodeon, a number greater than all those who went to circuses, the theater, and vaudeville.

The nickelodeons provided a form of amusement, especially to working-class immigrants, that was less expensive than a ticket to a vaudeville show and much less forbidding than the venues of high culture like concert halls or opera houses. You could drop in on your way to a saloon or home from work, or on the weekends with your family. No advance preparation, dress codes, or gracious behavior was required. The nickelodeons were places where those not yet acclimated to the English language or the native customs could watch a movie and socialize among friends, often from the same town or village in Europe.

Film historians have commonly argued that the nickelodeons, and movies in general, helped "Americanize" the immigrants, teaching them the mores of their adopted country, easing the cultural transition from the Old World to the New.[8] Yet the majority of the films the immigrants (and the middle class) saw in the nickelodeons actually came from abroad. "Hollywood" did not yet exist, and neither did the worldwide dominion of the American film industry. For the moment, the center of moviemaking was not in New Jersey or southern California, but in Paris and Rome.

The Globalization of American Films

Hollywood's ascendancy on the world stage was not preordained. Before World War I, the French and Italian movie industries regularly surpassed the United States in film exports. Both countries were also ahead of America in establishing their own movie industries and in experimenting with new cinematic methods.

The leading French film companies in the first two decades of the

twentieth century were Pathé and Gaumont. Because the French audience for films was relatively small, each company needed to export its movies to other countries in order to make money. So by 1910, two-thirds of the movies in the global marketplace came from France.

Pathé was particularly aggressive in expanding its production facilities in France and in other countries, building or buying movie theaters in large cities (including New York), and creating a network of distributors from Europe to Latin America to India and Japan. In the United States alone, Pathé sold or rented twice as many films in 1908 as did all the American film companies combined. The nickelodeons in the United States might not have prospered had it not been for the availability of French films, since there were not enough American movies to satisfy the public's hunger for something to see on the screen. In the absence of genuine competition from America's filmmakers, Pathé's ability to control the production, distribution, and exhibition of its movies, as well as to constantly improve its film equipment, made it the prototype for the studio system that ultimately emerged in Hollywood.[9]

By 1912 both French and Italian directors were turning out multireel feature films, starting with a French version of *Queen Elizabeth,* starring the legendary theater actress Sarah Bernhardt, who seemed incapable of adjusting her histrionic stage technique to the subtler demands of the movies. Italian film companies like Cinès specialized in on-location costume dramas about ancient Rome, taking advantage of the ruins and monuments scattered all over the landscape. In 1913 and 1914 the Italians released *Quo Vadis?, The Last Days of Pompeii,* and *Cabiria,* all of them crowd-packed spectacles running between one and two hours.[10]

Yet the French and Italian command of the international film market was fleeting. As American film companies grew in size and economic strength, and as they developed their own movie stars and multireel epics (culminating with D. W. Griffith's *The Birth of a Nation* in 1915), they began to challenge their European counterparts.

Moreover, the nascent French and Italian film industries had intrinsic weaknesses. Essentially, they were too small, too decentralized, and too underfunded to compete permanently with the Americans. Indeed, in 1913 Pathé chose to concentrate more on the distribution and

exhibition, rather than on the production, of movies. Hence by 1914 the share of original French films in the world market had been cut in half, to 35 percent.[11] The decline in production opened the door in France itself to the import of foreign-made films, especially from the United States.

The final blow came with the outbreak of World War I. French and Italian productions were temporarily suspended just as American exports were accelerating. After the war the need to invest in economic reconstruction meant that little money was left over in France or Italy for large-scale moviemaking. Unscathed by the war, the United States alone had the resources to enlarge its film operations. As a result, America soon became the leader in the production and distribution of movies for a global audience, a distinction the French and Italian studios were never able again to contest.[12]

Apart from the effects of the war, there were commercial and institutional factors that accounted for America's supremacy in the movie business. During the teens and 1920s American studio executives recognized the growing financial importance of foreign markets for their wares. So they boosted their production budgets and the number of films they could show annually to both domestic and international audiences. Then they charged lower rental fees overseas and undersold their foreign rivals. Meanwhile, through the imposition of tariffs on movies imported from abroad and the use of other discriminatory practices like block-booking America's films in American theaters, the studios protected their home market against the encroachment of foreign moviemakers.

The studios also adopted the assembly line techniques successful in other American industries. They began signing their employees to long-term contracts, standardized their products, created "brand names" through the star system, and exercised firm control over their foreign subsidiaries and distribution system. In addition, American film companies came to own half the most fashionable movie houses abroad, including three-quarters of all the theaters in France. Not surprisingly, most of the screen time in the overseas theaters was devoted to American movies.

In all these endeavors, the U.S. government supported the studios. In 1918, for example, Congress passed the Webb-Pomerene Act,

permitting companies that normally competed at home to organize cartels, exempt from antitrust laws, for the purpose of selling their products abroad. Under the auspices of this legislation, the studios united in 1922 to form an association called the Motion Picture Producers and Distributors of America. The MPPDA acted as a lobby both in Washington and abroad, and pressured countries overseas to show the studios' movies.

In retaliation, several European governments sought to limit the import, and thereby the impact, of American movies. From 1925 to 1927, Britain, Germany, France, and Italy imposed quotas on the number of American films that could be shown in local movie theaters. All four countries were trying with these regulations to buttress their own national film industries.

But the American studios found ways to evade the quotas. Sometimes, the studios threatened to cut off the showing of foreign films in the United States. At other times, the studios invested in cheap and poorly made foreign movies, especially in Britain. Many of these films were so feeble that foreign audiences avoided them while retaining their affection for American movies. More important, European exhibitors habitually opposed any restrictions on the screening of American films because they knew their customers favored movies made in the United States.

Above all, America's film companies benefited from a huge domestic market, a market far larger than any of their main foreign rivals. Because there were so many Americans who could purchase movie tickets, the studios expected to retrieve their production costs and turn a profit solely within the borders of the United States. This advantage enabled them to finance big-budget extravaganzas and to spend more money on stars, directors, special effects, location shooting, and publicity—the very elements that also attracted international audiences to American movies. While overseas rentals and sales became increasingly significant (by the 1920s, 20 percent of the studios' gross income came from abroad), American filmmakers could normally count on the cushion of their home market for the bulk of their earnings.[13]

Nevertheless, esthetics were as important as economics in ensuring the global popularity of American films. Many foreigners believed that the Americans simply made better movies. The plots seemed more absorbing, the "look" was more luxurious, and the stars were more

magnetic. The studios' sheer stylistic verve, the superiority of the lighting and cinematography, and the elaborate costumes and set designs all made American movies more attractive to foreign audiences than the films produced in Europe, Latin America, or Asia.[14]

As a consequence, America's movies dominated markets overseas. By the mid-1920s, 75 percent of all the films shown in the world were American. The figures in Europe were especially striking. In Britain, 95 percent of the movies people saw came from the United States; in Spain and Portugal, 90 percent; in the Netherlands, 85 percent; in Italy, 80 percent; in France, 70 percent; and in Germany, which had an energetic film industry of its own during the 1920s, 60 percent. American companies also replaced the French and Italians as the major exporter of movies to Latin America, the Middle East, and Asia. Thus, 90 percent of the movies screened in Mexico, Brazil, Argentina, Australia, and New Zealand were American-made. By the 1930s American studios controlled 75 percent of the market in China and Egypt.[15]

These percentages fluctuated country by country over subsequent decades—notably in Europe during World War II, when the Nazis prohibited the showing of American films in the nations they occupied, and in China after the success of the Communist revolution in 1949. But from the 1920s until today, most of the films that appealed to international audiences were America's.

The global fascination with American movies made artists and intellectuals abroad and at home apprehensive. Foreign critics and filmmakers often contended that the studios were deliberately "Americanizing" the imaginations and attitudes of people throughout the world. After all, audiences seemed to go to American movies out of habit rather than conscious choice. They also devoured fan magazines that gushed over American stars, pined for American products, and fantasized about living like the American upper class.

In reality, the critics charged, American movies (and America's mass culture generally) were brash, superficial, vulgar, infantile, and inane. Far from being a new art form, American films were just another product available for consumption, designed to seduce a gullible public, a commodity to be advertised and merchandised, no different from detergents and washing machines.

Worst of all, America's movies allegedly lowered the standards of knowledge and taste. It was as if the American barbarians (the barely literate potentates who ran the studios) were at the gates. And the gate-keepers—poets and painters, composers and novelists, philosophers and academics, all the defenders of high culture—were in danger of being overrun.

Clearly, American culture (especially the movies) represented a threat to the status and self-esteem of the foreign intellectual elite. How could they continue to act as moral and cultural guides if the masses abandoned Shakespeare, Goethe, Dante, and Confucius for the meretricious charms of Douglas Fairbanks and Mary Pickford? The elites assumed that they alone knew what was good for people, and that if left to their own devices the less educated would invariably prefer trash to enlightenment. It was difficult, therefore, for the intelligentsia (either in the United States or overseas) to admit that American movies had not been imposed or inflicted upon the populace, that the common folk were voluntarily and enthusiastically embracing what their mentors told them to shun.[16]

Hooray for Hollywood

The migration of filmmakers to southern California began as early as 1907 and intensified over the next decade. The West Coast enjoyed a sunnier climate than that of the East, which allowed movie companies to shoot outside throughout the year. And the geography offered nearby valleys, mountains, lakes, forests, and deserts. The Los Angeles area was also attractive especially to Jewish entrepreneurs because there were no social, ethnic, or economic constraints to impede their rise to the top of a brand new industry—and no snooty old families to make them feel like Sammy Glicks.[17] So by the end of the teens, "Hollywood" had become the hub of film production in America.

Next to jazz, movies were the most "American" of cultural enterprises. Yet Hollywood was launched and shaped largely by immigrants or their children, as well as by expatriates and refugees. Most of the founders of the major studios were born outside the United States: in Germany, Poland, Hungary, and Russia. Many of them started out in the retail trades before becoming owners of vaudeville houses or

nickelodeons. Carl Laemmle of Universal once sold clothes in Germany. Adolph Zucker of Paramount was a furrier from Hungary. William Fox, whose movie company later became Twentieth Century–Fox, was also from Hungary and had been a garment worker as a child in New York and a secondhand clothes dealer. Samuel Goldwyn, born in Warsaw, was originally a glove salesman, and Louis B. Mayer, from Minsk, was a scrap metal dealer; both Goldwyn and Mayer were involved in the formation of MGM. Harry Cohn, the head of Columbia, was the son of German Jewish immigrants and initially a song plugger on Tin Pan Alley, while Sam and Jack Warner, who built Warner Brothers, were the children of a Polish cobbler. Only Darryl Zanuck, who eventually ran Twentieth Century–Fox, was a Gentile; he was born not in Warsaw but in Wahoo, Nebraska.

With their backgrounds in merchandizing, the studio bosses understood the need to cater to the tastes of the customers, even if what they wound up selling were movies rather than coats.[18] Yet the moguls were not just merchants. They were also visionaries. They cared as much about the movies they made as about the profits they piled up. Even the names of their studios—Universal, Twentieth Century–Fox, Paramount, Columbia—reflected their desire to construct a business as lofty as a university, as "civilized" as the theater or opera, or as reputable as a white-shoe law firm. Moreover, their movies were meant to have an importance that transcended America. They were to be truly "universal" in their appeal to a worldwide audience.

The way to invest movies with upper-class elegance was through the creation and nurturing of "stars." Stars existed, of course, before the invention of Hollywood. Theaters, operas, circuses, and Wild West shows all had their celebrities, none more famous at home and in Europe at the dawn of the twentieth century than Buffalo Bill (who hoped toward the end of his life to become a movie star). But films needed a particular kind of idol, not only someone who understood the kind of acting movies required but someone whom the camera adored. Such a person—a Lillian Gish, a Mary Pickford, a Douglas Fairbanks, a Rudolph Valentino—could be transformed through the movies into a figure of fantasy who lived an enchanted life, on screen and off.

In the silent era, as Gloria Swanson's Norma Desmond points out in *Sunset Boulevard,* "we didn't need dialogue. We had faces!" But the

faces had to be lit. Early on, the studios developed a filtered or soft-focus style of lighting the stars (especially the women), as if an actress had stepped straight out of an Impressionist painting. By the 1920s MGM—which boasted that it had more stars than there were in the heavens—relied on high-key lighting without shadows, or backlighting for close-ups, the better to illuminate the glamour of a Greta Garbo.[19] And Gloria Swanson herself, in the mid-1920s the highest-paid star in Hollywood, knew exactly how to pose for the camera and its lights. She was always ready for her close-up.

As American stars became national and global icons, some of them sought to take charge of their own careers. In 1919 Mary Pickford, Douglas Fairbanks, and Charlie Chaplin, along with the director D. W. Griffith, formed United Artists—not so much a studio as a company that would distribute their movies.

Yet it was the studios, not independent filmmakers, that were the overseers of the Hollywood that emerged full-blown at the end of the 1920s. After nearly two decades of mergers and acquisitions, five "major" studios (MGM, Paramount, Warner Brothers, Fox, and RKO) and three smaller companies (Columbia, Universal, and United Artists) dominated filmmaking in the United States.

The studios controlled every aspect of the production, distribution, and exhibition of their movies. Men like Louis B. Mayer and Irving Thalberg shaped the scripts, determined the shooting schedules, and chose the casts, the set and costume designers, the composers, the directors, the cameramen, and the editors. The studios also owned the best movie theaters in the largest cities. By 1939 the five "majors" had access to 126 out of 163 first-run theaters in America. These theaters accounted for 70 percent of the profits at the box office.[20] Thus the studios were able to reach the widest possible audience and make sure they had a steady income for their films.

The movies the public saw—both in the United States and overseas—portrayed a mythic America, a country defined by the daydreams of the studio heads and the style they imposed on their films. You could often tell what studio made a movie not so much by its stars or directors as by its subject matter and cinematic techniques. MGM, under Mayer and Thalberg, was known for its glossy melodramas, historical blockbusters, and literary adaptations, each an effort on the part of the

studio to project an image of civility and artistic uplift. Indeed, MGM's motto was Ars Gratia Artis, or Art for Art's Sake—even though most of its films were designed for the sake of selling tickets rather than for the approval of the cultural esthetes. Yet Mayer, who claimed to have been born on the Fourth of July, also insisted that his movies idealize small-town America and the values of family life, particularly if by the 1930s and 1940s the family had a son like Mickey Rooney or a daughter like Judy Garland.[21]

Paramount's movies were usually more sophisticated than MGM's, more cosmopolitan, and more overtly sexual. In fact, Paramount had a reputation for being the most "European" of the American film companies, largely because of the presence at the studio of illustrious émigrés like Maurice Chevalier, Marlene Dietrich, and Ernst Lubitsch.

The most distinctive studio style belonged to Warner Brothers. Its movies, especially in the 1930s, were frequently populated by bootleggers and racketeers, gangsters and private eyes, loners and losers, most of them played by a rogue's gallery of character actors like James Cagney, Edward G. Robinson, Paul Muni, John Garfield, and Humphrey Bogart. They appeared in films whose stories seemed ripped from the headlines and the radio bulletins, featuring characters who were unmistakably urban. The movies at Warners conveyed a feeling of intense modernity with their glimpses of touring cars and beer trucks careening down city streets, their sensitivity to the gloom of pool halls and saloons, and—despite Norma Desmond's lament—their crackling dialogue. Unlike the more genteel Mayer, Jack Warner (who thought of himself as Hollywood's rebel) appreciated films that depicted a darker America, filled with people who were flippant, cynical, and hard-boiled, but who occasionally demonstrated a sympathy for other underdogs and outsiders.[22]

At the beginning of Hollywood's reign, a substantial part of the audience was itself composed of outsiders, people who were much like the scramblers who ran the studios. Many American movies were aimed at immigrants and blue-collar workers. But these groups, also like the studio heads, wanted to escape their lowly origins and were hungry for acceptance. Silent movies through their visual imagery could teach the immigrants about American customs, expectations, and codes

of conduct. The pictures could help them or their children assimilate to their new world and, some day, ascend to the middle class.

The studios achieved respectability more quickly than did the immigrant working class by increasingly pleasing affluent patrons, making pictures (as in the case of MGM) that the entire family could attend. In the 1920s and 1930s Mayer and his rivals at the other studios made going to the movies feel like going to the theater, with glitzy premiers, the bestowing of "academy" awards, and the description of the stars in fan magazines as supremely refined, without any hint of vaudevillian vulgarity.[23]

The studios also needed movie theaters that didn't just show first-run films but that were luxurious, like opera houses. To the executives at the studios, a theater should resemble a cultural haven rather than be merely a cozy place where people could spend a few amusing hours. So the first plush movie house, called the Regent, opened in New York in 1913, followed by the 3,300-seat Strand on Broadway in 1914 and the 2,400-seat Central Park Theater in Chicago in 1917. By the 1920s movie "palaces," as they were now known, had spread throughout the country. They all had gigantic lobbies, numerous balconies in addition to "orchestra" seating, and ushers clad in elaborate uniforms, with tunics, gold braids, and tassels, who escorted viewers with military precision to their well-upholstered quarters.

The palaces reflected the American habit of mixing up artistic influences from Europe, the Middle East, Latin America, and Asia, all as a way of serving the needs of mass culture in the United States. A deluxe movie theater could be built with a Romanesque or Gothic façade, set off by fake Doric or Ionic columns. Alternatively, the stylistic inspiration might come from pre-Columbian Mexico, Moorish Spain, Italy, ancient Persia, India (in the shape of mock-Hindu temples), or China.

Sid Grauman's Chinese Theater in Los Angeles, which opened in 1927, had a pagoda and street in front where the stars (America's Mandarins) could place their hands and feet in cement, giving them and the audience a whiff of immortality.[24] Meanwhile, the chandelier in the lobby of San Antonio's Aztec Theater, built in 1926, was a replica of an Aztec sacrificial calendar stone, complete with painted bloodstains to remind the audience of the tribe's victims. San Francisco's Fox The-

ater offered a lobby that seemed like a shrine to Europe's monarchs and its high culture, with throne chairs, statues, ornate vases, and a duplicate of a chapel at Versailles. Loews's Paradise in Brooklyn was equally eclectic: its lobby was a facsimile of a Venetian Renaissance courtyard, decorated with busts of Lorenzo de Medici, Shakespeare, and, improbably, Benjamin Franklin.

The Depression curtailed the construction of these immense mausoleums. Still, the decade's love affair with Art Deco shaped the style of a few new movie palaces, notably Hollywood's Pantages Theater and Rockefeller Center's Radio City Music Hall, which accommodated nearly 6,000 people. Now, however, the theaters of the 1930s made more money selling popcorn than tickets. Besides, unlike opera houses and the "legitimate" theater, the movie palaces were designed for a heterogeneous audience. All customers (as long as they were white), whether immigrants, workers, or members of the middle and upper classes, were treated identically, and they could sit anywhere. The movies, after all, were meant to entertain everyone, whatever their level of education or their economic resources.

It was the very heterogeneity of America's moviegoers—their ethnic, class, and regional diversity—that forced Hollywood from the early years of the twentieth century to experiment with messages, images, and story lines that had a broad multicultural appeal. This appeal turned out to be equally potent for multiethnic audiences abroad. The American public, and its filmmakers, were international in their complexion. As the British expatriate director Alfred Hitchcock observed, "When we make films for the United States, we are automatically making them for all the world—because America is full of foreigners."

Once the American studios learned how to speak to a variety of groups and classes inside the United States, they had little trouble captivating people from different nations and backgrounds overseas. In effect, the domestic market was a laboratory for and a microcosm of the world market. In contrast, foreign filmmakers, operating for the most part in countries with homogeneous populations, had little incentive to communicate with a multicultural audience, and were ill-equipped to compete with Hollywood in the international arena.[25]

Hollywood was adept at creating products that ignored class divisions, international borders, and ultimately language barriers. The

latter skill became essential once the movies began to talk. But before they did, they created a silent film vocabulary, and a movie icon, that were as global in their popularity as any words a character might utter.

Griffith and the Tramp

D. W. Griffith was an anomaly. In the first two decades of the twentieth century, he combined a modernist style with a Victorian sensibility. On the one hand, Griffith hoped to instill in the masses a renewed appreciation for nineteenth-century values. So he relied in his movies on melodramatic conflicts between good and evil, heroes and villains, as well as sentimental portraits of women caught between virtue and degradation.

On the other hand, Griffith drew on and perfected the grammar of the new artistic medium. He exceeded his predecessors in his use of a mobile camera, tracking shots, cross-cutting and parallel editing, dissolves, flashbacks, and a split screen to tell a story. Above all, he varied the emotional intensity of his camera work and the length of time a scene was on the screen by employing long and medium shots as well as sustained close-ups of faces and hands, the better to emphasize a particular facet of the drama and to guide the viewer toward what was important about a character or a piece of action. Each of these methods made watching one of his movies far different from seeing everything unfolding on a stage.

Griffith was especially attuned to the distinctive ways that actors should perform for the camera. He insisted on less stagy affectations and greater subtlety in the use of gestures. Griffith realized that close-ups allowed an actor to express his or her private feelings merely through a raised eyebrow, a fluttering finger, a wisp of hair out of place, a twinkle or teardrop in the eyes, or the hint of a smile. Thus the close-up made movies a more intimate art form than the theater or a Wild West show. In short, Griffith merged all of these stylistic innovations, many of them discovered by other directors, into a coherent approach to filmmaking.[26]

Griffith, however, was as interested in entertainment as in art. He wanted not just to astound the critics with new cinematic techniques but to reach a mass audience and make as much money as possible. In

this desire, he was typically American in his urge to blend modernism and entrepreneurship.

Though he turned out more than four hundred short films between 1908 and 1913, it was not until *The Birth of a Nation* in 1915 (inspired by the Italian film *Quo Vadis?*) that Griffith had a spectacular, if controversial, success at the box office. Based on Thomas Dixon's 1905 novel *The Clansman,* the movie romanticized the role of the Ku Klux Klan in the post-Reconstruction South, and it depicted blacks with all the stereotypes (devious, shiftless, dull-witted) that evolved into the standard portrait of African Americans in the movies until the 1950s.

Yet *The Birth of a Nation* was Hollywood's first blockbuster, the greatest commercial triumph of the silent era, and the studios' most profitable movie until Walt Disney's *Snow White and the Seven Dwarfs* in 1937.[27] It also had an enormous influence on the future of filmmaking, not least because in its cast were two actors who would become eminent directors: Raoul Walsh as John Wilkes Booth and John Ford as an uncredited Klansman. In addition, *The Birth of a Nation* made the feature film, lasting from ninety minutes to two hours, the norm for American movies, helping Hollywood to surpass its competitors abroad in releasing movies at a length people wanted to see.

Griffith's career, however, faded in the 1920s. His tendency to moralize and his pious attitude toward his characters seemed increasingly old-fashioned in a more mischievous and satirical age, one for which the wit of the Marx Brothers or Cole Porter was more pertinent than the Victorian earnestness of a Griffith film. What Americans appeared to want was a clown, though one whose balletic grace and comic genius converted him into the most recognizable figure in the history of film.

Though Charlie Chaplin became a superstar in America, he was incontrovertibly British. Born in London in 1889, he always spoke with an English accent and retained his British nationality throughout his life. Entertainment in England, as in America, provided an escape from the poverty that marked Chaplin's childhood. Appearing on the Victorian stage and in British music halls, Chaplin was by the age of ten a prodigy as a dancer, acrobat, juggler, pantomimist, and comedian, talents he ultimately carried with him to Hollywood.

In 1906 Chaplin attracted the attention of Fred Karno, an impre-

sario who managed theater companies throughout Britain. Between 1910 and 1913 Chaplin (along with another young comic who eventually named himself Stan Laurel) made several tours of the United States with one of Karno's troupes.[28] It was as the leading comedian of Karno's organization that Chaplin was seen by Mack Sennett, who hired him in 1913 for his Keystone Film Company. Chaplin's first movie role, in a one-reel comedy called *Making a Living,* occurred in 1914.

Comedy was the most popular genre in early films. And many of the most celebrated comedians, actresses, and technicians got their start in movies with Sennett: Fatty Arbuckle, Buster Keaton, W. C. Fields, Gloria Swanson, Carole Lombard, and Frank Capra. Indeed, Sennett's Keystone comedies—with their characteristically American mockery of self-important elites and middle-class decorum—were partly responsible for Hollywood's primacy in the global film market during and after World War I.[29]

Still, no comic actor punctured the arrogance of the powerful and well born more craftily than Chaplin, once he discovered his alter ego. By his second film for Sennett, Chaplin had invented the tramp: a "little fellow" dressed in baggy pants and a tight coat, a derby too small for his head and shoes too large for his feet, with a dainty mustache and an elegant walking stick, and a slightly awkward gait that made him look like he was a boulevardier about to take a pratfall at any moment. Chaplin's tramp blended upper-class fastidiousness with a hobo's seedy charm. He was the sort of personage who would carefully tuck a napkin under his chin before eating his shoe. Yet the tramp, in the teens and 1920s, was not so much an analyst of social inequities as a universal symbol of the absurdity of modern times.

By the 1930s, though, the tramp was becoming less a free spirit than a character trapped by economic and political circumstances. In *City Lights* (1931) the tramp is still an outsider with only marginal connections to the social order. Insofar as the forces of authority acknowledge his existence, they are neither antagonistic nor deliberately repressive. The cops chase the tramp almost absentmindedly, as if he is less a danger than a minor annoyance. In effect, the people in power consider Charlie irrelevant, and he in turn responds with indifference to them, as he had in his previous films.

But in *Modern Times* (1936), the last movie in which the tramp

appeared, factories and machines have replaced pompous butlers and bumbling cops. Increasingly, Charlie is victimized by institutions that possess a conscious design. As a blue-collar worker, he is a helpless extension of industrialized processes, his arms twisting imaginary bolts even after the assembly line has stopped, a victim of a new and omnipotent technology gone berserk.

Throughout his career, many observers wondered whether Chaplin, with his dark eyes and curly hair and his screen demeanor as an outcast—a rootless cosmopolite, as Stalin might have said—was Jewish. Chaplin always declined to refute such speculation because, he believed, to do so would only legitimize the bigotry of the world's anti-Semites. Yet it also did not evade people's notice that the tramp, with his mustache and his puppetlike movements, resembled a certain tyrant in Germany.

So in *The Great Dictator* (1940), Chaplin abandoned the tramp in order to play both a Jewish barber and Adenoid Hynkel, the dictator of Tomania. As Chaplin confronts an ideology that pursues the individual not by accident but as a matter of policy, the sight gags of his earlier films are now insufficient. Although there are moments in the movie of brilliant pantomime—especially the dictator's dance with the global balloon—slapstick has given way to speech. Sauntering down an open road is no longer physically or morally possible. Now, at the close of the film, Chaplin addresses the audience directly, hurling words against organized power, relinquishing the advantages of personal freedom for a denunciation of fascism. At last, and unhappily, the little fellow has accommodated himself to the modern world.[30]

Even though the tramp had finally vanished, Chaplin remained influential with the public and the intelligentsia both in America and overseas. Indeed, 70 percent of the gross income on Chaplin's movies was earned abroad. Chaplin was especially revered by foreign artists and writers. The tramp, with his jerky body and his sensitivity to the illogic of human rituals, seemed a creation of Cubism or an embodiment of the Dadaist scorn for bourgeois propriety. In *Waiting for Godot,* Samuel Beckett used Chaplin as a model for his two mythical tramps, Vladimir and Estragon.[31] And Federico Fellini's sympathy for clowns and circuses owed a large debt to the tramp's ability to laugh at or disregard the world's social and cultural snobs.

Nevertheless, the words Chaplin spoke at the end of *The Great Dictator* represented his own surrender to the transformation of filmmaking. The audience wanted to hear as well as to see. Thus the microphone began to convey information as effectively as the camera, first in America, and then across the planet.

From Sight to Sound

For many intellectuals and film critics in the 1920s, the silent cinema had become a dream world full of visual symbols and poetic images, to be appreciated in the same way that one might gaze at a painting. The viewer, as at an art gallery, could be staggered by the use of light and shadow, the brushstrokes in the form of the ethereal camera work, and the poignancy of the faces addressing us wordlessly on the screen as they once did on a canvas. What the audience saw in the movie palaces were, literally, moving pictures.

Yet from the beginning, the movies were always meant to be talkies. The original silence of the cinema was the result of an early failure to devise recording equipment that could correspond with the pictures. Thomas Edison hoped his kinetograph would provide a set of images to accompany the sounds on his phonograph. In France at the turn of the century, Pathé and Gaumont tried, unsuccessfully, to promote a sound system that would complement their movies. But even when movies lacked dialogue, they weren't "silent." Instead, films were shown in theaters with pianos, organs, orchestras, vocalists, and narrators explaining plots and reading subtitles.[32]

By the early 1920s the main obstacles to the introduction of sound involved synchronization (making actors' lip movements correspond to the words they were speaking on screen), amplification (reproducing sounds an entire audience in a theater could hear), and the development of a standardized technology acceptable throughout America and the world.

As radio began to compete with the movies, certain studios in Hollywood, notably Warner Brothers and Fox, had an extra incentive for adding sound to their films. In 1926 Jack Warner—who prided himself on his iconoclasm, and whose studio was among the least profitable of the majors—formed a partnership with Western Electric to

create the Vitaphone Corporation, which initially used discs to record the sound on short musical films. The shorts, though, were just an experiment. In 1927 Warner Brothers revolutionized the film industry with its release of *The Jazz Singer,* essentially a silent movie with songs, except for the immortal lines of dialogue that Al Jolson exclaimed to the camera: "Wait a minute, wait a minute, you ain't heard nothin' yet!"

Jolson was right. Moviegoers, in America and abroad, hadn't heard anything yet. But they soon did with the success of *The Jazz Singer* in London in 1928 and in Paris in 1929, followed by *The Singing Fool,* Jolson's second sound film, which broke box office records in Berlin in 1929. By the start of the 1930s, much to the chagrin of the critics, the silent cinema had perished. It was replaced by a process called sound-on-film (rather than Warner's sound-on-disc), a superior technique pioneered by Fox's Movietone and Germany's Tobis-Klang-film.[33]

Yet however swiftly talk supplanted silence, the birth of the sound era in America was not uncomplicated. Studios and movie theaters needed to be wired for sound, an expensive proposition, especially with the onset of the Great Depression. More important, the whole conception of how to make movies had to be reexamined. In 1952 *Singin' in the Rain* satirized many of the difficulties associated with early sound films: immobile cameras, silly plots and stilted dialogue, actors with squeaky voices leaning over plants to speak into hidden microphones, static on the soundtrack, and laughter in the audience. Meanwhile, studio executives worried that their overseas markets might evaporate if movies in English could not be easily translated, dubbed, or subtitled into foreign languages.[34]

It turned out that many of these problems were ephemeral. As Monroe Stahr understood, sound films required new types of writers who could manufacture sophisticated dialogue. So Hollywood recruited playwrights, novelists, and especially journalists, who were accustomed to deadlines and editing and who could create (often in their own self-image) the fast-talking, wise-cracking personalities who inhabited the movies of the 1930s. Within a few years, the leading screenwriters in Hollywood included William Faulkner, Nathanael West, F. Scott Fitzgerald, Dashiell Hammett, Maxwell Anderson, Ben Hecht,

Robert Benchley, George S. Kaufman, Dorothy Parker, S. J. Perelman, Donald Ogden Stewart, Billy Wilder, and Herman Mankiewicz—the man who wrote the ultimate newspaper movie, *Citizen Kane*.[35]

The dialogue of these writers demanded verbal agility, a skill that silent actors adept at pantomime could not always supply. Their ostentatious style of acting, with its poses, its florid gestures, and its reliance on exaggerated facial expressions, no longer suited the more intimate and naturalistic performances that sound favored. Now actors had to be able to convey ideas, jokes, and emotions through talk.

The centrality of language in the films of the 1930s led to a dependence in Hollywood on British actors (like Cary Grant, Leslie Howard, Charles Laughton, Claude Rains, and Laurence Olivier) or on Americans who sounded vaguely British (like Bette Davis, Katharine Hepburn, and Helen Hayes). It was illustrative of how important British talent was to Hollywood that the two most famous southern belles in American fiction and drama—Scarlett O'Hara and Blanche DuBois—were both played in the movies by the English actress Vivien Leigh. The studio heads assumed that actors with experience on the London or Broadway stage were innately articulate, with polished voices that could bring to Hollywood an aura of class.

Nevertheless, British enunciation often sounded artificial, as if the characters belonged forever in an aristocratic drawing room exchanging epigrams from Oscar Wilde. Consequently, Hollywood producers and directors were also attracted to actors with flat "American" voices —actors like Gary Cooper, Henry Fonda, and John Wayne, who were succinct and comfortable with the lingo of ordinary people, and who seemed not to be acting at all. Approached by a young man who wanted to learn how to act in the movies, Spencer Tracy allegedly growled: "Don't let them catch you at it." They never caught Tracy at it. Which is why he and many of his contemporaries—even those who were sometimes garrulous, like James Cagney, James Stewart, and Jean Arthur—all sounded so distinctive, their voices and speech patterns more riveting than (as in the case of silent film stars) their looks.

Silent movies, however, had one major advantage over sound in the international marketplace. Since silent films didn't depend on language, they had a universal appeal; they could be understood in coun-

tries all over the world. Moreover, they were easily adaptable to local customs and expectations. American movies in the teens and 1920s were shown abroad often with different musical accompaniments and title cards written in the national vernacular, each as a way of allowing foreign audiences to appreciate a film that corresponded to their own cultural values.

The coming of sound, therefore, seemed as if it would threaten Hollywood's grip on the global audience. The first American sound films distributed overseas were marred by inadequate subtitles, execrable dubbing, and inept synchronization. Hence, foreigners—faced with an inferior American product—might turn again to their own domestic productions, with performances in a language they could comprehend. And indeed, in the early 1930s there was an increased demand in Europe for German, French, Spanish, and Italian movies, all of them with characters speaking in their audiences' native tongues. For a while, it appeared as if Hollywood might have to compete, as it had before World War I, with other countries' national film industries.

In response, some of the Hollywood studios experimented with multilingual movies, releasing one version of a film in English for American, British, Canadian and Australian audiences, and the other in French, German, or Spanish for moviegoers on the European continent and in Latin America. Paramount was especially committed to producing films in several languages, opening a studio in 1930 in the Paris suburb of Joinville that employed European actors, writers, and directors where they lived instead of transporting them to Los Angeles. But making duplicate versions of the same movie proved too expensive. Besides, audiences preferred the original American stars (even those who were in fact foreign-born, like Greta Garbo or Maurice Chevalier) to local substitutes.

The real solution to the problem of exporting American sound films was mechanical, not artistic. As sound technology and equipment improved, subtitles and dubbing became less disconcerting and more acceptable to foreign audiences. Although dubbing—with its removal of the original actor's voice—was like scrawling over a painting, it permitted foreigners to enjoy an American movie in their own idioms. With dubbing (which France, Germany, and Italy insisted upon), filmgoers abroad could still relish the glamour of Hollywood but see it min-

gled with their indigenous culture, thereby making American movies seem less "foreign," if no less fascinating.

In the end, Hollywood's dominance was barely affected by the arrival of sound. People abroad still flocked to American movies. If anything, the heightened cost of producing a sound film forced Hollywood to rely even more heavily on the international market to buttress its earnings.[36] As it happened, sound—whether in America or overseas—became indispensable to the studios' most profitable and creative period from the 1930s to the mid-1940s. Without sound, there would have been no screwball comedies, no musicals, no stylish romances or sardonic gangster films, and most of all, no *Citizen Kane*.

Hollywood's Golden Age

In the early years of the Depression in America, despite the introduction of sound, audiences declined, profits fell, and the studios reduced the number of films they released each year. Entertainment, at least the kind that cost money, was a luxury for many Americans facing the loss of jobs and business failures. But as the economy began to improve in the middle and late 1930s, and as prosperity returned to the home front during World War II, movie attendance rose. By 1939, eighty-five million people went to the movies once a week; by 1946 that number had reached one hundred million. Seventy-five percent of the American people had become regular moviegoers.[37] And Hollywood was turning out an average of 476 films a year to meet the demand. Moviegoing was a national habit and the main form of amusement for the majority of Americans—surpassing radio, sports, reading books, listening to music, and every other use of one's leisure time.

To celebrate the primacy of films in the lives of ordinary Americans and of people throughout the world, and to enhance the stature of the studios, Louis B. Mayer dreamed up the Academy of Motion Picture Arts and Sciences in 1927. The Academy's chief function each year was to award "Oscars" to the best films, performances, directors, and technicians in the movie industry. Among the movies that won Oscars in the 1930s and early 1940s were *Grand Hotel, It Happened One Night* and *You Can't Take It with You* (both directed by Frank Capra),

Gone with the Wind, John Ford's *How Green Was My Valley,* and *Casablanca.*

All these films illustrated what came to be known as the "classic" style of Hollywood's golden age. The studios' guiding principle was that cinematic techniques should always be subordinated to the development of a movie's characters and its overarching narrative. As Frank Capra insisted, "An audience should never realize that a director has directed the picture or that a cinematographer has photographed it. That is why 'directorial touches' and photographic 'splurges' should be kept out of a picture. They detract from the story." Instead, the plot ought to flow smoothly from one shot and scene to the next, and the editing should be "invisible." Cinematic pyrotechnics and directorial idiosyncrasies only interfered with the unfolding of the tale.[38]

In short, a movie should never call attention to itself as a movie. It should maintain the illusion that audiences were viewing a reproduction of reality in the form of an engrossing drama, rather than an "arty" collection of bizarre camera angles, jump cuts, and self-indulgent directorial intrusions. What the audience wanted to focus on was a doomed love affair on screen between Humphrey Bogart and Ingrid Bergman, not the behind-the-scenes commands of Michael Curtiz.

Yet the classic Hollywood style was mostly a myth. Audiences were always aware that they were watching a movie. How could you see a comedy, especially one with Charlie Chaplin or the Marx Brothers, without being conscious of the artifice of the gags (especially when Groucho delivered his lines directly to the camera)? How could you see a Busby Berkeley musical without admiring the cinematographic spectacle? How could you go to a John Ford Western without appreciating the vistas of Monument Valley, or a film noir thriller without noticing the shadows and the rain-slicked pavements?

In fact, Americans went to the movies in the 1930s and 1940s precisely because they were movies, not glimpses of real life. Even if they had wished for more reality, Hollywood's production code—adopted in 1930 and enforced starting in 1934—censored any allusions to the more authentic aspects of human behavior. The code stipulated (among numerous prohibitions) that no film exhibit sympathy for criminals or sinners, nor ridicule religion or question the sanctity of

marriage. Neither should there be any display of nudity, profanity, and "excessive or lustful" kissing. Not even scenes of childbirth, the product presumably of a healthy marriage and theologically sanctioned physical affection, were permitted.

If the production code had never existed, however, the mundane details of daily life might still have rarely appeared on the screen. It is striking how few American movies during the 1930s dealt with the plight of the poor and the unemployed. With the notable exception of John Ford's movie version of *The Grapes of Wrath,* most of the films that explored the social problems of the day (like Fritz Lang's *Fury*) were ponderous and predictable, though highly praised by the partisans of the proletarian esthetic.

Indeed, the most "political" film of the decade—but one loathed by the Left and banned after World War II in the Soviet Union and Eastern Europe—was Ernst Lubitsch's impudent comedy *Ninotchka,* with a script cowritten by Billy Wilder and starring Greta Garbo. Garbo plays a Soviet commissar, initially a defender of the Moscow Trials ("there are going to be fewer but better Russians"), who falls in love in and with Paris, and ultimately defects from the workers' paradise. *Ninotchka* was a testimonial to the absurdity of social movements and ideological abstractions, a lesson both timely and timeless, and one that Hollywood preached throughout the 1930s.

Insofar as the Hollywood studios had a social philosophy ("If you want to send a message," Samuel Goldwyn advised his writers, "call Western Union"), it was that the rich were appalling not because they exploited the masses but because they were insufferably smug. In contrast, the eccentric heroes of the decade's screwball comedies (usually assisted by a worldly wise if cynical dame) recognized the futility of status and position, and refused to surrender to the pressures of compulsive moneymaking or the corruptions of political power.

No director dramatized these themes more often or with greater vigor than Frank Capra. Born in Sicily in 1897, Capra emigrated with his family to the United States when he was six years old. Capra began directing movies in the 1920s, working for Mack Sennett, but moved to Columbia in 1927. By the 1930s he had become Columbia's foremost director. The success of his films (beginning with *It Happened*

One Night, which won five Oscars, including best picture and best director) gave the studio the prestige it had never previously enjoyed.

Capra's movies helped define America's values in the 1930s. In *Mr. Deeds Goes to Town* (1936), *Mr. Smith Goes to Washington* (1939), and *Meet John Doe* (1941), Capra commemorated the natural wisdom of the common folk. Through the classically "American" faces and small-town voices of Gary Cooper and James Stewart (who were perpetually battling against the Machiavellian intrigues of the media and big-city capitalism in the corpulent person of Edward Arnold), Capra created a world in which the average person—however credulous and naïve—inevitably triumphed over the schemes of the rich and well born.

Yet Capra—unlike many artists and writers in the 1930s—was not content to worship at the altar of the "little people." Nor did he believe that the "forgotten American" was inherently virtuous and democratic. Underneath the pieties about loving thy neighbor, his films tended to lay bare the stupidities of the ordinary citizen and the perils of political conformity. What Capra truly admired was the lone individual standing up against the mob: Mr. Smith filibustering on the floor of the Senate, hoarsely quoting from the Constitution and the Declaration of Independence as his erstwhile constituents swallow the propaganda of those who control the radio and the press, fighting on behalf of one more lost cause, the only kind of cause worth fighting for. Capra's films were allegories on the need for personal independence apart from the herd instincts of the faceless crowd. Good men, like Mr. Smith and John Doe, might prevail over economic inequities and political sleaze, and the villains might confess their sins in the final reel. But Capra's faith was more suited to the individualism of the 1920s than to the collectivist yearnings of the 1930s.[39]

In any case, the hard times of the 1930s bred a desire in America for both social change and a sense of stability. The New Deal could provide reforms, but the culture could offer comfort. It was understandable, therefore, that the most popular novel and movie of the decade was *Gone with the Wind.* Here, in an epic story about survival in the midst of catastrophe—a saga of endurance echoed in that other famous novel of the 1930s, *The Grapes of Wrath*—readers and movie-

goers could hope that they, like Scarlett O'Hara and Ma Joad, might prevail over their current predicaments, or summon the toughness to keep going even as the vision of a more affluent and adventurous life had vanished.

Hollywood in the 1930s encouraged acceptance, not anger, in its audiences. And also an embrace of what America presumably stood for at its best. Which explains the significance of another of the decade's most cherished films, *The Wizard of Oz*. In *The Wizard,* a girl named Dorothy (played by a young and radiant Judy Garland) is transported from her drab, gray, Kansas farm to the enchanted Technicolor land of Oz. She and her companions—a scarecrow, a tin woodsman, and a cowardly lion—all seeking to change themselves or their circumstances, go off to see the wizard because of the wonderful things he does.

But the wizard turns out to be a charlatan. Still, he has an important lesson to teach, not just to his supplicants but to American audiences in the 1930s. People, he says, don't need a wizard to give them a brain, a heart, or courage. All they need to do is look inside themselves. Inner strength, not a social miracle, is the wizard's (and Hollywood's) key to salvation. So a movie that begins with Dorothy imagining a fantasy world somewhere over the rainbow ends with her back in Kansas, proclaiming that "there's no place like home!"

Such an insight was hardly radical. But radicalism in the 1930s and early 1940s, particularly in one movie, had more to do with style than with politics. At the end of the Great Depression, Hollywood was able, for a moment, to give a director the freedom to make an enigmatic and disorienting film that continues to influence the cinema all over the world.

Orson Welles arrived in Hollywood in 1939. He was invited by RKO to make a movie on any subject he wanted, with artistic control over the entire production, including the right (denied to almost all other studio directors) of final cut. Welles's phenomenal reputation preceded him. Working for the Federal Theater Project and as the head of his own Mercury Theater, Welles had directed *Macbeth* in 1936 with an all-black cast, *Julius Caesar* in 1937 as a parable about fascism, and Marc Blitzstein's *The Cradle Will Rock,* also in 1937. In 1938 he managed to put on what became the most legendary radio broadcast in the

history of the medium: an adaptation of H. G. Wells's *The War of the Worlds,* which caused panic in listeners who believed that America (or at least New Jersey) was actually being invaded by Martians. By the age of twenty-three, Welles had appeared on the cover of *Time* and been profiled in the *New Yorker.*

Welles may have been a megastar in the theater and on radio, but he knew little about filmmaking. Over the next year, as he considered various subjects for his movie, he studied other directors' films. He was especially influenced by the fluid camera work in John Ford's *Stagecoach.*

Yet like so many of his American counterparts in painting, architecture, and music, Welles also borrowed heavily from foreign sources. He was intrigued by the eerie lighting, portentous shadows, and exaggerated perspectives of the German Expressionists in the 1920s. In addition, Welles was impressed with the advantages of deep focus cinematography as used by the French director Jean Renoir. Renoir's reliance on deep focus allowed people in the foreground and background to be photographed clearly and simultaneously, whereas Hollywood's films usually cut between characters within a scene. Moreover, deep focus allowed moviegoers to better grasp the relationship of individuals to their physical environment as well as to one another.

Nevertheless, for all his admiration of foreign filmmakers, the movie Welles ultimately made, in 1941, was archetypically American in its wedding of modernist artistic techniques with pure entertainment. Collaborating with Herman Mankiewicz as screenwriter, Gregg Toland as cameraman, and Bernard Herrmann as composer, Welles created what was essentially a gripping mystery story about a media mogul named Charles Foster Kane, with a reporter as detective trying to uncover the "truth" of Kane's life. And the audience, like *The Last Tycoon*'s George Boxley, always wants to know what happens next.

The stylistic virtuosity of the film added to its suspense—particularly the long takes and rapid cuts, and the alteration of pace between slow scenes and brief vignettes. Just as important was the movie's imaginative use of sound. As a veteran of radio, Welles understood the potency of music, disembodied voices, overlapping dialogue, and the ability to edit aurally rather than visually by having one person begin

a sentence to be completed by someone else in another place at another time. Words were used not simply to convey information or establish character but to invent a special world filled with extraordinary people in extreme situations, all of them grappling with their deeply ambivalent feelings about Charlie Kane. In this way, the soundtrack of *Citizen Kane* was as memorable as the images on the screen.

But beyond the experiments with sight and sound, Welles was rebelling against the conventional Hollywood notions of how to tell a story. He declined to proceed chronologically. Instead, Welles circled around his subject, recounting events from different points of view, juxtaposing scenes of youth and age, starting the movie with the death of Kane and then reexploring his life, mixing up the normal progression of time and plot in order to force the audience to think constantly about what it was seeing and hearing.

Welles's major preoccupation, in *Citizen Kane* and in most of his later movies, was to illuminate the moral difficulties in passing judgment on a person's life. His protagonists, like Kane, never realize their dreams, betray their most precious ideals, are seduced by unlimited power, and end up as tragic and solitary figures. Yet they are always charismatic, and far more complicated than any effort to define who they are or sum up what they've done.

From *Kane*'s opening newsreel, through the conflicting recollections of the people the reporter interviews, to the final omniscient camera eye, the movie was a testament to the ambiguity of truth. No one knows the whole story about Kane. Each bit of information is biased, selective, and incomplete. Hence viewers are compelled to participate in and reflect on the mystery with which they are confronted, searching like the journalist for clues to the meaning of events, coming to their own conclusions on the basis of whatever the movie chooses to show.

This task is doubly perplexing because the film makes little effort to condone or condemn, nor to elicit a facile series of reactions from the audience. The movie continually shifts in mood from pity and sympathy to satire and mockery. Throughout, Kane is pictured both as a genius and a menace, an audacious entrepreneur who imagines it would be "fun to run a newspaper" and a cynic who can tell

the whole nation what to think, a man of noble ideals and a narcissistic hypocrite.

These contradictions are reinforced by Kane's critics and eulogists. For the disenchanted Jedediah Leland, Kane is more interested in power and public applause than in the defense of the common man. Kane's original "declaration of principles" turns out to be as much a relic as the sculptures he stores in the basement of his baroque castle, Xanadu. For his second wife, Susan Alexander, Kane is both egocentric and pathetic, an obsessive collector of people and objects, an aging emperor surrounded by stone monuments to his faded ambitions, but still someone about whom it is possible to "feel sorry." For the loyal Mr. Bernstein, Kane is a person who lost everything he had, who pokes among the ruins of his childhood for the love and innocence he can never retrieve.

Perhaps, though, Kane is none of these things. Even the reporter, unable to unravel the meaning of "rosebud," concludes that no single "word can explain a man's life." Later, in *Touch of Evil* (1958), surveying the wreckage of the corrupt and now-dead cop Hank Quinlan, another megalomaniac played by Welles, Marlene Dietrich as the jaded Tanya asks, "What does it matter what you say about people?" Quinlan, after all, frames men who are in fact guilty.

In Welles's world it really didn't matter what you said. His movies are not about good and evil—or rather, they are about both, all jumbled up together, one of Susan Alexander's jigsaw puzzles never to be finished.

For Welles, the point of the cinema was not to sermonize but to keep the audience alert to what it was experiencing. *Citizen Kane* was designed as an elaborate spectacle, with each element calling attention to itself. Welles was forever talking to his viewers, commenting on the action through repetitions and multiple perspectives, indulging in an exhibition of "magic" tricks often unrelated to the tale, all as means of reminding the spectators that they were looking not at life but at a movie. And as they left the theater, they would have to determine for themselves what they thought, or might say, about what they'd just seen.

After *Citizen Kane*, Welles never again had the liberty to make

a movie on his own terms. His subsequent films were underfinanced, cut or reedited by various studios, and often tossed into theaters without publicity.[40] But *Kane* shattered the classical style of Hollywood filmmaking. And in its adaptation of foreign filmmaking techniques, its demands on its audience, and its refusal to supply a happy ending, *Citizen Kane* became a model for American movies from the 1940s to the present.

Night and Fog

FROM GERMAN EXPRESSIONISM TO FILM NOIR

■

In the summer of 2003, when I was a visiting professor at the University of Vienna, I went to an exhibition commemorating the music of the Austro-Hungarian empire in the early twentieth century. The exhibit contained photographs of conductors and composers. Beneath the photographs were signs indicating the dates and places of births and deaths. Invariably, the signs read: born in Vienna, Salzburg, Prague, Budapest, Moravia, Silesia; died in Los Angeles.

If you didn't know the story of why these people fled from the Old World and found refuge in the New (and the exhibit was vague on this point), you might never have known how they wound up in Los Angeles. And why Hollywood, not just Los Angeles, was where they reinvented their lives and careers.

Among the musicians featured in the exhibition were Max Steiner, Erich Wolfgang Korngold, Franz Waxman, and Miklós Rózsa. Whatever their differing backgrounds and early triumphs in Vienna, they were ultimately responsible for the lush, romantic film scores—in effect, the soundtracks—that engulfed almost every major American movie from the 1930s through the 1950s.

Steiner was the earliest émigré, leaving Vienna for America in 1914. After serving as an arranger for Broadway operettas and musi-

cals in the 1920s, he arrived in Hollywood in 1929. Subsequently, Steiner composed the scores for *King Kong, The Informer, Gone with the Wind, Casablanca, The Big Sleep, The Treasure of the Sierra Madre,* and *The Searchers.* Korngold, born in Brno, was considered a prodigy as a composer in Vienna and in Germany before he moved to the United States in 1934. Thereafter, his semi-Wagnerian compositions seemed suitable for grandiose movies like *The Adventures of Robin Hood* (for which he won an Oscar) and *Of Human Bondage.* Waxman, originally from Silesia, escaped from Berlin after the Nazis seized power in 1933 and came to America in 1935. His most notable scores included *The Philadelphia Story, Sunset Boulevard, A Place in the Sun,* and *Rear Window.* Rózsa, from Budapest, resettled in America in 1939, and later composed the music for *Double Indemnity* and *Ben-Hur.*

Not all the itinerant composers were middle-European. Dimitri Tiomkin, born in Ukraine, spent his early years in pre-Soviet Russia, Berlin, and Paris. But he emigrated to the United States in 1925 and journeyed to Hollywood in 1930. As it turned out, his affinity for Russian folk tunes, as well as his reliance on brass and drums in his scores, made him the perfect composer for movie Westerns, especially *Red River, High Noon,* and *Rio Bravo.*

Composers, of course, were not the only European migrants to Hollywood. Nor were they alone in shaping American movies. From the beginning of the American film industry, Hollywood's moguls enlisted talent from all over the world. To composers, directors, cinematographers, and actors who thought about transplanting themselves to Hollywood, the studios offered more money, greater technical resources, and a larger audience than any other country could provide. Indeed, the persistent recruitment of foreigners was one of the principal ways in which Hollywood undercut its adversaries overseas and maintained its supremacy in the international marketplace. For their part, the émigrés were either seduced by Hollywood's economic and artistic allure, or they were running from the death camps that appeared first in Germany in the 1930s and then spread throughout central Europe.

Yet whether they came to Hollywood as refugees or simply in search of more lucrative careers, the Europeans influenced American

movies as much as the studios changed them. They brought with them, and rarely jettisoned, their cinematic dexterity or their artistic preoccupations. And they created a new American genre, film noir, which had its roots deeply embedded in German Expressionism.

In short, the lost worlds of Vienna and Berlin were resurrected in Hollywood. So Hollywood became the home of a modernist style of moviemaking that was both European in its origins and American in its popular appeal.

The German Cinema in the 1920s

One of the clichés about European filmmakers is that they conceive of movies as another form of art, comparable to painting or literature. In contrast, their American counterparts, attentive to the studios' hunger for profits, care mostly about amusing the masses. In Europe films are presumably a component of high culture, with production facilities traditionally located in the centers of intellectual and political ferment—like London, Paris, Berlin, and Rome. Whereas the American movie industry flourished in the cultural wasteland of Los Angeles, far from New York or Chicago, cities where the theater, novels, and modern art mattered.

In the 1920s this notion that European films were part of an avant-garde movement in the arts—drawing on the same impulses as Dadaism, Surrealism, and Expressionism—was fashionable on both sides of the Atlantic. Few directors in the United States (except for D. W. Griffith and Charlie Chaplin) could gain admittance to a European pantheon that included Sergei Eisenstein, F. W. Murnau, Fritz Lang, and Carl Dreyer. How many American movies could match the aesthetic experimentalism or complexity of Eisenstein's *Battleship Potemkin*, Robert Wiene's *The Cabinet of Dr. Caligari*, or Lang's *Dr. Mabuse?* Movies like these might not have been commercially successful, but they seemed more serious, more ambiguous in their narratives, more willing to highlight the director's vision, less concerned with resolving every problem in the final reel.

Partly, the Europeans' argument that their films were artistically superior to Hollywood's products was a reaction to and a defense against the worldwide invasion of American movies.[1] Yet the majority

of American intellectuals and film critics shared the belief that Hollywood movies were rubbish, another sign of America's continuing sense of inferiority in its cultural contest with Europe.

But the main difference between American and European films was that Hollywood directors were more sensitive to the need to establish an emotional connection with the audience. American films, after all, had always been faintly disreputable, closer in spirit to circuses and vaudeville than to the theater. Consequently, a movie could be provocative, but it first had to be engrossing, particularly to an audience that preferred excitement to enlightenment, an audience that above all else did not want to be bored.

If anything, American filmmakers showed greater respect for the intelligence of their viewers by speeding up the action, telling a story succinctly, avoiding repetitions, and focusing on riveting characters. What the audience did not need was to be pelted (as in the case of European movies) with grand concepts, messages, and symbols. Directors like Griffith, Chaplin, Frank Capra, John Ford, and even the consummate magician Orson Welles all recognized that the foundations of their art rested on the demands of the market and the urge to captivate the filmgoer. *Citizen Kane* might be esthetically challenging, but it was also fun to watch. Hence there was no contradiction, at least in American movies, between culture and commerce. Instead, the economic requirements of the studios often coincided with, rather than obstructed, the artistic ambitions of the director.

Still, the disparity between European and American filmmaking was never as stark as the critics on both continents alleged. Indeed, in the 1920s Hollywood had a rival, the German film industry, whose movies were as internationally well known and sometimes as profitable as those produced in southern California.

The German film market had been closed to American imports throughout World War I. As a result, German filmmakers were able to develop their own alternatives to American movies at the very moment Hollywood was achieving global dominance. By the 1920s Berlin emerged as the center of German and European film production, attracting directors and actors from Vienna, Budapest, Copenhagen, and Stockholm. German movies therefore appealed not only to German audiences but also to viewers in France, Scandinavia, Britain, and the

United States. For a time, German filmmakers could imagine that they had devised both a new art form and a product for popular consumption.[2]

The entity most responsible for the prominence of German movies in the 1920s was a studio called Universum Film AG, or UFA. Launched by the German government in 1917 to make propaganda films, UFA was privatized in 1921. Located in Babelsberg on the outskirts of Berlin, UFA soon became the largest and best-equipped studio in Europe. It modeled itself on the vertically integrated studios in Hollywood, with a large budget overseen by powerful production heads; a permanent staff of actors, directors, and technicians; and a chain of movie palaces in Germany that showed all the films the studio released each year. Given these advantages, it was not unreasonable that UFA's executives believed they could compete with Hollywood for a sizable share of the international film market.[3]

And UFA had its visionary chieftains, just like MGM. No one at UFA more resembled Louis B. Mayer or Irving Thalberg than Erich Pommer. As the most important producer at UFA, Pommer supervised the making of such Expressionist masterpieces as *The Cabinet of Dr. Caligari* (1920), *Dr. Mabuse* (1922), Murnau's *The Last Laugh* (1924), Lang's *Metropolis* (1927), and *The Blue Angel* (1930). Nevertheless, though Pommer was committed to artistic innovation in his films, he was also an entrepreneur (like his American competitors), interested as much in worldwide box office receipts as in the creation of a uniquely German cinema.[4]

Ironically, the one major German director with whom Pommer did not work fit his ideal for a filmmaker who could win the favor of esthetes and the global mass audience. Ernst Lubitsch, born in Berlin in 1892 to a middle-class Jewish family, started his career as an actor in theater and films. Between 1918 and 1921, as a director, he specialized in contemporary comedies and costume epics. His most notable early film was *Madame DuBarry* (1919), which was a success not only in Berlin but also in New York, where it was released in 1920. With this movie, Lubitsch demonstrated that it was possible for a German film to penetrate the American market—at least if it resembled a Hollywood picture.[5] But Lubitsch, already skilled in the American style of straightforward filmmaking and concise storytelling, was about to leave

his German colleagues behind, embarking on a pilgrimage to Hollywood that they themselves would eventually undertake when conditions in Germany were no longer economically or politically conducive for an experimental cinema.

In the meantime, UFA became the studio that nourished German Expressionism. Along the way, Expressionism (a product of the nerve-wracked culture of postwar Berlin) made famous a new, young generation of German directors, writers, and actors: Lang, Murnau, Douglas Sirk, Josef von Sternberg (who was born in Vienna, raised in New York, and made movies both in Germany and America), Robert Siodmak, Fred Zinnemann, Billy Wilder, Peter Lorre, Conrad Veidt, and Marlene Dietrich. This eruption of film talent in a single generation would not be matched until the late 1960s and 1970s in America, with the emergence of Francis Ford Coppola, Martin Scorsese, Steven Spielberg, Robert Altman, Woody Allen, Robert De Niro, Al Pacino, Dustin Hoffman, Jack Nicholson, and Meryl Streep. In fact, one way of understanding the significance and originality of German Expressionism is to see it as equivalent—in an earlier era of political and cultural upheaval—to the transformation of Hollywood during the Vietnam War and Watergate.

The Expressionist style was unmistakable. Sharp contrasts between ribbons of light and insidious shadows, distorted camera angles and disconcerting perspectives, vertiginous staircases, windows that entrapped individuals rather than offering them views of the outside world, claustrophobic close-ups, and exaggerated acting, all these were the hallmarks of German Expressionism in the 1920s. As if to reinforce the volatility of the camera work, the protagonists in Expressionist films were often psychotic geniuses (like Dr. Caligari), monsters or vampires (as in Murnau's *Nosferatu* from 1922, his version of the Dracula legend), or master criminals (like Dr. Mabuse).[6] They could even be child murderers, like Peter Lorre in *M*, Lang's first sound film in 1931. These mad villains, and the disorienting techniques with which they were presented to the audience, served to underscore the Expressionist obsession with images of abnormality, alienation, and terror. Contemporary life seemed like a nightmare from which the somnambulant characters who populated Expressionist films could never awaken.

The mood of anxiety in these movies was reinforced by the menace of the modern city. Born in Vienna in 1890, Fritz Lang was fascinated with and alarmed by Viennese architecture, especially the city's massive statues and its implacable buildings looming over the citizenry. In 1924, after he had already become an accomplished director, Lang (along with Erich Pommer) visited the United States. Lang asserted that his first glimpse of the Manhattan skyline inspired him to make *Metropolis,* his pre-Orwellian vision of a futuristic city divided between the omnipotent rich and worker-slaves.[7] The movie was also an indication of how America's urban architecture and culture could mesmerize even the most Germanic of filmmakers.

Many of these stylistic idiosyncrasies and attitudes toward modernity would influence the mood and themes of film noir. Yet despite the artistic prestige of the Expressionist movies, the German film industry had trouble competing with Hollywood, not only in the international market but increasingly at home. Hollywood's slick productions perpetually intruded upon and undermined the German cinema's conception of its identity as the European antidote to American movies.

Throughout the 1920s the relationship between Berlin and Hollywood was complicated, in large part because UFA and other German studios faced continuing economic difficulties which ultimately made them dependent on American financial support. Neither quotas against the import of American movies nor the efforts of German film companies to make money in the American market were effective.

From 1926 until the end of the decade, German studios tried to become the center of a continent-wide movie industry, called Film Europe, that might diminish the appeal of Hollywood's exports. The idea behind Film Europe was for the German film industry (led by UFA's Erich Pommer) to develop coproductions and distribution arrangements with other countries, sharing directors and casts, exploring European subjects and locales, thereby making movies that would capture a continental audience. But although Film Europe did achieve some success in the late 1920s at attracting European moviegoers, it was never able to jeopardize the popularity of Hollywood's movies either on the Continent or elsewhere.[8]

Paradoxically, at the same time that German studios were trying to protect the European market for their films, they were cooperating

more closely with Hollywood. In 1925 UFA entered into an agreement with Paramount and MGM that gave UFA more capital to produce its films while permitting the American movie companies access to UFA's distribution network and theater chains. As a consequence, by 1927, 75 percent of German films were partially or completely financed by Hollywood. Meanwhile, the agreement made UFA a junior collaborator in Hollywood's growing domination of the German film market.[9]

An additional result of the agreement was that Germany became a leading source of talent for Hollywood. During the last half of the decade, American film producers and studio executives traveled frequently to Berlin, buying up actors, directors, and cinematographers. In 1927, for example, the German star Emil Jannings accepted an offer from Hollywood. The following year, he won the first Oscar ever given for best actor in recognition of his performances in two films: *The Way of All Flesh* and *The Last Command,* the latter directed by Josef von Sternberg.

Pommer himself spent two years in Hollywood in the mid-1920s, learning how to make less "arty" films, ones with more comprehensible stories that sought to entertain rather than educate viewers. After he returned to Germany in 1927, Pommer concentrated on movies that would be more consistently profitable as well as technically innovative. His efforts culminated in 1930 with the release (in both a German and an English-language version) of *The Blue Angel,* a hit film again directed by von Sternberg and featuring Jannings and a relative newcomer, Marlene Dietrich, who soon became a megastar in the United States. Yet the success of this movie did not ensure that other German films would be welcomed in America.

The unequal partnership between Hollywood and Berlin led to German movies that looked more and more like American films. In the late 1920s German movies (apart from those that still indulged in Expressionist methods) began to imitate Hollywood's realistic camera angles, acting styles, and "invisible" editing.[10] Germany's filmmakers had become acolytes, studying the work of American directors and stars. By the early 1930s, as the repressive culture of the Third Reich replaced the unruly spirit of the Weimar Republic, German (and European) filmmakers were already prepared to adapt to Hollywood's requirements even before they arrived in America.

The Émigré Directors

However familiar foreign directors were with American movies, working in Hollywood still came as a shock. In their home countries, directors like Ernst Lubitsch, F. W. Murnau, Fritz Lang, and Alfred Hitchcock had been treated like stars. And indeed the Hollywood studios, from the 1920s on, were attracted to European and British filmmakers because their movies seemed more "artistic," more stylistically audacious, and more personal than those churned out in America.

Yet the studios—for all the economic and technical advantages they offered to émigré directors—demanded that the newly arrived filmmaker accept Hollywood's values. What the studios wanted were movies that would not be too murky or pretentious, movies that featured clear-cut narratives and compelling characters with whom the audience could identify, and above all movies that triumphed at the box office. Moreover, the studios expected their directors, foreign or native-born, to be team players—to compromise with producers, cameramen, costume and set designers, and the high-priced actors and actresses who were always the real stars of American movies, all of whom could interfere with the director's plans at any moment.[11]

Some directors were never able to adjust to the Hollywood assembly line. In 1926, after the international success of *The Last Laugh*, F. W. Murnau received an invitation from Fox to come to Hollywood. A year later, he completed his first American movie, *Sunrise*. Despite Murnau's status as a modernist filmmaker, *Sunrise* was a slow, lugubrious melodrama that made its rural American protagonists look like nineteenth-century German peasants. So although the film won a special Oscar for "Unique and Artistic Production," it lost money. Murnau himself gained a reputation for being an obstinate prima donna, insisting that everyone on a set wait until he got precisely the shot he wanted. After the financial failure of *Sunrise*, Fox gave him less prestigious projects, and he faded from prominence, ultimately dying in an automobile accident in 1931.[12]

While Murnau's talents and temperament turned out to be unsuitable for Hollywood, other émigré directors were more amenable to the studios' wishes and routines. But along the way, they were able to impose their own vision on Hollywood's genres, instilling comedies,

horror movies, gangster and detective films, and even Westerns with a cosmopolitan flair and point of view.

No émigré in the 1920s and 1930s adapted more easily to Hollywood than Ernst Lubitsch. At the request of Mary Pickford, who wanted him to direct her next movie, Lubitsch decamped for Hollywood in 1922 with a reputation not as a haughty artist (like Murnau) but as a commercially proficient filmmaker in Germany. By the mid-1920s Lubitsch had become the highest-paid director in the American movie industry. In 1935 he assumed the position of head of production at Paramount, the only émigré director ever to be given such power at a major studio. Lubitsch's success in America was due largely to his mastery of Hollywood's procedures and its assumptions about how to make a profitable movie, knowledge he had put to good use in Germany before he came to the United States.

Yet despite his embrace of Hollywood's methods, Lubitsch never abandoned his European heritage. Specializing in musicals and romantic comedies, he was influenced particularly by the mordant wit of Oscar Wilde and Noël Coward. In the films he directed in the 1930s and early 1940s—*Design for Living* (based on a Coward play), *The Merry Widow, Ninotchka, The Shop around the Corner,* and *To Be or Not to Be*—Lubitsch focused on his characters' capacity to behave with charm, grace, and savoir-faire in the face of human folly. Lubitsch's people maintain their sanity by adopting disguises, playing roles, and keeping up appearances. For them, good manners and clever conversation, and the ability to conduct oneself properly no matter how tragic the situation, are more important than political commitments and dogmatic philosophies—a stance unusual amid the overheated ideologies of the Depression years.

In the end, the heroes of a Lubitsch movie were not interested in transforming social institutions. Instead, they were prepared to accept the world as it was, bowing to the limitations it imposed, hoping merely to escape its more painful dilemmas though humor and a sense of personal decorum. These were stances more in keeping with a European recognition that the universe was full of sadness and even of horror, one not readily susceptible to the American faith in progress and human perfectibility.[13]

Josef von Sternberg also retained a "European" sensibility. The

titles of the films he made in Hollywood in the early 1930s with his muse, Marlene Dietrich—*Morocco, Dishonored, Shanghai Express, Blonde Venus, The Scarlet Empress, The Devil Is a Woman*—reflected von Sternberg's affinity for whatever appeared exotic and alien to American tastes. Most of these movies were modestly successful, though they grew less popular with audiences as the Depression dragged on.

On the other hand, émigré directors like William Wyler (who was born in Alsace and came to the United States in 1920) and Fred Zinnemann (who was born in Vienna and worked in Berlin before arriving in Hollywood in 1929) concentrated on "American" topics, especially after World War II. In 1946 Wyler directed *The Best Years of Our Lives,* about veterans returning to an America that was about to be completely transformed in the postwar era. The movie won seven Academy Awards, including best picture and one for Wyler as best director, the second of three Oscars Wyler received in his career.

Zinnemann was responsible for one of the classic Westerns of the 1950s, *High Noon* (in part, a parable about McCarthyism as the frightened residents of a frontier community refuse to help defend their marshal or their town against the specter of outlaws arriving on the noon train). Additionally, in 1953 Zinnemann directed the movie version of James Jones's best-selling novel *From Here to Eternity.* The novel and the film were set on the eve of the Japanese attack on Pearl Harbor. But Jones and Zinnemann explored the conflict, typical for America in the 1950s, between a rebel who is increasingly obsolete in the modern world and an organization man who knows how to manipulate the rules but survive in a tightly structured bureaucratic society. Zinnemann, however, did not entirely reject his European background. In 1977, in *Julia,* he re-created the terrifying atmosphere of Austria and Germany in the 1930s, with his characters navigating the intrigue and violence that accompanied the destruction of European civilization.

Murnau, Lubitsch, Wyler, and Zinnemann all settled in Hollywood before the Nazis captured power in Germany in 1933. Among the first of the European directors who came to America as a refugee rather than as an expatriate was Fritz Lang. During the 1920s Lang had declined invitations from Hollywood because Germany provided him with all the resources and stature he needed. But in 1933, under

pressure from the new Nazi regime, UFA fired its Jewish employees. Lang was not Jewish, but his mother had been before converting to Catholicism. According to Lang, Joseph Goebbels (Hitler's minister of propaganda) ignored this family blemish and offered him the chance to head the German film industry. Had Lang accepted Goebbels's proposal, he—not Leni Riefenstahl—would have become the most notorious of the Nazi filmmakers. Instead, Lang fled to Paris (a temporary shelter for many German and central European producers, directors, screenwriters, and actors, including Erich Pommer, Robert Siodmak, Billy Wilder, and Peter Lorre).

For Lang, as for the other refugees, Paris was the first stop before Hollywood. He arrived in the United States in 1934, not speaking any English, with a one-year contract at MGM. To familiarize himself with his new country, Lang read newspapers and comic strips to get a "feeling" for the American "atmosphere." More important, Lang concluded that his movies in America would have to focus not as in Europe on a "superman" or a psychopath, but on a "John Doe," a "man of the people." Thus in his first American films, *Fury* and *You Only Live Once* (based on the legend of Bonnie Parker and Clyde Barrow), Lang explored the plight of individuals caught in the web of an unforgiving social order.

Despite his efforts to adapt to American preconceptions, Lang's perspective remained European. In most of his movies, society was depicted as hostile and confining. Lang's heroes, as he acknowledged, were involved in a futile "fight against [their] destiny." At the same time, they were trapped by external forces over which they had no control—fate, chance, inexplicable accidents, economic oppression, human intolerance. The pervasive determinism of his films found their visual correlative in innumerable images of jail cells, railroad tracks, geometric shadows on immovable walls, and actors rushing toward the camera only to be stopped at the last moment by some invisible but omnipotent barrier which they could never elude. Compared to the habitual optimism of Hollywood's movies, Lang's films presented no hope of social reform or personal salvation.

Yet there was one point of connection between Lang's European outlook and America's cultural traditions. As a boy in Vienna, Lang had been entranced by the myth of the American West as it was inter-

preted in the novels of the German writer Karl May. And Lang had eagerly attended Buffalo Bill's Wild West Show when it came to Vienna in 1905. Moreover, one of the first movies Lang ever saw was Edwin S. Porter's *The Great Train Robbery*. This infatuation with Westerns culminated in two Lang films in the early 1940s: *The Return of Frank James* and *Western Union*. But even in these movies, Lang believed he was making not just a cowboy tale but an American version of the "Saga of the Nibelungen."[14] So Lang remained a European filmmaker, forever battling against Hollywood's notions of what a lucrative movie should be.

Those refugee directors who followed Lang to Hollywood were less recalcitrant. Douglas Sirk, married to a Jewish woman, escaped from Germany in 1937 and came to America in 1939.[15] During the 1950s he devoted himself to romantic melodramas like *Magnificent Obsession, Written on the Wind,* and *Imitation of Life,* all of them elegantly photographed and bathed in Hollywood's glistening light, a significant departure from the gloom of Expressionism. Robert Siodmak, from a family of Polish Jews who had migrated to Germany, was more faithful to the Expressionist style. Leaving Paris for Hollywood in 1939, he became one of the pioneers of film noir in the 1940s, particularly in movies like *The Spiral Staircase* and *The Killers*.

Otto Preminger was far more eclectic than either Sirk or Siodmak. Born in Poland in 1906, Preminger moved with his family to Vienna when he was ten years old. By the 1920s Preminger was serving as an assistant to the celebrated Austrian theater director Max Reinhardt. In 1935, when Jews could leave Vienna before Austria succumbed to the Nazis, Preminger came to America and began working both on Broadway and in Hollywood, mostly for Twentieth Century–Fox.[16] Over the next thirty years, Preminger directed a variety of movies, from Expressionist-tinged mysteries like *Laura,* to comedies like *The Moon Is Blue,* to courtroom dramas like *Anatomy of a Murder* and political blockbusters like *Exodus* and *Advise and Consent*. These films made money but few (except for *Laura*) owed much to the practices or perceptions of the European cinema.

Of all the refugee directors, the one most adept at fusing European attitudes with American subjects was Billy Wilder. Born in Galicia to Jewish parents and educated in Vienna, Wilder spent his early

career in the 1920s as a journalist and screenwriter in Berlin. But his mother, who eventually died at Auschwitz, had filled her son with stories of America's splendors: its liberties, its wealth, its factories and trains, its amusement parks, and its Wild West shows. (Wilder, whose given name was Samuel, received his nickname Billy from his mother as a tribute to Buffalo Bill.) So Wilder grew up adoring American movies, jazz, cars, and popular culture.

More than most of his contemporaries, Wilder instantly recognized the peril of remaining in Germany once the Nazis seized control. The night after the Reichstag fire on February 27, 1933, Wilder took the train to Paris. By 1934 he had landed in America, armed with a three-month contract from Columbia and ready to assimilate as rapidly as possible. He learned English listening to the radio, especially to baseball games and soap operas. During the rest of the 1930s, Wilder wrote screenplays, several for Ernst Lubitsch, who was his model for how an immigrant from Europe might thrive in Hollywood.

Like Lubitsch (and unlike many other refugees), Wilder understood from his absorption in America's mass culture what could make American audiences laugh. In 1942 Wilder directed his first movie, a comedy called *The Major and the Minor*—a film whose humor would ultimately expand into such sardonic masterpieces as *Some Like It Hot* in 1959 and *The Apartment* in 1960. But Wilder also preserved his affection for German Expressionism, transmitting its mannerisms to Hollywood's more chilling movies in the 1940s, becoming one of the leading practitioners of film noir, notably in *Double Indemnity* (1944) and *Sunset Boulevard* (1950).

Over the course of his career in Hollywood, Wilder won six Oscars either as a writer or director, a record no other refugee equaled. Yet for all his success as an American filmmaker, and for all his knowledge of American culture, he never lost his European pessimism about human behavior. The characters in his finest movies are amoral con men, murderers, alcoholics, and egomaniacs imprisoned in their own schemes and fantasies, just as they might have been in a German film from the 1920s.

In the end, Wilder's assimilation (like that of his colleagues) was incomplete. He became a part of, while keeping some of himself always apart from, the ethos both of Hollywood and America.[17] And this

ambivalence about America affected not only directors like Wilder but European actors who also found a second home in Hollywood.

The Émigré Actors

Movie stardom was largely an American phenomenon. In Europe, actors—however well known to audiences—constantly moved back and forth between theater and films. Moreover, European viewers and critics admired movies for their direction and themes, and their artistic ambitions, not for their casts.[18]

In America, stars were the primary attraction; the subject matter, the director (with a few exceptions, like Alfred Hitchcock), and even the stories were secondary. Consequently, once an actor in America reached Hollywood, he or she rarely returned to the stage. After his revolutionary performance in 1947 as Stanley Kowalski in Tennessee Williams's *A Streetcar Named Desire*, Marlon Brando began making movies and never again appeared on Broadway. Stardom—for Brando and for many other American actors in Hollywood—was a full-time occupation.

Yet to entice international audiences, Hollywood depended on actors from abroad, often transforming them into idols as illustrious as, though more mysterious than, their American counterparts. If Charlie Chaplin was the first British star in American movies, Rudolph Valentino (born in Italy) was Hollywood's first leading man from the European continent. Valentino came to the United States in 1913 and became a celebrity in the early 1920s, particularly in two films with appropriately sensational titles: *The Four Horsemen of the Apocalypse* and *The Sheik*.

Similarly, Pola Negri (born in Poland) worked in Germany at UFA and played the title role in Ernst Lubitsch's *Madame DuBarry* before moving to Hollywood in 1923. During her brief run as the embodiment of a movie vamp, Negri managed to have highly publicized affairs with Chaplin and Valentino. At Valentino's funeral in 1926, she "fainted" several times for the benefit of photographers and placed a floral display on his coffin that helpfully spelled out her name. Years later, Negri rejected Billy Wilder's offer to play Norma Desmond in *Sunset Boulevard;* perhaps the role was too reminiscent

of her excesses in the 1920s as a star in Hollywood, albeit one from central Europe.

More than Negri, Greta Garbo captured the image of the European woman as both sensual and inaccessible. Recruited from Sweden by Louis B. Mayer, Garbo—whose training had been mostly in the theater—started appearing in MGM's movies in 1926. Throughout the late 1920s and 1930s, Garbo's films were more popular overseas than in America, until World War II, when the Germans banned American movies on the Continent and she lost her European audiences.[19] Still, she was among MGM's most incandescent stars, never trendy yet always beguiling. Then she decided abruptly to retire in 1942 and thus became an even more enigmatic symbol of the foreign actress in America.

Valentino, Negri, and Garbo were among the most renowned of the European actors who flourished, at least for a time, in Hollywood. But they were joined by a flood of émigrés during the 1920s and 1930s: Maurice Chevalier and Charles Boyer from France, Marlene Dietrich from Germany, Béla Lugosi from Hungary, Hedy Lamarr from Austria.

Even actors normally considered "American" had foreign roots. Paul Muni, originally from Galicia, came with his family to the United States in 1902. Muni got his start in the Yiddish theater before going on to Broadway and then to Hollywood at the end of the 1920s. Meanwhile, Edward G. Robinson (born in Bucharest) came to America in 1903, grew up on New York's Lower East Side, made his debut on Broadway in 1915, and became a star in the movies once Hollywood converted to sound.

Not all foreign actors in Hollywood were from Europe. Because of the importance of the Latin American and especially the Mexican market, the studios hired Hispanic actors like Gilbert Roland, Ramón Novarro, Dolores del Río, Lupe Vélez, Carmen Miranda, and Cantinflas to play a range of south-of-the-border stereotypes, from "Latin lovers" to fiery women to bandits and clowns. But eventually Hispanic actors were taken more seriously. José Ferrer, born in Puerto Rico, became the first Latino to win the best-actor Oscar, for his lead role in *Cyrano de Bergerac* (1950).[20]

In the sound era, foreign voices of all types were in demand. This is, in part, why Garbo and Dietrich were such charismatic stars in the

1930s. And why—in one of the most famous of all Hollywood films, *Casablanca*—nearly every actor except for Humphrey Bogart and Dooley Wilson (who played Sam, the piano player) was an émigré or a refugee from Europe.

The list of foreigners who contributed to *Casablanca* included the director, Michael Curtiz. Born in Budapest, Curtiz directed movies in Hungary, Denmark, Austria, and Germany before coming to Warner Brothers in 1926. Curtiz quickly adjusted to the commercial prerequisites of the studio system. By the early 1940s he had developed into one of Hollywood's most reliable filmmakers—a perfect choice to direct what was initially regarded as a commonplace movie, one that might feature such characteristically American actors as Ann Sheridan and Ronald Reagan. But *Casablanca* turned into an enthralling film that dramatized the predicament of refugees attempting frantically to flee from the terror of Hitler's Europe.

In the movie, released in 1942, the city of Casablanca and Rick's café provide a temporary sanctuary for an assortment of displaced souls. The film's exploration of panic, of people on the run, hunting for exit visas that will enable them to grab the night flight to Lisbon, was enhanced by a cast of migrants who had either willingly departed or been forcibly uprooted from their native lands.

Even an American actor like Bogart seemed dislocated in these surroundings. Having recently graduated from playing third-rate gangsters to the role of Sam Spade in *The Maltese Falcon*, Bogart in *Casablanca* resembled—in his lonely existential fatalism—the French actor Jean Gabin.[21] Like Gabin, Bogart invented a character bereft of the comforts of home and family, a man aware of the absurdity of his situation and courting disaster with a knowing sneer. It was fitting, then, that another French actor, Jean-Paul Belmondo, equally skillful at impersonating cynical rogues, would imitate Bogart in Jean-Luc Godard's *Breathless* in 1960. Here was another example of a trend—in this case an acting style—that started in Europe, drifted to America, and ricocheted back to Europe.

The original title for *Casablanca* was "Everybody Comes to Rick's." And everyone did, at least among the international cast that boasted one Swede (Ingrid Bergman), one Austrian (Paul Henreid), two Brits (Claude Rains and Sidney Greenstreet), one German (Conrad

Veidt), two Hungarians (Peter Lorre and S. Z. "Cuddles" Sakall), and one Frenchman (Marcel Dalio).

Ingrid Bergman arrived in Hollywood in 1939 to act in the English-language version of *Intermezzo,* a Swedish film in which she had starred in 1936. Paul Henreid came to Hollywood in the same year, after having left Austria for Britain in 1935. For Bergman as Ilsa Lund and Henreid as the resistance fighter Victor Laszlo, *Casablanca* offered roles that became indelible both in their careers and in the history of American movies.

Claude Rains had begun acting in the theater in London and appeared on Broadway in the 1920s. He became a regular presence in Hollywood films in the 1930s and was nominated for an Oscar as best supporting actor for his role as a corrupt senator in Frank Capra's *Mr. Smith Goes to Washington* (1939). But he became legendary for his performance as Captain Renault, the urbane and amoral police chief in *Casablanca* who is always rounding up the usual suspects and has most of the best lines in the movie. Sidney Greenstreet was also a stage actor in England and America before making his Hollywood debut in 1941 as Kasper Gutman, the fat man in *The Maltese Falcon* who likes talking to a man who likes to talk. As the fly-swatting Signor Ferrari, the "leader of all illegal activities in Casablanca" and therefore an "influential and respected man," Greenstreet was as shady and charming as Rains; the two collaborated in nearly stealing the film.

Among the ironies of being a German refugee in Hollywood was the requirement that one play Nazis, either cultured or cruel. No movie Nazi was more memorable than Conrad Veidt's Major Strasser. Veidt, born in Berlin, had acted in *The Cabinet of Dr. Caligari* and other German Expressionist films in the 1920s. A week after marrying a Jewish woman in 1933, Veidt (a fervent opponent of Hitler's regime) left Germany for Britain. Eventually, he settled in 1940 in Hollywood, where he made a few movies before his death in 1943. But his reputation as an actor capable of playing poised and dedicated Nazis rested with his role in *Casablanca.*

Most refugee actors, however, could secure only minor parts in Hollywood's movies. Peter Lorre had been a participant in the avant-garde theater in Berlin in the 1920s, particularly as an actor in the plays of Bertolt Brecht and Kurt Weill. His rendition of a child killer in Fritz

Lang's *M* brought him recognition outside Germany, just in time for him to escape from Berlin to Paris in 1933 after the Nazis' rise to power. In 1934, now in Britain, Lorre played a villain in the first version of Alfred Hitchcock's *The Man Who Knew Too Much*. By 1935 Lorre had traveled to Hollywood, showing up in a series of forgettable movies until he played Joel Cairo in *The Maltese Falcon* and Ugarte in *Casablanca,* each of them a small-time crook seeking either to snatch the black bird or hide the stolen letters of transit.

Other bit players in *Casablanca* included "Cuddles" Sakall, formerly a major actor in the Hungarian and German theater. Sakall, who played Carl the waiter, escaped from Hungary to Hollywood in 1940; many of his relatives died in the concentration camps. Marcel Dalio, the croupier who hands Captain Renault his winnings after Renault is "shocked, shocked to find that gambling is going on" in Rick's café, had appeared in Jean Renoir's *Grand Illusion* and *The Rules of the Game.* Dalio (like Bogart's Rick) left Paris in 1940 in the midst of the Nazi invasion of France. After making his way to Lisbon, he spent time in Mexico and Canada before finally entering the United States. Neither of his parents was so fortunate; both perished in Hitler's gas chambers.

Among the uncredited performers in *Casablanca* was Lotte Palfi, a Jewish stage actress from Germany. In the movie, she plays a woman trying desperately to sell her diamonds in order to buy a visa. Thirty-four years later, in *Marathon Man* (1976), Palfi reappeared as a concentration camp survivor who chases a Nazi dentist (Laurence Olivier) down a New York street as he's escaping with the diamonds he's robbed from his victims, shrieking that he is the "white angel" of death.[22]

As Billy Wilder remarked about the refugees in *Casablanca*'s cast, "It must have been a . . . heartbreaking reunion for the people who worked in the movie. Like meeting on the Alexanderplatz old pals, friends who were in the theater with you for years." They brought with them to the picture a sense of grief at having had to abandon their livelihood and their communities in the Old World. So it was understandable that one of the film's most poignant moments occurs when, at Victor Laszlo's command and with Rick's assent, the people at the café drown out a German anthem by singing *La Marseillaise*. During the filming of the scene, one of the actors saw that most of his colleagues

were crying. "I suddenly realized," he recalled, "that they were all real refugees."[23] And that the movie was about them.

Because of its multinational cast, *Casablanca* became globally popular after World War II. In addition, many of its lines (written by Julius and Philip Epstein and Howard Koch) became so treasured that they could be recited by people all over the planet even if they didn't always know what movie the words came from. "Of all the gin joints, in all the towns, in all the world, she walks into mine." "The Germans wore gray, you wore blue." "You played it for her, you can play it for me!" "We'll always have Paris." "Here's looking at you, kid." This was the sort of hard-edged yet romantic dialogue that reinforced the universal impact of the film.

But in one important respect, *Casablanca* was still a classically American movie. Although there were allusions to the causes of the day (Rick's experiences as a gun-runner in Ethiopia and a combatant on the Loyalist side in the Spanish Civil War, his ultimate decision to stick his neck out for the anti-Nazi resistance), the film concentrated on its characters' deepest emotions instead of dwelling on headline events. Such an emphasis on inner feelings and on personal rather than social commitments was typical for Hollywood movies, even during World War II. American films customarily focused on human relationships, not on the problems of a particular time and place. They told tales about love, intrigue, success, failure, moral conflicts, and survival. *Casablanca* was only the most celebrated instance of Hollywood's aversion to preaching, to sending its audiences political communiqués.

Yet it was precisely the psychological, as opposed to the ideological, preoccupations of America's movies and its mass culture that accounted for the worldwide popularity of American entertainment. Everyone everywhere wrestled at some point with the types of private dilemmas that afflicted the characters in Hollywood's movies. So audiences—no matter where they resided—could see some parts of their own lives reflected in *Casablanca*'s story of love and loss.

Casablanca also pointed toward the future of American filmmaking. In its use of diffuse light and fog in the climactic airport scene, in its fondness for saloons with their ubiquitous cigarette smoke, and in its fascination with morally complex individuals, the movie anticipated the emergence of film noir in the United States—a stylistic move-

ment derived from the European cinema that would dominate American movies in the years after World War II.

The Ascendancy of Film Noir

As a way of boosting movie attendance in America during the depths of the Depression, theater owners and the Hollywood studios began showing two films for the price of a single ticket—a practice called the "double feature" that lasted until the early 1950s. But a reliance on double features meant that Hollywood would have to turn out more films.

In order to meet the increased demand for movies without straining their annual budgets, the studios started making what came to be known as B pictures. These were less expensive movies, often without major stars or lavish costumes and sets, and also without the supervision that the studios imposed on their costlier and more highly publicized films. Thus the directors of B movies could frequently experiment with new techniques and less conventional themes of the sort that a producer on an A film might have forbidden.

B movies, with their stripped-down plots and truncated shooting schedules, where the dimly lit ambience of a movie mattered more than its actors or their dialogue, were a perfect medium for film noir.[24] And for émigré directors too little known or eccentric to be entrusted with big-budget movies. Indeed, without the phenomenon of the B movie, film noir might have never emerged in the United States.

The first examples both of B pictures and film noir were horror movies, one of the most popular genres of the 1930s. Universal was the principal studio specializing in tales of fear, often under the guidance of Tod Browning or James Whale, a British stage director who had come to Hollywood at the beginning of the 1930s. Browning and Whale directed some of the classic horror films of the decade: *Dracula, The Invisible Man, Frankenstein,* and *The Bride of Frankenstein.*

Most of these movies—usually starring Béla Lugosi or Boris Karloff (who, like Whale, was from Britain)—were reinterpretations of stories that had their origins either in European literature or in German Expressionist films. Browning's *Dracula* in 1931 was essentially a remake of F. W. Murnau's *Nosferatu.* Whale's two *Frankenstein* films

were based on Mary Shelley's British novel, itself an exploration of Gothic terror fashionable in nineteenth-century European fiction. The horror movies were therefore full of ominous lighting and treacherous shadows, lifeless forests and fog-bound swamps, crumbling castles and petrified townspeople, demented scientists and alien monsters. The pervasive atmosphere of violence, terror, and death was an inheritance both from the more frightening novels of the previous century and from the Expressionist canon of the 1920s.

An additional Expressionist ingredient in these films was their fascination with megalomania. The true villains of the horror movies were not the monsters but those who wished to tamper with the natural order of the universe. The personification of evil was generally an isolated, half-crazed scientist who dedicated his career to the unfettered pursuit of knowledge regardless of its consequences. The effort, as in the case of the *Frankenstein* films, to defy death and create an ideal human specimen was also a quest for unlimited power over the world. Hence the scientist threatened society not just because he was deranged but because he presumed to put himself in the place of God, ignoring the ordinary restrictions of law and morality.

The horror movies, like their Expressionist predecessors, warned that some mysteries were better left unsolved, that to pass beyond the boundaries of human custom and social norms was to invite madness and desolation.[25] In the age of Hitler, this was an admonition that viewers were gleaning from the headlines as well as at the movies.

Whatever the Expressionist influences on the horror movies, film noir also drew on American literary and cinematic traditions. The crime and detective fiction of the 1920s and 1930s—especially the novels of Dashiell Hammett, Raymond Chandler, and James M. Cain—contributed to the unsentimental mood of many American films in the 1940s. Hammett's *The Maltese Falcon* (1930), Cain's *The Postman Always Rings Twice* (1934) and *Double Indemnity* (1936), and Chandler's *The Big Sleep* (1939) all possessed a tough-minded prose style (borrowed from Hemingway), an intimate familiarity with the city's mean streets, and a keen sense of irony that characterized not only the movies adapted from their novels but the whole outlook of film noir. It was not surprising, then, that Chandler should have been welcomed in Hollywood. Together with Billy Wilder, Chandler wrote the script

for the movie version of *Double Indemnity* in 1944 and worked on the screenplay for Alfred Hitchcock's *Strangers on a Train* in 1951.

Two American movies from 1941 were particularly influential in the creation of film noir. *Citizen Kane* might well have been the greatest Expressionist movie ever made in America. All the elements in the movie—its extreme camera angles, its baroque compositions, its images of people trapped in gigantic prisons like Xanadu, its attentiveness to the lunacy of unbridled power—reproduced the Expressionist obsessions of the 1920s. But the movie also established the tone and visual idioms for film noir in the 1940s.

So, too, did John Huston's interpretation of Dashiell Hammett's *The Maltese Falcon*. With its terse dialogue, Hammett's novel sounded like a screenplay. As a result, it was impossible to read the words of Sam Spade, Joel Cairo, and Kasper Gutman without hearing the voices of Humphrey Bogart, Peter Lorre, and Sidney Greenstreet.

Like the novel, the movie helped construct the iconography of the solitary private eye, adrift in a world of shifting identities, dishonesty, and betrayal, a world in which no one can be trusted and nothing is ever what it seems. The characters in *The Maltese Falcon* are always concealing their true purposes as they search for a prize whose value none can estimate. Even for Spade, the falcon remains a mystifying Holy Grail, cloaked in disguises and a maze of historical legends, eternally eluding the grasp of ordinary mortals. At best, the falcon is, as Spade (echoing Shakespeare) says at the end of the film, "the stuff that dreams are made of." Meanwhile, like the other damaged protagonists in film noir, Spade survives by keeping his emotions and opinions to himself, carrying out distasteful assignments while adhering to a private conception of morality, a professional code of conduct, and an existential sense of honor.[26]

Still, for all that it owed to American sources, film noir was inconceivable without the participation of European refugee directors like Fritz Lang, Billy Wilder, Otto Preminger, and Robert Siodmak. The somber Freudian films that proliferated in wartime and postwar America depended on the refugees' experience of disillusion and exile, and their sensitivity to persecution, to being stalked by nightmarish forces that could annihilate them in an instant. Their perpetual insecurity, even in Hollywood, led to the furtive quality of their movies, as

if every character was involved in a clandestine activity where the line between appearance and reality, between friends and enemies, was always obscure.

The refugees brought their tortured memories to Hollywood. And with Wilder's *Double Indemnity* and *Sunset Boulevard,* Preminger's *Laura,* and Lang's *The Big Heat* (as well as Howard Hawks's *The Big Sleep,* Raoul Walsh's *White Heat,* and two later movies by Orson Welles, *The Lady from Shanghai* and *Touch of Evil*), film noir became a European-style art cinema wedded to American subjects.[27]

Much of film noir's originality was attributable to its Expressionist techniques. In contrast to A pictures, with their comforting ideas, deluxe sets, and inconspicuous camerawork and editing, the "dark" movies of the 1940s emphasized their cinematography often at the expense of coherent story lines. (When the screenwriters on *The Big Sleep,* William Faulkner and Leigh Brackett, couldn't decipher who murdered a particular character, a chauffeur, they asked the author of the novel, Raymond Chandler, to explain. Chandler couldn't figure out who killed the chauffeur either.) To compensate for the convoluted plots and modest budgets of B movies, the directors of film noir resorted to Expressionist lighting, sinister shadows that obscured the faces of actors, distorted close-ups, and low-angle shots. Interiors featured Venetian blinds, staircases, banisters, walls, any geometric design that would (as it had in Fritz Lang's German films) reinforce a character's feeling of being ensnared by fate.[28]

The locale of film noir, as of many Expressionist movies in the 1920s, was primarily urban. The action in American films usually took place in apartments, bungalows, hotel rooms, bars, gyms, boxing rings, or pool halls. Outside were flashing neon signs and rain-coated streets enveloped in fog. The climaxes frequently occurred in alleys, subway tunnels, train yards, or (as in the case of *White Heat*) power plants.[29] All these settings underscored the malaise of the modern (now American) city. New York, San Francisco, and Los Angeles had replaced Berlin as the centers of anxiety and malevolence.

Sometimes, to untangle the labyrinthine stories, film noir (unlike Expressionist movies, which were mostly silent) offered audiences a voice-over narration, a tale told by a man who is either dying or dead. Voice-overs were one of Billy Wilder's favorite devices. A mortally

wounded Walter Neff, played by Fred MacMurray, ruefully confesses his crimes through a Dictaphone to Edward G. Robinson's hard-bitten insurance claims investigator, who can neither avert nor fathom a murder in *Double Indemnity.* In *Sunset Boulevard,* we listen throughout the movie to the acerbic voice of William Holden lying dead at the bottom of Norma Desmond's swimming pool (with Erich von Stroheim, one of the original émigré filmmakers and the visual embodiment of an Expressionist brute, playing Desmond's former director and husband Max Von Mayerling, now her butler, preparing to shoot her one last close-up).

Yet what can the narrators really clarify? If the years of the Weimar Republic were filled with random violence and abnormality, in the era of Auschwitz and Hiroshima everyone seems capable of murder. Greed, corruption, criminality, these tendencies are all inherent in human nature, at least according to the verdict of film noir. Everyone —policemen, adulterous wives, jealous husbands, self-absorbed lovers, unemployed writers, faded movie stars—are driven to manipulate, deceive, and occasionally slaughter one another. At each moment of decision, characters (there are no heroes) compromise their integrity and sell their talents to the highest bidder.

In such a world, where partners and friends are also conspirators, it is natural to stop being a slum-bred, socially victimized outlaw, as in the movies of the 1930s, and become a psychotic killer (like James Cagney's Cody Jarrett in *White Heat*). Meanwhile, postwar audiences witnessed the transformation of Humphrey Bogart from the jaded private eye or café owner of *The Maltese Falcon, Casablanca,* and *The Big Sleep* to the paranoid villain of John Huston's *The Treasure of the Sierra Madre.* Indeed, it would not be very long before Bogart began to specialize in depictions of psychopaths, culminating in his steel-ball-rolling, strawberry-hunting Captain Queeg in *The Caine Mutiny.*

No institution, least of all marriage, was exempt from neurotic or amoral behavior in a noir film. Where in Expressionist movies men were regularly monstrous, in film noir it is women who are lethal. Barbara Stanwyck in *Double Indemnity,* Lana Turner in *The Postman Always Rings Twice,* Rita Hayworth in *The Lady from Shanghai* and *Gilda,* and Gloria Swanson in *Sunset Boulevard* are all a menace to romance and to family life. The men in these movies are either physically

crippled, like Everett Sloane in *The Lady from Shanghai,* or caged, like William Holden in *Sunset Boulevard.* Swanson especially presides over a Gothic mansion in which her men, whether Holden or von Stroheim, are captives, both at the mercy of a woman as vampire.[30]

In the end, though, the men and the women in film noir are always defeated. There are no happy conclusions either in Expressionism or in film noir. The best anyone can hope for is to live a little longer. "The only way to stay out of trouble," Orson Welles muses at the close of *The Lady from Shanghai,* "is to grow old, so I guess I'll concentrate on that." Or one can shrug, as Marlene Dietrich does in the final scene of *Touch of Evil,* her very presence in that movie a reminder of how much film noir was indebted to German Expressionism. And then there is the howling laughter with which *The Treasure of the Sierra Madre* finishes, when the two surviving prospectors realize that their gold has gone back to the mountains, a laughter that signals their acceptance of what God or fate delivers to humans no matter who they are or what they do.

All of these movies—whether made by a John Huston or a Billy Wilder—were classic examples of how noir films undermined the optimistic premises of postwar American power and affluence. Yet the preeminent director of film noir was neither an American nor a refugee from Germany, but an expatriate from Britain.

Born in London in 1899, raised as a Catholic with a deep sense of apprehension about the world and about the sinfulness of human beings, Alfred Hitchcock began working in the British film industry in 1920 as a designer of title cards for silent movies. He started to direct his own movies in 1922, though it would take several more years before he became known as a major British filmmaker.

In the meantime, Hitchcock spent 1924 and 1925 in Germany, mostly at the UFA studio in Berlin, absorbing the techniques of Fritz Lang and F. W. Murnau. Hitchcock was particularly attracted to the disturbing elements in Expressionism, its fixation with the murderous and the macabre, and its recognition of the way that ordinary events can conceal the most fearsome and maniacal dangers. But Hitchcock was also enchanted with American movies—especially the films of D. W. Griffith, Charlie Chaplin, Buster Keaton, and Douglas Fairbanks. He appreciated as well the American notion of moviemaking as

a business, with its emphasis on marketing and public relations. Thus Hitchcock wanted to inject an Expressionist style into movies that would appeal to (even as they might frighten) a mass audience.

During the late 1920s and 1930s, back in Britain, Hitchcock acquired a reputation as a superlative director of thrillers and spy films —notably *Blackmail* (1929), *The Man Who Knew Too Much* (1934), *The 39 Steps* (1935), and *The Lady Vanishes* (1938). Given the artistic and commercial success of these movies, David O. Selznick (the producer and mastermind of *Gone with the Wind*) invited Hitchcock in 1939 to come to Hollywood. For Hitchcock, as for other émigré directors, the Hollywood studios provided more sophisticated filmmaking facilities than existed in Britain or Europe.[31] The studios also promised an ambitious director like Hitchcock the chance to make A pictures, and to thereby become rich and famous. Still, Hitchcock's American films retained many of the same Expressionist preoccupations that had characterized his movies in Britain.

The specter of evil lurking beneath the everyday activities of normal people—a concern both of Expressionism and film noir—remained Hitchcock's central theme throughout his British and American careers. The heroes of *Rear Window* (1954), the American version of *The Man Who Knew Too Much* (1956), *The Wrong Man* (1956), and *North by Northwest* (1959)—whether played by James Stewart, Henry Fonda, or Cary Grant—are all average men who find themselves accused of or inadvertent witnesses to crimes, espionage, and treachery.[32] *The Man Who Knew Too Much* begins with James Stewart and Doris Day, the personifications of commonplace American respectability, as a couple taking a vacation in Morocco with their son. Within a few minutes of the film's opening, a wounded man whispers a secret to Stewart (before dying in Stewart's arms) about a plot to assassinate a foreign dignitary. Soon after, the son is kidnapped. And the mother and father are immediately plunged into a world of conspiracy and mayhem.

Indeed, Hitchcock's universe is one in which routines of all sorts can at any moment become hazardous. We all hear and see birds chirping in trees or congregating on telephone wires, but we don't expect them to turn on us in a deadly assault, as they do in *The Birds* (1963). Everyone takes a shower, but in *Psycho* (1960) this act becomes the occasion for the most brutal kind of insanity and bloodshed.

Hitchcock's world is also one in which social institutions and systems of belief are unable to keep the absurd at bay. Usually, the police and the courts are of no help. In *The Wrong Man,* the forces of law and order are resolutely trying to convict Henry Fonda's character of a robbery he did not commit. In *The Man Who Knew Too Much,* Stewart cannot go to the police for fear that his kidnapped child will be killed. When he finally does consult the authorities, he discovers that they are restricted by such legal niceties as search warrants and a respect for the diplomatic immunity of foreign embassies. Nor does religion offer any solace. The criminals in *The Man Who Knew Too Much* pose as clerics, and a London chapel provides a haven for homicidal schemes.

Essentially, Hitchcock—like his fellow film noir directors—warned his audiences that civilization barely masked the possibilities of madness and anarchy. Thus many of his most alarming stories and scenes take place among the reassuring symbols of culture and social life: a typical small town, imagined by the screenwriter Thornton Wilder, in *Shadow of a Doubt* (1943); an ostensibly bucolic Indiana cornfield and Mount Rushmore in *North by Northwest;* an aristocratic Albert Hall in *The Man Who Knew Too Much.* At the same time, Hitchcock's villains behave with charm and elegance. Joseph Cotten in *Shadow of a Doubt,* Claude Rains in *Notorious* (1946), and James Mason in *North by Northwest* may play killers, even Nazis in the case of Rains, but they are all debonair.

What made these insights doubly perplexing was the realization that Hitchcock's innocents were not much different from his robbers, assassins, and spies. Hitchcock emphasized the slender wall between the normal and the abnormal in *Rear Window,* where Stewart solves a murder largely because he is a voyeur. And Janet Leigh is butchered by a schizophrenic in *Psycho,* but she herself is a thief.

The surrealism of Hitchcock's narratives was underscored by his characters finding themselves propelled into symbolic dream worlds. Hence the fantasy of being chased across a vast field (*North by Northwest*), the nightmare of hanging precariously from some terrifying height and in danger of plummeting to one's death (*North by Northwest* or *Vertigo* in 1958), the fear of being imprisoned in a tiny space where one's scream for help is unheard (the shower in *Psycho,* a tele-

phone booth in *The Birds*). It made a bizarre kind of sense, then, that Hitchcock should have conscripted Salvador Dalí to design a dream sequence in *Spellbound* (1945), a movie that was an ode to Freudian psychoses.

For Hitchcock, sanity could never be taken for granted. His characters are often in the grip of compulsions that psychologists (as at the close of *Psycho*) can seldom explain, much less cure. Consequently, characters like Robert Walker's Bruno Anthony in *Strangers on a Train* (1951) or Anthony Perkins's Norman Bates in *Psycho,* or even the vengeful birds (whose harmlessness we have too casually assumed) are all disruptors of our daily comforts, architects of dread beyond logical understanding. What is more disturbing, the monsters are undetectable, their irrationality and destructiveness ignored until they have us trapped in a nondescript motel room or dangling by our fingers from some horrifying precipice.

Hitchcock's "lesson," which his audiences paid good money to learn, was that it could happen to them, while riding a train or enjoying a holiday or taking a bath. After seeing one of his films, audiences found themselves in a world less sensible than they liked to believe. On the contrary, moviegoers discovered that they were surrounded by dark forces that could periodically threaten to upset the tidiness of their lives. And at the end of the chaos, after our safeguards have failed, all we are left with is Norman Bates—another incarnation of Dr. Caligari or M—staring at the camera with a perverse, self-satisfied smile.[33]

Hitchcock's movies attracted audiences all over the world. But they were just part of the movement that made film noir an international and particularly a transatlantic phenomenon. What started in Germany in the 1920s and flourished in America in the 1940s now returned to Europe as one of the leading genres of the postwar French and British cinema.

The Impact of Film Noir Abroad

During and after World War II, despite their fierce hostility to the "Americanization" of European culture, French intellectuals fell in love with modern American literature. Writers like Jean-Paul Sartre, Albert

Camus, and André Gide were especially passionate about the works of Ernest Hemingway, William Faulkner, John Dos Passos, and John Steinbeck, as well as about the hard-boiled novels of Dashiell Hammett and Raymond Chandler. What the French admired about America's novelists were their portraits of desperate people caught in extreme situations, their emphasis on vagabonds and tough guys, the elliptical style of their prose, their impatience with philosophy, and their refusal to tell their readers what to think.

To some degree, the French praise of American fiction, like the French adoration of American jazz, was a bit patronizing. In complimenting American novelists for their stylistic restraint and their fondness for taciturn characters, French intellectuals were hinting that American writers should leave the deep thoughts to the Europeans. The Americans, apparently, would do well to concentrate on those genres at which they excelled: detective stories, semijournalistic exposés of crime and corruption, novels with fast-paced plots and monosyllabic dialogue featuring heroes who were not introspective and spent little time contemplating the meaning of their lives.

Yet the French were also converting American novelists into existentialists, as if Hemingway or Faulkner (like Sartre and Camus) were participants in the wartime resistance movement, and thus the products of a European rather than an American sensibility. Moreover, in applauding the earthiness of American fiction, Sartre and Camus were ridiculing and rejecting what were, to them, the calcified literary traditions in France and the stuffy bourgeois culture of Europe.[34]

In view of their special, if insular, interpretation of American literature, it was not surprising that French intellectuals in the postwar years should equally appreciate a certain type of American film. Once the Nazis were defeated and American movies could again be shown in France, many filmgoers discovered pictures like *The Maltese Falcon,* *Laura,* and *Double Indemnity.* Indeed, the term *film noir* was a French invention, first applied to Hollywood movies in 1946 by the critic Nino Frank, and then expanded in 1955 by Raymond Borde and Etienne Chaumeton in their book *Panorama du film noir américain 1941–1953.* For the French critics, film noir described a cinema of urban turmoil, distrust, and malice, filled with the images and sounds of panic and death.[35]

It was not long before French directors started to make their own

noir films. Among the most memorable were Henri-Georges Clouzot's *The Wages of Fear* (1953) and *Les Diaboliques* (1955), Jean-Luc Godard's *Breathless* (1960), and François Truffaut's *Shoot the Piano Player* (also 1960). But the most authentic example of European film noir came earlier, and not from France but from Britain.

With Carol Reed's *The Third Man,* released in 1949 and based on a story and screenplay by Graham Greene, we are back in Vienna, where (along with Berlin) Expressionism and film noir began. As in the 1920s, Vienna after World War II remains supremely decadent, full of spies and black-marketeers, from which only flight preserves innocence. Into this maelstrom—accentuated by tilted camera shots, dizzying staircases, grotesque close-ups, and giant shadows projected on the façades of crumbling buildings—strides Holly Martins, an American author of second-rate Westerns, played by Joseph Cotten. He is searching for an old friend, Harry Lime, who turns out to be Orson Welles (it's as if half the cast of *Citizen Kane* has landed in postwar Vienna).

Martins is an American naïf who has no idea of the evil he is confronting in the Old World. "Go home, Martins, like a sensible chap" advises a British Major Calloway (Trevor Howard). "You don't know what you're mixing in, get the next plane." "As soon as I get to the bottom of this," Martins promises, "I'll get the next plane." To which Calloway responds, "Death's at the bottom of everything, Martins. Leave death to the professionals."

The scenario of *The Third Man* is as intricate and often as baffling as the plots of *The Maltese Falcon* and *The Big Sleep.* Eventually, Martins finds Lime, but only after Martins learns that his friend is a killer, selling watered-down penicillin to hospitals where the children who receive it are rendered incapable of fighting their diseases. Yet Lime—like the villains in Hitchcock—is a charming cynic, utterly amoral and thoroughly captivating, particularly as personified by Welles. In fact, Welles has all the wittiest dialogue, some of which he wrote himself, including the most famous lines in the film: "In Italy for thirty years under the Borgias they had warfare, terror, murder, and bloodshed, but they produced Michelangelo, Leonardo da Vinci, and the Renaissance. In Switzerland they had brotherly love—they had five hundred years of democracy and peace, and what did that produce? The cuckoo clock."

Unraveling the mystery of Harry Lime does Holly Martins no good. At the end of the film, he is alone, staring down an empty Vienna thoroughfare as the woman he loves passes him by without a glance. This is the way noir films usually end. And will continue to end during an entirely new cycle of paranoid, "neonoir" thrillers in the 1970s. Yet whether it's Berlin in the 1920s, or southern California in the 1940s, or postwar Vienna, or the Washington of Watergate, in the last reel we always finds ourselves in "Chinatown."

Haunted by the fevers of the Weimar Republic and the subsequent rise of Hitler, the German Expressionists brought their anxieties and sense of despair to America. But America, or at least Hollywood, embraced the darkness, the disarray, and the neuroses that seemed an even larger part of the modern world and of modernist culture. It may be startling that Berlin found a new home in Hollywood. Still, just as the United States has always adapted foreign influences to its needs, so American moviemakers took the most innovative films of the early twentieth century, the films that UFA produced in the 1920s, and transformed them into a distinctively American cinema, a cinema more suitable for global consumption than the Berliners could have ever imagined.

The New Wave Abroad

■

From the end of World War II until the 1970s, the American film industry was in trouble. While America's movies continued to dominate the international market, four factors eroded the power of the old Hollywood: the appearance of alternative forms of entertainment, the disintegration of the traditional studio system, the rise of independent producers and directors, and the growing appeal of British and foreign-language movies in the United States.

Each of these developments weakened Hollywood's grip on the imagination of audiences in America and abroad. During the postwar years, American movies seemed once again—as they had at the beginning of the twentieth century and in the 1920s—artistically inferior to the works of their foreign competitors. And now, unlike the 1930s, there were no refugees and far fewer émigrés to invigorate the American actors, directors, cameramen, and other technicians who toiled for the studios. For the most part, foreign talent remained overseas; Hollywood was no longer a beacon or a haven for the world's moviemakers.

Yet despite these misfortunes, Hollywood managed to release some of its finest movies in the 1950s and early 1960s. Moreover, the seeds were being planted for a revolution in American filmmaking in the late 1960s and 1970s. As it turned out, the cinematic "new wave" abroad ultimately led to a new wave at home.

The Decline of the Studios

In 1946 American films grossed $1.7 billion domestically, the most lu-
crative year in the history of the industry. The movies collected ninety
cents of every dollar Americans spent on entertainment. Nearly 100
million people went to the movies each week. At the same time, Hol-
lywood was producing around 400 films a year.

In 1963 Hollywood released only 141 movies. By the start of the
1970s movie attendance in America had fallen to 17 million people a
week. Meanwhile, from 1947 through the end of the 1950s, four thou-
sand downtown and neighborhood movie theaters closed (indeed, only
the number of drive-in theaters expanded in the 1950s, reflecting the
growth in car ownership and highway construction, which made it fea-
sible to erect large outdoor theaters in pastures beyond a city's bound-
aries). The decrease in moviegoing and film production coincided with
and accelerated the disappearance of double features and B pictures,
and the decline of cartoons, shorts, and newsreels.[1]

The studios were suffering not only from a loss of their mass au-
dience but also from an assault on their economic structure and their
central role in how Americans used their leisure time. In 1948 the
Supreme Court—ruling that Hollywood was monopolizing the distri-
bution and exhibition of its films—forced the studios to sell the theaters
they owned in the United States and end the practice of block booking.
Henceforth, the studios could no longer count on a steady flow of do-
mestic receipts, as they had in the past.

Simultaneously, television—free entertainment one could savor
in the comfort of one's living room—began to draw people away from
movie theaters. Television rapidly became America's main medium for
information and amusement. There were just one million television sets
in the United States in 1948; that figure had soared to thirty-eight mil-
lion by 1954. By 1956, three-quarters of all American homes possessed
at least one TV set.

But television wasn't the sole rival the movies confronted. The
migration of millions to the suburbs, the focus on family life as a con-
sequence of the baby boom, the shift in consumer spending to furniture
and appliances, the swelling interest in other leisure pursuits (garden-
ing, boating, backyard barbeques, vacations), all these made going to
the movies less compelling.[2]

The studios responded to the challenge especially of television by offering audiences visual and aural spectacles they couldn't see or hear at home, squinting at a small screen whose programs were in black and white. New technologies like CinemaScope, VistaVision, Panavision, and Todd-AO made possible wide-screen extravaganzas shot in Technicolor with wrap-around sound. These devices were particularly suitable for the biblical sagas, adaptations of Broadway musicals, war films, and Westerns that postwar Hollywood hoped would retrieve its audience.[3] A number of the 1950s blockbusters—like *Quo Vadis* (a remake of the Italian epic from 1913), *The Greatest Show on Earth,* and *The Robe*—did make piles of money for the studios. None surpassed the success of *Ben-Hur,* the 1959 spectacular that cost $15 million (the most expensive movie Hollywood had ever made) but earned $75 million and won a record eleven Oscars, including best picture, best director (William Wyler), best actor (Charlton Heston), and best musical score (Miklós Rózsa).

Eventually, though, the studio heads learned that if they couldn't beat television, they could join it, even take it over. During the 1950s the studios sold or leased many of their pre-1948 movies to local stations, which showed these films—often mercilessly cut and interrupted by commercials—in the afternoons and late at night. But in 1961 more recent movies became a staple of prime-time programming with the debut of NBC's *Saturday Night at the Movies.*[4] Now people could still stay home, but to watch movies in addition to regular television fare.

In the mid-1950s two icons of Hollywood turned up with their own shows on television. The two hosts could not have been more different in their sensibilities or in the content of their programs. Yet their arrival on television signaled that Hollywood was growing more interested in the new medium as an adjunct of and an advertisement for films.

On ABC, then the most marginal of the television networks and therefore in need of a major star, Walt Disney became the master of ceremonies in 1954 for a show called *Disneyland,* eventually rechristened *The Wonderful World of Disney.* The program promoted Disney's new theme park in Anaheim as well as his movies. In fact, Disney recognized that television was not an adversary of but a partner for Hollywood.[5] Where Charles Foster Kane had thought it would be "fun [just] to run a newspaper," Disney (like Rupert Murdoch thirty years

later) understood the benefits of "synergy," of presiding over a movie studio, a television program, an amusement park, and all of the spin-off products these could generate, as in the case of Davy Crockett's coonskin caps.

Disney was a comforting, avuncular figure on his show. Alfred Hitchcock was hardly reassuring, and no one ever regarded him as Uncle Alfred. Yet *Alfred Hitchcock Presents,* featuring Hitchcock's droll introductions and commentaries about half-hour dramas filled with sinister characters plotting mayhem and murder, ran on CBS from 1955 to 1960, and then on NBC until 1965. From 1962 until 1965, the program expanded to an hour. Hitchcock himself directed only eighteen episodes. But his rotund silhouette and his ominous "good evening" were hallmarks of the way a Hollywood superstar could still hypnotize the television audience.

The twin triumphs of Disney and Hitchcock on the small screen helped persuade the studios that television could be a profitable venture, especially as the audience for traditional movies shrank. As television converted from live programming to film in the late 1950s, and the center of TV production moved from New York to Los Angeles, Warner Brothers, Columbia, and Twentieth Century–Fox started to make shows for the networks. Soon, B pictures had revived in the form of police and medical dramas, Westerns, and situation comedies, all of them providing the studios with reliable revenues not only from initial sales to the networks but also from reruns, syndication, and foreign distribution. By 1960 Hollywood was supplying 80 percent of the prime-time shows in the United States and a substantial proportion of the programs people saw abroad.[6]

Nevertheless, Hollywood's entrance into and control over television did not propel audiences back to the movie theaters. Nor were the legendary entrepreneurs who created the movie industry able any longer to divine what the masses wanted. Indeed, they seemed unable to comprehend the changes in people's habits and tastes. As a result, they departed the studios, through either retirement or death. Louis B. Mayer was forced to leave MGM in 1951. David O. Selznick produced his last film in 1957. Samuel Goldwyn stopped making movies in 1959.[7] Harry Cohn, of Columbia, died in 1958. Jack Warner sold Warner Brothers to Seven Arts Productions in 1966, and he died in

1978. The idols who had graced the moguls' movies were dying as well: Humphrey Bogart in 1957, Errol Flynn in 1959, Clark Gable in 1960, Gary Cooper in 1961, Marilyn Monroe in 1962.

The chief beneficiaries of this transformation in Hollywood were a new generation of stars, their agents, and independent production companies. It was increasingly impractical for the studios to maintain a large pool of actors, producers, directors, writers, composers, and other employees, all signed to long-term contracts. The studios could function more effectively as bankrollers (as United Artists had always done), financing and distributing individual movies designed and made by freelance actors and directors as part of a discrete package put together by powerful talent agencies. The particular project and an artist's creative freedom were what mattered now, not the studio's monitoring every facet of a film's development and an actor's career. By 1958, 65 percent of American movies were made by independents, often shooting on location.[8] "Hollywood" had become an economic abstraction instead of a place where movies were actually made.

Yet ironically, the competition from television, the deterioration of the studio system, and the increasing importance of independent productions were all responsible for some of the most memorable films of the 1950s and early 1960s. And the new pressures on and reconfiguration of the movie industry prepared Hollywood for entirely different sorts of American movies that would appear in the years after 1965.

American Films in the 1950s

One of the myths embedded in the history of American films is that the period from 1950 until 1967 was a time of inane, big-budget movies intended only to earn money and entertain the dwindling number of viewers—usually adolescents—who could be seduced away from their television sets. In addition, the effects of McCarthyism and the blacklist in Hollywood allegedly frightened filmmakers into avoiding the major issues of their era. The movies of the postwar years were supposedly mediocre and mindless. And so it would not be until the late 1960s that a new generation in Hollywood returned to making "serious" works of art.

One might never know, then, that in the 1950s and early 1960s

audiences in America and abroad could see some of Alfred Hitchcock's and Billy Wilder's best films. They could also watch John Ford's *The Searchers* and *The Man Who Shot Liberty Valence;* Joseph Mankiewicz's *All about Eve;* Elia Kazan's interpretation of Tennessee Williams's *A Streetcar Named Desire, Viva Zapata!, On the Waterfront, East of Eden,* and *Splendor in the Grass;* Orson Welles's *Touch of Evil;* John Huston's *The Misfits,* which proved that Marilyn Monroe, in her last film, could be a sensitive actress, not just a sex symbol; John Franken-heimer's *The Manchurian Candidate;* Sidney Lumet's *12 Angry Men* and *The Pawnbroker;* Robert Rossen's *The Hustler;* Martin Ritt's *Hud* and his adaptation of *The Spy Who Came in from the Cold,* John le Carré's portrait of what his main character, Alec Leamas, calls the "seedy, squalid bastards" who (unlike the dashing James Bond) become spies in order to "brighten their rotten little lives"; Stanley Kubrick's *Dr. Strangelove,* another dismantling of the Cold War's mystique; and Mike Nichols's movie version of Edward Albee's *Who's Afraid of Virginia Woolf?*

Most of these movies were inexpensive and shot in black and white, their style and often their content a legacy of film noir. They may not have attracted the huge audiences that flocked to *Ben-Hur.* But they addressed the problems and defined the mood of America (if not also the world) as perceptively as did the films of the 1930s or the 1970s.

A striking number of Hollywood's postwar films, frequently using the metaphor of the entertainment world, examined the ways in which a social system devoted to the incentives of greed or power drove human beings to manipulate and corrupt one another. Certainly, this was one of the themes of *All about Eve* (1950), the wittiest as well as the most disturbing movie ever made about the theater and the moral perils of becoming a star.

Similarly, in *Sweet Smell of Success* (1957), Burt Lancaster's J. J. Hunsecker is a savage gossip columnist, a caricature of Walter Winchell, whose opaque glasses hide his omniscient eyes. Hunsecker lords it over the New York night world that is the country's center of media and money, and of its competitiveness and fear ("I love this dirty town," Hunsecker muses from his regal balcony overlooking the scurrying crowds on the street). The press agent on whom he depends for

"items" to put in his column is a rodent named Sidney Falco, played manically by Tony Curtis. Falco will do anything Hunsecker wants, whatever his occasional qualms ("But me no buts, Sidney"), because he longs to be "in the big game with the big players." They're both cookies "full of arsenic" as Hunsecker says of Falco. And they're slimy and unscrupulous; that's how they've survived in a society that values fame over honor.

In most of these movies, amid the pressures to compromise one's integrity, there is a brief moment when the (usually male) protagonist remembers what it feels like to be his own man. In *Requiem for a Heavyweight,* a 1962 film based on a live television play written in 1956 by Rod Serling, Mountain Rivera (played in the movie by Anthony Quinn) is a battered prize fighter trying to resist the plea of his manager (Jackie Gleason) to make a few extra dollars by transforming himself into a clown in fixed wrestling matches. Mountain takes pride in only two memories as a boxer: the knowledge that the authorities had once "ranked me number five," and that he never "took a dive." And yet at the end of the movie, Mountain has lost whatever is left of his dignity. He dons an Indian headdress, whooping and cavorting around the wrestling ring, turning himself into a freak, while his ex-corner man (Mickey Rooney) watches from the back of the arena, tears streaming down his face.

No movie better captured the underside of America's postwar self-satisfaction than *The Hustler* (1961)—one of the era's masterpieces, a film shrouded in the grime and gloom of a city's back streets and alleys, with a young Paul Newman as Fast Eddie Felson, a pool player with "talent" but no character; Piper Laurie as Sarah, his alcoholic lover; George C. Scott, who delivered the most chilling performance of his career as a pimp named Bert Gordon ("I'm a businessman, kid"); and Jackie Gleason as Minnesota Fats. Like other midcentury American films, *The Hustler* is preoccupied with how people use, deceive, betray, and destroy one another. The pool hall becomes a "church" where the prayers of the hustlers, the players hungry to "win" and humiliate their opponents, are answered. Though to Eddie's partner, the place looks less like a cathedral than a morgue: "Those tables are the slabs they lay the stiffs on."

But midway through the movie, Eddie (his thumbs broken and

momentarily incapable of hustling pool, about to sell his services to an exploiter of other people's skills) tells Sarah how it feels when he's not hustling but playing as well as he can, how "the pool cue's a part of me," when winning or losing is less important than the sense of being really good at something. "You're not a loser, Eddie," Sarah responds, "you're a winner. Some men never get to feel that way about anything."

Yet it eventually takes Sarah's suicide to give Eddie the "character" that sets him apart from the hustlers and the hustled. This gift, though, comes with a heavy price tag. After Eddie has at last defeated Minnesota Fats and refused to pay Bert part of the purse, Bert accepts Eddie's defiance. But Bert warns Eddie in a hushed voice full of menace, "don't ever walk into a big-time pool hall again." Eddie—like Robert Rossen in the early 1950s—has been blacklisted, at least until he reappears in 1986 in Martin Scorsese's *The Color of Money*.

Still, the obsession in these films with selling out, with the dangers that come from living by the ethic of success, with the spiritual poverty that accompanies the acquisition of wealth, was a commentary on the presumed complacency of America in the 1950s. These were the genuine problems of an affluent society, and few among the career-minded organization men (and their wives) in the audience could feel free to pay to themselves the final, simple compliment that Fast Eddie and Minnesota Fats pay to each other: "You shoot a great game of pool."

American movies in the 1950s were equally preoccupied with the failure of parents, older siblings, and authority figures of all types to comprehend the young. Unlike the situation comedies on television (with the conspicuous exception of Jackie Gleason's *The Honeymooners*), Hollywood rarely celebrated family life. Instead, the movies lamented the absence of strong fathers and empathetic mothers (as in *Rebel without a Cause* or *Splendor in the Grass*), parents who might have provided some credible moral guidance to their offspring. In effect, the parents in these films are reminiscent of all the adults in J. D. Salinger's 1951 novel *The Catcher in the Rye*: they are banal, hypocritical, and oblivious to their children's needs.

This conflict between the generations was reinforced by the emergence of new stars like Montgomery Clift, Marlon Brando, and James Dean. These were actors who personified the rebellion in the 1940s

and 1950s of the Abstract Expressionists, the Beats, the African American jazz musicians, the rock and roll singers, and the juvenile gangs, all of whom seemed to be an antidote to the smugness of the postwar years.[9]

Montgomery Clift, for example, was often paired with masculine, brawny actors, adroit if pathologically stubborn embodiments of authority, like John Wayne in *Red River* and Burt Lancaster in *From Here to Eternity*. In Howard Hawks's *Red River* (1948), Clift plays Matthew Garth, the adopted son of John Wayne's Thomas Dunson. Throughout the film, even when he is appalled by Dunson's fanaticism and has taken over the cattle drive, Clift's Garth seems physically and emotionally vulnerable, traits seldom seen in the conventional Western hero. The contest between Wayne and Clift, between "father" and symbolic son, is underscored by Clift's almost adolescent anguish versus Wayne's certitude and strength.[10]

The same clash pervades *From Here to Eternity*. Here, Burt Lancaster's Sergeant Warden has a magnetic presence, just like John Wayne. Warden is cynical, clever, resourceful, willing to take only those risks whose consequences he has calculated in advance, capable of manipulating the system but always careful to accept the rules of the game. He is a jaded adult who knows how to flourish in the modern, if constricted, world. By contrast, Clift as Private Robert E. Lee Prewitt is a principled nonconformist, but (like any teenager) he is perpetually bewildered and inarticulate. He is also, as his name implies, a throwback to an earlier time, before the grown-ups established their codes of conduct. So Prewitt cannot survive; his rebellion (however appealing) against the army, against the omnipotent institutions of the adult world, is ultimately futile.

Marlon Brando's characters—less adolescent but just as insubordinate and as tongue-tied—have the same trouble navigating the complexities of maturity. "What're you rebelling against, Johnny," a waitress asks Brando in *The Wild One* (1953). "Whaddya got?" Brando replies. Brando's shredded T-shirt in *A Streetcar Named Desire* and his black leather jacket in *The Wild One* symbolized the generalized, if incoherent, alienation the young were supposed to have felt in the 1950s.

Even when he played roles rooted in historical periods or con-

crete social settings (as in *Viva Zapata!* or *On the Waterfront*), Brando's singular magnetism lay in the loneliness and estrangement he projected beyond the special situations in these movies. Brando raised the image of the outsider to the level of myth, transcending time and place. This attraction to marginal figures, without roots and dependent only on a small band of comrades, would be extended in the 1960s to the point where whole films, rather than single characters, became glorifications of beguiling outlaws: *Bonnie and Clyde, Midnight Cowboy, The Wild Bunch*.

Still, in *Viva Zapata!* (1952), Elia Kazan and his screenwriter John Steinbeck hoped to make a political point. Or several contradictory political points. On one level, the movie was an effort to depict the deprivations of the Mexican peasantry in the early twentieth century. All the actors, including Brando and Anthony Quinn as Zapata's brother, Eufemio, are made up to look as if they've stepped out of a Diego Rivera mural.[11] The film was even more remarkable in its passionate defense of the Mexican revolution, and indeed of any revolution in the midst of the Cold War and McCarthyism.

As befitted a movie written by the author of *The Grapes of Wrath*, *Viva Zapata!* indulged in an ample dose of agrarian rhetoric about the inner strength of people with ties to the land, who have to rely solely on themselves for salvation. Yet if these sentiments seemed left over from the 1930s, Tom Joad transformed into a Mexican campesino, the script had little sympathy for the pieties of liberal reform. Francisco Madero—the president who believes in law and patience—is portrayed as ineffectual, naïve, ignorant of the uses of power, giving off a pungent "odor of goodness." Madero is another father figure, typical of the 1950s, who disappoints his "children."

But the real villain of *Viva Zapata!* is the radical as Stalinist. When Joseph Wiseman's Fernando first arrives at Zapata's camp, an intellectual armed not with a gun but with a typewriter (which he calls the "sword of the mind"), he takes one glance at the chaotic conditions of the guerrilla band and pronounces the fateful judgment of the truly modern revolutionary: "This is all very disorganized." He then proceeds to "organize" the revolution, to rationalize the bloodshed, to hold on to power at any price, including the ultimate betrayal of Zapata himself. By the end of the film, Fernando is dressed in a uniform

that makes him look like a Bolshevik commissar. He is committed to no cause and no movement, only to the logic of revolutionary justice —and thus to endless purges, killings, and destruction. And, as Zapata says, Fernando—like his Stalinist successors—"will never change."

So however much *Viva Zapata!* was a testimonial to the courage and nobility of the Mexican people, it also reflected Kazan's and Steinbeck's disenchantment with the totalitarian fanaticism of the twentieth century. By the 1950s, like many other writers and artists in America and abroad, they had come to mistrust ideologues and true believers. As Zapata warns his peasant followers toward the end of the movie, leaders "change, they desert, they die." Above all, they go bad, like his brother Eufemio, who abandons the ideals of the revolution and begins to steal the peasants' land and their wives. In Kazan's world, you cannot have faith in your elders because (like Andy Griffith's hillbilly demagogue in *A Face in the Crowd* or both sets of parents who try to control the lives of Warren Beatty and Natalie Wood in *Splendor in the Grass*) they will always fail in their obligations to you.

By 1954, when *On the Waterfront* was released, Kazan himself had engaged in what many saw as his own act of treachery. In 1952 he had testified before the House Un-American Activities Committee, identifying some of his former colleagues in the Group Theater in the 1930s as members of the Communist Party. In part, *On the Waterfront* was a defense of informing, particularly when Brando's Terry Malloy appears before the Waterfront Commission to expose corruption in the dockworkers' union. "I'm glad what I done," Terry insists, refusing to be labeled a "pigeon," just as Kazan never apologized for his cooperation with HUAC.

On the Waterfront was also an attempt to combine Italian neorealism and on-location shooting with a religious parable. At times, there are Eisenstein-like close-ups of a dockworker as he emerges to speak his piece before fading back into the mass. In addition, the movie is frequently burdened with a heavy-handed use of Christian imagery: the nuns who teach Edie Doyle (Eva Marie Saint) the virtues of truthtelling, a eulogy by a priest (Karl Malden) for a murdered longshoreman that is filled with references to crucifixion and the need for Christian solidarity, the suggestion that all the dockworkers are not merely victims or martyrs but Christ's disciples.

Yet the movie is far more than an up-dated proletarian or theo-logical melodrama, or a vehicle through which Kazan could justify his role as a "friendly witness." As played by Brando, Terry Malloy is a more embittered version of the 1950s juvenile: angry, instinctive, un-comfortable with words, and let down by the adults in his milieu—the crooked labor leader, John Friendly (Lee J. Cobb), and especially his older brother (Rod Steiger).

"You was my brother, Charley," Brando reminds Steiger in *On the Waterfront*'s legendary taxicab scene; "you shoulda looked out for me a little bit. You shoulda taken care of me just a little bit so I would-n't have to take them dives for the short-end money." When Steiger replies that the mob had some bets down for him, Brando responds with a wail that could have summed up the frustration of every ado-lescent confronted with a baffled adult: "You don't understand." And then Brando utters some of the most famous lines in the history of American movies: "I coulda had class. I coulda been a contender. I coulda been somebody, instead of a bum, which is what I am, let's face it." At this moment, we are at the heart of the national yearning not just for success but for self-respect.

Brando's characters in the 1950s and early 1960s are often pun-ished for being rebels and outcasts.[12] They get beaten up in *On the Wa-terfront* or killed in *Viva Zapata!* and *The Fugitive Kind*. James Dean's characters (Jim Stark in *Rebel without a Cause*, Cal Trask in *East of Eden*) merely suffer from a lack of parental insight or love. Their prob-lems, unlike Brando's, stem from dysfunctional families, and from the moody neuroses that come from growing up in a home where no one appreciates anyone else. Mothers are absent and fathers are unap-proachable (as in *East of Eden*). One had the feeling that if only the parents in his movies displayed some sympathy and affection, Dean's torments would be eased.

Nevertheless, Dean became a cultural hero for the young in the 1950s because of his sensitive, even trembling, portraits of middle-class delinquents longing to find some form of compassion in a nation of in-flexible law-abiding conformists. The most that adolescents can achieve, however, is to create a surrogate family (which Dean, Natalie Wood, and Sal Mineo do in *Rebel without A Cause*). Or, finally, to embrace a nearly mute, bedridden father, as at the end of *East of Eden*. It helped

in the latter film that Dean and Raymond Massey, who played the fa-
ther, detested one another, a mutual loathing that Elia Kazan encour-
aged, so that their ultimate reconciliation was more poignant if not
necessarily credible.[13]

"What we've got here is failure to communicate." This immortal
line, delivered by the great character actor Strother Martin, playing the
captain of a chain gang in *Cool Hand Luke* (1967), seemed to capture
the political and social discord of the late 1960s. But the line was
equally applicable to the generational quarrels of the 1950s. And in-
deed the lack of communication between parents and children would
persist in the American and foreign movies of the 1950s and 1960s—
from François Truffaut's first film, *The 400 Blows,* through *Hud, The
Graduate, Alice's Restaurant,* and *Five Easy Pieces* (where Jack Nichol-
son repeats the scene at the close of *East of Eden,* though Nicholson
here is trying unsuccessfully to explain his life to an infirm father who
cannot hear or accept what his son is saying).

Yet the American movies that starred actors like Paul Newman,
Montgomery Clift, Marlon Brando, and James Dean did more than
delineate the themes of the postwar era. Hollywood's best films also
offered a stylistic model that foreign directors could imitate and si-
multaneously surpass. There were "auteurs" everywhere during these
years, and the reciprocal influences helped invigorate both the Ameri-
can and the world's cinema.

The Impact of American Films in Postwar Europe

During World War II the Nazis forbade American movies from being
shown on the Continent. Thus when the war ended, Hollywood had a
large stockpile of unseen films ready to be shipped to European the-
aters. Moreover, the studios looked on the European market, and on
foreign revenues generally, as a partial solution to their loss of viewers
at home. Increasingly, exports to Europe and to other parts of the
world would determine a film's commercial success.

Hollywood needed to make sure that there were no restrictions
on the showing of its films overseas, no import quotas or high tax rates
imposed by foreign governments that might reduce the studios' earn-
ings abroad. So in 1945 the studios created the Motion Pictures Ex-

port Association, a successor to the Motion Picture Producers and Dis-
tributors of America. Working closely with the State Department, the
MPEA bargained with or pressured foreign governments, especially in
Europe, to remove all impediments to the import and exhibition of
American films.

At the same time, Secretary of State James Byrnes negotiated a
treaty in 1946 with Léon Blum, France's former prime minister, to re-
open the French market to American movies in return for Washington's
financial aid. The Blum-Byrnes agreement initially had a devastating ef-
fect on the French film industry, which—without the competition from
American movies—had flourished during World War II under the Nazi
occupation. The production of French films dropped by 50 percent in
1947, while American movies were now playing throughout the coun-
try. Yet by the early 1960s France developed into a center of European
filmmaking with the appearance of a new generation of directors who,
ironically, learned much of their craft by watching and worshiping Hol-
lywood's postwar movies.

Italy proved to be the most important market on the Continent
for the MPEA. American films made more money in Italy in the late
1940s and 1950s than in any other European country besides Britain
—Hollywood's largest and most reliable overseas market since the
1920s.[14]

The situation in West Germany was thornier. Immediately after
the war, the American government launched in its zone of occupation
a de-Nazification campaign, which sought to eradicate Hitler's influ-
ence in politics, education, and journalism. Washington also hoped to
resurrect a German film industry that would be committed to demo-
cratic values, as it had been in the 1920s. So Billy Wilder and Erich
Pommer briefly returned to Germany, working with the American
army to help revive the cinematic traditions of the Weimar years. But
refugees like Wilder and Pommer who had escaped the Nazi tyranny
were now resented by their former German colleagues. Meanwhile,
the MPEA persuaded the State Department that American movies—
with their celebration of freedom and affluence—could more effec-
tively reeducate the Germans and turn them into dependable anti-
Communists in the Cold War than could films made by the West
German studios.

As a result, by 1949, 70 percent of the films shown in the American zone came from Hollywood. And in the 1950s movies like *The Wild One, Rebel without a Cause,* and *Blackboard Jungle* influenced the dress styles and behavior of the young in West Germany. Even with the appearance in the 1950s of popular German-made "Heimat" (or "homeland") films that stressed the values of marriage, family, community, and rural life, American movies continued to affect those among the West German audience (including future directors like Wim Wenders and Werner Herzog) who longed to jettison the culture of their parents and the Nazi past.[15]

By the 1950s most of the countries in Western Europe were inundated with Hollywood's movies. American films occupied 85 percent of the screen time in Ireland; 75 percent in Belgium, Denmark, and Luxembourg; 70 percent in Britain, Finland, the Netherlands, and Greece; 65 percent in Italy and Portugal; 60 percent in Norway and Sweden; and 50 percent in France and Switzerland. In 1958 nearly half of Hollywood's profits came from abroad (compared with 20 percent in the 1920s and 40 percent in 1937), and European ticket sales accounted for the major portion of these earnings.[16]

The omnipresence of American films in Europe led to a reconsideration of their artistic content and techniques. In France, for example, film clubs (beginning with the establishment of the Cinémathèque Française in 1936 under the direction of Henri Langlois) became for young intellectuals a major source of exposure to foreign and American movies. In the 1940s and early 1950s, François Truffaut, Jean-Luc Godard, Claude Chabrol, Alain Resnais, and Jacques Rivette—all of whom would emerge first as critics and then as the directors of the French "New Wave"—were educated at the Parisian cinema clubs.

After the war, they especially discovered American movies. Until now, film reviewers on both sides of the Atlantic had dismissed American movies as mere entertainment, or (when they were feeling less charitable) as exemplifications of the commercialism and tastelessness of America's mass culture. In either case, there appeared to be no point in scrutinizing the works of hacks who labored on the Hollywood assembly line. But Truffaut and his friends found themselves entranced with the directorial idiosyncrasies of John Ford and Nicholas Ray, the

veiled themes in the camera work of Alfred Hitchcock and Howard Hawks, the visual pyrotechnics of Orson Welles.

Nowhere else in Europe was there as extensive or as favorable a reassessment of American movies as in France in the 1950s. And in no other country did critics like Truffaut and Godard marshal so much knowledge about the esthetics, if not the prosaic details, of filmmaking to defend a previously maligned Hollywood. Soon they were investing American movies—sometimes quite ordinary movies—with meanings and metaphors normally discerned only in the greatest works of fiction, poetry, and the theater. And they developed a theory—the auteur theory—that conferred on film directors in the United States the status of modernist painters, architects, and composers.

The idea that directors were the "authors" of their films was not new. For a long time, critics had referred to European directors like F. W. Murnau, Carl Dreyer, Sergei Eisenstein, and Jean Renoir as the authors of their respective films. What made the young French filmgoers unusual as well as controversial was their insistence that directors in Hollywood were also creators of their own movies. Where other critics customarily described the American director as a hired hand, assigned to a picture by the studio bosses, with no control over the script or the cast, the French writers searched through the reels of Hollywood's movies for the director's distinctive personality and point of view.

Their guide in this quest was an older critic, André Bazin, who had started to write about movies in 1943. In the late 1940s Bazin reexamined Hollywood films, arguing that American directors like Welles and William Wyler were turning out a body of work which was comparable in quality to the best of Europe's movies. In 1951 Bazin became the cofounder of a new journal, *Cahiers du Cinéma*. Among the other editors and frequent contributors were Truffaut, Godard, Chabrol, Rivette, and Éric Rohmer. *Cahiers* quickly evolved into the most influential film journal in Western Europe and acquired a number of followers in the United States. By the end of the 1950s the magazine and its writers had changed the way movies, particularly American movies, were seen and evaluated.

Why did European movies suddenly seem no better than, and possibly inferior to, their American counterparts? In his 1954 *Cahiers*

article "A Certain Tendency of the French Cinema," Truffaut attacked what he called the "tradition of quality" in postwar French films. He complained that these and other European movies were too prim, too didactic, too reliant on expensive costumes and elaborate sets, and too content simply to illustrate novels and plays. The true auteur, of the sort one could find in America, used film as a instrument of personal expression in which the script, the plot, and a social message mattered less than a director's cinematic style.

In fact, for the *Cahiers* critics, Hollywood was the perfect place to look for a director's vision precisely because of the pressures to conform to whatever the studios wanted. In their estimation, America's directors were alienated artists, struggling against the obstructions of witless producers, injecting into their films an array of visual clues to their private preoccupations that only those who were most attuned to a movie's symbolism and images could uncover. Hence, *Cahiers* converted the lowly Hollywood director into a master of indirection, a secret poet and subtle moralist, an abused and neglected genius.

According to the French analysts, one could not identify an authentic auteur by the subject matter of his film. This was a convenient proposition for the *Cahiers* critics, since most of them were not fluent in English, and so could readily ignore the banality of an American film's dialogue and its hackneyed plot. Instead, they concentrated on camera angles, lighting, pace, the positioning of actors, and the relationship of one shot to another—all the cinematic elements they called the mise-en-scène. Only in the formal structure of a movie could one locate the director's individuality, his intentions, his values.

This emphasis on style enabled the *Cahiers* writers to launch or rescue the reputations of dozens of Hollywood directors. They paid close attention to the majestic landscapes looming over the doomed cavalry in a John Ford Western, the accelerated rhythms of a Raoul Walsh gangster film, the glances between a man and a woman in a Howard Hawks thriller, the haze of cigarette smoke and the murk of a city night in the film noirs of Billy Wilder and Otto Preminger, the explosions of color in the musicals of Vincente Minnelli, the loneliness in the silences between characters in the movies of Nicholas Ray.

The auteur theory and the concept of the mise-en-scène rapidly entered the vocabulary of film critics throughout the world. In the

United States, the French passion for American movies served as an endorsement of America's culture. Most American writers and filmmakers cared deeply what the Europeans, and especially the French, thought. The French critics seemed to be confirming the presence in America of a cinematic tradition capable of reaching the summit of art.

Yet at times, as in the French idolization of American jazz in the 1930s, the contributors to *Cahiers* appeared to be praising the technical dexterity of American directors while minimizing their intellectual sophistication. Moreover, many *Cahiers* critics were defending American movies for reasons that had less to do with the excellence of filmmaking in the United States than with their contempt for the current state of movies in France, and with their desire to become directors themselves. Using the Hollywood film as a model, Truffaut, Godard, Chabrol, Rohmer, and Rivette wanted to modernize the French cinema and, not incidentally, become the chief creators of an entirely new kind of movie in Europe.[17]

Which they succeeded in doing. The auteur theory provided the basis not only for the emergence of the French New Wave but for an appreciation of a postwar generation of directors in Italy, Sweden, and Britain whose movies redefined the art of the film. And ultimately, the newfound respect for Hollywood's movies that helped inspire a revolution in European filmmaking also transformed the American cinema in the 1960s and 1970s.

The Renaissance of Foreign Films

Despite Hollywood's continuing command of the global film market and its reliance on income from overseas, the decline in the number of movies being produced in America during the 1950s meant that the studios had relatively fewer films available for export. Meanwhile, other countries—especially Britain, France, Italy, Japan, and India—had an opportunity to enlarge their own film industries and to turn out movies that appealed to international audiences, including viewers in the United States.

In fact, the postwar years were a golden age of foreign filmmaking. An extraordinary group of European and Asian directors made movies that people everywhere not only wanted to see but felt they *had*

to see if they cared about movies at all. For a brief period, Ingmar Bergman, Federico Fellini, Michelangelo Antonioni, François Truffaut, Jean-Luc Godard, Akira Kurosawa, and Satyajit Ray were the world's most illustrious auteurs. And America's audiences as well as its directors looked to the deities abroad for examples of what a modern movie should be.

As in the fourteenth century, the renaissance (now of filmmaking) began in Italy, though this time by way of America. In the 1930s Italian literary critics and aspiring directors had fallen in love with the "realism" of contemporary American fiction. They admired the lean prose and attention to social detail in the novels of Sinclair Lewis, John Dos Passos, Erskine Caldwell, John Steinbeck, and above all Ernest Hemingway. For the Italians, the American literary style seemed gritty but truthful, not fraudulent and bombastic like the language of Mussolini's fascism. Thus in 1943 Luchino Visconti—who became one of Italy's leading postwar directors—based his first movie, *Ossessione*, on James M. Cain's *The Postman Always Rings Twice*.[18]

But Italian filmmakers quickly developed their own style of "neo-realism," which in turn impressed American directors and filmgoers. In 1945 Roberto Rossellini released *Rome, Open City* (cowritten by Federico Fellini), which grossed one million dollars in the United States in 1946, the greatest success for a foreign-language film in America since the arrival of sound. Rossellini followed this triumph with *Paisan* in 1946, another profitable film in America. Before long, the Italian neorealists were dominating the foreign cinema, particularly with movies like Vittorio De Sica's *Shoeshine* (1946), *The Bicycle Thief* (1948), and *Umberto D.* (1952).

What these films had in common was a semidocumentary veneer, the use of nonprofessional actors, improvised scripts, shooting on rubble-strewn streets, and a preoccupation with the urban and rural poverty that resulted both from the fascist past and the wreckage of the war.[19] The neorealists' affection for black-and-white photography and their focus on ordinary people had a profound effect on those American movies in the 1950s, like *Marty* and *On the Waterfront*, which sought to capture the sights and flavor of working-class life.

Soon, however, the Italian cinema grew less hard-boiled, more mystical, sometimes more comical, but even more internationally pres-

tigious. Theaters outside Italy, particularly in America, regularly featured movies like Fellini's *La Strada* (which won the Oscar in 1954 for best foreign-language film), Mario Monicelli's *Big Deal on Madonna Street* (a satire on Warner Brothers gangster movies with actors—Vittorio Gassman, Marcello Mastroianni, and Claudia Cardinale—who were growing into worldwide stars), Visconti's *Rocco and His Brothers*, and De Sica's *Two Women* (in which Sophia Loren won an Oscar for best actress). By the early 1960s Italy had become the second-largest film exporter in the world, behind only the United States, which was why Rome began to be known as "Hollywood on the Tiber."

Three movies—Fellini's *La Dolce Vita* (1960) and *8½* (1963) and Michelangelo Antonioni's *L'Avventura* (1960)—confirmed Italy's status as the place where a director's vision and personality were on the most spectacular display. Working constantly with the composer Nino Rota, who later created the haunting scores for *The Godfather: Parts I and II,* Fellini had a lifelong attraction, reflected in his movies, to music halls, chorus girls, circuses, clowns, magicians, corrupt impresarios, and all the sordid but uproarious trappings of show business. His fascination with the surrealist connections between religion and entertainment (a statue of Christ floating over the rooftops of a dissolute Rome in *La Dolce Vita*), and with the dream world of the artist who has lost his faith but thrives in the decadence of the modern city (in *8½*), became touchstones for American films in the 1970s about the music or movie industries. Fellini's preoccupations and style—eclectic, bizarre, improvisational, autobiographical—could be seen in Robert Altman's *Nashville,* Bob Fosse's *All That Jazz,* and especially Woody Allen's *Stardust Memories.*

Antonioni was more austere than Fellini. His films, particularly *L'Avventura,* were punctuated with long tracking shots and pans, cryptic dialogue, excruciating silences, and cerebral angst-ridden characters who seemed unable to decide on or complete a course of action. Indeed, plot-driven narratives mattered less to Antonioni than the soul-destroying emptiness of modern life.[20] Antonioni's most influential movie, however, was *Blow-Up* (1966), probably because it was in English and also because it was a modernist thriller, an updated example of film noir, in color and transferred to swinging London. Its air both of mystery and horror, and of the solitude surrounding the man who

cannot figure out what he's seen or heard, made it a model for Francis Ford Coppola's *The Conversation* (1974) and Brian De Palma's *Blow Out* (1981).

Italian movies from the 1940s until the 1960s were more commercial and meant less for the cognoscenti than were the films of the French New Wave. Still, in Italy as in France, movies were regarded first of all as works of art, as they were not in the United States. But for those Americans who did care about the artistic potential of movies, French directors had as strong an impact on young audiences and would-be filmmakers in the United States as did their Italian colleagues.

During the 1950s ordinary people in France (like the majority of Americans) began to desert the movies in favor of television. Hence costly films of the kind François Truffaut scorned as "quality" movies became less profitable. Meanwhile, the French government under Charles de Gaulle was increasingly willing to subsidize films that might not make much money but did demonstrate the artistic superiority of French culture. At this moment, a band of young directors, many of them former film critics, set out to create inexpensive movies that would be modernist in their style and appeal to a smaller, more elite audience bored with the conventions of cinematic storytelling.[21]

They burst onto the world's stage at the Cannes film festival in 1959 with Truffaut's *The 400 Blows* (for which he won the festival's award as best director) and Alain Resnais's *Hiroshima mon amour*. These films were swiftly followed by Jean-Luc Godard's *Breathless* (1960), Truffaut's *Shoot the Piano Player* (1960) and *Jules and Jim* (1962), and Resnais's *Last Year at Marienbad* (1961).

Some of the New Wave films owed a substantial debt to Hollywood's genres, as one might have expected from directors who had spent their early years captivated by American movies. *The 400 Blows*, though based on Truffaut's own childhood, resembled *Rebel without a Cause* in its portrait of an adolescent persecuted by stuffy and mean-spirited parents, teachers, policemen, and judges. *Breathless* (dedicated to Monogram Pictures, the humblest of the Hollywood studios, and starring Jean-Paul Belmondo as a French Humphrey Bogart) and *Shoot the Piano Player* copied the tough-guy style of America's movies about mobsters and two-bit crooks—another instance of how often transatlantic cultural influences seemed like a hall of mirrors.

Yet the French directors were making movies that looked utterly different from Hollywood's products. Since the French films were shot on a tight budget, typically using the director's friends and lovers as members of the cast and crew, the New Wave movies depended on techniques that were experimental and spontaneous, like those of a Jackson Pollock painting. If a scene was too protracted, as happened in the filming of *Breathless*, Godard simply (and sometimes arbitrarily) snipped what was now deemed extraneous material, so that the result was a disconcerting combination of long takes and jump cuts. The New Wave directors also adored the informality of handheld cameras and unrehearsed dialogue, as well as exaggerated close-ups and freeze frames that could leave the viewer perplexed (as at the end of *The 400 Blows*).

Indeed, one of the hallmarks of the New Wave directors, like those of other modernist artists, was their delight in disorienting their audiences. As Godard remarked, with a bow to *Citizen Kane* and anticipating Quentin Tarantino's *Pulp Fiction*, "a story should have a beginning, a middle and an end, but not necessarily in that order." So he and Truffaut broke with the American tradition of "invisible" editing. They dispensed with intelligible narratives, inserted allusions to film history and popular culture, and shifted abruptly from comedy to violence (a juxtaposition that was soon reproduced in American movies, starting with *Bonnie and Clyde*). The point was to remind viewers that they were watching not a tale full of characters with whom they could identify but a movie, an artificial construct composed of a sequence of shots and images.[22] There would be no guideposts, no messages, no conclusions in the last reel. Audiences would have to decide for themselves at the end of a film how to respond.

Godard's films in particular were the cinematic equivalent of Bertolt Brecht's plays. Godard stuffed his movies with disquisitions on society and politics (the action in *Breathless* inexplicably stops while Belmondo and Jean Seberg spend twenty enervating minutes of screen time in an apartment discussing their philosophies of life). At one point in his career, Godard announced that he was making films only "for one or maybe two people"—a sure sign of the directorial narcissism implicit in the auteur theory.[23]

Truffaut, however, was far more interested in reaching a large

audience, as he did later in his life with *Day for Night* (which won the Oscar for best foreign-language film in 1973) and *The Last Metro* in 1980. But his masterwork was *Jules and Jim*. Here Truffaut presented a triangular love story, with Jeanne Moreau as Catherine, the inscrutable object of the two men's fascination and desire. In spite of the characters' complicated relationships, the film was a lyrical tribute to a vanished world of bohemians in the early twentieth century, before the age (in Europe and America) of political regimentation and social conformity. Nevertheless, its sexual intricacies would reappear in muted form in *Bonnie and Clyde,* the 1967 movie that inspired the American New Wave, though now with Faye Dunaway's Bonnie as an occasionally irritated outsider witnessing the playful shenanigans between Warren Beatty's Clyde and Michael J. Pollard's C. W. Moss. (It was not surprising that *Bonnie and Clyde* borrowed the mannerisms of the French New Wave, since David Newman and Robert Benton, *Bonnie and Clyde*'s screenwriters, offered the script first to Truffaut and then to Godard, both of whom turned down the chance to direct.)

Truffaut was always a romantic in his films. There was nothing wistful about the movies of Ingmar Bergman. Yet Bergman's movies in the 1950s and early 1960s also captured a worldwide audience. For some Americans, weary of Hollywood's more genial fare, *The Seventh Seal, Wild Strawberries, The Virgin Spring,* and *Through a Glass Darkly* were among the finest as well as the most enigmatic imports, not least because of Max von Sydow's chilly visage, personifying the metaphysical agonies at the center of Bergman's dramas.

Bergman's films were unmistakably Swedish, just as Akira Kurosawa's *Rashômon, Seven Samurai,* and *Yojimbo* were drenched in Japanese history and culture. But it was frequently hard to tell what country a European movie came from because many were financed and coproduced by a variety of governments. And their directors and casts were often multinational and multilingual.

Thus *Never on Sunday* (1960) with Melina Mercouri was one of Greece's most commercially successful films. Yet it was directed by an American, Jules Dassin, who had been blacklisted in the early 1950s and spent the remainder of his career working in Europe. Dassin went on to direct an enormously popular caper movie, *Topkapi* (1964), which was shot in Istanbul and boasted an international cast that in-

cluded Mercouri, Maximilian Schell, Peter Ustinov, and Robert Morley. Then there was *Z* (1969), a film about the investigation of an assassinated politician during the rule of the military junta in Greece. The director was Costa-Gavras, who was born and grew up in Greece before leaving to study filmmaking in France. The screenwriter was Jorge Semprún, originally from Spain, though he spent many years after the Spanish Civil War in exile in France. The film was shot mostly in Algiers and two of the leading roles were played by French actors—Yves Montand and Jean-Louis Trintignant. *Z* won the Oscar for best foreign-language film, but it was nominated by Algeria, not Greece or France.

No "European" movie, however, jumbled the cultural traditions of particular countries more controversially than *Last Tango in Paris* (1972). The film was directed by an Italian, Bernardo Bertolucci, with a soundtrack in French and English. It featured the French actress Maria Schneider and starred Marlon Brando as a far more melancholy American in Paris than Gene Kelly had ever been. In fact, the movie is really about Brando, who drew on his life and his roles in the theater and the movies. So in *Last Tango* he plays the alienated bum at middle age, Stanley Kowalski or Terry Malloy twenty years older, still searching for the moment when he can be a contender and announce to the world—as Brando proclaims to Schneider in the film's closing scene—that "this is the title shot, baby. We're going all the way."

Before Brando got to Paris, foreign films were arriving in large numbers in the United States. And beginning with the success of the Italian neorealist movies in the late 1940s, they provided throughout the 1950s and early 1960s a compelling alternative to the reign both of television and the Hollywood movie. For those Americans especially in their teens and twenties during these years, the foreign film permanently altered their notions of why they went to the movies and what they expected to see.

The Popularity of Foreign Films in America

During the postwar years, more foreign films entered the United States than at any time since the first decade of the twentieth century, when French and Italian movies flooded the American market. Yet at the

height of their popularity, foreign films in the 1950s and 1960s attracted only 5 percent of American moviegoers (though this modest figure contrasted starkly with the less than 1 percent of Americans who frequented foreign movies in the 1980s and early 1990s).[24]

Nonetheless, the sliver of the American audience who regularly attended foreign films was crucial to the transformation of America's movies. Among those viewers were college students, young critics like Andrew Sarris and Pauline Kael, who absorbed and quarreled about the auteur theory, and budding filmmakers like Martin Scorsese and Woody Allen, who learned about directing from the movies of Fellini, Antonioni, and Bergman—not to mention already established but eccentric directors like Sam Peckinpah, whose idea of the Western was shaped as much by Akira Kurosawa and Sergio Leone as by John Ford.

The growing presence of foreign films in American theaters accompanied the decay of the Hollywood studio system. Louis B. Mayer liked to say that MGM made "family" pictures, by which he meant movies aimed at the mass audience. Now that audience had splintered.[25] Older viewers, raised on traditional Hollywood spectacles, still went to see *Ben-Hur* and *The Sound of Music*. But for younger filmgoers, foreign movies were a revelation. Because of their unconventional stories, their realism, and their greater openness about sex, films from abroad seemed more emotionally challenging than the situation comedies on television or a Doris Day–Rock Hudson movie still inhibited by the moralistic production code inherited from the 1930s.

Given the association of foreign films with high culture (Antonioni's first name, after all, was Michelangelo), the place to see movies from overseas—dubbed or subtitled—was in "art" houses. In 1956 there were two hundred art houses in the United States. By the end of the 1960s the number of such theaters had risen to one thousand. They were located not only in metropolises like New York, Boston, and Los Angeles but in college towns across the nation.[26] The notion of an "art" house suggested an atmosphere of refinement and discrimination despite the seedy decor. In the lobby you could order espresso but never popcorn. Still, it was in these theaters that many Americans were first exposed to the foreign cinema.

Americans also discovered that foreign—particularly European

—films had stars as magnetic as those in the United States. Previously, Americans had noticed European actors and actresses only if, like Greta Garbo or Marlene Dietrich, they had emigrated to Hollywood. Otherwise, as in the case of Jean Gabin, an actor might achieve fame in his own country while being virtually unknown in America. Now, British and European performers—Alec Guinness, Peter Sellers, Julie Christie, Jeanne Moreau, Simone Signoret (the first woman to win a best actress Oscar in a non-American film, in 1959 for her role in *Room at the Top*), Catherine Deneuve, Jean-Paul Belmondo, Yves Montand, Sophia Loren, Marcello Mastroianni, Melina Mercouri—became international stars, as well known as Marilyn Monroe and James Dean.

No European actress was more mesmerizing—abroad or in America—than Brigitte Bardot. Her breakthrough performance came in *And God Created Woman,* released first in France in 1956 and then in the United States in 1957. By 1958 its American receipts totaled four million dollars, breaking the previous record for a foreign film of one million dollars that *Rome, Open City* had earned in 1946. Where American movies about France had traditionally romanticized the era of late-nineteenth-century Impressionism (*Gigi, Moulin Rouge, Lust for Life, Can-Can*), Bardot's movies epitomized the country's modernity, its hedonism, its youthful restlessness, its addiction to fast cars and contemporary music.[27] Moreover, Bardot was much more erotic than America's sex symbols—Marilyn Monroe, Elizabeth Taylor, and Ava Gardner—so she seemed to embody (literally) the grown-up themes and sophistication of the European cinema.

But the foreign films that earned the highest profits in America were British. British movies had a double advantage over those made in France, Italy, Sweden, or Japan. On the one hand, they were more accessible since all the actors spoke English (though sometimes, indecipherably, with a Scottish or Welsh brogue). On the other hand, their subject matter appeared sufficiently "foreign" to distinguish them from Hollywood movies.

During the 1950s the British excelled at political satires and comedies, the kinds of movies that had flourished in Hollywood in the 1930s but were now mostly absent from the studios' repertoire. If any single actor could take credit for the postwar popularity of British films in the United States, it was Alec Guinness. Beginning with *Kind Hearts*

and Coronets in 1949 and extending through *The Lavender Hill Mob,
The Man in the White Suit, The Ladykillers,* and *The Horse's Mouth,*
Guinness made robbery and murder seem like thoroughly civilized
forms of behavior. His characters were both ordinary and psycho-
pathic, a combination also captured by Alastair Sim in *The Green Man*
and later (with more frenzy) by Peter Sellers in *The Mouse That Roared*
and *I'm All Right Jack.*

By the early 1960s the comedies gave way to a cycle of caustic
films about the class divisions in British society. With their harsh black-
and-white photography and their use of actual locations in the dreary
industrial towns north of London, the British portraits of working-class
life were clearly influenced by Italian neorealism. With the exception of
an occasional Hollywood film like *On the Waterfront,* shot on the
docks of Hoboken, audiences in America were unaccustomed to movies
as grim in their settings as *Room at the Top* (with Laurence Harvey as
a serpentine social climber), *Saturday Night and Sunday Morning, A
Taste of Honey, The Loneliness of the Long Distance Runner, This
Sporting Life, Billy Liar,* and *Darling.*

Americans were also introduced in these movies to a talented
group of British directors, like John Schlesinger and Tony Richardson,
just starting their careers, and to the performances of an unheralded
generation of actors (Albert Finney, Richard Harris, Tom Courtenay,
Julie Christie), all of whom specialized in characters at once charming
and self-absorbed. It was a sign of Britain's newly acquired eminence
in filmmaking that *Tom Jones*—directed by Richardson and starring
Finney, filled with French New Wave techniques like handheld cam-
eras and characters speaking directly to the audience—won the Oscar
for best picture in 1963.

One major reason for the success of British and European films
in the United States during the 1950s and 1960s was the willingness of
the Hollywood studios to finance, produce, and distribute those movies
in America. The studios, though, were interested in bankrolling only
certain types of European films—movies that might be esthetically ad-
venturous yet sufficiently entertaining to please American viewers. The
studios' ideal transcontinental film could have a European director and
a predominantly European cast, but it also needed to include plenty of
action sequences, spectacular scenery, heroes burdened with moral or

romantic dilemmas, and often the presence of at least one American star. Most of all, the movie had to be in English.

Thus in 1957 the American producer Sam Spiegel (who was born in Galicia but fled to the United States in 1935) and the British director David Lean joined to make *The Bridge on the River Kwai*, with Alec Guinness and William Holden. In 1962 Spiegel and Lean collaborated again on *Lawrence of Arabia*, with an international cast that included not only Guinness and Peter O'Toole but also Anthony Quinn and Omar Sharif. In 1964 Quinn starred in *Zorba the Greek*, directed by Michael Cacoyannis and produced by Twentieth Century–Fox. In 1965 Lean and the Italian producer Carlo Ponti made *Doctor Zhivago*, whose cast included a galaxy of British stars along with Sharif and Rod Steiger, an American Method actor playing a lascivious Russian. The movie itself was funded by MGM. During the mid-1960s, United Artists was the principal financier and distributor of the Italian "spaghetti Westerns" directed by Sergio Leone and featuring a young Clint Eastwood. United Artists also subsidized *Last Tango in Paris* in the hope that Marlon Brando still had enough charisma to fill American theaters.[28]

Topping the British imports to America, there was Bond. James Bond. Especially as played by Sean Connery. The Bond films were produced by an American, Albert Broccoli, and a Canadian, Harry Saltzman (who was also the executive producer for *Saturday Night and Sunday Morning*). The series was distributed by United Artists. And it was (and remains) the most successful franchise, in America and abroad, in the history of movies.

Beginning with *Dr. No* in 1962 and continuing with *From Russia with Love, Goldfinger, Thunderball,* and *You Only Live Twice*, Connery's Bond (like Daniel Craig's more recent incarnation) is a combination of elegant and working-class Britishness. Yet Bond is a British spy who works easily with his counterparts in the CIA, since both have a common purpose in waging the Cold War. The Americans are equally skilled and dedicated, unlike the well-meaning but bumbling "cousins" who muck up George Smiley's operations in the novels of John le Carré.

Richard Burton as Alec Leamas in *The Spy Who Came in from the Cold*—alcoholic, disheveled, despondent—was hardly an action

hero. Nor did Burton's movie have the sorts of production values and spectacle dear to Hollywood. But the Bond films were filled with special effects, high-speed chases, exotic locales, and spectacular women with outlandish names. Bond was British, but—apart from the Savile Row suits and the Aston Martin cars—he might as well have been an American Batman, a prototype for all the comic book figures who zapped America's enemies in the Hollywood blockbusters of the 1980s and 1990s. So it made sense that Connery should appear in 1989 as Indiana Jones's father in Steven Spielberg's *Indiana Jones and the Last Crusade.*[29]

Still, despite the popularity in the United States of the big-budget, American-financed British and European extravaganzas, it was the smaller New Wave pictures that had the greatest impact on America's filmmakers. Movies like *La Dolce Vita* and *Jules and Jim* became exemplars of the types of films that American directors wanted to make —movies with quirky stories and an avant-garde style, with complex characters who were neither conventionally good nor bad, and without Hollywood-style happy endings (or any endings at all).

Indeed, one of the paradoxes for postwar European and Asian directors was their success in spawning American imitations. As it turned out, the foreign filmmakers were almost too influential. They helped transfigure the American cinema so that it became a more dominant force in the world by the 1970s than it had been before. As a result, the film industries in other countries found it even harder in the late twentieth century to compete with the global allure of American movies.

The New Wave at Home

■

Between 1967 and 1980, from *Bonnie and Clyde* to *All That Jazz,* most of the movies worth seeing originated in America. Although a young generation of American directors, critics, and moviegoers were deeply affected by foreign films, Hollywood's own products again became essential to anyone anywhere who cared about movies. Once more, the films people argued about and remembered, that spoke directly to their social concerns and private predicaments, flowed from the United States. In few other periods were the works of American directors so central in shaping the experience and attitudes of audiences all over the world.

The renaissance in American filmmaking coincided with the political and cultural upheavals of the late 1960s and 1970s: the emergence of a New Left and a counterculture, the corruption of power emanating from Watergate, and above all the Vietnam War. While Hollywood declined to confront the issue of the war overtly until the last American troops evacuated Saigon in 1975, the conflict hovered over America's movies as a symbol of a society falling apart, a society that had lost its sense of direction, its goals and values—the qualities that had inspired so many American movies in the past. If the characters in America's films now seemed ambivalent or morose, if the movies themselves were ambiguous and confusing, such traits were reflections

of a country whose people could no longer agree on a definition of the good life.

Just the names of the movies that won the Oscar for best picture during these years are a sign of how much American films had changed. It is hard to imagine in any other era Hollywood's top award being bestowed on movies like *Midnight Cowboy, The Godfather: Parts I and II, One Flew over the Cuckoo's Nest, Annie Hall,* and *The Deer Hunter.*

The appearance of these and other American movies confirmed that the newest cinematic geniuses were home grown. A few years earlier, Ingmar Bergman, Federico Fellini, Michelangelo Antonioni, François Truffaut, Jean-Luc Godard, and Akira Kurosawa had been the world's leading auteurs, their freedom to direct and edit their movies envied by everyone who wanted to use the camera as a form of personal expression without having to fend off executives screeching about budgets and the bottom line. Now, seeking both to imitate and outshine their foreign masters, directors like Sam Peckinpah, Robert Altman, Martin Scorsese, Francis Ford Coppola, Steven Spielberg, and Woody Allen were responsible for the revitalization of American movies. And—though they did not intend this—for the end of Europe's and Asia's brief reign as centers of imaginative filmmaking.

Who in any country needed to see another *La Dolce Vita* when they could enjoy *Nashville*? Why try to decipher *Jules and Jim* or *L'Avventura* when you could savor *The Graduate* or *Five Easy Pieces*? Wasn't it conceivable that *Seven Samurai* might not be as electrifying a movie as *The Wild Bunch*? The Americans may have owed their improvisational methods, their quick cuts and disorienting camera shots, their blend of comedy and violence, and their autobiographical preoccupations largely to Italian neorealism and the French New Wave. But they applied these techniques to themes and stories that were intrinsically American. And in the process, they invented an American New Wave that has influenced filmmaking at home and abroad ever since.

The "New" Hollywood

Even as the mass audience for movies receded in the United States during the 1950s and 1960s, some younger American writers and filmgo-

ers began to embrace the foreign idea that the cinema should be viewed as an art, not as a form of escapism. In order for Americans to take films seriously, no doctrine seemed more useful than the European notion of the director as auteur, as the artist who more than any other person on the set created the look and feel of a movie.

The concept of the auteur was first popularized in America by film critics and reviewers in magazines like *Time, Newsweek, Esquire,* and the *New Yorker.* But the most influential exponent of the auteur theory was Andrew Sarris, who wrote for the *Village Voice.* In 1962 Sarris published an article in the journal *Film Culture* entitled "Notes on the Auteur Theory." He expanded his argument in 1968 in a book called *The American Cinema.* In his essay and his book, Sarris rejected the conventional assumption that movies should be judged on the basis of their political or social significance, or on the "meaning" conveyed in their plots and dialogue. Instead, he ranked American and foreign directors solely according to what he considered their cinematic and esthetic skills.[1] Good intentions and liberal values were irrelevant to Sarris. What mattered, as it did for the French contributors to *Cahiers du Cinéma,* was the artistic brilliance of the director.

Predictably, the American directors whom Sarris placed in his "pantheon" included D. W. Griffith, John Ford, Howard Hawks, and Orson Welles, along with such émigrés to Hollywood as Charlie Chaplin, Alfred Hitchcock, Ernst Lubitsch, and Fritz Lang. Residing on the "far side of paradise" were Frank Capra, George Cukor, Vincente Minnelli, Otto Preminger, and the perennial favorite of the French critics, Nicholas Ray. Among those whose films Sarris regarded as "less than meets the eye" were John Huston, Elia Kazan, and Billy Wilder. Still, it was better to find oneself in this category than to be labeled "lightly likeable" (Busby Berkeley) or a purveyor of "strained seriousness" (Stanley Kubrick, Sidney Lumet, and Robert Rossen).

The majority of the directors Sarris admired had either died or reached the ends of their careers. Sarris's formidable rival in the battle for disciples was Pauline Kael, whose predilections were more contemporary. Kael began writing and broadcasting movie reviews in San Francisco in the 1950s before graduating to magazines like the *New Republic* and *Harper's* a decade later. In 1968 she ascended to the *New Yorker* as a regular film reviewer at precisely the moment when Amer-

ican movies were being transformed, and when young filmgoers were debating among themselves (and ultimately, in their minds, with her) about the pictures they had just seen.

Unlike Sarris, Kael was not a formalist or a theorist. She reacted to movies emotionally, either loving or loathing a particular film. For her, movies had to be both provocative and pleasurable. She could tolerate a picture that was pure garbage if the filmmakers were honest about trying to make a buck. What she couldn't abide were movies that reeked of high culture.

In one of her most eloquent articles, "Trash, Art, and the Movies," published in *Harper's* in 1969, Kael reminded readers that movies had not traveled far from their roots in the "peep show, the Wild West show, the music hall, [and] the comic strip"—all those amusements that were "coarse and common." But that was part of the appeal of the movies; they allowed people to take a "vacation from proper behavior and good taste and required responses." The types of movies that Kael really detested were the middlebrow efforts to educate the audience. "The lowest action trash," she proclaimed, "is preferable to wholesome family entertainment." Because, she went on, "when you make movies respectable, you kill them. The wellspring of their *art,* their greatness, is in not being respectable."

Yet Kael did not want movies just to be fun. Nor did she ignore the importance of directors. Along with Sarris, she applauded auteurs whose films (like *Citizen Kane*) were at once innovative and exhilarating. Among her ideal American directors while she was at the *New Yorker* were Francis Ford Coppola, Martin Scorsese, Robert Altman, Sam Peckinpah, and Steven Spielberg—but exactly because these filmmakers merged the serious with the sensational.

What Kael craved were movies that rose above their lowly origins while challenging the expectations of the "official" culture. "If we've grown up at the movies," she acknowledged, "we know that good work is continuous not with the academic . . . tradition but with the glimpses of something good in trash, yet we want the subversive gesture carried to the domain of discovery. Trash has given us an appetite for art."[2] In the American movies of the late 1960s and 1970s, Kael found what she was looking for.

Of course, one needn't rely on film critics—even those as force-

ful as Sarris or Kael—to recognize the magnitude of the director's role. Television in the 1950s was a training ground for directors and actors (Paul Newman, Robert Redford, Clint Eastwood, Steve McQueen) who later became fixtures in Hollywood. The small screen especially permitted youthful directors to experiment with plot development, shot placements, and camera angles, as well as to gain experience working with actors. Live television drama served as an incubator for the talents of Sidney Lumet, John Frankenheimer, and Arthur Penn. Meanwhile, Sam Peckinpah directed TV Westerns, particularly *Gunsmoke* and *The Rifleman*. Robert Altman was the most eclectic of his colleagues in television, directing installments of *Alfred Hitchcock Presents, Peter Gunn,* and *Maverick,* in addition to eight episodes of *Bonanza* (though you could be sure that neither McCabe or Mrs. Miller ever showed up at the Ponderosa).

Nevertheless, the auteur theory flourished in the universities. The film studies programs at UCLA, USC, and NYU offered courses in the history of movies, the techniques of screenwriting and editing, and the requirements of budgets and marketing campaigns. More important, precocious students like Francis Ford Coppola at UCLA, George Lucas at USC, and Martin Scorsese at NYU learned about the primacy of the director by scrutinizing the works of foreign filmmakers and the legendary old masters of Hollywood.[3] And like their French predecessors, they yearned to become directors themselves.

They got their chance at Roger Corman's postgraduate academy. During the late 1950s and 1960s, Corman was a producer and director at American International Pictures, a low-rent studio with a reputation for shooting horror and biker movies cheaply and quickly, sometimes in two or three days. Corman aimed his films at the youth market; he had no aspirations to be an "artist." But he was willing to take risks the major studios avoided, and he allowed people just starting out in the movie business to work as cameramen, editors, and directors.[4] Among Corman's protégés were Coppola, Scorsese, Lucas, Peter Bogdanovich, Bob Rafelson, and the screenwriter Robert Towne, who would go on to doctor or write the scripts for *Bonnie and Clyde* and *Chinatown*. Corman also employed unknown actors like Jack Nicholson, Peter Fonda, Dennis Hopper, Bruce Dern, and Warren Oates, none of whom remotely resembled a traditional movie star. Yet

Corman's contribution to the revolution in American movies—especially the opportunities he gave to embryonic directors—was as profound as that of Sarris, Kael, or the film schools.

Apart from the impact of foreign directors and the auteur theory on young American filmmakers, Hollywood itself was being buffeted by the structural alterations in the industry that had begun in the 1950s. One of the most far-reaching of these changes was the collapse of the studios' production code, which had endured since the 1930s. In 1952 the Supreme Court ruled that movies were entitled to the free-speech protections of the First Amendment to the Constitution. Soon afterward, Otto Preminger's *The Moon Is Blue* and *The Man with the Golden Arm,* together with Billy Wilder's *Some Like It Hot* and Alfred Hitchcock's *Psycho,* were released without the industry's seal of approval. By the 1960s, faced with the competition from more graphic foreign films, studio heads invoked the principle of "artistic merit" to grant a certificate to *The Pawnbroker* despite a brief display of a woman's bare breasts, and to tolerate the profanity in *Who's Afraid of Virginia Woolf?*[5] Finally, in 1968, the studios replaced the code with a ratings system. Now nearly anything could be said or shown on the American screen. So much so that *Midnight Cowboy* (1969) won three Oscars despite receiving an adults-only X rating and *Last Tango in Paris* (1972), similarly rated, earned Oscar nominations for Bernardo Bertolucci as best director and Marlon Brando as best actor.

Still, for a while in the 1960s, most Hollywood movies remained fairly tame, as if they could have been made in any previous decade. Some of the most profitable films of the 1960s—*Doctor Zhivago, The Sound of Music, My Fair Lady*—were nearly three hours long and featured lavish sets, sumptuous costumes, and melodramatic story lines reminiscent of *Gone with the Wind.* But equally expensive movies like *Cleopatra, Doctor Dolittle,* and *Hello, Dolly!* turned out to be spectacular flops.

The problem for the corporate executives and conglomerates now running the studios was that they had no clue about what sorts of movies would consistently make money, or about what the new, young countercultural audience wanted. Indeed by 1968, 48 percent of all the movie tickets in America were being purchased by people under the age of twenty-four. Meanwhile, the commercial success of foreign films

in the United States demonstrated that low-budget movies with contemporary themes, shot by directors with their own eccentric preoccupations, could attract a select group of filmgoers.[6] So the studios were willing, briefly, to let anyone with an idea make a movie. And they invited into the American movie industry a band of gifted and idiosyncratic directors (Altman, Coppola, Scorsese, Bogdanovich, Spielberg, Lucas, and Woody Allen, as well as Arthur Penn and Mike Nichols) who wanted to make European-style movies—films that were mostly character studies, without conventional plots or linear narratives, and with lots of stylistic experimentation.

These American auteurs were accompanied by a new generation of atypical actors and actresses. Most of those who became movie stars in the late 1960s and 1970s—Warren Beatty, Dustin Hoffman, Robert De Niro, Al Pacino, Jack Nicholson, Gene Hackman, Richard Dreyfuss —were basically character actors, with little of the physical charisma exuded by the stars of the 1930s and 1940s. No one would mistake any of these actors, except maybe Beatty, for Clark Gable or Cary Grant. In fact, they often played characters who were inept (one of Beatty's specialties), crooks who always bungled the job (as in *Dog Day Afternoon*), down-and-out hustlers (as in *Midnight Cowboy*), or psychopaths (as in *Taxi Driver*).[7]

Although critics describe this era as exclusively masculine, with a profusion of "buddy" pictures that offered few interesting roles for women, several actresses emerged who were as compelling as their male counterparts. Faye Dunaway's neurotic performances in *Bonnie and Clyde, Little Big Man, Chinatown, Three Days of the Condor,* and *Network* established her as the period's leading actress. Diane Keaton, in addition to her parts in Woody Allen's movies (winning an Oscar as best actress for *Annie Hall*), appeared, memorably, in *The Godfather: Parts I and II, Looking for Mr. Goodbar,* and *Reds.* Jill Clayburgh was indelible as a divorcée discovering the absurdities and emancipation of a new life in *An Unmarried Woman,* while Meryl Streep became a star as a result of her role in *The Deer Hunter,* as well as smaller but equally striking appearances in *Kramer vs. Kramer* and *Manhattan.*

Yet despite Hollywood's hospitality to fresh talent, male and female, the major studios retained control over the financing and distribution of American films. Consequently, the new directors and stars

continued to work within the confines of the studio system, however much they might have to surrender some of their artistic freedom, because the studios still had the power to approve and market a movie.[8] In effect, the "old" Hollywood merged with the new—the devotees of the auteur theory, the graduates from television and the film schools, the filmmakers no longer constricted by the production code, and a collection of actors and directors committed to offbeat roles in modernist movies. Together with the studios' producers, they created a body of work unique in the history of American film.

The Americanization of the Foreign Cinema

The modernism of American movies in the late 1960s and 1970s— their disjointed stories, their elliptical style, their often-baffling characters—reflected the influence of the New Wave abroad. For the first time since the end of World War II, European art forms (and music, given the impact of the Beatles and the Rolling Stones) were shaping America's popular culture. No ambitious director could avoid the stylistic devices common across the Atlantic. American films were now filled with jump cuts, split screens, slow-motion tableaus, freeze frames, and shots from a zoom lens—all the techniques of the European cinematic avant-garde.[9]

One of the reasons for the European effect on American movies was the voyage once again—as in the 1920s and 1930s—of émigré directors to the United States. John Schlesinger, from Britain, knew little about the underside of New York night life when he came to America to make *Midnight Cowboy* in 1969, but he won an Oscar for best director nonetheless. Schlesinger followed this movie in 1976 with *Marathon Man,* a thriller with a convoluted plot in which most of the characters, in the tradition of film noir, are not what or who they appear to be. Roman Polanski, from Poland, and therefore all-too-familiar with the omnipresence of evil during World War II and the Cold War, translated his sense of an irrational European world into *Rosemary's Baby* (1968) and *Chinatown* (1974). Milos Forman, from Czechoslovakia, believed that America itself could sometimes seem Kafkaesque. When he was considering the opportunity to direct *One Flew over the Cuckoo's Nest* (1975), a friend told him he would never

be able to capture such an "American" story. Forman replied that he had "lived that story." For him, "the Communist Party was Nurse Ratched." So to Forman, the movie would be as much about Czechoslovakia as about America.[10] His insight was vindicated when his direction of the film won an Oscar.

American directors were also eager to use foreign cinematographers. László Kovács came to the United States after the Hungarian Revolution in 1956, worked in the 1960s for Roger Corman, and shot Dennis Hopper's *Easy Rider* in 1969 and Bob Rafelson's *Five Easy Pieces* in 1970, helping to turn both movies into European-style mood pieces. Néstor Almendros was born in Spain, lived in Cuba, and worked with François Truffaut and Éric Rohmer before arriving in America. He served as the cameraman for Terrence Malick's *Days of Heaven* in 1978, for which he won an Oscar for best cinematography. Perhaps the best-known émigré cinematographer was Vittorio Storaro, Bernardo Bertolucci's frequent cameraman, who had shot *Last Tango in Paris*. Storaro, like many of his foreign colleagues, went on to win an Oscar, in his case for the ghostly cinematography of Francis Ford Coppola's *Apocalypse Now* in 1979.

As they had in the past, the émigrés helped make American movies more cosmopolitan, and more appealing to a global audience. But in the 1960s and 1970s the pessimistic spirit of foreign, particularly European, films infected American movies in part because of the interminable and pointless war in Vietnam. Thus many American filmmakers avoided tidy conclusions in which the dilemmas of the characters were simplistically resolved in the final reel.[11] On the contrary, a striking number of the "heroes" in these movies end up defeated (as in *The Conversation* and *Chinatown*) or dead (as in *Bonnie and Clyde, Cool Hand Luke, Easy Rider, The Wild Bunch, McCabe and Mrs. Miller,* and *Butch Cassidy and the Sundance Kid*). In this sense, American films were embracing the aura of doom that hovered over European movies like *Breathless* and *Jules and Jim*.

One result of movies, both in Europe and America, that featured protagonists with no coherent goals, embroiled in aimless narratives, was that audiences had to work harder to figure out what a story "meant." And what they thought of enigmatic characters like Jack Nicholson's Bobby Dupea in *Five Easy Pieces* or Al Pacino's Michael

Corleone. Films shot in the manner of *Easy Rider* and *The Graduate* were (like so many modernist paintings and novels) as much about style as content. So they forced the audience to be more aware that it was watching not a depiction of the outside world but a movie, where the editing and lighting called attention to itself, where one was always conscious of the director's eye behind the camera, where viewers had to follow the action with considerable effort and concentration.[12] It was as if every young American director hoped to make a movie as mysterious and artistically difficult as *L'Avventura*.

Yet the foreign influence on American movies was always limited by the entrenched but also pleasurable traditions of Hollywood. Although film students, as Martin Scorsese recalled, were instructed "that the only serious filmmaking was foreign," that they ought to be ashamed to admit that they "liked anything American," they "grew up on . . . American films." Indeed, one of the consequences of the auteur theory was to liberate America's would-be filmmakers from the cultural snobbery that Pauline Kael railed against, and to encourage them to appreciate American auteurs like John Ford, Howard Hawks, Vincente Minnelli, and Elia Kazan.[13] So when they became full-fledged directors, the Americans did not abandon what they had learned from their foreign mentors. Instead, they combined foreign techniques with American tales and tastes.

Thus the pace of their movies was faster, the dialogue crisper and funnier. Moreover, American directors had a greater faith in the audience's ability to fill in the gaps and supply their own transitions between shots rather than having characters deliver information or meditate incessantly about their lives, as they do in *Last Year at Marienbad* and *La Dolce Vita*.[14] Nor did American movies repeat scenes half a dozen times (as in *Seven Samurai,* where the villagers are forever wailing at their plight), just to make sure that viewers got the point. American filmmakers appeared to have a higher regard for the intelligence of their audience, so their movies were more sophisticated, verbally and visually.

Their films were also more familiar despite the adoption of a modernist esthetic. American movies in the late 1960s and 1970s still relied on—even as they modified—Hollywood's hallowed genres: gangster films, detective stories, Westerns, comedies, musicals. And the

performances continued to matter; the star, from Robert Redford to Robert De Niro, remained the cornerstone of Hollywood's profits. Meanwhile, audiences were encouraged to connect with the characters however mystifying they might occasionally be.[15] Clyde Barrow and Bonnie Parker, Benjamin Braddock and Mrs. Robinson, Butch and Sundance, John McCabe, J. J. Gittes, Alvy Singer and Annie Hall, and all the Corleones involved viewers emotionally, just as the icons of Hollywood's golden age in the 1930s and 1940s had engrossed previous generations of moviegoers.

As with American painting, architecture, and music, American movies adapted foreign styles to the expectations of the audience. The auteurs abroad may have been the godfathers of America's cinematic renaissance. But the real godfathers were much closer to home.

"Ain't Life Grand?"

Bonnie and Clyde, the movie that heralded the emergence of a "new" Hollywood, opens with the camera caressing the face and body of Faye Dunaway as she inspects her lips in a mirror, and wanders around her bedroom, naked. These are not images audiences before 1967 would have ordinarily seen in an American film. In fact, the sequence is supposed to recall a similar shot of Brigitte Bardot in *And God Created Woman.* Bardot returned the favor on French television, donning a tight skirt and beret and toting a tommy gun in tribute to Dunaway while singing a duet with Serge Gainsbourg of his deadpan "Bonnie and Clyde."[16] The similarity between Dunaway and Bardot suggested that *Bonnie and Clyde* was as much a product of the French New Wave as it was an archetypal American gangster movie.

The references to the modern French cinema were not accidental. The saga of Bonnie Parker and Clyde Barrow had been filmed before in America, notably by Fritz Lang in *You Only Live Once* (1937) and Nicholas Ray in *They Live by Night* (1948). But *Bonnie and Clyde*'s screenwriters, Robert Benton and David Newman, conceived of the movie as an homage to the New Wave, particularly in their portrait (borrowed from Jean-Luc Godard's *Breathless* and François Truffaut's *Jules and Jim*) of lovers trapped in their own myths and facing certain death. After Truffaut and Godard declined offers to direct the movie,

the producer and star of the film, Warren Beatty, turned to Arthur Penn. Penn's earlier movies like *The Left Handed Gun* (1958) and *Mickey One* (1965) were full of surreal camera work and elusive meanings, and they had been praised by French critics including Truffaut.

Nevertheless, *Bonnie and Clyde* was quintessentially an American countercultural romance, one that drew on the sympathy of young audiences in the 1960s for rebels and outlaws who identify with the poor and despise the establishment, in this case the banks. At the same time, Bonnie and Clyde resemble the Pop Artists in their hunger for fame. They send their photographs to the newspapers, and Bonnie writes poems eulogizing their exploits before their demise. "You know what you done there?" exults Clyde after one of Bonnie's poems has been published. "You told my story." Then, as if he had achieved the recognition that always eluded Marlon Brando's Terry Malloy, Clyde reminds Bonnie that "I told you I was gonna make you somebody. That's what you done for me. You made me somebody they're gonna remember."

Much of the movie is filled with Clyde's high spirits. And with comic scenes worthy of the Keystone Kops—embellished with antique cars careening down dirt roads, chased by the incompetent police, accompanied by the ebullient banjo music of Lester Flatt and Earl Scruggs. Often, Clyde is a bumbler (like many of Beatty's characters, especially John McCabe in *McCabe and Mrs. Miller* and John Reed in *Reds*). Trying to impress Bonnie, Clyde holds up a bank, only to be told that it failed weeks before. Admitting to his brother Buck (Gene Hackman) that he needn't have chopped off two of his toes in prison to avoid hard time because he got paroled a few days later, Clyde chortles: "Ain't life grand?"

Yet the movie shifts abruptly from comedy and ineptitude to violence and tragedy—leaving the audience unsure about what kind of film it is watching. Upon robbing another bank, the Barrows search frantically for their getaway car, which their endearing if dimwitted accomplice, C. W. Moss (Michael J. Pollard), has parallel-parked. After Moss rams cars to pull out onto the street, the gang is about to escape when a bank teller jumps on the running board. Suddenly, the slapstick scene is transformed. Clyde shoots the teller in the face and, without the edits between a gun firing and a person being hit that the

production code previously required, we see the teller's head exploding in blood.[17] This instant juxtaposition between laughter and horror, another hallmark of the French New Wave, is a central theme, stylistically and emotionally, of *Bonnie and Clyde*.

Beyond the violence that stunned audiences in 1967, the movie is suffused with sadness. The longing, usually futile, for a surrogate family dominated the films of the 1950s, as it did in many of Arthur Penn's movies at the end of the 1960s, particularly *Alice's Restaurant* (1969) and *Little Big Man* (1970). After visiting Bonnie's mother and being told they'd best keep running, Bonnie acknowledges that "I don't have no mama. No family either." To which Clyde responds poignantly, "Hey, I'm your family." But the "family" Bonnie and Clyde have created is ephemeral. They have no future, no fantasy of a happy ending. Lying in bed in the scene before they are ambushed, Bonnie asks Clyde, "What would you do if some miracle happened and we could walk out of here tomorrow morning and start all over again clean? No record and nobody after us, huh?" Clyde replies: "Well . . . I guess I'd do it all different. First off, I wouldn't live in the same state where we pull our jobs." Bonnie turns over on her side, her face enveloped in regret that Clyde does not understand the point of her question, and she desolately accepts their fate.

Their slaughter at the end of the movie—their bodies perforated with bullets, shot by four cameras running at different speeds from multiple angles, in a blur of rapid cuts and slow motion—was unprecedented for American films (though it was reminiscent of a mortally wounded Jean-Paul Belmondo lurching down a Paris street at the close of *Breathless*). Indeed, the carnage in *Bonnie and Clyde* offended many American critics. The film received scathing reviews in the *New York Times,* the *New Republic,* and *Newsweek* (although Joe Morgenstern, *Newsweek*'s critic, changed his mind and later published a favorable piece on the movie).[18]

But Pauline Kael's pioneering defense of *Bonnie and Clyde* in the *New Yorker* signaled that American movies had entered a new era combining European cinematic complexity with Hollywood-style excitement. This was the movie Kael (and presumably her readers) had been waiting for. "Our experience as we watch it," she exclaimed, "has some connection with the way we reacted to movies in childhood: with

how we came to love them and to feel that they were ours." Still, the difference between the classic Hollywood melodramas on which Kael had grown up and America's New Wave was that a movie like *Bonnie and Clyde* did not give its audience a "simple, secure basis for identification." Viewers "are made to feel but are not told *how* to feel."[19]

Thus the movie—in true modernist fashion—forced but also freed viewers to make their own judgments about a complicated, unpredictable work of art. The modernism of *Bonnie and Clyde,* together with its roots in American entertainment, were underscored when the Pop Artist Robert Rauschenberg created a collage of images from the movie for the cover of *Time* magazine in December 1967. Soon the film became a hit in the United States and in Europe.[20] More important, the movie demonstrated that American directors could now make any sort of film they wanted in any way they liked. At least for the next few years.

If in 1967 *Bonnie and Clyde* astonished a new generation of American moviegoers, so too did Mike Nichols's *The Graduate.* Nichols had already impressed audiences with his direction, a year earlier, of the film version of *Who's Afraid of Virginia Woolf?* Nichols converted Edward Albee's harrowing play into a cinematically fluid and maniacal love story, with Richard Burton giving the most gripping performance of his career as George, alternating between acerbic humor, fury, and an indestructible attachment to Elizabeth Taylor's Martha.

Now in *The Graduate,* Nichols—who was born in Berlin and arrived in America with his Russian-German-Jewish parents in 1939—combined his affection for foreign films with his background as an improvisational comedian. Like the creators of *Bonnie and Clyde,* Nichols was entranced with the French New Wave, especially with *Jules and Jim.* Initially, he considered casting Jeanne Moreau as Mrs. Robinson, before settling on Anne Bancroft (who was only six years older than Dustin Hoffman).[21] Throughout *The Graduate,* Nichols's style was ostentatiously European. He particularly indulged in the jump cuts beloved by French directors, as when Benjamin plunges into a swimming pool that instantaneously becomes Mrs. Robinson's bed.

But the comedy in *The Graduate,* its satire on the smug hypocrisies of affluent liberals, stemmed from Nichols's partnership in the

1950s and early 1960s with Elaine May. So when Benjamin first kisses Mrs. Robinson in a hotel room, she has just taken a drag on a cigarette. She's forced to hold in the smoke before she exhales after the kiss—a moment that is an exact replica of a Nichols and May routine. And, of course, Mrs. Robinson's daughter is named Elaine.

Moreover, just as the exploits of *Bonnie and Clyde* were augmented by the music of Flatt and Scruggs, *The Graduate* is unimaginable without the songs of Simon and Garfunkel. Their songs comment on and illuminate the story, none more eloquently than "The Sounds of Silence" which escorts Benjamin at the beginning of the film as he is carried along, like his suitcase, on a conveyor belt to a blank future full, most likely, of "plastics."

The song is reprised at the end, after Benjamin and Elaine escape from her wedding, board a bus, chuckle with self-satisfaction, and then stare at the camera, their smiles slowly fading, faced with the abyss (and the silence) of their future together. In fact, the final scene was spontaneous, befitting Nichols's extemporaneous technique. Just before it was filmed, Nichols was fuming. "I told Dustin and Katharine [Ross, who played Elaine], 'Look, we've got traffic blocked for 20 blocks, we've got a police escort, we can't do this over and over. Get on the bus and laugh, God damn it.'" When Nichols looked at the rushes, he realized that Hoffman and Ross were "terrified," the perfect conclusion to the movie. "My unconscious did that," Nichols conceded. "I learned it as it happened."[22]

This was the way many scenes in American movies "happened" in the Hollywood of the 1960s and 1970s. No film was less planned, with episodes that were more impromptu, than *Easy Rider* in 1969. The movie was produced by one of the new, lenient, and politically radical movie executives, Bert Schneider, who also supervised *Five Easy Pieces* and *The Last Picture Show*. Indeed, *Easy Rider* could never have been made in any other era. What reputable studio in the 1950s would have entrusted half a million dollars to a madman like Dennis Hopper and the equally eccentric Peter Fonda to make a movie that had no script, about characters called Captain America and Billy the Kid who score a drug deal and hop on their motorcycles heading for Mardi Gras in New Orleans, picking up an alcoholic lawyer along the way, played by a marginal actor named Jack Nicholson? And with all of their ad-

ventures accentuated by the hallucinogenic sounds of Steppenwolf, the Byrds, and Jimi Hendrix?

Actually, Hopper and Fonda were inspired by avant-garde European movies, especially the Italian film *Il Sorpasso* (1962), about two men played by Vittorio Gassman and Jean-Louis Trintignant who cruise across Italy in a convertible, contemplating their lives to the accompaniment of popular songs. The movie in English was called *The Easy Life,* which is how *Easy Rider* got its name.

But in the American rendition of this story, in their journey from West to East (reversing the familiar pattern of cowboy movies), the characters have no rationale except to flee the world of conformists and rednecks. Which, it turns out, is impossible. "We blew it," Fonda mumbles at the end of the film. The audience doesn't know what that line means. Did they blow the movie? The false paradise of New Orleans? The effort to realize the utopian values of the 1960s? Or are they one more example of wanderers without any motivation besides their hatred of "straight" society, a revulsion echoed in *Bonnie and Clyde* and *One Flew over the Cuckoo's Nest?*[23]

The same sense of drift is at the heart of *The Last Picture Show* and *Five Easy Pieces.* In both movies, life ain't grand. It's mostly vacuous.

Like the French New Wave directors, Peter Bogdanovich—the director of *The Last Picture Show* (1971)—started out as a film critic, interviewing and writing about the auteurs in Europe and America, before he began making his own movies, first for Roger Corman. Among Bogdanovich's cinematic heroes were Howard Hawks (whose *Red River* is the last picture being shown at the movie theater before it shuts down) and John Ford. Yet in *The Last Picture Show* none of the characters has a mission, as they do in the films of Hawks and Ford. Most are trapped in the drab, dusty town of "Anarene" (the fictional name for Archer City, Texas, the home town of Larry McMurtry, who wrote the novel on which the movie was based and where most of the film was shot). All they can do is roam, without purpose or point, through the empty streets, their barren lives underlined by the gloominess of the country music on the soundtrack.

The one authority figure whom everyone respects is Sam the Lion —played by Ben Johnson, a longtime member of John Ford's stock

company who won an Oscar as best supporting actor for his perform-
ance in Bogdanovich's film. Sam is the owner of the movie theater, a
memento of the town's more vibrant past, and he is also a symbolic fa-
ther for "Sonny" (Timothy Bottoms). But Sam—like Homer Bannon in
McMurtry's novel *Hud*—is himself a relic from another time, with an
outmoded set of values. And he's not around long enough to offer
Sonny a glimpse of an alternative existence in the present. So as Sonny
unhappily acknowledges near the end of the film, "nothin's really been
right since Sam the Lion died."

The relationship between father and son is more dispiriting in
Five Easy Pieces. Jack Nicholson's Bobby Dupea is another nomad, in
the tradition of *Bonnie and Clyde* and *Easy Rider.* Bobby, however,
flees whenever he is bombarded with other people's demands—partic-
ularly the nagging displeasure of women who want him to settle down
or become a serious concert pianist instead of faking Chopin and other
"easy pieces."

The most painful scene in the movie occurs when Bobby is trying
to make his itinerant life comprehensible to his mute father (some of the
lines were written by Nicholson). "I don't know if you'd be particularly
interested in hearing anything about me," Bobby begins. "My life, I
mean. . . . Most of it doesn't add up to much. . . . I move around a lot
because things tend to get bad when I stay." But Bobby knows the con-
versation is useless. "My feeling is, that if you could talk, we probably
wouldn't be talking." Yet at the end of his stumbling soliloquy, Bobby
dissolves into tears. All he can think of to say to his father is "I'm sorry
it didn't work out."

Bobby is a sadder, adult version of Huckleberry Finn, surrounded
by people who want to "sivilize" him.[24] At the close of the movie
Bobby abandons his girlfriend at a gas station and hitches a ride on a
truck whose destination is unimportant. In these movies, destinations
never do matter. Bobby, like Huck, is lighting out for the territories.
And the audience is left to decide, as it often was in the foreign and
American films of the 1960s and 1970s, what to make of the story or
the characters or the morally ambiguous conclusion.

In movies like *Bonnie and Clyde, The Graduate,* and *Five Easy
Pieces,* institutions—whether families or the law—are repressive. In
fact, America's novels and films had always described society as intru-

sive. And the (male) heroes are forever in flight to Walden Pond, or heading out to sea, or vanishing into the wilderness.

During the 1970s, though, in the wake of Vietnam and Watergate, American movies began to portray a country whose institutions were not just overbearing but corrupt. The government, the corporations, the CIA had all been debased, or so it seemed; they had lost their legitimacy in the eyes of the public. The moment was therefore ideal for the resurrection of film noir.

"You May Think You Know What You're Dealing with . . . "

The paranoid thrillers of the 1970s differed substantially from the noir films of the 1940s. In an earlier, simpler time, the villains in American movies were motivated by greed. Now the objective of those who are rich or run America's institutions is sheer power. The conspirators are men (rarely homicidal women, as in the movies of the 1940s) entrenched in high places. And they don't lurk in the black-and-white shadows of postwar film noir. Instead, they dominate movies bathed in gleaming color.

Corruption at the summits of business or government was not a theme unique to America or to American films. In 1969 Costa-Gavras's *Z*, a depiction of honest if impotent individuals struggling to investigate the crimes of the Greek dictatorship, served as a prototype for a number of the "neonoir" American films made in the 1970s. The influence of *Z* was apparent in Alan Pakula's *The Parallax View* (1974), in which Warren Beatty plays a reporter trying to penetrate the secrets of a mysterious corporation that carries out political assassinations. Beatty's journalist never learns what the corporation's purposes are or who designates the targets, but he gets killed in his attempt to find out.

Even when the protagonists of the noir films in the 1970s do unearth the source of the treachery, they are hardly ever able to prevent the crime or crush the conspiracy. Usually whatever knowledge they acquire comes too late and the "heroes" themselves are defeated. Nor does their defeat have the existential magnetism of Humphrey Bogart's Sam Spade or Philip Marlowe in the 1940s. The "detectives" of the 1970s are mostly bewildered and despondent.

In Francis Ford Coppola's *The Conversation* (which won the Palme d'Or for best picture at the Cannes film festival in 1974), Gene Hackman plays Harry Caul, a surveillance expert who compulsively replays a tape about a murder plot, but utterly misunderstands who's scheming to kill whom. Unlike the freelance photographer in Michelangelo Antonioni's *Blow-Up* who accidentally takes a picture of what he thinks might be a murder, Harry is employed by a sinister corporation that wants his tape but not his interpretation. For most of the movie, Harry believes he's hearing two lovers, one the wife of the head of the corporation, saying, "He'd *kill* us if he got the chance," implying that they are the intended victims. Ultimately, Harry realizes that what they're actually saying is "He'd kill *us* if he got the chance," meaning they plan to kill the corporate executive first. Then they will take over the corporation.

But the revelation does Harry no good. He can't avert the murder. And at the end of the film, Harry discovers that his own apartment is bugged ("We'll be listening to you," warns a voice on his telephone). After he rips up the walls and the furniture in a futile effort to locate the hidden microphone, he winds up sitting in the wreckage of his apartment, playing a mournful saxophone, isolated and overpowered by the faceless forces he can't identify or expose.

The movie that most closely recaptured the spirit both of German Expressionism and film noir in the 1940s was *Chinatown,* directed in 1974 by Roman Polanski, who knew a thing or two about the madness of the modern world. *Chinatown* starred Jack Nicholson as J. J. Gittes, an archetypical private eye who could just as easily have been at home on the set of *The Maltese Falcon* or *The Big Sleep*. Indeed, of all the actors of his generation, Nicholson—with his rasping voice and worn-out face—seemed like a reincarnation of Humphrey Bogart. The similarity was never greater than in *A Few Good Men* (1992) where Nicholson plays a crazed, authoritarian Colonel Jessep, blood brother to Bogart's Captain Queeg in *The Caine Mutiny* (1954). Jessep is another officer who eventually melts down on the witness stand, defending his honor against upstart juniors who know nothing about war and enemies—though in this case, Nicholson's Jessep is obsessed not with strawberries but with the fact that the innocents, clothed in their legalities, "can't handle the truth."

In an even uncannier reference to the cinematic past, the archvillain of *Chinatown*, with the biblical name of Noah Cross, is played by John Huston, the director of *The Maltese Falcon* and one of the inventors—thematically and stylistically—of film noir. But unlike Sidney Greenstreet's Kasper Gutman, who simply wants the falcon for the wealth it might bring, Cross is a megalomaniac who is not interested in the money he may accumulate from controlling the water rights in southern California. "Why are you doing it?" Gittes wonders. "How much better can you eat? What can you buy that you can't already afford?" Cross's answer is central to the power hunger of the 1970s. "The future," Cross retorts, "the future."

Cross is a monster. Yet what really terrifies Gittes is "Chinatown"—not just the place, but a metaphor for chaos and absurdity, where he once tried to keep someone he cared about from being hurt and miserably failed. Now he is caught up again, as were his detective-predecessors in the 1940s, in a universe of puzzles, sleaze, and deceit. A universe, symbolized by Chinatown, that he can neither fathom nor decode.

"You may think you know what you're dealing with," Cross cautions, "but, believe me, you don't." This could have been the tag line of all noir films, in the 1940s and the 1970s. It certainly applies to Gittes, the self-assured detective who, like Harry Caul, misinterprets every clue. When Gittes reluctantly returns to Chinatown, he is again incapable of protecting the innocent or punishing the guilty, the descendants of Dr. Caligari who (as Cross recognizes) "at the right time and the right place [are] capable of . . . anything!" In fact, Gittes's good intentions—to save Faye Dunaway's Evelyn Mulwray and her daughter ("my sister, my daughter")—accomplish nothing except to provoke another catastrophe.[25]

The movie concludes, as do so many noir films, with a shrug. "Forget it, Jake," says one of his colleagues. "It's Chinatown." So the audience is left with no happy ending, no sense of resolution, only a perception of frustration and helplessness that seems the indelible attribute of modernity.

The same lack of clarity or emotional fulfillment occurs in Sydney Pollack's *Three Days of the Condor* (1975). Here, the source of evil is not some anonymous corporation or malevolent lunatic but the gov-

ernment itself. Robert Redford plays Joseph Turner, a low-level CIA analyst who uncovers a conspiracy at the highest levels of the agency. But the best he can do is give the story to the *New York Times*. In response, his CIA control officer asks: "How do you know they'll print it?" Turner doesn't know and neither do we.

At the *Washington Post,* they do print it. At least in *All the President's Men* (1976), the only movie among the noir films of the 1970s in which the protagonists succeed in unraveling the crimes and bringing down the conspirators. The movie was directed by Alan Pakula, by now a specialist in contemporary film noir, with Redford and Dustin Hoffman as Bob Woodward and Carl Bernstein, and Jason Robards in an Oscar-winning performance as the *Post*'s executive editor, Ben Bradlee. Since viewers already knew the outcome of the Watergate scandal, the film was structured as a mystery focusing on the techniques of the journalists, confined mostly to a newspaper office drenched in glaring fluorescent lights, with Woodward and Bernstein as reporter/detectives working the telephones and following leads like all classic private eyes until their investigation, in this instance, reaches into the Oval Office.[26]

The aura of fear and suspense is heightened by the spectral figure of Deep Throat, Woodward's most important informant, played by Hal Holbrook (who, it turned out, looked and sounded eerily like the real Deep Throat, Mark Felt, then the associate director of the FBI). Woodward and Deep Throat meet periodically at night in an empty underground garage, with Deep Throat's haunted face only half-illuminated as he lights a cigarette and croaks his enigmatic answers to Woodward's questions. The shots of Deep Throat are reminiscent of a similar one in *Citizen Kane* when the butler (the last of Kane's storytellers) lights a match, framing his face, and says to the reporter: "Rosebud? Sure, I tell you about Rosebud. How much is it worth to you?" Finally, Woodward has to scream: "I need to know what you know." When Deep Throat replies that the criminality leads everywhere, and that the reporters' "lives are in danger," a perfect film noir chill descends on the movie.

Like J. J. Gittes, Woodward and Bernstein are not supersleuths. They make mistakes, print stories that are inaccurate, get the newspaper into trouble. Near the close of the movie, Bradlee sardonically sums

up the pressure they're all under: "Nothing's riding on this except the . . . First Amendment to the Constitution, freedom of the press, and maybe the future of the country. Not that any of that matters, but if you guys fuck up again, I'm going to get mad."

The guys don't fuck up again. At the end, they're clattering away at their typewriters while, one by one, Richard Nixon's men are convicted and jailed, until Nixon himself resigns the presidency. For once, the private eyes have triumphed.

Perhaps because it showed two intrepid reporters vanquishing Richard Nixon, the decade's ultimate embodiment of the Parallax Corporation and Noah Cross, *All the President's Men* became one of the most popular films of the 1970s, at home and abroad. The movie also helped make journalists culture heroes, at least temporarily: if you're a reporter, you know you're a deity when you're played in the movies by Robert Redford or Dustin Hoffman.

Yet the somber mood of American movies in the 1970s did not vanish with Nixon. On the contrary, few of the art forms sacred to the old Hollywood—from musicals to mysteries—escaped the cool, cynical gaze of the new directors and stars. No one, not even a journalist, was safe from the camera's jaundiced reassessment of the myths that had pervaded America's films for half a century. Nowhere was this more evident than in that most venerable of movie genres, the Western.

Revising the Legend

Hollywood had always relied on genres in part because these could be easily exported to other countries.[27] Foreign as well as domestic audiences knew what to expect from the stars, the stories, and the conventions of an American comedy or thriller. Moreover, no matter how indigenously American were the characters played by a John Wayne or a Bette Davis, a James Dean or a Marilyn Monroe, their screen personas could be readily understood and embraced by viewers abroad.

No genre was more popular, globally, than the American Western. Nor, ever since Buffalo Bill's Wild West Shows, were the images and themes of any other genre as familiar to audiences everywhere. Consequently, from the 1920s through the 1950s, 25 percent of all the films that Hollywood turned out were Westerns.[28] And in the 1950s

and early 1960s, Westerns were equally pervasive on television, in series like *Gunsmoke* and *Bonanza* that eventually showed up on prime-time TV all over the world.

Many people, in the United States and overseas, assumed that a "typical" Western would dramatize certain elemental conflicts—the clash between civilization and nature, cities and wide open spaces, social restrictions and personal freedom. The Westerner, supposedly, was a loner (a cowboy, an outlaw, a sheriff defending a town with no help from its cowardly inhabitants, an inveterate rambler). Most of all, the Western hero was in flight from the farmers and their fences, from the schoolteachers and lawyers, from all the entanglements that women and families imposed—in effect, from the respectability and the tedium of life in the "East."[29]

The Easterner talks; the Westerner acts, often without being able to say why. In one of the classic Hollywood Westerns, *High Noon* (1952), Grace Kelly plays a teacher and a Quaker who doesn't believe in using bullets to solve problems. "Don't try to be a hero!" she begs her husband, Gary Cooper's Will Kane, the marshal charged with protecting the town—alone—against outlaws bent on gunning him down. "You don't have to be a hero, not for me!" Kane's response is simple, as befits the mostly silent Westerner: "I've got to, that's the whole thing."

It was precisely this laconic style that symbolized the Western (and masculine) version of liberty—an escape from the pieties of law and order as exemplified by women. No wonder, then, that the most common locale for those American actors who were especially terse— Cooper, Henry Fonda, John Wayne—was the West, the frontier, all that inexhaustible territory where you could still have an epic cattle drive from Texas to Missouri (as in *Red River*) or embark on a seven-year quest across a lonesome desert landscape (as in *The Searchers*).

Yet the master of the American Western, John Ford, challenged many of these stereotypes long before the "revisionist" Western emerged in the late 1960s and 1970s. Ford's heroes are usually not outsiders. Instead, they cherish the rituals of social life. They participate in the public ceremonies of the town in which they live, and they're tied to institutions like the army. For Ford, society was not a place from which to flee but a repository of cultural precedents and shared re-

sponsibilities. His characters are bound by duties that must be discharged and roles that must be obeyed, regardless of the cost (as when his troops reluctantly follow the orders of Henry Fonda's Colonel Thursday in *Fort Apache* even though their compliance leads to a predictable disaster). Whatever the consequences, Ford's people, and Ford himself, believe in the values of the community, not the sovereignty of the individual.

Those who violate the codes of society, however personally charismatic they may be, are perpetually isolated. This dilemma accounts for the fact that in his most demanding roles John Wayne was a more complex actor, capable of greater range than he was normally given credit for. In Howard Hawks's *Red River* (1948), Wayne played Thomas Dunson, a man driven by ambition and anger. Dunson is not admirable; often, he is a zealot, seeking to recover his stewardship of the cattle drive. So the whole movie had an offbeat, volatile tone that audiences didn't anticipate when they went to see a John Wayne Western. As Ford remarked after seeing *Red River,* "I didn't know the son-of-a-bitch could act!"

Later, in Ford's *The Searchers* (1956), another movie that departed from the "traditional" Western, Wayne's Ethan Edwards is again not an untainted hero or a one-dimensional personification of American righteousness. *The Searchers* is a sprawling, episodic, quasi-Homeric tale of exile and return, filled with Ford's signature interludes: people brawling, teasing one another, singing and dancing—all the signs of a community gathered together to celebrate their foibles, affections, and memories. Except that Ethan is cut off from the rest of the people who populate the movie because of his hatred of Indians, not a sentiment one would normally find questioned in an American Western, at least not before the 1960s.

Ethan's "search" is for a young white girl named Debbie, played by Natalie Wood, who has been captured by "Scar," a particularly nasty Comanche chief. Ethan assumes that Debbie has grown up Indian. And so she is irredeemable. When he finds her, he will kill her. This is to be retribution dispensed by an unrepentant obsessive, a maniac consumed with rage, a man who is capable of horrifying everyone around him. Hardly an emblematic role for John Wayne.

In the end, of course, Ethan doesn't murder Debbie. Instead, he

delivers her back to her family. Yet Ethan himself has no home to which he can return. He is still, and always, a wanderer. In the film's closing shot—one of the most famed in the history of American movies —the camera frames Wayne, alone in the doorway of the house into which the rest of the family has already disappeared. Wayne holds his left elbow with his right hand, a gesture that shows how separate he is from everyone else. He stares back at the camera, then turns and saunters away, into the dust. He has no kin, no companions, no human bonds. His solitude is breathtaking, and it encapsulates just how lonely Wayne's characters were, even in those of his Westerns that tried to commemorate the virtues of social solidarity.

These themes are explored further in *The Man Who Shot Liberty Valance* (1962), another of Ford's semirevisionist Westerns. Wayne plays Tom Doniphon, a Westerner rapidly becoming obsolete in the face of law and civilization, represented by a "pilgrim" from the East: James Stewart's Ransom Stoddard. Eventually, Doniphon loses his woman and his dreams to Stoddard, and to the future. In one of the film's most disturbing sequences, a drunken Doniphon burns down the house he's been building, and we discover at the end of the movie that he (no doubt like Ethan Edwards) dies alone.

Along the way, we are told (and shown) who really shot Liberty Valance. It is not a reassuring or heroic yarn. The willingness of Wayne's character to kill a villain not in a classic faceoff in the streets of the town, but shrouded in darkness, practically shooting a man in the back, reminds us that the making of the West was hardly a tale of human progress, that the West's real history was soaked in fraudulence and violence.[30]

Yet Ford, even at the expense of the truth, was unwilling to dismantle all the myths of the West, which is why *The Man Who Shot Liberty Valance* is only semirevisionist. Ransom Stoddard has become wealthy and powerful as a result of his having allegedly killed Liberty. And he's taken his territory to statehood. Everyone is now "civilized" and grateful. But Stoddard is distressed by the hoax on which his reputation and respect are founded. When he finally tells some reporters the actual story of the shoot-out, the journalists dutifully take notes, which they then tear up. There are no Woodwards and Bernsteins here. "You're not going to use the story?" Stoddard asks one of the re-

porters. "This is the West, sir," the journalist responds. Whereupon he delivers one of the eternal lines in the long saga of Western films: "When the legend becomes fact, print the legend."

Legend or truth, Ford's movies created a blueprint for the images and plots of Westerns not only in America but in other parts of the world. Ford's influence was particularly evident in the films of Akira Kurosawa in the 1950s, where feudal warriors in *Seven Samurai* became Japanese-style gunfighters. But as in the case of Ford's heroes, the samurai's mission is to protect society against external threats, not to revolt against social constraints.[31]

Seven Samurai, released in 1954, so closely replicated the tropes of the American Western that Hollywood remade the story in 1960 as *The Magnificent Seven,* directed by John Sturges and starring Yul Brynner, Steve McQueen, Charles Bronson, and Eli Wallach, as a consummate Mexican bandido who, unlike Alfonso Bedoya's "Gold Hat" in *The Treasure of the Sierra Madre,* never snarls that he doesn't have to show the Gringos "any stinking badge." *The Magnificent Seven* was positioned halfway between the standard American Western and the revisionist movies that were to come. The seven gunmen, like the swordfighters in *Seven Samurai,* are becoming archaic. But they are still in their prime, skilled at their jobs, lithe and balletic in their movements. Their aging successors (as in *The Wild Bunch*) would no longer save peasants or be as adept at their more dubious occupations. Instead, adrift in the early twentieth century, they are exhausted, physically and emotionally.

By the 1960s and 1970s the number of Westerns made by Hollywood steadily declined. The genre no longer resonated with young audiences in America, who were more concerned with contemporary issues. Meanwhile, the careers of Howard Hawks and John Ford, the two directors most responsible for the Western fable, were coming to an end. And John Wayne's movies were becoming less iconographic, more mediocre, and more defiantly conservative. But the Western continued to flourish, though in a radically altered form. Just not in the United States.

Between 1963 and 1973, four hundred Westerns were made in Italy. Indeed, Westerns dominated Italy's film exports during these years, including to the American market.[32] At the same time, more

American actors were willing to work in Italy (or in Spain, where most of the Italian "spaghetti" Westerns were shot, because the landscape resembled the American West).

It is impossible to fully appreciate the subject matter and style of the revisionist Westerns created by Sam Peckinpah and Robert Altman in the late 1960s and 1970s without recognizing the cinematic impact of Sergio Leone. Leone's Westerns, the films that made Clint Eastwood a star, were the first signs that the genre was fundamentally changing —that it was becoming more graphically violent, more visually operatic, and less plot-driven. Leone, who was conversant with the films of both Akira Kurosawa and John Ford, showed us characters (even "heroes") caked in dirt, who were unshaven, sweated profusely, and could be as brutal and self-serving as the ostensible bad guys. In fact, everyone in a Leone film looked like a bandido.

Moreover, Leone loved extreme close-ups, particularly in his climactic scenes. At the moment of a gunfight, he focused for what feels like an eternity on the planes of an actor's face, his squint, his impatient fingers, his weapons, the most minute expressions of a man about to blow his enemies away.[33] Words, explanations, motivations don't matter in a Leone film (as one might expect from movies that were simultaneously dubbed in Italian and English). When John Wayne is challenged in *The Searchers,* he regularly replies: "That'll be the day." When Clint Eastwood is confronted in *A Fistful of Dollars, For a Few Dollars More,* and *The Good, the Bad, and the Ugly,* he says almost nothing. He's an abstraction, a Man with No Name—a pure killer, out for revenge, or gold, or just a perfect rifle shot. Henry Fonda's face in Leone's *Once Upon a Time in the West* is equally opaque; all we see are his icy blue eyes as he pulls the trigger.

The eccentricities of a Leone film were reinforced by the music of Ennio Morricone. Instead of imitating American-style Western music (swelling chords, Coplandesque themes, choruses singing "She Wore a Yellow Ribbon"), Morricone used gunshots, crackling whips, whistles, electric guitars—instruments and sounds that gave Leone's movies a modernist tinge.

American directors eagerly adopted Leone's mannerisms, none more devotedly than Sam Peckinpah. Peckinpah once described himself as "John Ford's bastard son." But he was also the ornery son of Akira

Kurosawa and Sergio Leone. His Westerns are a classic example of how American movies initially influenced filmmakers abroad, then returned to the United States with an esthetic that was as much Asian and European as American.

Peckinpah clearly owed some of his themes and techniques to Ford (the emphasis on men attached to groups to which they are intensely faithful), to Kurosawa (the time-honored rules of combat), and to Leone (the grime of the Southwest at the dawn of the twentieth century and the relentless close-ups of grizzled faces). But in Peckinpah's masterpiece, *The Wild Bunch* (1969), there are no ancient members of a warrior caste and no broad-shouldered John Wayne intervening to rescue society from decadence. And no Clint Eastwood peering through cigar smoke and a rifle sight to dispense rough justice to the bad and the ugly. Rather, *The Wild Bunch* is an ode to a dying (if not necessarily estimable) way of life, and to outlaws who are now marginal to the modern world.

The actors in *The Wild Bunch*, some of them veterans of John Ford's movies, certainly looked as if they'd been cast by Sergio Leone: William Holden (no longer the glamorous star he had been in the 1950s, but a wearier and more rueful presence on screen), Robert Ryan, Ernest Borgnine, Edmond O'Brien (who spent most of the movie doing an imitation of Walter Huston in *The Treasure of the Sierra Madre*), Warren Oates, and Ben Johnson. Meanwhile, Holden's Bunch is fleeing some of the seediest bounty hunters ("egg-suckin', chicken-stealing gutter trash" is what Robert Ryan calls Strother Martin and L. Q. Jones) ever to appear in an American film. Finally, the cast included some brilliant Hispanic actors, notably Jaime Sánchez as Angel (a name reminiscent of his role five years earlier as Jesús, the Puerto Rican assistant to Rod Steiger's Sol Nazerman in *The Pawnbroker*), and Emilo Fernández as the sleazy General Mapache.

Still, we know we're in Peckinpah territory from the opening scene, as the outlaws, dressed as soldiers, ride into a town to rob a bank. We see children tormenting and burning a scorpion, anticipating the cruelty of their elders. Once the gang enters the bank and the customers have their hands up, Holden growls: "If they move, kill em'!" And immediately afterward, the last credit appears on the screen: "Directed by Sam Peckinpah."

Despite the violence audiences had come to expect from Peckin-
pah, he has his wistful, even idealistic, intervals. Part of the movie takes
place in an Indian village, where it is made clear that the villagers can
overthrow the pillaging armies and mendacious politicians if only they
have enough guns and ammunition. One of the most elegiac scenes in
the film occurs when the outlaws slowly ride out of the village—a ma-
jestic procession, worthy of Ford or Kurosawa, with the Indians wav-
ing to the men they have temporarily adopted, even as those men are
on their way to an inescapable annihilation.

The rest of the movie plays out in the fictional town of Agua
Verde. "What's in Agua Verde," Robert Ryan asks Strother Martin.
"Mexicans," Martin shrugs, "what else?" But Aqua Verde is the di-
lapidated fortress of General Mapache, a counterfeit warrior with his
bogus medals, his stolen gold, his self-important German advisers, his
sycophantic lieutenants, and his whores, all of them lording it over the
peasants who reside for their own safety in the town. Mapache and his
soldiers, despite their pretensions, are shabby thieves—but in contrast
to the Wild Bunch, thieves without honor. "We ain't nothin' like [Ma-
pache]!" Ernest Borgnine asserts. "We don't *hang* nobody!"

William Holden plays Pike Bishop, the leader of the Bunch. He'd
like to "make one good score and back off," but there's nowhere to
back off to. All he's left with is a belief in the camaraderie of his band,
and in loyalty above all else. "When you side with a man, you stay with
him," he instructs the other members of his crew. Otherwise, they're no
better than animals. Contrary to the cliché that American movies typ-
ically glorified individualism, *The Wild Bunch* (like John Ford's films)
is a commemoration of the community, however undomesticated this
particular community may be.

Still, it falls to Borgnine's Dutch, Pike's closest friend, to define
the real meaning of loyalty and community—a meaning that has noth-
ing to do, as it does in Ford's movies, with institutions or social struc-
tures. Near the climax of *The Wild Bunch*, Pike and Dutch argue over
the role of Robert Ryan's Deke Thornton, a former member of the
Bunch, now a railroad's "Judas-goat," who, to keep from returning to
prison, is chasing his ex-colleagues as head of the bounty hunters. "He
gave his word," declares Pike. "To a railroad," Dutch responds. "It's
his word," Pike repeats. "That ain't what counts!" Dutch roars, in a

key not only to this film but to Peckinpah's values generally. "It's who you give it to!"

The fidelity to those few souls with whom you have sided is the principle that compels the Wild Bunch to reenter Agua Verde in order to liberate Angel, who is being tortured by Mapache. "Let's go," Pike says, in a phrase that recurs throughout the movie. "Why not?" is the inexorable reply from the rest of the Bunch. And so they stride through the churning dust, accompanied by the sound of Mexican music and drum rolls, to their predestined confrontation with Mapache, and to one of the most ferocious shoot-outs in the history of the American cinema—filled with telephoto long shots, close-ups, slow-motion sequences, cameras running at different speeds, blood spurting from bodies jerking like puppets—all of it culminating in a Götterdämmerung that leads to the Bunch's inevitable demise.[34]

Yet *The Wild Bunch* does not end with their deaths. The Indians, now armed, ride up to the site of the massacre, in which only the wounded and the vultures remain. Sykes, the last of the Bunch, played by Edmond O'Brien, who has been protected and nursed back to health by the Indians, invites Deke, the lone survivor of the bounty hunters, to join the Indians in the work they have to do. "It ain't like it used to be," Sykes muses, "but it'll do."

And then, as at the close of *The Treasure of the Sierra Madre*, O'Brien and Ryan dissolve into laughter. Indeed, laughter permeates *The Wild Bunch*. It occurs mostly at times of disaster and failure, but also at moments of passionate comradeship. The laughter conveys both a shared experience and a recognition of fundamental sadness. In the end, as in *Butch Cassidy and the Sundance Kid*, you don't get the gold, or the final successful score, or the ability to survive the cold-blooded efficiencies that will be the hallmarks of the twentieth century. All that's left is an allegiance to one's partners. And the remembrance of a world that will soon be wiped out by cars (like the one that runs over Jason Robards at the end of Peckinpah's most lyrical film, *The Ballad of Cable Hogue*), as well as by machine guns, airplanes, and all the rest of the blessings of modern life.

Both Leone and Peckinpah were trying to deconstruct the folk tales of the American Western. Robert Altman never appeared to believe in those tales in the first place. His Westerns were not memorials

to a lost, if blood-spattered, world; they were comic meditations on an America populated by bunglers, fantasists, and clowns.

Altman was also more heavily indebted than was Peckinpah to the French New Wave. He relied on his actors' improvisations, on narratives untethered to a preordained script, on zoom lenses and fluid (sometimes erratic) camera work. But Altman borrowed as well from Orson Welles, especially in the use of overlapping dialogue and stories told from multiple perspectives. Altman's methods resulted in modernist films that refrained from explaining events or characters to the audience, that forced viewers to supply their own meanings and reach their own conclusions.

Altman's movies, including his Westerns, were more whimsical but no less provocative than the films of Leone and Peckinpah. One of his most audacious and mischievous movies, along with *Nashville,* was *McCabe and Mrs. Miller* (1971)—with Warren Beatty as a small-time gambler and incompetent owner of a whorehouse, not the sort of starring role one normally identified with either a Gary Cooper or a Clint Eastwood. Moreover, the soundtrack was not punctuated with the grandiose chords of Dimitri Tiomkin but with the mordant songs of Leonard Cohen, whose "Sisters of Mercy" accompanies a group of prostitutes as they arrive on a wagon. Meanwhile, the limitless horizons and imposing geography of the traditional Western are undercut in *McCabe* by the dingy, claustrophobic town of "Presbyterian Church." There's no Monument Valley here.

And no Shane either. In fact, the characteristic images of men and women in the Western are not just reversed but obliterated in *McCabe.* McCabe is a dreamer ("I got poetry in me!"), while Julie Christie's Mrs. Miller is a hardheaded businesswoman, a madam who knows how to run a proper brothel. Nonetheless, they are both alone at the end, just as isolated as Ethan Edwards in *The Searchers.* McCabe is dead after a shoot-out and frozen in the snow, while Mrs. Miller is anesthetized in an opium den, the camera closing in on her eyeball but offering no comfort or illumination whatsoever to the audience.[35]

In 1976 Altman revisited the Western, this time as it might have been imagined by Federico Fellini. *Buffalo Bill and the Indians,* with its subtitle *Sitting Bull's History Lesson,* is a hilarious contemplation of history, myth, and show business. The cast is full of gifted actors: Paul

Newman as a vain Buffalo Bill, unsteady on his white horse; Burt Lancaster as Ned Buntline, the cynical publicist (a nineteenth-century version of J. J. Hunsecker) who thinks he has invented Bill; Geraldine Chaplin as a self-absorbed Annie Oakley; and Joel Grey as Bill's manager and master of ceremonies (though without the Expressionist grin with which he once greeted us at the cabaret).

The movie begins with what seems like a shot of a Western landscape. Then the camera pulls back to reveal that we're only watching a Wild West show, a fictionalized version of a West that never existed. We're also reminded that we're seeing a movie. And that the characters all yearn to be movie stars (as did Buffalo Bill in real life).

But movies, Altman knew, were the instruments that turned reality into mythology. Near the end of the film, Newman's Buffalo Bill is hallucinating about the now-dead Sitting Bull. And about the West, heroism, and what the movies will make of both. "In a hundred years," Bill rumbles to Sitting Bull's apparition, "I'm still gonna be [a] star, and you're still gonna be an Indian." So, according to Bill, everyone will always be printing (and filming) the legend.

Except that they wouldn't. After the films of Leone, Peckinpah, and Altman, the American Western was never the same. But then, in the late 1960s and 1970s, no American genre—not comedies, not gangster films, not horror or science fiction thrillers, not war stories—could ever replicate the kinds of movies that had flourished during Hollywood's golden age. American directors had learned too much from their foreign idols. Besides, the society itself was now too splintered for people to believe in the folklore of an earlier time. What those Americans who still went to the movies wanted, and were getting from the new generation of filmmakers, was a less sentimental, more modernist point of view. And at least in one case, laughter tinged with a rueful appreciation of the close connections between love and death.

Woody

No American director from the 1970s on, except for Clint Eastwood, has exerted more control over every aspect of his movies—from the script, to the cast, to the editing, to the music—than Woody Allen. And few actors have manufactured such a recognizable screen personality.

As Alvy Singer in *Annie Hall* (1977), Isaac Davis in *Manhattan* (1979), Sandy Bates in *Stardust Memories* (1980), and Mickey Sachs in *Hannah and Her Sisters* (1986), Allen converted his own obsessions into a model for everyone who hates sunlight, California, and mellowness as a way of life.

Since his main preoccupation has been with the relationship between men and women, Allen also created more intriguing roles for actresses than any director of his generation. Indeed, four actresses have won five Oscars for their performances in Allen's films: Diane Keaton in *Annie Hall*, Dianne Wiest in *Hannah and Her Sisters* and *Bullets Over Broadway* (1994), Mira Sorvino in *Mighty Aphrodite* (1995), and Penélope Cruz in *Vicky Cristina Barcelona* (2008).

Like the works of other directors in the 1970s, Allen's films had a "European" sensibility—which may explain why they often earned more money in France than they did in the United States. Yet Allen continually punctured the pretensions of Europe's high culture with jokes rooted in the absurdities of bourgeois American (and Jewish) life. "I was suicidal," Allen announces in *Annie Hall*, "and would have killed myself, but I was in analysis with a strict Freudian, and, if you kill yourself, they make you pay for the sessions you miss." In *Crimes and Misdemeanors* (1989), Mia Farrow returns Allen's love letter. "It's probably just as well," Allen admits. "I plagiarized most of it from James Joyce. You probably wondered why all the references to Dublin." And in *Mighty Aphrodite*, members of a Greek Chorus are anxiously calling out to their gods for help. But all they get is a recording: "This is Zeus. I'm not home right now, but you can leave a message and I'll get back to you. Please start speaking at the tone."

For all the humor, the influence of Ingmar Bergman on Allen was obvious, especially in his characters' search for a purpose in the universe, and some consolation for our inevitable deaths. Allen's casting of Max von Sydow in *Hannah and Her Sisters* as a cold, emotionally stifled intellectual was a tribute to Bergman and to the kind of men von Sydow frequently played in Bergman's films. Similarly, Allen used Bergman's favorite cameraman, Sven Nykvist, as the cinematographer on *Crimes and Misdemeanors*.

Yet no one would confuse Bergman's films with those of Charlie Chaplin, the Marx Brothers, or Bob Hope—three equally important

inspirations for Allen's movies. Just as he deflated the European high-brow mystique, so Allen "Americanized" Bergman, merging the Swede's dour view of the world with a comic vision of how much men misunderstand women, and with a tender recognition of those fleeting moments when life seems worth living.

The electricity between Allen and Diane Keaton was always palpable in their movies in the 1970s—as it was not in Allen's films in the 1980s with Mia Farrow, when their characters were usually romantically involved with someone else, rather than with each other. In no movie was the exuberance between Allen and Keaton more evident than in *Annie Hall.* The film begins, like *Citizen Kane,* at the end. Allen opens with a comic monologue, addressing the audience directly with a modernist emphasis on himself as the auteur of the movie. He concludes, though, with the sad acknowledgment that "Annie and I broke up." The rest of the movie, in flashbacks, shows why.

Alvy Singer falls in love with Annie because of her eccentricities and her willingness to try anything, including singing. Their delight and amusement with one another is never more apparent than when they're trying to catch a lobster that's loose in the kitchen. Alvy asks whether Annie doesn't "speak shellfish," then wonders if he can't seduce the lobster with a "little dish of butter sauce" and a "nutcracker."

But their love affair disintegrates because Alvy seeks and ultimately fails to transform Annie into a duplicate of himself, someone, as Annie says, who's "incapable of enjoying life." At the same time, Alvy has forgotten the very qualities that initially attracted him to Annie. Alvy and Annie wind up interpreting the same events from thoroughly different perspectives. At one point, on a split screen, they are in their respective psychiatrists' offices. Each therapist asks how often they make love. Alvy responds: "Hardly ever. Maybe three times a week." Annie replies: "Constantly. I'd say three times a week."

Still, at the end of the movie, Alvy and Annie meet for coffee, and afterward (again with Allen narrating on the soundtrack as the camera stares down a street empty of people) Alvy remembers "what a terrific person" Annie is and "how much fun it was just knowing her." He then repeats the old joke about the guy who goes to a psychiatrist because his brother thinks he's a chicken. But he can't turn his brother in because "I need the eggs." Which is how Alvy (and Woody) now feel about rela-

tionships. "They're totally irrational, and crazy, and absurd," Alvy admits, but all of us keep going through them because we "need the eggs."

Manhattan is a frostier examination of the same themes. The real love affair here is not so much between a man and a woman as with New York—especially the New York of the 1930s and 1940s. So it's appropriate that the movie is saturated with the music of George Gershwin. Yet once again Allen's character (Isaac Davis) fails to turn a lover (Keaton's Mary Wilkie) into a mirror of his own concerns. "You always think you're gonna be the one who'll make them act different," he reminds himself after their affair has collapsed.

Nevertheless, the movie ends on one of Allen's most poignant notes. His seventeen-year-old girlfriend, Tracy (played by Mariel Hemingway), whom he's earlier dropped, is now about to fly to London for six months to study the theater. Isaac, who's realized that her face is one of the few things that make his life worthwhile, pleads with her unsuccessfully not to go because she'll change, become a "completely different person." "Not everyone gets corrupted," Tracy reassures Isaac. "You have to have a little faith in people." Then Allen's own face crumples with the realization that Tracy is already wiser than he is, or than are any of the adult sophisticates in the movie.

However much Ingmar Bergman shaped Allen's outlook, Allen's most European film, *Stardust Memories,* owes far more to Federico Fellini. *Stardust Memories* is Allen's adaptation of *8½*. Like Marcello Mastroianni's director, Guido, Allen's Sandy Bates is a filmmaker who can't finish a movie, and who is besieged by producers, agents, fans, multiple lovers, and actors who keep shifting between real life and their roles on the screen.

Ultimately, though, *Stardust Memories* is a Woody Allen film, not a re-creation of Fellini's world. Sandy wants to make "serious" movies, ones that will deal with people suffering and dying. But he's told by an imaginary Martian: "You want to do mankind a real service? Tell funnier jokes."

Meanwhile, the loveliest scene in the movie occurs when Sandy and one of his women, played by Charlotte Rampling as Dorrie, are simply enjoying a Sunday afternoon. She's lying on the floor reading the *New York Times,* occasionally glancing up with a tiny smile on her face as Sandy (and the camera) behold her with affection. Dorrie is a neurotic, a "kamikaze" woman who flies into and almost demolishes

the men she's with. But at this point, it doesn't matter. As Sandy recalls, "For one brief moment everything just seemed to come together perfectly and I felt happy, almost indestructible in a way." That moment recurs in Allen's *Radio Days* (1987), when toward the end of the film the movie just stops, and in a nightclub on New Year's Eve the camera focuses intimately on Diane Keaton singing Cole Porter's "You'd Be So Nice to Come Home To." Anyone who imagines that Woody Allen is a misogynist has never watched those scenes.

As it turns out, the end of *Stardust Memories* is very different, and more cheerless, than the final scene in *8½*. At the close of Fellini's movie, all the characters, including Guido, gather together in a festival, holding hands in a dance that is a celebration of life.[36] In *Stardust Memories,* Sandy Bates is alone, his movie completed, watching a blank, flickering screen. Then he departs, like Chaplin's tramp, as the screen and his life fade to black. There is no affirmation here, no acceptance of the way art can provide an antidote to death.

Yet in Allen's films there is always a wisp of hope. In *Hannah and Her Sisters,* Allen's Mickey Sachs is contemplating suicide (even though he lives in a New York filled with restaurants that stay open late). But Mickey decides to stay alive. Instead of "searching for answers" about death and eternity that he's "never gonna get," he opts to enjoy life "while it lasts. . . . I mean maybe there is something, nobody really knows. I know maybe is a very slim reed to hang your whole life on, but that's the best we have."

That was certainly the best Woody could offer. And for American filmgoers in the 1970s, Woody's tentative embrace of life was more satisfying than what Bergman or even Fellini proposed. But the effort to define a fulfilling life, given the specter of death, was hardly a fixation unique to Woody Allen. Nor was it a peculiarly Jewish dilemma. Italian-American directors, too, were afflicted with the same doubts, and the same attempts to adopt the techniques of the foreign cinema to resolve their own spiritual quandaries.

"Better to Be King for a Night"

Like his contemporaries, Martin Scorsese worshiped the films of the Italian neorealists, and of Fellini, Kurosawa, and the French New Wave. But perhaps more than any other director of his generation,

Scorsese was also immersed in the history of American movies, especially the works of Orson Welles, John Ford, and Elia Kazan, as well as the noir films of the 1940s. All of these influences were reflected in Scorsese's films—particularly the impact of the neorealists on *Mean Streets* (1973) and of John Ford on *Taxi Driver* (1976).

Yet what foreign filmmakers and the auteur theory taught American directors above all else was to make movies that were semiautobiographical, that dramatized their personal preoccupations and exemplified their private visions of the world. So where an earlier generation of Italian-American directors like Frank Capra and Vincente Minnelli—bowing to the wishes of the studio heads—had avoided making films about the Italian experience in the United States, Scorsese and Francis Ford Coppola deliberately used their ethnic backgrounds to address larger American themes.

Scorsese grew up in a working-class Italian neighborhood in New York, and early on he became accustomed to the tough street gangs and mobsters that were an integral part of his urban surroundings. His Manhattan was hardly the elegant preserve of the narcissistic intellectuals who inhabited Woody Allen's films. Moreover, by the 1970s the miasma and violence of New York and the pervasive decay of the city were showing up in movies like Sidney Lumet's *Serpico* and *Dog Day Afternoon*. Isaac Davis still loves Sutton Place and Central Park. Robert De Niro's Travis Bickle in *Taxi Driver* thinks "someone should just take this city and . . . flush it down the fuckin' toilet."

In his youth, Scorsese thought seriously about becoming a priest (whereas when Mickey Sachs in *Hannah and Her Sisters* considers converting to Catholicism, the best he can do is bring home a cross, a copy of the New Testament, and a loaf of white bread). Scorsese, however, was constantly caught between the ephemeral comforts of the church and the ambiguities of modern urban life. "You don't make up for your sins in church," Scorsese himself says as a narrator in *Mean Streets*. "You do it in the streets. You do it at home. The rest is bullshit and you know it."

Actually, in Scorsese's films, whether you're Italian or American, you never make up for your sins. And you rarely find salvation anywhere—except maybe in the enticements of fame. Many of Scorsese's characters are unhinged, consumed with rage and an inchoate hunger

for recognition. None more so than Travis Bickle, a psychotic veteran of the Vietnam War, alone with his fantasies of power. "Loneliness has followed me my whole life," Travis acknowledges. "In bars, in cars, sidewalks, stores, everywhere. There's no escape. I'm God's lonely man." So Travis writes notes to himself in his room and strikes poses in front of the mirror ("You talkin' to me?"), but he's the only one there.

Finally, Travis assumes the role of John Wayne in *The Searchers,* rescuing Jodie Foster's Iris (an urbanized version of Natalie Wood) from a pimp played by Harvey Keitel, who wears an Indian headband and is called "Sport" (an updated, streetwise allusion to John Ford's Indian chief "Scar").[37] But unlike Ethan Edwards, who remains permanently alone, Travis Bickle (after a bloody rampage) becomes the psychopath as celebrity, a hero, a somebody. It's equally appropriate that in *Raging Bull* (1980) an aging, obese Jake LaMotta (played again by De Niro in an Oscar-winning performance) should recite Marlon Brando's "I coulda been a contender" lines in his dressing room before going on stage in a seedy nightclub. LaMotta's notoriety, his claim to being somebody, rests on his memories of destroying other boxers and having stayed on his feet for fifteen savage rounds against Sugar Ray Robinson ("You didn't get me down, Ray").

Scorsese fully explored the lunacy of fame in *The King of Comedy* (1982), one of his most unusual, least brutal movies. De Niro plays an aspiring but untalented comic named Rupert Pupkin who concocts a scheme to kidnap a television talk-show host in order to force the producers to give him a spot on the show for his monologue. The TV host was modeled on Johnny Carson, who was originally offered the part, but an abnormally recessive and sullen Jerry Lewis played the role in the movie. Much like Robert Altman's *Buffalo Bill and the Indians* and Woody Allen's *Stardust Memories,* Scorsese's film satirizes show business and the hidden machinery of stardom, all those executives and publicists scurrying behind the curtain. But here it's possible to achieve every crazed fan's longing for applause. As Pupkin observes at the end of a monologue that is more embarrassing than funny, "better to be king for a night than schmuck for a lifetime."

It turns out, though, that—no matter how demented or even murderous you are—you can be king for a lifetime. At least you can in

Taxi Driver and *The King of Comedy.* And you can as well if you're a Mafia Don, or a tenacious shark hunter, or a self-made emperor pondering the poems of T. S. Eliot while ordering the slaughter of hundreds in the jungles of Cambodia. The movies of the 1970s were full of fanatics, not only on the screen but also in the director's chair. To be an authentic auteur, after all, was to play out one's own dreams and nightmares for audiences—sometimes huge audiences—not just in America but around the world.

The Blockbusters

The majority of America's New Wave films, like their foreign counterparts, were low-budget movies that attracted a modest number of viewers. By the 1970s, though, a few of the American films were beginning to break box office records. *The Godfather, Jaws,* and *Star Wars* were still personal. But they were immensely profitable.

Mario Puzo's novel *The Godfather,* published in 1969, was a spectacular best-seller, with one million hardcover copies and twelve million paperbacks sold before the movie version opened in 1972. Paramount had bought the rights to the novel, and was willing to invest a bundle of money to ensure that the movie would be as successful. The studio intended the film to be a big-budget extravaganza, with major stars and a leading American or European director (at one point, the studio offered the film to Sergio Leone). *The Godfather* would certainly not be another cult movie for the art-house crowd.

Yet in the end, the studio chose Francis Ford Coppola to direct. Coppola's track record was singularly unimpressive. He had directed only four previous movies, all of them commercial failures, though he did win an Oscar for best screenplay for *Patton.* Coppola—like most of the young American auteurs—wanted to make artistic films, not blockbusters. But he needed the money and the screen credit. Nevertheless, he did not surrender his ambition to make an idiosyncratic movie. Instead, Coppola turned *The Godfather* and its sequel in 1974, *The Godfather: Part II,* into an epic not merely about the Mafia but about the breakdown of Italian family life amid the consolidation of capitalism in the twentieth century.

Coppola caused Paramount apoplexy when he insisted that Mar-

lon Brando play the role of Don Vito Corleone. Brando carried with him a string of box office flops and a reputation for causing trouble on the set. Coppola then filled the rest of the cast of both films with actors who at the time were virtually unknown: Al Pacino, Robert De Niro, Robert Duvall, John Cazale, and Michael V. Gazzo—not to mention the legendary head of the Actors Studio, Lee Strasberg, who had performed only rarely since the early 1930s. Indeed, so problematic were Coppola's casting and his direction that during the course of the first film he was nearly fired (possibly to be replaced by Elia Kazan) until Brando threatened to leave the picture as well.

Like Martin Scorsese, Coppola drew on his Italian heritage. Not only did the characters often speak in a Sicilian dialect, but the music was composed by Nino Rota, who customarily collaborated with Federico Fellini. Moreover, the films were structured like operas, with complicated plots, set pieces that resembled arias, and cinematography by Gordon Willis (who later worked on *All the President's Men, Annie Hall, Manhattan,* and *Stardust Memories*) that alternated between shadowy rooms where men softly plotted mayhem and sunlit exteriors, especially at moments of weddings and festivals. And also like Scorsese, Coppola juxtaposed religious ceremonies with murder, as when Michael Corleone's godchild is being christened in the church while rival gang members are being machine gunned in the streets.

But Coppola was recounting an American tale as well. The chronicle of the Corleones is a commentary on the disappearance of an older, more intimate society and the rise of an impersonal corporate-style capitalism, packed with lawyers and accountants arguing about mergers and acquisitions. Robert De Niro's young Vito Corleone in *The Godfather: Part II* is an Italian Robin Hood, acting on behalf of neighbors and friends victimized by primitive mobsters. His son Michael (played by Al Pacino) becomes a rational American businessman, grimly eliminating competitors. The difference between father and son is foreshadowed near the end of the first film, when Brando's Vito tells Michael, "I never wanted this for you. I work my whole life, I don't apologize, to take care of my family. And I refused to be a fool dancing on the strings held by all of those big shots. . . . But I always thought that when it was your time, that you would be the one to hold the strings. Senator Corleone, Governor Corleone, something."

Michael tries to comfort his father: "We'll get there, Pop." Yet they never do.

In fact, the family itself—which is the bond that holds all the characters together when most other American films were portraying the absence of communication between parents and children—ultimately crumbles in *The Godfather: Part II*. Michael throws his wife out of the house because she has aborted his next son. And he has his brother Fredo (played by John Cazale) executed because Fredo betrayed the family to Michael's opponents. Michael's credo, in contrast to his father's occasional sentimentality, is professionally dispassionate: "If anything in this life is certain—if history has taught us anything— it's that you can kill anyone." At the end of the second film, all we see is the death of the immigrant (and American) dream, Michael sitting alone in a chair, his enemies purged, the camera closing in on his lifeless eyes.

Coppola managed in both movies to unite art and commercial success. Each film won the Oscar for best picture, and Coppola received an Oscar as best director for *The Godfather: Part II*. The first movie made $150 million worldwide, an international achievement surpassing *Gone with the Wind* and *The Sound of Music*. *The Godfather: Part II* earned much less than its predecessor because it was a more complex film, shifting abruptly between the ethnic vibrancy of New York in the early twentieth century and modern, antiseptic Las Vegas. The sequel was also less romantic about the Mafia and about the family as a refuge from a pitiless world.[38] But taken as a whole, the saga of the Corleones as interpreted by Coppola became among the most memorable of all American movies, not just in the 1970s but in the history of the global cinema.

Steven Spielberg was always more commercially oriented than his peers. He was not a graduate of a film school, nor was he trained by Roger Corman. Instead, he started out in television, directing episodes of series and TV movies.[39] *Jaws* was only Spielberg's second Hollywood film. Based loosely on Peter Benchley's best-selling novel, *Jaws*— like *The Godfather*—already had an audience waiting for the movie before it was released in 1975.

The casting of the movie was brilliant, with Roy Scheider as the police chief who abhors the ocean (Scheider improvised the famous

line: "You're gonna need a bigger boat"); Richard Dreyfuss as a caustic marine scientist; and the British actor Robert Shaw as Quint, Captain Ahab's descendant. "Y'all know me," Quint reminds the people of Amity Island (in reality, Martha's Vineyard). "Know how I earn a livin'. I'll catch this bird for you, but it ain't gonna be easy. Bad fish. . . . Ten thousand dollars for me by myself. For that you get the head, the tail, the whole damn thing." Shaw also helped write the narrative of the USS *Indianapolis* that brought crucial elements of the first atomic bomb to a U.S. airbase on Tinian in the Pacific. Afterward, the ship was torpedoed and sunk by a Japanese submarine. "So," as Quint retells the story, "eleven hundred men went in the water; 316 men come out and the sharks took the rest. . . . Anyway, we delivered the bomb."

Ironically, *Jaws* was frightening in part because the mechanical shark rarely worked. Hence Spielberg used a camera in the water to take the place of the shark, and filmed many of the attacks from the shark's point of view. This wound up increasing the sense of dread. The anticipation of the shark's assaults was additionally intensified by the pounding chords of the Stravinskyesque musical score, written by John Williams.

Jaws was the first, bloodcurdling, summer blockbuster, showing in 440 theaters on its opening weekend. After *Jaws,* wide releases in the summertime became standard practice for the Hollywood studios.

George Lucas was a close friend and protégé of Francis Ford Coppola's who had the same vision about making movies influenced by foreign directors. But in typical American fashion, Lucas turned out to be both an artist and an entrepreneur.

His first film in 1971 was *THX 1138,* an experimental and futuristic thriller that few people saw. So Lucas's next movie, *American Graffiti* (1973), was a much more autobiographical (and more popular) film rooted in his experiences growing up in Modesto, California, in the 1950s and early 1960s. *American Graffiti* was crammed with the images and sounds of adolescent culture: drag racing, cruising through drive-in restaurant parking lots, searching for girls, all accompanied by rock music and the barking voice of the disc jockey Wolfman Jack.

At the end of the movie, we're told what happens to the four main

characters. One becomes an insurance agent, another is killed in an auto accident, a third is listed as missing in action in Vietnam. The fourth character, Curt (played by Richard Dreyfuss), is described as a writer living in Canada. Anyone in the audience in 1973 would have known what that meant: Curt has fled to Canada to escape the draft and the war.

Yet Lucas's first two movies only hinted at the film that made him rich and transformed the movie business. *Star Wars,* released in 1977, was reminiscent of the comic books and movie serials of the 1930s. But it was full of modernistic special effects that buttressed an adventure infused with the mythology of outer space and other worlds. *Star Wars* became the highest-grossing American movie until *Titanic* in 1997. More important, by the early 1980s it had made $1.5 billion from the sale of spin-off products. Most of these earnings went directly to Lucas, whose contract with Twentieth Century–Fox gave him the merchandising rights. The money enabled Lucas to launch his own company, Lucasfilm, with its subsidiaries Industrial Light and Magic and the THX sound system, each of which provided the special effects indispensable to Hollywood's blockbusters from the 1980s on.[40] Lucas was now a filmmaker whose freedom exceeded the fantasies of all the other American auteurs.

Jaws and *Star Wars* would change the way American movies were debuted and marketed. But not before Hollywood finally and fully tackled the one subject it had avoided throughout the late 1960s and 1970s: Vietnam.

One Shot

In 1976 Francis Ford Coppola and his crew traveled to the Philippines to make a movie, based on Joseph Conrad's *Heart of Darkness,* about the war in Vietnam. Conditions in the Philippines were chaotic. The weather was atrocious; at one point, a typhoon destroyed the sets. Martin Sheen replaced Harvey Keitel as Captain Willard and then had a heart attack. Marlon Brando showed up vastly overweight, without having read either the novella or the script. Dennis Hopper as a drugged-out photojournalist sounded as if were still doing scenes from *Easy Rider.* The movie took sixteen months to shoot, and it wasn't ed-

ited and released until 1979. In many respects, *Apocalypse Now* was a mess. It is also a great film.

Conrad's novella, published in 1902 at the dawn of the modernist era, and *Apocalypse Now* each tell a terrifying story from the perspective of a man embarking on a journey into madness. Our understanding—to the extent that we do understand—depends on the narrator's awareness of and his psychological reactions to the bizarre world in which he finds himself. In the case of the movie, that sinister world is Vietnam.

"Everyone gets everything he wants," Willard ruminates at the start of the film. "I wanted a mission, and for my sins, they gave me one. . . . It was a real choice mission, and when it was over, I never wanted another." Willard's assignment is to locate a Green Beret colonel named Kurtz who has allegedly gone berserk, and to "terminate" him "with extreme prejudice." For Willard, as for Marlow in the novella, there is no way to tell Kurtz's story "without telling my own. And if his story really is a confession, then so is mine."

Thus begins Willard's trip upriver into Cambodia and into his own mind. Along the way, everything and everyone he encounters is surreal. Not least of all, Colonel Kilgore (the name is appropriate), played by Robert Duvall, who seemed to be channeling George C. Scott both as General Buck Turgidson in *Dr. Strangelove* and in Coppola's own depiction of General Patton.[41] Kilgore is a mock-heroic, deranged military officer who obliterates Vietnamese villages from helicopter gunships that are blaring Wagner ("My boys love it"). Kilgore himself loves to see his boys surfing in the midst of a battle ("Charlie don't surf"), and he adores "the smell of napalm in the morning" because it smells like "victory." "If that's how Kilgore fought the war," Willard muses, "I began to wonder what they really had against Kurtz."

Yet neither Kilgore nor anyone else is in charge of this war. Outposts are soaked in thunderstorms, skirmishes with the enemy occur in a supernatural nighttime glow, Playboy Playmates emerge out of nowhere to entertain the besotted troops, and innocent Vietnamese in sampans are blown away. Meanwhile, Willard's odyssey on a boat manned by acid-dropping "rock-and-rollers with one foot in their grave" brings him and the viewers closer to the event they apprehensively await: the ultimate confrontation with Kurtz.

In large part, as Coppola recognized, we are waiting throughout the movie for Kurtz to appear because he will be played by Marlon Brando. When the film came out, critics derided Brando's performance for being unintelligible and incoherent. But Brando, with his half-swallowed words, gives Kurtz a subtlety as well as a maniacal majesty that dominate the final segments of the movie. We strain to listen to him, just as we sometimes struggled to hear the Godfather's hoarse voice. In each instance, this is the hushed voice of power.

"Are you an assassin?" asks Kurtz when Willard finally arrives at the end of his lunatic quest. "I'm a soldier," Willard responds. "You're neither," Kurtz observes. "You're an errand boy, sent by grocery clerks, to collect a bill." But Kurtz has indeed departed from what passes for the "civilized" world. In his megalomania, his refusal to be judged by the army or society, he's ruling a collection of native tribesmen from some ancient planet, and he adorns his headquarters with their severed heads. His transgressions have become unforgivable even to himself. "Everybody wanted me to do it," Willard says of his task, "him most of all. I felt like he was up there, waiting for me to take the pain away. . . . Even the jungle wanted him dead, and that's who he really took his orders from anyway." And so, Willard slays the king.

But the last words on the soundtrack are Brando's. Echoing the close of Conrad's novella, Brando whispers: "The horror . . . the horror." Here, though, the horror is not a voyage up the Congo river in Africa but the senseless carnage in Vietnam. Coppola—perhaps the preeminent American director of the 1970s—had offered an unforgettable portrait of the war's insanity, one that won the Palme d'Or for the year's best picture at the Cannes film festival in 1979 even before the movie was completed.

Yet the horror of Vietnam had been presented even more disturbingly in a movie released a year before *Apocalypse Now*. Until 1978 few people in Hollywood or elsewhere had ever heard of Michael Cimino. He had directed only one film: an unusually lighthearted Clint Eastwood vehicle in 1974 called *Thunderbolt and Lightfoot*. But in 1978 he released a more somber movie, this one on the inferno in Vietnam. Where *Apocalypse Now* was somewhat abstract and multifaceted, like a Cubist painting, *The Deer Hunter* focused in an intensely personal way on the lives and tragedy of three soldiers and the friends

they'd left behind. Whether by design or by accident, Cimino succeeded in turning his movie into the most emotionally wrenching American film of the 1970s.

The Deer Hunter starred Robert De Niro (in what is the most powerful performance he has ever given on screen) as Michael; Christopher Walken as Michael's closest friend, Nick (Walken's later reputation as one of America's strangest actors is belied in this film by his exquisitely sensitive interpretation of his character, for which Walken won an Oscar as best supporting actor); and Meryl Streep as Linda, the lover of both Nick and Michael. The superb ensemble cast also included John Savage as Steven, the third soldier who goes to war, and John Cazale, who was dying of cancer, as Stan, one of those who stays home.

The cinematographer for the film was Vilmos Zsigmond, who, together with Lázló Kovács, had fled Hungary in 1956. After landing in America, Zsigmond served as the cinematographer for *McCabe and Mrs. Miller* and for Steven Spielberg's *Close Encounters of the Third Kind* in 1977.

The Deer Hunter was less about the war itself than about the sorts of people who were drafted to fight the war and what the experience did to them. In fact, the first hour of the movie has little to do with Vietnam. It is instead a meticulous and joyous rendition of ethnic working-class life of the kind viewers rarely saw in an American film. If anything, the concentration on the rituals and wedding festivities of a Ukrainian community was reminiscent of (and possibly influenced by) the British working-class movies of the early 1960s, though without the bitterness of those films. Much of this portion of the movie was shot in the steel towns of Ohio, western Pennsylvania, and West Virginia. And what comes through (often reinforced by the spontaneity and improvisational quality of the acting) is the camaraderie among six friends—three headed off to war and three remaining at home—as well as their relationships to their women, to their taverns and bowling alleys, and to the holy grail of the deer hunt (which was actually filmed in the mountains of Washington State).

Michael is clearly the leader of this band. But Linda and the others think of him as "weird." While Nick confesses humbly that he likes "the way that the trees are on [the] mountains," Michael is unable or

unwilling to put his feelings into words. He doesn't engage in the ordinary courting of women; he wants but tries not to need a lover. Mostly, Michael is a character straight out of Hemingway, that most modernist of novelists about war and resilience in the twentieth century. Michael reserves his highest regard for technique, competence, skill, craftsmanship. He expects people on a deer hunt to bring along the correct clothes, boots, knives, and guns. Above all, they're supposed to adhere to Michael's doctrine that "a deer has to be taken with one shot" to the head—a lesson he tries to teach to his friends though "they don't listen."

The metaphor of "one shot" prefigures the most traumatic scenes in the movie. After the friends have returned from the deer hunt, they are sitting in a tavern, drinking beer, and listening quietly to one of them play an elegiac nocturne by Chopin on the piano. Instantly, in a jump cut worthy of Godard, Michael, Nick, and Steven are catapulted out of the comforts and ceremonies of their community into a harrowing landscape of violence and sadism. They are captured by the Vietcong and forced to play Russian roulette, a contest on this occasion to see who can avoid one shot to the head. Eventually they kill their tormentors and escape, but they are never the same.

Michael, however, is a survivor. He comes home but, like Jake Barnes in *The Sun Also Rises,* he is psychically maimed though still unbroken. Yet he feels a similar nausea and sense of embarrassment, an alienation from his former community that Hemingway's veterans so often demonstrate. In one of the moments in the film that most evokes this estrangement, Michael, just off the train, rides by his house in a taxi. His friends have prepared a party, complete with American flags and welcome-home banners to greet the hero back from the war. Michael instinctively decides to avoid the celebration. He orders the cab driver to take him to a motel. There, alone in his room, in silence, with only the haunting guitar music on the soundtrack, Michael deals with himself. He sits on the bed, crouches against the wall, holds his head in his hands, and gazes at a photo of Nick's lover, soon to be his own. Nothing is said or can be said. De Niro, in a dazzling piece of acting, has communicated everything we need to know about what it means to feel "distant" with the same (visual) economy and precision of Hemingway's prose.

Michael returns to the war, but only to redeem his promise not to leave Nick behind. Yet Michael can only save himself. Nick, now high on heroin, is also addicted to Russian roulette. And the final words he says to Michael, with a faint smile on his face, are "one shot"—before he blows his brains out.

After Nick's funeral, his friends engage in yet another necessary social rite. There is none of the ambiguity some critics found in this closing scene. The mourners gather around a table, again drinking beer. No longer believing in a war that has shattered them all, they burst (as if they don't know what else to do) into "God Bless America." But the song is not a patriotic anthem or an affirmation of America's values. It is a requiem for the dead.

And then they lift their glasses and offer a toast "to Nick." Afterward, the credits roll while we see a montage of shots of the characters from a happier time, when they and their community were still intact. But as Jake Barnes famously says, "The bill always came. That was one of the swell things you could count on." Like their fellow Americans in the late 1960s and 1970s who fought in the war or watched it on television, the people in *The Deer Hunter* have paid the costliest possible bill.

The Deer Hunter was an enormously controversial film. On the one hand, it won the Oscar for best picture, and Cimino received the Oscar for best director. Moreover, in 1979 a Vietnam veteran named Jan Scruggs who was a counselor at the U.S. Department of Labor saw the movie and conceived of the idea of building a National Memorial for Vietnam Veterans. He established and operated the fund that ultimately paid for the memorial wall in Washington, D.C. On the other hand, when *The Deer Hunter* was screened at the Berlin film festival in 1979, the Soviet and Eastern European delegations walked out in protest against the movie's unflattering portrayal of the Vietnamese people. And many opponents of the war, in other parts of the world as well as in the United States, objected to the movie for the same reason.

Whatever the political disagreements about the movie, Cimino came to be known—for a while—as a master of the cinematic universe. United Artists gave him open-ended financing to make his next movie about any topic he desired. When you ask American directors what kind of film they'd like to make, more often than not they'll say a mu-

sical or a Western. Cimino chose the latter. In 1980 he released *Heaven's Gate,* a movie stunningly photographed again by Zsigmond, about the Johnson Country cattle wars in Wyoming in the 1890s, in which ranchers tried to stop the influx of immigrant farmers. The movie cost $40 million, the most expensive film up to that time. The original version was five hours long, before the studio insisted it be cut to less than three hours. The alterations made no difference. No one could follow the story and *Heaven's Gate* was a critical and commercial catastrophe. The movie nearly bankrupted United Artists and effectively destroyed Cimino's career as a filmmaker.

Star Wars had shown the Hollywood studios how much money they could make on a movie. *Heaven's Gate* showed them how much they could lose. Thereafter the studios were no longer eager to trust their fate to unknown directors who wanted to make unconventional movies. From the 1980s on, Hollywood relied increasingly on blockbusters replete with special effects. Personal, low-budget, "independent" films would continue to be made, particularly in the 1990s and in the opening decades of the twenty-first century, many of them winning awards at home and overseas. But Hollywood's second golden age, the age of the foreign-influenced American auteur, was over.

A Method They Couldn't Refuse

The glamour of modernism has always rested on the flamboyant performance of the artist. We are awestruck by the paintings of Picasso, the buildings of Frank Lloyd Wright or Mies van der Rohe, the compositions of Igor Stravinsky, the music of Charlie Parker and Miles Davis, the songs of George Gershwin, the films of Orson Welles. Yet we prize not only the brilliance of the final product but the way that modern art calls attention to the charisma of the creator—the towering personality confronting a canvas, a blueprint, a musical score, or a film script.

In the case of the movies, the artist was never just the man or woman behind the camera. Films do not depend purely on the imagination of the director, the cinematographer, the editor, or the set and costume designer. Movies are also, and essentially, about acting. After all, when people are considering what movie to see, the first thing they want to know is who's in it. And they're right to ask. Actors are indispensable to the power of the cinema; without them, no one would care about camera angles, the juxtaposition of light and shadows, jump cuts, or deep focus. Actors, no less than directors, are the auteurs of their movies. They are also another example of the modern artist who is at the same time an entertainer and performer.

Acting in the movies had its roots in the theater, especially after

the coming of sound. But the importance of the theater to the cinema stemmed not just from the arrival in Hollywood in the 1930s of actors whose careers began on the British or American stage, and who could deliver the dialogue that sound required. From the start of the twentieth century, first in Russia and then in the United States, the theater was the place where a new type of acting emerged, based on techniques that would eventually transform the performances of movie actors in America and throughout the world.

The revolution in theater acting, originating abroad, turned out to be central to the modernism of America's movies. So the American actor became a partner with modernist painters, architects, composers, and musicians in creating a new art form and a new style of behavior that mirrored the upheavals and agonies of life in the twentieth century.

The Birth of the Method

In the nineteenth century, in America as well in Europe, the theater was dominated by actors and actresses who transfixed audiences with their stentorian voices, their extravagant gestures signifying happiness or fear (a histrionic practice that continued in silent films), and their tendency to address the audience directly instead of the other actors on the stage. By the turn of the twentieth century, however, acting grew less declamatory, as performers came to rely on microphones to project their speeches to the back of the auditorium. In addition, actors gradually accepted the notion that an artificial "wall" separated the posturing thespians from the theatergoers. Now actors could focus on one another and pretend to ignore the audience, even the prosperous patrons seated in the front rows.[1] These modifications led to a more realistic mode of acting, though one that still depended on performers striking poses rather than trying to plumb the emotions of their characters.

Nevertheless, the last vestiges of the nineteenth-century acting style, with its fondness for oratory and affectation, were about to fade away. In 1897 a visionary Russian actor and director named Constantin Stanislavski founded the Moscow Art Theater. Stanislavski conceived of his theater as a venue for contemporary and naturalistic plays, in contrast to the creaky melodramas that engulfed the Russian stage.

The Moscow Art Theater soon specialized in the works of Anton Chekhov—particularly *The Seagull, Uncle Vanya, Three Sisters,* and *The Cherry Orchard.* Chekhov's plays were ideal for Stanislavski's theater because they concentrated on the interior lives of the characters, on the silences and the veiled sentiments beneath the spoken words, and on the intuitive rather than rhetorical interchanges between the actors.[2] These were the very skills that Stanislavski hoped to instill in those who flocked to study with him in the early decades of the twentieth century.

By 1906 Stanislavski had developed a "system" for training actors. In his "studios" and workshops, he functioned as a director, a therapist, and a guru, teaching actors how to uncover their deepest feelings and apply these to the play they were rehearsing. Stanislavski railed against the blatant theatricality and flashy mannerisms that the idols of the Russian stage employed to win applause or divert attention from their fellow actors. Instead, he wanted his students not just to recite their lines or impersonate a character but to genuinely see, think, and react—in short, to create a fully realized human being on the stage.

The principal means of achieving this authenticity, according to Stanislavski, was to use what he called "affective" memory. Like Freud, Stanislavski was fascinated with the subconscious. He sought to excavate an actor's submerged remembrances so that the performer might better understand why a character spoke or behaved in a certain way. He encouraged actors to recall the most vital experiences in their own lives—their relationships with parents, friends, enemies, lovers—in order to generate the emotions needed to make a character seem "real." Stanislavski did not intend that actors should wind up playing themselves, constantly a danger in a system so dependent on dredging up the recollections and passions of the past. Ultimately, Stanislavski believed that his system served the play, not just the actor—that by merging their own personalities with the social and psychological predicaments of their characters, actors could "live" the role rather than merely indulge in a masquerade.

In Stanislavski's system, actors were supposed to know the background of their characters and why they sat or walked as they did, why they wore a particular kind of clothes, how they would confront an unexpected situation, information the playwright did not always supply. Hence Stanislavski relied on improvisation, especially in rehearsals.

If actors could extemporize, ad-libbing their lines, they could better comprehend the biography and the temperament of their characters, before they moved on to the play itself and the author's own dialogue.

But actors had to do more than internalize the emotions of their characters. They had to observe carefully how actual people conducted themselves in everyday life. And they had to pay attention to their colleagues on stage; to Stanislavski, listening to what someone else said was as important as speaking one's own lines. The ability to hear and respond to another actor was a major reason why Stanislavski emphasized the ensemble over the individual, the entire cast of a play instead of its putative "stars." The Moscow Art Theater was meant to be a communal endeavor, not a rostrum for celebrities.

Over time, Stanislavski's ideas on how to train actors evolved. He became interested in techniques that were less psychologically exhausting for actors. While he never repudiated the concept of affective memory, Stanislavski began to stress as well the significance of physical actions. Actors, he insisted, could also "speak" through their bodies, their facial muscles, their surreptitious glances, the plasticity of their hands, the nonverbal communications that would help convey the subtext of a play. Yet whether their interpretation of a role was based on their personal histories, their imaginations, or their physical movements, actors should persistently view themselves as the embodiments of an author's themes. The primary objective of Stanislavski's exercises was not to produce a generation of tongue-tied narcissists but to illuminate the play, and thereby to create a sense of truthfulness in the theater.[3]

Whatever his second thoughts about how to prepare actors, Stanislavski's original emphasis on memory, improvisation, listening, observation, and the centrality of the ensemble remained at the core of his teaching. And it was these maxims, more than his later revisions, that inspired his American disciples from the 1920s on.

The Method Comes to America

Starting in the 1920s the most prestigious theatrical organization in the United States was the Theatre Guild. The Guild specialized in weighty European and American plays, especially those of George Bernard

Shaw and Eugene O'Neill. It also produced some of America's most renowned musicals, including *Porgy and Bess, Oklahoma!,* and *Carousel.* During the early 1960s, as part of the Kennedy administration's efforts at cultural diplomacy, the Guild assembled a theater company that toured Europe and South America, introducing foreign audiences to the works of Tennessee Williams and Thornton Wilder. Its productions, at home and abroad, featured illustrious if relatively conventional actors like the Barrymores, Alfred Lunt and Lynn Fontanne, Katharine Cornell, and Helen Hayes.

Despite the Theatre Guild's commitment to promoting high culture on the stage, it was always a profit-oriented operation. The success of its plays depended on the sort of stars who could attract an affluent Broadway clientele. The Guild never tried to train actors in a set of common techniques, nor was it interested in creating a repertory company devoted to shared theatrical ideals.[4] The Guild's eminence rested with the marquee names of its individual performers, playwrights, and composers.

Early on, though, an alternative model to the Theatre Guild appeared in the United States. In 1922 Stanislavski brought his Moscow Art Theater to America for a two-year exhibition that publicized the Theater's structure and acting style. Stanislavski's troupe gave 380 performances, beginning in New York and then traveling to Chicago, Cleveland, Detroit, Pittsburgh, Boston, and Washington, D.C. Americans were already accustomed to famous Russian artists —like Tchaikovsky, Rachmaninoff, and Prokofiev—touring in America. And articles about Stanislavski had appeared in American theater journals in the first two decades of the twentieth century.[5] Yet to see a repertory company, even one putting on plays in Russian, offer a lesson in ensemble acting, with performers probing the psyches of their characters rather than emoting in front of the footlights, was a revelation for a group of aspiring young American actors in the audience.

Among those who were spellbound by the performances of the Moscow Art Theater was Stella Adler, the daughter of Jacob Adler, one of the icons of the Yiddish Theater. She was joined by Lee Strasberg, who had emigrated to New York as a child in 1909 from the remotest provinces of the Austro-Hungarian empire but never quite lost his eastern European accent or his rabbinical aura.[6] Strasberg in par-

ticular was impressed by the emotional concentration of the Moscow Art Theater's actors, and by their ability to reveal their characters' inner lives. Neither Strasberg nor Adler had ever witnessed a comparable intensity on the American stage.

They soon got an opportunity to study Stanislavski's system in depth. In 1923, two alumni of the Moscow Art Theater—Richard Boleslavsky and Maria Ouspenskaya—remained in the United States and established the American Laboratory Theater to teach Stanislavski's methods to American actors. Their students included Adler, Strasberg, and Harold Clurman, who was more inclined to become a director and producer than an actor. For the remainder of the 1920s the American Laboratory Theater was the conduit through which Stanislavski's theories and his emphasis on actors as members of a unit rather than as egocentric celebrities were transmitted to the United States.

Yet the American Laboratory Theater was not truly "American." It was instead a Russian outpost in New York, a place where actors could absorb Stanislavski's principles from his former students and apply what they'd learned to the performance of Russian and European plays. By the dawn of the 1930s and the arrival of the Great Depression, Strasberg and Clurman had come to believe that the theater needed an indigenous company of actors and directors who would focus on new American plays, plays that reflected the current social and economic turbulence in the United States. So they set out to adapt Stanislavski's psychological realism to the requirements of American culture, and to the expectations of an American audience.

The notion of a theater whose plays dealt with contemporary problems, and that fostered a spirit of community and cooperation among performers and spectators alike, was in keeping with the collectivist impulses of the 1930s. The Depression gave birth to a number of repertory companies like the New Deal's Federal Theater and Orson Welles's Mercury Theater, each of which attempted to produce plays that were artistically challenging as well as socially relevant.

No company embodied the values of the Depression era more faithfully than the aptly named Group Theater. Launched in 1931, with Clurman as chief promoter and spokesman, Strasberg as a director and acting teacher, and Cheryl Crawford as the financial administrator, the Group used the Moscow Art Theater as its paradigm. But the Group

tailored Stanislavski's precepts to fit both the commercial pressures faced by nearly every theatrical company in America and the urge for social solidarity that surfaced in a decade when the nation's traditional institutions seemed to be falling apart.

The Group wanted to make money. Yet it also hoped to create a theater that favored collaboration among the actors, directors, and writers. The Group's leaders preferred artistic and emotional cohesion among the participants to self-assertion, and they insisted (rhetorically, if not necessarily in practice) that everyone share responsibility for the choice of scripts and the interpretation a play should receive. The Group also sought to develop a permanent audience that would provide it with a steady source of income and identify with the Group's social idealism.

The Group's exaltation of ensemble acting and its hostility to prima donnas attracted a number of young leftist actors in the 1930s. Among the Group's members were Stella and Luther Adler, John Garfield, Franchot Tone, Lee J. Cobb, Karl Malden, Morris Carnovsky, and Elia Kazan. Some of these briefly formed a "Communist cell" within the Group, a sin that imperiled or destroyed their careers in the wake of McCarthyism in the 1950s. Meanwhile, the Group's most admired playwright was Clifford Odets, whom many in the company regarded as their American Chekhov.

But not every actor was entranced with the Group's communal ethos. A young actress with a Brahmin voice and striking cheekbones showed up at an early meeting of the Group. She listened politely to Clurman's spiel, then declined to join the Group because she wanted, she said, to be a star. Shortly, she got her wish. The actress was Katharine Hepburn.

As it turned out, many in the Group were not themselves immune to secret ambitions, inflated egos, and the craving for stardom. The moment they achieved even a modicum of success in a play, they were vulnerable to blandishments from Broadway and Hollywood. In spite of their faith that the Group could provide a refuge from the profit motive and a haven from the corruptions of the larger society, they often surrendered to the temptations of fame and the marketplace. Tone, Garfield, Cobb, Malden, and Kazan all eventually found on Broadway and in the movies the rewards, commercial and emotional, that they could not attain in the radical theater.

Moreover, the Group's plays were usually more poetic than political or propagandistic. One the one hand, the Group was proud of Odets's *Waiting for Lefty,* a one-act series of vignettes produced in 1935 that portrayed the plight of New York's taxicab drivers. *Waiting for Lefty* was the quintessential 1930s-style proletarian drama about the need to organize a union. And as an illustration of the class struggle, it worked; on opening night, the audience leaped from their seats at the end of the play to join the Group's actors in chanting "Strike, Strike, Strike!"

On the other hand, Odets's most characteristic play was *Awake and Sing!,* which also debuted in 1935. *Awake and Sing!* was a lyrical evocation of the conflicts in a Jewish family between a grandfather, a mother, and a son. The play's strength arose from the ardent conversations of its characters, a combination of hard-boiled urban cynicism and the desperate longing of immigrants and their offspring for a foothold in American life. *Awake and Sing!* dwelt more on the psychological battles between parents and children, as well as on the humor and pain of their common predicament, than it did on the promise of a socialist utopia. The play therefore lent itself to an acting style that was instinctive rather than hortatory.

Ultimately, like the characters in an Odets play, the members of the Group could not reconcile their sense of moral idealism with the allure of worldly achievements. Without consistent support from a working-class or bourgeois audience, the Group was compelled to rely on subsidies from friends, ex-colleagues, Broadway financiers, and Hollywood producers. Dependent increasingly on the vagaries of the box office, forced to compete with other theatrical organizations for flattering reviews and booming ticket sales, the Group was becoming indistinguishable from its show-business counterparts at the Theatre Guild or in the movie studios.

Whatever the contradictions between its avant-garde dreams and its hunger for success, the Group managed to endure throughout the 1930s. But faced with the end of the Depression and the onset of war, the Group grudgingly shut down in 1941.

Yet the real legacy of the Group lay not in its plays, or in its social consciousness, but in its impact on American acting. For most of his decade with the Group, Lee Strasberg had preached the virtues of

Stanislavski's affective memory. Strasberg wanted the actors in the Group to depart from the text, invent their own dialogue, explore their own feelings, and examine their own lives, all as a way of bringing greater passion to the play.[7]

When it came to acting, Strasberg was as much a missionary as Stanislavski. And he communicated his fervor to those in the Group who were similarly disposed to experiment with new forms of acting. Thus it was not surprising that some of the veterans of the Group in addition to Strasberg—like Stella Adler, Elia Kazan, Robert Lewis, and Sanford Meisner—went on to become enormously influential acting teachers. Nor that those actors trained in what Strasberg began to call the "Method," the Americanized version of Stanislavski's system, emerged as the most compelling performers in the theater and in postwar American movies.

A Studio for Actors

From the 1930s to the 1950s, two styles of acting—one British, the other American—were dominant on stage and on the screen. British actors like Laurence Olivier, John Gielgud, and Ralph Richardson were more verbally dexterous than most of their American rivals, befitting their background in the Shakespearean theater. Trained in the lofty language of the Bard, the British had a deep respect for the text of a play. For them, words were the foundation of their performances, the impetus for their interpretation of a role. Their task was to make a character's thoughts and motivations comprehensible through the way they spoke and what they said. Their approach was primarily external; they worked, as Olivier acknowledged, from "the outside in."[8] What they did not seek to do was substitute their own idioms for those of the playwright, or inject their private emotions into the creation of a character.

Among American actors, Orson Welles at times sounded British. He was certainly Shakespearean, not only in his periodic attempts to make movies of Shakespeare's plays but in his outsized and almost comic persona, as if he were playing Falstaff no matter whether he was supposed to be Charles Foster Kane, Harry Lime in *The Third Man*, Hank Quinlan in *Touch of Evil*, or Will Varner in *The Long, Hot Summer*.

Like his British peers, Welles depended on his magisterial voice. But he used his voice as more than just a tool to deliver lines. Welles understood that to pause enigmatically between two words or to adopt an indecipherable southern accent (as he did in *Touch of Evil* and *The Long, Hot Summer*) could more effectively beguile an audience than if he spoke clearly and in flowing sentences. Moreover Welles, unlike Olivier, could not help calling attention to himself even when he hid (as Olivier often did) behind disguises, wigs, and fake noses. Welles did not vanish into his roles. He was perpetually a guest star—on radio, on television talk shows, and in the movies, whether directed by him or someone else. Welles stole *The Long, Hot Summer* from the official star, Paul Newman, simply by his massive presence and his self-mocking rendition of a cornpone King Lear. He also once observed that Harry Lime was the best role an actor could ever have because the audience waited nearly half the film for Lime to appear—and when he did, he was yet again the charming magician and raconteur, the international entertainer known as Orson Welles.[9]

In contrast to Olivier and Welles, American movie stars were usually too curt to play Shakespeare. John Wayne typified the male idols —Gary Cooper, Clark Gable, Spencer Tracy, Humphrey Bogart, Henry Fonda—who reigned over the classical Hollywood cinema. Moviegoers perceived these actors to be playing themselves, or at least a version of themselves, on screen. They were naturalistic, unlike Welles, and without the rhetorical flourishes associated with the stage. In their films, they seemed unpretentious. They might even speak in a monotone, as in the case of Cooper or Fonda, since their elocution was less important than their physique, the planes of their faces, the glint in their eyes, and the rigidity of their jaws.

The one actor who did not comply with this hypermasculine image was James Stewart. Stewart could be emotional, even neurotic, in his movies, as he was in Alfred Hitchcock's *Vertigo*. Like a devotee of Stanislavski's system, Stewart sounded habitually as if he were improvising; he interrupted himself, rarely completed a thought before moving on to the next line, and stumbled over his own words. Yet it was Stewart's Capraesque, common-man qualities that permitted him to play more disorienting, faintly feminine roles.[10]

Apart from Stewart, however, neither British actors like Olivier

nor American stars like Orson Welles or John Wayne were guides for a generation of acting students who wanted to modernize the theater and films. Those young actors quickly got their chance, through a host of new institutions, to study with teachers reared on but now tinkering with Stanislavski's techniques.

In 1939 the New School for Social Research in New York invited Erwin Piscator—a refugee German director and producer—to preside over a "dramatic workshop" at the School. Piscator was no fan of Stanislavski; he had worked with Bertolt Brecht in the 1920s and believed that an actor should merely be an instrument for whatever the playwright and the director desired.[11] But Piscator was willing to incorporate Stanislavski's followers, notably Stella Adler, into his workshop. Among Adler's apprentice actors were Rod Steiger and an unruly young man with raw talent who had migrated to Manhattan in 1943 from the drearier precincts of the Midwest. His name was Marlon Brando, and he was soon Adler's star student.

Meanwhile, Elia Kazan was becoming a major theater and movie director. Between 1942 and 1947 Kazan directed ten plays on Broadway, including Thornton Wilder's *The Skin of Our Teeth*, Kurt Weill's *One Touch of Venus*, and *All My Sons*, Arthur Miller's first dramatic triumph. Kazan also won an Oscar as best director for *Gentleman's Agreement*, released in 1947.

By 1947 as well, Kazan had decided that American actors needed an institute, not dependent on the New School, where they could learn more about Stanislavski's methods. The prospective institute, though influenced by the ideals of the Group Theater, would not put on plays. It would function instead as a clinic for professional actors who wanted to hone their skills while pursuing their separate careers.

The institute, called the Actors Studio, opened its doors on October 5, 1947, two months before the sensational debut on Broadway of *A Streetcar Named Desire*, the play that would advertise the glories of the Studio and the Method. The Studio's founders were Kazan and two other alumni of the Group, Cheryl Crawford and Robert Lewis. Present at its initial meeting were Brando (who was preparing to play Stanley Kowalski), John Garfield, Montgomery Clift, Julie Harris, Maureen Stapleton, Shelley Winters, and Eli Wallach. The first classes at the Studio attracted Karl Malden (Brando's costar in *Streetcar* and

later in *On the Waterfront*), Patricia Neal, Mildred Dunnock (the original Mrs. Loman in *Death of a Salesman*), E. G. Marshall, Sidney Lumet, and Jerome Robbins.[12] All of these actors (and directors) would become leading practitioners of the Method.

During the first year of the Studio, Kazan was the driving force, largely because of his reputation as an incandescent director on Broadway and in Hollywood. Like his predecessors in the Group, Kazan emphasized psychology as the basis of an actor's performance. In addition, he encouraged actors to behave naturally, not theatrically. But since Kazan was in so much demand as a director he asked Lee Strasberg in 1948 to join the Studio's faculty. By 1951 Strasberg had risen to the position of "artistic director," and he remained the Studio's commandant until his death in 1982.

Under Strasberg, the Studio lured actors who already knew how to use their voices and bodies but wished to channel their emotions and even their private lives into the interpretation of a role. The Studio therefore translated Stanislavski's emphasis on memory and the postwar American fascination with psychoanalysis into devices that reshaped acting in the United States.[13] The Americanization of Stanislavski converted Strasberg into a sage, at least for his students. But it also made him an object of ridicule for critics and directors not enamored with the Method who thought that the Studio only turned out dazed actors searching incessantly for their character's motivation.

For those at the Studio who listened raptly to Strasberg, the Method was not a joke. It was a set of mechanisms to bring a character, with all of his or her unspoken complexities, to life on the stage.

The two formulas, inherited from Stanislavski, that Strasberg repeatedly stressed were improvisation and affective memory. But these ideas were no longer uniquely Russian. They corresponded to fashionable trends in America's culture. Improvisation, for example, was indispensable for Abstract Expressionists like Jackson Pollock and jazz musicians like Dizzy Gillespie, Charlie Parker, and Thelonious Monk. Among artists and musicians as well as actors, the ability to make it up as you went along was a key to self-expression. This did not mean that Strasberg was liberating his actors to do whatever they pleased at the Studio or in a play. He believed that teaching actors to improvise was a way to keep their performances fresh, so that their actions on stage

did not seem planned and their lines would not sound memorized. The trust in improvisation occasionally led Method actors to appear tentative, as if they really didn't know what they were going to say next. Yet it also gave their performances a startling spontaneity not frequently seen on Broadway or in Hollywood.[14]

The most controversial element of Strasberg's instruction was his reliance on memories and "private moments" to enhance an actor's performance. Although Stanislavski had also urged his actors to investigate their feelings and remembrances, Strasberg made these tools seem more like psychotherapy, in which the purpose was to uncover the roots of an actor's neuroses.[15] Indeed many of Strasberg's students were in analysis, which had become almost a fad among American artists and intellectuals in the 1940s and 1950s. At the Studio, as in Freudian therapy, the goal was to enable a person to recall his or her most painful emotions. In releasing hidden feelings, an actor freed the unconscious to function more creatively in the building of a character.

As it happened, Strasberg's preoccupation with unblocking an actor's intimate emotions worked better in movies than in the theater. While actors in a play could respond to one another on stage, in the movies they were often performing just for the camera. (In the famous taxicab scene in *On the Waterfront,* Rod Steiger's close-ups were filmed after Marlon Brando had left the set for a session with his psychiatrist. Steiger was talking to himself.) Actors in the movies were thrown back on their own resources, their multiple takes reconstructed later by the editor or director. How well an actor could summon up an assortment of feelings in an environment swarming with lighting and sound technicians, makeup artists, and hairdressers depended on a capacity for introspection that the theater did not usually demand.

Nonetheless, Strasberg's techniques had detractors, even among those who also believed in Stanislavski's doctrines. Stella Adler was the one American acting teacher who had actually studied with Stanislavski —for five weeks, in Paris, in 1934. She returned to the Group Theater complaining that Strasberg's overuse of affective memory undermined the meaning of a play and produced actors who were self-indulgent. In her own teaching in the 1940s and afterward, Adler argued that actors should utilize their imaginations, concentrate on their character's

clothes and behavior, and pay greater attention to the playwright's lan-
guage, rather than immerse themselves in their own psyches.[16]

Adler's former colleague in the Group, Sanford Meisner, was
equally suspicious of Strasberg's practices. Meisner was more inter-
ested in the interactions between characters, and in exercises that per-
mitted a performer to repeat certain phrases or actions until they
became internalized.

It was sometimes difficult to grasp the distinctions between these
versions of the Method. Strasberg, Adler, and Meisner all commended
actors who brought their own emotional idiosyncrasies to bear on a
role. In part, the specific disagreements among the Method's teachers
were caused by their competitiveness with one another and a hefty dose
of professional jealousy. Mostly, though, their disputes stemmed from
the fact that Stanislavski had never codified his "system," and never
stopped experimenting with alternate procedures, so his American
apostles wound up drawing on his ideas at different stages of their de-
velopment.[17]

Despite their quarrels, Strasberg, Adler, and Meisner were re-
sponsible for making the Method the most powerful form of acting in
the United States for the next fifty years. Whatever the disparagements
of Strasberg's psychological priorities, the Actors Studio became the
principal mecca for actors who wanted to learn the Method. The names
of those who studied at various times with Strasberg reads like a cata-
log of America's foremost stars: Paul Newman, James Dean, Al Pacino,
Robert De Niro, Dustin Hoffman, Jack Nicholson, Gene Hackman,
Sidney Poitier, Christopher Walken, Nicolas Cage, Jane Fonda, Anne
Bancroft, Joanne Woodward, Geraldine Page, Julianne Moore, and—
most improbably—Marilyn Monroe.

For her part, Stella Adler in 1949 founded her own Conserva-
tory, where she taught Warren Beatty, Martin Sheen, Harvey Keitel,
and De Niro, among others. Meanwhile, at the Neighborhood Play-
house in New York, Sanford Meisner's students included Steve Mc-
Queen, James Caan, Jon Voigt, Robert Duvall, Tom Cruise, Diane
Keaton, Anjelica Huston, and Philip Seymour Hoffman. Even Meryl
Streep—who did not study with any of the Method's mentors but grad-
uated instead from the Yale Drama School—reproduced the Method's
quirks, particularly in her characteristic hesitations and off-balance
reading of her lines.

Yet for all the authority of the Method's teachers, it was Marlon Brando who made the Method the most recognizable style of acting in the United States. And because of his performance in one of America's most haunting plays, Brando became a role model for generations of actors in America and ultimately abroad.

Streetcar

The Method was well suited for modern American plays, especially those in which much of the action took place inside a character's head. A work like Arthur Miller's *Death of a Salesman* required that any actor who played Willy Loman be able to convey Willy's psychology, his internal emotions and mad fantasies.[18] Thus in 1949, when *Death of a Salesman* opened on Broadway with Elia Kazan as director, Lee J. Cobb—the first Willy—used his bulky body and embittered voice to portray a shambling, exhausted man full of bottomless disappointment. In the televised rendition of the play in 1966, Cobb lingered over the word *remarkable* to suggest his bafflement that he, the salesman who desperately wants to be well liked, has only one friend. Later, on Broadway in 1984, Dustin Hoffman returned Willy to Miller's original conception: a diminutive and frenetic go-getter, eternally whining, who carries on semihysterical conversations in his own mind. Hoffman's Willy is also in a battle with everyone around him, but he is—like Cobb's Willy—just as crushed by his counterfeit dreams.

Tennessee Williams's *A Streetcar Named Desire* was more surreal than *Death of a Salesman*. The play, as Williams imagined it, was really about a woman, Blanche DuBois, who is on the brink of insanity. As interpreted by Jessica Tandy in the Broadway production, also directed by Kazan, Blanche was a frantic, panic-stricken, lost soul who longs for sympathy but is mostly the object of pity.[19]

Yet Tandy's Blanche was overshadowed by Marlon Brando's Stanley Kowalski. Brando had appeared in a few undistinguished plays in the mid-1940s, but the critics were starting to pay attention to him. So Kazan sent Brando to Williams as a possible Stanley after John Garfield and Burt Lancaster had turned down the part.[20] Williams approved of the casting, and Brando—who was twenty-three years old when *Streetcar* debuted on Broadway in December 1947—instantly became the central figure in the play.

Brando's performance on stage—preserved in the film version in 1951—subverted Williams's intention that Blanche and Stanley be evenly matched. Like a consummate Method actor, Brando surmounted the script. His Stanley was not just a working-class brute, swilling beer, smashing plates, scratching his muscular chest, and howling for his wife, Stella. Brando brought humor and a sense of humanity to the role of Stanley, together with a wounded sensitivity that didn't exist in the words Williams wrote. Moreover, he became the blunt, sarcastic spokesman for reality, undercutting Blanche's pretensions as the protector of culture and civilization, and mocking her insistence on maintaining a world filled with illusions. Consequently, it was Brando's Stanley, not Tandy's Blanche, who won the audience's affection.[21]

Brando's depiction of Stanley as a sardonic rebel made him a star in the theater. So much so that when Kazan came to direct *Streetcar* as a film, he knew he needed a different, more riveting actress for the role of Blanche, one whose own star power could restore the equality between Blanche and Stanley. In the London production of *Streetcar* in 1949, under the direction of her husband, Laurence Olivier, Vivien Leigh had created a Blanche brimming with sexual guile. But Leigh suffered for years from bouts of manic-depression. By the time Kazan chose her to play Blanche in the movie, Leigh was no longer just acting. In many ways, she *was* Blanche.

Leigh's theatrical manner, in contrast to Brando's Method-inflected surliness, intensified the contest between Blanche and Stanley. Yet Leigh's Blanche is more than a highfalutin pest. Leigh plays Blanche as an aging Scarlett O'Hara. She is at once flirtatious and fragile—a woman who, for all her reveries about her faded past, is almost too weary to go on with her life. In Leigh's interpretation, Blanche carries with her, in her perfumes and powders, the scent of her own doom. And indeed Leigh makes Blanche's disintegration the core of the movie, as Jessica Tandy was never able to do in the play.

As a result, *Streetcar* once again became Blanche's tragedy, not an opportunity for Brando to seduce the audience with his roguish charisma. In the film, Brando's Stanley is hardly a barbarian, but neither is he so easy to laugh or identify with as he was in the play.[22] If anything, Leigh dominates the movie; whenever she's on screen, you can't take your eyes off of her. On occasion she even seems to intimi-

date Brando: at one point, after he's pounded on the bathroom door, she opens it, all freshly cleansed and oozing southern charm, and he recoils as if he's confronting his own insecurities, threatened in his household by an alien presence he doesn't truly understand. *Streetcar* is in fact the only movie in which someone outacts Brando in his prime.

But the beauty of Leigh's performance lies in her ineffable sadness as Blanche. She makes you want to believe in her dim lightbulbs and lanterns, her desire for magic, and to forgive her "unforgivable" cruelty in driving her young, gay husband to suicide. Finally, when she utters Blanche's famed exit line, "I have always depended on the kindness of strangers," Leigh is heartbreaking.

For her role in *Streetcar,* Leigh won her second Oscar as best actress (her first was for *Gone with the Wind*). Brando was nominated for best actor but lost the prize to Humphrey Bogart as the scruffy Charlie Allnut in *The African Queen* (by this stage of his career, Bogart was no longer specializing in mistrustful saloon keepers or private detectives). Meanwhile, *An American in Paris* won the Oscar for best picture. The last two awards were a testimonial to the continuing power of the old, pre-Method movie industry.

Still, *Streetcar* confirmed Elia Kazan's status as one of America's leading film directors. And whatever the magnitude of Vivien Leigh's performance, Brando's screen image as Stanley became indelible. Afterward, actors had to compete with, when they did not simply imitate, Brando's air of menace, along with his passion and his vulnerability. For his successors in the 1950s and beyond, Brando was the exemplar of the Method actor's quest for authenticity in the theater and in the movies.

As a play, *Streetcar* was also a success abroad, as well as a training ground for young actors. The first production of *Streetcar* outside the United States took place in Havana in 1948. During the rest of the decade and into the 1950s, in addition to its presentation in London, *Streetcar* appeared in Western and Eastern Europe, as well as in Australia, Japan, and South Korea. In Sweden, *Streetcar*'s director was Ingmar Bergman, though what the wintry Bergman knew about the erotic demimonde of New Orleans was uncertain. In Italy the play was directed by Luchino Visconti and it starred Vittorio Gassman as Stanley and Marcello Mastroianni as Mitch, Stanley's best friend and Blanche's

self-conscious but deceived suitor. Frequently, foreign directors of *Streetcar* adapted the play to the predilections of their own domestic audiences. Hence the Italian version (as one might expect from a neorealist filmmaker like Visconti) emphasized the class conflict between Stanley and Blanche.[23]

In America, however, the transition of *Streetcar* from the stage to the screen underscored the increasing importance of Method acting in films. What had begun with Stanislavski as a technique meant for the theater was now becoming the signature style for a new generation of actors who were bent on conquering Hollywood.

The Method in the Movies

Neither Lee Strasberg nor Elia Kazan was wedded to the theater. In their view, the Method gave actors skills they could use just as readily on television or in the movies as on stage. Moreover, films in particular could advertise the Method, bringing its mannerisms and magnetism to the attention of a mass audience as the theater could not. The potential popularity of the Method especially appealed to Kazan. As a result, Kazan's movies in the 1950s—*Streetcar, Viva Zapata!, On the Waterfront, East of Eden*—were populated by his own and Strasberg's students, heralding the arrival of the Method as America's most distinctive form of acting.

On the screen, Method actors seemed more intense and untamed than the traditional movie star. The impression that Method actors were all "wild" ones was embellished by the camera. The Method was a pictorial acting style whose power could not be captured as easily in a theater unless you were sitting near the stage. But Method acting was made for close-ups. In the movies, a Brando, a James Dean, or a Montgomery Clift could act with his eyes, the curl of his lips, his hands, and his body. The actor suggested depths of meaning in the way he shrugged or slouched. And the camera captured his every twitch. Part of the reason why Brando abandoned the theater for the movies was that he believed films were a more intimate medium, one where his face and physical movements could be as eloquent as his speech, and where he did not have to project his fairly thin voice to people sitting high in the balcony.

Indeed, what the Method promoted in movie acting was a tran-
scendence of language. Hollywood's addiction to the modernist visual
pyrotechnics of film noir, neorealism, and the French New Wave was
reinforced by the nonverbal style of most Method actors, from Brando
to De Niro.

The tendency to mumble (as the critics invariably complained
about Method actors) was not always in vogue. In the 1930s, during
the first decade of sound, words in the movies mattered—whether they
were spoken by suave British émigrés like Cary Grant or taciturn Amer-
ican stars like Gary Cooper and Henry Fonda whom audiences could
at least hear and understand.

After Brando's performance in *Streetcar,* however, American act-
ing was marked by a brooding, almost inarticulate, introspectiveness
that one didn't find in the glib heroes or heroines of the screwball come-
dies and gangster films of the 1930s. In effect, Brando and his follow-
ers revolted against both the British school of Shakespearean-bred
actors who subordinated their personalities to whatever role they were
playing, and the classic American film stars who treated a script as a ve-
hicle to polish their familiar screen images.

Method actors rarely showed much reverence, as did their British
counterparts, for the written or spoken word. Instead, they stammered,
paused, and stared into the middle distance. Summoning up their prior
experiences and childhood memories often at the expense of what a
playwright or screenwriter intended, they communicated feelings rather
than lines. Their emotions seemed too complex for dialogue to unravel.
So the mystique of their acting lay more in what was not said, in the un-
earthing of torments that could never be described in words.[24]

The Method actor's retreat into silence was especially appropri-
ate for a cinema that, from the 1950s on, put a premium on the inex-
pressible. Just as important, the Method actor's disregard for language
permitted global audiences—especially those not well versed in English
—to appreciate what they were watching in American films.

What those audiences saw were actors who seemed eccentric, es-
tranged, and incurably rebellious. Although whispers and mutterings
don't necessarily launch revolutions, many Method actors did create
characters at odds with Hollywood's or America's notions of heroism.
Brando in *On the Waterfront,* Dean in *East of Eden,* Warren Beatty in

Bonnie and Clyde, Dustin Hoffman in *Midnight Cowboy,* Jack Nicholson in *Five Easy Pieces,* and Robert De Niro in *Taxi Driver* were all playing "bums," men incapable of adjusting to a world of middle-class values and adult respectability. Yet their characters—especially Dean's—were often less seditious than damaged, as if they all had experienced, deep down, the emotional injuries of a Blanche DuBois.

In fact, if the early Method actors like Brando, Dean, and Clift were not as delicate as Blanche, they were nonetheless feminine. Whether enhanced by their widely rumored bisexuality or just because of their ingrained sensitivity, they seem to have had a preternatural ability to identify with women, and to ignore the boundaries between acceptable male and female behavior. In any case, their ability to display feelings normally associated with women—Clift's gentleness, Brando's melancholy, Dean's agitation—may have explained why they became stars more easily, and had a greater artistic impact on the movies, than did Method actresses in the 1950s. The actors were appropriating the emotions that women alone were supposed to possess.[25]

Thus in *A Streetcar Named Desire,* Brando's Stanley continually soothes Stella even as he destroys Blanche. And when Stanley moans for Stella at the end of the film, Brando is in tears. In *On the Waterfront,* in a scene that was improvised in rehearsal, Eva Marie Saint drops her white glove on the ground and Brando picks it up. But instead of returning the glove to her, he slips it on his own hand and admires how it looks. It's as though Brando is modeling a woman's fashion accessory. Then in the taxicab with Rod Steiger's Charley, when Terry talks about losing his chance to be a contender, Brando's pain is nearly inconsolable. But so too is his sorrow when he discovers Charley's body hanging from a hook. Brando strokes Steiger's cheek just as tenderly as he caresses his pigeons.

Meanwhile, throughout *On the Waterfront,* the camera often shoots over Eva Marie Saint's shoulders, focusing on Brando's face, with its puffy scarred eyelids and busted nose. In this movie—unlike conventional Hollywood films—it is the man, not the woman, who gets the close-ups. Brando, rather than Saint, is the object of beauty. Given Brando's femininity, it was fitting that at one point in Woody Allen's *Sleeper* (1973), Allen and Diane Keaton start exchanging lines from *Streetcar*—with Keaton, not Woody, mimicking Brando.

One could detect the same feminine qualities in Warren Beatty's aching romanticism in his first film, *Splendor in the Grass* (directed by Kazan), and in the gracefulness of Christopher Walken as he dances at the wedding in *The Deer Hunter*. But only Dustin Hoffman spent most of a movie, *Tootsie,* actually playing a woman—though Hoffman's performance (unlike those of Clift or Dean) is comic, not tremulous.

By the late 1960s and 1970s, however, Method actors no longer had a monopoly on sensitivity. Actresses influenced by the Method—like Keaton, Faye Dunaway, Jane Fonda, and Meryl Streep—were becoming stars in their own right. In their roles, they exhibited the same neurotic uncertainties and barely buried tensions that characterized the performances of male Method actors.

Yet whether they were men or women, insolent or anguished, those who had absorbed the principles of the Method were now the trendsetters for the movie industry. And what counted here was not just the quality of the films in which Method actors appeared. Audiences everywhere were even more mesmerized by their iconographic performances. Essentially, the disciples of Stanislavski and Strasberg were using the screen to redefine for the world what it felt like to be a modern American.

The Method Actor as Star

The first Method actor to become a movie star was not Marlon Brando but Montgomery Clift. Brando's first movie, *The Men,* was released in 1950, whereas Clift had established himself in the cinema two years earlier, in *Red River,* playing opposite John Wayne. Yet Brando and Clift had a lot in common. Both were born in Omaha (Clift was four years older). During the 1940s and 1950s they were friends, mutual admirers, and competitors. They formed a closed circle that other younger Method actors could not easily penetrate, especially not James Dean, whom Brando couldn't stand.

But Clift was a different type of actor from Brando. On screen, Clift seemed more brittle and less intimidating. With his trembling voice and his physical fragility, Clift was an unusual cowboy in *Red River* and an even more peculiar soldier in *From Here to Eternity*. He gained his power in films by choking back his words as if he were stran-

gling on his thoughts, and by simply standing still, using his slender body and porcelain-skinned face to convey a reservoir of feelings (and also to steal scenes from other actors).[26]

In 1956 that face was shattered. Driving home from a party at Elizabeth Taylor's house, Clift smashed his car into a telephone pole. He suffered a broken nose and jaw, a fractured sinus, and facial lacerations, all requiring extensive plastic surgery. Afterward, Clift was never the same. He subsisted on pills and alcohol to diminish the pain, and his health steadily deteriorated. In his later films, he had trouble remembering his lines.

Nevertheless, he delivered one of his most memorable performances in 1961, five years before his death, in *Judgment at Nuremberg*. The film was long and plodding, but it boasted an all-star cast: Spencer Tracy (dipping into his customary bag of tricks, sticking his tongue in his cheek before uttering a line); the always-stalwart Burt Lancaster, here impersonating a German judge who has carried out Hitler's decrees; Richard Widmark; a weepy Judy Garland; Marlene Dietrich; and the Austrian actor Maximilian Schell, who earned a best actor Oscar with a Method-tinged but slightly over-the-top depiction of a conflicted defense attorney. In short, the movie provided everyone with an occasion to emote.

Clift has only one scene in the film, an appearance which lasts for twelve minutes. He plays a victim of the Holocaust who testifies at the trial about the medical experiments inflicted on him in the camps. Yet Clift's performance is the emotional center of the movie. Sitting in a chair, without the lengthy speeches given to the other actors, Clift depends on his quivering fingers and feverish eyes to create the portrait of a ravaged man, the ultimate victim of the Holocaust horrors. In his brief turn before the camera, Clift offered the other luminaries in the cast a lesson in acting, showing how a master of the Method truly inhabits a role.

Yet earlier in his career, Clift had declined the opportunity to play Terry Malloy in *On the Waterfront* and Cal Trask in *East of Eden*. Consequently, he was never in a movie that gave him the kind of legendary status achieved by Brando and Dean.[27]

Brando was much shrewder about the cinematic choices he made in the 1950s, at least with *On the Waterfront*. He recognized that the

core of the movie was not its story about corruption on the docks but its exploration of what and how Terry thinks. Throughout the film, Brando's gaze rarely settles on another person.[28] He's constantly looking upward or inward, as if Terry is trying to decide what to say and do. Indeed, the youthful Brando specialized in the representation of inner turmoil. Despite his screen image as a Mexican revolutionary in *Viva Zapata!*, the leader of a motorcycle gang in *The Wild One*, or a washed-up boxer in *On the Waterfront*, Brando resembled a modernist poet, preoccupied more with his self-realization than with social rebellion.

James Dean struggled throughout his short life and career to realize some semblance of a stable identity. He worshiped Brando and Clift, but he frequently competed for roles on television and in the movies with Paul Newman and Steve McQueen. At times, Dean's persona seemed more European than American; his public image, with a cigarette dangling from his mouth, was adopted from a photograph he saw on a book jacket of Albert Camus. But Dean was no existentialist. Mostly, he seemed exceptionally neurotic, more impulsive in his performances than Brando or Clift, not quite in control of his craft.

Dean's acting range was also narrower than those of many of his peers. Basically, in *East of Eden* and *Rebel without a Cause*, he was playing the same role: a haunted, tortured adolescent, with hunched shoulders and a constricted voice, his emotions too muddled to explain. Yet the camera loved Dean (as it did Marilyn Monroe). And it wouldn't let him grow up. Of course, his death in a car crash in 1955, at the age of twenty-four, ensured that Dean would never mature as an actor. He remained a perpetual teenager, preserved in amber and celluloid.[29]

For all the differences in their styles and moods, Clift, Brando, and Dean defined what Method acting in the movies meant for audiences in the 1950s and early 1960s. Paul Newman and Steve McQueen were less obvious practitioners of the Method. Their manner was more masculine than Clift's or Dean's, cooler, more restrained (even though, later in his career, Newman could play a man of emotional frailty, as he did with Frank Galvin, the constantly drinking, ambulance-chasing, down-to-his-last-case lawyer in Sidney Lumet's *The Verdict* in 1982).

Restraint is not a word one would normally use to describe the acting style of Rod Steiger. With his faintly foreign accent and his habit

of hissing his lines, Steiger was always chewing the scenery. But in *The Pawnbroker* (1964), another film directed by Lumet, Steiger is unusually quiet. As Sol Nazerman, Steiger embodies the unutterable pain and the isolation of a Holocaust survivor. His voice is dead, and so are his emotions. Only when Nazerman's Puerto Rican assistant is killed does Steiger allow his character to feel some human contact. But he does so with a silent scream, his body shuddering, convulsed by wordless grief.

Three years later, Steiger won an Oscar as best actor for a role that could not have been more dissimilar from Nazerman. In *In the Heat of the Night,* Steiger plays a voluble, gum-chomping, redneck Mississippi sheriff, full of bluster and down-home overconfidence. Certain he has solved a murder, Steiger's policeman brashly declares: "I got the motive which is money and the body which is dead." Steiger's showy performance also brought out the best in his costar, Sidney Poitier, whose poised body and self-protective hands only hint at the racial fury underneath Virgil Tibbs's elegant demeanor.

Steiger was Brando's contemporary, part of the generation that brought the Method to the cinema. But by the 1960s, after his triumphs in Elia Kazan's movies, Brando was laboring under the weight of being a culture hero who was supposed to transform not only the theater and the movies but American life.[30] Although he gave some fascinating performances in his films in the late 1950s and 1960s—in *The Fugitive Kind, One-Eyed Jacks* (the only movie Brando ever directed), and *Reflections in a Golden Eye*—he appeared to be waiting for some new auteurs to reinvigorate his career and take full advantage once again of his gifts as an actor. With Frances Ford Coppola and Bernardo Bertolucci, Brando found the directors he needed.

In the meantime, a second generation of Method actors, Brando's "children," was starting to emerge. I saw one of them at the beginning of his career, when he was an unknown. In 1967 the Charles Playhouse in Boston mounted a revival of Clifford Odets's *Awake and Sing!* Since I was working on a Ph.D. dissertation (which eventually became a book) about the culture of the 1930s, I decided I'd better go see the play. The cast was adequate but bland. Except for the young actor who played the son, Ralph—a role originally performed in the Group Theater production by John Garfield. Every time the actor took the stage, he was gripping; he seemed as if he were on another planet from the

rest of the cast. I felt like I was a scout at a high school baseball game; I thought I should remember the actor's name because I might hear of him in the future. I soon did. His name was Al Pacino.

Brando's children—Pacino, Robert Duvall, James Caan, Diane Keaton, Robert De Niro, John Cazale—were all on display in *The Godfather* and its sequel, *The Godfather: Part II*. Both movies were tributes to the Method. In the first film, the actors whom Brando had sired were eager to watch him at work.[31] But Pacino was nervous before his initial scene with Brando. When a friend asked him why, Pacino replied that he was "acting with God."

Although Brando was on screen in *The Godfather* for less than half the film, he dominated the movie not only because of his central role as Don Vito Corleone but also because of his ingenuity as an actor. With his whispery voice and his paternal gestures, Brando invests the Don with a mixture of absolute authority, wisdom, and munificence. Brando's Godfather is a man to be respected and feared, as well as loved. Pacino was right: Brando was a god in the movie and a father figure for the other actors on the set.

Yet Pacino wound up in the *Godfather* saga acting with another divinity. Before the filming of *The Godfather: Part II*, Pacino and Francis Ford Coppola were trying to decide who should play the part of the Jewish gangster Hyman Roth. At first, they approached Elia Kazan, who declined the role. Then they made an inspired choice, asking Lee Strasberg to play Roth. Strasberg had been training actors, including Pacino, for decades. But he now had to prove, at the age of seventy-two, that he himself could act. This was, literally, an offer he couldn't refuse.

Strasberg passed the test brilliantly. His performance—based on an accumulation of tiny internalized details, like the click in his throat that resembles a death rattle—was a vindication of the Method.[32] Moreover, in his scenes with Pacino, Strasberg became not just a teacher acting with his former student but a surrogate (if Machiavellian) father dispensing what turns out to be treacherous advice to his adopted son. For his performance, Strasberg received an Oscar nomination as best supporting actor (though the award went to Robert De Niro as the young Vito Corleone).

Pacino's Michael Corleone, however, is really the main character

in both *Godfathers*. And as Pacino plays him, Michael is undemonstrative in his ruthlessness. He listens more than he talks. Pacino permits Michael to communicate mostly with his jaw muscles and his pitiless gaze.[33] In his later films, Pacino often overacted, particularly when the script or the plot was pedestrian. But here, his power as an actor is expressed almost inaudibly, in the intensity of the silences between his words and sentences. In Coppola's films, Pacino becomes the personification of an icy killer.

For De Niro in *The Godfather: Part II*, the challenge was to both invoke and erase the audience's memory of Brando's performance in the first *Godfather*. "I didn't want to do an imitation" of Brando as the aged Don, De Niro recalled, "but I wanted to make it believable that I could be him as a young man."[34] Thus De Niro needed to provide viewers with a hint of how Brando sounded, but to put his own stamp on the role of Vito Corleone. In addition, De Niro had to play the part almost entirely in Sicilian. De Niro's complex rendition of Vito as an immigrant and affectionate family man, but at the outset of his career in crime, was a stunning achievement, suggesting that of all the Method actors in the 1970s and 1980s he was Brando's truest heir.

Certainly De Niro was the most versatile of the second generation of Method stars. He had an uncanny ability not only to portray an assortment of characters but to look like a different person from one role to the next. So he could be lean and dashing in *The Godfather: Part II*, a squat backwoods baseball catcher in *Bang the Drum Slowly*, hard-bodied in *Taxi Driver*, bearded and initially unrecognizable in *The Deer Hunter*, and muscular as well as corpulent in *Raging Bull*.

Notwithstanding the success that Pacino and De Niro enjoyed as Brando's descendants, Brando was not yet finished as an actor; he had one more astonishing performance to give. In the same year, 1972, that he appeared as the Godfather, Brando starred in Bernardo Bertolucci's *Last Tango in Paris*—a movie Pauline Kael compared to Stravinsky's *The Rite of Spring* because of its "hypnotic excitement" and modernist capacity to shock audiences all over the world.

With Bertolucci's encouragement, Brando improvised most of his dialogue, combining memories of his alcoholic mother and distant father, and of his early career as a boxer, with references to his previous movie roles (his gum chewing in *On the Waterfront*, his discovery of

Tahiti in *Mutiny on the Bounty*). Where Brando's performance in *The Godfather* was influenced by his observations about how mobsters spoke and behaved, his character in *Tango* was rooted in an exploration of his own psyche.[35] This was the ultimate summation of the Method, an amalgam of ferocity and anguish, particularly in the scene where Brando's character is mystified and enraged by his wife's suicide. Throughout the film, Brando depends on his intuition and his willingness to expose his emotions as fully as he can.

The Godfather and *Last Tango in Paris* were reminders of Brando's breadth and inventiveness as an actor. But both movies left him depleted. "That's the last time I use up my energies," he said after *Tango*.[36] He would never dig that deep again.

For all of Brando's creativity, people rarely thought of him—despite his performance as Stanley Kowalski—as an amusing actor. Dustin Hoffman, however, was (intentionally or not) the funniest of all the Method stars. While playing characters as varied as Benjamin Braddock in *The Graduate*, Ratso Rizzo in *Midnight Cowboy*, and Carl Bernstein in *All the President's Men*, Hoffman seemed to have an innate sense of humor, embedded in his nasal voice and his bouncy, almost Chaplinesque, walk.

Hoffman could even be the butt of jokes. Before a harrowing scene in *Marathon Man* (1976) in which his character is to be tortured by Laurence Olivier's Nazi dentist, Dr. Szell, Hoffman purportedly stayed awake for two nights so that he could appear properly exhausted. When Olivier saw him in the morning, he is supposed to have said: "Dear boy, you look absolutely awful. Why don't you try acting? It's so much easier."[37] The story illustrated not only Hoffman's reputation for delving so excessively into his roles that he drove his costars and directors crazy but also the disdain that many British actors felt for the Method.

Yet Hoffman was capable of satirizing himself and the Method. In *Tootsie* (1982), Hoffman plays a barely employable Stanislavskian named Michael Dorsey who gets fired from a TV commercial because, as a tomato, he refuses to sit down. It was "illogical," he explains to his exasperated agent (Sydney Pollack); tomatoes don't sit. "A tomato doesn't have logic," his agent bellows. To which Michael responds: "I was a stand-up tomato." Besides, "nobody does vegetables like me. I

did an evening of vegetables off-Broadway. I did the best tomato, the best cucumber . . . I did an endive salad that knocked the critics on their ass."

Jack Nicholson could be equally comical. Unlike Pacino or De Niro, Nicholson never seemed to take himself or his characters that seriously. Even in semitragic roles, like Bobby Dupea in *Five Easy Pieces* and Randle McMurphy in *One Flew over the Cuckoo's Nest,* or as murderous scoundrels like Colonel Jessep in *A Few Good Men* and Frank Costello in *The Departed,* Nicholson—with his maniacal grin and impish eyebrows—was always playing Jack. Indeed, Nicholson studied the Method only briefly; he was essentially an irrepressible ham like Orson Welles, putting on a show for the audience, and savoring his own one-liners.[38]

But all the Method stars were, at heart, entertainers. For them, entertaining and performing were part of what it meant to be a modernist artist. Whatever the objectives of Stanislavski's Moscow Art Theater or Lee Strasberg's Actors Studio, the Method called attention not so much to the psychology of a character in a play or a movie as to the style and personality of the actor. In this sense, Method actors resembled the Cubists and Abstract Expressionists who made the viewer concentrate on the lines and colors of their paintings, the Bauhaus architects who highlighted the design of their buildings, and the modernist composers who emphasized the structure of their music. Modern artists, including Method actors, were using their techniques as the primary subject of their work.[39]

Still, for most exponents of the Method, as for most twentieth-century painters, architects, composers, and jazz musicians, a performance was not just a way of demonstrating one's skill and delighting the audience. It was also a crucial component of that other characteristic of modernism, the struggle for self-discovery and self-revelation. So at its best, what you saw with the Method was an artist laying bare his or her psyche and soul.

As in the case of other art forms in the United States, the American actor had absorbed and modified ideas that originated in Europe (in this instance, Russia). Now these altered ideas were about to be transported back to the Old World as the key to a new kind of acting on stage and, more evocatively, in the movies.

The Method Abroad

From its inception in 1947, the Actors Studio aroused the interest of foreign actors, playwrights, and directors. Visitors came to the Studio from the theaters and movie sets of Europe, Israel, Central and South America, and Asia. Charlie Chaplin, who would soon emigrate to Switzerland, showed up at the Studio in 1950 searching for an actress to star in his new film, *Limelight*. In 1967 Lee Strasberg acknowledged the European fascination with the Method by giving a seminar on his techniques in Paris. Among those in attendance were François Truffaut, Jeanne Moreau, and several members of the august French national theater, the Comédie-Française.[40]

In spite of Laurence Olivier's scorn for the Method, a younger generation of British actors was especially attracted to Strasberg's ideas. Given the growing impact in Britain of working-class dramas onstage and in the movies during the late 1950s and 1960s, critics and actors recognized the need for a performance style that was more modern than Shakespearean, more in keeping with the plays and films that took place in the bleak industrial towns of northern England. Everyone in the theater and in the cinema was wondering who might become the British Marlon Brando.[41]

One obvious candidate was Richard Burton because of his mercurial performance as the frustrated and rebellious Jimmy Porter in the screen version of John Osborne's *Look Back in Anger* (1959). The movie and the play on which it was based were clearly influenced by *A Streetcar Named Desire,* and Jimmy was a British replica of Stanley Kowalski. Burton, however, had never been a Method actor. Neither were two other contestants for the mantle of Brando, both of whom (like Burton) sprang from the working class: Sean Connery and Michael Caine.

The actors who came closest in the 1960s to Anglicizing the Method were Richard Harris in *This Sporting Life* and Albert Finney in *Saturday Night and Sunday Morning*. Finney in particular looked a bit like Brando, and he certainly sounded—with his thick Lancashire accent—like an actor trained to garble his words.

But the British actor, later on, who most enthusiastically welcomed the Method was Daniel Day-Lewis. Day-Lewis disliked the

"brilliant dialogue" in British plays. He preferred the American-style reticence he found in the performances of Brando, Montgomery Clift, and Robert De Niro. For Day-Lewis, this reserve was not simply a matter of acting. "In America," he believed, "the articulate use of language is often regarded with suspicion." And Day-Lewis shared that distrust. Thus as an actor he wanted to embody a character rather than engage in "clever talk."[42] Day-Lewis took the Method seriously, and he captured its nonverbal, emotional power in *My Left Foot, Gangs of New York,* and *There Will Be Blood.*

Day-Lewis may have embraced the Method more than any of his British colleagues. But many contemporary actors, at home and abroad, absorbed at least some of the lessons of the Method. You can see its effects in the performances of Johnny Depp, Sean Penn, Julia Roberts, Javier Bardem, Tilda Swinton, and Russell Crowe. (Crowe started out in Australia as a rock singer. The title of the first song he wrote was "I Want to Be Like Marlon Brando.")

The widespread influence of the Method was a classic example of how a foreign idea, intended for the stage, was adapted in postwar America to the movies, and then reexported to the rest of the planet as a model for both cinematic and social behavior. It was also an illustration of how often Americans converted an institution of high culture, in this case the theater, into a form of global entertainment. So the international popularity of America's culture, as reflected in the Method, would endure even after the Method itself became a more familiar, less revolutionary style of acting, and the movies—where the Method had flourished—became by the close of the twentieth century more expensive to make and less open to artistic innovation.

The Global Popularity of American Movies

In the 1920s American novelists like Ernest Hemingway and William Faulkner, together with composers like George Gershwin and Aaron Copland, benefited from the upheavals in painting, literature, and music that transformed Western culture in the late nineteenth and early twentieth centuries. Similarly, American actors after World War II drew on ideas and techniques that had been developed in the Russian theater before the Bolshevik Revolution. And many American filmmakers modeled their work on the stylistic experimentations of the German Expressionists, the Italian neorealists, and the missionaries of the French New Wave. In all these cases, America's artists and entertainers were participating in the modernist crusade to make the pandemonium of the contemporary world—its wars, social disorders, urban anomie, and technological disorientations—more comprehensible and slightly more bearable.

By the 1990s the artist's ability to capture the tumultuousness of modern society—and to jolt people in museums, concert halls, or movie theaters with a representation of their own inner turmoil—had begun to dissipate. One could see this loss of a visceral connection between art and the audience in the diminished power of the movies to affect people's lives. Fewer American films at the start of the twenty-first century offered intimations of one's own or the country's predica-

ments in the way that *The Graduate* or *Annie Hall, Nashville* or *The Deer Hunter* had spoken to an earlier generation of moviegoers. Nor did the screen images of present-day stars, however much these could attract the multitudes on a movie's opening weekend, seem as emotionally consequential as the performances of a Marlon Brando or a young Robert De Niro.

Movies now had less of a social or personal impact not so much because computers and the Internet competed for a viewer's time and attention; television had been just as hypnotic a menace to the movies from the 1950s through the end of the 1970s. Rather, it appeared as if the modernist movement itself—a movement embodied in the cinema—had relinquished its hold on the public's imagination abroad and at home.

So people stopped arguing about movies, though they didn't stop watching them. The waning of modernism did not decrease the domestic or the international appeal especially of American films, at least as measured by box office receipts or DVD rentals and sales. Hollywood's new directors might no longer be as deferential toward their foreign peers as their predecessors had been through much of the twentieth century. But as usual, the Americans kept on making movies that were both commercially successful and technically sophisticated. On occasion, they even produced films that were as provocative and exhilarating as the seminal movies of the 1970s. Moreover, despite the periodic disaffection overseas with the political and economic policies of the United States, the global prominence of America's films reflected the continuing allure of American culture for people all over the world.

Commerce and Art in Contemporary Hollywood

The economic foundations of American filmmaking had been changing ever since the 1960s. The once-proud and sovereign studios that were responsible for Hollywood's golden age from the 1920s through the 1950s succumbed inexorably to the bottom-line prerequisites of their new masters, the corporate conglomerates. After a blizzard of mergers and consolidations, the only remnants left of the studios' former grandeur were their legendary logos. And even these did not signal— as they had in the 1930s and 1940s—a particular kind of film, a Co-

lumbia screwball comedy or an MGM musical. Instead of being welcomed to a Paramount or a Warner Brothers movie, what a viewer encountered at the beginning of a film was a mystifying inventory of companies that had cofinanced the production. But behind the battalion of executive producers listed in the credits stood the multimedia giants whose tentacles reached not just into the movie business but into the music industry, book and magazine publishing, television, and the Internet.

By the outset of the new century, Twentieth Century–Fox had become a subsidiary of the News Corporation (itself the flagship of Rupert Murdoch's media empire); Paramount was owned by Viacom; Universal had been absorbed into the NBC Universal Corporation, presided over by Comcast; Columbia was acquired by Sony; Warner Brothers was an auxiliary of Time Warner; and MGM was part of a shifting consortium of firms who were mainly interested in distributing rather than making movies. Meanwhile, the Disney corporation was itself a conglomerate, turning out live-action and animated films, administering theme parks, and overseeing the ABC and ESPN television networks.

All of these media combinations could be unscrambled and reassembled at any moment. Yet whatever the forms of the mergers, the corporations were hedging their bets as the old studios—dependent exclusively on annual box office returns—could not. Now, if the movie business lost money in any given year, the conglomerates could harvest their profits elsewhere in the entertainment world.

The experience of viewing a movie changed along with the configuration of the film industry. Many of the shabby art houses and stand-alone theaters that had specialized in showing the works of the foreign and American auteurs of the 1960s and 1970s closed down, to be replaced by multiplexes in or near suburban shopping malls.[1] These sleek complexes mostly featured the latest blockbusters, stuffed with explosions, car chases, and video-game annihilations, all designed predominantly for an adolescent audience.

Yet fewer people of any age were congregating at the movie theaters. Why schlep to the multiplex when you could see a movie at home, on your mammoth flat-screen TV, or downloaded on your computer? Why bother reading movie reviews when Netflix offered a cheap

and efficient outlet for 100,000 films, available to millions of sub-
scribers, allowing viewers to make their own selections unfettered by
the opinions of the cineastes in highbrow publications like the *New
York Times* and the *New Yorker*? Who needed a successor to Pauline
Kael when anyone could post his or her own snarky comments about
a film on the Web site of the Internet Movie Database?

Moviegoing had long since ceased to be a weekly habit as it was
before and just after World War II. In 1946, 100 million Americans
attended the movies every week. In 2003 that figure had shrunk to 25
million, or 10 percent of the population in the United States (though
this was an improvement over the 17 million people who went weekly
to the movies in America at the beginning of the 1970s). As a result of
the decline in theatergoing, two-thirds of the studios' revenues by 2004
came from rentals or sales of DVDs, and the leasing of films to cable
television channels.[2]

Theatrical releases were still important in generating publicity for
a movie. And launching a star-packed film, enhanced by digital sights
and Dolby sound, in thousands of theaters both in America and
abroad, particularly in the summer or at Christmas, remained a key to
the studios' marketing campaigns. Thus, where *Jaws* opened in 440
theaters in 1975, the first installment of *Mission: Impossible* debuted in
more than 3,000 theaters, at home and overseas, in 1996.[3] Yet the stu-
dios and their corporate proprietors made their real, long-term money
in people's living rooms and bedrooms, not at the box office.

Wherever people saw them, the most popular and profitable
American movies of the recent past included George Lucas's sequels to
Star Wars—*The Empire Strikes Back* and *Return of the Jedi*—movies
Lucas wrote and produced though he did not direct; as well as Steven
Spielberg's *E.T.: The Extra-Terrestrial,* his *Indiana Jones* trilogy in the
1980s, and *Jurassic Park.* These were joined at the cash register by
Ghostbusters, The Terminator, the 1989 *Batman* film, *Pretty Woman,
Forrest Gump, Independence Day,* the *Lethal Weapon* and *Die Hard*
franchises, *The Lion King,* and *The Dark Knight,* among other special-
effects extravaganzas.

Whether they were fables, romances, action films, or glorified
cartoons, all of these movies were unmistakably American. Only in
the United States could filmmakers afford the internationally known

megastars, the production costs, and the hundreds of technicians re-
quired to translate the daydreams of a Spielberg or Lucas into a grip-
ping movie. But it was precisely those daydreams, the childhood
fantasies brought to the screen, not only the money spent on advertis-
ing and publicity, that made American movies preeminent. When it
came to understanding what moviegoers wanted, in the United States
and abroad, American filmmakers had always been more astute than
their foreign rivals. This sensitivity to the passions of the worldwide
audience explained why one American movie, more than any other,
became not just a commercial success but a global phenomenon.

At first, everyone in Hollywood thought that James Cameron's
compulsive efforts to tell the story, yet again, of the sinking of the *Ti-
tanic* would be a catastrophe at the box office, comparable to the mon-
umental failures of *Cleopatra* in 1963 and Michael Cimino's *Heaven's
Gate* in 1980. There were good reasons for these premonitions. *Titanic*
—the most expensive American film of the twentieth century—cost
$200 million to make, more money than it took to build the original
ship. Like Cimino, Cameron (the adroit director of *The Terminator* in
1984) kept reshooting scenes in the interest of historical authenticity,
and he constantly fidgeted with the special effects, so that the movie's
opening was delayed from the summer to Christmas 1997. Eventually,
Twentieth Century–Fox entered into a deal with Paramount to share
the distribution rights and minimize the financial damage the film was
sure to inflict.

As it turned out, all the Cassandras were wrong. *Titanic* earned
$1.8 billion worldwide, which made it at the close of the century the
highest grossing film in the history of Hollywood. The movie also won
eleven Oscars, tying *Ben-Hur*'s record from 1959. And Cameron be-
came the first Canadian to receive an Oscar for best director.

Given that audiences throughout the world knew the outcome of
the tale—the ship struck an iceberg on the night of April 14, 1912, and
swiftly sank, killing 1,517 passengers and members of the crew—why
was the movie such a sensational hit? The major factor was that
Cameron converted a historical incident into an epic romance, remi-
niscent of *Gone with the Wind* and *Casablanca,* films that also used
public crises as backdrops for private conflicts. Though he was careful
at the beginning of the movie to explain why the ship went down,

Cameron insisted that *Titanic* was primarily the story of a woman, not a documentary about a calamity at sea. Moreover, unlike other block-busters that bombarded viewers with action sequences and comic strip heroes, *Titanic* concentrated on the emotions of the characters, a per-spective reinforced by James Horner's melancholy, Celtic-tinged score and Céline Dion's best-selling anthem, "My Heart Will Go On."

Beyond the mythical love affair between Rose (Kate Winslet) and Jack Dawson (Leonardo DiCaprio), the movie chronicled the emanci-pation of a woman—symbolized not only by the lessons Jack teaches Rose on the ship but by the photographs at the end of the film of Rose as an airplane pilot and riding a horse like a man (not sidesaddle). Hence *Titanic* particularly attracted teenage girls who may have been infatuated with the baby-faced DiCaprio but were also striving for their own self-awareness and independence from parental assumptions. In-deed, *Titanic*'s principal audience of young women differed from the mob of pubescent males who flocked to *Batman* or *Lethal Weapon* and their incessant sequels. Sixty percent of *Titanic*'s viewers were female, many of them returning with their friends to see the drama again. These "repeaters" contributed substantially to the film's huge profits.[4]

On one level, *Titanic* was a classic American movie in which we are told—as if we had not heard the message a thousand times before—that people are free to live their lives however they chose, that class divisions don't matter, and that happiness is preferable to wealth and power. Yet if the movie could have been directed in any earlier age by Frank Capra, what accounted now for its immense popularity abroad?

Certainly not its reputation for being an exceptional film. In the eyes of foreigners, no movie as trendy as *Titanic* could be an esthetic masterpiece. Art and profits were supposed to be incompatible, and an esoteric work by a Jean-Luc Godard was always superior to a main-stream American bauble.

I was living and lecturing in Europe in 1998 when the movie was widely released overseas. I often asked audiences if they had seen *Ti-tanic*. Half the people would raise their hands, guiltily, and look around to see if others were joining them in this confessional. They usually of-fered the excuse that they wanted to better understand the tastes, how-ever primitive, of their children. They themselves were not taken in by all the hype. They assured me that they knew the film was preposter-

ous, another instance of Hollywood hokum, and that they were slumming. The very mention of the movie invariably got a laugh from the audience; it was a guaranteed punch line everywhere I went. Indeed, it was this laughter that enabled people to enjoy *Titanic* without suffering any pangs of conscience about wasting their time on such trivia. Nevertheless, the embarrassment of foreigners at having surrendered to another American seduction was palpable.

In reality, audiences overseas responded to *Titanic* according to their own cultural traditions. *Titanic*'s world premier took place in Tokyo even before the movie opened in the United States, an indication of how indispensable the international market was to the film's success. Apparently, Japanese viewers were impressed with what they saw as the stoic conduct of the ship's passengers in the face of misfortune, a theme that evoked their own reactions to the disastrous experiences of World War II in Japan. In Britain, *Titanic* reminded viewers of a distant, more gallant era of the sort re-created in the "heritage" films of Ismail Merchant and James Ivory, movies like *A Room with a View, Howards End,* and *The Remains of the Day.* Within a month of *Titanic*'s debut in Iceland, 40 percent of the population had seen the movie, though here perhaps the audience was rooting for the iceberg. On a more macabre note, the ship's band continuing to play as the vessel sank suggested to Israelis the orchestras in the concentration camps that serenaded Europe's Jews as they were herded to the gas chambers.[5]

However it was interpreted, *Titanic* was a colossal triumph for American filmmaking, a movie whose personal themes of love and liberation transcended its historical setting as well as national borders. But for every high-tech, stunt-filled Hollywood blockbuster, the studios also underwrote quieter, less expensive, more intimate movies intended for grown-ups. These were movies that foreign audiences often didn't get the chance to see because such films weren't regularly shown abroad. Their existence, though, was a testament to the extraordinary diversity of the American cinema at the dawn of the twenty-first century.

Idiosyncratic films like *Driving Miss Daisy, Glengarry Glen Ross, Pulp Fiction, The Usual Suspects, Groundhog Day, Fargo, Shakespeare in Love, High Fidelity, The Hours, The Royal Tenenbaums,* and *Lost in Translation* reflected the two-tier system of financing and production

that emerged in Hollywood starting in the 1980s. Unlike the costly spectacles designed for the summer and Christmas seasons, many of these more multifaceted movies had low or medium-sized budgets and appeared initially at film festivals in Cannes, Berlin, or Toronto, or at the Sundance festival in Utah. They featured a new generation of American and foreign-born actors: Kevin Spacey, Denzel Washington, Samuel L. Jackson, Morgan Freeman, Frances McDormand, Gwyneth Paltrow, Hilary Swank, Nicole Kidman, Cate Blanchett, Ed Harris, John Cusack, Philip Seymour Hoffman, Bill Murray. And their success depended not on gaudy returns at the box office during their opening weekend but on favorable reviews and praise on the Internet or from one's friends, so that their audiences (both in the theaters and for DVDs) grew slowly but steadily over time.

One of the central reasons for the eclecticism of American film-making was the rise of smaller, semi-independent companies dedicated to the production and distribution of innovative, even avant-garde, movies. These enterprises focused on niche markets rather than on the mass audience.[6] As subdivisions of the major studios, they might not earn a lot of money for their corporate parents, but their movies did collect awards, particularly Oscars.

The most prominent of the boutique studios was Miramax, a subsidiary of Disney beginning in 1993 but operated from 1979 until 2005 by Bob and Harvey Weinstein. The Weinsteins had come of age in the 1960s and 1970s idolizing the films of François Truffaut, Federico Fellini, Robert Altman, and Martin Scorsese. Harvey Weinstein especially yearned to bankroll similar types of movies, whether made in America or overseas. Thus Miramax's first coup was Steven Soderbergh's *Sex, Lies, and Videotape,* which won the Palme d'Or at Cannes in 1989. Soderbergh's film cost only $1.2 million but grossed $25 million in the United States.[7] Thereafter, Miramax sponsored foreign films like *My Left Foot, The Crying Game, Il Postino,* and *Life Is Beautiful,* in addition to Quentin Tarantino's *Pulp Fiction, Shakespeare in Love* (which won seven Oscars including the one for best picture, and was the wittiest movie about the theater since *All about Eve*), *The Hours,* Scorsese's *Gangs of New York,* Ethan and Joel Coen's *No Country for Old Men* (another Oscar recipient for best picture), and *There Will Be Blood.*

Miramax's track record inspired the studios to create or purchase their own subsidiaries that would be committed to domestic and international art films. New Line Cinema, a division of Warner Brothers, coproduced or distributed *Glengarry Glen Ross, Se7en,* and *About Schmidt.* Sony Pictures Classics, owned by the Sony Corporation, helped distribute biographies of artists and writers like *Pollock* and *Capote,* as well as foreign-language films like *Run Lola Run, Crouching Tiger, Hidden Dragon,* and *The Lives of Others.* Fox Searchlight Pictures, a subsidiary of Twentieth Century–Fox, took at least partial credit for *Boys Don't Cry, Sideways, Little Miss Sunshine, Juno,* Wes Anderson's *The Darjeeling Limited,* and a winner of eight Oscars, *Slumdog Millionaire.* DreamWorks, Steven Spielberg's studio, cooperated at various junctures with Paramount and Universal to release *Saving Private Ryan, American Beauty,* and Woody Allen's *Match Point.* Focus Features, the art division of NBC Universal, sponsored Sofia Coppola's *Lost in Translation* and Ang Lee's *Brokeback Mountain.* And Touchstone Pictures, another Disney brand, was partly responsible for *High Fidelity,* Spike Lee's *He Got Game,* and three Wes Anderson films: *Rushmore, The Royal Tenenbaums,* and *The Life Aquatic with Steve Zissou.*

Despite the artistic aspirations of the studios and the executives who backed these movies, some were commercial disappointments. At the same time, Oscars frequently went to films released by the boutiques that most people hadn't seen or heard of. Still, a Miramax or a Fox Searchlight helped fund the ambitions of young directors to replicate the unconventional, character-driven movies of the 1960s and 1970s with their elliptical styles of storytelling and their excursions— sometimes hilarious, often moody—into the world of eternally ambivalent souls.

No director was more fanatical about classic Hollywood movies and the modernist films of the foreign and American New Wave than Quentin Tarantino. Before he became a screenwriter and director, Tarantino had worked in a video store in California. Like the obsessive characters played by John Cusack and Jack Black in *High Fidelity,* who can barely pause in their arguments about rock bands and albums to sell records to their customers, Tarantino had crammed his brain with countless scenes and snatches of dialogue from old movies. So his own

films, as well as many of the actors he used, were tributes to the techniques and icons of the cinematic past. He even named his production company A Band Apart, a reference to Jean-Luc Godard's 1964 film *Bande à part* (or *Band of Outsiders* in English).

Tarantino was hardly content to be an outsider. He wanted to make movies that appealed equally to the connoisseurs and the masses. With *Pulp Fiction* in 1994 he produced a movie that was at once artistically intricate and saturated with allusions to popular culture and the history of filmmaking.

The title of the movie summoned memories of the hard-boiled novels and Warner Brothers gangster films of the 1930s. But *Pulp Fiction*'s nonlinear style and jumbled time frame, its flashbacks and flashforwards, were an homage to *Citizen Kane*. Meanwhile, the multiple characters and the disparate but interlinked story lines could have been invented by Robert Altman.

The films of Welles and Altman were only part of *Pulp Fiction*'s heritage. The fighter to whom Butch (Bruce Willis) is supposed to lose is called Wilson, the name of Terry Malloy's opponent when Terry takes a dive in *On the Waterfront*. When Vincent Vega (John Travolta) gets up to dance in a restaurant filled with employees who look like Ed Sullivan, Buddy Holly, and Marilyn Monroe, we can't help smiling because we're also being transported back to Travolta's performance as Tony Manero in *Saturday Night Fever* in 1977, though with the still-captivating Travolta now seventeen years older and thirty pounds heavier.[8] When Christopher Walken shows up as a slightly unhinged Vietnam veteran, it's as if Nick in *The Deer Hunter* has been resurrected, having somehow survived the carnage of Russian roulette. In the final scene in a diner, as Vincent, Jules (Samuel L. Jackson), and Honey Bunny (Amanda Plummer) aim guns at one another, we've returned to the standoff between Clint Eastwood, Eli Wallach, and Lee Van Cleef near the end of Sergio Leone's *The Good, the Bad, and the Ugly*. Above all, we never discover the glowing contents of the briefcase that precipitates the slaughter of half the characters; it's as mysterious a treasure as the Maltese falcon.

Yet Hollywood's traditions and those of the New Wave are here to be ransacked, not simply revered. Tarantino's hit men, for example, do not resemble the taciturn mobsters of *The Godfather*. Nor are they

similar to the hooligans in Martin Scorsese's *Mean Streets* (though Harvey Keitel appears as Winston Wolfe, the affable fixer who solves problems). Instead, Vincent and Jules are garrulous, constantly talking about life, foot massages, and why the Europeans (who are on the metric system) call a McDonald's Quarter Pounder a "Royale with Cheese." But unlike the characters in a Godard film who chatter interminably about politics, Vincent and Jules are mostly debating the value of religion and the likelihood of miracles.

At this point, the connection between the church and crime does remind one of the themes in a Francis Ford Coppola or Scorsese movie. In *Pulp Fiction*, however, salvation is possible, particularly for Jules, as it is not for Michael Corleone. As Jules acknowledges to the two robbers, Pumpkin (Tim Roth) and Honey Bunny, in the diner, "Normally, both your asses would be dead . . . but you happened to pull this shit while I'm in a transitional period so I don't wanna kill you, I wanna help you. . . . I'm tryin' real hard to be a shepherd."

Pulp Fiction had no theological resolution. Nor, with its fragmented episodes, a comforting ending of any kind. Still, it was both an artistic and an exceedingly entertaining movie, one that gained the approval of elite filmgoers and made money at the multiplex. *Pulp Fiction* received the Palme d'Or at Cannes; Tarantino shared an Oscar for best screenplay; and the movie (which cost $9 million to make) earned just over $100 million in the United States and nearly $213 million at box offices throughout the world.[9] Tarantino proved that youthful, esthetically sophisticated directors could turn low-budget films into works that were pioneering and popular.

Where Tarantino revised the gangster movie, other directors tinkered with the conventions of film noir. On the one hand, Bryan Singer's *The Usual Suspects* (1995) and Curtis Hanson's *L.A. Confidential* (1997) observed even as they updated the rituals of film noir in the 1940s and 1970s. Each movie offered a complicated plot and people who either don't know the truth or can never be believed. The hapless policemen in both films were later parodied by the suave if bumbling detective Guy Noir (played by Kevin Kline) in Robert Altman's last movie, *A Prairie Home Companion* (2006). On the other hand, in the Coen brothers' *Fargo* (1996), the police chief (Frances McDormand's Marge Gunderson) is not—as in older noir films—a femme

fatale but a woman who can actually unravel a conspiracy. And the crimes themselves occur in a snow-draped rural landscape, not in the sinister alleys of urban America.

If any director carried in her veins the artistic yearnings of the previous generation of filmmakers, it was Sofia Coppola. Yet her movies—especially *Lost in Translation* in 2003—were quirkier and more poignant than those of her father.

Lost in Translation was also one of the most discerning movies ever made about the culture shock Americans experience when they confront the world. An aging actor, Bob Harris (Bill Murray) has arrived in Tokyo to film a whiskey commercial ("For relaxing times, make it Suntory time"). The premise of the movie was inspired by Francis Ford Coppola's having shot a Suntory commercial in the 1970s with Akira Kurosawa. But Bob is no master of the cinema or the stage. His career is fading; he hasn't made a decent film since the 1970s; and he's "getting paid two million dollars to endorse a whiskey when [he] could be doing a play somewhere." So he's jet-lagged, surrounded by Japanese counselors and guides who are eager to please, bemused by his inability to fathom their version of English, nodding and smiling even though he's clueless about what's going on. When the young equally baffled American woman he meets in his hotel, Charlotte (Scarlett Johansson), asks why the Japanese "switch the r's and l's," Bob explains: "For yuks. . . . They have to amuse themselves, 'cause we're not making them laugh."

Mostly, Bob (like the characters Murray has usually played) is having a midlife crisis. "Do I need to worry about you?" his wife inquires on a phone call from the States. "Only if you want to," Bob replies. Where in the movies of the 1950s it was the children of affluent suburbanites who were rebels without a cause, now it's the adults who want to take a break from their families, as in *American Beauty* and *The Hours*.

Inevitably, Bob and Charlotte (who is also frustrated with her marriage, as well as with her prospects in life) fall in love—with each other and with Tokyo. But *Lost in Translation* doesn't conform to the audience's expectations or the rules of a Hollywood romantic comedy. The characters don't have an affair and the movie doesn't end predictably, as does Rob Reiner and Nora Ephron's *When Harry Met Sally*

or Ephron's *You've Got Mail*. After their restrained goodbye in the hotel lobby, Bob and Charlotte embrace and kiss on a crowded Tokyo street. Bob whispers some words to Charlotte, but viewers don't know what he's saying. Then they part—a conclusion that reminds one of *Annie Hall* and *Manhattan*, with Bill Murray in a taxicab staring at the sights of the city and emotionally exhausted, just as Woody Allen finds himself alone at the close of his films.

Wes Anderson's movies were as cosmopolitan as *Lost in Translation*. But they weren't really comedies or conventional love stories either. Like Tarantino's films, they're packed with quotations from popular culture, music, and movies (both American and foreign-made). *The Royal Tenenbaums* (2001) is set somewhere in the 1970s, though the time period is never clarified. Apparently, this was the decade when the film's characters enjoyed their most cherished triumphs—hit plays and victorious tennis matches—before the happiness wanes. *The Darjeeling Limited* (2007), which takes place in an almost mythological India, is dedicated to the memory of Satyajit Ray. And Anderson's movies, like those of John Ford, are always brimming with minor, often eccentric characters engaged in their own adventures—dancing, laughing, quarreling—that seem only tangentially related to the main tale. One character in *The Life Aquatic with Steve Zissou* (2004) spends the entire movie unaccountably singing the songs of David Bowie—in Portuguese.

Anderson's films are also bursting with dysfunctional families: con-men fathers, absent or inattentive mothers, siblings who can scarcely tolerate their parents or one another. In *The Life Aquatic*, a young man (played by Owen Wilson) who might be Zissou's son asks him, "Why didn't you ever try to contact me?" Zissou (Bill Murray) responds frigidly, "Because I hate fathers, and I never wanted to be one." In *The Darjeeling Limited*, one of the three brothers (Jason Schwartzman) wonders whether they all "would've been friends in real life. Not as brothers, but as people."

Yet like *Lost in Translation*, Anderson's movies contain a wry, wistful humor. His characters may be regretful, lonely, and lost, but they are ultimately saved by their sardonic self-knowledge and the kindness of others, none of them strangers. "I wonder if it remembers me," Zissou says when he and his comrades in a submersible find the "jaguar

shark" that has eaten his friend and mentor, Esteban. At this point, everyone in the cast of the movie puts their hands on Zissou's shoulders to comfort him as he nearly dissolves into tears. Indeed, most of Anderson's films end on a note of consolation, with a slow-motion processional in which all the characters (as in Fellini's *8½*) join together to take their bows before the curtain descends.

Sometimes, however, the parade turns into a joyous ballet, as in the final scene of *Fantastic Mr. Fox* (2009), Anderson's animated adaptation of a story by the British novelist Roald Dahl. In the movie, Dahl's animal characters are both Americanized and Andersonized. Mr. Fox (George Clooney) is a charming, self-absorbed, rascal—another version of Royal Tenenbaum and Steve Zissou—with existential conflicts. Mrs. Fox (Meryl Streep) is a distracted, disapproving wife who spends her time pursuing a career as an artist while her children compete for parental notice and affection. The voices of the rest of the cast are supplied by the Anderson repertory company: Jason Schwartzman as the Foxes' neurotic son; Bill Murray as a morose badger who doubles as Mr. Fox's attorney and real estate adviser; Owen Wilson as a spaced-out "Coach Skip," who tries to teach the animals the arcane rules of "Whackbat"; Michael Gambon as a would-be Colonel Kilgore, who calls in air strikes to obliterate his animal adversaries; and Willem Dafoe as a rat with a menacing southern drawl, backed up by whistles and ominous music that sounds like an outtake from a spaghetti Western.

All of this brew is photographed in the vivid colors that Anderson typically favors, with dollhouse cutouts showing the animals engaged in various unrelated activities, and culminating in an elaborate rescue operation reminiscent of Steve Zissou leading his merry band as they assault a pirate lair. Despite its origins in a British children's tale, *Fantastic Mr. Fox* as a film owes more to Anderson's signature style and middle-aged preoccupations than to the vision of Roald Dahl.

It is not a coincidence that these movies either featured or starred Bill Murray. Murray emerged from the television sketches of *Saturday Night Live* in the 1970s and his raucous if juvenile comedies of the 1980s to become one of the subtlest and most intriguing American actors in the 1990s and early twenty-first century. His impassive demeanor and deadpan delivery of even the funniest lines underscored

the fundamental sadness of the movies—particularly those of Sofia Coppola and Wes Anderson—whose contemplative tone he shaped.

Neither Coppola nor Anderson had a monopoly on sorrow. Or, along with Tarantino, on the creation of offbeat characters and narratives. As it happened, the most versatile director of the 1990s and the opening decade of the twenty-first century was not a young new entrant into the movie business who longed to be an auteur like the giants of the French and American New Wave, but a veteran whose career had actually begun in the 1960s and 1970s. Clint Eastwood specialized in but amended the genres, familiar to people around the world, that had been staples of American filmmaking for decades: Westerns (*Unforgiven*), murder mysteries (*Midnight in the Garden of Good and Evil, Mystic River*), boxing tales (*Million Dollar Baby*), war movies (*Flags of Our Fathers, Letters from Iwo Jima*).

As an actor, Eastwood was himself a throwback to the era of John Wayne, Henry Fonda, and Gary Cooper. Eastwood's brusque minimalism, his reliance on a repertoire of tics (narrowed eyes, a curled upper lip) that reinforced his commanding physical presence, his voice (unlike Wayne's) an intimidating whisper but filled with authority, all these traits reminded audiences of how American actors had sounded and behaved before the arrival of the Method.[10]

As a director, Eastwood was equally traditionalist. In contrast to Tarantino, Eastwood never fiddled with the chronology of his films or tried to disorient his viewers. Nor was he addicted, like so many other modern directors, to displays of technical bravura. Instead, Eastwood simply told a compelling story from start to finish. And the power of his films depended not just on their plots but on the performances of highly skilled actors, some of whom had been stars since the 1970s (like Gene Hackman and Meryl Streep), others who emerged in the 1980s and 1990s (like Morgan Freeman, Kevin Spacey, John Cusack, Sean Penn, Tim Robbins, and Hilary Swank, together with the Japanese actor Ken Watanabe).

Yet Eastwood sought to make movies that were both artistic and profitable, unusual and accessible. *Unforgiven,* for instance, owes its themes as much to Sergio Leone and Robert Altman as it does to John Ford. The movie is a reconsideration of the myths of the West as well as a partly elegiac, partly ironic reverie of the kind Altman concocted

in *McCabe and Mrs. Miller* and *Buffalo Bill and the Indians,* but that Ford also presented in *The Searchers* and *The Man Who Shot Liberty Valance.*[11] So it's appropriate that Gene Hackman's cheerfully brutal sheriff, Little Bill Daggett, spends much of *Unforgiven* telling his life story to a dime novelist, in the same way that James Stewart's Ransom Stoddard recounts the fabled origins of his political rise to a pair of journalists and Burt Lancaster's Ned Buntline offers a running commentary on the legend of Buffalo Bill.

Still, Eastwood's Will Munny is both connected to and far beyond any character that John Wayne impersonated. Munny is a former gunfighter haunted by his past. "It's a hell of thing, killing a man," Munny observes. "Take away all he's got and all he's ever gonna have." These are not the pensive lines one would associate with Wayne's Tom Doniphon, lurking in the shadows, about to pull the trigger on Liberty Valance. In fact, for most of *Unforgiven,* Munny is an anti-Wayne and even an anti-Eastwood (at least in Leone's Westerns). "I ain't like that no more," Munny keeps saying. "I'm just a fella now. I ain't no different than anyone else."

At the end of the movie, though, Munny reverts to his archetypal Western role as the dispenser of vengeance and justice. "I don't deserve . . . to die like this," wails Little Bill. To which Eastwood replies, in his best Man with No Name snarl: "Deserve's got nuthin' to do with it." We've returned to the codes of the Old West (or Western), but with a harder edge and much less romanticism than existed in the movies of John Wayne or John Ford. It was fitting, therefore, that Eastwood dedicated *Unforgiven* to "Sergio and Don" (the latter was Don Siegel, who directed Eastwood's first Dirty Harry film in 1971). Munny, after all, is a nineteenth-century version of Harry, whatever qualms Eastwood expressed in *Unforgiven* or *Mystic River* about violence and revenge.

Eastwood won two best director Oscars, for *Unforgiven* (1992) and *Million Dollar Baby* (2004). Although his movies were never blockbusters, they did moderately well at the box office and on DVD, at home and abroad. And their popularity was a sign of Hollywood's continuing dominance in the global marketplace.

Nevertheless, even in America, the interest in foreign films was growing in the 1990s, which was one reason why Eastwood chose in 2006 to portray the battle for Iwo Jima from the Japanese point of

view. The cinema, and culture in general, were becoming more multi-national. American film companies, directors, and audiences had to take into greater account what was transpiring on the rest of the planet.

Hollywood and the World

During the 1980s and early 1990s, few Americans went to see movies produced in Europe, Latin America, or Asia (the one exception being martial arts films from Hong Kong). Foreign-language movies, with subtitles Americans traditionally despised, claimed less than 1 percent of the box office receipts in the United States.

What was more startling, audiences abroad (apart from those in India, Japan, and Hong Kong) seemed equally indifferent to movies made in their own countries. In the late 1990s the market share in Italy for Italian films was 15 percent; for domestic films in Britain and Spain, 12 percent; in Germany, 10 percent; in Brazil, 5 percent; and in Australia (the home of internationally popular movies in the 1980s like *Breaker Morant, Gallipoli,* and *Crocodile Dundee*), just 4 percent. Even in France, where viewers worshiped the auteur theory and had always preferred French films, the market share for movies made by French directors dropped to 27 percent in 1998.[12] Meanwhile, as they had since the 1920s, American films attracted nearly 80 percent of the moviegoers worldwide.

Part of the reason, at least in Europe, for the decline of interest in locally produced films was that many people who were now prosperous and middle-aged had moved to the suburbs, where they could enjoy other leisure activities. At the same time, younger filmgoers—like their counterparts in the United States—were enthralled by blockbusters with fanciful special effects, the types of movies that could be churned out only by Hollywood. In Belgium, for example, viewers in their teens and twenties considered European films too obscure and too indistinguishable from the high culture taught in their schools, while American movies were fun, unburdened by the obligation to improve minds or change society.[13]

In addition, European governments tried to insulate their film industries from the pressures of the marketplace. They customarily offered subsidies to moviemakers while seeking to limit cultural imports

of all kinds from America. By the 1990s the typical European movie re-ceived 70 percent of its funding from the government. So where Amer-ican film companies focused on the global market, European directors were less entrepreneurial, less concerned with the overseas distribution of their movies, and more attentive to the demands of the cultural bu-reaucrats in Paris, Bonn, or Rome. Supposedly, the protectionist poli-cies pursued by various governments ensured that European audiences would not be engulfed and their tastes polluted by the rubbish ema-nating from Hollywood.

But if you knew your movie would automatically be shown on a government-run television channel, why worry about whether anyone was watching? Why bother with such trivia as stories, characters, and performances when you could concentrate on being avant-garde? In the pact between the politicians and the filmmakers, the desires of the audience rarely mattered; the whims of the director and the guidelines of the state took precedence. Unfortunately, the strategies of Europe's cultural ministers often led not to artistic experimentation or commer-cial viability, nor to the preservation of a national cinema, but to self-indulgence on the part of the exalted auteur.[14]

Yet while direct government support could be counterproductive, public and cable television networks did help revive some of Europe's film industries in the 1990s. In France, Canal Plus—launched in 1984 as a premium pay TV channel—bankrolled 80 percent of French films by the beginning of the twenty-first century, including *Amélie,* which grossed $33 million in the United States in 2001, breaking the record *La Cage aux Folles* set in 1979.[15] In Britain, the BBC and Channel Four were instrumental in funding British films. Among the many movies Channel Four supported was *Four Weddings and a Funeral* in 1994, the most profitable film up to that point in the history of the British cinema; it earned more than $260 million internationally, exceeding the revenue for *Chariots of Fire* and *Gandhi,* both of which won best picture Oscars in the early 1980s.

All these movies reflected the distinctive cultures of the countries in which they were made, counteracting to some degree the massive in-fluence of Hollywood. Indeed, by the first decade of the new century, American films were losing some of their market share in Europe and Asia. In 1998, the year of *Titanic,* American movies collected 64 per-

cent of the ticket sales in France. Nine years later, in 2007, Hollywood's portion of the French market had fallen to 50 percent. In 1998 as well, American films accounted for 70 percent of the tickets sold in South Korea. In 2008 that figure too had dropped to less than 50 percent. It was not so much that the fascination with American movies had weakened abroad, but that local film industries were now in a slightly better position to compete with Hollywood's fare.[16]

Moreover, a growing number of American movie aficionados seemed willing to sample films from overseas, particularly if they were available on DVD. Already in the 1990s, two Italian movies had succeeded in the American market: *Il Postino* (1994), which was the first foreign-language film since Ingmar Bergman's *Cries and Whispers* in 1973 to be nominated for a best picture Oscar; and *Life Is Beautiful* (1997), which was also nominated for best picture while its star, Roberto Benigni, won an Oscar for best actor. *Life Is Beautiful* earned nearly $58 million in the United States, making it the most popular Italian movie for American audiences in the twentieth century.

Within a few years, other foreign films were enticing American viewers. Among these were Japanese cartoons and animated movies, Ang Lee's *Crouching Tiger, Hidden Dragon* (which made $128 million in the United States at the start of the twenty-first century and was nominated for an Oscar for best picture), and German films like *Run Lola Run, Good Bye Lenin!, Downfall,* and *The Lives of Others.*[17]

Martial arts movies from Hong Kong resided in a category by themselves. These films were meant to make money, not to win awards. Though their primary constituency was in Asia among the millions of Chinese living in Taiwan, Thailand, Singapore, Malaysia, and Indonesia, they had since the 1970s attracted young and especially African American filmgoers in the United States. The Hong Kong action movies, however uninterested in realistic character development, appeared vaguely familiar to American audiences because Hong Kong directors incorporated into their films the plots and acrobatic choreography of Gene Kelly's musicals, Westerns (particularly the slow-motion mayhem in Sam Peckinpah's films), thrillers like Steven Spielberg's *Indiana Jones* saga, and police dramas like *Dirty Harry* and *The French Connection.* The visual pyrotechnics of the Hong Kong movies in turn affected American designers of computer games as well as filmmakers

like Quentin Tarantino, who devised his own martial arts epic in 2003 and 2004, *Kill Bill: Volumes 1 and 2*.[18]

The popularity of Hong Kong films in America made it possible for some Asian directors to move back and forth between their home countries and Hollywood. John Woo, born in China but raised in Hong Kong, adapted smoothly to the conventions of American filmmaking, notably with *Mission: Impossible II* in 2000 (the first *Mission: Impossible* film in 1996 had been directed by a certified American auteur from the 1970s and early 1980s, Brian De Palma). Ang Lee, born in Taiwan, not only created a classic Chinese martial arts, swordplay, and mythmaking fantasy, *Crouching Tiger, Hidden Dragon,* but also directed *Brokeback Mountain* in 2005, a tragic modern Western for which he received an Oscar as best director.

For all the accomplishments of Asian directors in Hong Kong, Japan, and increasingly China, India was the only country in the world that had a national film industry comparable to America's. From the 1930s on the center of India's movie business was located in or on the outskirts of Bombay (now Mumbai), a filmmaking complex that came to be known affectionately as "Bollywood" to underline its similarities with Hollywood.

Yet Bollywood often surpassed its American rival. At the beginning of the twenty-first century, Bollywood was producing more than 800 movies a year, compared with the 250 films that Hollywood annually released. And despite the lavish song-and-dance numbers that punctuated nearly every Bollywood movie, Indian films usually cost a few million dollars to make, so they were often more profitable than America's blockbusters.

Like the American film industry, Bollywood was from the outset a commercial venture that flourished without the dependence (as in Europe) on government subsidies. Moreover, Indian producers (again like their counterparts in Hollywood) had the advantage of a large domestic market they could potentially dominate.

But India's society was divided—regionally, ethnically, theologically—as was the pluralistic American audience. So Indian movie executives faced the same cultural problem as the heads of the Hollywood studios: the Indians had to develop the images and story lines, as well as the stars, that would transcend their nation's class, caste, linguistic,

and religious boundaries. Once they were able to make films for the entire Indian population, they could and did overwhelm the lure of foreign movies, including those that came from America. In 2009 Indian filmgoers bought three billion tickets, 95 percent of which were for movies made in India.

The crucial difference, however, between the American and Indian film industries lay in their approach to and command of the export market. Indian movies outside India appealed primarily to those who were part of the Indian Diaspora: native and second-generation Indians living in Britain, South Asia, Africa, the Middle East, and North America. But Bollywood films had a harder time drawing viewers who were not from or had no ties to India. Even though the elements of a Bollywood project frequently duplicated the staples of Hollywood films —action, romance, fantasies, the family—it was more difficult for non-Indian audiences to grasp or empathize with what was going on in an Indian movie.

Bollywood films emphasized visual spectacle, complete with exaggerated acting styles and overblown emotions, rather than conventional narratives with characters whose motivations, as in Hollywood movies, were more easily comprehensible to people in other parts of the world.[19] To understand Indian films, therefore, it helped to know something about India's history, politics, music, culture, and social traditions. In contrast, to appreciate an American movie, a non-American needed to know very little, if anything, about America's political or cultural life, past or present. Hence Hollywood's films were more likely to captivate audiences of all backgrounds, wherever they lived.

Sometimes, though, India itself could seem less like a country than a movie set. In Calcutta, for instance, a traveler from the West was assaulted by all the stereotypes about the wretched subcontinent: swarms of beggars and touts trying to sell you every item in sight, monstrous traffic jams, bureaucratic inefficiency, and political intrigue. Much of this chaos summoned up the opening images of John Huston's 1975 movie adaptation of Rudyard Kipling's *The Man Who Would Be King;* one half-expected to see Sean Connery and Michael Caine sauntering down the teeming street, plotting to conquer the Hindu Kush.

Yet Calcutta also flaunted its opulent five-star hotels, which once may have catered to British sahibs but now hosted conferences of en-

trepreneurs and elite academics from all over the world. The chasm be-
tween modernity and deprivation was equally dramatic in New Delhi
and Mumbai, both of which were more Western-style cities exuding
political and commercial ambition, but with the homeless and impov-
erished just as ubiquitous as in Calcutta.

It was exactly these sights and extreme contradictions that began
to make Indian films (as long as they were in English) more spellbind-
ing to American audiences in the first decade of the twenty-first century.
Movies like *Monsoon Wedding* and *The Namesake* (both directed by
Mira Nair in 2001 and 2006) focused on the tensions in Indian culture
and family life, while *Slumdog Millionaire* (codirected by Danny Boyle
and Loveleen Tandan in 2008) explored—as its title implied—the vast
discrepancy between poverty and wealth in contemporary India. To
mark the growing international popularity of Bollywood's movies,
Slumdog Millionaire became the first Indian film to win an Oscar for
best picture.

Another sign of Bollywood's global power were the budding part-
nerships between Hollywood and the moguls of India's cultural indus-
tries. American companies like Disney were investing in Indian films
and trying to make more movies with Indian stars. On the other hand,
Indian media conglomerates like the Reliance ADA Group were ar-
ranging deals with such Hollywood luminaries as Steven Spielberg,
Tom Hanks, Brad Pitt, and George Clooney to finance American
films.[20] These collaborations suggested that Asia was becoming as im-
portant as Europe as a market and a source of funding for American
movies.

As part of the increasing internationalization of the cinema, Hol-
lywood continued to bring foreign directors to the United States, as it
had throughout the history of the American movie industry. Despite
the growing profitability of foreign movies in their local markets, Hol-
lywood could still offer émigré filmmakers bigger budgets, higher
salaries, more publicity, and greater global exposure for their movies
than they could obtain at home.

So in addition to the Asian filmmakers Ang Lee and John Woo,
Hollywood imported a number of European directors to make movies
in America. Among the most successful of the migrants was Ridley
Scott, from Britain, who directed *Alien* (1979), *Blade Runner* (1982),

Thelma and Louise (1991), *Gladiator* (2000), and *American Gangster* (2007). Other British directors who accommodated themselves to the swifter rhythms of American filmmaking were Adrian Lyne, who directed *Fatal Attraction* in 1987; Sam Mendes, who won a best director Oscar for *American Beauty* in 1999; and Anthony Minghella, a recipient of an Oscar for his direction of *The English Patient* in 1996 (primarily a British film, though it was produced by Miramax) and who went on to direct *The Talented Mr. Ripley* in 1999. Wolfgang Petersen, from Germany, directed a Clint Eastwood movie, *In the Line of Fire*, in 1993. Roland Emmerich, also from Germany, was responsible for the gigantic blockbuster *Independence Day* in 1996. And Paul Verhoeven, who wanted to turn out commercial movies rather than the art films he had been crafting in his native Holland, directed another Hollywood hit, *Basic Instinct*, in 1992.[21]

Perhaps the most transnational of all the Hollywood movies in the early twenty-first century was *Babel* (2006). The film's four stories took place in Morocco, Mexico, Japan, and the United States. Its director, Alejandro González Iñárritu, was the first Mexican filmmaker to be nominated for an Oscar as best director. In addition, the movie starred not only Brad Pitt and the Australian actress Cate Blanchett but also a Mexican and a Japanese actress, Adriana Barraza and Rinko Kikuchi, both of whom were nominated for best supporting Oscars.

Yet none of the new directors or movies from abroad had an artistic impact on American filmmakers comparable to that of the German Expressionists, the Italian neorealists, and the French New Wave. Most of the expatriate directors of the late twentieth century simply adjusted to the mores of American moviemaking rather than providing Hollywood with alternative styles and themes as their predecessors had done from the 1920s until the 1960s.

Moreover, to be seen and make money, a foreign-language or multilingual film still needed to be distributed and publicized, in America and overseas, by a Hollywood studio. Thus *Babel* was released by Paramount. Foreign movies might be attracting more viewers abroad and even in the United States. But the centrality of Hollywood in the international film business had not changed. Neither had the enduring influence of America's own movies around the world.

The Universality of American Films

Hollywood's proceeds from foreign markets increased steadily throughout the twentieth and early twenty-first centuries. In the 1920s, 20 percent of the studios' earnings came from abroad. By the late 1950s, Hollywood relied on the international box office for nearly 50 percent of its profits. In 2006 overseas sales accounted for 63 percent of Hollywood's revenues. Most of this income came from Canada, Britain and other European countries, Mexico, Brazil, Japan, and Taiwan. But even in predominantly Muslim countries like Turkey, Lebanon, and Egypt, American movies remained popular, regardless of suspicions in the Middle East about Washington's foreign policy and close ties with Israel.[22]

Certainly, the economic and technological foundations of globalization had much to do with Hollywood's strength in the late twentieth century. The continuing ascendancy of America's films and its mass culture was linked to the rise of transnational corporations, the vital role of the Internet, and the integration of markets in all parts of the world.[23] The ability of America's media conglomerates to control the production and distribution of their products in the global marketplace was a major factor in the worldwide spread of American entertainment.

But the power of American capitalism was not the only, or the most important, explanation for the global popularity of America's films. Hollywood had always intended its movies for an international audience. The visual dynamism of American films, along with their stars and stories, was supposed to (and usually did) fascinate people of all ages, religions, regions, and ethnic identities.[24]

Moreover, the emergence of English as a global language was essential to the acceptance of American culture. By the beginning of the twenty-first century, English was the native tongue for 320 million people on the planet, and another one billion people spoke English as a second language. English had become the international idiom for science, medicine, air travel and space exploration, sports, commerce, diplomacy, and the Internet.

English was not necessarily understood in the same way by everyone everywhere. Millions of nonnative speakers added their own words and meanings, creating a hybrid language rooted in local needs.

Yet the adaptability of English made it an eminently suitable language for mass communications. Unlike German or Russian, English had a simpler structure and grammar that could be turned into colloquial speech. And its tendency to value shorter, less abstract words and more concise sentences was especially advantageous for the composers of song lyrics, advertising slogans, cartoon captions, newspaper headlines, and movie dialogue.

Whatever its variations, English was a language indispensable to the worldwide diffusion of American movies and popular culture. Conversely, in countries where Hollywood's films and TV shows were subtitled rather than dubbed, and where songs were performed in English on the radio or on the Internet, people became even more familiar with the language and were likelier to use at least a vernacular form of English in their daily lives.[25]

Of course, movies drenched in special effects needed fewer words, whether they were translated or spoken in the original English. Consequently, the Hollywood studios regarded action films as easier to export.[26] Still, movies as diverse as *Titanic* and *Pulp Fiction,* both of which depended on dialogue as much as on the physical exploits of their characters, were equally able to cash in at box offices overseas.

As in the past, Hollywood also recruited stars from abroad who would appeal to viewers in the countries from which the actors came. Modern American movies were populated with actors from Britain (Daniel Day-Lewis, Daniel Craig, Clive Owen, Kate Winslet, Jude Law, Anthony Hopkins), Belgium (Jean-Claude Van Damme), and Spain (Antonio Banderas, Penélope Cruz, Javier Bardem), together with a sizable contingent who were either born or had started their careers in Australia (Mel Gibson, Russell Crowe, Nicole Kidman, Cate Blanchett, Judy Davis).

Wherever the stars in Hollywood movies came from, the films themselves rarely pestered audiences with a social message. Indeed, American movies reflected the larger resistance in American culture to political and ideological sermons. Instead, Hollywood's producers and directors tried to focus on passions that were widely shared across the globe.

It was not that the dramatization of themes like romance, solitude, mystery, tragedy, humor, violence, and redemption existed only in American movies. But Hollywood's treatment of these subjects was

almost always personal, as if the characters in American films lived inside their own psyches rather than in pursuit of some collective endeavor. The most memorable movies of the Depression era (with the exception of John Ford's version of *The Grapes of Wrath*) were comedies and musicals about mismatched people falling in love, not socially conscious films that dealt with the issues of hunger and joblessness. Similarly, the finest movies about World War II (*Casablanca*) or the Vietnam War (*The Deer Hunter*) lingered in the mind long after these conflicts had ended because each film explored the private pain of its characters rather than the cataclysms in which they were embroiled.

The intimate feelings highlighted in Hollywood movies—the concentration on expressions of joy, sadness, personal triumph or defeat —were identical to those that people everywhere struggled with in their own lives. So Europeans, Asians, and Latin Americans flocked to *Titanic* as they once had to *Gone with the Wind* not because these films glorified "American" values but because their tales of love and heartbreak were universal experiences.[27]

To establish this emotional connection with global audiences, Hollywood directors—like many modernist painters, composers, and musicians—recognized that there was no inherent divergence between art and entertainment. From Charlie Chaplin and Orson Welles to Francis Ford Coppola and Clint Eastwood, American filmmakers combined a seriousness of purpose with an urge to enthrall the audience. But they realized that high-minded or well-meaning films could be both pretentious and soporific. So they set out to seize and hold the attention of viewers before their films could inspire the audience to see the world in new ways. Engagement preceded enlightenment.

The American movie industry was undeniably a commercial enterprise. But for the best directors, the urge to make a profit on a film coincided with the yearning to create a work that was original and challenging. For them, the requirements of the market and the desire to entertain both served as stimulants for art. As far as the movies were concerned, the relationship in America between commerce and culture was symbiotic.

As a result of the widespread use of English, the importation of ideas and talent from overseas, the economic roots of American moviemaking, and the universality of Hollywood's themes, America's films

did not seem all that foreign to foreigners. On the contrary, the conventions and formulas of American movies were deeply entrenched in the consciousness of people who lived outside the United States.

So, too, were the indelible memories of Chaplin's tramp, Orson Welles on Charles Foster Kane's deathbed muttering "rosebud," a whiskey-soaked Humphrey Bogart in a white dinner jacket ordering Sam to play it for him as he'd played it for her, John Wayne as the mythic if ambiguous Westerner, Fred Astaire on a dance floor, Marlon Brando in the back of the taxicab, Robert De Niro in front of the mirror, Faye Dunaway posing for a photo in a beret, Robert Redford and Dustin Hoffman pecking at their typewriters as they bring down a president, Kate Winslet and Leonardo DiCaprio spreading their arms on the prow of a doomed ocean liner. These images had passed into the American and global bloodstream; they had become—just like Picasso's paintings, Mies van der Rohe's skyscrapers, Stravinsky's ballets, Gershwin's songs, and Charlie Parker's saxophone solos—part of everyone's common culture in the modern, and modernist, world.

EPILOGUE

The Modernism of American Culture

■

The diversity of America has mirrored the diversity of the world. Just as the United States is divided by region, class, religion, gender, and race, so the foreign recipients of American culture are equally heterogeneous. These disparities could have made it impossible for America's artists, composers, musicians, and filmmakers to find a substantial or cohesive audience for their works either in the United States or abroad. Yet unexpectedly, the modernist esthetic helped the Americans create a culture that charmed people no matter what their ethnic roots or where they happened to live.

One important way that the American media succeeded in transcending internal social divisions and national borders was by mixing up cultural styles. American musicians and composers followed the example of modernist artists like Picasso, Duchamp, and Stravinsky by intermingling elements from high and low culture, combining the sacred and the profane. Aaron Copland, George Gershwin, and Leonard Bernstein incorporated folk melodies, religious hymns, blues and gospel songs, and jazz into their symphonies, concertos, operas, and ballets. Similarly, Walt Disney drew on European folk tales as well as on classical music in his cartoons (especially *Fantasia*), giving his films a multinational veneer. Even an art as quintessentially American as jazz evolved during the twentieth century into a cosmopolitan amal-

gam of African, Caribbean, South American, and modernist European music.

Meanwhile, American advertising agencies and fashion designers employed the outlandish juxtapositions of the Surrealists and the Dadaists in order to make their products more beguiling. At the same time, Hollywood directors enlisted the techniques and the vision of the European modernists—particularly the disjointed time frames and perspectives of the Cubists, Surrealists, and German Expressionists—to produce a popular culture that conquered the world.

This willingness to ignore cultural boundaries was at the core of modernism. And it was precisely the blending of highbrow and popular styles that enhanced the appeal of America's culture for multiethnic domestic and foreign audiences by capturing their varied experiences and tastes.

Nevertheless, many people overseas regarded the worldwide spread of American culture as a threat to their languages, values, and national traditions. The sense that a country's cultural heritage was imperiled by the "invasion" of American architecture, movies, and music gave rise throughout the twentieth century to protectionist policies—the use of subsidies and quotas restricting American imports—on the part of governments in Europe as well as in Canada, Brazil, and Australia. These efforts, however, were increasingly futile toward the end of the century as the new forms of global communication—cable, satellites, DVDs, computers, e-mail, the Internet—overrode the desire of any politician or group of intellectuals to safeguard their nation's cultural identity.

Yet audiences were never passive in their response to an American movie, a television show, or a popular song. America's mass culture did not convert people into a collection of zombies, incapable of having any thoughts or feelings of their own. Nor were they mere receptacles, mindlessly ingesting and internalizing the information and images conveyed by the American media, coerced by advertisers into buying worthless products or watching movies that gave them only fleeting pleasure but no real satisfaction or insight.

On the contrary, audiences both in the United States and abroad have been active collaborators in determining the effects of America's mass culture, constantly reinterpreting its messages to fit their own so-

cial or personal circumstances. Residents of the modern world, accustomed to the endless chatter on the airwaves, they are selective in their reactions to the political or cultural signals embedded in movies or music. Moreover, people are affected not just by the media but by their genes, their childhoods, their parents, their spouses and friends, their encounters at work, and their problems at home. These assorted influences enable people overseas to adapt American culture to their own needs.

In addition, the themes and stories disseminated by the American media are frequently contradictory and ambiguous. There is no unified and distinctively "American" set of values promoted by Hollywood or the creators of Broadway musicals, by museum directors or the publishers of best-selling novels. Indeed, given the volatility of the entertainment market and the shifting preferences of the global audience, America's cultural producers have prospered by being eclectic, offering a multiplicity of symbols and viewpoints that have different meanings for different groups at different times in different countries.

As a result, the impact of American culture on foreign audiences has been more restrained than writers and policy makers abroad were willing to admit. Listening to *Rhapsody in Blue,* going to see *Oklahoma!* or *Gone with the Wind,* or working in a New York–style skyscraper did not mean that one had become "Americanized." The presence and popularity of America's products and culture overseas made them highly tempting items on the shelves of the global supermarket. But they were not so much instruments of seduction as ingredients in a hybrid culture, part American and part foreign. And they would remain attractive as long as they could be integrated with the social and cultural folkways that existed in every country across the Atlantic or Pacific or south of the border.[1]

Donald Duck, for instance, was one of the most famous of American icons, courtesy of Walt Disney's cartoons and comic books. But in Germany, where he was immensely admired, the duck was more a philosopher than a curmudgeon. He was politically and grammatically correct, speaking in a lucid voice instead of an unintelligible quack, quoting Schiller and Goethe rather than snorting at Mickey Mouse.

Similarly, in Indonesia, reality TV programs supplanted soap operas from Latin America, Japan, and Hong Kong. Yet many of these re-

ality shows originated in Britain or the Netherlands. Only later did they become identified with America. So the Indonesians took what was initially a European genre, already modified to suit an American audience, and then altered it further to fit the requirements of Indonesian culture and social life.[2]

As the reality shows in Indonesia demonstrated, the suppleness and resilience of local and regional cultures, notably in Asia, tempered to some extent the global reach of the American media. By the beginning of the twenty-first century, the world's cultural capitals were located not only in New York and Hollywood but also in Tokyo and Mumbai. These cities became major participants with America's metropolises in the contest for global influence and profits.

In the case of Japan, people in Tokyo had grown up since the 1960s with the music of John Coltrane and the Pop Art of Andy Warhol, as well as with the older but even more legendary European paintings of van Gogh and Picasso. Yet in the late twentieth century, the Japanese were transmitting their own audiovisual technology and popular culture to other countries in Asia and around the world. The export of Japanese consumer goods—television sets, DVD players, computer games, digital cameras, karaoke machines, fashion, and food—made Japan a leading purveyor of modern mass culture second only to the United States. Which was why the video arcades of Tokyo and the glittering signs publicizing the latest Japanese cultural commodities besiege the American visitors in *Lost in Translation* whenever they leave their hotel.

Perhaps the most significant of Japan's exports was anime. The designers of Japanese cartoons, comic books, and animated films owed a large debt to Walt Disney. In order to make their own animations as globally attractive as Disney's creations, Japanese artists and cartoonists often made their characters look and act like Americans and Europeans. Along with Hollywood producers, the Japanese understood the necessity of conforming to, or at least manipulating, the models and story lines that prevailed in other countries and cultures. Thus by 2004 anime had grown into a $19 billion industry in Japan, and one that had become a key component of both Japanese and international culture.[3]

But no one anywhere believed the purchase of a Japanese elec-

tronic product or the viewing of a Japanese animated movie meant that people in other countries were imbibing Japanese values. There was little fear that the world was becoming "Japanized." Rather, globalization has led not to cultural uniformity but to multiple forms of art and entertainment. Voices, images, and ideas can spring up anywhere and be circulated all over the planet.

Fast food provides just one illustration of this cultural pluralism. Crowds, particularly of young people, continue to flock to McDonald's—whether in the United States or in Moscow, Paris, and Beijing. Yet every country has its own version of fast food. There are wurst stands in Germany and Austria, fish and chips shops in Britain, noodle restaurants in Seoul and Singapore, and kabob outlets on innumerable downtown street corners (including in America), all of which compete effectively with the Big Mac.

The variety of cuisines and cultural products has resulted in more choices for consumers and audiences. And though we might now be connected to the world through the Internet, we sign on at our own time, according to our own inclinations. Most middle-class people in the West and in Asia live today in a universe full of cultural options; they constantly decide what to accept and what to ignore. America can no longer claim, as it did in the second half of the twentieth century, to be the sole creator of modern culture. American media conglomerates therefore have to contend with their counterparts abroad in shaping the cravings and aspirations of global consumers.

Yet for all the world's cultural diversity, people still worry about the Americanization of their countries. America remains the cultural elephant in everyone's living room. Part of this suspicion is historic; it reflects the hostility vocalized by foreign intellectuals since the early twentieth century that America is culturally intrusive, subverting the music and literature of other nations. But the dread of Americanization has also been an implicit tribute to America's success in adopting and transforming the art and ideas it received from overseas, before sending these back in forms that were more mesmerizing for the masses.

Foreigners certainly appropriated elements of America's culture, intertwining these with their own national mores and attitudes. Yet for their part, Americans revised the painting, architecture, and music es-

pecially of modernism to construct a civilization that was unique but hardly unfamiliar to people abroad. American artists and filmmakers were always receptive to the benefits of cross-fertilization, engaging in a reciprocal exchange of ideas that has made America's cultural relationships with the world less "imperialistic" and more codependent.

There are, however, aspects of America's social and cultural life that have given the United States an advantage over its foreign rivals. America may no longer dominate the export of computer and media technology, but it is still the principal provider of cultural content to the world. And while the United States eventually became the home of modernism, it was also for most of its history the land of modernity. No country has cherished novelty as much as America—the nation of immigrants and pragmatists who have worshiped the radiant future far more than the messy past. Thus Americans have continually followed Ezra Pound's exhortation to "make it new." In painting, architecture, jazz, and the movies, Americans have been making it new throughout the twentieth century and into the twenty-first.

American culture has often been witless and crude, as its critics at home and abroad have regularly complained. But at their best, Americans have converted what they inherited from others into a culture that audiences everywhere could comprehend and embrace—a culture that is, much of the time, both emotionally and artistically compelling for millions of people all over the globe.

So the danger of Americanization is mostly a fantasy. America's culture has not turned the world into a replica of the United States. Instead, its reliance on foreign cultures has made America a replica of the world.

NOTES

1
Modernism in Europe and America

1. The population figures can be found in Alan Bullock, "The Double Image," in *Modernism, 1890–1930,* ed. Malcolm Bradbury and James Mc-Farlane (New York: Penguin, 1976), 59; and Patricia McDonnell, "American Early Modern Artists, Vaudeville, and Film," in *On the Edge of Your Seat: Popular Theater and Film in Early Twentieth-Century American Art,* ed. Patricia McDonnell (New Haven: Yale University Press, 2002), 9.
2. Patrick McGilligan, *Fritz Lang: The Nature of the Beast* (London: Faber and Faber, 1997), 6.
3. Bullock, "The Double Image," 63; Calvin Tomkins, *Duchamp: A Biography* (New York: Holt, 1996), 94; Martin Green, *New York 1913: The Armory Show and the Paterson Strike Pageant* (New York: Scribner's, 1988), 244.
4. For a more extended description of Parisian culture at the turn of the twentieth century, see Peter Watson, *The Modern Mind: An Intellectual History of the 20th Century* (New York: HarperCollins, 2001), 23–24; and William Everdell, *The First Moderns: Profiles in The Origins of Twentieth-Century Thought* (Chicago: University of Chicago Press, 1998, © 1997), 142–143. Hereafter, a publication date given in this fashion means that the page references are from the 1998 edition of a work copyrighted in 1997.
5. Robert Muccigrosso, *Celebrating the New World: Chicago's Columbian Exposition of 1893* (Chicago: Ivan Dee, 1993), 65; R. Roger Remington, *American Modernism: Graphic Design, 1920 to 1960* (New Haven: Yale University Press, 2003), 8, 17; Peter Conrad, *Modern Times, Modern Places: How Life and Art Were Transformed in a Century of Revolution, Innovation and Radical Change* (New York: Knopf, 1999), 281.

6. On Berlin in the 1920s, see Watson, *The Modern Mind,* 221, 229; Maurice Zolotow, *Billy Wilder in Hollywood* (New York: Putnam, 1977), 31; Frederic Grunfeld, *Prophets without Honour: Freud, Kafka, Einstein, and Their World* (New York: Kodansha America, 1996, © 1979), 27; and Anthony Heilbut, *Exiled in Paradise: German Refugee Artists and Intellectuals in America from the 1930s to the Present* (Berkeley: University of California Press, 1997, © 1983), 2–4, 13–14.

7. On Chicago as a cultural competitor with New York, see Christine Stansell, *American Moderns: Bohemian New York and the Creation of a New Century* (New York: Metropolitan, 2001, © 2000), 50–51.

8. For a more detailed discussion of the urban use of electricity in Europe and America, see Wanda Corn, *The Great American Thing: Modern Art and National Identity, 1915–1935* (Berkeley: University of California Press, 1999), 158; and William Leach, *Land of Desire: Merchants, Power, and the Rise of a New American Culture* (New York: Pantheon, 1993), 342–343.

9. On the American use of lighting, in Times Square and elsewhere, see Leach, *Land of Desire,* 50; William Leach, "Introductory Essay," in *Inventing Times Square: Commerce and Culture at the Crossroads of the World,* ed. William Taylor (New York: Russell Sage, 1991), 235, 237–238; and Roland Marchand, *Advertising the American Dream: Making Way for Modernity, 1920–1940* (Berkeley: University of California Press, 1986, © 1985), 280–281.

10. Ann Douglas, *Terrible Honesty: Mongrel Manhattan in the 1920s* (New York: Noonday, 1996, © 1995), 304; Eric Homberger, "Chicago and New York: Two Versions of American Modernism," in Bradbury and McFarlane, *Modernism, 1890–1930,* 155; Charles Hamm, *Music in the New World* (New York: Norton, 1983), 340.

11. On the cultural relationship between African Americans and whites, see Nathan Huggins, *Harlem Renaissance* (New York: Oxford University Press, 1973, © 1971), 14, 18, 118, 128–129, 306–307.

12. For a fuller description of Greenwich Village's importance for the prewar New York intellectuals, see Stansell, *American Moderns,* 13, 40, 43, 160; and Douglas, *Terrible Honesty,* 180.

13. On the origins and early style of the *New Yorker,* see Watson, *The Modern Mind,* 218; and Neil Harris, "Covering New York: Journalism and Civic Identity in the Twentieth Century," in *Budapest and New York: Studies in Metropolitan Transformation, 1870–1930,* ed. Thomas Bender and Carl Schorske (New York: Russell Sage, 1994), 260.

14. Harris, "Covering New York," 259; Douglas, *Terrible Honesty,* 70.

15. On the complaints of James and Eliot about what American society lacked, see Huggins, *Harlem Renaissance,* 234–235.

16. For the European migration to America in the early twentieth century, see

Corn, *The Great American Thing*, xvi–xviii, 53–55, 91; Mardges Bacon, *Le Corbusier in America: Travels in the Land of the Timid* (Cambridge: MIT Press, 2001), xiv; Carol Oja, "George Antheil's *Ballet Mécanique* and Transatlantic Modernism," in *A Modern Mosaic: Art and Modernism in the United States*, ed. Townsend Ludington (Chapel Hill: University of North Carolina Press, 2000), 175; and Steven Watson, *Prepare for Saints: Gertrude Stein, Virgil Thomson, and the Mainstreaming of American Modernism* (New York: Random House, 1998), 58.

17. Douglas, *Terrible Honesty*, 190; Kristin Ross, *Fast Cars, Clean Bodies: Decolonization and the Reordering of French Culture* (Cambridge: MIT Press, 1995), 33.

18. On Ford's economies of scale and his impact together with other American inventors on Europe, see Douglas, *Terrible Honesty*, 187; Jeffrey Jackson, *Making Jazz French: Music and Modern Life in Interwar Paris* (Durham, N.C.: Duke University Press, 2003), 75–76; and Corn, *The Great American Thing*, 56.

19. Douglas, *Terrible Honesty*, 182–183; Jackson, *Making Jazz French*, 75.

20. For more extended analyses of the European attraction to American popular culture, see Corn, *The Great American Thing*, 57; Douglas, *Terrible Honesty*, 346; Malcolm Bradbury, "The Nonhomemade World: European and American Modernism," in *Modernist Culture in America*, ed. Daniel Singal (Belmont, Calif.: Wadsworth, 1991, © 1987), 32; and Bernard Gendron, *Between Montmartre and the Mudd Club: Popular Music and the Avant-Garde* (Chicago: University of Chicago Press, 2002), 13.

21. Daniel Singal, "Towards a Definition of American Modernism," in Singal, *Modernist Culture in America*, 4–5.

22. On developments in physics in the early twentieth century, see Conrad, *Modern Times, Modern Places*, 71; Bullock, "The Double Image," 66; Jackson Lears, *Something for Nothing: Luck in America* (New York: Viking, 2003), 280, 287; Watson, *The Modern Mind*, 23, 90, 93–95, 134, 256–258, 261; David Shi, *Facing Facts: Realism in American Thought and Culture, 1850–1920* (New York: Oxford University Press, 1995), 275–276; and Tomkins, *Duchamp*, 59.

23. For the connections between science and modernist art, see Singal, "Towards a Definition of Modernism," 12–13; Robert Crunden, *American Salons: Encounters with European Modernism, 1885–1917* (New York: Oxford University Press, 1993), xii; Todd Gitlin, "Postmodernism: Roots and Politics," in *Cultural Politics in Contemporary America*, ed. Ian Angus and Sut Jhally (New York: Routledge, 1989), 349; McDonnell, "American Early Modern Artists, Vaudeville, and Film," 28; and Lears, *Something for Nothing*, 279.

24. On the American use of Freud, particularly by Edward Bernays, see Douglas, *Terrible Honesty*, 24, 47, 122, 129.

25. For the avant-garde's hostility to the middle class, see Green, *New York 1913*, 37–38; Tomkins, *Duchamp*, 69; and Homberger, "Chicago and New York," 158.

26. On the modernist belief that stylistic innovations could alter people's consciousness, see George Roeder, "What Have Modernists Looked At? Experiential Roots of Twentieth-Century American Painting," in Singal, *Modernist Culture in America*, 97; Barbara Tischler, *An American Music: The Search for an American Musical Identity* (New York: Oxford University Press, 1986), 7; and Stuart Hobbs, *The End of the American Avant Garde* (New York: New York University Press, 1997), 8, 11. I have described the effect of these ideas on American poets and novelists in the 1920s in *Radical Visions and American Dreams: Culture and Social Thought in the Depression Years* (New York: Harper and Row, 1973), 33–38.

27. Douglas, *Terrible Honesty*, 71, 121.

28. Everdell, *The First Moderns*, 323–324; Russell Lynes, *The Lively Audience: A Social History of the Visual and Performing Arts in America, 1890–1950* (New York: Harper and Row, 1985), 271.

29. The various casualty figures in World War I can be found in Watson, *The Modern Mind*, 146; Douglas, *Terrible Honesty*, 182; and Conrad, *Modern Times, Modern Places*, 205.

30. Ernest Hemingway, *A Farewell to Arms* (New York: Scribner's, 1957, © 1929), 184–185.

31. Robert Crunden, *Body and Soul: The Making of American Modernism* (New York: Basic, 2000), 290–291.

32. Ernest Hemingway, *The Sun Also Rises* (New York: Scribner's 1954, © 1926), 148.

33. Ibid., 247.

34. I have analyzed more extensively the impact of American novelists on writers in Italy and France in *Not Like Us: How Europeans Have Loved, Hated, and Transformed American Culture since World War II* (New York: Basic, 1997), 244–252.

35. See Tyler Cowen, *In Praise of Commercial Culture* (Cambridge: Harvard University Press, 2000, © 1998), 2–3, 18–19, 60, 89, 108–109.

36. The use of high culture in America to instruct the masses is one of the main themes of Lawrence Levine's *Highbrow/Lowbrow: The Emergence of Cultural Hierarchy in America* (Cambridge: Harvard University Press, 1990, © 1988). See especially 177, 200, 206–207.

37. Ibid., 231; Sumiko Higashi, *Cecil B. DeMille and American Culture: The Silent Era* (Berkeley: University of California Press, 1994), 9; Todd Gitlin, *Media Unlimited: How the Torrent of Images and Sounds Overwhelms Our Lives* (New York: Metropolitan, 2001), 66; James Collier, *Jazz: The American Theme Song* (New York: Oxford University Press, 1993), 148–149.

38. Levine, *Highbrow/Lowbrow*, 232; Collier, *Jazz*, 131. I have discussed at greater length the European and American intelligentsia's critique of mass culture from the 1930s though the 1950s in *The Liberal Mind in a Conservative Age: American Intellectuals in the 1940s and 1950s* (New York: Harper and Row, 1985), 216–232.

39. Gendron, *Between Montmartre and the Mudd Club*, 16, 107.

2
Painting Modernity

1. Alan Bullock, "The Double Image," in *Modernism, 1890–1930*, ed. Malcolm Bradbury and James McFarlane (New York: Penguin, 1976), 58; Peter Conrad, *Modern Times, Modern Places: How Life and Art Were Transformed in a Century of Revolution, Innovation, and Radical Change* (New York: Knopf, 1999), 160; Richard Bulliet, "High Culture," in *The Columbia History of the 20th Century*, ed. Richard Bulliet (New York: Columbia University Press, 1998), 8.

2. On the style and intentions and Cubism, see Calvin Tomkins, *Duchamp: A Biography* (New York: Holt, 1996), 49, 66.

3. Ibid., 79; Bulliet, "High Culture," 16.

4. Tomkins, *Duchamp*, 65.

5. For the vaudevillian proclivities of Dada, see Bernard Gendron, *Between Montmartre and the Mudd Club: Popular Music and the Avant-Garde* (Chicago: University of Chicago Press, 2002), 78; and Tomkins, *Duchamp*, 234.

6. Peter Watson, *The Modern Mind: An Intellectual History of the 20th Century* (New York: HarperCollins, 2001), 202–203; George Roeder, *Forum of Uncertainty: Confrontations with Modern Painting in Twentieth-Century American Thought* (Ann Arbor: UMI Research Press, 1980), 151; Martha Bayles, *Hole in Our Soul: The Loss of Beauty and Meaning in American Popular Music* (Chicago: University of Chicago Press, 1996, © 1994), 42; Conrad, *Modern Times, Modern Places*, 21.

7. On the Surrealists' tastes in filmmakers, see Murray Smith, "Modernism and the Avant-Gardes," in *World Cinema: Critical Approaches*, ed. John Hill and Pamela Gibson (Oxford: Oxford University Press, 2000), 16.

8. Martin Green, *New York 1913: The Armory Show and the Paterson Strike Pageant* (New York: Scribner's, 1988), 132–134.

9. For the collections of nineteenth-century American industrialists and financiers, and the styles of the museums they funded, see Steven Watson, *Prepare for Saints: Gertrude Stein, Virgil Thomson, and the Mainstreaming of American Modernism* (New York: Random House, 1998), 83–84; and Alan Wallach, "Class Rites in the Age of the Blockbuster," in *High-Pop: Making Culture into Popular Entertainment*, ed. Jim Collins (Malden, Mass.: Blackwell, 2002), 123–124.

10. Roeder, *Forum of Uncertainty*, 31; Robert Muccigrosso, *Celebrating the New World: Chicago's Columbian Exposition of 1893* (Chicago: Ivan Dee, 1993), 105.

11. On Stein's Parisian salon, see William Scott and Peter Rutkoff, *New York Modern: The Arts and the City* (Baltimore: Johns Hopkins University Press, 1999), 52–53.

12. For a fuller description of Stieglitz's early career and ideas, see Martin Green, "The New Art," in *1915, the Cultural Moment: The New Politics, the New Woman, the New Psychology, the New Art, and the New Theatre in America,* ed. Adele Heller and Lois Rudnick (New Brunswick, N.J.: Rutgers University Press, 1991), 162; Edward Abrahams, "Alfred Stieglitz's Faith and Vision," ibid., 190; Russell Lynes, *The Lively Audience: A Social History of the Visual and Performing Arts in America, 1890–1950* (New York: Harper and Row, 1985), 226–227; David Shi, *Facing Facts: Realism in American Thought and Culture, 1850–1920* (New York: Oxford University Press, 1995), 287; Roeder, *Forum of Uncertainty,* 28; Scott and Rutkoff, *New York Modern,* 57; Tompkins, *Duchamp,* 167; and Barbara Haskell, *The American Century: Art and Culture, 1900–1950* (New York: Norton, 1999), 95.

13. On the planners of and works shown at the Armory Show, see Tomkins, *Duchamp,* 114; Shi, *Facing Facts,* 289; George Roeder, "What Have Modernists Looked At? Experiential Roots of Twentieth-Century American Painting," in *Modernist Culture in America,* ed. Daniel Singal (Belmont, Calif.: Wadsworth, 1991, © 1987), 73; Roeder, *Forum of Uncertainty,* 8; and Milton Brown, "The Armory Show and Its Aftermath," in Heller and Rudnick, *1915, the Cultural Moment,* 168.

14. Green, "The New Art," 159; Lynes, *The Lively Audience,* 89; Annie Cohen-Solal, *Painting American: The Rise of American Artists, Paris 1867–New York 1948,* trans. Laurie Hurwitz-Attias (New York: Knopf, 2001), 231.

15. Roeder, *Forum of Uncertainty,* 9.

16. For a more detailed discussion of the role of Duchamp, the Arensbergs, and Dreier, see Wanda Corn, *The Great American Thing: Modern Art and National Identity, 1915–1935* (Berkeley: University of California Press, 1999), 50, 52; Green, *New York 1913,* 264; Tomkins, *Duchamp,* 166, 226; Lynes, *The Lively Audience,* 374; and Carol Oja, *Making Music Modern: New York in the 1920s* (New York: Oxford University Press, 2000), 184.

17. Wanda Corn, "The Artist's New York: 1900–1930," in *Budapest and New York: Studies in Metropolitan Transformation, 1870–1930,* ed. Thomas Bender and Carl Schorske (New York: Russell Sage, 1994), 276; Green, *New York 1913,* 226.

18. On Stella, see Pellegrino D'Acierno, "From Stella to Stella: Italian Amer-

ican Visual Culture and Its Contribution to the Arts in America," in *The Italian American Heritage: A Companion to Literature and Arts,* ed. Pellegrino D'Acierno (New York: Garland, 1999), 511; and Corn, *The Great American Thing,* 137, 143, 179.

19. Roeder, *Forum of Uncertainty,* 71, 135.

20. For more information about the founders of the Museum of Modern Art, see Watson, *Prepare for Saints,* 140; and Scott and Rutkoff, *New York Modern,* 168.

21. Watson, *Prepare for Saints,* 95; Cohen-Solal, *Painting American,* 270.

22. On MoMA's exhibitions in the 1930s, see Alice Marquis, *Alfred H. Barr, Jr.: Missionary for the Modern* (Chicago: Contemporary, 1989), 69, 153; and Alice Marquis, *Hopes and Ashes: The Birth of Modern Times, 1929–1939* (New York: Free Press, 1986), 173.

23. Roeder, *Forum of Uncertainty,* 154.

24. For the role of Barry in building MoMA's film library, see Marquis, *Alfred H. Barr, Jr.,* 129.

25. I analyzed the conflicting inclinations in the culture of the 1930s in *Radical Visions and American Dreams: Culture and Social Thought in the Depression Years* (New York: Harper and Row, 1973).

26. On the Mexican muralists and Rivera's painting at Rockefeller Center, see Pam Meecham, "Realism and Modernism," in *Varieties of Modernism,* ed. Paul Wood (New Haven: Yale University Press, 2004), 91; and Marquis, *Hopes and Ashes,* 161.

27. Scott and Rutkoff, *New York Modern,* 292.

28. For the attitudes and popularity of the Regionalists, see David Noble, *Death of a Nation: American Culture and the End of Exceptionalism* (Minneapolis: University of Minnesota Press, 2002), 158, 161; and Corn, *The Great American Thing,* 288–289, 340.

29. Erika Doss, *Benton, Pollock, and the Politics of Modernism: From Regionalism to Abstract Expressionism* (Chicago: University of Chicago Press, 1991), 229, 232–233; Michele Bogart, *Artists, Advertising, and the Borders of Art* (Chicago: University of Chicago Press, 1995), 271.

30. The isolation of Hopper's characters is noted in Scott and Rutkoff, *New York Modern,* 126–127; Robert Silberman, "Edward Hopper and the Theater of the Mind: Vision, Spectacle, and the Spectator," in *On the Edge of Your Seat: Popular Theater and Film in Early Twentieth-Century American Art,* ed. Patricia McDonnell (New Haven: Yale University Press, 2002), 138, 143; and John McClymer, *The Birth of Modern America, 1929–1939* (Maplecrest, N.Y.: Brandywine, 2005), 143.

31. Watson, *The Modern Mind,* 335–336.

32. Anthony Heilbut, *Exiled in Paradise: German Refugee Artists and Intellectuals in America from the 1930s to the Present* (Berkeley: University of California Press, 1997, © 1983), 24–26.

33. Frederic Grunfeld, *Prophets without Honour: Freud, Kafka, Einstein, and Their World* (New York: Kodansha America, 1996, © 1979), 169–170.

34. Watson, *The Modern Mind*, 300–301.

35. I have described the exodus of European scientists, intellectuals, and artists to the United States at greater length in *Not Like Us: How Europeans Have Loved, Hated, and Transformed American Culture since World War II* (New York: Basic, 1997), 22–31. On Varian Fry's rescue operation, see Grunfeld, *Prophets without Honour*, 276–277.

36. For the participants in the "Artists in Exile" exhibition and its effect on American painters, see Haskell, *The American Century*, 327; Watson, *The Modern Mind*, 510; and Dickran Tashjian, *A Boatload of Madmen: Surrealism and the American Avant-Garde, 1920–1950* (New York: Thames and Hudson, 1995), 8–9.

37. Watson, *The Modern Mind*, 356–357; John Taylor, *Strangers in Paradise: The Hollywood Émigrés, 1933–1950* (New York: Holt, Rinehart and Winston, 1983), 186.

38. Doss, *Benton, Pollock, and the Politics of Modernism*, 367.

39. On the Abstract Expressionists' background in the social art of the 1930s, see Marquis, *Alfred H, Barr, Jr.*, 162; Doss, *Benton, Pollock, and the Politics of Modernism*, 348; and Glen MacLeod, *Wallace Stevens and Modern Art: From the Armory Show to Abstract Expressionism* (New Haven: Yale University Press, 1993), 176.

40. Richard Schickel, *Intimate Strangers: The Culture of Celebrity in America* (Chicago: Ivan Dee, 2000, © 1985), 218; MacLeod, *Wallace Stevens and Modern Art*, 158; Meecham, "Realism and Modernism," 100.

41. For the influence of Hofmann on the Abstract Expressionists, see Marion Deshmukh, "Cultural Migration: Artists and Visual Representation Between Americans and Germans during the 1930s and 1940s," in *Transatlantic Images and Perceptions: Germany and America Since 1766*, ed. David Barclay and Elisabeth Glaser-Schmidt (New York: Cambridge University Press, 1997), 281.

42. On the Abstract Expressionists' attraction to Surrealist ideas, see Roeder, *Forum of Uncertainty*, 190–191; Scott and Rutkoff, *New York Modern*, 297; and Charles Harrison, "Jackson Pollock," in Wood, *Varieties of Modernism*, 135.

43. Pollock's drip painting and his affinity for jazz are described in Lisa Phillips, *The American Century: Art and Culture, 1950–2000* (New York: Norton, 1999), 16; and Brenda Dixon-Gottschild, "Stripping the Emperor: The Africanist Presence in American Concert Dance," in *Ceremonies and Spectacles: Performing American Culture*, ed. Teresa Alves, Teresa Cid, and Heinz Ickstadt (Amsterdam: VU University Press, 2000), 276.

44. Harold Rosenberg, "The American Action Painters," in *The Tradition of the New* (New York: Horizon, 1959), 25–27.

45. On Peggy Guggenheim's collection of modernist art and the role of her Art of This Century gallery, see Tomkins, *Duchamp*, 318; and Scott and Rutkoff, *New York Modern*, 298.

46. Phillips, *The American Century*, 322; Tomkins, *Duchamp*, 361.

47. Stuart Hobbs, *The End of the American Avant Garde* (New York: New York University Press, 1997), 128.

48. Bogart, *Artists, Advertising, and the Borders of Art*, 292; Roeder, *Forum of Uncertainty*, 212.

49. On *Life*'s article about and Hans Namuth's photos of Pollock, see Roeder, *Forum of Uncertainty*, 213; and Meecham, "Realism and Modernism," 106.

50. Hobbs, *The End of the American Avant Garde*, 152.

51. I have written extensively about America's cultural diplomacy in the Cold War and its use of Abstract Expressionist paintings in *Not Like Us*, chapters 2–3. See also Michael Krenn, *Fall-Out Shelters for the Human Spirit: American Art and the Cold War* (Chapel Hill: University of North Carolina Press, 2005), 2, 63–64, 194; Phillips, *The American Century*, 40; and Roeder, *Forum of Uncertainty*, 223.

52. Conrad, *Modern Times, Modern Places*, 128–129.

53. On Duchamp's readymades and his *Mona Lisa*, see Corn, *The Great American Thing*, 69, 71–72, 80; and Tomkins, *Duchamp*, 221.

54. For the Pop Artists' attraction to commercial culture and mass production, see Phillips, *The American Century*, 114; and Christin Mamiya, *Pop Art and Consumer Culture: American Super Market* (Austin: University of Texas Press, 1992), 134.

55. Phillips, *The American Century*, 125, 129; Mamiya, *Pop Art and Consumer Culture*, 9.

56. On the attendance figures for museums in 1954 and the diversions they offered to visitors, see Michael Kammen, *American Culture, American Tastes: Social Change and the 20th Century* (New York: Basic, 2000, © 1999), 117; and Wallach, "Class Rites in the Age of the Blockbuster," 120.

57. For examples of these criticisms, see Fredric Jameson, "Postmodernism and Consumer Society," in *Movies and Mass Culture*, ed. John Belton (New Brunswick, N.J.: Rutgers University Press, 2000, © 1996), 201; and Hobbs, *The End of the American Avant Garde*, 137.

3
The Globalization of American Architecture

1. Ann Douglas, *Terrible Honesty: Mongrel Manhattan in the 1920s* (New York: Noonday, 1996, © 1995), 448; Lucy Fischer, *Designing Women: Cinema, Art Deco, and the Female Form* (New York: Columbia University Press, 2003), 16.

2. For a fuller description of the buildings and offices at Rockefeller Center, see Lewis Erenberg, *Swingin' the Dream: Big Band Jazz and the Rebirth of American Culture* (Chicago: University of Chicago Press, 1998), 163.

3. Daniel Singal, "Towards a Definition of American Modernism," in *Modernist Culture in America,* ed. Daniel Singal (Belmont, Calif.: Wadsworth, 1991, © 1987), 16.

4. For more on the influence of Japanese art and architecture on Wright, see Peter Blake, *The Master Builders: Le Corbusier/Mies van der Rohe/Frank Lloyd Wright* (New York: Norton, 1996, © 1960), 306; Margo Stipe, "Wright and Japan," in *Frank Lloyd Wright: Europe and Beyond,* ed. Anthony Alofsin (Berkeley: University of California Press, 1999), 24, 27; and Carter Wiseman, *Shaping a Nation: Twentieth-Century American Architecture and Its Makers* (New York: Norton, 1998), 81–82.

5. Wiseman, *Shaping a Nation,* 99, 103; David Noble, *Death of a Nation: American Culture and the End of Exceptionalism* (Minneapolis: University of Minnesota Press, 2002), 177.

6. Blake, *The Master Builders,* 392; Glenn Andres, "Urbanization and Architecture," in *Modern American Culture: An Introduction,* ed. Mick Gidley (London: Longman, 1993), 201.

7. Mardges Bacon, *Le Corbusier in America: Travels in the Land of the Timid* (Cambridge: MIT Press, 2001), 114.

8. On the favorable foreign attitudes toward Wright's works, see Wiseman, *Shaping a Nation,* 111; Anthony Alofsin, "Wright, Influence, and the World at Large," Bruno Zevi, "Wright and Italy: A Recollection," Jean-Louis Cohen, "Useful Hostage: Constructing Wright in Soviet Russia and France," and Alberto Sartori, "Wright and South America," in Alofsin, *Frank Lloyd Wright,* 2, 6, 16, 21, 70, 84, 118, 151; and Pat Kirkham, *Charles and Ray Eames: Designers of the Twentieth Century* (Cambridge: MIT Press, 2001, © 1995), 56.

9. Alofsin, "Wright, Influence, and the World at Large," 14.

10. For Le Corbusier's architectural ideas, see J. David Hoeveler, *The Postmodernist Turn: American Thought and Culture in the 1970s* (New York: Twayne, 1996), 87; R. Roger Remington, *American Modernism: Graphic Design, 1920 to 1960* (New Haven: Yale University Press, 2003), 22; and Wiseman, *Shaping a Nation,* 164.

11. Le Corbusier's lecture tour in America is described in greater detail in Bacon, *Le Corbusier in America,* 3, 60, 63, 105, 118, 129; and Blake, *The Master Builders,* 92.

12. On the Bauhaus prescriptions for working-class housing, see Anthony Heilbut, *Exiled in Paradise: German Refugee Artists and Intellectuals in America from the 1930s to the Present* (Berkeley: University of California Press, 1997, © 1983), 12; Hoeveler, *The Postmodernist Turn,* 87; Margret Kentgens-Craig, *The Bauhaus and America: First Contacts,*

1919–1936 (Cambridge: MIT Press, 1999, © 1993), xvi; and Tom Wolfe, *From Bauhaus to Our House* (New York: Farrar, Straus and Giroux, 1981), 23, 32.

13. Kentgens-Craig, *The Bauhaus and America*, 36, 72–74.

14. For the backgrounds of Hitchcock and Johnson and their role (along with Barr) in reinterpreting the Bauhaus for American audiences, see Kentgens-Craig, *The Bauhaus and America*, 39, 50–51; Steven Watson, *Prepare for Saints: Gertrude Stein, Virgil Thomson, and the Mainstreaming of American Modernism* (New York: Random House, 1998), 141, 144; Alice Marquis, *Hopes and Ashes: The Birth of Modern Times, 1929–1939* (New York: Free Press, 1986), 154; Russell Lynes, *The Lively Audience: A Social History of the Visual and Performing Arts in America, 1890–1950* (New York: Harper and Row, 1985), 361; William Scott and Peter Rutkoff, *New York Modern: The Arts and the City* (Baltimore: Johns Hopkins University Press, 1999), 171; and Bacon, *Le Corbusier in America*, 176, 282.

15. On Gropius's views of and migration to America, see Kentgens-Craig, *The Bauhaus and America*, 85, 88; and Wiseman, *Shaping a Nation*, 151.

16. Wolfe, *From Bauhaus to Our House*, 68; Heilbut, *Exiled in Paradise*, 143.

17. For the influence of postwar American architecture on West Germany, see Peter Krieger, "Learning from America: Postwar Urban Recovery in West Germany," in *Transactions, Transgressions, Transformations: American Culture in Western Europe and Japan,* ed. Heide Fehrenbach and Uta Poiger (New York: Berghahn, 2000), 192, 194, 198–199.

18. Botond Bognar, "Surface above All? American Influence on Japanese Urban Space," in Fehrenbach and Poiger, *Transactions, Transgressions, Transformations,* 72–73.

19. Wiseman, *Shaping a Nation*, 220.

20. Ibid, 269.

21. On Venturi's experience in Rome and his attraction to commonplace American buildings, see Hoeveler, *The Postmodernist Turn*, 89; Wiseman, *Shaping a Nation*, 254; and Wolfe, *From Bauhaus to Our House*, 104.

22. Wiseman, *Shaping a Nation*, 358; Hoeveler, *The Postmodernist Turn*, 82.

23. Wiseman, *Shaping a Nation*, 303.

24. On the development of the Parisian arcades, see Richard Woodward, "Making a Pilgrimage to Cathedrals of Commerce," *New York Times,* March 11, 2007.

25. For Gruen's ideas about malls, and the reality of what they became in America, see Malcolm Gladwell, "The Terrazzo Jungle," *New Yorker,* March 15, 2004, pp. 122–127; and James Twitchell, *Lead Us into Temp-*

tation: The Triumph of American Materialism (New York: Columbia University Press, 1999), 259.

26. On some of Walmart's difficulties overseas, see Mark Landler and Michael Barbaro, "No, Not Always: Wal-Mart Discovers That Its Formula Doesn't Fit Every Culture," *New York Times,* August 2, 2006; and Miguel Bustillo, "After Early Errors, Wal-Mart Thinks Locally to Act Globally," *Wall Street Journal,* August 14, 2009.

4
Modernism in the Marketplace

1. For an extended analysis of the European origins of mass consumption, see Peter Stearns, *Consumerism in World History: The Global Transformation of Desire* (New York: Routledge, 2001), 15–17, 19, 29, 31.

2. William Leach, *Land of Desire: Merchants, Power, and the Rise of a New American Culture* (New York: Pantheon, 1993), 74.

3. On the contrast between the department stores' bargain basements and the more elegant amenities for the upper-class customer, see Leach, *Land of Desire,* 72, 78; and Neil Harris, *Cultural Excursions: Marketing Appetites and Cultural Tastes in Modern America* (Chicago: University of Chicago Press, 1990), 64.

4. The use of mirrors and indirect lighting in department stores is described in Leach, *Land of Desire,* 75–76.

5. Ibid., 36; Carol Duncan, "Museums and Department Stores: Close Encounters," in *High-Pop: Making Culture into Popular Entertainment,* ed. Jim Collins (Malden, Mass.: Blackwell, 2002), 142.

6. For a more detailed discussion of the technical innovations in visual imagery and their impact on advertising, see Michele Bogart, *Artists, Advertising, and the Borders of Art* (Chicago: University of Chicago Press, 1995), 6, 22, 75; and Gunther Barth, *City People: The Rise of Modern City Culture in Nineteenth-Century America* (New York: Oxford University Press, 1980), 105.

7. On the work of commercial artists and photographers in the teens and 1920s, see Leach, *Land of Desire,* 52; Roland Marchand, *Advertising the American Dream: Making Way for Modernity, 1920–1940* (Berkeley: University of California Press, 1986, © 1985), 8; Robert Crunden, *Body and Soul: The Making of American Modernism* (New York: Basic, 2000), 142–143; Bogart, *Artists, Advertising, and the Borders of Art,* 179; and Barbara Haskell, *The American Century: Art and Culture, 1900–1950* (New York: Norton, 1999), 177.

8. On Coiner's use of modernist art in his advertisements, see Bogart, *Artists, Advertising, and the Borders of Art,* 137, 157, 160, 162, 167; and Harris, *Cultural Excursions,* 371–372.

9. Marchand, *Advertising the American Dream,* 127–128, 142, 144, 149; Bogart, *Artists, Advertising, and the Borders of Art,* 139.

10. On the use of Surrealism, and especially the work of Dalí, in advertising, see Dickran Tashjian, *A Boatload of Madmen: Surrealism and the American Avant-Garde, 1920–1950* (New York: Thames and Hudson, 1995), 50, 67–68, 82–84; and Alice Marquis, *Alfred H. Barr, Jr.: Missionary for the Modern* (Chicago: Contemporary, 1989), 158.

11. Bogart, *Artists, Advertising, and the Borders of Art,* 151.

12. On the use of Mondrian's geometric abstractions by advertisers, see Peter Gay, *Modernism: The Lure of Heresy* (New York: Norton, 2007), 142; and Thomas Hine, *The Total Package: The Evolution and Secret Meanings of Boxes, Bottles, Cans, Tubes, and Other Persuasive Containers* (Boston: Little, Brown, 1995), 192.

13. Lucy Fischer, *Designing Women: Cinema, Art Deco, and the Female Form* (New York: Columbia University Press, 2003), 16–19; R. Roger Remington, *American Modernism: Graphic Design, 1920 to 1960* (New Haven: Yale University Press, 2003), 79.

14. Stewart Ewen, *All Consuming Images: The Politics of Style in Contemporary Culture* (New York: Basic, 1999, © 1988), 173, 178; Marchand, *Advertising the American Dream,* 182, 184, 196.

15. For the backgrounds and ideas of Bel Geddes, Teague, and Loewy, see Leach, *Land of Desire,* 307; Harris, *Cultural Excursions,* 187; Hine, *The Total Package,* 113; and Arthur Pulos, *The American Design Adventure, 1940–1975* (Cambridge: MIT Press, 1988), 283.

16. On the connection between movies and the fine arts, see Christina Wilson, "Cedric Gibbons: Architect of Hollywood's Golden Age," in *Architecture and Film,* ed. Mark Lamster (New York: Princeton Architectural Press, 2000), 114.

17. For Gibbons's adoption of Art Deco techniques, see Beverly Heisner, *Hollywood Art: Art Direction in the Days of the Great Studios* (Jefferson, N.C.: McFarland, 1990), 77–78.

18. Ibid., 165–166.

19. Fischer, *Designing Women,* 123.

20. On Astaire's Art Deco attire, see Philip Furia, *Irving Berlin: A Life in Song* (New York: Schirmer, 1998), 176.

21. Fischer, *Designing Women,* 86; Heisner, *Hollywood Art,* 40.

22. On the appeal in the 1950s of Scandinavian-style and high-tech furniture and appliances, see Pulos, *The American Design Adventure,* 29, 79, 83, 297; Pat Kirkham, *Charles and Ray Eames: Designers of the Twentieth Century* (Cambridge: MIT Press, 2001, © 1995), 1, 204; and Ewen, *All Consuming Images,* 216.

23. Tom Wolfe, *From Bauhaus to Our House* (New York: Farrar, Straus and Giroux, 1981), 72. For the use of modern art reproductions in homes,

see George Roeder, *Forum of Uncertainty: Confrontations with Modern Painting in Twentieth-Century American Thought* (Ann Arbor: UMI Research Press, 1980), 212; and Erika Doss, *Benton, Pollock, and the Politics of Modernism: From Regionalism to Abstract Expressionism* (Chicago: University of Chicago Press, 1991), 364.

24. Pulos, *The American Design Adventure*, 235, 242–243.
25. I have described USIA's exhibit in Moscow at greater length in *Not Like Us: How Europeans Have Loved, Hated, and Transformed American Culture since World War II* (New York: Basic, 1997), 86.

5
From *The Rite of Spring* to *Appalachian Spring*

1. For examples of this excessively romantic view of early-nineteenth-century musical culture, see David Ewen, *Music Comes to America* (New York: Allen, Towne and Heath, 1947, © 1942), 4; Alex Ross, *The Rest Is Noise: Listening to the Twentieth Century* (New York: Farrar, Straus and Giroux, 2007), 25; and Lawrence Levine, *Highbrow/Lowbrow: The Emergence of Cultural Hierarchy in America* (Cambridge: Harvard University Press, 1990, © 1988), 104.
2. Levine, *Highbrow/Lowbrow*, 146.
3. On Thomas's views, see Richard Crawford, *America's Musical Life: A History* (New York: Norton, 2001), 305, 307, 310; and Joseph Horowitz, *Understanding Toscanini: How He Became an American Culture-God and Helped Create a New Audience for Old Music* (New York: Knopf, 1987), 30.
4. John Dizikes, *Opera in America: A Cultural History* (New Haven: Yale University Press, 1993), 231; William Leach, *Land of Desire: Merchants, Power, and the Rise of a New American Culture* (New York: Pantheon, 1993), 140.
5. Ross, *The Rest Is Noise*, 25; Ewen, *Music Comes to America*, 68.
6. On the Damrosches' role at the Metropolitan Opera and Carnegie Hall, see Ewen, *Music Comes to America*, 39; and Horowitz, *Understanding Toscanini*, 32.
7. Ewen, *Music Comes to America*, 96.
8. For the American reaction to German music during and after World War I, see Ross, *The Rest Is Noise*, 93–94; and Barbara Tischler, *An American Music: The Search for an American Musical Identity* (New York: Oxford University Press, 1986), 73.
9. For more detailed discussions of the tours of Lind, Strauss, Bartók, and Ravel, see Ewen, *Music Comes to America*, 4–5, 90; Carol Oja, *Making Music Modern: New York in the 1920s* (New York: Oxford University Press, 2000), 293; and Edward Jablonski, *Gershwin* (New York: Doubleday, 1987), 154.

10. Alyn Shipton, *A New History of Jazz* (London: Continuum, 2001), 169; Russel Nye, *The Unembarrassed Muse: The Popular Arts in America* (New York: Dial, 1970), 314.

11. Philip Furia, *Irving Berlin: A Life in Song* (New York: Schirmer, 1998), 103; Tyler Cowen, *In Praise of Commercial Culture* (Cambridge: Harvard University Press, 2000, © 1998), 144.

12. Ewen, *Music Comes to America*, 178.

13. Nye, *The Unembarrassed Muse*, 323.

14. For the global dissemination of American popular music through records, versus the prevalence of European music on American classical recordings, see Ross, *The Rest Is Noise*, 78; and William Kenney, *Recorded Music in American Life: The Phonograph and Popular Memory, 1890– 1945* (New York: Oxford University Press, 1999), 74.

15. Kenney, *Recorded Music in American Life*, 69.

16. On Sarnoff's musical aspirations for NBC, see Ross, *The Rest Is Noise*, 263.

17. For the size of the audience of these radio concerts, see Alice Marquis, *Hopes and Ashes: The Birth of Modern Times, 1929–1939* (New York: Free Press, 1986), 56; and Horowitz, *Understanding Toscanini*, 139.

18. Ross, *The Rest Is Noise*, 263.

19. Ewen, *Music Comes to America*, 186; George Douglas, *The Early Days of Broadcasting* (Jefferson, N.C.: McFarland, 1987), 159.

20. For Damrosch's educational ambitions and the works he emphasized on his *Music Appreciation Hour*, see Ewen, *Music Comes to America*, 62, 188; Richard Butsch, *The Making of American Audiences: From Stage to Television, 1750–1990* (New York: Cambridge University Press, 2000), 226; and Horowitz, *Understanding Toscanini*, 202, 204–205.

21. On Toscanini's preferences in music, see Donald Meyer, "Toscanini and the NBC Symphony Orchestra: High, Middle, and Low Culture, 1937– 1954," in *Perspectives on American Music, 1900–1950*, ed. Michael Saffle (New York: Garland, 2000), 310, 314; and Horowitz, *Understanding Toscanini*, 138.

22. For examples of this sort of criticism, see Nye, *The Unembarrassed Muse*, 328; Craig Roell, "The Development of Tin Pan Alley," in *America's Musical Pulse: Popular Music in Twentieth-Century Society*, ed. Kenneth Bindas (Westport, Conn.: Praeger, 1992), 117; and Russell Lynes, *The Lively Audience: A Social History of the Visual and Performing Arts in America, 1890–1950* (New York: Harper and Row, 1985), 31, 39.

23. On music and nationalism in Europe, see Crawford, *America's Musical Life*, 377; John Struble, *The History of American Classical Music: MacDowell through Minimalism* (New York: Facts on File, 1995), xviii; and Charles Hamm, *Music in the New World* (New York, Norton: 1983), 413.

24. For a more extended analysis of nineteenth-century American music, and especially the works of Gottschalk and Gilbert, see Tischler, *An Ameri-*

can Music, 5, 182; Struble, *The History of American Classical Music,* 9; Jack Sullivan, *New World Symphonies: How American Culture Changed European Music* (New Haven: Yale University Press, 1999), 198; and Barbara Zuck, *A History of Musical Americanism* (Ann Arbor: UMI Research Press, 1980), 75.

25. William Scott and Peter Rutkoff, *New York Modern: The Arts and the City* (Baltimore: Johns Hopkins University Press, 1999), 38–39; David Noble, *Death of a Nation: American Culture and the End of Exceptionalism* (Minneapolis: University of Minnesota Press, 2002), 188–189; Ross, *The Rest Is Noise,* 131–132.

26. On Dvořák's musical experiences in America, see Sullivan, *New World Symphonies,* 13, 131; Zuck, *A History of Musical Americanism,* 57–59; Hamm, *Music in the New World,* 411; and Struble, *The History of American Classical Music,* 68.

27. Alan Levy, *Musical Nationalism: American Composers' Search for Identity* (Westport, Conn.: Greenwood, 1983), 33; Crawford, *America's Musical Life,* 568.

28. Ross, *The Rest Is Noise,* 148; Peter Watson, *The Modern Mind: An Intellectual History of the 20th Century* (New York: HarperCollins, 2001), 230.

29. For more detailed discussions of the first performance of *The Rite of Spring* and the structure of its music, see Ross, *The Rest Is Noise,* 75; Calvin Tomkins, *Duchamp: A Biography* (New York: Holt, 1996), 120; Levy, *Musical Nationalism,* 34; William Everdell, *The First Moderns: Profiles in the Origins of Twentieth-Century Thought* (Chicago: University of Chicago Press, 1998, © 1997), 331, 333; and Peter Gay, *Modernism: The Lure of Heresy* (New York: Norton, 2007), 259.

30. The performance of Stravinsky's music in and his trip to America in 1925 are described in Oja, *Making Music Modern,* 48, 286; and Charles Joseph, *Stravinsky Inside Out* (New Haven: Yale University Press, 2001), 37.

31. Scott and Rutkoff, *New York Modern,* 229.

32. Virgil Thomson, *Virgil Thomson/By Virgil Thomson* (New York: Da Capo, 1977, © 1966), 75; Joan Peyser, *The Memory of All That: The Life of George Gershwin* (New York: Simon and Schuster, 1993), 97.

33. Levy, *Musical Nationalism,* 59; Peyser, *The Memory of All That,* 100; Howard Pollack, *Aaron Copland: The Life and Work of an Uncommon Man* (Urbana: University of Illinois Press, 2000, © 1999), 48, 65.

34. Pollack, *Aaron Copland,* 114.

35. Zuck, *A History of Musical Americanism,* 248; Pollack, *Aaron Copland,* 122, 134.

36. Thomson, *Virgil Thomson/By Virgil Thomson,* 117, 279.

37. Horowitz, *Understanding Toscanini,* 200; Ross, *The Rest Is Noise,* 278.

38. For the fusion of American and modernist music in the 1930s, see Tischler, *An American Music,* 119; and Scott and Rutkoff, *New York Modern,* 227.

39. Hamm, *Music in the New World,* 437; Thomson, *Virgil Thomson/By Virgil Thomson,* 90, 105; Steven Watson, *Prepare for Saints: Gertrude Stein, Virgil Thomson, and the Mainstreaming of American Modernism* (New York: Random House, 1998), 302.

40. Ross, *The Rest Is Noise,* 380.

41. Morris Dickstein, "Copland and American Populism in the 1930s," in *Aaron Copland and His World,* ed. Carol Oja and Judith Tick (Princeton: Princeton University Press, 2000), 94.

42. Ross, *The Rest Is Noise,* 301.

43. The history of the major recordings of *Appalachian Spring* is recounted in Pollack, *Aaron Copland,* 405.

44. Ibid., 389–390.

45. On Copland's encounter with McCarthyism and the nonpolitical uses of his music, see Ross, *The Rest Is Noise,* 277, 379–381; and Pollack, *Aaron Copland,* 361.

46. Peter Gay, "We Miss Our Jews: The Musical Migration from Nazi Germany," in *Driven into Paradise: The Musical Migration from Nazi Germany to the United States,* ed. Reinhold Brinkman and Christoph Wolff (Berkeley: University of California Press, 1999), 21–22. I have described the exodus of European musicians, composers, and conductors in *Not Like Us: How Europeans Have Loved, Hated, and Transformed American Culture since World War II* (New York: Basic, 1997), 26.

47. Tischler, *An American Music,* 169.

48. On the nonverbal advantages of European musicians, see Gay, "We Miss Our Jews," 24; and Hermann Danuser, "Composers in Exile: The Question of Musical Identity," in Brinkman and Wolff, *Driven into Paradise,* 157.

49. On Schoenberg's reasons for leaving Germany and settling in Los Angeles, see Danuser, "Composers in Exile," 161–162; and Frederic Grunfeld, *Prophets without Honour: Freud, Kafka, Einstein, and Their World* (New York: Kodansha America, 1996, © 1979), 166.

50. For Schoenberg's adventures in Hollywood, see Joseph Horowitz, *Artists in Exile: How Refugees from Twentieth-Century War and Revolution Transformed the American Performing Arts* (New York: HarperCollins, 2008), 114; Grunfeld, *Prophets without Honour,* 167–168; and Ross, *The Rest Is Noise,* 294–296.

51. Charles Joseph, *Stravinsky and Balanchine: A Journey of Invention* (New Haven: Yale University Press, 2002), 160.

52. On Stravinsky as a celebrity in America, see Joseph, *Stravinsky Inside Out,* 4; and Joseph, *Stravinsky and Balanchine,* 28.

53. For the postwar prominence of American musicians, see John Joyce, "The Globalization of Music: Expanding Spheres of Influence," in *Conceptualizing Global History,* ed. Bruce Mazlish and Ralph Buultjens (Boulder: Westview, 1993), 206.

54. Ross, *The Rest Is Noise,* 348; Michael Krenn, *Fall-Out Shelters for the Human Spirit: American Art and the Cold War* (Chapel Hill: University of North Carolina Press, 2005), 97. I have written more extensively about the State Department's sponsorship of American music in *Not Like Us,* 85.

55. On the experience of America's orchestras and Bernstein in the Soviet Union and China, see Daniel Wakin, "Another Movement of Musical Diplomacy," *New York Times,* December 11, 2007.

56. Ross, *The Rest Is Noise,* 406. See also Struble, *The History of American Classical Music,* 323.

6
All That Jazz

1. For more on the urban modernism of jazz, see Berndt Ostendorf, "Ralph Waldo Ellison: Anthropology, Modernism, and Jazz," in *New Essays on Invisible Man,* ed. Robert O'Meally (New York: Cambridge University Press, 1988), 112–113.

2. See Scott DeVeaux, *The Birth of Bebop: A Social and Musical History* (Berkeley: University of California Press, 1997), 28; and James Collier, *Jazz: The American Theme Song* (New York: Oxford University Press, 1993), 91–92, 103.

3. On the social elements of African and African American music, see Collier, *Jazz,* 28–29.

4. For the importance of European music and instruments in jazz, see Martha Bayles, *Hole in Our Soul: The Loss of Beauty and Meaning in American Popular Music* (Chicago: University of Chicago Press, 1996, © 1994), 23; Ted Gioia, *The Imperfect Art: Reflections on Jazz and Modern Culture* (New York: Oxford University Press, 1988), 35; and Barbara Zuck, *A History of Musical Americanism* (Ann Arbor: UMI Research Press, 1980), 74.

5. For the mixture of African American and European styles in ragtime, see Perry Hall, "African-American Music: Dynamics of Appropriation and Innovation," in *Borrowed Power: Essays on Cultural Appropriation,* ed. Bruce Ziff and Pratima Rao (New Brunswick, N.J.: Rutgers University Press, 1997), 38; Susan Curtis, *Dancing to a Black Man's Tune: A Life of Scott Joplin* (Columbia: University of Missouri Press, 1994), 66; and Jeffrey Melnick, *A Right to Sing the Blues: African Americans, Jews, and American Popular Song* (Cambridge: Harvard University Press, 2001, © 1999), 81.

6. William Scott and Peter Rutkoff, *New York Modern: The Arts and the City* (Baltimore: Johns Hopkins University Press, 1999), 37.

7. Joel Dinnerstein, *Swinging the Machine: Modernity, Technology, and African American Culture between the World Wars* (Amherst: University of Massachusetts Press, 2003), 110; James Collier, *The Making of Jazz: A Comprehensive History* (New York: Delta, 1979, © 1978), 63.

8. For more details on the history of the Creoles in New Orleans, see Collier, *The Making of Jazz*, 6, 59–61, 65; Collier, *Jazz*, 189, 201; and Charles Nanry, "Swing and Segregation," in *America's Musical Pulse: Popular Music in Twentieth-Century Society*, ed. Kenneth Bindas (Westport, Conn.: Praeger, 1992), 187.

9. On the Original Dixieland Jazz Band's records and early fame, see Richard Crawford, *America's Musical Life: A History* (New York: Norton, 2001), 563, 567; Alyn Shipton, *A New History of Jazz* (London: Continuum, 2001), 105; and William Barlow, "Cashing In: 1900–1939," in *Split Image: African Americans in the Mass Media*, ed. Jannette Dates and William Barlow (Washington, D.C.: Howard University Press, 1990), 30.

10. Shipton, *A New History of Jazz*, 98; Barlow, "Cashing In," 25.

11. On Armstrong's career in the 1920s and 1930s, see Crawford, *America's Musical Life*, 626; Shipton, *A New History of Jazz*, 138; Martin Williams, *The Jazz Tradition* (New York: Oxford University Press, 1993), 50; Collier, *Jazz*, 116–117; and Frederick Starr, "Amadeus and Satchmo," in *Satchmo Meets Amadeus*, ed. Reinhold Wagnleitner (Innsbruck: Studienverlag, 2006), 50.

12. Krin Gabbard, *Jammin' at the Margins: Jazz and the American Cinema* (Chicago: University of Chicago Press, 1996), 69.

13. On Ellington's artistic aspirations, see Ted Gioia, *The History of Jazz* (New York: Oxford University Press, 1997), 125, 128; and Collier, *Jazz*, 110.

14. For the worldwide spread of jazz in the 1920s and 1930s, see Jeffrey Jackson, *Making Jazz French: Music and Modern Life in Interwar Paris* (Durham, N.C.: Duke University Press, 2003), 23; and Reinhold Wagnleitner, "Jazz: The Classical Music of Globalization," in Wagnleitner, *Satchmo Meets Amadeus*, 292.

15. The contradictions between jazz as "primitive" and jazz as modern are alluded to in Ann Douglas, *Terrible Honesty: Mongrel Manhattan in the 1920s* (New York: Noonday, 1996, © 1995), 353; Tyler Stovall, *Paris Noir: African Americans in the City of Light* (Boston: Houghton Mifflin, 1996), 33; and Bernard Gendron, *Between Montmartre and the Mudd Club: Popular Music and the Avant-Garde* (Chicago: University of Chicago Press, 2002), 79.

16. Jackson, *Making Jazz French*, 110; Anthony Heilbut, *Exiled in Paradise:*

German Refugee Artists and Intellectuals in America from the 1930s to the Present (Berkeley: University of California Press, 1997, © 1983), 11.

17. For the European response to Bechet, Hawkins, Armstrong, and Ellington, see Bill Moody, *The Jazz Exiles: American Musicians Abroad* (Reno: University of Nevada Press, 1993), 4–5; Robert Crunden, *Body and Soul: The Making of American Modernism* (New York: Basic, 2000), 157–158; DeVeaux, *The Birth of Bebop,* 86–88; D. L. LeMahieu, *A Culture for Democracy: Mass Communication and the Cultivated Mind in Britain between the Wars* (Oxford: Clarendon, 1988), 95; Sieglinde Lemke, *Primitivist Modernism: Black Culture and the Origins of Transatlantic Modernism* (New York: Oxford University Press, 1988), 92; Glenn Watkins, *Pyramids at the Louvre: Music, Culture, and Collage from Stravinsky to the Postmodernists* (Cambridge: Harvard University Press, 1994), 194; Gabbard, *Jammin' at the Margins,* 168; and Collier, *Jazz,* 109.

18. For the influence of jazz on Debussy, Stravinsky, Ravel, and Milhaud, see Mervyn Cooke, *Jazz* (London: Thames and Hudson, 1998), 35; Joan Peyser, *The Memory of All That: The Life of George Gershwin* (New York, Simon and Schuster, 1993), 96; Watkins, *Pyramids at the Louvre,* 183; and Gioia, *The Imperfect Art,* 22.

19. Jackson, *Making Jazz French,* 121.

20. For a further discussion of the European jazz critics, see MacDonald Moore, *Yankee Blues: Musical Identity and American Culture* (Bloomington: Indiana University Press, 1985), 115; and Neil Leonard, *Jazz and the White Americans: The Acceptance of a New Art Form* (Chicago: Chicago University Press, 1962), 135, 137.

21. Shipton, *A New History of Jazz,* 358, 361; Jackson, *Making Jazz French,* 7, 124, 203.

22. For a description of the "sweet" music of the white big bands, see Collier, *The Making of Jazz,* 78.

23. On the role of radio in broadcasting the music of the big bands nationwide, see DeVeaux, *The Birth of Bebop,* 129; Gene Lees, *Singers and the Song* (New York: Oxford University Press, 1987), 32–33; and Lewis Erenberg, *Swingin' the Dream: Big Band Jazz and the Birth of American Culture* (Chicago: Chicago University Press, 1998), 161, 164.

24. Kenneth Bindas, *Swing, That Modern Sound* (Jackson: University Press of Mississippi, 2001), 166.

25. Philip Ennis, *The Seventh Stream: The Emergence of Rocknroll in American Popular Music* (Hanover, N.H.: Wesleyan University Press, 1992), 85.

26. DeVeaux, *The Birth of Bebop,* 15, 29.

27. On klezmer music and Goodman's familiarity with it, see Shipton, *A New*

History of Jazz, 319; and Gerald Mast, *Can't Help Singin': The American Musical on Stage and Screen* (Woodstock, N.Y.: Overlook, 1987), 36.

28. For more detail on Goodman's career in the 1930s, see Erenberg, *Swingin' the Dream*, 5, 42, 65–66, 75.

29. Cooke, *Jazz*, 89.

30. Gioia, *The History of Jazz*, 156; Nanry, "Swing and Segregation," 193; Reebee Garofalo, "Crossing Over: 1939–1989," in Dates and Barlow, *Split Image*, 61; and Erenberg, *Swingin' the Dream*, 217.

31. DeVeaux, *The Birth of Bebop*, 169.

32. Scott and Rutkoff, *New York Modern*, 261; Collier, *Jazz*, 212.

33. On the purposes of the jam session, see DeVeaux, *The Birth of Bebop*, 204, 207; and Shipton, *A New History of Jazz*, 447.

34. Gioia, *The Imperfect Art*, 71; Alex Ross, *The Rest Is Noise: Listening to the Twentieth Century* (New York: Farrar, Straus and Giroux, 2007), 92.

35. DeVeaux, *The Birth of Bebop*, 411.

36. Scott and Rutkoff, *New York Modern*, 280.

37. For Brubeck's experiments with time signatures, see Shipton, *A New History of Jazz*, 702–703.

38. For the loss of interest in jazz among African Americans in the 1950s and young whites in the 1960s, see Collier, *Jazz*, 207–210; Stuart Hobbs, *The End of the American Avant Garde* (New York: New York University Press, 1997), 75; and Gendron, *Between Montmartre and the Mudd Club*, 321–322.

39. Collier, *Jazz*, 145–146, 150, 220.

40. On jazz in France during and after World War II, see Jackson, *Making Jazz French*, 194; and Stovall, *Paris Noir*, 169.

41. I have described the use of jazz in the State Department's cultural diplomacy and especially on the Voice of America in *Not Like Us: How Europeans Have Loved, Hated, and Transformed American Culture since World War II* (New York: Basic, 1997), 85. See also Penny Von Eschen, "The Real Ambassadors," in Wagnleitner, *Satchmo Meets Amadeus*, 97; Penny Von Eschen, "'Satchmo Blows Up the World': Jazz, Race, and Empire during the Cold War," in *"Here, There, and Everywhere": The Foreign Politics of American Popular Culture*, ed. Reinhold Wagnleitner and Elaine May (Hanover, N.H.: University Press of New England, 2000), 166; Collier, *Jazz*, 141; and Uta Poiger, *Jazz, Rock, and Rebels: Cold War Politics and American Culture in a Divided Germany* (Berkeley: University of California Press, 2000), 146–148.

42. Shipton, *A New History of Jazz*, 794, 800, 828.

43. Ibid., 522.

7
They're Writing Songs of Love

1. Ann Douglas, *Terrible Honesty: Mongrel Manhattan in the 1920s* (New York: Noonday, 1996, © 1995), 348.

2. On Sousa's "serious" music and his popularity in Japan, see Masako Notoji, "Cultural Transformation of John Philip Sousa and Disneyland in Japan," in *"Here, There and Everywhere": The Foreign Politics of American Popular Culture,* ed. Reinhold Wagnleitner and Elaine May (Hanover, N.H.: University Press of New England, 2000), 219, 222; and Robert Muccigrosso, *Celebrating the New World: Chicago's Columbian Exposition of 1893* (Chicago: Ivan Dee, 1993), 170.

3. Philip Furia, "Irving Berlin: Troubadour of Tin Pan Alley," in *Inventing Times Square: Commerce and Culture at the Crossroads of the World,* ed. William Taylor (New York: Russell Sage, 1991), 191.

4. On the role of vaudeville in popularizing songs, see Martin Laforse and James Drake, *Popular Culture and American Life: Selected Topics in the Study of American Popular Culture* (Chicago: Nelson-Hall, 1981), 128; and Robert Snyder, *The Voice of the City: Vaudeville and Popular Culture in New York* (Chicago: Ivan Dee, 2000, © 1989), 125.

5. For the different types and purposes of songs on records or the radio, see Philip Furia, *The Poets of Tin Pan Alley: A History of the Great Lyricists* (New York: Oxford University Press, 1990), 25; and Philip Furia, *Irving Berlin: A Life in Song* (New York: Schirmer, 1998), 104.

6. Ronald Davis, *A History of Music in American Life,* vol. 2, *The Gilded Years, 1965–1920* (Huntington, N.Y.: Krieger, 1980), 141; Foster Hirsch, *Harold Prince and the American Musical Theater* (New York: Cambridge University Press, 1989), 6.

7. For a more extended discussion of Gilbert and Sullivan's success in America and the influence of their musicals, see John Dizikes, *Opera in America: A Cultural History* (New Haven: Yale University Press, 1993), 203–204, 206–207; and Rick Altman, *The American Film Musical* (Bloomington: Indiana University Press, 1989, © 1987), 135.

8. Davis, *A History of Music in American Life,* 2: 156.

9. William Hyland, *George Gershwin: A New Biography* (Westport, Conn.: Praeger, 2003), 79.

10. On the structure of the Ziegfeld Follies and other revues, see Andrea Most: *Making Americans: Jews and the Broadway Musical* (Cambridge: Harvard University Press, 2004), 28; Robert Allen, "'A Decided Sensation': Cinema, Vaudeville, and Burlesque," in *On the Edge of Your Seat: Popular Theater and Film in Early Twentieth-Century American Art,* ed. Patricia McDonnell (New Haven: Yale University Press, 2002), 86; Henry Jenkins, *What Made Pistachio Nuts? Early Sound Comedy and the*

Vaudeville Aesthetic (New York: Columbia University Press, 1992), 89; and Davis, *A History of Music in American Life,* 2: 147.

11. Nathan Huggins, *Harlem Renaissance* (New York: Oxford University Press, 1973, © 1971), 290.

12. On Cohan's "American" style, see Furia, *The Poets of Tin Pan Alley,* 30; and Furia, *Irvin Berlin,* 58.

13. On the musical traditions of Jews in eastern Europe and their rapid ascent in the new entertainment industries in America, see Lary May, *Screening Out the Past: The Birth of Mass Culture and the Motion Picture Industry* (New York: Oxford University Press, 1980), 173; James Collier, *Jazz: The American Theme Song* (New York: Oxford University Press, 1992), 12; and Gerald Mast, *Can't Help Singin': The American Musical on Stage and Screen* (Woodstock, N.Y.: Overlook, 1987), 35.

14. Kenneth Bindas, *Swing, That Modern Sound* (Jackson: University Press of Mississippi, 2001), 111.

15. The shared pathos of cantorial and African American music is further described in Jeffrey Melnick, *A Right to Sing the Blues: African Americans, Jews, and American Popular Song* (Cambridge: Harvard University Press, 2001, © 1999), 169, 182.

16. Charles Hamm, *Music in the New World* (New York: Norton, 1983), 355–357, 360.

17. On the structure of the standard song in the early twentieth century and the task of the lyricist in putting words to music, see Furia, *The Poets of Tin Pan Alley,* 13; William Hyland, *The Song Is Ended: Songwriters and American Music, 1900–1950* (New York: Oxford University Press, 1995), 84; and Philip Furia, *Ira Gershwin: The Art of the Lyricist* (New York: Oxford University Press, 1996), 16.

18. For more on the literary background and ambitions of the lyricists, see Richard Crawford, *America's Musical Life: A History* (New York: Norton, 2001), 676; Furia, *Ira Gershwin,* 12; and Furia, *The Poets of Tin Pan Alley,* 7.

19. Furia, *The Poets of Tin Pan Alley,* 15.

20. For the eclectic background of Berlin's music, see Douglas, *Terrible Honesty,* 357; and Hamm, *Music in the New World,* 347.

21. On the success in America and Europe of "Alexander's Ragtime Band," see David Sanjek, "They Work Hard for Their Money: The Business of Popular Music," in *American Popular Music: New Approaches to the Twentieth Century,* ed. Rachel Rubin and Jeffrey Melnick (Amherst: University of Massachusetts Press, 2000), 11; Michael Alexander, *Jazz Age Jews* (Princeton: Princeton University Press, 2001), 162; and Furia, *Irving Berlin,* 41, 56.

22. Hyland, *George Gershwin,* 186.

23. Furia, *Irving Berlin,* 204.

24. Ibid., 4.

25. For the ethnic and American influences on Gershwin's music, see Barbara Zuck, *A History of Musical Americanism* (Ann Arbor: UMI Research Press, 1980), 83; Charles Schwartz, *Gershwin: His Life and Music* (New York: Da Capo, 1979, © 1973), 28; and John Struble, *The History of American Classical Music: MacDowell Through Minimalism* (New York: Facts on File, 1995), 95.

26. The Gershwin quotation can be found in Hyland, *George Gershwin*, 68.

27. Carol Oja, *Making Music Modern: New York in the 1920s* (New York: Oxford University Press, 2000), 328.

28. On the Aeolian Hall concert and its audience, see Schwartz, *Gershwin*, 85; and Hyland, *George Gershwin*, 67.

29. On the differing appeal of *Rhapsody in Blue* and the *Concerto in F* to audiences, see Schwartz, *Gershwin*, 94, 116.

30. For the reactions to Gershwin's works on the part of his colleagues and jazz musicians, see Hyland, *George Gershwin*, 61, 74; and Alyn Shipton, *A New History of Jazz* (London: Continuum, 2001), 215.

31. Jack Sullivan, *New World Symphonies: How American Culture Changed European Music* (New Haven: Yale University Press, 1999), xvi; Schwartz, *Gershwin*, 93.

32. Gershwin's conversations with Boulanger and Stravinsky are recounted in Edward Jablonski, *Gershwin* (New York: Doubleday, 1987), 157, 168. For more detail on Gershwin's trip to Europe, see Schwartz, *Gershwin*, 156; and Alex Ross, *The Rest Is Noise: Listening to the Twentieth Century* (New York: Farrar, Straus and Giroux, 2007), 146.

33. Mast, *Can't Help Singin'*, 76.

34. For Gershwin's operatic aspirations and the musical elements that went into *Porgy and Bess*, see Hamm, *Music in the New World*, 450; and Ross, *The Rest Is Noise*, 150.

35. For the reactions of audiences and critics to *Porgy and Bess*, see Ross, *The Rest Is Noise*, 149; Jablonski, *Gershwin*, 289; Krin Gabbard, *Jammin' at the Margins: Jazz and the American Cinema* (Chicago: University of Chicago Press, 1996), 170; and Hyland, *George Gershwin*, 173.

36. Charles Hamm, "Towards a New Reading of Gershwin," in *The Gershwin Style: New Looks at the Music of George Gershwin*, ed. Wayne Schneider (New York: Oxford University Press, 1999), 14.

37. Hyland, *George Gershwin*, 240, 243; Mast, *Can't Help Singin'*, 67.

38. On Kern, see Mast, *Can't Help Singin'*, 53; and Furia, *The Poets of Tin Pan Alley*, 183.

39. Mast, *Can't Help Singin'*, 185.

40. For the partnership between Balanchine and Stravinsky, see Charles Joseph, *Stravinsky and Balanchine: A Journey of Invention* (New Haven: Yale University Press, 2002), 2.

41. Furia, *The Poets of Tin Pan Alley,* 42.
42. Ibid., 189.
43. On the consequences of Rodgers fitting his music to Hammerstein's lyrics, see Denny Flinn, *Musical! A Grand Tour: The Rise, Glory, and Fall of an American Institution* (New York: Schirmer, 1997), 220, 228.
44. Ibid., 227.
45. For de Mille's dance esthetic and the influence of her dream ballets, see Joseph, *Stravinsky and Balanchine,* 136; Carol Easton, *No Intermissions: The Life of Agnes de Mille* (Boston, Little Brown, 1996), 54, 148, 203, 208; and Beverly Heisner, *Hollywood Art: Art Direction in the Days of the Great Studios* (Jefferson, N.C.: McFarland, 1990), 87.
46. Ethan Mordden, "Six Decades Later, Still the Great American Musical," *New York Times,* February 24, 2002; Michael Krenn, *Fall-Out Shelters for the Human Spirit: American Art and the Cold War* (Chapel Hill: University of North Carolina Press, 2005), 96.
47. Most, *Making Americans,* 159.
48. On Porter's use of Shakespeare's lines, see Mast, *Can't Help Singin',* 197.
49. For the influence of Gilbert and Sullivan on and the climax of *My Fair Lady,* as well as the popularity of its cast album, see Mast, *Can't Help Singin',* 306, 308–309; and Flinn, *Musical!* 342.
50. Jerome Delamater, *Dance in the Hollywood Musical* (Ann Arbor: UMI Research Press, 1981), 18.
51. Furia, *The Poets of Tin Pan Alley,* 234.
52. I have described Berkeley's techniques and his 1930s-style themes in *Radical Visions and American Dreams: Culture and Social Thought in the Depression Years* (New York: Harper and Row, 1973), 282. See also Furia, *Irving Berlin,* 166.
53. On the origins and centrality of tap dancing, see Hyland, *George Gershwin,* 187; Richard Kislan, *Hoofing on Broadway: A History of Show Dancing* (New York: Prentice Hall, 1987), 157; Mark Grant, *The Rise and Fall of the Broadway Musical* (Boston: Northeastern University Press, 2004), 122; and Joel Dinnerstein, *Swinging the Machine: Modernity, Technology, and African American Culture between the World Wars* (Amherst: University of Massachusetts Press, 2003), 224.
54. Furia, *Ira Gershwin,* 137.
55. Altman, *The American Film Musical,* 167.
56. For the labor involved in Kelly's dancing, see Mast, *Can't Help Singin',* 251; and Delamater, *Dance in the Hollywood Musical,* 158.
57. Mast, *Can't Help Singin',* 242.
58. Delamater, *Dance in the Hollywood Musical,* 98.
59. Ibid., 175.
60. For the connections between the Kit Kat Club and the outside world, see Mast, *Can't Help Singin',* 321.

61. On Fosse's choreography, see Grant, *The Rise and Fall of the Broadway Musical*, 284.

62. For the difficulties in the plot of *Nashville* and the Judy Garland–like vulnerability and assassination of Barbara Jean, see Helene Keyssar, *Robert Altman's America* (New York: Oxford University Press, 1991), 136–137; Altman, *The American Film Musical*, 327; and John Orr, *Contemporary Cinema* (Edinburgh: Edinburgh University Press, 1998), 172.

63. For more detail on *All That Jazz*, see Glen and Krin Gabbard, *Psychiatry and the Cinema*, 2nd ed. (Washington, D.C.: American Psychiatric Press, 1999), 190, 201; Robert Long, *Broadway, the Golden Years: Jerome Robbins and the Great Choreographer-Directors, 1940 to the Present* (New York: Continuum, 2001), 170, 174; and Mast, *Can't Help Singin'*, 340.

64. On the similar backgrounds and artistic ambitions of Bernstein and Robbins, see Hyland, *George Gershwin*, 251; and Long, *Broadway, the Golden Years*, 111.

65. For Robbins's credit as choreographer and director of *West Side Story*, see Flinn, *Musical!* 248.

66. Jesse Green, "The Song Is Ended," *New York Times Magazine*, June 2, 1996, p. 48.

67. On the mechanical and electronic paraphernalia of contemporary musicals, see Grant, *The Rise and Fall of the Broadway Musical*, 6, 199, 209.

8
"I Was Just Making Pictures"

1. On the impact of different shots and parallel editing, see David Grossvogel, *Didn't You Use to Be Depardieu? Film as Cultural Marker in France and Hollywood* (New York: Lang, 2002), 5; and Leo Charney, "In Order: Fragmentation in Film and Vaudeville," in *On the Edge of Your Seat: Popular Theater and Film in Early Twentieth-Century American Art*, ed. Patricia McDonnell (New Haven: Yale University Press, 2002), 113.

2. Jim Cullen, *The Art of Democracy: A Concise History of Popular Culture in the United States* (New York: Monthly Review, 1996), 140; Daniel Czitrom, *Media and the American Mind: From Morse to McLuhan* (Chapel Hill: University of North Carolina Press, 1982), 38; Gorham Kindem, "United States," in *The International Movie Industry*, ed. Gorham Kindem (Carbondale: Southern Illinois University Press, 2000), 310.

3. For the competition between the Lumières and Edison, see John Izod, *Hollywood and the Box Office, 1895–1986* (London: Macmillan, 1988), 3; Beverly James, "Hungary," in Kindem, *The International Movie Industry,* 167; Alan Williams, *Republic of Images: A History of French Filmmaking* (Cambridge: Harvard University Press, 1992), 31; and David

Puttnam, *The Undeclared War: The Struggle for Control of the World's Film Industry* (New York: HarperCollins, 1997), 27–28.

4. Grossvogel, *Didn't You Use to Be Depardieu?* 4.

5. William Everdell, *The First Moderns: Profiles in the Origins of Twenti-eth-Century Thought* (Chicago: University of Chicago Press, 1998, © 1997), 195; Randy Kennedy, "When Picasso and Braque Went to the Movies," *New York Times,* April 15, 2007.

6. Izod, *Hollywood and the Box Office,* 5; David Cook, *A History of Narrative Film,* 3rd ed. (New York: Norton, 1996), 8–9.

7. For more on the techniques of *The Great Train Robbery* and the popularity of early Westerns, see A. O. Scott, "How the Western Was Won," *New York Times Magazine,* November 11, 2007, p. 56; Cook, *A History of Narrative Film,* 25, 30; D. L. LeMahieu, *A Culture for Democracy: Mass Communication and the Cultivated Mind in Britain between the Wars* (Oxford: Clarendon, 1988), 62; and Joy Kasson, *Buffalo Bill's Wild West: Celebrity, Memory, and Popular History* (New York: Hill and Wang, 2001, © 2000), 256.

8. On the spread of nickelodeons and their importance for the immigrant working class, see Cullen, *The Art of Democracy,* 142; Peter Gay, *Modernism: The Lure of Heresy* (New York: Norton, 2007), 368; Puttnam, *The Undeclared War,* 45; and Neal Gabler, *An Empire of Their Own: How the Jews Invented Hollywood* (New York: Anchor, 1989, © 1988), 55–56.

9. For the origins of the French film industry and the role of Pathé, see Williams, *Republic of Images,* 80; Louis Menand, "Paris, Texas: How Hollywood Brought the Cinema Back from France," *New Yorker,* February 17–24, 2003, p. 169; Cook, *A History of Film Narrative,* 48; Puttnam, *The Undeclared War,* 41, 43; and Tom Gunning, "Early American Film," in *American Cinema and Hollywood: Critical Approaches,* ed. John Hill and Pamela Gibson (Oxford: Oxford University Press, 2000), 36.

10. For more on the French and Italian historical epics, see Cook, *A History of Film Narrative,* 40; and Peter Bondanella, *Italian Cinema: From Neorealism to the Present* (New York: Continuum, 1997, © 1983), 2–3.

11. Richard Abel, *French Cinema: The First Wave, 1915–1929* (Princeton: Princeton University Press, 1984), 6, 9, 12.

12. I have described the impact of World War I on the American, French, and Italian film industries in *Not Like Us: How Europeans Have Loved, Hated, and Transformed American Culture since World War II* (New York: Basic, 1997), 15. See also Kristin Thompson, *Exporting Entertainment: America in the World Film Market, 1907–1934* (London: British Film Institute, 1985), 49.

13. For the economic factors that made American films internationally pop-

ular, see Pells, *Not Like Us*, 15, 17, 208, 214. See also Thompson, *Exporting Entertainment*, 111; Richard Maltby and Ruth Vasey, "'Temporary American Citizens': Cultural Anxieties and Industrial Strategies in the Americanisation of European Cinema," in *"Film Europe" and "Film America": Cinema, Commerce, and Cultural Exchange, 1920–1939*, ed. Andrew Higson and Richard Maltby (Exeter: University of Exeter Press, 1999), 36; and Richard Schickel, *Matinee Idylls: Reflections on the Movies* (Chicago: Ivan Dee, 1999), 186.

14. Pells, *Not Like Us*, 16; Richard Maltby, "Introduction: 'The Americanisation of the World,'" in *Hollywood Abroad: Audiences and Cultural Exchange*, ed. Melvyn Stokes and Richard Maltby (London: British Film Institute, 2004), 8.

15. The statistics on American films abroad are calculated in Pells, *Not Like Us*, 16; Ann Douglas, *Terrible Honesty: Mongrel Manhattan in the 1920s* (New York: Noonday, 1996, © 1995), 191; Geoffrey Nowell-Smith, "Introduction," in *Hollywood and Europe: Economics, Culture, National Identity, 1945–95*, ed. Geoffrey Nowell-Smith and Steven Ricci (London: British Film Institute, 1998), 3; Kristin Thompson, "The Rise and Fall of Film Europe," in Higson and Maltby, *"Film Europe" and "Film America,"* 56; and Todd Gitlin, *Media Unlimited: How the Torrent of Images and Sounds Overwhelms Our Lives* (New York: Metropolitan, 2001), 183.

16. I have discussed in greater detail the elites' fear of American movies in *Not Like Us*, 14, 236–239. See also Maltby and Vasey, "'Temporary American Citizens,'" 41; and Puttnam, *The Undeclared War*, 20.

17. Gabler, *An Empire of Their Own*, 5, 105; David Thomson, *The Whole Equation: A History of Hollywood* (New York: Vintage, 2006, © 2005), 164; Cook, *A History of Narrative Film*, 44.

18. For the background of the movie moguls, see Joseph Horowitz, *Artists in Exile: How Refugees from Twentieth-Century War and Revolution Transformed the American Performing Arts* (New York: HarperCollins, 2008), 235, 246; Richard Bulliet, "Popular Culture," in *The Columbia History of the 20th Century*, ed. Richard Bulliet (New York: Columbia University Press, 1998), 38; Lester Friedman, *Hollywood's Image of the Jew* (New York: Ungar, 1982), 60; and John Tibbetts, "The New Tin Pan Alley: 1940s Hollywood Looks at American Popular Songwriters," in *Perspectives on American Music, 1900–1950*, ed. Michael Saffle (New York: Garland, 2000), 359.

19. Beverly Heisner, *Hollywood Art: Art Direction in the Days of the Great Studios* (Jefferson, N.C.: McFarland, 1990), 58.

20. For more on the studio system, see Kindem, "United States," 319; Thomas Schatz, *Old Hollywood/New Hollywood: Ritual, Art, and Industry* (Ann Arbor: UMI Research Press, 1983), 31, 39; Louis Giannetti,

Masters of the American Cinema (Englewood Cliffs, N.J.: Prentice-Hall, 1981), 16; and Geoff King, *New Hollywood Cinema: An Introduction* (New York: Columbia University Press, 2002), 26.

21. On the role of the studio heads in creating a fictional America, see Gabler, *An Empire of Their Own*, 6, 189, 215–216; Schickel, *Matinee Idylls*, 42; and Patrick McGilligan, *Fritz Lang: The Nature of the Beast* (London: Faber and Faber, 1997), 210.

22. I have analyzed Warner Brothers' style in *Radical Visions and American Dreams: Culture and Social Thought in the Depression Years* (New York: Harper and Row, 1973), 271. See also Gabler, *An Empire of Their Own*, 190, 195, 197.

23. For the appeal of movies both to immigrant workers and the middle class, see Gabler, *An Empire of Their Own*, 5; Herbert Gans, *Popular Culture and High Culture: An Analysis and Evaluation of Taste* (New York: Basic, 1999), 71; Lewis Erenberg, *Steppin' Out: New York Nightlife and the Transformation of American Culture, 1890–1930* (Westport, Conn.: Greenwood, 1981), 69; Peter Stead, *Film and the Working Class: The Feature Film in British and American Society* (London: Routledge, 1989), 13, 15; and Lary May, *Screening Out the Past: The Birth of Mass Culture and the Motion Picture Industry* (New York: Oxford University Press, 1980), 158.

24. For general information on the movie palaces, see Andrew Heinze, *Adapting to Abundance: Jewish Immigrants, Mass Consumption, and the Search for American Identity* (New York: Columbia University Press, 1990), 210; Cook, *A History of Film Narrative*, 41; May, *Screening Out the Past*, 150, 163; and Izod, *Hollywood and the Box Office*, 42.

25. See Pells, *Not Like Us*, 209. The Hitchcock quotation can be found in Peter Bogdanovich, ed., *Fritz Lang in America* (New York: Praeger, 1967), 7.

26. On Griffith's Victorianism and his stylistic innovations, see Cook, *A History of Film Narrative*, 59, 64, 66, 69–70; LeMahieu, *A Culture for Democracy*, 63, 65; Russell Lynes, *The Lively Audience: A Social History of the Visual and Performing Arts in America, 1890–1950* (New York: Harper and Row, 1985), 259–260, 262; and May, *Screening Out the Past*, 72.

27. For Griffith's commercial aspirations and the success of *The Birth of a Nation*, see Lynes, *The Lively Audience*, 258; Martin Williams, *Hidden in Plain Sight: An Examination of the American Arts* (New York: Oxford University Press, 1992), 19; Schickel, *Matinee Idylls*, 182; and Richard Koszarski, *An Evening's Entertainment: The Age of the Silent Picture, 1915–1928* (Berkeley: University of California Press, 1994, © 1990), 320.

28. For more information on Chaplin's background in England, see John

Taylor, *Strangers in Paradise: The Hollywood Émigrés, 1933–1950* (New York: Holt, Rinehart and Winston, 1983), 17; and Giannetti, *Masters of the American Cinema*, 81.

29. Cook, *A History of Narrative Film*, 199.
30. I have discussed Chaplin's films in the 1930s in *Radical Visions and American Dreams*, 284–285.
31. For Chaplin's success and influence abroad, see Giannetti, *Masters of the American Cinema*, 79; and James Naremore, *Acting in the Cinema* (Berkeley: University of California Press, 1988), 115.
32. Cook, *A History of Narrative Film*, 5, 239; Williams, *Republic of Images*, 158; Raymond Fielding, "The Technological Antecedents of the Coming of Sound: An Introduction," in *Sound and the Cinema: The Coming of Sound to American Films*, ed. Evan Cameron (Pleasantville, N.Y.: Redgrave, 1980), 4–5.
33. For the development of sound technology in America and the international success of *The Jazz Singer*, see Cook, *A History of Narrative Film*, 239, 246; Fielding, "The Technological Antecedents of the Coming of Sound," 6; J. Hoberman, "On *The Jazz Singer*," in *Entertaining America: Jews, Movies, and Broadcasting*, ed. J. Hoberman and Jeffrey Shandler (Princeton: Princeton University Press, 2003), 78; Koszarski, *An Evening's Entertainment*, 90; Donald Crafton, *The Talkies: American Cinema's Transition to Sound, 1926–1931* (Berkeley: University of California Press, 1999, © 1997), 419; Williams, *Republic of Images*, 160; Thomas Saunders, *Hollywood in Berlin: American Cinema and Weimar Germany* (Berkeley: University of California Press, 1994), 224–225; and Izod, *Hollywood and the Box Office*, 77.
34. Cook, *A History of Narrative Film*, 244, 261.
35. On the new screenwriters of the 1930s, see Mark Feeney, *Nixon at the Movies: A Book about Belief* (Chicago: University of Chicago Press, 2004), 135–136; and Cook, *A History of Narrative Film*, 264.
36. I have described the impact of American sound films abroad in *Not Like Us*, 17–18. See also Maltby and Vasey, "'Temporary American Citizens,'" 39–41, 49; Ruth Vasey, *The World According to Hollywood, 1918–1939* (Madison: University of Wisconsin Press, 1997), 67–69, 92, 94, 97; Thompson, *Exporting Entertainment*, 148; Puttnam, *The Undeclared War*, 140, 144–145; Crafton, *The Talkies*, 430; and Martine Danan, "Hollywood's Hegemonic Strategies: Overcoming French Nationalism with the Advent of Sound," in Higson and Maltby, *"Film Europe" and "Film America,"* 234, 236, 241.
37. Crafton, *The Talkies*, 216; Thomson, *The Whole Equation*, 201; Charles Joseph, *Stravinsky Inside Out* (New Haven: Yale University Press, 2001), 103; and Robert Ray, *A Certain Tendency of the Hollywood Cinema, 1930–1980* (Princeton: Princeton University Press, 1985), 30.

38. The Capra quotation is reproduced in Crafton, *The Talkies*, 535; See also Ray, *A Certain Tendency of the Hollywood Cinema*, 32; Schatz, *Old Hollywood/New Hollywood*, 218; King, *New Hollywood Cinema*, 38; and Carl Boggs and Tom Pollard, *A World in Chaos: Social Crisis and the Rise of Postmodern Cinema* (Lanham, Md.: Rowman and Littlefield, 2003), 190, 192, 210.

39. I have analyzed Capra's films at greater length in *Radical Visions and American Dreams*, 278–279, 282. See also Gabler, *An Empire of Their Own*, 172, 200; and Schickel, *Matinee Idylls*, 73.

40. For more on Welles and *Citizen Kane*, see Pells, *Radical Visions and American Dreams*, 287–291; Sanford Schwartz, "The Master Builder," *New York Review of Books*, March 15, 2007, p. 52; James Naremore, *The Magic World of Orson Welles* (Dallas: Southern Methodist University Press, 1989, © 1978), 36, 39, 48; Michael Anderegg, *Orson Welles, Shakespeare, and Popular Culture* (New York: Columbia University Press, 1999), 70–71; and Schatz, *Old Hollywood/New Hollywood*, 219.

9
Night and Fog

1. For the European belief that their films were works of art, see Rick Altman, *The American Film Musical* (Bloomington: Indiana University Press, 1989, © 1987), 59; Louis Giannetti, *Masters of the American Cinema* (Englewood Cliffs, N.J.: Prentice-Hall, 1981), 4; Victoria de Grazia, *Irresistible Empire: America's Advance through Twentieth-Century Europe* (Cambridge: Harvard University Press, 2005), 304; and Tom Ryall, *Alfred Hitchcock and the British Cinema* (London: Croom Helm, 1986), 8–9.

2. On the German challenge to Hollywood's supremacy, see Heide Fehrenbach, "Persistent Myths of Americanization: German Reconstruction and the Renationalization of Postwar Cinema, 1945–1965," in *Transactions, Transgressions, Transformations: American Culture in Western Europe and Japan*, ed. Heide Fehrenbach and Uta Poiger (New York: Berghahn, 2000), 84; John Baxter, *The Hollywood Exiles* (New York: Taplinger, 1976), 21; and Thomas Saunders, *Hollywood in Berlin: American Cinema and Weimar Germany* (Berkeley: University of California Press, 1994), 6, 13, 20, 245.

3. David Cook, *A History of Narrative Film*, 3rd ed. (New York: Norton, 1996), 106; Patrick McGilligan, *Fritz Lang: The Nature of the Beast* (London: Faber and Faber, 1997), 75–76; de Grazia, *Irresistible Empire*, 286; Kristin Thompson, *Herr Lubitsch Goes to Hollywood: German and American Film after World War I* (Amsterdam: Amsterdam University Press, 2005), 21.

4. On Pommer's desire to blend art and commerce, see Saunders, *Hollywood in Berlin,* 197.

5. Thompson, *Herr Lubitsch Goes to Hollywood,* 14, 19–20; Saunders, *Hollywood in Berlin,* 60.

6. For more on the style and subject matter of Expressionism, see Giannetti, *Masters of the American Cinema,* 238; and McGilligan, *Fritz Lang,* 53.

7. On the impact of Viennese and New York architecture on Lang, see McGilligan, *Fritz Lang,* 6; Lucy Fischer, *Designing Women: Cinema, Art Deco, and the Female Form* (New York: Columbia University Press, 2003), 206; and Peter Bogdanovich, ed., *Fritz Lang in America* (New York: Praeger, 1967), 15.

8. For more on the assumptions behind and the moderate success of Film Europe, see Victoria de Grazia, "European Cinema and the Idea of Europe, 1925–95," in *Hollywood and Europe: Economics, Culture, National Identity, 1945–95,* ed. Geoffrey Nowell-Smith and Steven Ricci (London: British Film Institute, 1998), 22; and Andrew Higson and Richard Maltby, "'Film Europe' and 'Film America': An Introduction," and Kristin Thompson, "The Rise and Fall of Film Europe," in *"Film Europe" and "Film America": Cinema, Commerce and Cultural Exchange, 1920–1939,* ed. Andrew Higson and Richard Maltby (Exeter: University of Exeter Press, 1999), 3, 63.

9. Marc Silberman, "Germany," in *The International Movie Industry,* ed. Gorham Kindem (Carbondale: Southern Illinois University Press, 2000), 212; de Grazia, *Irresistible Empire,* 312; Thomas Saunders, "Germany and Film Europe," in Higson and Maltby, *"Film Europe" and "Film America,"* 165.

10. For the effects of Hollywood's domination on the German film industry in the late 1920s, see Saunders, *Hollywood in Berlin,* 11, 16, 118; Fehrenbach, "Persistent Myths of Americanization," 83; Higson and Maltby, "'Film Europe' and 'Film America,'" 19; and Thompson, *Herr Lubitsch Goes to Hollywood,* 14, 16.

11. For the conflicts foreign directors faced between their expectations about and the realities of working in Hollywood, see Graham Petrie, *Hollywood Destinies: European Directors in America, 1922–1931* (Detroit: Wayne State University Press, 2002, © 1985), xi, 166.

12. On Murnau's failure in Hollywood, see John Taylor, *Strangers in Paradise: The Hollywood Émigrés, 1933–1950* (New York: Holt, Rinehart and Winston, 1983), 23–24; and David Puttnam, *The Undeclared War: The Struggle for Control of the World's Film Industry* (New York: HarperCollins, 1997), 113.

13. I have analyzed Lubitsch's American films in *Radical Visions and American Dreams: Culture and Social Thought in the Depression Years* (New York: Harper and Row, 1973), 283. See also Taylor, *Strangers in Para-*

dise, 20; Thompson, *Herr Lubitsch Goes to Hollywood,* 31; Petrie, *Hollywood Destinies,* 23; and Giannetti, *Masters of the American Cinema,* 121, 126.

14. I have described the pessimism of Lang's Hollywood movies in *Radical Visions and American Dreams,* 277. The quotations from Lang can be found in Bogdanovich, *Fritz Lang in America,* 17, 22, 35, 40. For more on Lang's migration to and career in America, see Taylor, *Strangers in Paradise,* 47; McGilligan, *Fritz Lang,* 17, 32, 173; Giannetti, *Masters of the American Cinema,* 230; and Andrew Dickos, *Street with No Name: A History of the Classic American Film Noir* (Lexington: University Press of Kentucky, 2002), 22.

15. Lutz Koepnick, *The Dark Mirror: German Cinema between Hitler and Hollywood* (Berkeley: University of California Press, 2002), 208.

16. David Denby, "Balance of Terror: How Otto Preminger Made His Movies," *New Yorker,* January 14, 2008, pp. 78–79; Taylor, *Strangers in Paradise,* 67.

17. On Wilder's background in Europe and his career in America, see Maurice Zolotow, *Billy Wilder in Hollywood* (New York: Putnam, 1977), 19, 21, 24–25; Giannetti, *Masters of the American Cinema,* 313; Saverio Giovacchini, *Hollywood Modernism: Film and Politics in the Age of the New Deal* (Philadelphia: Temple University Press, 2001), 32; Taylor, *Strangers in Paradise,* 195; and Anthony Heilbut, *Exiled in Paradise: German Refugee Artists and Intellectuals in America from the 1930s to the Present* (Berkeley: University of California Press, 1997, © 1983), 235, 255, 258.

18. Puttnam, *The Undeclared War,* 58, 156.

19. On Garbo's popularity abroad, see Ruth Vasey, *The World According to Hollywood, 1918–1939* (Madison: University of Wisconsin Press, 1997), 164; and Richard Schickel, *Matinee Idylls: Reflections on the Movies* (Chicago: Ivan Dee, 1999), 32, 186.

20. Charles Berg, *Latino Images in Film: Stereotypes, Subversion, Resistance* (Austin: University of Texas Press, 2002), 22, 101–102.

21. Dickos, *Street with No Name,* 43, 51.

22. For the foreign backgrounds and subsequent careers of some of the actors in *Casablanca,* see Robert Ray, *A Certain Tendency of the Hollywood Cinema, 1930–1980* (Princeton: Princeton University Press, 1985), 27; Koepnick, *The Dark Mirror,* 144; McGilligan, *Fritz Lang,* 147; and Aljean Harmetz, *Round Up the Usual Suspects: The Making of Casablanca: Bogart, Bergman, and World War II* (New York: Hyperion, 1992), 225.

23. The quotations are reproduced in Harmetz, *Round Up the Usual Suspects,* 213, 225.

24. On the emergence of the B movie and its connection to film noir, see Richard Martin, *Mean Streets and Raging Bulls: The Legacy of Film Noir*

in Contemporary American Cinema (Lanham, Md.: Scarecrow, 1997), 13; John Izod, *Hollywood and the Box Office, 1895–1986* (London: Macmillan, 1988), 121; and Paul Schrader, "Notes on Film Noir," in *Movies and Mass Culture,* ed. John Belton (New Brunswick, N.J.: Rutgers University Press, 2000, © 1996), 165.

25. I have discussed the style and themes of horror films in *Radical Visions and American Dreams,* 269–270. See also Andrew Tudor, "Horror Movies," in *Passport to Hollywood: Film Immigrants, Anthology,* ed. Don Whittemore and Philip Cecchettini (New York, McGraw-Hill, 1976), 295; and Donald Crafton, *The Talkies: American Cinema's Transition to Sound, 1926–1931* (Berkeley: University of California Press, 1999, © 1997), 371.

26. For a lengthier analysis of Hammett's novel, see *Radical Visions and American Dreams,* 238–239.

27. Koepnick, *The Dark Mirror,* 166; Giannetti, *Masters of the American Cinema,* 241.

28. For more on the style of film noir, see John Belton, "Introduction," in Belton, *Movies and Mass Culture,* 18; and Dickos, *Street with No Name,* 5.

29. Dickos, *Street with No Name,* 8; Giannetti, *Masters of the American Cinema,* 242.

30. On Swanson's rendition of a female vampire, see John Orr, *Cinema and Modernity* (Cambridge: Polity, 1993), 165–166.

31. On Hitchcock's background and career in Britain, and his decision to move to Hollywood, see Don Whittemore and Philip Cecchettini, "Alfred Hitchcock," in Whittemore and Cecchettini, *Passport to Hollywood,* 328; and Ryall, *Alfred Hitchcock and the British Cinema,* 119, 173, 175–176.

32. Hitchcock is quoted about the bizarre things that happen to average and innocent people in D. L. LeMahieu, *A Culture for Democracy: Mass Communication and the Cultivated Mind in Britain between the Wars* (Oxford: Clarendon, 1988), 243.

33. Richard Schickel, *Schickel on Film: Encounters—Critical and Personal—with Movie Immortals* (New York: Morrow, 1989), 73–74, 77–78; Thomas Schatz, *Old Hollywood/New Hollywood: Ritual, Art, and Industry* (Ann Arbor: UMI Research Press, 1983), 266.

34. I have discussed the French attraction to American literature at greater length in *Not Like Us: How Europeans Have Loved, Hated, and Transformed American Culture since World War II* (New York: Basic, 1997), 247–252.

35. On the postwar French exposure to American movies and the critics' definitions of film noir, see Dickos, *Street with No Name,* 191; Orr, *Cinema and Modernity,* 156; and Louis Menand, "Paris, Texas: How Hollywood

Brought the Cinema Back from France," *New Yorker*, February 17–24, 2003, p. 171.

10
The New Wave Abroad

1. For statistics on the movie business in the postwar years, see Robert Ray, *A Certain Tendency of the Hollywood Cinema, 1930–1980* (Princeton: Princeton University Press, 1985), 129; Geoff King, *New Hollywood Cinema: An Introduction* (New York: Columbia University Press, 2002), 24; Emanuel Levy, *Oscar Fever: The History and Politics of the Academy Awards* (New York: Continuum, 2001), 89; Ken Belson, "Reflecting National Trend, the Buffalo Drive-In Theater Reaches 'The End,'" *New York Times*, September 2, 2007; and Tino Balio, "Introduction to Part I," in *Hollywood in the Age of Television*, ed. Tino Balio (Boston: Unwin Hyman, 1990), 3.
2. I have described the 1948 Supreme Court ruling and the competition from other leisure activities in *Not Like Us: How Europeans Have Loved, Hated, and Transformed American Culture since World War II* (New York: Basic, 1997), 213. See also David Thomson, *The Whole Equation: A History of Hollywood* (New York: Vintage, 2006, © 2005), 271; Michael Kammen, *American Culture, American Tastes: Social Change and the 20th Century* (New York: Basic, 2000, © 1999), 183; and Balio, "Introduction to Part I," 3.
3. Balio, "Introduction to Part I," 24; Brad Chisholm, "Red, Blue, and Lots of Green: The Impact of Color Television on Feature Film Production," in Balio, *Hollywood in the Age of Television*, 222–223.
4. David Puttnam, *The Undeclared War: The Struggle for Control of the World's Film Industry* (New York: HarperCollins, 1997), 238; Balio, "Introduction to Part I," 31; King, *New Hollywood Cinema*, 232.
5. Neal Gabler, *Walt Disney: The Triumph of the American Imagination* (New York: Knopf, 2006), xiv, 506–507.
6. Ibid., 520; Jim Cullen, *The Art of Democracy: A Concise History of Popular Culture in the United States* (New York: Monthly Review, 1996), 205; King, *New Hollywood Cinema*, 227; Balio, "Introduction to Part I," 33; Richard Maltby, "'Nobody Knows Everything': Post-Classical Historiographies and Consolidated Entertainment," in *Contemporary Hollywood Cinema*, ed. Steve Neale and Murray Smith (London: Routledge, 1998), 29.
7. Lester Friedman, *Hollywood's Image of the Jew* (New York: Ungar, 1982), 139.
8. On the growing importance of agents and independent producers, see Tino Balio, "New Producers for Old: United Artists and the Shift to In-

dependent Production," in Balio, *Hollywood in the Age of Television,* 165; Thomas Schatz, *Old Hollywood/New Hollywood: Ritual, Art, and Industry* (Ann Arbor: UMI Research Press, 1983), p, 172; Warren Buckland, "A Close Encounter with *Raiders of the Lost Ark:* Notes on Narrative Aspects of the New Hollywood Blockbuster," in Neale and Smith, *Contemporary Hollywood Cinema,* p, 166; King, *New Hollywood Cinema,* 6; David Cook, *A History of Narrative Film,* 3rd ed. (New York: Norton, 1996), 510; and Louis Giannetti, *Masters of the American Cinema* (Englewood Cliffs, N.J.: Prentice-Hall, 1981), 20–21.

9. Steve Vineberg, *Method Actors: Three Generations of an American Acting Style* (New York: Schirmer, 1991), 102.

10. On Clift's differences from Wayne, see Foster Hirsch, *A Method to Their Madness: The History of the Actors Studio* (New York: Norton, 1984), 313; and James Harvey, *Movie Love in the Fifties* (New York: Knopf, 2001), 126.

11. Richard Schickel, *Brando: A Life in Our Times* (New York: Atheneum, 1991), 73.

12. Ibid., 84.

13. Graham McCann, *Rebel Males: Clift, Brando, and Dean* (New Brunswick, N.J.: Rutgers University Press, 1993, © 1991), 142, 149.

14. I have discussed the export of American films to postwar Europe in greater detail in *Not Like Us,* 212–219. See also John Izod, *Hollywood and the Box Office, 1895–1986* (London: Macmillan, 1988), 118.

15. On American films and the West German audience in the late 1940s and 1950s, see Anthony Heilbut, *Exiled in Paradise: German Refugee Artists and Intellectuals in America from the 1930s to the Present* (Berkeley: University of California Press, 1997, © 1983), 243; Ursula Hardt, *From Caligari to California: Eric Pommer's Life in the International Film Wars* (Providence: Berghahn, 1996), 172; Victoria de Grazia, *Irresistible Empire: America's Advance through Twentieth-Century Europe* (Cambridge: Harvard University Press, 2005), 291, 335; John Taylor, *Strangers in Paradise: The Hollywood Émigrés, 1933–1950* (New York: Holt, Rinehart and Winston, 1983), 177; Pells, *Not Like Us,* 216; Uta Poiger, *Jazz, Rock, and Rebels: Cold War Politics and American Culture in a Divided Germany* (Berkeley: University of California Press, 2000), 71; Heide Fehrenbach, "Persistent Myths of Americanization: German Reconstruction and the Renationalization of Postwar Cinema, 1945–1965," in *Transactions, Transgressions, Transformations: American Culture in Western Europe and Japan,* ed. Heide Fehrenbach and Uta Poiger (New York: Berghahn, 2000), 94, 102; and Lutz Koepnick, *The Dark Mirror: German Cinema between Hitler and Hollywood* (Berkeley: University of California Press, 2002), 197.

16. The statistics are calculated in Pells, *Not Like Us,* 219.

17. I have discussed the French film critics and the auteur theory in *Not Like Us,* 253–258. See also Guy Austin, *Stars in Modern French Films* (London: Arnold, 2003), 8; Paul Monaco, *Ribbons in Time: Movies and Society since 1945* (Bloomington: Indiana University Press, 1988), 34, 37; Antoine de Baecque and Serge Toubiana, *Truffaut: A Biography,* trans. Catherine Temerson (Berkeley: University of California Press, 2000, © 1999), 84; and Louis Menand, "Paris, Texas: How Hollywood Brought the Cinema Back from France," *New Yorker,* February 17–24, 2003, p. 170.

18. I have described at greater length the Italian attraction to the realism of modern American literature in *Not Like Us,* 245–247. See also Peter Bondanella, *Italian Cinema: From Neorealism to the Present* (New York: Continuum, 1997, © 1983), 25; and Cook, *A History of Narrative Film,* 426.

19. On the commercial success and style of Italian neorealist films, see Tino Balio, *United Artists: The Company That Changed the Film Industry* (Madison: University of Wisconsin Press, 1987), 224; Douglas Gomery, *Shared Pleasures: A History of Movie Presentations in the United States* (Madison: University of Wisconsin Press, 1992), 181; and Bondanella, *Italian Cinema,* 42–43.

20. For the global popularity of Italian movies in the late 1950s and early 1960s, and especially of Fellini's and Antonioni's films, see *Not Like Us,* 221, 224; Victoria de Grazia, "Mass Culture and Sovereignty: The American Challenge, 1920–1960," *Journal of Modern History* 61 (1989): 83; Bondanella, *Italian Cinema,* 109, 113, 145, 229–231; and Richard Schickel, *Matinee Idylls: Reflections on the Movies* (Chicago: Ivan Dee, 1999), 168–169.

21. Alan Williams, *Republic of Images: A History of French Filmmaking* (Cambridge: Harvard University Press, 1992), 327; Vanessa Schwartz, *It's So French! Hollywood, Paris, and the Making of Cosmopolitan Film Culture* (Chicago: University of Chicago Press, 2007), 146–147; Monaco, *Ribbons in Time,* 33, 36, 53, 60.

22. For more on the methods of the New Wave directors and their desire to shock their audience, see Richard Martin, *Mean Streets and Raging Bulls: The Legacy of Film Noir in Contemporary American Cinema* (Lanham, Md.: Scarecrow, 1997), 23; King, *New Hollywood Cinema,* 40; Ray, *A Certain Tendency of the Hollywood Cinema,* 273–274; Noël Carroll, *Interpreting the Moving Image* (Cambridge: Cambridge University Press, 1998), 254; and Cook, *A History of Narrative Film,* 535.

23. On Godard's Brechtian techniques, see Williams, *Republic of Images,* 383; Patrick McGilligan, *Fritz Lang: The Nature of the Beast* (London: Faber and Faber, 1997), 449–450; and Cook, *A History of Narrative Film,* 628. Godard's statement about making movies for a few people is reproduced in Schickel, *Matinee Idylls,* 195.

24. Jeremy Tunstall and David Machin, *The Anglo-American Media Connection* (Oxford: Oxford University Press, 1999), 216.

25. Ray, *A Certain Tendency of the Hollywood Cinema,* 138.

26. Gomery, *Shared Pleasures,* 181, 184–185.

27. On the success of *And God Created Woman* in the United States, and the "modernity" of Bardot, see Pells, *Not Like Us,* 222; and Schwartz, *It's So French!* 19–20, 121, 137.

28. For the popularity of British comedies and working-class films in the United States, and Hollywood's funding of movies with international casts, see Pells, *Not Like Us,* 222–223, 226–227. See also James Chapman, *Licence to Thrill: A Cultural History of the James Bond Films* (London: Tauris, 1999), 67.

29. On the Bond phenomenon and its influence in America, see Chapman, *Licence to Thrill,* 13–14, 21–22, 55; and Sarah Street, *Transatlantic Crossings: British Feature Films in the United States* (New York: Continuum, 2002), 187–188.

11
The New Wave at Home

1. On the emergence of "serious" film criticism in magazines and Sarris's esthetic predilections, see Robert Ray, *A Certain Tendency of the Hollywood Cinema, 1930–1980* (Princeton: Princeton University Press, 1985), 266; and Stephen Crofts, "Authorship and Hollywood," in *American Cinema and Hollywood: Critical Approaches,* ed. John Hill and Pamela Gibson (Oxford: Oxford University Press, 2000), 88.

2. The quotations from Kael can be found in Pauline Kael, "Trash, Art, and the Movies," in *For Keeps* (New York: Plume, 1996, © 1994), 203, 210, 218, 227. Emphasis in the original. See also Louis Menand, "Finding It at the Movies," *New York Review of Books,* March 23, 1995, pp. 12–13; and David Thomson, *Overexposures: The Crisis in American Filmmaking* (New York: Murrow, 1981), 279.

3. Thomson, *Overexposures,* 55; Thomas Schatz, *Old Hollywood/New Hollywood: Ritual, Art, and Industry* (Ann Arbor: UMI Research Press, 1983), 203–204.

4. Schatz, *Old Hollywood/New Hollywood,* 205; Michael Pye and Lynda Myles, *The Movie Brats: How the Film Generation Took over Hollywood* (New York: Holt, Rinehart and Winston, 1979), 60.

5. Mark Harris, *Pictures at a Revolution: Five Movies and the Birth of the New Hollywood* (New York: Penguin, 2008), 184, 236.

6. Ibid., 382; David Cook, *A History of Narrative Film,* 3rd ed. (New York: Norton, 1996), 920.

7. For more on the new generation of male movie stars, see Ray, *A Certain*

Tendency of the Hollywood Cinema, 260; and Mark Feeney, *Nixon at the Movies: A Book about Belief* (Chicago: University of Chicago Press, 2004), 304.

8. On the continuing power of the studios, see Geoff King, *New Hollywood Cinema: An Introduction* (New York: Columbia University Press, 2002), 62–63; and David Puttnam, *The Undeclared War: The Struggle for Control of the World's Film Industry* (New York: HarperCollins, 1997), 275.

9. For more on the impact of Europeans culture and film techniques on American movies, see Paul Monaco, *Ribbons in Time: Movies and Society Since 1945* (Bloomington: Indiana University Press, 1988), 60; Noël Carroll, *Interpreting the Moving Image* (Cambridge: Cambridge University Press, 1998), 261; and King, *New Hollywood Cinema,* 12.

10. The quotations from Forman can be found in Dave Kehr, "From One Cuckoo's Nest to Another," *New York Times,* February 10, 2008.

11. Thomas Elsaesser, "American Auteur Cinema: The Last—or First—Picture Show?" in *The Last Great American Picture Show: New Hollywood Cinema in the 1970s,* ed. Thomas Elsaesser, Alexander Horwath, and Noel King (Amsterdam: Amsterdam University Press, 2004), 60.

12. For the pressure that American movies in the late 1960s and 1970s put on viewers to figure out the characters and the plots, see Peter Kramer, "Post-classical Hollywood," in Hill and Gibson, *American Cinema and Hollywood,* 80; and David Thomson, "The Decade when Movies Mattered," and Christian Keathley, "Trapped in the Affection Image: Hollywood's Post-traumatic Cycle (1970–1976)," in Elsaesser, Horwath, and King, *The Last Great American Picture Show,* 74, 300.

13. The quotations from Scorsese and his appreciation of American films can be found in George Hickenlooper, *Reel Conversations: Candid Interviews with Film's Foremost Directors and Critics* (Secaucus, N.J.: Carol, 1991), 20.

14. On the audience's ability to understand a film visually without having to be shown the connections between shots, see Todd Gitlin, *Media Unlimited: How the Torrent of Images and Sounds Overwhelms Our Lives* (New York: Metropolitan, 2001), 89; and Richard Schickel, "Life Goes to the Movies," in Hickenlooper, *Reel Conversations,* 205–206.

15. Jonathan Rosenbaum, "New Hollywood and the Sixties Melting Pot," in Elsaesser, Horwath, and King, *The Last Great American Picture Show,* 140.

16. On the similarities between Dunaway and Bardot, see Louis Menand, "Paris, Texas: How Hollywood Brought the Cinema Back from France," *New Yorker,* February 17–24, 2003, p. 177.

17. Ibid., 176.

18. For the final scene and the critical reaction to *Bonnie and Clyde,* see Gitlin, *Media Unlimited,* 89; Harris, *Pictures at a Revolution,* 256;

Menand, "Paris, Texas," 175, 177; and Louis Giannetti, *Masters of the American Cinema* (Englewood Cliffs, N.J.: Prentice-Hall, 1981), 382.

19. Kael's quotations can be found in Pauline Kael, "Bonnie and Clyde," in *For Keeps,* 141, 145. Emphasis in original. See also Kramer, "Post-classical Hollywood," 71.

20. Menand, "Paris, Texas," 176–177.

21. Harris, *Pictures at a Revolution,* 237.

22. Nichols's remembrance of the last scene in *The Graduate* is recounted in Charles McGrath, "Mike Nichols, Master of Invisibility," *New York Times,* April 12, 2009.

23. For more on the countercultural attitudes of *Easy Rider,* see King, *New Hollywood Cinema,* 18; and Ray, *A Certain Tendency of the Hollywood Cinema,* 304.

24. Ray, *A Certain Tendency of the Hollywood Cinema,* 297.

25. For additional discussions of Gittes's powerlessness in *Chinatown,* see Dennis Bingham, *Acting Male: Masculinities in the Films of James Stewart, Jack Nicholson, and Clint Eastwood* (New Brunswick, N.J.: Rutgers University Press, 1994), 127; Keathley, "Trapped in the Affection Image," 297; and Jim Shepard, "Jolting Noir with a Shot of Nihilism," *New York Times,* February 7, 1999.

26. Feeney, *Nixon at the Movies,* 260, 263.

27. Lutz Koepnick, *The Dark Mirror: German Cinema between Hitler and Hollywood* (Berkeley: University of California Press, 2002), 100.

28. Garry Wills, *John Wayne's America: The Politics of Celebrity* (New York: Simon and Schuster, 1997), 311–312.

29. For a more detailed discussion of the contrasts between nature and civilization in the American Western, see Ray, *A Certain Tendency of the Hollywood Cinema,* 59–60, 63.

30. Winfried Fluck, "Film and Memory," in *Sites of Memory in American Literatures and Cultures,* ed. Udo Hebel (Heidelberg: Universitätsverlag C. Winter, 2003), 224.

31. On Kurowawa's "Westerns," see Peter Conrad, *Modern Times, Modern Places: How Life and Art Were Transformed in a Century of Revolution, Innovation, and Radical Change* (New York: Knopf, 1999), 521, 682.

32. Peter Bondanella, *Italian Cinema: From Neorealism to the Present* (New York: Continuum, 1997, © 1983), 253–254.

33. Ibid., 258.

34. For more on the style of *The Wild Bunch,* see Lee Mitchell, *Westerns: Making the Man in Fiction and Films* (Chicago: University of Chicago Press, 1996), 239, 247, 250, 252.

35. The look and themes of *McCabe and Mrs. Miller* are discussed at greater

length in King, *New Hollywood Cinema,* 89; Schatz, *Old Hollywood/ New Hollywood,* 249; and Helene Keyssar, *Robert Altman's America* (New York: Oxford University Press, 1991), 183, 190, 197.

36. For additional interpretations of Woody Allen's films, see Carl Boggs and Tom Pollard, *A World in Chaos: Social Crisis and the Rise of Postmodern Cinema* (Lanham, Md.: Rowman and Littlefield, 2003), 141; Mark Shechner, "Woody Allen: The Failure of the Therapeutic," in *From Hester Street to Hollywood: The Jewish-American Stage and Screen,* ed. Sarah Cohen (Bloomington: Indiana University Press, 1983), 232; Schatz, *Old Hollywood/New Hollywood,* 225; and Richard Schickel, *Schickel on Film: Encounters—Critical and Personal—with Movie Immortals* (New York: Murrow, 1989), 290. On the end of *8½,* see Bondanella, *Italian Cinema,* 134, 231, 244.

37. On Scorsese's cinematic influences and the connection between *The Searchers* and *Taxi Driver,* see Krin Gabbard, *Jammin' at the Margins: Jazz and the American Cinema* (Chicago: University of Chicago Press, 1996), 269; Pye and Myles, *The Movie Brats,* 10; Richard Martin, *Mean Streets and Raging Bulls: The Legacy of Film Noir in Contemporary American Cinema* (Lanham, Md.: Scarecrow, 1997), 83; Pellegrino D'Acierno, "Cinema Paradiso: The Italian American Presence in American Cinema," in *The Italian American Heritage: A Companion to Literature and Arts,* ed. Pellegrino D'Acierno (New York: Garland, 1999), 565–566; John Orr, *Cinema and Modernity* (Cambridge: Polity, 1993), 153; and Ray, *A Certain Tendency of the Hollywood Cinema,* 359.

38. For more details on the making and success of the first two *Godfather* films, and on Coppola's themes and style, see Pye and Myles, *The Movie Brats,* 90; Patricia Bosworth, *Marlon Brando* (New York: Penguin, 2001), 167, 174; Michael Sragow, "Godfatherhood: Twenty-Five Years Later, Francis Ford Coppola Thinks It's a Mixed Blessing," *New Yorker,* March 24, 1997, p. 51; D'Acierno, "Cinema Paradiso," 577; Ray, *A Certain Tendency of the Hollywood Cinema,* 343, 345; David Thomson, *The Whole Equation: A History of Hollywood* (New York: Vintage, 2006, © 2005), 330; and Feeney, *Nixon at the Movies,* 269.

39. Schatz, *Old Hollywood/New Hollywood,* 204.

40. On Lucas and the profits from *Star Wars,* see Elsaesser, "American Auteur Cinema," 53; Richard Maltby, "'Nobody Knows Everything': Post-Classical Historiographies and Consolidated Entertainment," in *Contemporary Hollywood Cinema,* ed. Steve Neale and Murray Smith (London: Routledge, 1998), 24; and Schatz, *Old Hollywood/New Hollywood,* 208.

41. Schatz, *Old Hollywood/New Hollywood,* 259.

12
A Method They Couldn't Refuse

1. Paula Cohen, *Silent Film and the Triumph of the American Myth* (New York: Oxford University Press, 2001), 117; Richard Butsch, *The Making of American Audiences: From Stage to Television, 1750–1990* (New York: Cambridge University Press, 2000), 15, 115; James Naremore, *Acting in the Cinema* (Berkeley: University of California Press, 1988), 46.

2. Foster Hirsch, *A Method to Their Madness: The History of the Actors Studio* (New York: Norton, 1984), 31, 34.

3. On Stanislavski's ideas, see Hirsch, *A Method to Their Madness,* 39–40, 43; Sonia Moore, *The Stanislavski System: The Professional Training of an Actor* (New York: Penguin, 1984, © 1960), 4, 9, 20, 27, 32, 36, 42–44, 46–49, 55, 59, 60, 63, 68, 73; Vasily Toporkov, *Stanislavski in Rehearsal: The Final Years,* trans. Christine Edwards (New York: Routledge, 1998, © 1979), 177, 218; and Edward Easty, *On Method Acting* (New York: Ballantine, 1989, © 1981), 15, 125.

4. Hirsch, *A Method to Their Madness,* 53.

5. Sharon Carnicke, *Stanislavsky in Focus* (Amsterdam: Harwood, 1998), 18; David Garfield, *A Player's Place: The Story of the Actors Studio* (New York: Macmillan, 1980), 8.

6. Carnicke, *Stanislavsky in Focus,* 62.

7. I have analyzed the Group Theater and its plays at greater length in *Radical Visions and American Dreams: Culture and Social Thought in the Depression Years* (New York: Harper and Row, 1973), 256–262. See also Hirsch, *A Method to Their Madness,* 66, 72, 76; Carnicke, *Stanislavsky in Focus,* 40, 44; and Steve Vineberg, *Method Actors: Three Generations of an American Acting Style* (New York: Schirmer, 1991), 52.

8. Olivier's statement is quoted in Michael Gilmore, *Differences in the Dark: American Movies and English Theater* (New York: Columbia University Press, 1998), 69.

9. For more on Welles as an actor, see Michael Anderegg, *Orson Welles, Shakespeare, and Popular Culture* (New York: Columbia University Press, 1999), 141–142, 146, 155, 157–159; and Claudia Pierpont, "The Player Kings," *New Yorker,* November 19, 2007, p. 70.

10. Dennis Bingham, *Acting Male: Masculinities in the Films of James Stewart, Jack Nicholson, and Clint Eastwood* (New Brunswick, N.J.: Rutgers University Press, 1994), 10, 14.

11. Richard Schickel, *Brando: A Life in Our Times* (New York: Atheneum, 1991), 17.

12. On the formation of the Actors Studio, see Garfield, *A Player's Place,* 44; Hirsch, *A Method to Their Madness,* 120–121; Patricia Bosworth, *Mar-*

lon Brando (New York: Penguin, 2001), 32; and Robert Long, *Broadway, the Golden Years: Jerome Robbins and the Great Choreographer-Directors, 1940 to the Present* (New York: Continuum, 2001), 81.

13. On the transition from Kazan to Strasberg, see Hirsch, *A Method to Their Madness*, 122, 124; Bosworth, *Marlon Brando*, 33; and Carnicke, *Stanislavsky in Focus*, 48, 51.

14. For more on Strasberg's emphasis on improvisation, see Easty, *On Method Acting*, 112, 122; and Naremore, *Acting in the Cinema*, 202.

15. Sharon Carnicke, "Lee Strasberg's Paradox of the Actor," in Alan Lovell and Peter Krämer, eds., *Screen Acting* (London: Routledge, 1999), 83; Naremore, *Acting in the Cinema*, 197.

16. For Adler's critique of Strasberg, see Howard Pollack, *Aaron Copland: The Life and Work of an Uncommon Man* (Urbana: University of Illinois Press, 2000, © 1999), 261; Bosworth, *Marlon Brando*, 18; and Schickel, *Brando*, 16.

17. Moore, *The Stanislavski System*, 6; Carnicke, *Stanislavsky in Focus*, 61.

18. Vineberg, *Method Actors*, 121.

19. For a description of Tandy's characterization of Blanche DuBois, see Philip Kolin, *Williams: A Streetcar Named Desire* (New York: Cambridge University Press, 2000), 19.

20. Graham McCann, *Rebel Males: Clift, Brando, and Dean* (New Brunswick, N.J.: Rutgers University Press, 1993, © 1991), 86; Kolin, *Williams*, 25.

21. On Brando's performance in the stage version of *Streetcar*, see Richard Schickel, *Intimate Strangers: The Culture of Celebrity in America* (Chicago: Ivan Dee, 2000, © 1985), 102; Claudia Pierpont, "Method Man," *New Yorker*, October 27, 2008, p. 68; and Hirsch, *A Method to Their Madness*, 299.

22. Hirsch, *A Method to Their Madness*, 299; Pierpont, "Method Man," 68.

23. For the foreign productions of *Streetcar*, see Kolin, *Williams*, 40–41, 48–50.

24. I have described the compatibility of Method acting with the movies in *The Liberal Mind in a Conservative Age: American Intellectuals in the 1940s and 1950s* (New York: Harper and Row, 1985), 371. See also Hirsch, *A Method to Their Madness*, 294–295, 314; and McCann, *Rebel Males*, 89, 91.

25. For more on the feminine quality of Method actors, see McCann, *Rebel Males*, 3; Hirsch, *A Method to Their Madness*, 318; and Christine Geraghty, "Re-enacting Stardom: Questions of Texts, Bodies and Performance," in *Reinventing Film Studies*, ed. Christine Gledhill and Linda Williams (London: Arnold, 2000), 198.

26. On Clift's mannerisms, see Vineberg, *Method Actors*, 142; and McCann, *Rebel Males*, 55.

27. McCann, *Rebel Males*, 25, 76.

28. Hirsch, *A Method to Their Madness*, 299–300; Naremore, *Acting in the Cinema*, 207.

29. On Dean's career and acting style, see McCann, *Rebel Males*, 24, 132–133; Peter Conrad, *Modern Times, Modern Places: How Life and Art Were Transformed in a Century of Revolution, Innovation, and Radical Change* (New York: Knopf, 1999), 561; and Vineberg, *Method Actors*, 192.

30. Schickel, *Intimate Strangers*, 100; McCann, *Rebel Males*, 113.

31. Bosworth, *Marlon Brando*, 176.

32. For Strasberg's technique in *The Godfather: Part II*, see Sharon Carnicke, "From Acting Guru to Hollywood Star: Lee Strasberg as Actor," in *Contemporary Hollywood Stardom*, ed. Thomas Austin and Martin Barker (London: Arnold, 2003), 129; and Vineberg, *Method Actors*, 109.

33. Hirsch, *A Method to Their Madness*, 314.

34. The De Niro quotation can be found in McCann, *Rebel Males*, 180.

35. Pauline Kael, "*Last Tango in Paris*," in *For Keeps* (New York: Plume, 1996, © 1994), 450. See also Schickel, *Brando*, 178.

36. For Brando's statement after *Last Tango in Paris*, see McCann, *Rebel Males*, 123. See also Schickel, *Intimate Strangers*, 111.

37. Olivier's remarks are quoted in Chloe Veltman, "British Actors Aren't Better Than Our Own," *Wall Street Journal*, March 24–25, 2007.

38. On Nicholson's rejection of the Method, see Bingham, *Acting Male*, 116; and Vineberg, *Method Actors*, 317.

39. For the modernist qualities of acting in the twentieth century, see Schickel, *Intimate Strangers*, 98, 103.

40. Garfield, *A Player's Place*, 98–99, 117, 254.

41. On the desire for a new form of acting in Britain, see Peter Stead, *Film and the Working Class: The Feature Film in British and American Society* (London: Routledge, 1989), 180, 190.

42. For the Day-Lewis quotations, see Lynn Hirschberg, "The New Frontier's Man," *New York Times Magazine.* November 11, 2007, p. 64.

13
The Global Popularity of American Movies

1. Tino Balio, "The Art Film Market in the New Hollywood," in *Hollywood and Europe: Economics, Culture, National Identity, 1945–95*, ed. Geoffrey Nowell-Smith and Steven Ricci (London: British Film Institute, 1998), 65.

2. For the statistics on movie attendance and ancillary revenues, see David Thomson, *The Whole Equation: A History of Hollywood* (New York: Vintage, 2006, © 2005), 350; Jon Gertner, "Box Office in a Box: How DVDs Are Changing Everything about Hollywood," *New York Times Magazine*, November 14, 2004, p. 106; and David Denby, "Big Pictures," *New Yorker*, January 8, 2007, p. 54.

3. Rick Lyman, "Even Blockbusters Find Fame Fleeting in a Multiplex Age," *New York Times,* August 13, 2001.

4. For more on the success and themes of *Titanic,* see Gaylyn Studlar and Kevin Sandler, "Introduction: The Seductive Waters of James Cameron's Film Phenomenon"; Justin Wyatt and Katherine Vlesmas, "The Drama of Recoupment: On the Mass Negotiation of *Titanic*"; Jeff Smith, "Selling My Heart: Music and Cross-Promotion in *Titanic*"; Peter Lehman and Susan Hunt, "'Something and Someone Else': The Mind, the Body, and Sexuality in *Titanic*"; and Peter Krämer, "Women First: *Titanic,* Action-Adventure Films, and Hollywood's Female Audience," in *Titanic: Anatomy of a Blockbuster,* ed. Kevin Sandler and Gaylyn Studlar (New Brunswick, N.J.: Rutgers University Press, 1999), 1, 7–8, 31, 34, 60, 89–90, 93, 124; and Emanuel Levy, *Oscar Fever: The History and Politics of the Academy Awards* (New York: Continuum, 2001), 101.

5. On the foreign reaction to *Titanic,* see Wyatt and Vlesmas, "The Drama of Recoupment," 38; Julian Stringer, "'The China Had Never Been Used!': On the Patina of Perfect Images in *Titanic,*" in Sandler and Studlar, *Titanic,* 206; and Stephanie Strom, "Tokyo," and Etgar Lefkovits, "Jerusalem," in Alan Riding, "Why 'Titanic' Conquered the World," *New York Times,* April 26, 1998.

6. On the emergence and tactics of the boutique studios, see Peter Biskind, *Down and Dirty Pictures: Miramax, Sundance, and the Rise of Independent Film* (New York: Simon and Schuster, 2004), 25; Balio, "The Art Film Market in the New Hollywood," 64; and Denby, "Big Pictures," 61–62.

7. Dave Kehr, "You Can Make 'Em Like They Used To," *New York Times,* November 12, 2006.

8. Foster Hirsch, *Detours and Lost Highways: A Map of Neo-Noir* (New York: Limelight, 1999), 270.

9. Biskind, *Down and Dirty Pictures,* 189.

10. For more on Eastwood's acting techniques, see Dennis Bingham, *Acting Male: Masculinities in the Films of James Stewart, Jack Nicholson, and Clint Eastwood* (New Brunswick, N.J.: Rutgers University Press, 1994), 221–222.

11. Ibid., 232.

12. For the figures on the market share of locally made films in various countries, see Toby Miller, Nitin Govil, John McMurria, and Richard Maxwell, *Global Hollywood* (London: British Film Institute, 2001), 4; Geoffrey Nowell-Smith, "Introduction," in Nowell-Smith and Ricci, *Hollywood and Europe,* 3; and Alan Riding, "French Fume at One Another over U.S. Films' Popularity," *New York Times,* December 14, 1999.

13. Marc Silberman, "Germany," in *The International Movie Industry,* ed. Gorham Kindem (Carbondale: Southern Illinois University Press, 2000), 218; Philippe Meers, "'It's the Language of Film!': Young Film Audiences

on Hollywood and Europe," in *Hollywood Abroad: Audiences and Cultural Exchange,* ed. Melvyn Stokes and Richard Maltby (London: British Film Institute, 2004), 160, 164–165.

14. I have discussed the problems with subsidies in *Not Like Us: How Europeans Have Loved, Hated, and Transformed American Culture since World War II* (New York: Basic, 1997), 210–211. See also David Bordwell, *Planet Hong Kong: Popular Cinema and the Art of Entertainment* (Cambridge: Harvard University Press, 2000), 6; Tyler Cowen, *Creative Destruction: How Globalization Is Changing the World's Cultures* (Princeton: Princeton University Press, 2002), 81; and David Puttnam, *The Undeclared War: The Struggle for Control of the World's Film Industry* (New York: HarperCollins, 1997), 301, 333.

15. John Hill, "Film and Television," in *World Cinema: Critical Approaches,* ed. John Hill and Pamela Gibson (Oxford: Oxford University Press, 2000), 223; Susan Hayward, "France," in Kindem, *The International Movie Industry,* 204; Miller, Govil, McMurria, and Maxwell, *Global Hollywood,* 103; Biskind, *Down and Dirty Pictures,* 445.

16. Michael Cieply, "When the Comedy Is Lost in Translation," *New York Times,* June 22, 2008; Lauren Schuker, "Indie Films Suffer Dropoff in Rights Sales," *Wall Street Journal,* April 20, 2009.

17. On the popularity of and box office receipts for recent foreign-language films in America, see Bordwell, *Planet Hong Kong,* 96; Biskind, *Down and Dirty Pictures,* 361; and Laura Holson, "Hollywood's Road Trip," *New York Times,* April 23, 2006.

18. For more detail on the Hong Kong film industry and the influence of American movies on its techniques, see Bordwell, *Planet Hong Kong,* 18, 50, 65, 84, 89, 123, 150, 200; David Desser, "The Kung Fu Craze: Hong Kong Cinema's First American Reception," in *The Cinema of Hong Kong: History, Arts, Identity,* ed. Poshek Fu and David Desser (New York: Cambridge University Press, 2000), 25; and Christina Klein, *Cold War Orientalism: Asia in the Middlebrow Imagination, 1945–1961* (Berkeley: University of California Press, 2003), 273–274.

19. On the structure and style of, and audience for, Bollywood films, see Cowen, *Creative Destruction,* 75; Diya Gullapalli, "Indians in U.S. Find New Sideline: Bollywood Moguls," *Wall Street Journal,* February 7, 2007; Nasreen Kabir, *Bollywood: The Indian Cinema Story* (London: Channel 4 Books, 2001), 1–2, 23, 215; Anupama Chopra, "Stumbling Toward Bollywood," *New York Times,* March 22, 2009; and Rosie Thomas, "Popular Hindi Cinema," in Hill and Gibson, *World Cinema,* 157–158.

20. Lauren Schuker and Merissa Marr, "Spielberg, India Firm Near Deal to Ally with DreamWorks," *Wall Street Journal,* June 18, 2008; Anand Giridharadas, "Hollywood Starts Making Bollywood Films in India,"

New York Times, August 8, 2007; Alexandra Alter, "A Passage to Hollywood," *Wall Street Journal,* February 6, 2009.

21. On Verhoeven's emigration and adaptation to Hollywood, see Rob van Scheers, *Paul Verhoeven,* trans. Aletta Stevens (London: Faber and Faber, 1997, © 1996), 97, 184; and Jonathan Rosenbaum, "Multinational Pest Control: Does American Cinema Still Exist?" in *Film and Nationalism,* ed. Alan Williams (New Brunswick, N.J.: Rutgers University Press, 2002), 221.

22. Sean Smith, "The $4 Billion Dollar Man," *Newsweek,* April 9, 2007, p. 83; Janet Staiger, "A Neo-Marxist Approach: World Film Trade and Global Culture Flows," in Williams, *Film and Nationalism,* 243; Robert Welkos and Ranwa Yehia, "Muslim World Still Loves American Movies," *Austin American-Statesman,* November 9, 2001.

23. Koichi Iwabuchi, "From Western Gaze to Global Gaze: Japanese Cultural Presence in Asia," in *Global Culture: Media, Arts, Policy, and Globalization,* ed. Diana Crane, Nobuko Kawashima, and Ken'ichi Kawasaki (New York: Routledge, 2002), 268.

24. Ruth Vasey, *The World According to Hollywood, 1918–1939* (Madison: University of Wisconsin Press, 1997), 165; Neal Gabler, "The World Still Watches America," *New York Times,* January 9, 2003.

25. I have analyzed the spread of English and its usefulness as a language of mass culture in *Not Like Us,* 206, 332. See also Barry James, "Online, and Off, English's Hegemony Is Challenged Globally," *International Herald Tribune,* February 12, 2001; Seth Mydans, "Nations in Asia Give English Their Own Flavorful Quirks," *New York Times,* July 1, 2001; Todd Gitlin, *Media Unlimited: How the Torrent of Images and Sounds Overwhelms Our Lives* (New York: Metropolitan, 2001), 186; and Puttnam, *The Undeclared War,* 323.

26. Gitlin, *Media Unlimited,* 94; Richard Schickel, *Matinee Idylls: Reflections on the Movies* (Chicago: Ivan Dee, 1999), 282.

27. For more on the universality of American films, see Richard Maltby and Ruth Vasey, "'Temporary American Citizens': Cultural Anxieties and Industrial Strategies in the Americanisation of European Cinema," in *"Film Europe" and "Film America": Cinema, Commerce and Cultural Exchange, 1920–1939,* ed. Andrew Higson and Richard Maltby (Exeter: University of Exeter Press, 1999), 33, 41–42; and Puttnam, *The Undeclared War,* 346.

Epilogue

1. I have described at greater length the ways audiences select and reinterpret what they receive from the American media in *Not Like Us: How Europeans Have Loved, Hated, and Transformed American Culture since*

World War II (New York: Basic, 1997), 273, 279–283, 330. See also Diana Crane, "Culture and Globalization: Theoretical Models and Emerging Trends," in *Global Culture: Media, Arts, Policy, and Globalization,* ed. Diana Crane, Nobuko Kawashima, and Ken'ichi Kawasaki (New York: Routledge, 2002), 14–15; Lawrence Levine, "The Folklore of Industrial Society: Popular Culture and Its Audiences," in *The Unpredictable Past: Explorations in American Cultural History* (New York: Oxford University Press, 1993), 295; and Michael Kammen, *American Culture, American Tastes: Social Change and the 20th Century* (New York: Basic, 2000, © 1999), 211.

2. On Donald Duck in Germany and reality TV shows in Indonesia, see Susan Bernofsky, "Why Donald Duck Is the Jerry Lewis of Germany," *Wall Street Journal,* May 23–24, 2009; and Norimutu Onishi, "Indonesia's TV Makeovers Now More Extreme Than Its Politics," *New York Times,* May 23, 2009.

3. For more on the impact of Japanese cultural exports including anime, see Gordon Matthews, *Global Culture/Individual Identity: Searching for Home in the Cultural Supermarket* (London: Routledge, 2000), 20; Koichi Iwabuchi, *Recentering Globalization: Popular Culture and Japanese Transnationalism* (Durham, N.C.: Duke University Press, 2002), 24, 28, 31, 47; Koichi Iwabuchi, "From Western Gaze to Global Gaze: Japanese Cultural Presence in Asia," in Crane, Kawashima, and Kawasaki, *Global Culture,* 258–259; Anthony Faiola, "Popular Culture Explodes as Japan's Hot New Export," *Austin American-Statesman,* December 29, 2003; J. D. Considine, "Making Anime a Little Safer for Americans," *New York Times,* January 20, 2002; and Julie Chao, "Exporting Cool: Japan's Pop-Cultural Influence, in Animé, Yu-Gi-Oh and More, Is at an All-Time High," *Austin American-Statesman,* April 20, 2004.

BIBLIOGRAPHY

I have listed here some of the sources that were extremely useful to me in writing this book. I have not attempted to re-cite all the entries in the notes. Nor have I included all the works that deal in some fashion with the topics the book discusses. Rather, I have indicated those books that I think can especially help the reader who wants to know more about the development of America's culture in the nineteenth and twentieth centuries, and its relationship to cultures in other parts of the world.

Histories of Modern Western Culture

Conrad, Peter. *Modern Times, Modern Places: How Life and Art Were Transformed in a Century of Revolution, Innovation, and Radical Change.* New York: Knopf, 1999.

Cowen, Tyler. *In Praise of Commercial Culture.* Cambridge: Harvard University Press, 1998.

Gans, Herbert. *Popular Culture and High Culture: An Analysis and Evaluation of Taste.* New York: Basic, 1999.

Watson, Peter. *The Modern Mind: An Intellectual History of the 20th Century.* New York: HarperCollins, 2001.

Histories of American Culture

Butsch, Richard. *The Making of American Audiences: From Stage to Television, 1750–1990.* New York: Cambridge University Press, 2000.

Collins, Jim, ed. *High-Pop: Making Culture into Popular Entertainment.* Malden, Mass.: Blackwell, 2002.

Cullen, Jim. *The Art of Democracy: A Concise History of Popular Culture in the United States*. New York: Monthly Review, 1996.

Czitrom, Daniel. *Media and the American Mind: From Morse to McLuhan*. Chapel Hill: University of North Carolina Press, 1982.

Gitlin, Todd. *Media Unlimited: How the Torrent of Images and Sounds Overwhelms Our Lives*. New York: Metropolitan, 2001.

Harris, Neil. *Cultural Excursions: Marketing Appetites and Cultural Tastes in Modern America*. Chicago: University of Chicago Press, 1990.

Hoberman, J., and Jeffrey Shandler. *Entertaining America: Jews, Movies, and Broadcasting*. Princeton: Princeton University Press, 2003.

Huggins, Nathan. *Harlem Renaissance*. New York: Oxford University Press, 1971.

Kammen, Michael. *American Culture, American Tastes: Social Change and the 20th Century*. New York: 1999; rpt. New York: Basic, 2000.

Kasson, Joy. *Buffalo Bill's Wild West: Celebrity, Memory, and Popular History*. New York: Hill and Wang, 2000.

Leach, William. *Land of Desire: Merchants, Power, and the Rise of a New American Culture*. New York: Pantheon, 1993.

Lears, Jackson. *Something for Nothing: Luck in America*. New York: Viking, 2003.

Levine, Lawrence. *Highbrow/Lowbrow: The Emergence of Cultural Hierarchy in America*. Cambridge: Harvard University Press, 1988.

———. *The Unpredictable Past: Explorations in American Cultural History*. New York: Oxford University Press, 1993.

Lynes, Russell. *The Lively Audience: A Social History of the Visual and Performing Arts in America, 1890–1950*. New York: Harper and Row, 1985.

McDonnell, Patricia. *On the Edge of Your Seat: Popular Theater and Film in Early Twentieth-Century American Art*. New Haven: Yale University Press, 2002.

Muccigrosso, Robert. *Celebrating the New World: Chicago's Columbian Exposition of 1893*. Chicago: Ivan Dee, 1993.

Noble, David. *Death of a Nation: American Culture and the End of Exceptionalism*. Minneapolis: University of Minnesota Press, 2002.

Nye, Russel. *The Unembarrassed Muse: The Popular Arts in America*. New York: Dial, 1970.

Pells, Richard. *The Liberal Mind in a Conservative Age: American Intellectuals in the 1940s and 1950s*. New York: Harper and Row, 1985.

———. *Radical Visions and American Dreams: Culture and Social Thought in the Depression Years*. New York: Harper and Row, 1973.

Schickel, Richard. *Intimate Strangers: The Culture of Celebrity in America*. 1985; rpt. Chicago: Ivan Dee, 2000.

Shi, David. *Facing Facts: Realism in American Thought and Culture, 1850–1920*. New York: Oxford University Press, 1995.

Taylor, William, ed. *Inventing Times Square: Commerce and Culture at the Crossroads of the World.* New York: Russell Sage, 1991.

Modernism

Bender, Thomas, and Carl Schorske, eds. *Budapest and New York: Studies in Metropolitan Transformation, 1870–1930.* New York: Russell Sage, 1994.

Bradbury, Malcolm, and James McFarlane, eds. *Modernism, 1890–1930.* New York: Penguin, 1976.

Crunden, Robert. *American Salons: Encounters with European Modernism, 1885–1917.* New York: Oxford University Press, 1993.

———. *Body and Soul: The Making of American Modernism.* New York: Basic, 2000.

Douglas, Ann. *Terrible Honesty: Mongrel Manhattan in the 1920s.* New York: Farrar, Straus and Giroux, 1996.

Everdell, William. *The First Moderns: Profiles in The Origins of Twentieth-Century Thought.* Chicago: University of Chicago Press, 1997.

Gay, Peter. *Modernism: The Lure of Heresy.* New York: Norton, 2007.

Gendron, Bernard. *Between Montmartre and the Mudd Club: Popular Music and the Avant-Garde.* Chicago: University of Chicago Press, 2002.

Heller, Adele, and Lois Rudnick, eds. *1915, the Cultural Moment: The New Politics, the New Woman, the New Psychology, the New Art, and the New Theatre in America* (New Brunswick, N.J.: Rutgers University Press, 1991.

Hobbs, Stuart. *The End of the American Avant Garde.* New York: New York University Press, 1997.

Hoeveler, J. David. *The Postmodernist Turn: American Thought and Culture in the 1970s.* New York: Twayne, 1996.

Ludington, Townsend, ed. *A Modern Mosaic: Art and Modernism in the United States.* Chapel Hill: University of North Carolina Press, 2000.

Scott, William, and Peter Rutkoff. *New York Modern: The Arts and the City.* Baltimore: Johns Hopkins University Press, 1999.

Singal, Daniel, ed. *Modernist Culture in America.* Belmont, Calif.: 1987; rpt. Wadsworth, 1991.

Stansell, Christine. *American Moderns: Bohemian New York and the Creation of a New Century.* New York: Metropolitan, 2000.

Watkins, Glenn. *Pyramids at the Louvre: Music, Culture, and Collage from Stravinsky to the Postmodernists.* Cambridge: Harvard University Press, 1994.

Watson, Steven. *Prepare for Saints: Gertrude Stein, Virgil Thomson, and the Mainstreaming of American Modernism.* New York: Random House, 1998.

Immigrants and Refugees

Baxter, John. *The Hollywood Exiles*. New York: Taplinger, 1976.

Brinkman, Reinhold, and Christoph Wolff, eds. *Driven into Paradise: The Musical Migration from Nazi Germany to the United States*. Berkeley: University of California Press, 1999.

D'Acierno, Pellegrino, ed. *The Italian American Heritage: A Companion to Literature and Arts*. New York: Garland, 1999.

Grunfeld, Frederic. *Prophets without Honour: Freud, Kafka, Einstein, and Their World*. New York: 1979; rpt. Kodansha America, 1996.

Heilbut, Anthony. *Exiled in Paradise: German Refugee Artists and Intellectuals in America from the 1930s to the Present*. 1983; rpt. Berkeley: University of California Press, 1997.

Horowitz, Joseph. *Artists in Exile: How Refugees from Twentieth-Century War and Revolution Transformed the American Performing Arts*. New York: HarperCollins, 2008.

Taylor, John. *Strangers in Paradise: The Hollywood Émigrés, 1933–1950*. New York: Holt, Rinehart and Winston, 1983.

Painting

Cohen-Solal, Annie. *Painting American: The Rise of American Artists, Paris 1867–New York 1948*. Trans. Laurie Hurwitz-Attias. New York: Knopf, 2001.

Corn, Wanda. *The Great American Thing: Modern Art and National Identity, 1915–1935*. Berkeley: University of California Press, 1999.

Doss, Erika. *Benton, Pollock, and the Politics of Modernism: From Regionalism to Abstract Expressionism*. Chicago: University of Chicago Press, 1991.

Green, Martin. *New York 1913: The Armory Show and the Paterson Strike Pageant*. New York: Scribner's, 1988.

Haskell, Barbara. *The American Century: Art and Culture, 1900–1950*. New York: Norton, 1999.

Krenn, Michael. *Fall-Out Shelters for the Human Spirit: American Art and the Cold War*. Chapel Hill: University of North Carolina Press, 2005.

MacLeod, Glen. *Wallace Stevens and Modern Art: From the Armory Show to Abstract Expressionism*. New Haven: Yale University Press, 1993.

Mamiya, Christin. *Pop Art and Consumer Culture: American Super Market*. Austin: University of Texas Press, 1992.

Marquis, Alice. *Alfred H. Barr, Jr.: Missionary for the Modern*. Chicago: Contemporary, 1989.

———. *Hopes and Ashes: The Birth of Modern Times, 1929–1939*. New York: Free Press, 1986.

Phillips, Lisa. *The American Century: Art and Culture, 1950–2000*. New York: Norton, 1999.

Roeder, George. *Forum of Uncertainty: Confrontations with Modern Painting in Twentieth-Century American Thought*. Ann Arbor: UMI Research Press, 1980.

Tashjian, Dickran. *A Boatload of Madmen: Surrealism and the American Avant-Garde, 1920–1950*. New York: Thames and Hudson, 1995.

Tomkins, Calvin. *Duchamp: A Biography*. New York: Holt, 1996.

Wood, Paul, ed. *Varieties of Modernism*. New Haven: Yale University Press, 2004.

Architecture

Alofsin, Anthony, ed. *Frank Lloyd Wright: Europe and Beyond*. Berkeley: University of California Press, 1999.

Bacon, Mardges. *Le Corbusier in America: Travels in the Land of the Timid*. Cambridge: MIT Press, 2001.

Blake, Peter. *The Master Builders: Le Corbusier/Mies van der Rohe/Frank Lloyd Wright*. 1960; rpt. New York: Norton, 1996.

Kentgens-Craig, Margret. *The Bauhaus and America: First Contacts, 1919–1936*. 1993; Cambridge: MIT Press, 1999.

Wiseman, Carter. *Shaping a Nation: Twentieth-Century American Architecture and Its Makers*. New York: Norton, 1998.

Wolfe, Tom. *From Bauhaus to Our House*. New York: Farrar, Straus and Giroux, 1981.

Advertising and Design

Bogart, Michele. *Artists, Advertising, and the Borders of Art*. Chicago: University of Chicago Press, 1995.

Ewen, Stewart. *All Consuming Images: The Politics of Style in Contemporary Culture*. 1988; rpt. New York: Basic, 1999.

Fischer, Lucy. *Designing Women: Cinema, Art Deco, and the Female Form*. New York: Columbia University Press, 2003.

Heisner, Beverly. *Hollywood Art: Art Direction in the Days of the Great Studios*. Jefferson, N.C.: McFarland, 1990.

Hine, Thomas. *The Total Package: The Evolution and Secret Meanings of Boxes, Bottles, Cans, Tubes, and Other Persuasive Containers*. Boston: Little, Brown, 1995.

Kirkham, Pat. *Charles and Ray Eames: Designers of the Twentieth Century*. Cambridge: MIT Press, 1995.

Lamster, Mark, ed. *Architecture and Film*. New York: Princeton Architectural Press, 2000.

Marchand, Roland. *Advertising the American Dream: Making Way for Modernity, 1920–1940*. Berkeley: University of California Press, 1985.

Pulos, Arthur. *The American Design Adventure, 1940–1975*. Cambridge: MIT Press, 1988.

Remington, R. Roger. *American Modernism: Graphic Design, 1920 to 1960*. New Haven: Yale University Press, 2003.

Classical and Modernist Music

Crawford, Richard. *America's Musical Life: A History*. New York: Norton, 2001.

Dizikes, John. *Opera in America: A Cultural History*. New Haven: Yale University Press, 1993.

Ewen, David. *Music Comes to America*. 1942; rpt. New York: Allen, Towne and Heath, 1947.

Gienow-Hecht, Jessica. *Sound Diplomacy: Music and Emotions in Transatlantic Relations, 1850–1920*. Chicago: University of Chicago Press, 2009.

Hamm, Charles. *Music in the New World*. New York: Norton, 1983.

Horowitz, Joseph. *Understanding Toscanini: How He Became an American Culture-God and Helped Create a New Audience for Old Music*. New York: Knopf, 1987.

Joseph, Charles. *Stravinsky and Balanchine: A Journey of Invention*. New Haven: Yale University Press, 2002.

———. *Stravinsky Inside Out* (New Haven: Yale University Press, 2001).

Levy, Alan. *Musical Nationalism: American Composers' Search for Identity*. Westport, Conn.: Greenwood, 1983.

Oja, Carol. *Making Music Modern: New York in the 1920s*. New York: Oxford University Press, 2000.

Oja, Carol, and Judith Tick, eds. *Aaron Copland and His World*. Princeton: Princeton University Press, 2000.

Pollack, Howard. *Aaron Copland: The Life and Work of an Uncommon Man*. Urbana: University of Illinois Press, 1999.

Ross, Alex. *The Rest Is Noise: Listening to the Twentieth Century*. New York: Farrar, Straus and Giroux, 2007.

Struble, John. *The History of American Classical Music: MacDowell through Minimalism*. New York: Facts on File, 1995.

Sullivan, Jack. *New World Symphonies: How American Culture Changed European Music*. New Haven: Yale University Press, 1999.

Thomson, Virgil. *Virgil Thomson/By Virgil Thomson*. 1966; rpt. New York: Da Capo, 1977.

Tischler, Barbara. *An American Music: The Search for an American Musical Identity*. New York: Oxford University Press, 1986.

Zuck, Barbara. *A History of Musical Americanism.* Ann Arbor: UMI Research Press, 1980.

Jazz

Bindas, Kenneth. *Swing, That Modern Sound.* Jackson: University Press of Mississippi, 2001.

Collier, James. *Jazz: The American Theme Song.* New York: Oxford University Press, 1993.

———. *The Making of Jazz: A Comprehensive History.* 1978; rpt. New York: Delta, 1979.

Cook, Mervyn. *Jazz.* London: Thames and Hudson, 1998.

Curtis, Susan. *Dancing to a Black Man's Tune: A Life of Scott Joplin.* Columbia: University of Missouri Press, 1994.

DeVeaux, Scott. *The Birth of Bebop: A Social and Musical History.* Berkeley: University of California Press, 1997.

Dinnerstein, Joel. *Swinging the Machine: Modernity, Technology, and African American Culture between the World Wars.* Amherst: University of Massachusetts Press, 2003.

Erenberg, Lewis A. *Swingin' the Dream: Big Band Jazz and the Rebirth of American Culture.* Chicago: University of Chicago Press, 1998.

Gabbard, Krin. *Jammin' at the Margins: Jazz and the American Cinema.* Chicago: University of Chicago Press, 1996.

Gioia, Ted. *The History of Jazz.* New York: Oxford University Press, 1997.

———. *The Imperfect Art: Reflections on Jazz and Modern Culture.* New York: Oxford University Press, 1988.

Jackson, Jeffrey. *Making Jazz French: Music and Modern Life in Interwar Paris.* Durham, N.C.: Duke University Press, 2003.

Poiger, Uta. *Jazz, Rock, and Rebels: Cold War Politics and American Culture in a Divided Germany.* Berkeley: University of California Press, 2000.

Shipton, Alyn. *A New History of Jazz.* London: Continuum, 2001.

Wagnleitner, Reinhold, ed. *Satchmo Meets Amadeus.* Innsbruck: Studienverlag, 2006.

Williams, Martin. *The Jazz Tradition.* New York: Oxford University Press, 1993.

Popular Music and Broadway Musicals

Bayles, Martha. *Hole in Our Soul: The Loss of Beauty and Meaning in American Popular Music.* Chicago: University of Chicago Press, 1994.

Bindas, Kenneth, ed. *America's Musical Pulse: Popular Music in Twentieth-Century Society.* Westport, Conn.: Praeger, 1992.

Davis, Ronald. *A History of Music in American Life*. Vol. 2, *The Gilded Years, 1965–1920*. Huntington, N.Y.: Krieger, 1980.

Flinn, Denny. *Musical! A Grand Tour: The Rise, Glory, and Fall of an American Institution*. New York: Schirmer, 1997.

Furia, Philip. *Ira Gershwin: The Art of the Lyricist*. New York: Oxford University Press, 1996.

———. *Irving Berlin: A Life in Song*. New York: Schirmer, 1998.

———. *The Poets of Tin Pan Alley: A History of the Great Lyricists*. New York: Oxford University Press, 1990.

Grant, Mark. *The Rise and Fall of the Broadway Musical*. Boston: Northeastern University Press, 2004.

Hyland, William. *George Gershwin: A New Biography*. Westport, Conn.: Praeger, 2003.

———. *The Song Is Ended: Songwriters and American Music, 1900–1950*. New York: Oxford University Press, 1995.

Jablonski, Edward. *Gershwin*. New York: Doubleday, 1987.

Kenney, William. *Recorded Music in American Life: The Phonograph and Popular Memory, 1890–1945*. New York: Oxford University Press, 1999.

Long, Robert. *Broadway, the Golden Years: Jerome Robbins and the Great Choreographer-Directors, 1940 to the Present*. New York: Continuum, 2001.

Mast, Gerald. *Can't Help Singin': The American Musical on Stage and Screen*. Woodstock, N.Y.: Overlook, 1987.

Melnick, Jeffrey. *A Right to Sing the Blues: African Americans, Jews, and American Popular Song*. Cambridge: Harvard University Press, 1999.

Most, Andrea. *Making Americans: Jews and the Broadway Musical*. Cambridge: Harvard University Press, 2004.

Peyser, Joan. *The Memory of All That: The Life of George Gershwin*. New York: Simon and Schuster, 1993.

Rubin, Rachel, and Jeffrey Melnick, eds. *American Popular Music: New Approaches to the Twentieth Century*. Amherst: University of Massachusetts Press, 2000.

Saffle, Michael, ed. *Perspectives on American Music, 1900–1950*. New York: Garland, 2000.

Schwartz, Charles. *Gershwin: His Life and Music*. 1973; rpt. New York: Da Capo, 1979.

Sheed, Wilfrid. *The House That George Built: With a Little Help from Irving, Cole, and a Crew of about Fifty*. New York: Random House, 2007.

Histories of Film

Belton, John, ed. *Movies and Mass Culture*. New Brunswick, N.J.: Rutgers University Press, 1996.

Boggs, Carl, and Tom Pollard. *A World in Chaos: Social Crisis and the Rise of Postmodern Cinema*. Lanham, Md.: Rowman and Littlefield, 2003.

Carroll, Noël. *Interpreting the Moving Image*. Cambridge: Cambridge University Press, 1998.

Cook, David. *A History of Narrative Film*. 3rd ed. New York: Norton, 1996.

Monaco, Paul. *Ribbons in Time: Movies and Society since 1945*. Bloomington: Indiana University Press, 1988.

Orr, John. *Cinema and Modernity*. Cambridge: Polity, 1993.

———. *Contemporary Cinema*. Edinburgh: Edinburgh University Press, 1998.

Puttnam, David. *The Undeclared War: The Struggle for Control of the World's Film Industry*. New York: HarperCollins, 1997.

Williams, Alan, ed. *Film and Nationalism*. New Brunswick, N.J.: Rutgers University Press, 2002.

Foreign Movies

Abel, Richard. *French Cinema: The First Wave, 1915–1929*. Princeton: Princeton University Press, 1984.

Austin, Guy. *Stars in Modern French Films*. London: Arnold, 2003.

Bondanella, Peter. *Italian Cinema: From Neorealism to the Present*. 1983; rpt. New York: Continuum, 1997.

Bordwell, David. *Planet Hong Kong: Popular Cinema and the Art of Entertainment*. Cambridge: Harvard University Press, 2000.

Chapman, James. *Licence to Thrill: A Cultural History of the James Bond Films*. London: Tauris, 1999.

de Baecque, Antoine, and Serge Toubiana. *Truffaut: A Biography*. Trans. Catherine Temerson. 1999; rpt. Berkeley: University of California Press, 2000.

Grossvogel, David. *Didn't You Use to Be Depardieu? Film as Cultural Marker in France and Hollywood*. New York: Lang, 2002.

Hardt, Ursula. *From Caligari to California: Eric Pommer's Life in the International Film Wars*. Providence: Berghahn, 1996.

Higson, Andrew, and Richard Maltby, eds. *"Film Europe" and "Film America": Cinema, Commerce, and Cultural Exchange, 1920–1939*. Exeter: University of Exeter Press, 1999.

Hill, John, and Pamela Gibson, eds. *World Cinema: Critical Approaches*. Oxford: Oxford University Press, 2000.

Kabir, Nasreen. *Bollywood: The Indian Cinema Story*. London: Channel 4 Books, 2001.

Kindem, Gorham, ed. *The International Movie Industry*. Carbondale: Southern Illinois University Press, 2000.

Koepnick, Lutz. *The Dark Mirror: German Cinema between Hitler and Hollywood*. Berkeley: University of California Press, 2002.

Nowell-Smith, Geoffrey, and Steven Ricci, eds. *Hollywood and Europe: Economics, Culture, National Identity, 1945–95*. London: British Film Institute, 1998.

Saunders, Thomas. *Hollywood in Berlin: American Cinema and Weimar Germany*. Berkeley: University of California Press, 1994.

Schwartz, Vanessa. *It's So French! Hollywood, Paris, and the Making of Cosmopolitan Film Culture*. Chicago: University of Chicago Press, 2007.

Stead, Peter. *Film and the Working Class: The Feature Film in British and American Society*. London: Routledge, 1989.

Williams, Alan. *Republic of Images: A History of French Filmmaking*. Cambridge: Harvard University Press, 1992.

American Movies

Altman, Rick. *The American Film Musical*. Bloomington: Indiana University Press, 1987.

Balio, Tino, ed. *Hollywood in the Age of Television*. Boston: Unwin Hyman, 1990.

Berg, Charles. *Latino Images in Film: Stereotypes, Subversion, Resistance*. Austin: University of Texas Press, 2002.

Biskind, Peter. *Down and Dirty Pictures: Miramax, Sundance, and the Rise of Independent Film*. New York: Simon and Schuster, 2004.

———. *Easy Riders, Raging Bulls: How the Sex-Drugs-and-Rock 'n' Roll Generation Saved Hollywood*. New York: Simon and Schuster, 1998.

Cohen, Paula. *Silent Film and the Triumph of the American Myth*. New York: Oxford University Press, 2001.

Crafton, Donald. *The Talkies: American Cinema's Transition to Sound, 1926–1931*. 1997; rpt. Berkeley: University of California Press, 1999.

Delamater, Jerome. *Dance in the Hollywood Musical*. Ann Arbor: UMI Research Press, 1981.

Dickos, Andrew. *Street with No Name: A History of the Classic American Film Noir*. Lexington: University Press of Kentucky, 2002.

Elsaesser, Thomas, Alexander Horwath, and Noel King, eds. *The Last Great American Picture Show: New Hollywood Cinema in the 1970s*. Amsterdam: Amsterdam University Press, 2004.

Feeney, Mark. *Nixon at the Movies: A Book about Belief*. Chicago: University of Chicago Press, 2004.

Friedman, Lester. *Hollywood's Image of the Jew*. New York: Ungar, 1982.

Gabler, Neal. *An Empire of Their Own: How the Jews Invented Hollywood*. New York: Crown, 1988.

Gomery, Douglas. *Shared Pleasures: A History of Movie Presentations in the United States.* Madison: University of Wisconsin Press, 1992.

Harmetz, Aljean. *Round Up the Usual Suspects: The Making of Casablanca: Bogart, Bergman, and World War II.* New York: Hyperion, 1992.

Harris, Mark. *Pictures at a Revolution: Five Movies and the Birth of the New Hollywood.* New York: Penguin, 2008.

Hill, John, and Pamela Gibson, eds. *American Cinema and Hollywood: Critical Approaches.* Oxford: Oxford University Press, 2000.

Izod, John. *Hollywood and the Box Office, 1895–1986.* London: Macmillan, 1988.

Kael, Pauline. *For Keeps.* New York: Dutton, 1994.

King, Geoff. *New Hollywood Cinema: An Introduction.* New York: Columbia University Press, 2002.

Koszarski, Richard. *An Evening's Entertainment: The Age of the Silent Picture, 1915–1928.* 1990; rpt. Berkeley: University of California Press, 1994.

Levy, Emanuel. *Oscar Fever: The History and Politics of the Academy Awards.* New York: Continuum, 2001.

Martin, Richard. *Mean Streets and Raging Bulls: The Legacy of Film Noir in Contemporary American Cinema.* Lanham, Md.: Scarecrow, 1997.

May, Lary. *Screening Out the Past: The Birth of Mass Culture and the Motion Picture Industry.* New York: Oxford University Press, 1980.

Miller, Toby, Nitin Govil, John McMurria, and Richard Maxwell. *Global Hollywood.* London: British Film Institute, 2001.

Neale, Steve, and Murray Smith, eds. *Contemporary Hollywood Cinema.* London: Routledge, 1998.

Pye, Michael, and Lynda Myles. *The Movie Brats: How the Film Generation Took Over Hollywood.* New York: Holt, Rinehart and Winston, 1979.

Ray, Robert. *A Certain Tendency of the Hollywood Cinema, 1930–1980.* Princeton: Princeton University Press, 1985.

Sandler, Kevin, and Gaylyn Studlar, eds. *Titanic: Anatomy of a Blockbuster.* New Brunswick, N.J.: Rutgers University Press, 1999.

Sarris, Andrew. *The American Cinema: Directors and Direction, 1929–1968.* New York: Dutton, 1968.

Schatz, Thomas. *Old Hollywood/New Hollywood: Ritual, Art, and Industry.* Ann Arbor: UMI Research Press, 1983.

Schickel, Richard. *Matinee Idylls: Reflections on the Movies.* Chicago: Ivan Dee, 1999.

———. *Schickel on Film: Encounters—Critical and Personal—with Movie Immortals.* New York: Murrow, 1989.

Stokes, Melvyn, and Richard Maltby, eds. *Hollywood Abroad: Audiences and Cultural Exchange.* London: British Film Institute, 2004.

Thompson, Kristin. *Exporting Entertainment: America in the World Film Market, 1907–1934.* London: British Film Institute, 1985.

Thomson, David. *Overexposures: The Crisis in American Filmmaking*. New York: Murrow, 1981.

———. *The Whole Equation: A History of Hollywood*. New York: Knopf, 2005.

Vasey, Ruth. *The World According to Hollywood, 1918–1939*. Madison: University of Wisconsin Press, 1997.

Directors

Anderegg, Michael. *Orson Welles, Shakespeare, and Popular Culture*. New York: Columbia University Press, 1999.

Bogdanovich, Peter, ed. *Fritz Lang in America*. New York: Praeger, 1967.

Giannetti, Louis. *Masters of the American Cinema*. Englewood Cliffs, N.J.: Prentice-Hall, 1981.

Hickenlooper, George. *Reel Conversations: Candid Interviews with Film's Foremost Directors and Critics*. Secaucus, N.J.: Carol, 1991.

Keyssar, Helene. *Robert Altman's America*. New York: Oxford University Press, 1991.

McGilligan, Patrick. *Fritz Lang: The Nature of the Beast*. London: Faber and Faber, 1997.

Petrie, Graham. *Hollywood Destinies: European Directors in America, 1922– 1931*. 1985; rpt. Detroit: Wayne State University Press, 2002.

Ryall, Tom. *Alfred Hitchcock and the British Cinema*. London: Croom Helm, 1986.

Thompson, Kristin. *Herr Lubitsch Goes to Hollywood: German and American Film after World War I*. Amsterdam: Amsterdam University Press, 2005.

Zolotow, Maurice. *Billy Wilder in Hollywood*. New York: Putnam, 1977.

Acting in the Theater and Movies

Bingham, Dennis. *Acting Male: Masculinities in the Films of James Stewart, Jack Nicholson, and Clint Eastwood*. New Brunswick, N.J.: Rutgers University Press, 1994.

Bosworth, Patricia. *Marlon Brando*. New York: Penguin, 2001.

Carnicke, Sharon. *Stanislavsky in Focus*. Amsterdam: Harwood, 1998.

Easty, Edward. *On Method Acting*. 1981; rpt. New York: Ballantine, 1989.

Garfield, David. *A Player's Place: The Story of the Actors Studio*. New York: Macmillan, 1980.

Hirsch, Foster. *A Method to Their Madness: The History of the Actors Studio*. New York: Norton, 1984.

Kolin, Philip. *Williams: A Streetcar Named Desire*. New York: Cambridge University Press, 2000.

McCann, Graham. *Rebel Males: Clift, Brando, and Dean.* New Brunswick, N.J.: Rutgers University Press, 1991.

Moore, Sonia. *The Stanislavski System: The Professional Training of an Actor.* 1960; rpt. New York: Penguin, 1984.

Naremore, James. *Acting in the Cinema.* Berkeley: University of California Press, 1988.

Schickel, Richard. *Brando: A Life in Our Times.* New York: Atheneum, 1991.

Toporkov, Vasily. *Stanislavski in Rehearsal: The Final Years.* Trans. Christine Edwards. 1979; rpt. New York: Routledge, 1998.

Vineberg, Steve. *Method Actors: Three Generations of an American Acting Style.* New York: Schirmer, 1991.

Global Impact of American Culture

Cowen, Tyler. *Creative Destruction: How Globalization Is Changing the World's Cultures.* Princeton: Princeton University Press, 2002.

Crane, Diana, Nobuko Kawashima, and Ken'ichi Kawasaki, eds. *Global Culture: Media, Arts, Policy, and Globalization.* New York: Routledge, 2002.

de Grazia, Victoria. *Irresistible Empire: America's Advance through Twentieth-Century Europe.* Cambridge: Harvard University Press, 2005.

Fehrenbach, Heide, and Uta Poiger, eds. *Transactions, Transgressions, Transformations: American Culture in Western Europe and Japan.* New York: Berghahn, 2000.

LeMahieu, D. L. *A Culture for Democracy: Mass Communication and the Cultivated Mind in Britain between the Wars.* Oxford: Clarendon, 1988.

Pells, Richard. *Not Like Us: How Europeans Have Loved, Hated, and Transformed American Culture since World War II.* New York: Basic, 1997.

Rydell, Robert, and Rob Kroes. *Buffalo Bill in Bologna: The Americanization of the World, 1869–1922.* Chicago: University of Chicago Press, 2005.

Wagenleitner, Reinhold, and Elaine May, eds. *"Here, There, and Everywhere": The Foreign Politics of American Popular Culture.* Hanover, N.H.: University Press of New England, 2000.

INDEX

Aalto, Alvar, 97
ABC, 110, 267–278, 375
Abstract Expressionists, 52–59, 61, 62, 148, 149, 273; techniques of, 54–55, 354, 370
Academy of Motion Picture Arts and Sciences. *See* Oscars
Actors Studio, 333, 353–356, 370, 371
Adagio for Strings (Barber), 110
Adams, Henry, 12, 16, 65
Adderley, Cannonball, 151
Adler, Jacob, 347
Adler, Luther, 349
Adler, Stella, 347, 348, 349, 351, 353, 355–356
Adorno, Theodor, 50
Adventures of Robin Hood, The (film), 234
advertising, 85, 86, 89–92, 97, 108, 122; Art Deco and, 93; Freudian theory and, 18; MoMA exhibitions of, 40; Regionalist painters and, 45
Advise and Consent (film), 245
Aeolian Hall (N.Y.C.), 174–175
affective memory, 345, 351, 354, 355, 368
African Americans, 8–9, 164; big bands and, 144, 145, 147; cultural diplomacy and, 154–155; dance influence of, 187; as expatriates, 4, 12,

138, 139; film stereotypes of, 217; migration from South of, 134; musical tradition and, 53, 112, 117, 119, 131–134 (*see also* jazz); rock and roll and, 153; white musicians and, 166–167, 177–178
African Queen, The (film), 359
Âge d'or, L' (film), 32
Agee, James, 45
Agon, (Stravinsky), 127
Albee, Edward, 270, 307
Albers, Josef, 72, 74
Alfred Hitchcock Presents (TV show), 268, 298
Algonquin Round Table, 10, 168
Alice's Restaurant (film), 277, 306
Alien (film), 394
All about Eve (film), 270, 380
Allen, Gracie, 109
Allen, Woody, 10, 135, 169, 175, 238, 295, 300, 325–329, 330, 331, 362, 381; influences on, 284, 289, 326, 328, 329; outlook of, 284, 325–329, 385
All My Sons (Miller), 353
All That Jazz (film), 130, 191–192, 195–196, 198, 284
All the President's Men (film), 314–315, 333, 369, 399
Almendros, Néstor, 302
Altman, Robert, 191–192, 194–195,